www.wadsworth.com

wadsworth.com is the World Wide Web site for Wadsworth Publishing Company and is your direct source to dozens of online resources.

At wadsworth.com you can find out about supplements, demonstration software, and student resources. You can also send e-mail to many of our authors and preview new publications and exciting new technologies.

wadsworth.com

Changing the way the world learns®

From the Wadsworth Series in Production

Albarran, Alan B., Management of Electronic Media

Alten, Stanley, Audio in Media, 5th ed.

Armer, Alan, Directing TV and Film, 2d ed.

Armer, Alan, Writing the Screenplay, 2d ed.

Azarmsa, Reza, Multimedia: Interactive Video Production

Butler, Jeremy G., Television: Critical Methods and Applications

Eastman, Susan Tyler, and Douglas A. Ferguson, *Broadcast/Cable Programming: Strategies and Practices*, 5th ed.

Gross, Lynne S., and Larry W. Ward, Electronic Moviemaking, 3d ed.

Hausman, Carl, Lewis B. O'Donnell, and Philip B. Benoit, *Modern Radio Production*, 4th ed.

Hilliard, Robert L., Writing for Television and Radio, 6th ed.

Kurland, Daniel J., Frank Messere, and Philip J. Palombo, *Introduction to the Internet for Electronic Media: Research and Application*

Mamer, Bruce, Film Production Technique: Creating the Accomplished Image

Meeske, Milan D., Copywriting for the Electronic Media, 3d ed.

Morley, John, Scriptwriting for High-Impact Videos: Imaginative Approaches to Delivering Factual Information

O'Donnell, Lewis B., Philip B. Benoit, and Carl Hausman, *Announcing: Broadcast Communicating Today*, 3d ed.

Viera, Dave, Lighting for Film and Electronic Cinematography

Zettl, Herbert, Sight Sound Motion, 3d ed.

Zettl, Herbert, Television Production Handbook, 6th ed.

Zettl, Herbert, Television Production Workbook, 6th ed.

Zettl, Herbert, Video Basics 2

Zettl, Herbert, Video Basics 2 Workbook

Zettl, Herbert, Zettl's Video Lab 2.1, CD-ROM

SIGHT SOUND MOTION

SIGHT

APPLIED

MEDIA

THIRD EDITION

SOUND MOTION

AESTHETICS

HERBERT ZETTL

San Francisco State University

WADSWORTH PUBLISHING COMPANY

An International Thomson Publishing Company I $\widehat{T}P^{\otimes}$

Executive Editor: Deirdre Cavanaugh Assistant Editor: Ryan E. Vesely Editorial Assistant: Matthew Lamm Marketing Manager: Mike Dew Marketing Assistant: Shannon Ryan Advertising Project Manager: Tami Strang

Project Editor: Cathy Linberg
Print Buyer: Barbara Britton
Permissions Editor: Robert Kauser
Designer: Gary Palmatier, Ideas to Images

Production Manager: Gary Palmatier, Ideas to Images

Copy Editor: Elizabeth von Radics

Cover Designers: Stephen Rapley, Gary Palmatier Cover Photographer: William Boorstein

Cover Printer: Phoenix Color, Inc. Compositor: Ideas to Images

Printer: R.R. Donnelley & Sons, Crawfordsville

Copyright © 1999 by Wadsworth Publishing Company

I P A Division of International Thomson Publishing Inc.

The ITP logo is a registered trademark under license.

Front cover photograph © 1998 William Boorstein of Sharon Fogarty Dance Theatre, Inc.

Printed in the United States of America.

1 2 3 4 5 6 7 8 9 10

For more information, contact Wadsworth Publishing Company, 10 Davis Drive, Belmont, CA 94002, or electronically at http://www.wadsworth.com

International Thomson Publishing Europe Berkshire House 168-173 High Holborn

London, WC1V 7AA, United Kingdom

Nelson ITP, Australia 102 Dodds Street South Melbourne Victoria 3205 Australia

Nelson Canada 1120 Birchmount Road Scarborough, Ontario Canada M1K 5G4

International Thomson Publishing Southern Africa Building 18, Constantia Square 138 Sixteenth Road, P.O. Box 2459 Halfway House, 1685 South Africa International Thomson Editores Seneca, 53 Colonia Polanco 11560 México D.F. México

International Thomson Publishing Asia 60 Albert Street #15-01 Albert Complex Singapore 189969

International Thomson Publishing Japan Hirakawa-cho Kyowa Building, 3F 2-2-1 Hirakawa-cho, Chiyoda-ku Tokyo 102 Japan

All rights reserved. No part of this work covered by the copyright hereon may be reproduced or used in any form or by any means—graphic, electronic, or mechanical, including photocopying, recording, taping, or information storage and retrieval systems—without the written permission of the publisher.

Library of Congress Cataloging-in-Publication Data

Zettl, Herbert.

Sight, sound, motion: applied media aesthetics / Herbert Zettl. -

- 3rd ed.

p. cm.

Includes bibliographical references and index.

ISBN 0-534-52677-2

1. Cinematography. 2. Motion pictures—Production and direction.

I. Title.

TR850.Z47 1998

778.5—dc21

98-2745

To Renée and Mike

About the Author

Arts at San Francisco State University, where he teaches in the areas of video production and media aesthetics. Prior to joining the SFSU faculty, he worked at KOVR (Sacramento-Stockton) and as a producer-director at KPIX, the CBS affiliate in San Francisco. He has participated in a variety of CBS and NBC network television productions. He has also been a consultant on television production and media aesthetics for universities and professional broadcasting operations here and abroad, and is currently engaged in various experimental television productions.

Zettl's other books include the *Television Production Handbook* and *Video Basics 2*, both of which, along with this book, have been translated into other languages. His numerous articles on television production and media aesthetics have appeared in major media journals in this country as well as in Europe and Asia. He has read key papers on television production and media aesthetics at a variety of communication conventions.

His interactive multimedia CD-ROM, Zettl's Video Lab 2.1, published by Wadsworth Publishing Company, has won several prestigious awards, among them the Macromedia People's Choice Award, the New Media Invision Gold Medal for Higher Education, and Invision Silver Medals in the categories of Continuing Education and Use of Video.

Preface

the basic purpose of this edition of *Sight Sound Motion* has not changed from the two previous ones: It describes the major aesthetic image elements—light, space, time/motion, and sound—and how they are used in television and film. With the ever-increasing demand for more and more higher-quality programs, a thorough understanding of the principles of media aesthetics and their prudent use is no longer a matter of choice; it has become an essential prerequisite for the responsible producer and consumer of television and film communication.

As media producers, we can no longer rely solely on instinct when it comes to encoding messages. We need to acquire the knowledge and skill to select and apply those aesthetic elements that help us translate significant ideas into significant messages efficiently, effectively, and predictably. Ever-increasing time and money restrictions make it impractical, if not impossible, to produce three or more versions of the same message before deciding on which one might be the most effective. Media aesthetics provides us with the techniques and criteria to produce optimal messages the first time around.

Media aesthetics supplies the basis for media literacy—an educational discipline that has become an essential prerequisite for responsible citizenship. The criteria explained in *Sight Sound Motion* help us, as consumers of media messages, to see behind the obvious text and experience and judge television and film communication on several emotional and intellectual levels with accuracy and consistency.

This book is not necessarily restricted to the media field, however. If we simply can be shaken loose from our perceptual complacency and made to see, feel, listen, and move about with heightened awareness and joy; if we can be helped to find our way through the chaos of daily experiences, to recognize the significant ones and share them with the people of our global community; and, finally, if we can be helped to reach even a minimal degree of emotional literacy that contributes to self-awareness, self-respect, and genuine compassion for our fellow human beings, this book has proved its worth.

Although media aesthetic principles are not necessarily linked to changes in production equipment, this edition contains several new concepts in media aesthetics that are a direct outgrowth of digital video effects (DVE). For example, the section on first- and second-order television space explains some

of the aesthetic consequences of digitally created video space. Other new concepts include the aesthetic uses of the jump cut, and new techniques available for complexity editing.

Here are some more features of this edition:

- Content and Method To make the book optimally readable without sacrificing any of its complex material, I have divided it into five principal aesthetic fields: (1) light and color, (2) two-dimensional space, (3) three-dimensional space, (4) time/motion, and (5) sound. This organization allows for careful study of the individual aesthetic elements while at the same time maintaining their essential interrelation. Many of the aesthetic principles described in this edition have been confirmed by rigorous empirical research. Others have been developed through keen observation and educated insight. Because aesthetics is contextual and not a rigorous science, the empirical method does not reign supreme; the various heuristic and phenomenological approaches serve the investigation of media aesthetics equally well.
- Cross-references Frequent reference is made in the text to how a specific aesthetic principle in one field recurs in another or several other fields. These cross-references should help students see the interrelationships among the various principles and their contextual effect on one another.
- New Chapter Because of the ever-increasing importance of post-production editing, I have divided the editing section into two separate chapters. I hope that this division will facilitate learning the complex aesthetics of editing while, at the same time, serve as a stimulus for thinking of new ways of sequencing images. These chapters include expanded aesthetic principles spawned by a new time consciousness and the advancement of digital technology.
- Instructor's Manual For the first time, this edition of Sight Sound Motion is accompanied by an extensive Instructor's Manual, containing suggestions for classroom demonstrations, exercises, discussions, and a battery of tests. It is intended strictly as a guide, not as a dictum. The demonstrations do not require top-of-the-line equipment. They can be done with a simple consumer camcorder and a low-end VCR; but they can also be done somewhat more effectively in a multicamera studio setup. Ideally, the Instructor's Manual should stimulate the instructor to come up with maximally effective ways to make the connection between media aesthetic principles and their applications.
- Zettl's Video Lab 2.1 CD-ROM This interactive CD-ROM combines the basic television production techniques with some of the fundamental aesthetic media principles. It is truly interactive, which means that the user can zoom in and out, turn on various lighting instruments, mix various sounds, and edit certain shots together and immediately see the results. An extensive quiz program and instant access to the glossary reinforce learning. It can be used as a convenient way to help the user acquire or reinforce basic video and film production techniques, and to show aesthetic concepts that need to be seen in motion. The Instructor's Manual refers to the relevant sections of the Zettl's Video Lab 2.1 CD-ROM for each chapter of Sight Sound Motion.

I should like to give sincere thanks to my colleagues Jim Carter of California University of Pennsylvania, Bill Deering of the University of Wisconsin/Stevens Point, Anthony Friedmann of Mount Ida College, Glen Johnson of Catholic University, Philip Kipper of San Francisco State University, Michael Korpi of Baylor

University, Michael Ogden of the University of Hawaii, and Robert Tiemens of the University of Utah for their astute comments during the writing of this book and their valuable suggestions for the final preparation of the text.

My tribute and thanks go to John Veltri for doing such a great job on the new photography for *Sight Sound Motion*.

As usual, the Wadsworth people were as demanding as they were helpful and accommodating. I am especially indebted to Randall Adams, acquisitions editor; Ryan Vesely, assistant editor; Matthew Lamm, editorial assistant; and Cathy Linberg, project editor. Special thanks to Melanie Field for her invaluable assistance in organizing the photographs that appear in these pages.

Gary Palmatier of Ideas and Images and copy editor Elizabeth von Radics were the ones who finally transformed my manuscript pages, scribbles, sketches, and the photos into the book you are holding in your hands. My gratitude for their superb job needs no explanation.

Many thanks also to my colleagues Jerry Higgins, Stuart Hyde, Hamid Khani, Nikos Metallinos, Winston Tharp, and Larry Whitney, who were always ready to lend their expert help; to the students who made me rethink and clarify many of the more difficult concepts; and to the photo models who helped translate aesthetic theory into practice. They are as follows:

		_
Martin Aichele	Daniel Gorrell	Kerry Moynahan
Mathew Baker	James Hally	André Nguyen
Shibani Battiya	Jan Hanson	Einat Nov
Brian Biro	Joshua Hecht	Dimitry Panov
George Caldas	Clark Higgins	Ildiko Polony
William Carpenter	Janellen Higgins	Rachel Rabin
NeeLa Chakravartula	Nicolina Higgins	Jon Rodriquez
Brandon Child	Shawn Higgins	Renée Stevenson
Laura Child	Akiko Kajiwara	Coleen Sullivan
Rebecca Child	Hamid Khani	José Tello
Joseph Cino	Phil Kipper	Marc Toy
Janine Clarke	Kimberly Kong	Selene Veltri
Peter Coakley	Surya Kramer	Athena Wheaton
S. Cowan	Jason Kuczenski	Carey Wheaton
Elsa Eder	Terri Loomis	Gabriel Wheaton
Askia Egashira	Susan Mahboob	Jim Wheaton
Chaim Eyal	Orcun Malkolar	Dunping Daniel Zheng
Helen Fong	Teri Mitchell	

Finally, a big hug for my wife, Erika, who supported me throughout this project and who, when I got stuck with my writing or thinking, helped me get unstuck.

Herbert Zettl

Contents

Prologue	1
Applied Media Aesthetics	2
Applied Media Aesthetics: Definition	3
Applied Aesthetics and Contextualism	4
Art and Experience 4	
Incidents of Life 5	
Contextualistic Aesthetics 5	
Context and Perception	5
Stabilizing the Environment 6	
Selective Seeing 6	
The Power of Context 7	
The Medium as Structural Agent	10
Applied Media Aesthetics: Method	11
Fundamental Image Elements 11	
Content 11	
Responsibility 12	
Summary	13
Notes 14	

The First Aesthetic Field: Light	16
,	
The Nature of Light	17
Lighting Purposes and Functions	18
The Nature of Shadows	19
Attached and Cast Shadows 20	
Falloff 22	
Outer Orientation Functions: How We See an Event	24
Spatial Orientation 24	
Tactile Orientation 24	
Time Orientation 26	
Inner Orientation Functions: How We Feel About an Event	28
Establishing Mood and Atmosphere 28	
Above- and Below-Eye-Level Key-Light Position 28	
Predictive Lighting 29	
Light and Lighting Instruments as Dramatic Agents 30	
Summary	30
Notes 31	

Notes

60

Silhouette Lighting
Media-Enhanced and Media-Generated Lighting
Single- and Multiple-Camera Lighting
Summary
The Extended First Field: Color 46
What Is Color? 47
How We Perceive Color
Basic Physiological Factors 48 Basic Psychological Factors 49 Compatible Color 50
How We Mix Color 50
Additive Color Mixing 51 Subtractive Color Mixing 52 Mixed Mixing 52
Relativity of Color
Light Environment 54 Surface Reflectance 54
Color Temperature 54
Surrounding Colors 55
Color Juxtaposition 56
Color Constancy 56
Colors and Feelings
Warm and Cold Colors 57
Color Energy
<i>Summary</i>

Structuring Color: Function and Composition	62
Structuring color. Function and composition	UZ
Informational Function of Color	63
Color Symbolism 64	
Compositional Function of Color	65
Color Energy 65	
Expressive Function of Color	66
Expressing Essential Quality of an Event 66	
Adding Excitement and Drama 67	
Establishing Mood 68	
Desaturation Theory	68
Colorizing Film 69	
Television Commercials 70	
Summary	70
Notes 71	

The Two-Dimensional Field: Area	72
Aspect Ratio	73
Aspect Ratio and Framing 74	
Changing the Aspect Ratio 77	
Object Size	80
Knowledge of Object 81	
Relation to Screen Area 81	
Environmental Context 82	
Reference to a Person 82	
Image Size	82
Image Size and Relative Energy 83	
People and Things 83	

Deductive and Inductive Visual Approaches	
Deductive Approach 83	
Inductive Approach 84	
Summary	
Notes 87	
7	
The Two-Dimensional Field: Forces Within the Screen 88	
Main Directions: Horizontal and Vertical	
Horizontal/Vertical Combination 90	
Tilting the Horizontal Plane 90	
Magnetism of the Frame	
Headroom 93	
Pull of Top Edge 94	
Pull of Side Edges 94	
Pull of Entire Frame 96	
Attraction of Mass 96	
Asymmetry of the Frame	
Up/Down Diagonals 97	
Screen-Left and Screen-Right Asymmetry 98	
Figure and Ground	
Figure-Ground Characteristics 100	
Psychological Closure	
Gestalt 102	
High- and Low-Definition Images 103	
Facilitating Closure 104	
Vectors	
Vector Field 106	
Vector Types 106	
Vector Magnitude 108	
Vector Directions 109	
<i>Summary</i>	
Notes 112	

Notes

139

Structuring the Two-Dimensional Field: Interplay of Screen Forces

_	_	_
1	1	Λ
		4

Stabilizing the Field Through Distribution of Graphic Mass and Magnetic Force \dots	116
Screen-Center 117	
Off-Center 117	
Counterweighting 118	
Stabilizing the Field Through Distribution of Vectors	119
Structural Force of Index Vectors 119	
Leadroom 120	
Converging Vectors 121	
Graphic Vectors 121	
Stages of Balance	122
Stabile Balance 122	
Neutral Balance 122	
Labile Balance 125	
Object Framing	126
Facilitating Closure 126	
Graphic Cues 127	
Premature Closure 127	
Natural Dividing Lines 128	
Illogical Closure 130	
Extending the Field with Multiple Screens	130
Continuing Graphic Vectors 132	
Off-Screen Space Limits 132	
Index Vector Combinations 133	
Z-axis Vectors in Three-Screen Space 135	
Dividing the Screen: Screens Within the Screen	136
Summary	137

The Three-Dimensional Field: Depth and Volume 140	
The Z-axis	
Graphic Depth Factors	
Overlapping Planes 144	
Relative Size 145	
Height in Plane 146	
Linear Perspective 147	
Aerial Perspective 150	
Depth Characteristics of Lenses 150	
Overlapping Planes: Wide-Angle Lens 151	
Overlapping Planes: Narrow-Angle Lens 151	
Relative Size: Wide-Angle Lens 152	
Relative Size: Narrow-Angle Lens 152	
Linear Perspective: Wide-Angle Lens 153	
Linear Perspective: Narrow-Angle Lens 153	
Achieving Aerial Perspective 154	
Major Graphication Devices	
Lines and Lettering 157	
First- and Second-Order Space 158	
Topological and Structural Changes 160	
<i>Summary</i>	
Notes 162	

Structuring the Three-Dimensional Field: Building Screen Volume	164
/olume Duality	165
Dominant Positive Volume 167	
Preponderant Negative Volume 169	
Applications of Volume Duality 170	
Z-axis Articulation	171
Narrow-Angle Lens Distortion 172	
Wide-Angle Lens Distortion 174	
Z-axis Blocking	176
Spatial Paradoxes	178
Superimposition 178	
Figure-Ground Paradox 179	
Relative Size Paradox 180	
Gummary	181
Notes 181	

Building Screen Space: Visualization 182
Storyboard
Ways of Looking
Looking At an Event 186
Looking Into an Event 186
Creating an Event 186
Field of View
Point of View
POV: Looking Up and Looking Down

POV: Subjective Camera	192
Assuming the Character's Point of View 192	
Being Discovered 194	
Direct-Address Method 194	
POV: Over-the-Shoulder and Cross Shooting	195
Over-the-Shoulder Shooting 196	
Cross Shooting 196	
POV: Multiple Z-axis Blocking	198
Angles	198
Angles for Vector Continuity 199	
Angles for Multiple Viewpoints 199	
Angles for Point-of-View Clarification 200	
Angles for Event Intensification 200	
Angles for Setting Style 203	
Summary	204
Notes 205	
17	
The Four-Dimensional Field: Time	206
The Importance of Time	207
What Is Time?	
Types of Time	211
Objective Time 211 Subjective Time 212	
Biological Time 215	
-	215
Time Direction	215
Past/Present/Future 216	
Saint Augustine and the Present 216 The Present as Subjective Time 216	
Transcending Time 217	
manacendina nine 21/	

Time Vectors in Live Television
Live Television and Objective Time Vectors 218
Live Television and Subjective Time Vectors 218
Time Vectors in Recorded Television and Film
Live-on-Tape 220
Instant Replays 221
Time Vectors in Edited Videotape and Film
<i>Summary</i>
Notes 222
13
The Four-Dimensional Field: Motion 224
Motion and Media Structure
Zeno and Film 225
Basic Structural Unit of Film 227
"At-At" Motion of Film 228
Bergson's Motion 228
Basic Structural Unit of Television 230
The Process Image of Television 230
Digital Video 231
Process Image of LCD and Plasma Displays 232
Film on Television 232
High-Definition Television 233
Motion Paradox
Frames of Reference 234
Figure-Ground Reversal 235
Z-axis Motion
Z-axis Motion

Slow Motion
Filmic Slow Motion: Frame Density 238
Slow Motion in Television: Playback Speed 238
Absence of Gravity 239
Aesthetic Effects of Slow Motion 239
Accelerated Motion
Filmic Accelerated Motion: Frame Density 240
Accelerated Motion in Television: Playback Speed 240
Summary 241
Notes 242
4 4
Control of Fig. 19 15 15 15 15 15 15 15 15 15 15 15 15 15
Structuring the Four-Dimensional Field:
Timing and Principal Motions 244
- Initing and I malpar mount
Types of Objective Time: Timing
- '
Types of Objective Time: Timing

Structuring the Four-Dimensional Field:	
	264
Graphic Vector Continuity	266
Index Vector Continuity	267
Continuing, Converging, and Diverging Index Vectors 267	
Index Vector–Target Object Continuity 269	
Successive Z-axis Index Vectors 271	
The Index Vector Line	272
Camera Placement for Cross Shooting 274	
Camera Placement for Over-the-Shoulder Shooting 275	
Z-axis Position Change 276	
Establishing the Index Vector Line 277	
Motion Vector Continuity	279
Continuing, Converging, and Diverging Motion Vectors 279	
Z-axis Motion Vectors and Continuity 282	
The Motion Vector Line	202
Establishing the Motion Vector Line 283	203
Motion and Index Vector Lines 285	
Special Continuity Factors	286
Action Continuity 287	
Subject Continuity 288	
Color Continuity 288	
Continuity of Environment 288	
Summary	289
Notes 280	

Structuring the Four-Dimensional Field: Complexity Editing	290
Metric Montage	292
Analytical Montage	293
Sequential Analytical Montage 293	
Sectional Analytical Montage 296	
Idea-Associative Montage	298
Collision Montage 300	
Summary	304

The Five-Dimensional Field: Sound 306 Television and Film Sound 308 **Television Sound** 308 Film Sound 310 Literal Sound 311 311 Nonliteral Sound Literal and Nonliteral Sound Combinations 312 The Importance of Context Dialogue 314 **Direct Address** 314 Narration 316

Duration

Melody

Harmony

Homophony

Polyphony

Attack/Decay

329

333

335

335

337

330

329

Loudness (Dynamics)

Outer Orientation Functions of Sound	317
Space 317	
Time 318	
Situation 319	
External Condition 319	
Inner Orientation Functions of Sound	320
Mood 320	
Internal Condition 320	
Energy 320	
Structure 321	
Aesthetic Factors	322
Figure-Ground 322	
Sound Perspective 322	
Sound Continuity 323	
Summary	323
Notes 325	
Structuring the Five-Dimensional Field: Sound Structures and Sound/Picture Combinations	227
Sound/Picture Combinations	326
Elements of Sound	327
Pitch 327	
Timbre 328	

Sound Structures and Dramaturgy	344
Sound Elements and Dramaturgical Parallels 344	
Sound Structures and Dramaturgical Parallels 344	
Picture/Sound Combinations	345
Homophonic Structures 346	
Polyphonic Structures 346	
Montage 349	
Picture/Sound Matching Criteria	351
Historical-Geographical 351	
Thematic 352	
Tonal 352	
Structural 352	
Summary	356
Notes 357	
Epilogue	359
Glossary	261
Glossary	301
Bibliography	377
Photo Credits	389
riioto cieuits	207
Index	391

Prologue

HIS book gives you the tools to clarify, intensify, and interpret events for television, computer, and film presentation. In effect, it teaches you how to apply major aesthetic elements to manipulate people's perceptions. Because media consumers are largely unaware of the power of media aesthetics, they must and do trust your professional judgment and especially your good intentions.

Irrespective of the scope of your communication—be it a brief news story, an advertisement, or a major dramatic production—your overriding aim should be to help people attain a higher degree of emotional literacy, the ability to see the world with heightened awareness and joy. All your aesthetic decisions must ultimately be made within an ethical context, a moral framework that holds supreme the dignity and well-being of humankind.

Applied Media Aesthetics

ONSCIOUSLY or not, you make many aesthetic choices every day. When you decide what to wear, or clean up your room so that things are put back where they belong, or choose what flowers to put on the dinner table, or even when you judge the speed or distance of your car relative to other cars while driving, you are engaging in basic perceptual and aesthetic activities. Even the everyday expression "I know what I like" requires aesthetic judgment.

When you select a certain picture to put on your wall, choose a specific color for your car, or look through the viewfinder of a camera, you are probably more conscious of making an aesthetic decision. This kind of decision making, as any other, requires that you know what choices are available and that you have some guidelines, or principles, to help you make optimal decisions with a minimum of wasted effort. Painting your bathroom first red, then pink, then orange only to discover that off-white is in fact the best color would be not only expensive and time-consuming but also cumbersome and unproductive.

As a responsible mass communicator, however, you need to go beyond everyday reflexes and approach creative problems with an educated perspective. You also need to develop a heightened sense of vision and learn how to give such vision significant form so that you can share it with your fellow human beings. Applied media aesthetics helps you in this formidable task. If not communicated effectively, significant vision subsides into an insignificant dream.

To provide you with some overview of applied media aesthetics and a background for its study, let us focus on five major areas: (1) applied media aesthetics: definition, (2) applied aesthetics and contextualism, (3) context and perception, (4) the medium as structural agent, and (5) applied media aesthetics: method.

Applied Media Aesthetics: Definition

Applied media aesthetics differs from the traditional concept of aesthetics in three major ways. First, we no longer limit aesthetics to the traditional philosophical concept that deals primarily with the understanding and appreciation of beauty and our ability to judge beauty with some consistency. Nor do we consider aesthetics only to mean the theory of art and art's quest for truth. *Applied media aesthetics* considers art and life as mutually dependent and essentially

interconnected. Its major functions are based on the original meaning of the Greek verb aisthanomai ("I perceive") and the noun aisthetike ("sense perception"). Aesthetics is not an abstract concept, but a process in which we examine a number of media elements, such as lighting and picture composition, and our perceptual reactions to them.² Second, the media—in our case primarily television and film and, to a lesser extent, visual computer displays—are no longer considered neutral means of simple message distribution, but essential elements in the aesthetic communication system. Third, whereas traditional aesthetics is basically restricted to analysis of existing works of art, applied media aesthetics serves synthesis as well—the creation of television shows, films, or computer screen displays. Finally, the criteria of applied aesthetics let you employ formative evaluation, which means that you can evaluate the relative communication effectiveness of the aesthetic production factors step-by-step while the production is still in progress.

Applied Aesthetics and Contextualism

Applied aesthetics emphasizes that art is not an isolated object hidden away in a museum and that aesthetic experiences are very much part of everyday life. Whatever medium you may choose for your expression and communication, art is a process that draws on life for its creation and, in turn, seems necessary in order to live life with quality and dignity. Even if you are not in the process of creating great works of art, you are nevertheless constantly engaged in myriad aesthetic activities—activities that require perceptual sensitivity and judgment.

But if ordinary life experiences are included in the process of art, how are you to distinguish between aesthetic processes that we call "art" and those that are not art? Is every aspect of life, every perceptual experience we have, art? No. Ordinary daily experiences may be full of wonder, but they are not art—not yet, in any case. But they do have the potential of serving as raw material for the process of aesthetic communication that we call art.

ART AND EXPERIENCE

What, then, is the deciding element that elevates an ordinary life experience into the realm of art? The critical factor is you—the artist—or a group of artists, such as the members of a television or film production team, who perceive, order, clarify, intensify, and interpret a certain aspect of the human condition for themselves or, in the case of media communication, for an audience.

The philosopher Irwin Edman pioneered a new aesthetic concept more than half a century ago that stresses the close connection between art and life. He wrote: "So far from having to do merely with statues, pictures, symphonies, art is the name for that whole process of intelligence by which life, understanding its own conditions, turns these into the most interesting or exquisite account." This process presupposes that life is given "line and composition" and that the experience is clarified, intensified, and interpreted. "To effect such an intensification and clarification of experience," Edman says, "is the province of art."

From this perspective, events that some may consider utilitarian or ugly have as much of a chance of becoming an aesthetic experience as a beautiful sunset. **SEE 1.1** This process of clarification, intensification, and interpretation is also the province of applied media aesthetics. Whenever you look through the viewfinder of a camera, arrange some visual elements on a computer screen, or edit a film or videotape sequence, you are engaged in the creative act of clarifying, intensifying, and interpreting some event for a particular audience.

Irwin Edman (1896–1954) was a philosopher and a professor of philosophy at Columbia University. His main theme in his teaching and writing was to connect, rather than isolate, art with the ordinary aspects of life.

1.1 Art and Life

Within the contextualistic framework, we can draw aesthetic experience from all aspects of life. By giving "line and composition" to even a relatively ordinary scene, an artist can help us perceive its inherent beauty.

INCIDENTS OF LIFE

In the spirit of Edman, *contextualism* stresses the essential, intimate, and purposeful relationship between art and life. This means that we should evaluate art within its historical epoch and according to what the artist felt while creating it. Contextualism is also concerned with "incidents of life," events that are alive and spontaneous in their present. No proven absolutes exist, because the incidents of life relate contextually, that is, we perceive them in relation to one another. All these incidents finally fuse together to become an event of significance.⁵

CONTEXTUALISTIC AESTHETICS

Contextualism, or *contextualistic aesthetics*, serves as a convenient frame of reference for the discussion of applied media aesthetics. As you will discover, the various fields of applied aesthetics consist of "perceptual incidents," which, when combined, can result in significant media experiences. Also, the various fields of applied media aesthetics (light, space, time/motion, and sound) are truly contextual—they all must interact to produce the final communication effect.

Context and Perception

We perceive our world not in terms of absolutes but rather as changing contextual relationships. When we look at an event, for example, we are constantly engaged in judging one aspect of it against another aspect or another event. A car is going fast because another one is going slow or because it moves past a relatively stationary object. An object is big because another one is smaller. The beam from

the same flashlight looks pitifully dim in the midday sun but bright and powerful in a dark room.

When you drive a car, your perceptual activities work overtime. You are constantly evaluating the position of your car relative to the surroundings, and the changes in the surroundings relative to your car. No wonder you feel tired after even a short drive through the city during rush hour. Even when you sit perfectly still and stare at a stationary object, such as a table, your eyes move constantly to scan the object. Then you fuse the many, slightly different views together into a single image of the table, much as a well-edited sequence of various camera angles becomes a cohesive image.

How, then, can we ever make sense of our multiple views of a changing world with its onslaught of sensations? Our mental operating system encourages a considerable perceptual laziness that shields us from an input overload. We all develop habitual ways of seeing and hearing that make us focus on and notice only a small portion of what actually is there. We screen out most of the sensations that reach our eyes and ears, and stabilize and simplify as much as possible what we do perceive.⁶

STABILIZING THE ENVIRONMENT

Our perceptual mechanisms are designed to stabilize and simplify our surroundings as much as possible so that they become manageable. We tend to cluster certain event details into patterns and simple configurations, perceive the size of an object as constant regardless of how far away we are from it, and see the same color regardless of the actual color variations when part of the color object is in the shade. Another of our automatic, "hardwired" perceptual stabilizers is the *figure-ground principle*, whereby we order our surroundings into foreground figures that lie in front of, or move against, a more stable background.⁷

SELECTIVE SEEING

Most of us tend to notice only those events, or details of events, that we want to see or are used to seeing. In our habitual ways of seeing, we generally select information that agrees with how we want to see the world, and we screen out almost everything that might interfere with our constructs. This type of *selective seeing*—frequently but not too accurately called "selective perception"—is like selective exposure to information. Once we have made up our minds about something, we seem to expose ourselves mostly to messages that are in agreement with our existing views and attitudes, ignoring those messages that would upset our deeply held beliefs. We also choose to look at things we like to see and are especially interested in, and ignore those that mean little to us. **SEE 1.2**

Although such cue reductions—the automatic screening of superfluous detail—in our perceptual processes are imperative to maintaining sanity, they can also create problems. For example, we often see and hear only those details of an experience that fit our prejudicial image of what the event should be and ignore the ones that interfere with this image. We then justify our questionable selection process by pointing out that the event details selected were, indeed, part of the actual occurrence. For example, if you have come to believe (perhaps through advertising or a recommendation) that the Shoreline Cafe has a nice atmosphere and serves excellent food, a friendly waiter may be enough evidence to verify your positive image, even if the restaurant's food is actually quite awful. By looking only at what we want to see rather than at all there is to see, we inevitably gain a somewhat distorted view of the world.
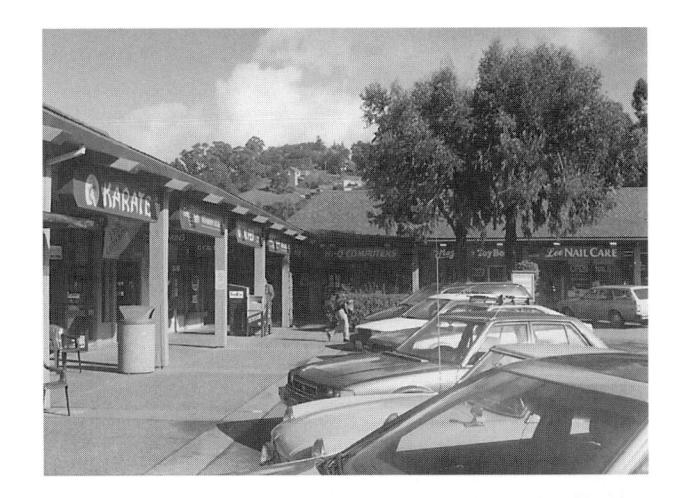

1.2 Selective Seeing

We tend to see events or event details that fit our perceptual expectations or that interest us highly. Each of us sees an event from his or her particular point of view according to a specific experiential context.

THE POWER OF CONTEXT

Many of our perceptions are guided, if not dictated, by the event *context*. Let's for a moment assume that you are to write down quickly the names of the major American television networks. You will probably end up with a list similar to the one shown here.

ABC NBC CIBS CNN FOX

Now we change the context to helping a child learn to write numbers from 11 to 15.

11 12 13 14 15

Take another look at the network names and the numbers. You may have noticed that the *B* in *CBS* and the *13* in the numbers series are very similar. In fact, they are identical. Obviously, the context has had a powerful influence on

1.3 Contextual Interpretation

In one context, the symbols at the center of this intersection are read as the letter *B*. In another context, they seem to be the number *13*.

the radically different perceptions of the identical sensation. As a matter of fact, you will probably find it difficult to see a *13* in the network context and the *B* in the numbers context. Going against the established context is almost as hard as nodding your head affirmatively while uttering "no" or shaking your head sideways while saying "yes." **SEE 1.3**

Some of our perceptual processes are so forceful that we respond to certain aesthetic stimuli in predictable ways even if we know that we are being perceptually manipulated. The many well-known optical illusions are good examples. SEE 1.4A AND 1.4B Although you may try vigorously to resist the idea of aesthetic manipulation, you cannot help perceiving the center circle in figure 1.4a as smaller than the one in Figure 1.4b although in reality they are exactly the same size. Again, the contextual circles make you perceive the central circles as being different sizes. When surrounded by small circles, the central circle appears larger than it does when surrounded by larger circles.

Sufficient consistency exists in human perceptual processes so that we can predict with reasonable accuracy how people will respond to specific aesthetic stimuli and contextual patterns. To test this, the next time you invite a friend to visit, move some of your pictures a little so that they hang slightly crooked. Then watch your friend. Most likely, he or she will soon get up and adjust the pictures so that they hang straight again. Your friend's action is a predictable response to a

1.4 Optical Illusion

Although we may know that the center circles in this Ebbinghaus figure are identical, we still perceive the center circle in (a) as smaller than the center circle in (b). The large surrounding circles make the center circle look relatively small (a), and the small surrounding circles make the center circle appear relatively large (b).

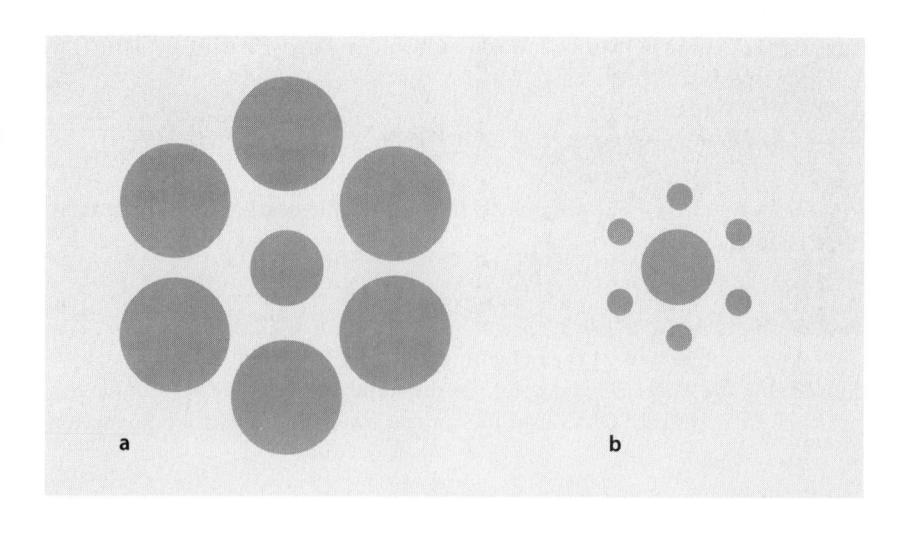

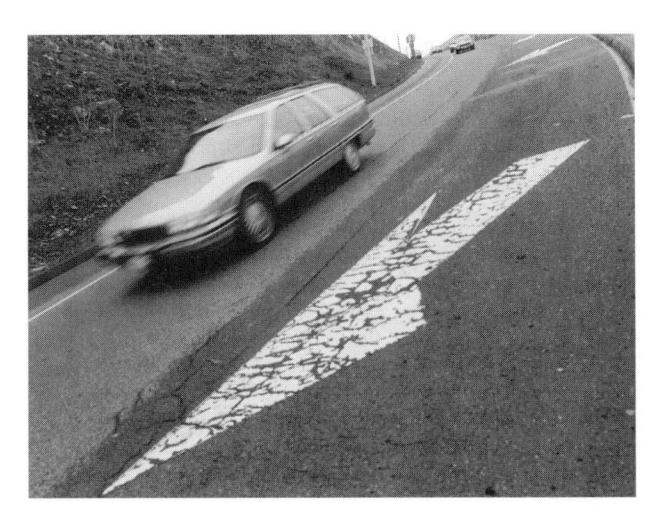

1.5 Tilted Horizon

We automatically perceive a tilted horizon line as a relatively unstable event. This car seems to travel precariously fast around the turn.

strong aesthetic stimulus—the disturbance of standing upright on level ground. You apply the same principle when you cant the camera to make a scene look more dynamic. **SEE 1.5**

Context establishes a code that dictates, at least to some extent, how you should feel about and interpret what you see. **SEE 1.6 AND 1.7** What is your initial reaction to the two advertisements?

Whereas you might respond positively to the eggs-for-sale sign and even buy some eggs if convenient, you would probably not be eager to sign up for your first flying lesson with Affordable Flights Company. Why? Because our experience tells us that awkward hand lettering may be appropriate in the context of a small, family-run, charmingly inefficient operation that occasionally sells surplus eggs. But in the context of aviation, the sloppy hand-lettered sign is not a good indicator of success, efficiency, and safety.

But if we seek only information that reinforces our personal projection of reality and are so readily manipulated by context, how can we ever attain a relatively unbiased view of the world? The fine arts have tried for centuries to break this vicious circle. Although we may still be tied to our automatic perceptual processes and stabilizing cue reductions, all art leads, at least to some extent, to counter this automatization, to see events from various points of view and shift from glance to insight. **SEE 1.8**

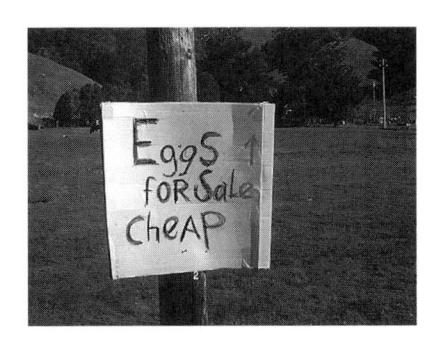

1.6 Eggs for Sale If convenient, would you respond to this sign and buy some eggs?

Justify your action.

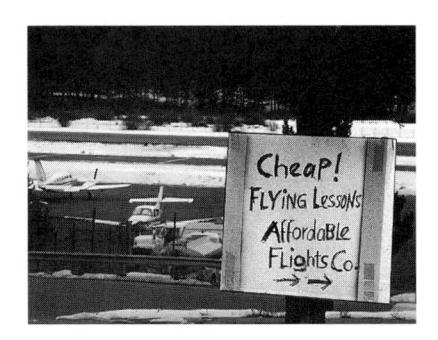

1.7 Cheap Flying Lessons

Would you respond to this advertisement and take some flying lessons from the Affordable Flights Company?

Justify your decision.

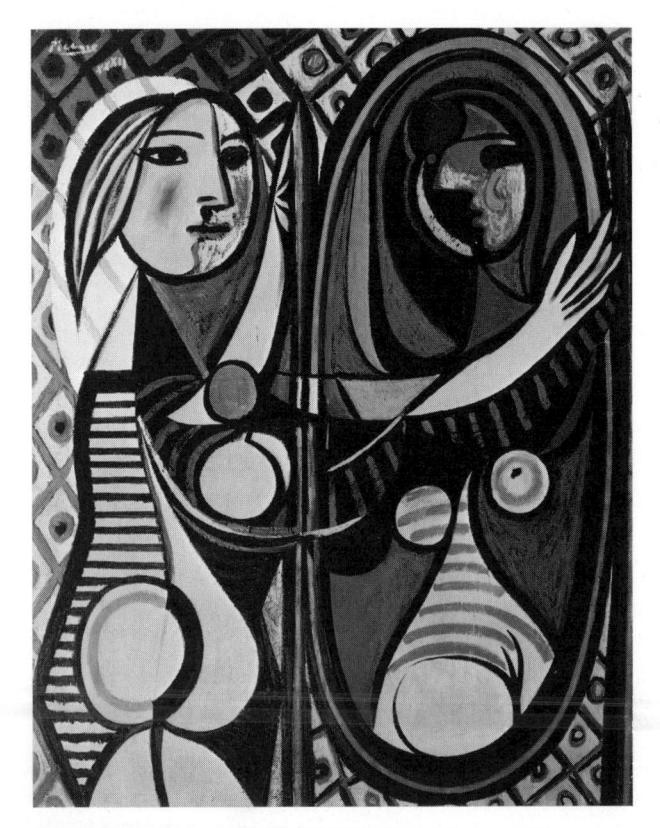

1.8 Looking into an Event

As in the Japanese film *Rashomon*, which shows one event from the perspectives of several different people, some paintings also permit a variation of viewpoints and a "looking into" the event. In this Picasso painting, we see the girl from straight on; we also see her profile and her reflection, representing her other self. Thus we perceive several layers of her existence. Pablo Picasso, *Girl Before a Mirror*, 1932, oil on canvas, 64" x 51½". Collection of the Museum of Modern Art, New York. Gift of Mrs. Simon Guggenheim.

Significant television and films, regardless of the genre, can and should do the same. Depending on where you put a camera or microphone, and what field of view or camera angle you select, your viewers have no choice but to share your point of view. You can prod viewers to see an event from different perspectives and advance them from "looking at" to "looking into." In essence, you can help viewers educate their perceptions.

Before you can expect to help viewers become more sensitive to their surroundings and unlearn, at least to some degree, their habitual ways of seeing, however, you will have to acquire a degree of aesthetic literacy that allows you to perceive the complexities, subtleties, and paradoxes of life and to clarify, intensify, and interpret them effectively for an audience.¹¹

The Medium as Structural Agent

Even when your primary function is to communicate specific information, you exert considerable influence on how a specific message is received. It certainly makes a difference to the receiver of the message whether you smile or frown when extending the familiar how-do-you-do greeting. As the medium, you influence the message significantly. The smile will show that you are, indeed, glad to see the other person; a frown would signal the opposite. The well-known communications scholar Marshall McLuhan proclaimed more than four decades ago that "the medium is the message." With this insightful overstatement, he meant that the media occupy an important position not only in the distribution of the message but also in *shaping* the message. Despite overwhelming evidence of how important the media are in

shaping the message, many prominent communication researchers still remain more interested in analyzing the content of the literal message than the combined effect of message and the medium as a structural agent.¹³ In their effort to keep anything from contaminating their examination of mass-communicated content, they consider the various media as merely neutral channels through which the all-important messages are distributed. Their analysis would reveal only your how-do-you-do greeting but ignore your smile or frown. This apparent lack of medium awareness stems from the very beginnings of systematic mass communication studies where the influence of the medium on the message was almost totally ignored.¹⁴ **SEE 1.9**

1.9 Communication Model

This model suggests that the communication process goes from idea to message and from message to recipient. It ignores the medium as an important factor in the communication process.

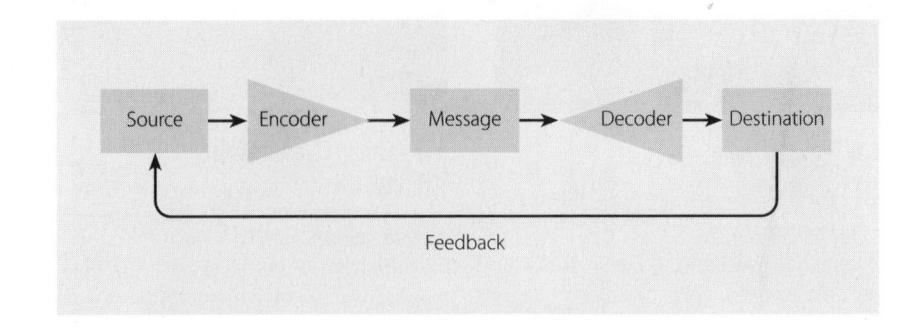

If you have ever tried to make oil paints or clay do what you wanted them to do, you will readily admit that the medium is not neutral by any means. In fact, it has a decisive influence on the final outcome of your creative efforts. Even if you intend to communicate the same message, you will have to go about it in different ways depending on whether, for example, you design this message for wide-screen cinema, television, or the computer screen.

Obviously, the encoding (production) as well as the decoding (reception) of the message are, to a considerable extent, a function of the technical and aesthetic potentials and requirements of the medium. Exactly how media, specifically television and film, shape or must shape the message for a specific viewer response is the subject of applied media aesthetics.

Applied Media Aesthetics: Method

The method of presenting applied media aesthetics is an inductive one based on theories and practices developed by the Russian painter and teacher Wassily Kandinsky. For Kandinsky, abstraction did not mean reducing a realistic scene down to its essential formal elements. **SEE 1.10** Rather, it meant an inductive process of building a scene by combining the "graphic elements"—the fundamental building blocks of painting, such as points, lines, planes, color, texture, and so forth—in a certain way. ¹⁵ **SEE 1.11** Following this approach, he was not limited by what was there in the world around him; instead he could extend his vision to what he felt *ought* to be there—the construction of a new world.

FUNDAMENTAL IMAGE ELEMENTS

In a similar inductive way, we have identified and isolated five fundamental and contextual *image elements* of television and film: (1) light and color, (2) two-dimensional space, (3) three-dimensional space, (4) time/motion, and (5) sound. In this book we will examine the aesthetic characteristics and potentials of these five elements and how we can structure and apply them within their respective aesthetic fields. This analysis is an essential prerequisite to understanding their contextual functions. Once you know the aesthetic characteristics and potentials of these fundamental image elements, you can study how they operate in the context of a larger aesthetic field and combine them knowledgeably into patterns that clarify, intensify, and effectively communicate significant experience. A thorough grasp of the five image elements will help you establish an aesthetic vocabulary and language unique to the medium of your choice—a language that will enable you to speak with optimum clarity and impact—and with a personal style.

CONTENT

You may wonder at this point what happened to content in all this discussion of fundamental aesthetic elements. Is not content the most fundamental of all aesthetic elements? Don't we first need an idea before we can shape it to fit the various medium and audience requirements? The answer to both of these questions is, of course, yes. But it is valuable to realize that a good idea by itself does not necessarily make for effective mass communication. You must learn how to mold an idea so that it fits the medium's technical as well as aesthetic production and reception requirements. This molding process, called *encoding*, presupposes a thorough knowledge of such production tools as cameras, lenses, lighting, audio, and so forth as well as applied aesthetics, such as the proper framing of a shot, the specific use of color, selective focus, and the use of a specific piece of music.

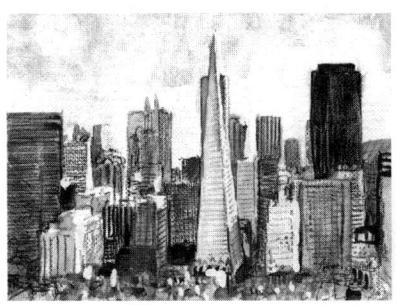

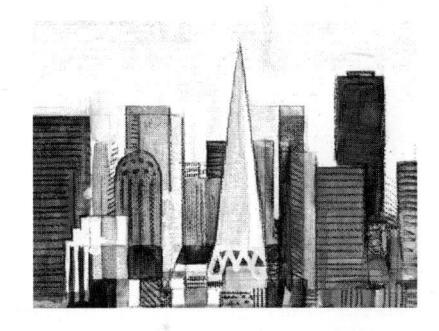

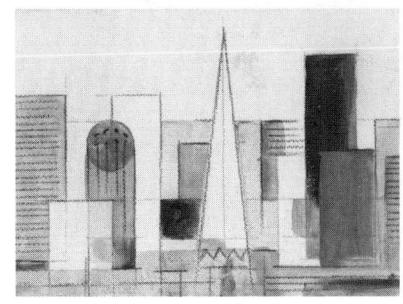

1.10 Deductive AbstractionIn the deductive approach to abstraction, we move from photographic realism to the essential qualities of the event.

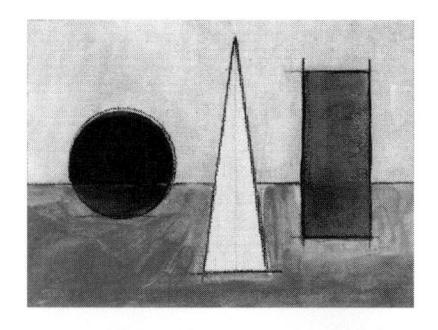

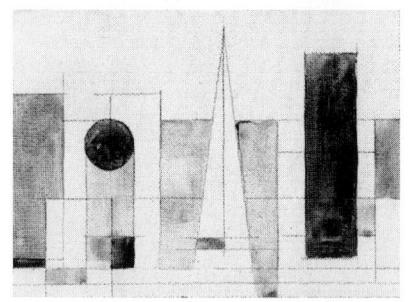

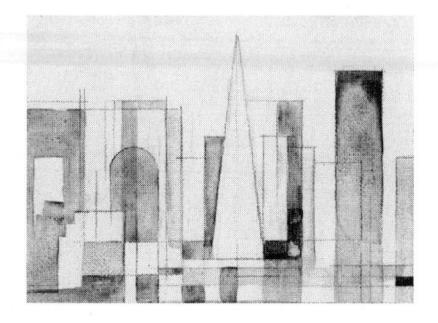

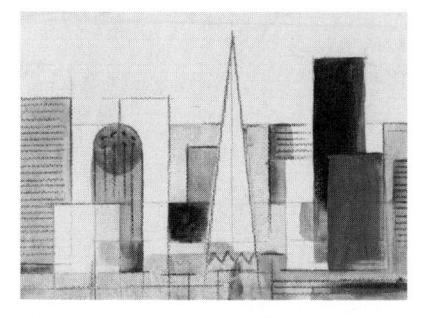

1.11 Inductive Abstraction

In the inductive approach to abstraction, we study the formal elements of painting, or of television and film, and then arrange these elements to express the essential quality of an event. In this case, we combine lines, circles, and areas to build up (inductively) the essence of a cityscape.

Wassily Kandinsky (1866–1944) was a painter and a teacher at the Bauhaus. The Bauhaus (literally translated "building house" or, more appropriately, "house for building") was founded by the well-known architect and artist Walter Gropius in Weimar, Germany, in 1919. Besides Kandinsky, members of the Bauhaus included such eminent artists as Paul Klee, Johannes Itten, Oskar Schlemmer, and László Moholy-Nagy. The Bauhaus developed a unique style for everyday objects, such as furniture, dishes, and tools, by following to its limits the basic credo: Form follows function. Its approach to educational theories was a thorough examination of such basic elements as light, space, movement, and texture. The Bauhaus was forced to close in 1933 as part of Hitler's drive to rid German culture of all "degenerate art." Later, Moholy-Nagy transferred the Bauhaus to Chicago, where it became the School of Design and, later, the Institute of Design. But it never reached the prominence of its forerunner, the Bauhaus. ¹⁶

This so-called formalistic approach to applied media aesthetics is similar to the study of production techniques. In both cases we learn the tools and techniques before putting them to work in a variety of contexts and for a variety of communication purposes. Concern about communication content is not unimportant, merely premature. The study of vocabulary and parts of speech does not preclude a respect for literature, but it is an essential prerequisite for writing the great novel.

Once you have a strong grasp of applied media aesthetics, you can select those elements and techniques that are most appropriate and maximally effective for shaping specific ideas. More important, you will gain the opportunity to combine aesthetic elements in nontraditional ways so that your viewers can perceive the world with fresh eyes and ears and from a new and unique perspective. Conversely, a knowledge of the requirements and potentials of applied media aesthetics could also generate new ideas—content that might otherwise have remained dormant. Finally, your familiarity with the formal elements of applied media aesthetics and their respective fields will enable you to exercise your creativity to its fullest.

RESPONSIBILITY

As you now know, the basic purpose of applied media aesthetics is to clarify, intensify, and interpret events for a large audience. Although such processes are designed to help the audience see the world from a new perspective and experience it in heightened ways, they also imply a direct manipulation of the audience's perceptions. Even when producing a simple commercial, you are essentially manipulating the feelings, emotions, and ultimately the behaviors of your recipients. Worse, the recipients of your aesthetically clarified and intensified messages are usually not even aware of being manipulated. For example, we may become aware of manipulation when watching blatantly biased editing, but most viewers remain largely unsuspecting when manipulated through subtle means such as lens distortions or specific lighting effects.

An anesthetized patient on the operating table and the aesthetically illiterate television or film viewer have much in common. Both have little control over what is happening to them and both must trust the skills, the good judgment, and, above all, the good intentions of someone else. Thus the surgeon and the media producer carry a heavy responsibility. One penetrates human beings with a scalpel whereas the other uses highly charged, keenly calculated aesthetic energy. This is why you, as a media communicator, must make all your decisions within the context of sound ethics—within a basically moral frame of reference. ¹⁷

As a mass communicator who daily influences millions of unsuspecting people, acceptance of such responsibility is a major job prerequisite. Skill alone is

not enough. First and foremost you must bring to the job a genuine concern and respect for your audience. And you must be prepared to bear responsibility for your actions.

As consumers of mass communication, we cannot escape similar responsibilities. If we want to guard against irresponsible persuasion and take an active part in making mass communication more beneficial to our fellow human beings, even as consumers we must learn as much as we can about the methods and techniques of media aesthetics.

Once we learn how lighting or sound can influence our perceptions and emotions, we are less susceptible to blind persuasion. We will be able to identify aesthetic techniques and the reasons for their use, enabling us to analyze the message for its true communication value, judge the mediated event as to its relative bias, and ultimately preserve our freedom of choice. Such media literacy will help us experience with heightened awareness and joy the mediated world on the screen as well as the real world in which we live.

When applied media aesthetics has become the common province of both communication producer and consumer, the imprudent use of media will become less of a problem. Both will find it easier to trust the other and to treat one another with the respect and dignity worthy of our global community.

Summary

Applied media aesthetics differs from traditional aesthetics in three major ways: Rather than being primarily concerned with beauty and the philosophy of art, applied aesthetics deals with a number of aesthetic phenomena, including light, space, time/motion, and sound, and our perceptual reactions to them; the media (television, film, computers) themselves play an important part in shaping the message; and whereas traditional aesthetics is used primarily for analysis, media aesthetics can be applied to both analysis and synthesis. Applied media aesthetics is an important factor in the production process.

In the framework of applied media aesthetics, every aspect of life has the potential to become art and serve as raw material for aesthetic processes, so long as it is clarified, intensified, and interpreted for an audience by the artist.

We perceive things in the context of changing relationships. In our perceptual process, we judge aesthetic phenomena and processes in a contextual frame of reference. The three major points are: stabilizing the environment, selective seeing, and the power of context.

To cope with the onslaught of changing stimuli and to make our environment more manageable, our mental operating system establishes perceptual filters and has us perceive stable patterns rather than unrelated event detail.

We tend to select information that agrees with how we want to see the world and screen out other data that might interfere with our constructs. Such habitual cue reductions tend to make us perceptually lazy and can even lead to prejudiced perceptions.

We perceive an event relative to the context in which it occurs, yet our perceptual processes are consistent enough to permit predictable reactions to certain aesthetic stimuli. Thus it is primarily the context in which the aesthetic stimulus operates that determines its predictable effect.

Applied media aesthetics places great importance on the influence of the medium on the message. The medium itself acts as an integral structural agent.

The method of presenting applied media aesthetics is an inductive one: Rather than analyze existing program fare and films, we isolate the five fundamental image elements of television and film, examine their aesthetic characteristics and potentials, and structure them in their respective aesthetic fields. These elements are: light and color, two-dimensional space, three-dimensional space, time/motion, and sound. We thus do not take the traditional content (ideas to be encoded) as an essential pre- or corequisite to the discussion of the formal image elements. Rather, we consider the study of the image elements to be the essential prerequisite to the proper shaping of ideas into messages.

Because the process of clarification, intensification, and interpretation of events is based on selection and a specific use of aesthetic elements, the recipient's perceptions are indirectly and, more often, directly manipulated. Such aesthetic manipulation must always occur and be evaluated within a framework of basic ethics. To facilitate effective communication, the consumers as well as the producers of mass communication have the responsibility to learn as much as possible about applied media aesthetics.

NOTES

- 1. The concepts of significant vision, significant form, and significant function constitute a major part of Stuart Hyde's treatise *History and Analysis of the Public Arts* (unpublished; available from the author, BCA Department, San Francisco State University). See also László Moholy-Nagy, *Vision in Motion* (Chicago: Paul Theobald and Co., 1947), pp. 42–45, and Susanne Langer, *Feeling and Form* (New York: Charles Scribner's Sons, 1953), pp. 26–41.
- 2. The word *anesthetic* suggests that we are bereft of all aesthetics, that our perceptions are dulled or totally shut off so that we no longer receive any stimuli, even physical ones.
- 3. Irwin Edman, Arts and the Man (New York: W. W. Norton and Co., 1939, 1967), p. 12.
- 4. Edman, Arts and the Man, p. 12.
- 5. Edman's aesthetic position that art and the ordinary pursuits of life are essential companions was further developed by Stephen C. Pepper, who called this aesthetic movement contextualism. For a discussion of the original concepts of contextualism, see Stephen C. Pepper, Aesthetic Quality: A Contextualistic Theory of Beauty (New York: Charles Scribner's Sons, 1938). Also see Stephen C. Pepper, The Basis of Criticism in the Arts (Cambridge, Mass.: Harvard University Press, 1945); Stephen C. Pepper, World Hypotheses (Berkeley: University of California Press, 1942, 1970); and Lewis Edwin Hahn, A Contextualistic Theory of Perception, University of California Publications in Philosophy, vol. 22 (Berkeley: University of California Press, 1939). A more modern representative of contextualistic aesthetics is Hans-Georg Gadamer. Although he calls the basis for his aesthetic theory hermeneutical epistemology, he nevertheless represents the contextualistic point of view. See his Truth and Method (New York: Seabury Press, 1975). His basic credo is that understanding (Verstehen) can occur only within the context of everyday living and that we interpret art not outside of our actual experiential context but very much within it.
- 6. Robert Ornstein, Multimind (New York: Anchor Books/Doubleday, 1989), pp. 35–46.
- 7. Bruce E. Goldstein, *Sensation and Perception*, 4th ed. (Pacific Grove, Calif.: Brooks/Cole Publishing, 1996), pp. 187–192.
- 8. The idea of selective exposure is broadly based on the theory of cognitive dissonance, advanced by Leon Festinger in his *A Theory of Cognitive Dissonance* (Evanston, Ill.: Row, Peterson, and Co., 1957). Basically, the theory states that we try to reduce dissonance by seeking out comments and other information that support—are consonant with—the decisions we have made.
- 9. This perceptual set is based on the B/13 experiment by Jerome S. Bruner and A. L. Minturn in their "Perceptual Identification and Perceptual Organization," *Journal of General Psychology*, 53 (1955): 21–28.

- 10. This figure is based on the classic Ebbinghaus illusions as published in various books on visual illusion. How such visual illusions were used for the George Lucas original Star Wars version, see Thomas G. Smith, Industrial Light and Magic: The Art of Special Effects (New York: Ballantine Books, 1986).
- 11. Being literate, or the term *literacy* in this context, does not mean "the ability to read and write" but, rather, having achieved proficiency and polish in some area of knowledge. *Media literacy* refers to a basic knowledge of how, for example, television structures pictures and sound for specific purposes. See Paul Messaris, *Visual Literacy: Image, Mind, and Reality* (Boulder, Colo.: Westview Press, 1994).
- 12. Marshall McLuhan, *Understanding Media: The Extensions of Man* (New York: McGraw-Hill, 1964), p. 314. Also Eric McLuhan and Frank Zingrone (eds.), *Essential McLuhan* (New York: Basic Books, 1995), pp. 151–161.
- 13. Compare the convincing argument that it is the information systems in general and the media specifically that shape media content rather than the other way around. See Joshua Meyrowitz, *No Sense of Place* (New York: Oxford University Press, 1985), pp. 13–16. See also Bernard Timberg and David Barker, "The Evolution of Encoding Research," *Journal of Film and Video* 14, no. 2 (1989): 3–14.
- 14. Wilbur Schramm, one of the pioneers in mass communication research, and others adapted this communication model from the basic model of information theory published by Shannon and Weaver in 1949. See Wilbur Schramm and Donald F. Roberts, eds., *The Process and Effects of Mass Communication*, rev. ed. (Urbana, Ill.: University of Illinois Press, 1971), pp. 22–26.
- 15. Wassily Kandinsky, Point and Line to Plane, trans. by Howard Dearstyne and Hilla Rebay (New York: Dover Publications, Inc., 1979). This work was originally published as Punkt und Linie zu Fläche in 1926 as the ninth in a series of fourteen Bauhaus books edited by Walter Gropius and László Moholy-Nagy.
- 16. One of the most comprehensive books on the Bauhaus is Hans M. Wingler, *The Bauhaus*, trans. by Wolfgang Jabs and Basil Gilbert (Cambridge, Mass.: MIT Press, 1969).
- Clifford G. Christians (ed.) and Mark Fackler, Media Ethics: Cases and Moral Reasoning,
 th ed. (New York: Longman Publishing Group, 1997), and Clifford G. Christians,
 Media Ethics, 4th ed. (New York: Longman Media Group, 1995).

The First Aesthetic Field: Light

IGHT is essential for life. It is necessary for most things to grow. It is the key ingredient of visual perception and orients us in space and time. It also affects our emotions. Light is the signal that our eyes receive and our brain translates into perceptions. When we look at our surroundings, we receive a great multitude and variety of light reflections. Each reflection has a certain degree of light intensity and complexity. The intensity variations appear to us as light or dark areas—as light and shadow—and the complexity as color.

Of course, we perceive light reflections as actual things. Most likely, we do not say, "I see the light variations that are reflected off these different surfaces." Rather, we say, "This is an automobile." Often we conceive light to be the property of the objects themselves. We speak of light and dark hair, a red ball, a green frog, a bright sky.

Television and film, as well as computer images, are pure light shows. In contrast to the theater, for example, where light is used simply to make things visible on stage and to set a mood, the final images on the film screen and electronic screens consist of light. The *materia* of the theater—the stuff that makes theater—is people and objects in the real space and time of the stage. The *materia* of television and film, however, is light. The control of light, called lighting, is therefore paramount to the aesthetics of television and film. *Lighting*, then, is the deliberate manipulation of light and shadows for a specific communication purpose. When creating computer images, such a manipulation of light and shadows is more akin to painting, where you simulate light with light-colored paints, and shadows with darker paint.

Before you try to manipulate light and shadows and use them creatively, you need to familiarize yourself with (1) the nature of light, (2) lighting purposes and functions, (3) the nature of shadows, (4) outer orientation functions of lighting, and (5) inner orientation functions of lighting.

The Nature of Light

Light is a form of radiant energy. Light consists of separate bits of energy (energy particles) that behave commonly as electromagnetic waves. It makes up a part of the total electromagnetic spectrum, which includes such other magnetic energy waves as radio waves, X-rays, satellite transmissions, and the waves in your microwave oven.

2.1 Visibility of Light

We see light only at its source and when it is reflected.

So-called white sunlight consists of a combination of light waves that are visible as various colors. When white sunlight is bent by a prism, it separates into a spectrum of clearly discernible hues: violet, blue, green, yellow, orange, and red. **SEE COLOR PLATE 1**

Because we can see the colors, that is, the various electromagnetic waves, light is usually defined as "visible radiant energy." Actually, light is invisible. We can see it only at its source or when it is reflected. **SEE 2.1** For example, a beam of light that shoots across a clean room or studio remains invisible to our eyes and to the camera unless the light hits a reflecting agent, such as dust, smoke, or an object or person.

If there were not a reflecting atmosphere, the sky would appear always dark, and you could see the stars even during the day. In deep space the astronauts see a black sky even in sunlight. If our surroundings did not reflect light, we would live in total darkness, much as if there were no light at all.

Lighting Purposes and Functions

Lighting is the deliberate control of light. The basic purpose of lighting is to manipulate and articulate the perception of our environment. Lighting helps us, or makes us, see and feel in a specific way. It can also establish a context for our experiences, a framework that tells us how we should feel about a certain event.

Through lighting we can articulate our outer space/time environment and our inner environment—our emotions. Lighting reveals what objects look like, where they are located, and what surface textures they have. It also influences how we feel about a person or an event. Very much like music, lighting seems to be able to bypass our usual perceptual screens—our rational faculty with its critical judgment—and affect us directly and immediately. Because lighting helps to articulate our outer and inner environments, we speak of outer and inner orientation functions of lighting. Both functions depend to a great extent on the proper control of shadows. Let us therefore take a closer look at shadows before discussing the specific orientation functions of lighting.

The Nature of Shadows

Ordinarily, we are not aware of shadows; we take them for granted. We readily accept the harsh and distinct shadows on a sunny day, the soft shadows on an overcast day, and the virtual absence of shadows under fluorescent lights. Only occasionally do we become more conscious of shadows. For example, we seek the shade when the sun gets too hot during an outdoor picnic, or we shift the reading lamp so that the shadow of our head or hand does not fall directly on the page, or we might chuckle when our shadow shows us an especially distorted image of ourselves.

As soon as you are engaged in clarifying and intensifying an event through lighting, however, you not only become very much aware of shadows, but you also learn to use them for specific orientation tasks. It is not the basic illumination that clarifies and intensifies the specific shape and texture of people and things—it is the various shadows. You will find out that in critical lighting situations, you often need more lighting instruments to control the shadows than you do for making things visible.

Let's take a look at an example. **SEE 2.2A** Both objects look like simple white discs; they are both lighted with highly diffused light (by using floodlights), rendering them practically shadowless and revealing little more than their basic contour.² As soon as you use a more directional light source, such as a Fresnel spotlight, and place it somewhat to the side of the object, you have no trouble distinguishing between the two. **SEE 2.2B** Because the directional light produces

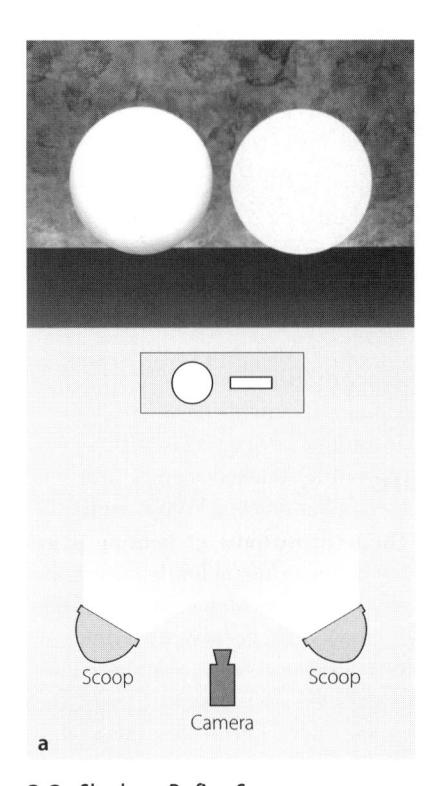

2.2 Shadows Define Space

When objects are lighted "flat" with a highly diffused light source, such as a scoop or a softlight pan, we see nothing more than their basic contour. Both appear pretty much as simple discs.

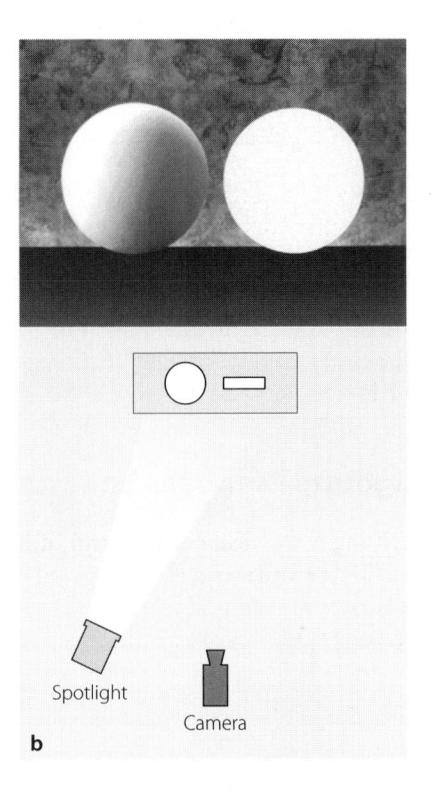

With a more directional light source, such as a Fresnel or ellipsoidal spot, placed somewhat to the side of the object, we see that the object on the left has a bright area that gradually changes into a shadow area; thus we perceive it as a sphere. The object on the right, however, remains evenly lighted without shadows; it is a disc.

2.3 Shadows Define Shape and Location

The attached shadows give us additional information about the true shape of the object (the cone). The attached shadow tells us where the object is relative to its surroundings.

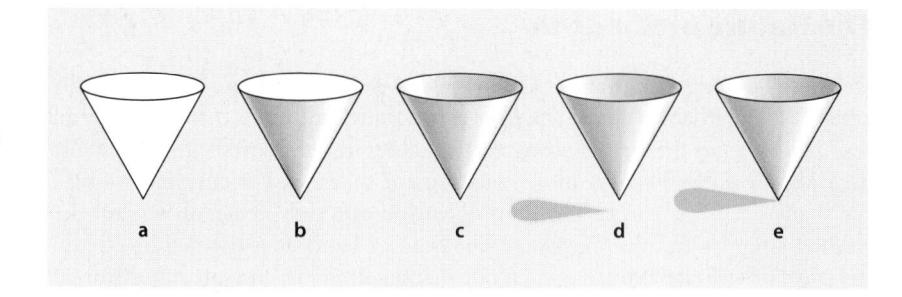

dense shadows, you can now see that the left object is a white ball and not a disc. But the object on the right remains evenly lighted, without any shadows. It looks like, and indeed is, a disc.

Now take a look at the next figure. **SEE 2.3** Without any shadows (figure 2.3a), we perceive only the basic contour of the object—a cone standing on its point—but the true spatial nature of the object and its location relative to its environment remain ambiguous. As soon as we attach a shadow (b), pretending that the main light source is coming from the right, we perceive the object as round and three-dimensional. An additional shadow on the top of the cone (c) reveals a new condition of the cone: It is hollow. The cone's shadow that is cast on another surface tells us where the cone is in relation to the horizontal surface (a table) directly underneath it (d); according to this shadow, the cone obviously floats above the table. The shadow in (e) is connected to the tip of the cone; we now see the cone as touching the table. Thus the initial spatial ambiguity has been drastically reduced by the various shadows.

Leonardo da Vinci (1452–1519), considered the most gifted genius of the Italian Renaissance, was equally versed as a painter, architect, designer, and inventor.

ATTACHED AND CAST SHADOWS

If you take another close look at figure 2.3, you will probably notice that some shadows are attached to the cone, and the others (the darker one in this illustration) are relatively independent of the cone. An equally astute observer, Leonardo da Vinci, called these two types of shadows: attached and cast.

2.4 Attached Shadow Reversal

In this ornament the attached shadow is at the top of the circles. Because we naturally expect light to be coming from above, we see this ornament first to indent, then to protrude, then to indent and protrude again.

This is the very same ornament as in (a) except that it is turned upside down. Now you will probably perceive the exact opposite: a protrusion first, then an indentation, another protrusion, then another indentation. By turning the book upside down, the ornaments will once more reverse.

Attached shadows An attached shadow is inevitably fixed to its object. No amount of wiggling or turning will remove the attached shadow from the object, assuming you keep it within the same illuminating source. The attached shadow helps to reveal the basic form of an object, but it can also fool you into perceiving what you normally expect to see. SEE 2.4 Figure 2.4a shows an ornament that protrudes; figure 2.4b shows one that is indented. The major clues for such perceptions are the attached shadows. Now turn your book upside down and take another look. Figure 2.4a now

shows an indented ornament, and figure 2.4b, a protruded one. Why? Because through lifelong experience, we assume that light comes from above rather than from below, and so we expect the attached shadows to appear below protrusions and above indentations. This perceptual habit is so strong that we will readily accept a change in the actual appearance of the object rather than the assumed direction of illumination.

If, therefore, the proper perception of protrusions and indentations by the audience is crucial, you must light the object steeply from above so as to place strong attached shadows where we ordinarily expect them to be. This type of space articulation is especially important for the scene painter who must suggest protrusions and indentations on a flat surface by painting in prominent attached shadows. Attached shadows help us primarily with interpreting the basic shape of an object and its texture.

Cast shadows These primarily help us locate the object relative to its surroundings. SEE 2.5 As you can see, the *cast shadow* indicates whether the object rests on the table or is away from it. Notice how the cast shadow becomes independent of the object and gets fuzzier as it moves farther away from the table. SEE 2.6 Contrary to the attached shadow, which is inevitably fixed to its object, a cast shadow may connect with the object that causes it or be totally free of it. SEE 2.7 The cast shadow that is still connected with its object is called *object-connected*; the one that is seen independent of its object is called *object-disconnected*. Note that object-connected cast shadows are not the same as attached shadows. In contrast to attached shadows, cast shadows become independent as soon as you move the object away from the surface on which it is resting. Figure 2.6 shows a good example: When the ball is lifted from the table, the cast shadow becomes object-disconnected and independent; the attached shadow, though, remains on the ball.

Although we are normally unaware of or unconcerned about cast shadows, we make continual spatial judgments by perceiving their general shape, intensity, and direction and are readily influenced by their dramatic implications and impact. Cast shadows can help break up large, monotonous surfaces and give the area more visual variety and interest. They can suggest a specific

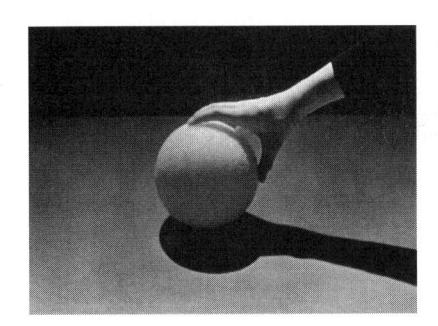

2.5 Cast Shadow: Object-Connected Cast shadows can reveal whether objects rest on another surface (in this case a table) or are separate from it. Notice here that the

shadow is still object-connected. The white

ball rests on the table.

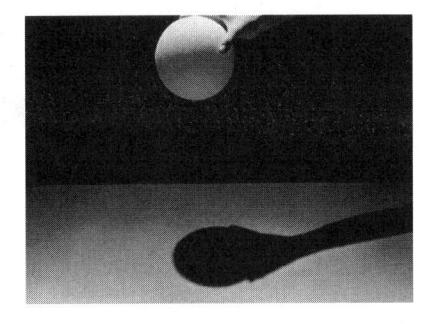

2.6 Cast Shadow: Object-Disconnected

Now the cast shadow has become objectdisconnected. In contrast to the attached shadow, which remains on the object, the cast shadow is now independent. The object no longer rests on the table.

2.7 Cast Shadow: Independent

The farther away the ball moves from the table, the fuzzier its cast shadow appears. Such interpretations of cast shadows are crucial for computer-generated images.

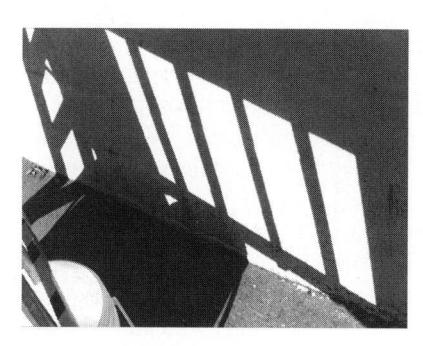

2.8 Cast Shadows Suggest Locale
Cast shadows are sometimes used to suggest a certain location, such as a prison, which isn't actually shown.

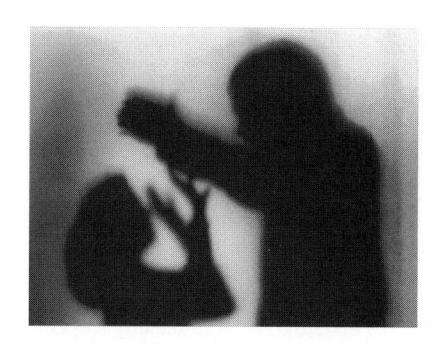

2.9 Cast Shadows Create Mood We can use cast shadows to create or emphasize a dramatic event.

locale. **SEE 2.8** And they can give drama to an event. **SEE 2.9** As we shall see later, they can also tell time.

Not all cast shadows are desirable, however. The infamous microphone boom or camera shadow on someone's face or on the living room wall are an ever-present potential menace during large studio productions.

This differentiation between attached and cast shadows is important not only in critical television and film lighting but also in creating programs for a graphics generator or in working out specific computer-generated designs. Although ultimately linked logically, attached and cast shadows require separate and careful attention during the design phase. For example, you need to have attached shadows change positions on the object when the object moves relative to the (usually virtual) light source, or the light source relative to the object. As you can see in figures 2.5–2.7, cast shadows must also get larger and less dense when the object moves away from the surface upon which the shadow is cast, or smaller and denser as the object moves toward such a surface. The constantly changing cast shadows are an important indicator of position change when you "walk through" a virtual-reality environment.

FALLOFF

We use the term *falloff* to mean two different yet related light/shadow relationships: the brightness contrast between the light and shadow sides of an object, and the rate of change from light to shadow.³

Contrast If the brightness contrast between the lighted side of an object and the attached shadow is high, we have fast falloff. This means that the illuminated side is relatively bright, and the attached shadow is quite dense and dark. **SEE 2.10** If the brightness contrast is low, the resulting falloff is considered slow. **SEE 2.11** In figure 2.11 the brightness difference between the illuminated side and the attached shadow side is relatively small. In extremely flat lighting, no contrast at all shows between the so-called illuminated and shadow sides. In this case falloff no longer exists. **SEE 2.12** Because most flash photography illuminates the subject directly from the front, both sides are often equally bright. Such an elimination of the light/shadow contrast—and with it, the falloff—results in the typically flat image of such snapshots.

Change Calling falloff "fast" or "slow" makes more sense when applied to the rate of change between light and dark. **SEE 2.13** Look, for example, at the tops of the steps in figure 2.13: They are exposed to the sun and are very bright, but they

2.10 Fast Falloff

Spotlights, which have a highly directional beam, produce fast-contrast falloff. Note that the light side and the dark attached-shadow side differ greatly in brightness contrast.

2.11 Slow Falloff

A highly diffused floodlight produces slow falloff. There is little brightness contrast between the illuminated and the shadow sides. The attached shadow has become transparent.

2.12 Elimination of Falloff

When both sides are equally bright, there is no falloff—there is no longer a discernible shadow side, and the picture looks flat.

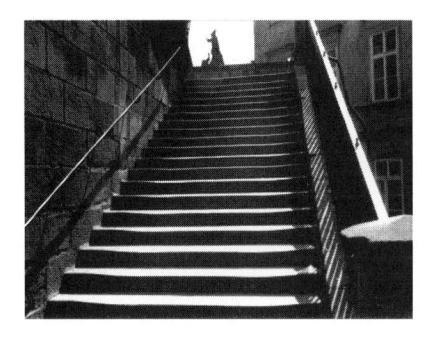

2.13 Fast Falloff: Edge

The lighting on these steps shows fast falloff. The change from light to dark is sudden, signifying a sharp edge or corner.

2.14 Slow Falloff: Curved Surface

The light on the object surface changes—falls off—gradually into its attached shadow. The surface of this building is obviously curved.

suddenly turn into dense attached shadows at the risers. Such an abrupt change from light to shadow causes extremely fast falloff. Conversely, you automatically interpret such fast falloff on a surface as an edge.

Now imagine yourself moving, like Superman, across the rounded surface of a building. You will move from bright sunlight to a hint of a shadow until you reach a dense area of attached shadow at the other end of the rounded building. The change from light to dense shadow is much more gradual than on the steps. The falloff on a curved surface is slow. **SEE 2.14** If the falloff on a curved surface is exceptionally fast, we have a tendency to perceive the rounded surface as an edge. Most lighting is, therefore, devoted to controlling falloff rather than illuminating a scene.

Controlling falloff You can control falloff by using highly directional or diffused light for the basic illumination and by the amount of fill light.⁴ The directional beam of a spotlight (or the sun) causes a sharp distinction between illuminated area and dense attached shadow. The resulting falloff is, therefore, fast. Floodlights, on the other hand, produce slow falloff. The highly diffused and more omnidirectional spread of a floodlight not only illuminates the side of the object that is oriented toward the light, but also "floods" the shadow side, rendering the attached shadow more or less transparent.

If the directional light source produces falloff that is too fast, with attached shadows so dense that you can no longer discern any detail in its area (as in figure 2.10), you need to slow down the falloff to some degree. Slowing falloff

means rendering the attached shadows somewhat transparent and reducing the contrast between light and shadow areas (see figure 2.11). You control such "contrast falloff" through various amounts of fill light. The more fill light you use, the more transparent the attached shadows become and the less contrast there is between light and dark. Instead of the fill light, you can use simple reflectors to slow down falloff. They are often used in outdoor shooting to make the sunlight do double duty—to work as both a key and a fill light. Many television camera operators prefer a foggy day to a brightly sunlit one when shooting outdoors. The fog acts as a giant diffuser of sunlight, producing soft, slow-falloff lighting with highly transparent shadows.

You may have noticed that it is the speed of falloff, and not the light itself, by which we perceive whether a light is "hard" (produced by spotlights) or "soft" (produced by floodlights). We tend to interpret fast falloff as hard light, and slow falloff as soft light.

Outer Orientation Functions: How We See an Event

Lighting orients us in space. It shows us what an object looks like: whether it is round or flat, has rough or smooth surfaces, and round or sharp edges. It can also show us where the object is in relation to other things. It lets us know whether it is day or night, morning or noon, summer or winter. The use of lighting to articulate the outer environment is known as *outer orientation*. Thus we can identify three principal functions: (1) spatial, (2) tactile, and (3) time.

SPATIAL ORIENTATION

Lighting reveals the basic shape of an object and where it is located relative to its environment. As you now know, the principal light source—the key light—and the attached shadows carry the major burden of fulfilling the basic shape function. The cast shadows indicate where the object is: whether it sits on a table or floats above it, whether it is close to the wall or away from it. Under certain circumstances, the cast shadows can give you a rough idea of what the object that precipitated the cast shadow looks like.

TACTILE ORIENTATION

Lighting for tactile orientation is very closely related to lighting for spatial orientation. Actually, texture is a spatial phenomenon because a texture, when sufficiently enlarged, resembles the peaks and valleys, ridges and crevasses of a rugged mountain range. The only difference is that lighting for space is done primarily to orient us better visually, whereas lighting for texture is supposed to appeal to our sense of touch. As in lighting for spatial orientation, control of falloff is of the utmost importance in lighting for tactile orientation.

To demonstrate the importance of falloff in texture, let us assume that the wrinkles and folds in a backdrop or curtain represent an enlarged surface texture. If you point a spotlight at the wrinkled side of a backdrop and direct the beam so that it hits the backdrop from the side, you will produce prominent, fast-falloff, attached shadows. Thus the wrinkles will be greatly emphasized. **SEE 2.15** When illuminating the identical portion directly from the front with a soft floodlight, however, the falloff is slowed down so drastically that the attached shadows become invisible to the camera. The backdrop now lacks texture and, therefore, looks taut. **SEE 2.16**

2.15 Fast Falloff on Cyc When a directional light hits a backdrop from the side, the texture (wrinkles and folds) show up prominently.

2.16 Slow Falloff on Cyc
When the very same portion of the backdrop is illuminated with diffused light from the front, the backdrop looks taut and wrinkle-free.

The same principle applies to lighting a face. You can use falloff control either to emphasize the texture of a face (wrinkles, pimples, or beard stubble) or to de-emphasize it and make the skin look taut and smooth. Thus, if you have to light the face of a rugged adventurer, you go for fast falloff. In our society we seem to associate a man's experience and masculinity, if not virility, with a moderate amount of wrinkles. **SEE 2.17** Not so with women. We seem to believe that women's faces should look reasonably smooth regardless of age and experience. To emphasize the smoothness of a woman's face, you obviously light for slow falloff. **SEE 2.18** How slow the falloff should be (which translates into how much fill light you use) depends on the specific message you want to convey. For example, if you need to demonstrate the effectiveness of a new skin cream, you light the model's face with extremely slow or no falloff. But to intensify the exhaustion of a woman climber after surviving a bad snowstorm, light for relatively fast falloff.

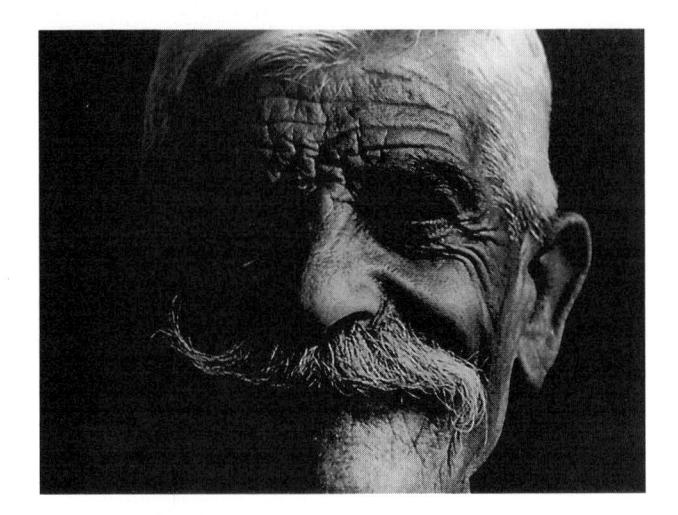

2.17 Fast Falloff: Facial Texture
Highly directional hard spotlights hitting the face from a steep angle create fast falloff. The facial texture—the wrinkles, ridges, and hollows—is accentuated.

2.18 Slow Falloff: Facial Texture

When you want to show the smooth, wrinkle-free skin we expect from women in our society, you need to reduce, rather than emphasize, facial texture.

As adults we sometimes forget that our tactile sense is a very important (if not the most direct) means for perceiving our environment, for experiencing the nature of the objects around us. As infants we tend to learn as much, if not more, about our environment by touching as by looking, smelling, or listening. Only gradually, and after many warnings by our parents not to touch this or that, do we finally manage to drive the tactile sense underground. But the many do-not-touch signs in stores and especially in museums suggest that apparently we still would like to touch objects in order to get to know them better and to enrich our experience.

Johannes Itten, who taught the famous Basic Course at the Bauhaus from 1919 to 1923, put great emphasis on the study of textures. One of the texture exercises in the Basic Course involved

making long boards on which a variety of different-textured materials were glued. The students would then run their fingers over these textures with their eyes closed. Itten found that through such systematic exercises the students' sense of touch improved to an amazing degree. In turn, the students learned to appreciate texture as an important design element as well as an orientation factor to the materials used. Itten stated that through such texture exercises, the students developed a real "design fever." An awareness of texture is especially important in television, which, with its low-definition picture mosaic, appeals more strongly to our tactile sense than film, for example. We tend to "feel," however subconsciously, that the dots make up the television image. Lighting for texture is, therefore, a very important factor in media aesthetics. 6

TIME ORIENTATION

Control of light and shadows also helps viewers tell time and even the seasons. In its most elementary application, lighting can show whether it is day or night. More-specific lighting can indicate the approximate hour of the day or at least whether it is early morning, high noon, or evening. With certain subtle color changes, you can also suggest whether it is winter or summer.

Day and night In general, daytime is bright and nighttime lighting is less bright. Because we are used to seeing the background only during the day, we keep the background illuminated to indicate daytime. **SEE 2.19** We leave it dark or only partially illuminated for nighttime. **SEE 2.20** A daytime scene needs a great amount of all-around light with everything brightly illuminated, including the background. On a sunny day, you encounter extremely fast falloff; when it is overcast, the falloff is much slower and the lighting more omnidirectional. Nighttime lighting needs more-specific and selective fast-falloff illumination.

You can use the same lighting principle for indicating day or night indoors. For a daytime interior, light so that the background is bright and the rest of the interior is bathed in slow-falloff illumination. **SEE 2.21** For nighttime, the background is predominantly dark, and the lighting in the rest of the interior becomes more selective. **SEE 2.22** In daytime lighting, the lamp is turned off and the window is light. In nighttime lighting, the lamp is on but the window is dark.

2.19 Outdoor Illumination: Day
To show that it is daylight, the sky
(background) is usually bright and the c

(background) is usually bright and the cast shadows are very pronounced. In sunlight, the falloff is fast.

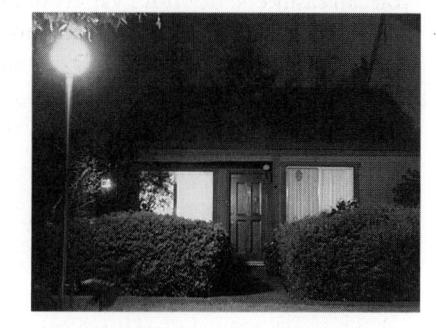

2.20 Outdoor Illumination: Night

In this nighttime scene, the background is dark, and the lighting is highly selective. The shadows are prominent, and the light comes from obvious sources, such as a streetlamp or a lighted window.

2.21 Indoor Lighting: Day

In this daylight interior scene, the window area (upper right) is light, indicating daylight outside, and the general interior lighting is rather flat, filtered by the window, with slow falloff.

2.22 Indoor Lighting: Night

In this nighttime interior, the window area is dark, the table lamp is turned on, the general interior is lighted for fast-falloff shadows. There are distinct cast shadows.

2.23 Cast Shadows Tell Time

Long cast shadows tell us that the sun is in an early-morning or late-afternoon position. At noon cast shadows are optimally short. In this picture the long cast shadow was produced by the early-morning sun.

Clock time The common indicator of clock time is the length of cast shadows. The early-morning and late-afternoon sun casts long shadows. **SEE 2.23** At high noon shadows are very short. Outdoors such shadows are usually cast along the ground. This is of little help, however, because the camera rarely shoots wide enough. What you must do, therefore, is produce cast shadows somewhere in the background, for example on the wall of a building, so that the camera can see them even in fairly tight shots.

The same shadow requirement holds for shooting indoors. Rather than have the cast shadows fall on the studio floor, you should devote a fair amount of background lighting to producing cast shadows, or even slices of light, that cut across the background at the desired angle. Though illogical, we readily seem to substitute a slice of light for a cast shadow. **SEE 2.24** If clock time is critical to the plot, you may want to reinforce your lighting with other, less subtle cues such as somebody saying, "Oh, it's five o'clock already," or by briefly intercutting a close-up of a clock. But you must make the lighting correspond with these additional cues.

Also ensure that any prominent cast background shadows are consistent with the attached shadows. If the window of the room is the prominent light source coming from the left, attached and cast shadows should be on the opposite side. Because the indoor lighting setup usually requires the use of several instruments, most of which come from somewhat different directions and angles, you can easily end up with a variety of cast shadows falling in different directions. For example, the hand that turned on the single light bulb in the cheap motel room should not all of a sudden cast multiple shadows on the wall. It would be just as awkward and confusing if in a studio scene we were to see a variety of cast shadows of the weary explorer stumbling through the hot desert at high noon. After all, our solar system has only one sun. What you must do is keep all distracting cast shadows out of camera range and show only one prominent cast shadow that falls opposite the major light source.

Seasons Generally, the winter sun is weaker and colder than the summer sun. Therefore the light representing the winter sun should be slightly more bluish than that for the summer sun. The winter sun also strikes the earth's surface from a fairly low angle, even at noon; this makes cast shadows in winter longer and not quite so dense. A slightly diffused light beam helps create softer winter shadows. Because snow reflects a moderate amount of diffused light, the falloff is somewhat slower than in a similar outdoor scene without snow.⁷

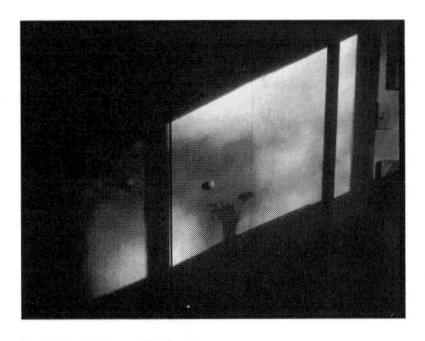

2.24 Slice of Light

An angled slice of light on the background can substitute for a cast shadow as a time indicator.

Inner Orientation Functions: How We Feel About an Event

So far we have explored outer orientation functions of lighting: light and shadows manipulated to articulate the outer environment. You now know the principles of lighting to show what an object looks like, what texture it has, and where it is located in space and time. Such articulation is a major factor in structuring screen space. But you can also use light to articulate the *inner* environment—that of our feelings and emotions—a lighting function we call *inner orientation*.

Specific inner orientation functions of lighting are (1) establishing mood and atmosphere, (2) predictive lighting, and (3) use of light and lighting instruments as dramatic agents.

ESTABLISHING MOOD AND ATMOSPHERE

Much like music, lighting can have an intuitive effect, influencing our emotions directly. Some lighting makes us feel happy, some sad, and still some other makes us feel uncomfortable or even frightened. The two major aesthetic lighting techniques for establishing mood and atmosphere are high-key and low-key lighting, and above- and below-eye-level key-light position.

High-key lighting This kind of lighting has nothing to do with either the position or intensity of the principal illuminating source, called the key light. Nor does it mean that the key light shines down on the scene from above. Rather, high-key lighting means that the scene has an abundance of bright, usually slowfalloff illumination and a light background. Television news sets, game shows, and many situation comedies have high-key illumination. The general feeling of high-key lighting is "up," very much like a high-keyed person.

Low-key lighting This type of lighting has less light than high-key lighting. The fast-falloff illumination of *low-key lighting* is highly selective, leaving the background as well as part of the scene predominantly dark. Scenes that deal with medieval dungeons, submarine interiors, caves, or nighttime exteriors or interiors normally call for low-key lighting. Whereas high-key lighting is "up," low-key lighting is "down."

ABOVE- AND BELOW-EYE-LEVEL KEY-LIGHT POSITION

These positions are, indeed, meant to tell where the key light is located. As pointed out before, we usually expect the major illuminating light source to come from above the object, producing attached shadows underneath various protrusions. This normal lighting is achieved by having the key light illuminate a person from above eye level. Note that *above and below eye level* refers to the eyes of the subject or the middle portion of the object lighted. As soon as the principal light source (key light) strikes the face from below eye level (sometimes called "reverse modeling"), the attached shadows reverse and are exactly opposite their expected position. Because we are so used to seeing the light come from above eye level, such a shadow reversal affixes to the outer disorientation an inner disorientation. This inner disorientation translates into surprise, suspicion, or fear.

This lighting technique is as blatant as it is effective. **SEE 2.25 AND 2.26** Whom, for example, would you trust more as a news anchor, computer salesperson, or attorney—the person on the left or the one on the right?

2.25 Below-Eye-Level Lighting

When the light source strikes the face from below, the shadows are exactly opposite of their expected positions. We are immediately disoriented. We affix to this outer disorientation an inner disorientation: The face appears unusual, ghostly, frightening.

2.26 Above-Eye-Level Lighting

When the principal light source, the key light, comes from above eye level, the shadows are below the protrusions and above the indentations, as expected. We experience "normalcy."

Most of us would probably opt for the person on the right (figure 2.26). Why? Because when seeing the lighting effect in figure 2.25, we probably will not take the time to trace the cause of the person's strange appearance to a beloweye-level key light and the subsequent reversal of attached shadows; rather, we simply label the person as weird. This seemingly minor position change of the key light has a decisive influence on our perception of the person's credibility, if not character. Worse, we have a tendency to extend such unexamined aesthetic manipulations of appearance to the psychological makeup and behavior of the person rather than a simple lighting effect.

PREDICTIVE LIGHTING

The *predictive lighting* technique helps to portend, however subtly, a coming event. Light that changes from high-key to low-key, from general to specific, from above eye level to below eye level can signal how the event will go. **SEE 2.27** The lighting changes from normal (above eye level) to an unusual high-intensity below-eye-level illumination. Such a drastic lighting change gives the viewer a strong clue to some unpleasant future event, even if the lighted character may be unaware of it. As in all good drama, we now know something the character doesn't and either empathize with her predicament or anticipate her doom.

2.27 Predictive Lighting

The light change in this picture series increases the tension of the event and suggests a somewhat ominous outcome for the woman.

Many films and television shows use lights as dramatic agents. Try to identify some of the films and analyze just how the lights intensify the scene. **Federico Fellini** (1920–1993), well-known Italian motion picture director, used light as a dramatic agent with great virtuosity in his by now classic films *La Dolce Vita* and $8\frac{1}{2}$.

In La Dolce Vita, he shows a television remote unit covering the events of an alleged miracle. Young children pretend to have seen the Virgin Mary descend from heaven and heard her speak to them. There is a great amount of confusion. Fellini cuts in close-ups of lighting instruments being turned on, shining their cold, controlled light beams over the highly emotional, ecstatic crowd. To counterpoint even more the discrepancy between the highly emotionally charged crowd, which represents the uncritical world of blind faith, and the analytical and soulless modern age as symbolized by the lighting instruments and cameras, he shows a tight close-up of a huge Fresnel lens bursting in the first seconds of a chilling downpour.

In 8½, Fellini uses many lighting instruments arranged in large circles, illuminating the representatives of humanity who, following the director's orders, march willingly, like circus clowns within the lights' periphery. The lighting instruments and the light, which occasionally shines directly into the camera, are a strong reminder that when properly "enlightened," we may discover that we are all part of a big cosmic joke that some superior power occasionally plays on us. Unless we embrace humanity and "join the show," we remain alienated from the circus of life and face an empty existence.

Similar predictions of unpleasant happenings are possible when you change the lighting of a party from high-key to low-key while maintaining the seemingly happy and innocent mood of the festivities, with all other aesthetic devices remaining the same. By reversing this procedure and changing from "down" to "up" lighting, you can predict the happy ending (the famous ray of light), even if the other aesthetic elements are still signaling disaster.

You can also use moving light sources in predictive lighting. You may have seen some version of a scene in which the old night watchman discovers that something is not quite right in Building 47, which houses secret documents. We see him getting up, looking left and right, and turning on his flashlight. We see the flashlight beam creeping nervously down the long, dark hallway until it finally uncovers—you guessed it—the broken lock, the open file cabinets, and papers strewn all over the floor. Changing from the high-key lighting to low-key lighting during an otherwise happy event can hint that all is not well.

As with any application of contextual aesthetics, predictive lighting rarely operates alone; it usually works in conjunction with appropriate sounds, suspenseful music, and the like. In fact, oncoming changes of events are more commonly introduced by predictive sounds than predictive lighting.

LIGHT AND LIGHTING INSTRUMENTS AS DRAMATIC AGENTS

You can use the light source itself as an effective dramatic agent—an element that operates as an important aesthetic intensifier in a scene. By showing the actual light source—the sun, the spotlight, or the flashlight—you can intensify the scene, assuming that it is set up properly for such intensification. Well-known, and often well-worn, examples are the close-up of the roving red or blue light on top of a police car, the flashing lights of a rock concert, or the searchlight from a prison tower that, by shining into the camera, not only searches for the escapees but also ruthlessly invades your privacy as a viewer. The dim overhead lights in a garage or the on/off blinking motel sign are other examples of using lighting as dramatic agents. Movies about extraterrestrials depend heavily on light as a dramatic agent. The creatures from space are usually introduced and dismissed as mysterious light beams, regardless of their eventual metamorphosis or whether they turn out to be friend or foe.

Summary

Light is what orients us in space and time and influences how we feel about a thing, a person, or an event. The five areas that need special attention when dealing with light are the nature of light, lighting purposes and functions, the nature of shadows, outer orientation functions, and inner orientation functions.

Light is a form of radiant energy that commonly behaves as electromagnetic waves. Perceptually, light is invisible except at its source and when it is reflected by some object.

Lighting is the deliberate control of light. Through lighting, we can articulate our outer space/time environment and our inner environment—our emotions.

These outer and inner orientation functions of lighting (how we see and feel) are primarily dependent upon the proper control of shadows.

There are two types of shadows, attached and cast. The attached shadow is inevitably fixed to its object. Whereas the attached shadow is dependent on its object, the cast shadow is independent. The cast shadow may be connected to its object or disconnected from it. The attached shadow reveals the basic form of the object; the cast shadow tells where the object is in relation to its surroundings.

Falloff is the contrast between the light and the shadow side, but also the relative rate of change from light to dark (shadow). Slow falloff means that the illuminated side and the shadow side have very little brightness contrast, or that the change from light to shadow area is gradual. Fast falloff means that the illuminated side and the shadow side have a great brightness contrast and that the change from light to shadow is abrupt.

The outer orientation functions of lighting include spatial, tactile, and time. The spatial orientation functions are to reveal the basic shape of the object and its location relative to its environment. The tactile orientation function means that fast-falloff lighting is employed to reveal and emphasize the object's surface texture. Time orientation is achieved primarily by controlling the relative brightness of the background and the length and angle of cast shadows. A light background suggests daylight; a dark background, nighttime. Long cast shadows suggest early morning or late afternoon; short shadows, high noon. The winter sun is slightly more bluish than the summer sun.

The inner orientation functions of lighting include establishing mood and atmosphere, predictive lighting, and using light as a dramatic agent. Mood and atmosphere are affected by low- and high-key lighting as well as from above-eye-level and below-eye-level key lighting. High-key lighting has an abundance of light, and the distribution of the light is nonspecific; the falloff is slow. Low-key lighting means that the overall light level is low and that the lighting illuminates specific areas; the falloff is fast. Above-eye-level key lighting places attached shadows in a normal position; below-eye-level key lighting reverses them vertically into an abnormal position. We interpret below-eye-level lighting as frightening or dangerous.

Predictive lighting refers to a lighting change that portends an upcoming event. One type of predictive lighting is a moving light source, such as a night watchman's flashlight, that reveals something.

Light and lighting instruments can be used as dramatic agents. This means that the light is used directly as an aesthetic intensifier. The flashing lights during a rock concert or revolving red light on a police car are examples of such intensifiers.

NOTES

- 1. Rudolf Arnheim, *Art and Visual Perception: The New Version* (Berkeley, Calif.: University of California Press, 1974), p. 305.
- 2. Herbert Zettl, *Television Production Handbook*, 6th ed. (Belmont, Calif.: Wadsworth Publishing Co., 1997), pp. 172–177.
- Herbert Zettl, Video Basics 2 (Belmont, Calif.: Wadsworth Publishing Co., 1998), pp. 120–124.
- 4. Zettl, Video Basics 2, pp. 123-124, 138-146.
- 5. Zettl, Television Production Handbook, pp. 156–157, 187–191.
- 6. Johannes Itten, *Design and Form: The Basic Course at the Bauhaus*, trans. by John Maas (New York: Van Nostrand Reinhold Co., 1963).
- 7. Gerald Millerson, *The Technique of Lighting for Television and Film*, 3d ed. (Boston and London: Focal Press, 1991), pp. 96–127.

Structuring the First Aesthetic Field: Lighting

IGHTING is the deliberate control of light and shadows to fulfill specific aesthetic objectives relating to outer and inner orientation. This chapter on structuring the first aesthetic field includes a discussion of the major lighting types and functions. You should realize, however, that these lighting types and functions are not etched in stone and are often adjusted to suit a certain theme or communication objective. They also depend on the specific application of other aesthetic elements, such as music. As elements of an aesthetic field, the specific functions frequently do, and should, overlap when finally applied to actual lighting situations.

All lighting shows up on the screen as an interplay of light and shadow. As you recall, some scenes need fast-falloff lighting with deep and pronounced attached and cast shadows. Others call for much softer slow-falloff lighting with highly transparent shadows. The lighting type that emphasizes light and dark, contrasting light and shadow areas, is called *chiaroscuro lighting*. The type that deemphasizes the light/dark contrast is called *flat lighting*. Most chiaroscuro and flat light techniques are relatively simple variations of the standard photographic principle, also called triangle lighting.

Standard Lighting Techniques

The standard photographic lighting technique is known as the *photographic principle*. This refers to the triangular arrangement of key, back, and fill lights, with the back light opposite the camera and directly behind the object, and the key and fill lights on opposite sides of the camera and to the front and side of the object. It is also commonly referred to as *triangle lighting*.¹

The *key light* is the principal source of illumination. It reveals the basic shape of the object or event. **SEE 3.1** The *back light* separates the figure from the background and provides sparkle. **SEE 3.2** The *fill light* controls falloff. **SEE 3.3** Additional light sources are the *side light*, which comes from the side, the *kicker*, which comes from the back, usually from below and off to one side, and the *background*, or *set*, *light* that illuminates the set and background. **SEE 3.4–3.6** The kicker is an extension of the back light and rims the object from below what the backlight can reach.

3.1 Standard Lighting Techniques: Key Light

Key light: principal source of illumination (normally a directional spot).

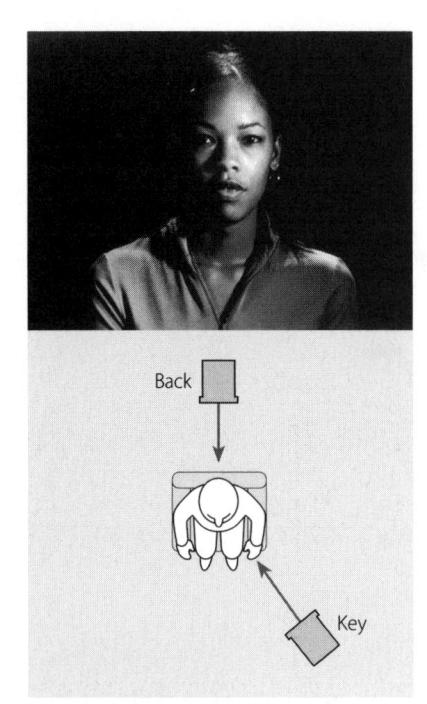

3.2 Standard Lighting Techniques: Back Light

Back light: rims top and separates subject from background (normally a directional spot).

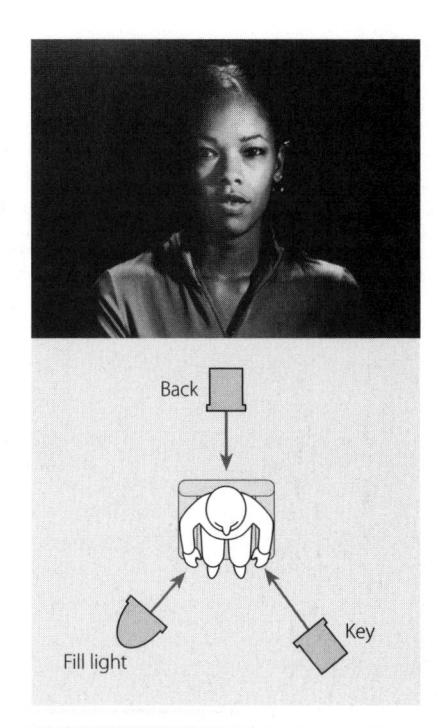

3.3 Standard Lighting Techniques: Fill Light

Fill light: controls falloff (normally a floodlight).

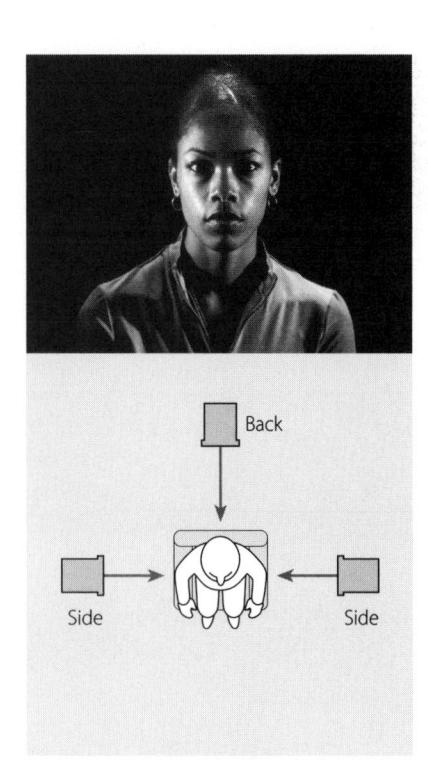

3.4 Expanded Lighting Techniques: Side Light

Side light: directional spotlight coming from the side. In this illustration, key and fill lights are both side lights.

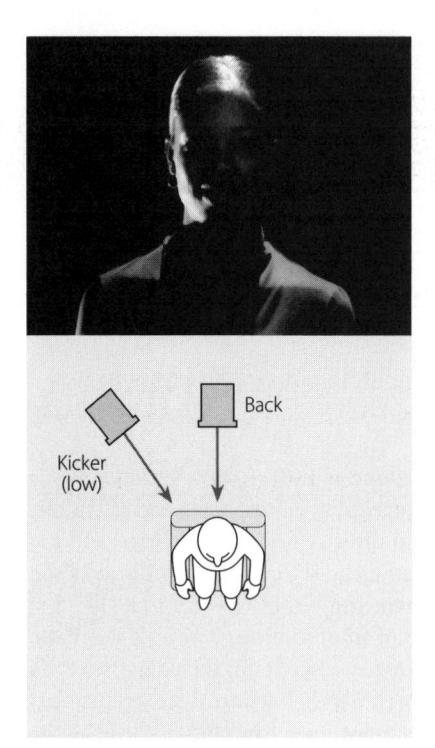

3.5 Expanded Lighting Techniques: Kicker Light

Kicker: directional spot from back, off to one side, usually from below.

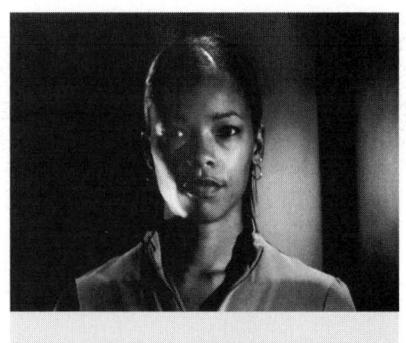

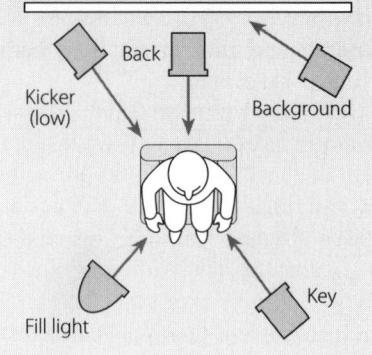

3.6 Expanded Lighting Techniques: Background, or Set, Light

Background light: background or set illumination (often by spots).

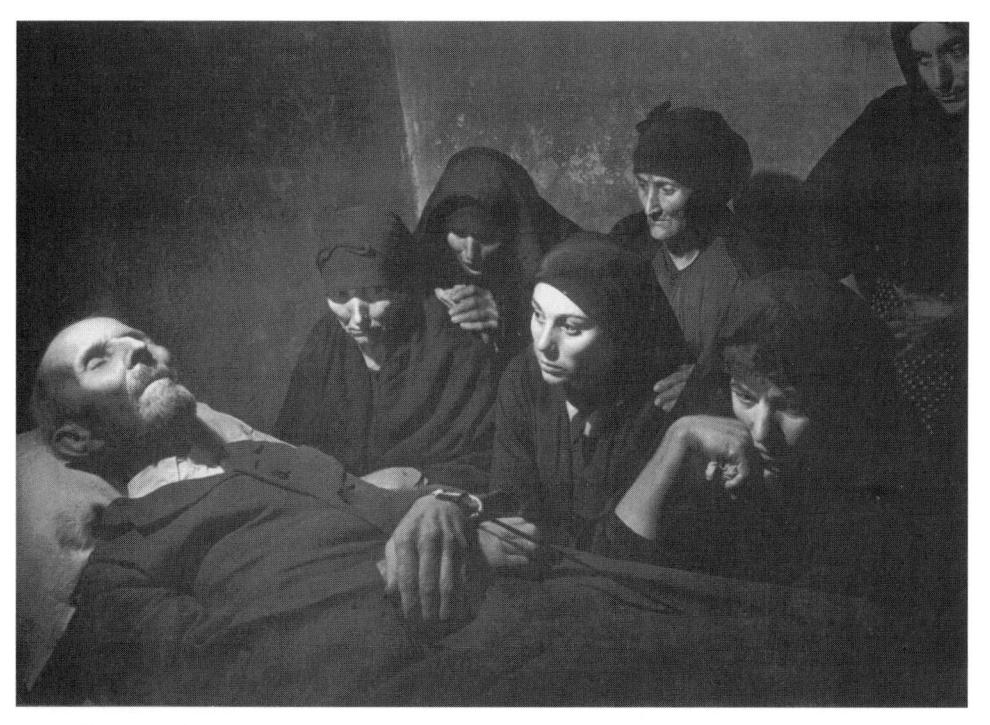

3.7 Chiaroscuro Lighting

In this photograph we can see major elements of chiaroscuro lighting: (1) selective illumination (faces, hands, part of the background); (2) low-key (background is predominantly dark, overall light level is low); and (3) fast-falloff lighting with distinct, dense attached shadows. *Spanish Wake*, courtesy of W. Eugene Smith.

Chiaroscuro Lighting

Chiaroscuro lighting means lighting for fast falloff and for light/dark contrast. The basic aim of this lighting type is to articulate space, to clarify and intensify the three-dimensional property of things and the space that surrounds them, and to give the scene an expressive quality. Chiaroscuro lighting creates volume and gives drama to a scene.

ANALYSIS OF CHIAROSCURO LIGHTING

Let us briefly analyze a chiaroscuro scene and see how the lighting contributes to our outer and inner orientation, that is, to how we see the event and how we feel about it. **SEE 3.7**

You probably feel that the scene (*Spanish Wake* by the late American master photographer W. Eugene Smith) is dramatic and emotionally involving. This emotional reaction is due in large measure to its highly charged subject matter—women mourning the death of a patriarch—but also the chiaroscuro treatment of the lighting. The chiaroscuro lighting of the scene adds to the intensity and drama of the event.

Light source and overall illumination The light source seems to come from a single direction, upper left. Although the actual photograph was taken with a flash that was positioned camera-left, we assume that the illumination originates from a small window or candles. It is highly specific, illuminating some parts of the scene while leaving others purposely dark. The overall illumination is low-key: The background is relatively dark, and the overall light level is low.

Shadow distribution and falloff The scene shows a fine example of fast-falloff lighting. The lighted areas change abruptly into dense attached shadows, telling us once again that the illumination source is highly directional. The faces of the people appear stark and sculpted, reflecting death and the expression of intense sorrow. The dark areas (shadows and black clothes) dominate the scene and are accented by carefully placed light areas. In a high-key scene, the opposite occurs: The light areas dominate and are only occasionally accented by shadows.

Texture The highly directional light source and the fast falloff emphasize the texture of the faces, the beard of the deceased, the clothing, and even the walls.

FUNCTIONS OF CHIAROSCURO LIGHTING

Chiaroscuro lighting performs several major aesthetic functions: (1) organic, (2) directional, (3) spatial/compositional, (4) thematic, and (5) emotional.

Organic function The lighting should look as organic as possible, that is, approximate as closely as possible the actual illumination source shown in the scene, such as a table lamp, a candle, or the sun. For example, if the only illumination source is a single candle, the lighting should look as though the scene were in fact illuminated by a single candle. You may be able to accomplish this by using only a single light or, more often, by having the principal light source (key light) come from the "organic" direction (the direction of the light source in the scene) so that the attached and cast shadows are in their appropriate place—opposite from the principal light source. In lighting for television, however, you will rarely get a satisfactory effect by simply duplicating the actual light source shown in a scene. In other words, a single candle will probably not yield enough light to create the lighting effect of a single candle. But there is no harm in trying to start out with a single candle or at least with as few lights as possible before adding more.

If you were asked to reproduce the scene of the painting *The Newborn Child* by Georges de La Tour, how would you light it? **SEE 3.8** Would you just hand one of the women a single candle and let it go at that? Hardly. Even when using high-quality equipment that operates properly under low-light conditions, you would probably find that a single candle is simply not enough light to effect such strong illumination as shown in the picture.

Even with highly light-sensitive television cameras, the lack of adequate baselight (overall light level) would probably cause picture noise (snowlike electronic interference) in the large shadow areas, especially in the background.² By looking at the painting more closely, you will undoubtedly discover that the light is coming not just from a single source. For example, the background light in the upper-left corner cannot possibly come from the candle. The following figure shows a possible lighting setup that simulates the illumination in the La Tour painting. **SEE 3.9** When duplicating the lighting setup, start out with one or two light sources. If they are sufficient, stop. If you need more, you may want to place them in the approximate positions indicated in figure 3.9.

Directional function You can use light to direct the viewer's attention to certain picture areas. In figure 3.7, the lighting guides us to the faces and hands of the people. In figure 3.8, the light directs our attention to the women's faces and ultimately to the child. Although this function is very important for theater lighting, painting, still photography, and even film, it is less critical in television, where we are much more readily guided by close-up shots than strategically placed points of illumination.

3.8 Functions of Chiaroscuro Lighting

The principal functions of chiaroscuro lighting are clearly identifiable in this reproduction of a La Tour painting: Organic function—the light seems to radiate from a single candle hidden behind the left woman's hand; directional—our eyes are lead to the women's faces and, ultimately, the newborn child; spatial/compositional—note the light-against-dark and darkagainst-light illumination that sets off the figures from the dark background as well as the balanced distribution of light and dark picture areas. The Newborn Child by Georges de La Tour (ca. 1630), courtesy of Musée des Beaux-Arts, Rennes, France.

Spatial/compositional function The light (high-energy) and dark (low-energy) areas should be distributed within the frame in such a way that they balance each other (see figure 3.8). The distribution of light and dark also contributes to a definition of volume, contour, and foreground and background planes. Note how in figure 3.8 the light profile of the left figure is set off against a dark background, while her darker headdress and clothing are contrasted against a slightly lighter background. Such light-against-dark and dark-against-light variations are favorite lighting techniques for defining foreground and background in rather static scenes.

Thematic function Lighting should emphasize the theme or story of the scene. The lighting in figures 3.7 and 3.8 clearly emphasizes the eternal themes of birth and death. In figure 3.8 the lighting focused on the two women and the child seems to suggest that the newborn child is itself part of the light source. All other aspects are deliberately kept dark and thus de-emphasized. The death theme in figure 3.7 is similarly communicated: The light is on the dead patriarch and the faces of the mourning women.

Emotional function Though closely related to the thematic function, the emotional function of chiaroscuro lighting is to affect our feelings directly regardless of the actual subject matter of the scene. Most often these two functions operate in unison. In both figures 3.7 and 3.8, the lighting determines a dominant mood and reflects the strong emotions that prevail in both scenes—one of deep sorrow and anguish, the other of wonderment and joy. Both have drama. But, although both lighting setups use chiaroscuro techniques, the tragedy of death in *Spanish Wake* is intensified through extremely fast falloff. In *The Newborn Child*, the falloff is much slower, underscoring the joy and wonder of birth.

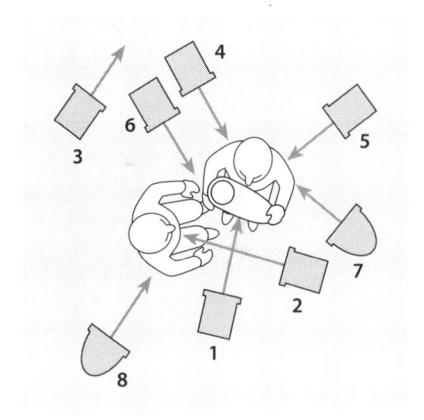

3.9 Lighting Setup for La Tour's *The Newborn Child*

Lighting instruments and major functions:

- 1 Key light for woman A
- 2 Key light for woman B
- 3 Background light to set off woman B
- 4 Kicker to rim head and shoulder of A
- 5 Kicker to rim right shoulder and arm of A
- **6** Back spot to rim hand and illuminate child
- 7 Soft fill to slow falloff on A
- **8** Soft fill to slow falloff and reveal some detail on back of B

Chiaroscuro is an Italian word, meaning light/dark (chiaro = light; oscuro = dark). Chiaroscuro lighting borrowed its name and technique from the chiaroscuro painters of the Mannerist (post-Renaissance) and Baroque periods (roughly from 1530 to 1650), who emphasized specific high-contrast "lighting" in their works. Chief among them are the Italian painter Michelangelo Merisi da Caravaggio (1573-1610), who is commonly considered to be the father of the chiaroscuro school, and the Dutch painter Rembrandt van Rijn (1606-1669), who brought the chiaroscuro technique to perfection.

All major functions of chiaroscuro lighting clearly operate harmoniously in both pictures: The lighting obviously contributes to the clarification, intensification, and interpretation of the scenes.

Specific Chiaroscuro Lighting Types

Rembrandt and cameo lighting are two distinct chiaroscuro lighting types. Both types are used in a great variety of ways, many of them displaying only part of their primary characteristics.

REMBRANDT LIGHTING

The major characteristic of *Rembrandt lighting* is its selectivity. Only specific areas are carefully illuminated, while others are kept purposely under- or unlighted. The falloff is quite fast, but there is enough fill light to render the attached shadows somewhat transparent. The background, although generally dark, is at least partially illuminated to outline and set off the figures or to fulfill other important orientation functions.

When you look at Rembrandt's *Old Woman Reading*, you can clearly see the basic characteristics of Rembrandt lighting. **SEE 3.10** Only some areas are illuminated (the woman's blouse, her face, her hands), while others are kept relatively dark. The falloff is fast, but the shadows are reasonably translucent. The book itself, acting as an efficient reflector, seems to emit light, although we do not actually see its illuminated side. The background is kept dark, but it is still carefully illuminated to set off the contour of the foreground figure. Such separation of background and foreground is especially important because Rembrandt did not simulate any backlighting.³

3.10 Rembrandt Lighting

The most widely applied chiaroscuro type—Rembrandt lighting—has selective lighting, transparent shadows, fairly fast falloff, and carefully placed background illumination. It is lighting for volume and drama. *Old Woman Reading* by Rembrandt, courtesy of the Duke of Buccleuch. Photograph by Tom Scott.

3.11 Cameo Stone
In a typical cameo, the light figures are sharply set off against a dark background.

3.12 Cameo Lighting
In this cameo scene, the performers are sharply set off against a dark background very much like the figures in an actual cameo stone. Note the extremely fast falloff and the dark, unlighted background. A cameo scene has no scenery.

CAMEO LIGHTING

Cameo lighting is chiaroscuro lighting pushed to its extreme. As a direct imitation of the cameo stone, in which white figures are seen sharply set off against a dark background, cameo lighting illuminates the foreground figures while leaving the background totally dark. **SEE 3.11** The lighting is highly directional, producing fast falloff with dense attached and sharply defined cast shadows. The cast shadows are usually visible only on the lighted floor areas or occasionally on the performers themselves. **SEE 3.12**

The high concentration on the performers and the lack of scenery should make cameo lighting an ideal television production technique. Unfortunately, this has not proved to be the case. The highly directional nature of the lighting makes it difficult for performers to move about without stepping out of the precisely defined light pools. Also, if the audio pickup is by boom microphone, you may find it hard to avoid boom shadows falling across the actors' faces. Such high-contrast lighting is also difficult to handle even for high-quality television cameras. If the camera is adjusted for the brightly illuminated areas, the dense shadow areas turn uniformly black and become subject to video noise. If adjusted to the dark areas, the light areas overload the camera circuits and start to "bloom" unnaturally bright. Extreme light/dark contrast also tends to distort color somewhat, especially in the shadow areas.⁴ The most serious problem of cameo lighting, however, is its visual intensity. Even if this stark and focused lighting were matched by an equally dramatic performance, the pictures would still look strangely theatrical and often removed from the television reality to which we have become accustomed.

Flat Lighting

The opposite of chiaroscuro lighting is flat lighting. Flat lighting uses highly diffused light that seems to come from all directions. It thus has very slow falloff and such highly transparent attached and cast shadows that we usually do not notice them. In flat lighting, we are not aware of any principal light source. **SEE 3.13**

The cameo stone has two connected layers. The upper layer of the stone is white or of light color, the lower one usually black or dark brown. The cameo artists carve the figures or portrait profiles out of the upper light layer, leaving the dark layer as background. Cameos are especially popular in Italy and Greece.

3.13 Flat Lighting

Note how in this scene the light does not come from a particular direction or source; it is simply there. The shadows are so transparent that they are, for all practical purposes, invisible. Flat lighting has slow or, more often, no falloff.

FUNCTIONS OF FLAT LIGHTING

Although flat lighting is often done for expediency, it can nevertheless fulfill several important aesthetic functions.

Visibility Flat lighting is high-key lighting for optimal visibility. Contrary to chiaroscuro lighting, where much of the picture detail is purposely hidden in deep shadows, flat lighting shows the whole scene more or less equally illuminated. Flat lighting is ideal for continuous action, making it possible for cameras to shoot from a great variety of angles without having to worry about lighting problems and thus affords performers maximum mobility. But while we can see a maximum of picture detail with flat lighting, the slow falloff reduces the three-dimensionality and texture of things and renders them oddly flat (see chapter 2). Extremely flat lighting can lead to serious disorientation, very much like total darkness. Sometimes, when the highly diffused light of an overcast day robs a snowy landscape of all shadows, and the white ground seems to blend into an equally white sky, skiers and mountain climbers experience a "whiteout," losing all sense of direction and no longer able to see, but only feel, whether they are moving upor downhill. You may have had a similar disorienting experience when driving in fog or standing in a television studio whose cyclorama is made to blend into the studio floor through uniform color and illumination.

Technically, the television camera likes flat lighting, because little contrast exists between light and shadow areas. Lacking prominent shadows, there is no danger of color distortion or excessive electronic picture noise. But the absence of shadows takes away important spatial orientation clues. Flat lighting *looks* flat, and it is uninteresting unless used to serve a specific aesthetic purpose.

Thematic and emotional functions In flat lighting, the thematic and emotional functions are so intertwined that we can discuss them together here. Flat lighting can suggest efficiency, cleanliness, truth, an upbeat feeling, and fun. News sets are always lit with flat lighting, not just to make the newscasters appear wrinkle-free but also to assure us of the "enlightened" accuracy of the news. Flat lighting can also spell mechanization, depersonalization, or disorientation. For example, if you want to stress the theme of high-tech operations and impress the viewer with its efficiency, you might do well by lighting the computer room flat rather than chiaroscuro. But you might also inevitably communicate the nonverbal message that this environment is devoid of human warmth and compassion.

Leonardo da Vinci preferred an overcast sky while painting. Under even, diffused light, the colors are less distorted than in bright sunlight with deep shadows. This is also the reason why, traditionally, studio windows are oriented toward the north: The light inside remains more even throughout the day than if the studio were subjected to changing, direct sunlight.

Or if you need to intensify the feeling of a prisoner's isolation in an interrogation room, you could use totally flat lighting in a white room to simulate the disorienting whiteout discussed earlier. The shadowless environment now prompts the viewer to empathize with the prisoner's isolation, his being in nothingness, probably more so than if he had been placed in the traditional chiaroscuro-lighted cell with the strong light source shining into his eyes.

On the other hand, high-key flat lighting can also express energy and fun. Game shows and many situation comedies are illuminated with flat lighting—apt signifiers of the energy and pleasant superficiality of such events. Sometimes situation comedies play in cramped quarters, such as army camps, small motel rooms, or restaurants, or they have action that happens at night. In such cases, moderate chiaroscuro lighting is obviously more appropriate to fulfill the organic functions, but it should not be so heavy as to take away from the comedic action.

Let's apply these theories and assume that you must light the set of a hospital corridor so that it first suggests to the viewer that the hospital is inefficient and run-down, and then rearrange the lights to indicate that it is clean and highly efficient without changing anything in the set itself. Which type of lighting would you use for the run-down hospital and which for the clean and efficient one?

Chiaroscuro is the most appropriate choice for the first assignment, and flat lighting for the second. Why? Because the many prominent shadow areas that stripe the corridor through chiaroscuro lighting inevitably provoke a response in the viewer that the hospital is so poor it cannot afford adequate lighting; it must be old because it obviously has too few windows that are also too small; it lacks adequate ventilation; it is likely to be untidy and dirty; it is a firetrap because we can't see where we are going; and the rest of the hospital, including its staff, must be just as antiquated.

With flat lighting, however, everything changes. Due to the profuse amount of shadowless illumination and increased visibility, we are now inclined to feel that the corridor and so the entire hospital is clean and germ-free; nothing is hidden in dark corners; it has big windows and is, therefore, modern throughout; it is a place where we can easily find our way around; and its staff and doctors must be equally bright and efficient.

Silhouette Lighting

Silhouette lighting type falls into neither the chiaroscuro nor the flat category, and yet it has characteristics of both. It is chiaroscuro because of its extreme light/dark contrast. It is also flat because it emphasizes contour rather than volume and texture. So far as lighting technique is concerned, silhouette is the exact opposite of cameo. In cameo we light the figure and not the background, but in silhouette we light the background and not the figure.⁵

Obviously, you light only those scenes in silhouette that gain by emphasizing the contour of things. A sharp, jagged jazz dance, in which outer movement is of the essence, calls for silhouette lighting. Romantic scenes take on special prominence when shown in silhouette. **SEE 3.14** You can also use silhouette lighting for concealing the identity of a person. If you're interviewing someone who has good reason to remain incognito, or show someone cautiously entering a luxurious mansion through the bedroom window, silhouette lighting will help dramatize either event.

On the other hand, always be aware of unintentional silhouette effects. A field reporter positioned against a sun-drenched white wall will certainly turn into an unflattering silhouette, especially if no reflector or additional lighting is used to offset the strong background light. A similar problem exists if you want

One specific flat-lighting technique is sometimes called limbo. In limbo lighting, the background is evenly illuminated, and the object in front of it is lighted with the standard photographic principle. Actually, limbo refers more specifically to a staging rather than a lighting technique. For example, if you are asked to set up a commercial display "in limbo," you need not light specifically for it. It simply means that you push the commercial display in front of a neutral, plain background (usually light colored) so that the emphasis is on the product and not on the environment.

3.14 Silhouette Lighting

Notice that this lighting is the exact opposite of cameo. In silhouette lighting, the background is lighted and the figures in front remain unlighted. Silhouette lighting shows only contour but no volume or texture. Silhouette lighting intensifies the outline of things.

to photograph someone on a sunny beach against the ocean. The water, reflecting the sunlight, acts like a giant background light, illuminating the background so much that the foreground person looks unlighted. As you now know, such a lighting contrast shows up as a silhouette. To cope with this abundance of light, the camera adjusts itself to the background light, making the foreground figures so dark that they appear as silhouettes. To avoid such problems, you may want to shoot beach scenes on an overcast day (thus reducing the glare of the sea), shoot against the land rather than the water, or put the subjects in the diffused shade of a beach umbrella. A more expensive way to offset the silhouette effect is to use additional illumination on the subject, such as powerful spotlights or giant reflectors.

The table on the facing page gives a brief overview of chiaroscuro and flat lighting techniques. **SEE 3.15** You should realize that each scene has its own specific lighting requirements, and that many variables exist to achieve similar effects.

Media-Enhanced and Media-Generated Lighting

All photographic arts (still photography, film, and television) can enhance, change, or simulate the lighting effects through manipulation by the medium. In photography and film, you can affect colors or the brightness contrast through various filters as well as in the processing phase. In television these variables can be manipulated through the camera controls, various electronic enhancement equipment, or through computer software. Television allows further electronic manipulation by the viewers, who may adjust, or misadjust, the brightness, contrast, and color controls of their television sets.

For example, you can easily change the appearance of a chiaroscuro scene by turning down the contrast control and turning up the brightness control. What you end up with is a washed-out picture with the original lighting setup no longer recognizable. You can increase falloff by simply turning up the contrast control as far as it will go.

Most of the media-controlled lighting effects are achieved through digital special-effects equipment or computer programs. In computer-generated images, all lighting effects are synthetic and totally independent of actual external light and lighting techniques. Most computer graphics programs let you simulate light sources and their resulting attached and cast shadows. Because the shadows are
3.15 Overview of Chiaroscuro and Flat Lighting Techniques

Туре	Source, illumination area	Illumination level	Falloff, shadow distribution
Rembrandt	Spotlights with barn doors. Carefully placed background lights. Specific area lighting— selective illumination but fill light for making shadows transparent.	Low-key. Selectively illuminated figures. Illuminated yet generally dark background.	Fast falloff. Transparent shadows.
Cameo	Directional spots. Directional fill. Back light. Minimum of spill, especially on background. Dark background.	Low-key. Illuminated figures only, dark background.	Fast falloff. Dense shadows.
Flat	Highly diffused floodlights (scoops and soft lights). Nonselective, omnidirectional illumination. Light is fairly evenly distributed.	High-key. Generally bright illumination with light background.	Slow falloff. Highly transparent shadows or no perceivable shadows.
Silhouette	Evenly lighted bright background (floodlights). No illumination on foreground figures.	High on background. No illumination on foreground figures.	No shadows, but figures appear as contoured, flat shadow areas.

independent of the light source, you can place the attached shadow anywhere on the object and create Escherlike paradoxes in which cast and attached shadows contradict each other in direction or relative to the principal light source. Other computer programs offer a wide choice of special effects, such as extremely fast falloff, flat lighting, spotlight effects (where one area of the picture is illuminated by the typical spotlight circle), solarization (high-contrast image), or posterization (reducing the tonal range of an image to a few steps). Some effects, such as solarization, show not only a lighting change, but suggest a structural change. See 3.16 To show somebody dying—the ultimate structural change—you need no longer resort to the traditional graphic Hollywood versions of expiring heroes. Rather, you can show a close-up of the person and, through progressive solarization, disintegrate the structure of the image and, with it, the person. You should realize, however, that such powerful effects need to be used with great caution. If used too frequently or for too long, they can quickly turn against you and deflate rather than intensify the emotional impact of the scene.

3.16 Solarization

In this solarization effect, the steps between the lightest and darkest spot in the picture have been radically reduced and the polarity (dark and light) reversed. The solarized image seems to emit its own light. Solarization affects the very structure of an image.

Single- and Multiple-Camera Lighting

Although basic lighting principles apply to all the photographic arts, certain operational differences exist between lighting for the single camera (such as film or single-camera video productions) and multicamera television productions that sometimes influence, if not dictate, a particular lighting technique.

SINGLE-CAMERA LIGHTING

Single-camera lighting is also called film lighting or film-style lighting because it is most commonly used in film production. Lighting for single-camera productions is set up for discontinuous, short-duration action. In film and single-camera video productions, each scene, if not each shot, is lighted separately. Lighting control is extremely high. Because all movements of actors, cameras, microphones, and so forth are carefully planned in advance, the instruments can be placed on the studio floor or on the floor of the particular location. Shadow control is improved by gobos and flags (small transparent or solid pieces of metal, plastic, or cloth panels) that are placed in front of the lighting instruments to block out unwanted light.

MULTIPLE-CAMERA LIGHTING

In contrast, lighting for multiple cameras that cover the scene simultaneously from a variety of angles is necessarily less precise. The lighting must satisfy the various points of view of the cameras as well as continuous, long-duration action, such as game shows, situation comedies, interviews, talk shows, or studio dramas. To accommodate the continuous camera travel, the lighting instruments must be suspended from the studio ceiling with only a minimum of instruments placed on the floor.

Summary

This chapter listed the major lighting types and functions. It also touched briefly on media-enhanced and media-generated lighting effects, as well as the differences in lighting techniques for single- and multiple-camera productions.

The photographic lighting principle consists of a key light (principal light source), a fill light (opposite the camera from the key), and a back light (in back of the subject).

The two major lighting types are chiaroscuro and flat. Chiaroscuro lighting emphasizes contrasting light and shadow areas and is fast-falloff lighting. Flat lighting is slow-falloff lighting. The shadows are highly transparent or, for all practical purposes, nonexistent.

Both lighting types have specific functions. The functions of chiaroscuro lighting are organic (to make the scene look realistic), directional (to lead the eye to specific picture areas), spatial/compositional (to define space and contribute to a balanced pictorial composition), thematic (to emphasize the theme or story being told), and emotional (to establish or emphasize a mood). The major function of flat lighting is to provide optimal visibility, but it can also have thematic and emotional functions similar to those of chiaroscuro lighting.

The specific chiaroscuro lighting techniques are Rembrandt and cameo. The characteristics of Rembrandt lighting are selectivity and fairly fast falloff. Cameo lighting illuminates only the subject, with the background remaining unlighted.

Flat lighting is highly diffused with extremely slow falloff. It is nonselective, and its light seems to come from all directions, rendering the attached shadows highly transparent or practically invisible. Flat lighting is high-key, implying high energy, efficiency, and cleanliness, but also mechanization and depersonalization.

Silhouette lighting is a hybrid between chiaroscuro and flat lighting. It shows unlighted figures against a bright, evenly illuminated background. The lighting makes the figures appear flat and dark, but it does accentuate their contour.

Media-enhanced and media-generated lighting effects refer to the control of the lighting effect by the medium itself. Media-enhanced effects include the various manipulations of lighting effects in the processing of film or, in electronic images, through computer software. Computer-generated images can simulate a variety of lighting effects and create special effects such as extremely fast falloff, flat lighting, spotlight effects (where one area of the picture is illuminated by the typical spotlight circle), solarization (high-contrast image), or posterization (reducing the tonal range of an image to a few steps).

Single-camera lighting for film and television (film-style) affords maximum control, because each scene or shot is set up and lighted separately. This method affords maximum image control. Many television studio shows, however, require multicamera setups for continuous action. In this case, lighting for overlapping action areas is needed, a technique that decreases considerably the aesthetic control of lighting.

NOTES

- 1. Herbert Zettl, *Television Production Handbook*, 6th ed. (Belmont, Calif.: Wadsworth Publishing Co., 1997), pp. 136–140.
- 2. Zettl, Television Production Handbook, p. 360.
- 3. See art books that have good reproductions of paintings by Rembrandt, Caravaggio, La Tour, and other chiaroscuro painters.
- 4. Zettl, Television Production Handbook, p. 137.
- 5. Zettl, Television Production Handbook, p. 181.
- 6. See the photos of American master printers. For example, on close examination of Jack Wellpot's prints, you will discover that he articulates lighting (and our attention in a subtle way) by making some areas darker and some lighter in the printing process. For electronic and computer effects, see Zettl, *Television Production Handbook*, p. 351, and William J. Mitchell, *The Reconfigured Eye* (Cambridge, Mass.: MIT Press, 1992, pp. 90–102. The latest user guides to the various computer graphics programs, such as Adobe Photoshop, will give you myriad examples of computer-generated lighting and color effects.

4

Georges Seurat, French, 1859–1891, A Sunday on La Grande Jatte, oil on canvas, 1884–1886, 207.5 \times 308 cm. Helen Birch Bartlett Memorial Collection, 1926.224. Photograph © 1997, The Art Institute of Chicago. All rights reserved.

The Extended First Field: Color

OLOR adds a new dimension to everything. It brings excitement and joy, makes us more aware of the things around us, and helps us organize our environment. A child likes to play with toys that are brightly colored. The colored lights at a rock concert push the high energy of the music even higher. In purchasing a car, many people feel that its color is as important as its performance. When we dress ourselves or decorate our living quarters, we make sure that the colors work together. We admire red tulips that stand out against the green of a lawn. We stop when the traffic light turns yellow or red—and we go on green. Every day, consciously or not, we make judgments based on color.

Although many of our daily activities are influenced by color, color perception has remained an elusive subject, so far defying precise scientific scrutiny and sometimes even common sense. Several plausible color theories exist, but no single one has been able to explain all the perceptual phenomena of color.¹

To confuse things even more, color is extremely relative. A certain color does not remain stable under all conditions but changes within different contexts. A particular red, for example, looks darker or lighter, depending on whether it is painted on a highly reflective surface, such as porcelain, or an absorbent one, such as cloth. The same red will also look different depending on what other colors surround it or how much and what kind of light falls on it. Worse, you and I may perceive colors quite differently yet react to a certain color similarly because we have simply learned to do so.

Despite this relativity of color and our lack of a precise scientific color theory, we have gathered enough working knowledge to describe and even predict fairly accurately how most of us will perceive and react to certain colors and color combinations. In this chapter we look at (1) what color is, (2) how we perceive color, (3) how we mix color, (4) color relativity, (5) colors and feeling, and (6) color energy.

What Is Color?

Color is the property of light, not of objects or liquids. Color is light that has been divided into one or more visible light waves by some object. We have all seen how white light—for example, sunlight—can be divided into rainbow colors by a prism

or prismlike agents such as water drops. These rainbow colors are called spectral colors because their wavelengths fall into the visible electromagnetic spectrum. **SEE COLOR PLATE 1** Note, however, that the waves of the visible spectrum are not colored; we simply perceive them that way.²

Translucent materials and liquids that appear colored, such as tinted sunglasses or green dishwashing liquid, do not reflect; rather, they selectively *transmit* certain wavelengths. When you want to create colored light, you can put a color filter, called a gel, in front of the lens of the lighting instrument. This color filter works by subtracting from the white light emitting from the instrument all colors other than the one of the filter. Thus, if you put a red filter in front of the lighting instrument, you get red light; with a blue filter, blue light, and so forth.

How We Perceive Color

Exactly how we perceive color is still subject to scientific debate.³ Fortunately, in the context of the extended first field, we do not depend so much on the relative accuracy of various color theories as on the various factors that influence our actual aesthetic perception of color.

BASIC PHYSIOLOGICAL FACTORS

As mentioned before, color perception means that the eye receives light of a certain wavelength or, more realistically, a mixture of wavelengths, that is transmitted to and interpreted by the brain as a color sensation. **SEE 4.1** As you can see in the figure, white light falls on an object, which selectively reflects certain wavelengths while absorbing others with its specific, built-in color filters. The lens of the eye focuses the reflected light on the light-sensitive cells of the retina, which comprises a combination of cones and rods. The cones are for bright daylight vision and therefore also receive the reflected light that makes up the color. Certain cones seem to be more sensitive to the blue end of the spectrum, others to the middle (green-yellow), and still others to the red end. In contrast, the rods help us see when the light is dim. But they do little, if anything, to make us see color. When the cones are stimulated, they fire electric charges that are probably encoded and mixed into a color signal before being transmitted to the brain. The brain, finally, decodes and interprets the signal as a color (see figure 4.1).⁴

4.1 Color Perception

The object reflects parts of the light spectrum, absorbing the rest. The reflected light is focused by the lens of the eye onto the light-sensitive cells of the retina—the cones and the rods. The cones are for bright daylight vision and therefore also receive the reflected light that makes up the color. The rods help us see when the light is dim. The color signal is then sent to the brain, which interprets it as a particular color.

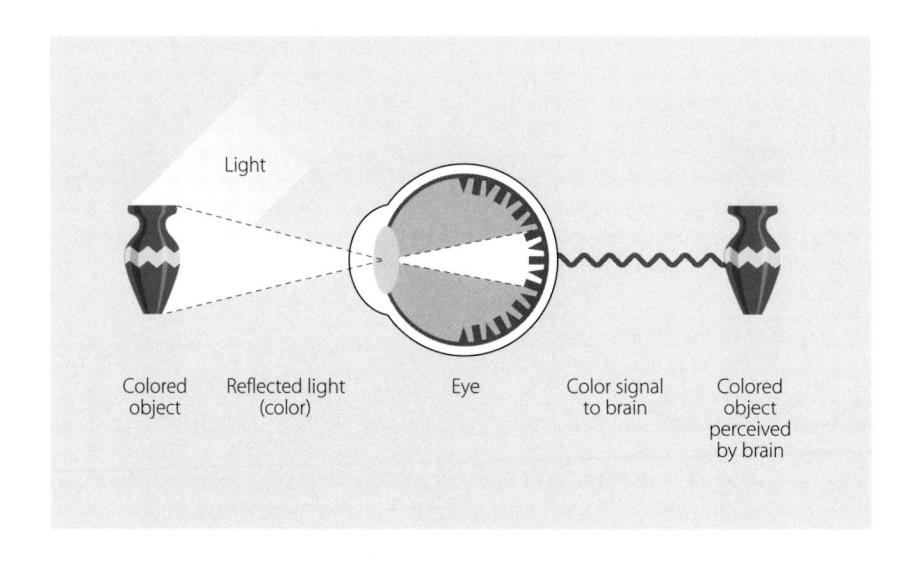

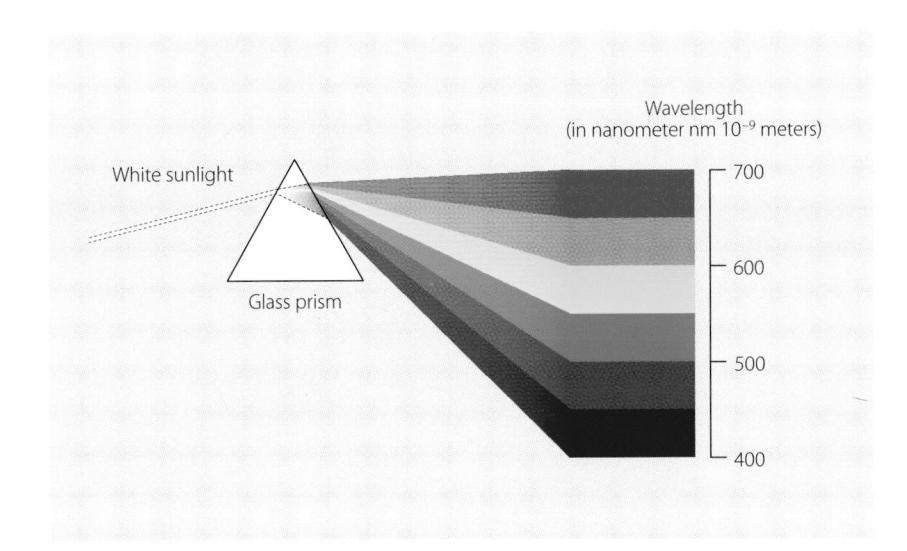

CP1 The Visible Spectrum

When we shine a beam of sunlight through a prism (diamonds or waterdrops create a similar effect), we see a series of colors ranging from red to violet. These rainbow colors are called spectral colors because their wavelengths fall into the visible electromagnetic spectrum.

CP2 Hue

Hue describes the color itself. Red, blue, green, and yellow are color hues.

CP3 Saturation

These colors have different degrees of saturation. Saturation describes the color richness—the color strength. The colors in the first row are highly saturated; in the second row, the colors are less saturated. Saturation is sometimes called *chroma* (Greek for "color"). White, gray, and black have no chroma (actual color saturation) and are, therefore, called achromatic colors.

CP4 Gradual Desaturation

The upper strip shows the gradual desaturation of an orange hue. When the strip is photographed in black-and-white, all degrees of saturation show the same gray.

CP5 Brightness

Brightness, or value, indicates how light or dark a color appears in a black-and-white photograph. The brightness of a color depends on how much light the color reflects. Black-and-white television produces images that vary in brightness only.

CP6 Hue Circle

The color hues are arranged around the periphery of a circle, called the hue circle, in their spectral, or rainbow, order. The colors that lie opposite each other are called complementary colors. When two complementary colors are mixed together, they produce an achromatic gray. Color afterimages are complementary to the basic color that produces the afterimage.

CP7 Partial Color Model

In a color model, the grayscale makes up the vertical axis. Because it has no actual color (zero saturation), it is called the achromatic axis. The hues are arranged around the achromatic axis like tree branches. The farther away the colors are from the achromatic axis, the more saturated they are.

CP8 Brightness Contrast

These three colors (yellow, green, and purple) have good brightness contrast; that is, they will show up as different shades of gray on a black-and-white monitor. The yellow will be the lightest gray, the purple the darkest, with green in the middle. If the branches grow out of the achromatic axis at the same spot (as in color plate 7), the colors show up as the same gray and are, therefore, incompatible.

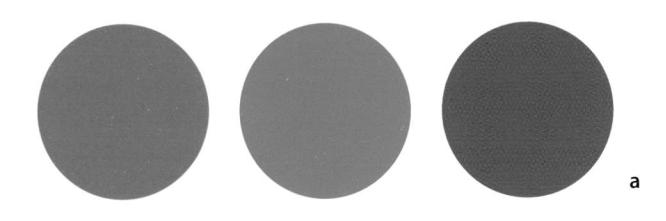

CP9 Color Primaries

Additive primaries: The additive (light) primaries are red, green, and blue.

Subtractive primaries: The subtractive (paint) primaries are magenta, yellow, and cyan.

CP10 Additive Color Mixing

Imagine that these three light primaries are produced with three slide projectors containing a red, a green, and a blue slide, respectively. If you add green to the red light, you get yellow. If you add blue instead, you get magenta. If you add green and blue together, you get cyan. If you add all three light primaries together, you get white. If you turn all projectors off, obviously you get black. If you now put each projector on a separate dimmer, you can produce a great number of different hues by simply varying the light intensity of either—or all—of the projectors.

CP11 Additive Color Mixing in Television

The color television receiver has a great number of additive primary color dots (rectangles): red, green, and blue. Three electron beams are assigned to activate their respective colors: one for the green dots, one for the red dots, and one for the blue dots.

CP12 Color Mixing in Pointillist Painting

The painting theory of the pointillists is based on our capacity to mix colors in the mind. Pointillists, such as the French painter Georges Pierre Seurat (1859-1891), built their paintings and color schemes by juxtaposing thousands of separate dots, all consisting of a few basic colors of varying saturation. Seen from a distance, the color dots blend into a wide variety of rich hues. Detail from A Sunday on La Grande Jatte (1884-1886), oil on canvas, 207.5 x 308 cm. Helen Birch Bartlett Memorial Collection, 1926.224. Courtesy of The Art Institute of Chicago.

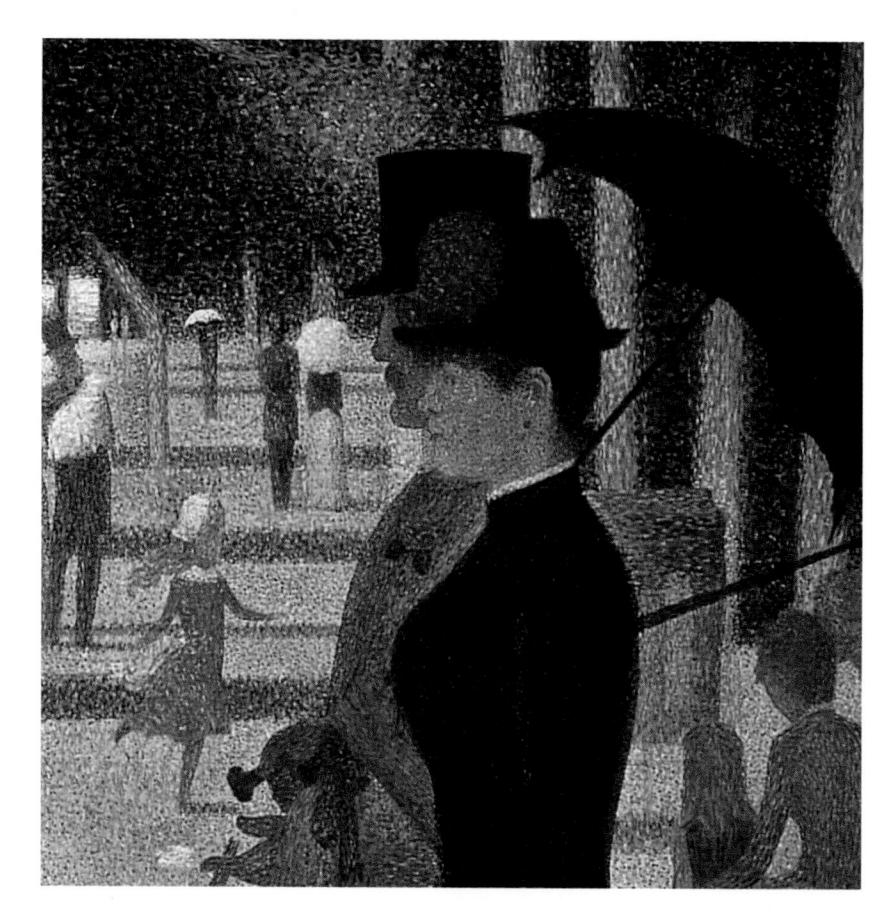

CP13 Subtractive Color Mixing

When all three subtractive primary filters overlap, we get black; they swallow one another's light until no light is passed. Note that where two subtractive colors overlap, they produce an additive primary.

E

CP14 Surrounding Colors

The blue of each middle rectangle is the same color. But we perceive slight differences in the color when it is surrounded by various hues and degrees of brightness.

F Sight, Sound, Motion Color Plates

CP15 Color Vibrations

When intended, color vibrations can provide an exciting visual experience. On television, however, color vibrations are often unintentional and undesirable. They happen when the television camera looks at narrow, highly contrasting patterns, such as thin stripes and checkered or herringbone designs.

The moiré effect is especially distracting when it occurs on a performer's clothes. As you can see, the small, highly contrasting checkered pattern of this newscaster's jacket causes an especially prominent moiré effect on his left shoulder. In extreme cases, these color vibrations bleed through the whole picture.

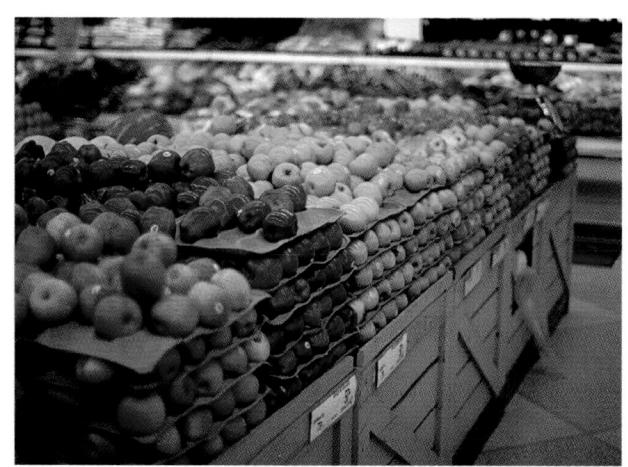

CP16 Informational Function of Color

Color tells us more about a scene; we simply get more information from a color picture than we do from a black-and-white one.

CP17 Identification by Color

The informational function of color is especially important when we have to identify and discriminate among things, such as the specific wires in a telephone cable. The color coding enables us to match the right wires at both ends of the cable.

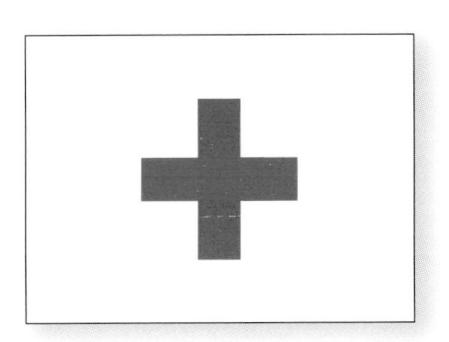

CP18 Color Symbolism

The red cross is so widely known throughout the world that it has become an almost universal symbol.

CP19 High- and Low-Energy Color Distribution

One of the most effective ways of combining high- and low-energy colors is to set off a high-energy color against a low-energy background.

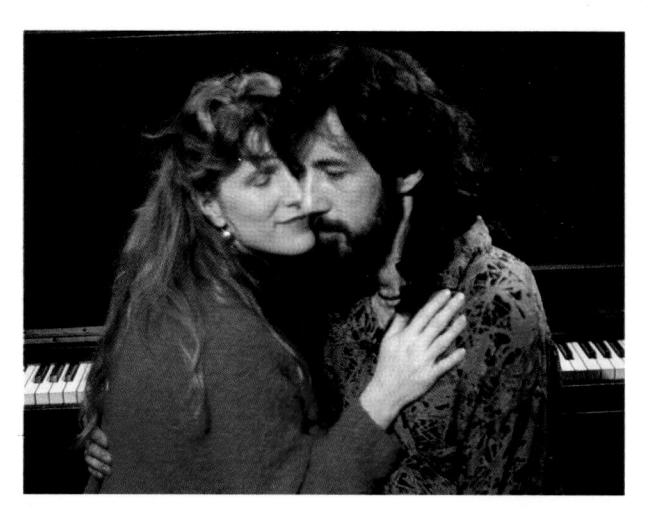

CP20 Normal Color Saturation

The normally saturated colors in this picture give us more information about the event, such as what colors the two people are wearing. Saturated colors make us look at the event, but not necessarily *feel* it.

CP21 Desaturation of Colors

When the colors are desaturated, the scene becomes more low-definition and so more accessible emotionally. The desaturated colors do not prevent us from looking into the event.

CP22 Total Desaturation: Black-and-White Image

We can achieve further low-definition by eliminating color altogether. In black-and-white, the outer event often serves as an extension of the inner event.

CP23 Low-Definition Rendering

When the black-and-white image is further reduced in definition, we are not only permitted but often compelled to deal with an inner reality. Low-definition images force us to fill in the missing parts mentally and thus become involved in the event.

BASIC PSYCHOLOGICAL FACTORS

When we look at colored objects, we can detect three basic color sensations: (1) the color itself—whether it is red, green, or blue; (2) the color strength—whether a red is deep and undiluted or looks faded and washed out; and (3) how light or dark it appears to us.⁵ These three basic color sensations we call *color attributes*.

Color attribute: hue Hue describes the color itself. Blue, red, yellow, green, and brown are all hues. **SEE COLOR PLATE 2** Only the colors of the spectrum are pure hues. Most colors we see are impure, which means that they combine several wavelengths.

Color attribute: saturation Saturation, sometimes called chroma (Greek for "color"), describes the relative strength or purity of a color. SEE COLOR PLATE 3 A highly saturated color looks rich; a color with low saturation looks washed out. Technically, saturation represents the amount of white, gray, or black mixed into the hue. White, gray, and black have no chroma and are, therefore, called achromatic. When you hear of chromatic colors, you should think of blue, green, vellow, and so forth, whereas the achromatic "colors" are black, gray, and white. When you desaturate a particular color, such as a deep red, with white, it turns progressively pink and lighter until all the color (red or pink) is gone and the resulting desaturated color is white. Obviously, the color moves up on the brightness scale during this type of saturation from the brightness of the original red—the specific gray you see when the red is photographed with black-andwhite film or when the chroma (color) is turned down in an electronic reproduction of this red—toward the white end. When you desaturate the same color with black, the red changes into a maroon color and eventually turns black. Because the desaturation agent is black, the original achromatic gray of the red color will move down on the brightness scale toward the black end. If you now desaturate this red with increasing amounts of its corresponding achromatic gray (the gray you see when showing this color on a black-and-white monitor), the red will turn into a progressively grayish pink until the red is totally overpowered by this particular gray. In this case, the desaturation has no effect on brightness. The brightness does neither increase (move up on the grayscale) nor decrease (move down on the grayscale), but stays at the same brightness level throughout the saturation process. A black-and-white photograph (film or video) of the chips that show the gradual desaturation from bright red to gray would show the gray for the whole strip.6 SEE COLOR PLATE 4

Color attribute: brightness Also called "value," or "lightness," *brightness* is how light or dark a color appears in a black-and-white photograph. Technically, brightness depends on how much light the color reflects. Perceptually, brightness refers to whether you see a color as light or dark. This condition of perceiving brightness—how much light the color reflects—is called *lightness*. Whereas you can measure brightness variations with a light meter; lightness you judge with your eyes. To avoid unnecessary confusion at this stage, we'll stick to the term *brightness* as the name for the third color attribute. **SEE COLORPLATE 5** In television and film, brightness is carefully charted by grayscale steps. Black-and-white, or monochrome, television shows only brightness. Obviously, it cannot show hue (the actual color) or saturation (how pure a color is). Even the best monochrome television sets cannot reproduce more than about nine brightness steps from black to white. The average monochrome receiver shows only about seven such steps. In color television we work with nine brightness, or grayscale, steps, including television white (a little off-white) and television black (not pitch black).

The hue change through desaturation with white is called *tint*, with black *shade*, and with its corresponding gray *tone*.

Color models In an attempt to standardize the color attributes and to show their basic interrelation, color theorists have devised color models.⁸ Although such models may differ in concept, they usually show the hues arranged in a circle in their spectral, or rainbow, order. If, for example, red is in the twelve o'clock position, we move clockwise from red to orange to yellow to green to blue to purple and back to red again. **SEE COLOR PLATE 6** The central axis is the brightness scale, or achromatic axis, which is nothing more than a vertically positioned grayscale. The degree of saturation is indicated by how far the hue is located from the achromatic axis. The hue that is farthest away from the achromatic axis has the highest degree of saturation; it is, after all, farthest away from being diluted by the corresponding gray. The closer the hue moves to the achromatic axis, the grayer it gets, and the color is completely desaturated when it reaches the achromatic axis. Technically, the color is now without hue. **SEE COLOR PLATE 7** Such models are quite helpful for printers who need a standard to ensure relatively accurate and consistent color reproductions. They also provide the standard for computer-generated colors. But in television and film, so many more factors influence color that such color models are, for all practical purposes, of little use.

COMPATIBLE COLOR

Technically, "compatible color" means that any color television signal must be encoded in such a way that it can be received and reproduced on a black-and-white television set. Aesthetically, it means that the various colors used in a scene have enough brightness difference that they will show up on the monochrome television screen as distinctly different shades of gray. If two contrasting, highly saturated hues, such as red and green, have the same brightness, they will photograph as the same gray.

Why bother with compatibility when black-and-white television is practically extinct except for industrial use? Because to be interesting aesthetically, a color scene needs variations not only in hue and saturation but also in brightness—regardless of whether it is viewed on a color or a monochrome receiver. Chiaroscuro painters often used rather subtle hues and equally subtle differences in saturation, yet they relied heavily on extreme variations in brightness. When, for example, you are asked to produce a commercial or music show in black-and-white instead of color, you must take care to choose colors that differ not only in hue, but also in brightness.

A good rule of thumb is to have the individual colors in the scene differ from one another by at least two grayscale steps. **SEE COLOR PLATE 8** What complicates matters is that you can change the brightness of a color quite readily by the amount of light that falls on the colored surface. If you flood the object with light, its color may climb several steps up the achromatic axis. In the same way, by reducing light you render a color darker than under normal illumination. Such color relativity is explored later in this chapter.

In order to ensure that a scene has compatible colors (colors with enough brightness difference), glance at it quickly with your eyes squinted. If the whole scene looks uniformly pale or dark, you need to use colors with a greater brightness difference among them. If it looks contrasting, you have good compatibility.

How We Mix Color

You probably discovered during your finger-painting days that by mixing red and green paints, you got a dirty brownish color. But then, having graduated to the finer art of studio lighting, you may be surprised to find that by shining a red and a green light on the same target area you get an amazingly clear and bright yellow.

This dramatic difference occurs because we are dealing with two separate and distinct color-mixing principles: additive and subtractive mixing. Additive color mixing means shining, or adding, colored lights on top of each other. Subtractive color mixing means mixing paints or combining color filters to absorb, or subtract, certain color frequencies so that only a specific color is reflected back. Whether you work with additive or subtractive mixing, you need only three basic colors to produce a wide range of other colors. These basic colors are called the primaries. **SEE COLOR PLATE 9**

ADDITIVE COLOR MIXING

The primaries for additive mixing are red, green, and blue, often referred to as "additive primaries," "light primaries," or, simply "RGB." In additive color mixing, we aim red light, green light, and blue light at the same target area. By adding these three colored lights in various intensities, we can achieve a great variety of hues.

Additive mixing with colored light Let's do some additive mixing by putting a red-colored slide in one slide projector, a green-colored slide in a second projector, and a blue-colored one in a third projector and overlapping them partially on a screen. What colors will you get? **SEE COLOR PLATE 10** The red-green overlap produces a bright yellow; the red-blue overlap produces a bluish red, called magenta; and the blue-green overlap yields a greenish blue, called cyan. The spot where they all overlap looks white. If you now were to dim one or the other slide projector, you could produce a great variety of colors. Computers use the same additive mixing principle. By generating the three primaries and adding them in various subtle proportions, they can produce thousands, if not millions, of different hues.

Additive mixing in video Color television works on the same principle. The white light that enters the camera is split inside the camera by mirrors or prisms into the three additive, or light, primaries: red, green, and blue. These three colors represent the three color signals that are processed and finally sent to your home receiver. There, the color signal activates three electron guns, each of which is designated to activate in turn its assigned color dots. One beam is responsible for the red dots, another for the green dots, and still another for all the blue dots that line the inside of the television screen. **SEE COLOR PLATE 11** By changing the intensity of either, or all, of the beams, you can achieve a great variety of colors.

The three electron guns operate on the same principle as the three slide projectors. When the red and green guns fire and the blue one doesn't, you get yellow. When the red and blue guns fire but not the green one, you get magenta. When the blue and green guns fire but not the red one, you get cyan. The black-and-white images on a color television are actually produced by the red, green, and blue electron guns all firing in unison at equally varying intensities. When all three guns fire at maximum strength, you perceive white; when they don't fire at all, you perceive black. When they fire only at half power, you see a middle gray.

Note that no actual additive mixing takes place in the television set. The television screen simply displays the three pure additive primaries side-by-side. Because the color dots or stripes are very small and lie close together, you need to be only a short distance away from the screen to have them mix into various wavelengths that our eye/brain mechanisms readily translate into a variety of colors. You can actually see the primaries by looking at sections of your color television set through a magnifying glass. This experiment works best while watching a black-and-white program during which, as you have just learned, all

three primaries—red, green, and blue—are activated at various intensities. Whereas you see the individual color dots in the magnified section, the nonmagnified dots seem farther away and, therefore, appear already mixed into various grays.

The color mixing in paintings of the pointillists is based on a similar principle. Rather than mixing paint into various hues (as in subtractive mixing) before putting them on the canvas, the pointillists made their paintings of thousands of discrete dots, all consisting of a few basic hues. Seen from a distance, the pure hues blend into each other very much like the colors on the television screen. **SEE COLOR PLATE 12**

SUBTRACTIVE COLOR MIXING

Now your finger-painting experience applies. When mixing paint, you are engaged in *subtractive color mixing*. Why? Because the paints, when mixed, filter each other out; in fact, each paint has color filters built-in that block any other frequencies (hues) from reaching your eye except the one whose hue you see. While we may be very happy with a red ball, the ball might not be so happy: The color it bears is the very one that was not accepted and was reflected back to your eyes.

Technically, subtractive mixing involves filtering out, or subtracting, from white light all colors except the one you want. If you want red, use a filter that prevents all other colors from reaching the eye except red. The red ball has such a filter built-in; so has red paint. Blue paint subtracts from the total light spectrum (white) everything except blue, which it reflects back. By combining two or more such filters (or by mixing paint), you can again achieve a wide variety of hues. An artist's palette is ample proof of such color variations.

Because in additive mixing, red, green, and blue light when combined in various intensities yield a maximum variety of hues, we can assume for subtractive mixing that we would need filters that are red-absorbing, green-absorbing, and blue-absorbing to achieve the same color sensations. True enough: The three subtractive (paint) primaries turn out to be the red-absorbing cyan (bluish green), the green-absorbing magenta (bluish red), and the blue-absorbing yellow. As a painter you would simply call the subtractive primaries red (for magenta), yellow, and blue (for cyan). In color photography (including film), these primary colors are created by filters in the film that subtract the unwanted colors and transmit the colors as seen by the lens.

When mixing subtractive primaries, you get the additive primaries: By overlapping magenta and yellow filters, you get red; cyan and yellow make green; and cyan and magenta mix into blue. **SEE COLOR PLATE 13** When you combine all three subtractive primaries, you get black. Instead of adding various light frequencies, as in additive mixing, the three filters now prevent one another's colors from passing.

MIXED MIXING

When lighting a set with colored lights (instruments that have color filters attached to them to produce a specific colored light), you may encounter additive and subtractive color mixing. When you shine red and green lights on a white or off-white background, you get yellow. But what would happen if you shined a red light on a green apple? Would the apple turn yellow? No, the apple would look nearly black. Why? Because you are now witnessing subtractive, rather than additive, mixing. The red light that shines on the apple contains no green. The apple, which wants to reject (and, therefore, display) green, is now bereft of its reflecting power and absorbs all colors shining on it. With no light reflected back, the apple looks black.

What would happen if an actor wore a yellow dress in a romantic scene that uses bluish light to simulate moonlight? Would her dress turn green? No, the dress would take on a gray color—quite similar to what you would see in actual moonlight. Because the blue filters absorb most of the yellow light, there is little yellow reflected back from the dress. Contrary to the apple example, this grayyellow effect is quite desirable.

This mixed-mixing effect of color filters comes in handy for controlling brightness in black-and-white photography. For example, if you want to have a light blue, such as the sky, come out a relatively dark gray (low end of the brightness scale), you use a filter that blocks some of the blue light: medium yellow. A lightgreen filter will make the reddish skin tones appear as a slightly dark, suntanlike gray. The following table gives an overview of the color filters most commonly used in black-and-white photography. **SEE 4.2**

Relativity of Color

As helpful as the theoretical color models are for standardizing the appearance of color and for making color more manageable in television and film, they cannot account for all the variables that could influence our color perception. One and the same red may look lighter or darker, purple or even black, bright or dull, strong or weak, depending on what kind of light or how much light falls

4.2 Color Filters for Black-and-White Photography

Scene	Effect	Filter
Sky and clouds	Heightened cloud effect, yet natural	Medium yellow
	Dark sky, white clouds	Orange
	Very dark sky, very bright white clouds; dramatic	Red
	Extreme contrast: black sky, brilliant white clouds; special effect (night scene)	Dark red
Fog (landscape)	Foreground pieces appear quite dark; silhouette against soft, light-gray background	Blue
Haze (landscape)	Reduces atmospheric haze	Medium yellow
Flowers and grass (colorful landscape)	More contrast between flowers and grass; bright flowers against dark grass	Medium yellow
Snow	Heightened contrast between light and dark (accentuates ridges, etc.)	Medium yellow
	Exaggerated contrast (ski goggles are usually medium yellow or orange to accentuate imperfections in the snow for the skier)	Orange
People (portraits, etc.)		
Outdoors	Accentuated skin tones but natural looking	Light green
Indoors	Suntan	Light green
	Light yet accentuated skin tones	Medium yellow

on it, on what colors surround it, and even on whether or not we know what kind of red it should be. Of the many factors that can influence how we perceive colors, we mention here the six most relevant: (1) light environment, (2) surface reflectance, (3) color temperature, (4) surrounding colors, (5) color juxtaposition, and (6) color constancy.

LIGHT ENVIRONMENT

Colors change depending on how much and what kind of light falls on the object or scene.

Minimum amount of light Because color is basically filtered and reflected light, we need to ensure a certain amount of light so that some of it can be reflected by the object after partial absorption. With adequate light, a colored object can reflect enough of the "rejected" light so that we can see its actual color. But when we gradually reduce illumination, these objects reflect less and less light, and the colors begin to lose their hue. Like the baselight requirement of the television camera or color film, colored objects also have a minimum illumination requirement to show their true colors. A full moon, for example, may emit enough light so you can distinguish between objects or even read a newspaper, but there is simply not enough light to reflect back the actual colors of illuminated objects. A moonlit scene is, therefore, strangely colorless.

Too much light Too much light can distort colors just as much as too little can. When you flood a colored object with light, it no longer reflects back only the rejected light, which makes up its color, but also most of the white light that falls on it. Consequently, all that the camera picks up is an overabundance of light that it translates into an extremely bright spot with little or no hue.

SURFACE REFLECTANCE

Whether a colored object reflects too much or too little light depends partly on the amount of light that falls on it, but also on how much light the surface of the object reflects. A mirror reflects almost all the light that falls on it, whereas a velvet cloth absorbs most of the light falling on it. This means that you need much less light to bring out the colors of an object with a highly polished surface than one with more light-absorbing, textured surfaces. Nylon, silk, and heavily starched cotton all reflect light very well. They can even project their colors onto adjacent surfaces, such as the face and arms of performers, which can be highly distracting if the reflected hues differ considerably from skin colors. A dense, reflecting set can also cause color spill, which unfortunately is picked up by nearby objects or performers. Light-absorbent set materials or paint help minimize such reflectance problems.

COLOR TEMPERATURE

Our perceptions are also influenced by the kind of light under which we experience them. Although we speak of "white light," no light we ordinarily experience is pure white. Some so-called white light has a reddish tinge, and other light a bluish one. Even sunlight changes color. At midday, sunlight has an extremely bluish tinge; during sunrise or sunset, it is much more reddish. This relative reddishness or bluishness of light is measured by *color temperature* in Kelvin degrees. ¹⁰

The more bluish the light, the higher the color temperature; the more reddish the light, the lower the color temperature. The ordinary tungsten

lightbulb in your home has a more reddish "white" light than fluorescent lighting. Note that color temperature has nothing to do with physical temperature—how hot or cool the lightbulb or fluorescent tube feels. The fluorescent tube may feel much cooler than the ordinary incandescent lightbulb, but bluish fluorescent light still has a higher color temperature (higher degrees K) than an ordinary incandescent lightbulb.

Because of these variations in white light, you need to adjust the television color camera to the prevailing light environment and readjust it every time you move into a new lighting environment. This is done by "white-balancing" the camera. During such a *white-balance*, the three primary color channels (red, green, and blue) are balanced against each other so that, when combined, they produce the white of the actual object.¹¹ Film has these color corrections built-in. Because outdoor light usually has a much higher color temperature (more bluish tinge) than indoor light, outdoor film has a filter that makes the light more reddish than indoor film. So if you shoot an indoor scene with outdoor film, the picture will have a definite reddish (warm) color tinge. But if you shoot outside with indoor film, the scene is bound to be washed in bluish colors.

From this discussion of how different kinds of light influence color, it should be apparent that when you apply makeup, you need to do it in the same lighting environment in which you perform. If the performance area has bluish light (high color temperature), you obviously need makeup colors that are relatively warm (reddish). If you work under relatively reddish lights, your makeup needs to have some bluish colors to compensate for the low-color-temperature lighting.

SURROUNDING COLORS

The way we perceive a color is greatly influenced by the surrounding colors. Sometimes a color looks brighter than its real brightness value, if it is set off against a dark background. The same color may practically disappear if put in front of a similarly colored background. Sometimes the foreground color may even take on another tinge caused by the surrounding background color.

Similar colors It seems obvious that when you use the same color for the foreground object as for the background, you will have a hard time seeing the object. Such problems can arise frequently in routine television shows, however, where you may have no control over what the guests wear. If, for example, a guest wears a suit of the same beige color as the background of your interview set, you may experience some difficulty even if you use high-quality cameras. One of the quickest solutions to such problems is to reduce the intensity of the background lights. Such a reduction will lower the background brightness, providing enough contrast between foreground and background.

Wearing blue in front of a blue background for chroma keying or any other blue-screen process has even more dire consequences. During the keying process, all blue areas—including the blue dress, suit, or tie—are replaced by the image being keyed, such as a weather map. You may see only the hands and face of the talent moving mysteriously in front of the weather map. As hilarious as such unintentional visual effects may be, they do reduce the effectiveness of communication.¹²

Contrast As stated earlier, similarity of hue and brightness between foreground and background leads to poor pictures; so does too much contrast between foreground and background. Putting a highly reflecting bright object in front of a dark-blue or black background may result in a contrast that exceeds the technical capabilities of a video camera. Generally, the contrast ratio for video should not

The color temperature standard for indoor lighting is 3,200°K and the standard for outdoors is 5,600°K. Through excessive dimming, the color temperature is lowered in both types of instruments, and skin colors turn reddish. On a clear, sunny day, the color temperature of outdoor light can be so extremely high that pictures take on a bluish tinge. In this case you must use the color filters on the television camera's filter wheel to lower the color temperature to the 3,200°K norm. You can use indoor lights outdoors only if they are equipped with outdoor-rated lamps or dichroic filters, which raise the indoor color temperature rating of the light to the 5,600°K outdoor norm.

exceed 40:1, which means that the brightest color in the picture can be only forty times brighter than the darkest picture area. Film, on the other hand, can handle as high a contrast ratio as 130:1. The difference in contrast ratios means that you can see more brightness steps in film than in television, a feature that contributes significantly to the so-called film look.

Simultaneous contrast This unfortunate term has nothing to do with brightness contrast. Rather, it describes the influence of the surrounding color on the hue of the foreground color. Generally, the foreground color takes on a slight tint that is complementary (opposite on the hue circle) to the surrounding background color. **SEE COLOR PLATE 14** Simultaneous contrast can cause an undesirable color to tinge parts of the scenery or even costumes. For example, if you place some light-gray or off-white set pieces in front of the customary chroma-key blue background, they will assume a slight yellow tinge. You can easily counteract this problem by pulling the set pieces a little farther away from the blue background, or by giving the set pieces a very light blue wash.

COLOR JUXTAPOSITION

When juxtaposing highly saturated complementary colors, such as red and green, in a single graphic rendering or static camera shot, you run the risk of causing "color vibrations." Somehow the two colors seem to compete for attention, pushing the simultaneous contrast to a point where it becomes an artifact (undesirable color distortion).

Similar color vibrations are also caused by narrow, highly contrasting patterns, such as a thinly striped black-and-white dress or a herringbone jacket. These artifacts are called *moiré effects*. They are caused not by a heightened simultaneous contrast, but by the inability of the electronic camera to adjust its scanning fast enough to the extreme dark/light contrast in the pattern.

Some painters—Isia Leviant, for example—create designs in order to generate just such vibrations and an impression of movement.¹³ But when they occur on scenery or the performer's clothes, such moiré effects are highly undesirable. Sometimes such vibration effects can bleed through the entire picture. **SEE COLOR PLATE 15** Unless you want to create these effects intentionally, in a dance number for instance, beware of thinly striped scenery or drapery, and tell performers to avoid clothes with highly contrasting patterns.

COLOR CONSTANCY

Just for a moment, move this book from the light into a shaded area. Do you still see black letters on a white page? Of course you do. But if you were now to measure the actual brightness of the white page, it would be considerably less than when the book was in the light. Your mental operating system tried to stabilize the situation as much as possible and made you perceive the white as white and the black as black regardless of the actual values of reflectance. This stabilization by your mental operating system is called *brightness constancy*.

Now take a yellow pencil and move it from the light into the shade. Is it still the same yellow as before? Yes, it is; at least it *appears* to be the same yellow. Even when only part of the pencil is in the shade, you still "see" the pencil as uniformly yellow.

If you were now to do an accurate painting of the pencil, you would probably be surprised at how much the yellows differ from each other, although in the finished painting the pencil appears again of uniform color. Why? Because your

perception is guided not only by what you actually see (the retinal stimulus), but also by your mental operating system, which tries to stabilize the environment as much as possible. Even if part of the pencil is in the shade and, therefore, a different color, you still perceive the pencil as a single unit in the context of its surroundings. In the case of color, such a stabilization is called *color constancy*.

Unfortunately, the color camera (television or film) knows nothing about contextual requirements for color constancy. Through close-ups, it can readily divorce an object from its context, naively reporting the colors it actually sees. If you were now to take a close-up of the pencil and pan the camera from the lighted portion to the shadow portion, the color camera would faithfully reproduce the differences in hue.

You can avoid most of such color problems by careful lighting and by showing the object in a proper context that allows us to apply color constancy even if the object is shown on the screen.

Colors and Feelings

Colors, or particular color groups, seem to influence our perceptions and emotions in fairly specific ways. Certain colors seem warmer than others; some appear closer or more distant. A baby is apt to overreach a blue ball because it seems farther away than it really is, and underreach a red ball because it seems closer. A box painted with a warm color seems heavier than the same-weight box painted a cooler color. In a room bathed in red light, we seem to feel that time moves more slowly; in one illuminated by cooler light, time seems to go a little faster. Some colors seem high-energy and excite us; others seem low-energy and calm us down.

Although consistency in such observations is commonplace, we still don't have enough hard scientific evidence to permit valid and reliable correlations or generalizations. The problem with such perceptual effects is that they are *contextual*—they rarely if ever occur in isolation; instead they usually operate in the context of other aesthetic variables. Also, these color effects seem to show up best in a positively predisposed context, that is, in a field in which most other elements display similar tendencies.

WARM AND COLD COLORS

It is generally assumed that red is warm and blue is cold. Thus a tendency exists to consider all colors of the red (long wave) end of the spectrum warm and all colors of the blue (shorter wave) end cold. This generalization is not accurate, however. We experience certain blues as warm, and some reds seem rather cold.

Rudolf Arnheim, a well-known perception psychologist and art theorist, suggests that it is not the main color that determines the warm/cold effect, but rather the color of the slight deviation from the main hue. Thus a reddish blue looks warm and a bluish red seems cold. ¹⁴ You can most readily see the relative warmness or coldness of a single color by looking at different yellows. Cold yellows have a definite bluish tint; warm yellows, a more orange one.

Warm reds and other warm colors seem to produce more excitement than cold blues or other cold colors. Assuming similar degrees of saturation and brightness, warm colors seem to us to be more active than cold colors. Highly saturated warm colors can make us feel "up," whereas cold colors of less saturation can dampen our mood so we feel "down." The traditional green room of the theater is supposed to make us feel calm and relaxed. The intense reds and oranges of some fast food restaurants is meant to produce just the opposite effect.

Note that the psychological property of color, which we call warm and cold, has nothing to do with color temperature—the relative reddishness and bluishness of white light—but rather with whether a color has a reddish tint (warm) or bluish tint (cold).

Color Energy

Color energy is the relative aesthetic impact a color has on us. The energy of a color depends on (1) the hue, saturation, and brightness attributes of a color; (2) the size of the colored area; and (3) the relative contrast between foreground and background colors.

When looking at *hues*, warm colors usually have more energy than cold ones. Colors that show up high on the *brightness* scale, such as a bright yellow, have higher energy than those low on the brightness scale, such as a dull brown.

It is the *saturation* of a color that especially determines that color's energy. When equal in saturation, a warm red obviously has more impact on us than a cold blue. But if the red is desaturated, the saturated cold blue becomes the more energetic color. In general, high saturation means high energy; low saturation, low energy.

As for color area, large areas usually carry more energy than small color areas. This assumes, however, that they are similar in saturation. A large field of red on a computer screen is "louder" and commands more attention than a small red dot.

Colors have more energy when set off against a background of contrasting brightness than against a background of similar brightness. A bright yellow has more energy against a dark purple background than against a white one. Even achromatic (no saturation) white and black can have high energy, especially if set off against a contrasting background.

High-energy colors are more active than low-energy colors. For instance, the high-energy red of a sports car seems to fit our concept of power and speed, and a red ball promises more fun than a white one. Apparently, we are quite willing to associate the relative color energy with a product that displays the particular hue. **SEE 4.3**

The advantage of translating colors into aesthetic energy is that you can integrate the effects of color more readily with other aesthetic elements which,

4.3 Aesthetic Energy of Colors

Attribute	Variable	Energy	
Hue	Warm	High	
	Cold	Low	
Brightness	High	High	
	Low	Low	
Saturation (major attribute)	High	High	
	Low	Low	
Area	Large	High	
	Small	Low	
Contrast	High	High	
	Low	Low	

when working in concert, can produce a variety of specific overall emotional effects. Best of all, this knowledge allows you to generate color composition in moving images. Such applications of color energies are explored more thoroughly in chapter 5.

Summary

This chapter discussed six major aspects of color—the extended first field: what color is, how we perceive color, how we mix color, color relativity, color and feeling, and color energy.

Colors are specific waves from the visible light spectrum. Color is reflected or transmitted light that has been specially filtered by an object or a liquid. When white light (sunlight) is divided by a glass prism, we see the spectral, or rainbow, colors ranging from red to violet. Objects do not possess color; they merely reflect back the colored light they are unable to absorb.

The basic physiological factors of color perception are that our eyes pick up the light reflected off an object and focus this on the retina. There the cones are mainly responsible for encoding the various wavelengths into a color signal that is then transmitted to the brain, where it is interpreted as a specific color.

The basic psychological factors are the three major attributes of color, and compatible colors. The three attributes (sensations) of color are hue, saturation, and brightness. Hue describes the color itself, for example, whether an object is red, blue, yellow, or green. Saturation describes the color richness or strength. A deep, rich blue is highly saturated. The same hue that looks washed out has a low saturation. Brightness or lightness indicates how light or dark a color would appear in a black-and-white photograph. Brightness is measured by the grayscale. The interrelation of these three attributes are standardized in a variety of color models.

Technically, compatible color means that any color television signal must be encoded in such a way that it can be received and reproduced by a black-andwhite television receiver. Aesthetically, color compatibility means that the various colors in a scene have enough brightness contrast so that they show up on a blackand-white television receiver as distinct shades of gray.

We can mix colors additively or subtractively. Additive mixing means the adding of the three light primaries (colored light) red, green, and blue. Television works on the additive mixing principle. It produces a wide variety of colors by stimulating clusters of the three light primaries—red, green, and blue—in different combinations and degrees.

Subtractive mixing refers to filtering certain light frequencies from the light that falls on an object. The frequency reflected back off the object is its color. Film works on the subtractive principle by filtering out certain colors by means of the three subtractive (paint) primaries: yellow, magenta (bluish red), and cyan (greenish blue).

When the light primaries are added, they produce white. When the paint primaries are added, they produce black (by filtering each other until no light passes). When shining colored light on a set that includes colored objects, we have a case of mixed mixing. When two colored lights overlap, we have additive mixing. When a colored light beam strikes a colored object, the object acts as a filter, resulting in subtractive mixing.

Colors are relative, that is, we perceive the same color differently under various conditions: light environment, surface reflectance, color temperature, surrounding colors, color juxtaposition, and color constancy.

If there is too little light, the object will not reflect back the true colors. When the lighting environment has too much light, the colors look washed out.

Highly reflective objects need less light for proper color renditions than highly light-absorbant objects.

Colors change depending on the relative bluishness or reddishness of white light. Outdoor light has a bluish tint and, therefore, a relatively high color temperature. Normal indoor light is reddish and therefore has a relatively low color temperature.

If a color is surrounded by a similar color, it loses its prominence. Contrasting hues and brightness steps are desirable, but the tolerance for brightness contrast is much more limited for television cameras than for film. Various hues can influence each other, which is called simultaneous contrast.

Color vibrations are caused by juxtaposing highly saturated complementary colors. Narrow, highly contrasting patterns may cause a moiré effect, which shows up as pulsating color vibrations.

Color constancy means that we perceive an object as uniformly colored, even if part of the object is shaded, greatly influencing its hue and brightness. When the object is isolated from its context, the color camera will faithfully display the color differences and interfere with perceptual color constancy.

Colors can influence our feelings in specific ways. We perceive some colors as warm, others cold. The relative warmness or coldness of a color is not so much the function of its hue (such as red and blue) but of the secondary hue that is mixed into the main color. For example, we usually consider red a warm color and blue a cold color, but a bluish red appears cold, and a reddish blue, warm.

Color energy refers to the relative aesthetic impact a color has on us. The energy depends on the hue, saturation, size of colored area, and contrast between foreground and background. Of these variables, saturation is the most influential in determining color energy.

NOTES

- 1. Bruce E. Goldstein, *Sensation and Perception*, 4th ed. (Pacific Grove, Calif.: Brooks/Cole Publishing, 1996), pp. 117–133.
- 2. Goldstein, Sensation and Perception, pp.112, 139.
- 3. Ralph M. Evans, *The Perception of Color* (New York: John Wiley and Sons, 1974). This book by the late Mr. Evans contains many color theories developed while he was working for the Eastman Kodak company.
- 4. Goldstein, Sensation and Perception, pp. 126-133.
- 5. Evans (1974) distinguishes among five color attributes: hue, saturation, brightness, lightness, and brilliance (p. 94). Lightness is a special condition of brightness and depicts our perception of reflectance. See also Goldstein, *Sensation and Perception*, p. 147.
- 6. Your computer's control panel may have a color model that demonstrates the various color attributes and their relationships. See also the latest version of Adobe Systems' *User Guide to Adobe Photoshop*. This software manual contains excellent pictures and information about color attributes. If you happen to own the Photoshop program, you can see how each attribute influences color perception. See Ralph M. Evans, *The Perception of Color* (New York: John Wiley and Sons, 1974), pp. 83–98; Frank A. Taylor, *Color Technology* (London: Oxford University Press, 1962), pp. 18–19; and Johannes Pawlik, *Theorie der Farbe* (Köln: Verlag M. Du Mont und Schauberg, 1967), pp. 50–51.
- 7. Herbert Zettl, *Television Production Handbook*, 6th ed. (Belmont, Calif.: Wadsworth Publishing Co., 1997), p. 372. See also Harry Mathias, and Richard Patterson, *Electronic Cinematography* (Belmont, Calif.: Wadsworth Publishing Co., 1985), pp. 82–104.

- 8. One of the most popular color models, devised by the American painter Albert H. Munsell (1858–1918), is appropriately called the Munsell color system. Twenty basic hues make up the hue circle. The brightness axis (which he called the value axis) is divided into nine steps, ranging from black to white. The saturation is uneven, depending on how much the basic hue can be saturated. The individual hue branches are numbered, as are the brightness steps and the saturation squares. Thus the appearance of a color can be specified very precisely; a 5Y 8/12 means a fairly warm yellow, rather light (almost to the top of the brightness scale), and highly saturated (twelve steps away from the brightness axis).
- 9. Herbert Zettl, Video Basics 2 (Belmont, Calif.: Wadsworth Publishing Co., 1998), color plates 1–4.
- 10. Zettl, Television Production Handbook, pp. 133-135 and color plate 11.
- 11. Zettl, Television Production Handbook, pp. 133-135.
- 12. Zettl, Television Production Handbook, pp. 344-345.
- 13. Try to look at and study some of the more widely reproduced paintings by Bridget Riley and Isia Leviant in books on kinetic art.
- Rudolf Arnheim, Art and Visual Perception: The New Version (Berkeley: University of California Press, 1974), p. 369.

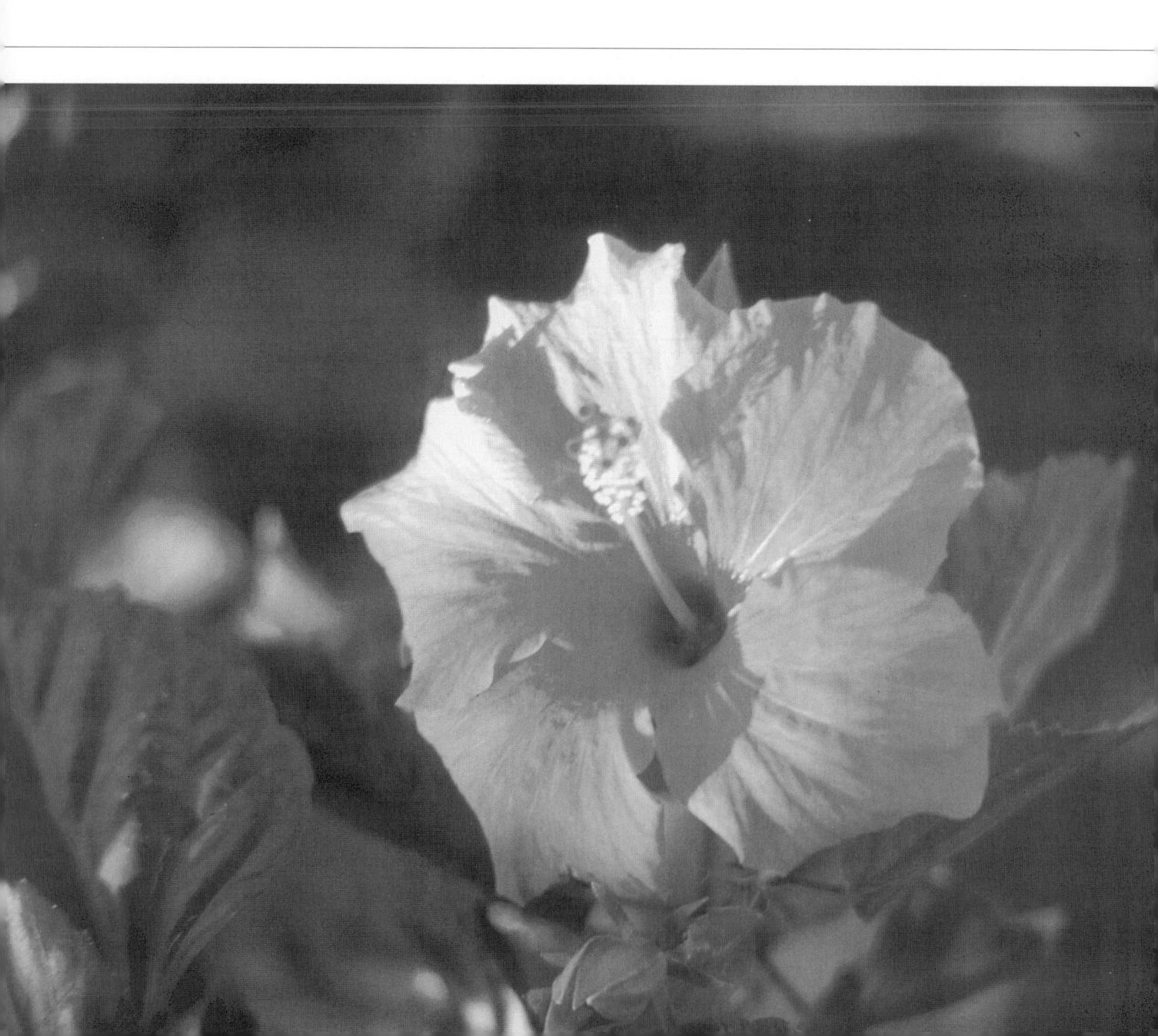

Structuring Color: Function and Composition

TRUCTURING color means to use color for a specific purpose in the overall quest for clarifying and intensifying a media-transmitted event. To do this effectively, you will need to acquire some insight into the principal functions of color: (1) informational, (2) compositional, and (3) expressive.

Informational Function of Color

The informational function of color is to tell us more about an event than would be possible without color, to help us distinguish among things, and to use specifically designed color codes. For instance, a color reproduction tells us more about the appearance of the event than a black-and-white rendering. **SEE COLOR PLATE 16** The colors not only make the event more realistic, but they also give us specific information about its conditions: You can easily distinguish the red apples from the green ones.

In medicine the diagnostician must rely heavily on the informational function of color; a difference in color may signal health or sickness. It goes without saying that in medical photography (still, computer display, television, and film), accurate color renditions are an absolute must.

Colors help to distinguish among objects and to establish an easy-to-read code: the red rose, the girl in the yellow dress, the fellow with the blue coat. The many wires in a telephone cable are color coded so that each wire can be easily identified and matched at both ends of the cable. **SEE COLOR PLATE 17** Mapmakers use color codes that enable us to read a certain variety of data quickly and accurately; such a code can indicate various elevations, for example. We also know that observance of the red-green-yellow color code in a traffic light can literally be a matter of life and death.

Within the context of the informational function of color, our primary task is to make one color as distinguishable as possible from the next. Considerations concerning color harmony remain secondary. Our main objective in the informational function of color is clarity.

This informational function is rendered meaningless in black-and-white (monochrome) screen displays. For example, monochrome television is colorblind and responds only to differences in brightness. As viewers, we cannot identify

5.1 Black-and-White Television Is Color-blind

The informational function of color is meaningless on black-and-white television. We cannot tell which of the four buttons is the green one.

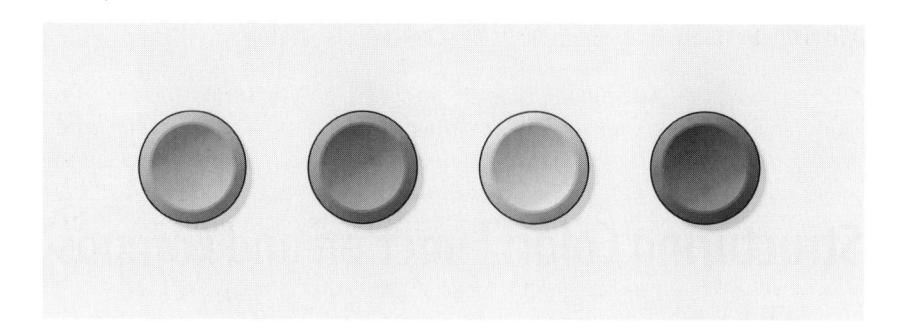

an object by its color or distinguish among various hues unless other cues, such as screen position or relative lightness or darkness of the objects, are given. **SEE 5.1**

Assume that one of the buttons in the figure is green and that you have to press only the green one in order to save the world from utter disaster. Which would you press? (It should have been the button on the extreme left.) Fortunately, monochrome images are used much more for establishing or reflecting a certain mood than inadequate color substitutes. We address the aesthetic functions of monochrome images later in this chapter.

COLOR SYMBOLISM

For many centuries people have used color to symbolize certain events, beliefs, and behavior. Color can symbolize life, death, hate, and faith, but such symbolic associations are learned and are, therefore, not uniform among all peoples. Rather, these associations are subject to peoples' habits, values, traditions, and myths, which vary considerably from culture to culture and from period to period. For example, some cultures use black as the color of mourning, whereas others use white and even pink. Such expressions as *blue blood*, *purple joke*, *greenhorn*, *redlight district*, *feeling blue*, *to be in the red or the black*, *black sheep*, *yellow coward*, or *blacklist* are all examples of color symbolism that apply in English-speaking countries. Translated into other languages, such color-oriented phrases often change or lose their meaning. For example, to be "blue" in German does not mean to be sad or even of royal blood; rather, it means to be heavily intoxicated.

Color symbolism also changes with the experiential context. As a religious symbol, white signifies purity, joy, and glory; but in war, it means surrender. Nevertheless, certain symbols have found almost worldwide acceptance, such as the red cross insignia or certain traffic signs. **SEE COLOR PLATE 18**

When you use color symbolically, make sure that you firmly establish the context within which you use the symbolic associations and especially ensure that a majority of your audience is familiar with the symbolism used. A symbol with an unknown referent serves no purpose whatsoever. Beware, therefore, of unexplained or obscure color symbolism, especially in television, film, and computer presentations. Contrary to a painting or a novel, which yields readily to close and repeated examination, moving screen events are not easily revocable for closer study; their color symbolism must therefore carry and reveal its meaning instantaneously.

The problem of symbolic color is obvious: An understated color symbol may remain undetected and so ineffective; an overstated one may prove too obvious to the sensitive viewer. For example, having the bad guy in cowboy movies wear a black hat and the good guy a white one has become such a hackneyed symbol that it is now used as an effective comic device.

If you establish a new symbolic color/event association, you must provide the audience with enough clues to learn this new association.

Sergei Eisenstein in his Film Form and Film Sense devotes a whole section (No. 3: Color and Meaning) to the symbolic use of color. But, inadvertently, his essay reveals more about the problems of precise symbolic associations through color than about the informational function of symbolic color itself.¹

Compositional Function of Color

Colors contribute greatly to the general form of the screen image. As in a painting, colors help define certain screen areas; that is, they emphasize some areas and deemphasize others. We may select a certain color as the focal point in the screen area and then distribute the other colors accordingly to achieve a balanced pictorial composition. Or we may choose certain colors or a certain color combination that will help produce a predetermined overall energy level. When colors are used for such purposes, we speak of the compositional function of color.

Generally, we aim at a harmonious color combination—a juxtaposition of colors that go together well. This means that we should be able to detect certain color relationships that yield rather easily to the perception of a dynamic pattern. In an effective color composition, colors are no longer random; each one of them has a purpose.

Advice on which colors go together or harmonize well is readily available in paint-store pamphlets or painting manuals. These resources usually tell you that colors harmonize best when they are (1) next to each other on the hue circle, (2) on opposite sides of the hue circle (which makes them complementary colors), or (3) on the tips of an equilateral triangle superimposed on the hue circle. **SEE COLOR PLATE 6**

In practice, such formulas are less than useful in television and film. For example, a certain red may easily overpower its complementary green if the red area is much larger than the green or if the red is more saturated. You acquire additional liabilities when composing color according to such formulas in television and film. The color composition can easily be upset by (1) the relative color temperature of the lighting, (2) the initial color setup in the camera, (3) the color setting of the display monitor, (4) any colored lights that may be shining on the scene, and (5) the moving camera. The primary factor that makes stable color composition in television and film so difficult is the movement of the camera and/or of the photographed subject and the camera's field of view. Certain colors that look pleasingly balanced in a long shot can fight one another in medium or close-up shots.

Should you give up now and simply forget about color composition? Not at all, but you will need a different approach to color composition than the usual formulas.

COLOR ENERGY

Rather than trying to identify hues that go well together, you will do much better by translating colors into *color energies* and then bringing the various energies into either balance or purposeful conflict.² As discussed in chapter 4, the energy of a color is principally determined by its level of saturation. Highly saturated colors carry more aesthetic energy than desaturated colors (see figure 4.3).

The most common compositional practice is to have small areas of high-energy colors set off against large background areas of low-energy color. **SEE COLOR PLATE 19** This color distribution is probably the arrangement you have in your own home. Many people have walls that are painted in low-energy colors (off-white, beige, light blue, pink, and so forth) to serve as a unifying element for the more high-energy colors of such accessories as plants, rugs, pillows, and paintings.

Such an energy distribution of color works especially well in scene design and costuming. Generally, you should try to keep large set areas in a rather uniform, low-energy color scheme, but then accent with high-energy accessories, such as bright curtains, pillows, upholstery, flowers, rugs, and the like. This gives you more control over the total effect, regardless of the various camera points of view.

Painting the background a high-energy color tends to reduce the energy of the more active foreground. Worse, it assaults our senses so much that we tend to protect ourselves with sensory filters that, in time, cause us to ignore the colors altogether. Technically, high-energy color backgrounds make it very difficult to maintain visual continuity in postproduction editing.

Similarly, you can keep the general color scheme of the costumes somewhat conservative, but then energize the scene by colorful, high-energy costume accessories, such as scarves, hats, belts, and the like.

When dealing with color energies, you can incorporate the compositional function of color more readily into the general aesthetic energy field than if you were dealing solely with the relationships of hues. As a matter of fact, by trying to balance color energies rather than hues, you may discover exciting new color combinations that defy tradition but not our quest for a clarified and intensified experience.

If you now had to design a color scheme for a fast, high-energy dance number for a music video, for example, how would you ensure some color balance during the dance? Rather than worry about the specific colors of the dancers' costumes or background scenery, you should first decide on the general distribution of high- and low-energy color areas. A good start would be to think, once again, of a low-energy background and high-energy colors for the dancers. Regardless of whether you shoot the dance wide or close-up or from a variety of angles, the high-energy colors of the dancers and their movements will be effectively set off against a low-energy background.

Best of all, the low-energy background will provide you with color continuity, which, as just mentioned, is especially important for extensive postproduction editing. With a background of a fairly uniform color, the editor will have little trouble matching the various shots even if the foreground colors of the dancers differ widely from shot to shot. But if the background is painted in various high-energy colors, the editor will find it extremely difficult to achieve even modest color continuity from shot to shot. With a high-energy background and a high-energy foreground, you would have to pay equal attention to the foreground and background in each shot, clearly a formidable and rather unproductive task in a fast dance number.

Expressive Function of Color

The expressive function of color is to make us feel a specific way. First, colors can express the essential quality of an object or event. Second, color can add excitement and drama to an event. And, third, color can help establish a mood.

EXPRESSING ESSENTIAL QUALITY OF AN EVENT

Picture, for a moment, your favorite sports car. What color is it? Now visualize a luxury limousine. What color do you give the limousine? You probably assigned the sports car the color red and the limousine black, gray, or perhaps silver. The high-energy color red expresses the power of the car, its mobility, and the fun of driving it. The low-energy colors of the limousine appropriately reflect the quiet elegance and understated wealth we associate with such a vehicle. How would you feel if a doctor performing surgery wore red and orange and the operating room were painted in pink candy stripes?

Package designers are careful to choose colors for their products that we associate most readily with their essential quality. A gold-striped purple box seems entirely fitting for a spicy perfume, but somewhat out of place for toothpaste. In

connection with perfume, the purple and gold colors suggest elegance, forbidden love, or secret passion; in connection with toothpaste, they signal bad taste. If the essential quality of the product is softness (such as hand lotion or tissue paper), we expect the color of the product to convey this quality. Desaturated pastel colors are the most appropriate to express softness. Strong spices, on the other hand, are best expressed by vibrant, highly saturated colors.

A dark, warm brown or a neutral off-white seems to express the objective, unbiased judicial activity in a courtroom more readily than a bright, highly saturated red. A soothing green reflects appropriately the cool, efficient activity of an operating room.

Here again, it is not so much the color itself—the hue—that we associate with the quality of the object or the event, but rather the energy of the color. In the bustling, noisy, and emotional environment of a carnival, high-energy colors are well suited to express the event's fun, joyful nature. But we tend to associate the cool, rational activity of a science laboratory most readily with low-energy, cold colors.

ADDING EXCITEMENT AND DRAMA

Colors can add excitement and drama to an event. The colorful uniforms of a marching band, the brightly colored costumes of dancers, the red and blue flashing lights of police cars, the color spotlights on the stage, the changing colors of a sunset or sunrise—are all examples of how colors excite us and dramatically intensify an event. A scene bathed in warm colors can communicate a glowing feeling of affection and compassion. Cold-colored scenes may indicate extreme sadness, sorrow, or disillusionment.

Color as principal event You can use color not only as an additional element of an event but also as the event itself. Laser light shows and abstract paintings that have as their subject various color areas are examples of using color as the basic *materia* of the event. To express someone's intense moments of rage or love, you could, for example, project red flashes over the entire screen. Yet the many attempts by video artists to use color as the primary event have not proved highly successful. Although temporarily exciting, most of these experiments do not seem to communicate the depth of feeling and significance we expect from art. Perhaps we have become so accustomed to seeing color used as a supplementary element within a scene that using it as the primary event does not hold our attention for long. In other words, we may be delighted by the juxtaposition of two high-energy colors such as yellow and red when they appear in a realistic picture—for example, two small children in yellow raincoats carrying a bright red plastic umbrella—but not when we see just two abstract color areas jostling for dominance.

Nevertheless, the various computer paint programs on the market offer exciting possibilities in the art of electronic painting—or at least in the distortion of natural colors to intensify an event. Some screen savers apply the tenet of color as principal event by producing a variety of moving and changing color patterns.

The advantage of such software is that you can run through a great number of colorization experiments in a relatively short time without elaborate lighting and camera setups. Once you are satisfied with a particular color effect, you can then transfer it to film or video.

Color and sound combinations Combining color and sound seems a natural thing to do. Aesthetically, we seem to react quite similarly to color and sound. Think of how we use musical terms to describe colors and color terminology to describe certain musical sounds. We speak of shrill and loud colors, or of harmonic

The expressive function of colored light was recognized long ago by the artists who crafted the stained-glass windows of the Gothic cathedrals.

Some of the early studies of color/sound relationships were done by Sir Isaac Newton (1642-1727) in the early part of the eighteenth century. They were continued by the Jesuit priest and mathematician Louis-Bertrand Castel who, in 1714, constructed the first color organ.3 Like Newton, the physicist Hermann L. F. von Helmholtz (1821-1894) tried to establish an analogy between the color spectrum and the notes of a musical scale.4 In the first decade of the twentieth century, Russian composer Alexander N. Scriabin (1872-1915) used a "lightclavier" to accompany the music of his 1910 composition Prometheus: The Poems of Fire. A few years later, Thomas Wilfrid built his own "clavilux," an instrument that projected patterns of light in rhythm of the music onto a screen. Other pioneers such as Adrian Bernard Klein, who published a treatise on the expressive function of color, Colour-Music: The Art of Light, as early as 1927, László Moholy-Nagy⁵ (see chapter 1) and Gyorgy Kepes,6 with their Bauhaus-inspired light experiments in the 1920s and 1930s—were all forerunners of the laser light shows of today. In the 1950s and 1960s, Norman McLaren produced hand-painted films of colored patterns that matched the music on the sound track; later, however, he returned to matching filmicly manipulated movements of dancers to music.7

and dissonant color combinations. We also talk about warm sounds, blue notes, and colorful cadenzas.

Many attempts to match colors and sounds in an aesthetic system, however, have so far largely failed. The problem is that although individual notes might correspond to specific colors in feeling and aesthetic energy, combinations of notes, as in a chord, rarely match similar combinations of assigned colors. A chord is quite different from the sum of its individual tonal components. The same is true of color. A color pattern has an expressive quality that differs, sometimes intensely, from the way each individual color feels. Matching color and sound patterns by their relative aesthetic energies rather than by individual notes and hues might be the most sensible approach to this problem.

ESTABLISHING MOOD

The expressive quality of color, like music, is an excellent vehicle for establishing or intensifying the mood of an event. This application of color requires that you pay particular attention to the relative warmness or coldness of the color

and its overall aesthetic energy. Generally, you can easily attach similar labels to the mood of a scene: There may be a high-energy hot scene or a low-energy warm scene; there may be a high-energy cold scene or a low-energy cold scene or any combination thereof. By using the color-energy table (see figure 4.3), you can easily find the color or color combination that fits harmoniously the feeling of the event. High-energy warm colors certainly suggest a happier mood or a more forceful event than low-energy cold colors. As with all uses of color, however, innumerable variations to this admittedly gross generalization are possible and successfully applied.

For example, you can intensify a scene just as readily by using a color palette that acts as a counterpoint to the other aesthetic elements in the event. An especially violent scene, for example, may gain intensity when presented in a cool, lowenergy color scheme. Warm, bright colors, on the other hand, can become a chilling counterpoint to a death scene. Whether to use colors harmonically (high-energy event matched by high-energy colors) or contrapuntally (low-energy event matched with high-energy colors) depends to a great extent on the context of the total event, your communication purpose, and the overall presentation style.

Desaturation Theory

Although bright, highly saturated colors are well suited to enhance an external high-energy scene, such as a football game, lively dance, or automobile race, they can also prevent us from getting caught up and involved in a quiet and intimate screen event. Showing in highly saturated basic colors an intimate love scene, a mother nursing her baby, a wounded soldier waiting helplessly on a battlefield, or a woman finally confessing her secrets to her friend might well hinder rather than help the intensification. Saturated colors often make such internal events, or *inscapes*, too external, luring the viewer into looking *at* rather than *into* the event.

One way of reducing the blunt and brazen impact of high-energy colors in a soft scene and of letting the viewer get close to an internal event is to desaturate the natural colors or omit color altogether. To portray the internal condition of an event means to penetrate outer reality—to make the viewers supply some of their own emotional energy to the communication process. Color on recognizable images (people and objects) emphasizes their appearance; thus, our attention is directed toward the outer, rather than inner, reality of an event. But when we render the scene more low-definition through desaturation of color or through posterization, mosaic, or soft-focus effects, the event becomes more transparent and invites the audience to apply psychological closure, that is, to fill in the missing elements of the low-definition images. In this way the viewers will inevitably get more involved in the event than if they were looking at high-definition color images. SEE COLOR PLATES 20–23

When to use color—or when not to use it—should no longer present too difficult a problem for you. If color, even when used expressively, prevents you from perceiving an event in all its depth and subtleties, use black-and-white. If color helps to clarify and intensify an event, use it. Obviously, if colors are needed for providing more information about an event, black-and-white no longer suffice. If you are after sheer excitement and spectacle, color is a must.

Generally, however, the more intimate and internal an event becomes, the more you can treat outer reality low-definition. The more low-definition the outer reality should be, the less important color becomes. Color intensifies landscape, not necessarily inscape.

COLORIZING FILM

Now you have at least one aesthetic theory that you can use when reading about the arguments of whether colorizing old black-and-white movies with digital paint programs is a good idea. If the film is a typical "landscape" movie, whose scenes are mostly external (galloping horses, large battle scenes, car chases, sports spectaculars), color will most often intensify the screen events. In any case, it certainly would not harm the intended effect of the film. If, however, the movie is primarily internal, with scenes that deal with deep and intense human emotions, color may well prevent us from the intended empathetic communication and sharing the characters' emotions. Color would thus destroy the film's intended effect.

We also need to question ethically as well as aesthetically the practice of colorization. Do we have the right to tamper with the finished work of a filmmaker? In the television business, the answer is yes. Since the beginning of transmitting films on TV, we have been editing motion pictures to fit the mores and time requirements of television. This "editing for television" practice hardly raised an eyebrow among filmmakers and the television audience. Squeezing a wide-screen movie onto a relatively small television set that has a differently proportioned picture area is, as you will read in chapter 6, a no less severe tampering with the film's original construct. Colorization, it seems, represents no more serious an aesthetic intrusion.

One could also argue that many films would probably have been shot in color had color been available at the time. But what about films that were deliberately shot in black-and-white in order to intensify the internal events? In Ingmar Bergman's *The Silence* and Steven Spielberg's *Schindler's List*, for example, colorization becomes a blatant, if not irresponsible, mutilation of the film. In fact, Spielberg films provide excellent examples of the desaturation theory. *Jurassic Park* is totally external and needs color as much as special effects. A black-and-white version of the film would definitely be a loss and make its superficiality even more apparent. *Schindler's List* is excruciatingly internal; a color version of the film would obliterate its surgical view of, and deep insight into, the extremes of the human condition.

The films of Swedish filmmaker Ingmar (Ernst) Bergman (1918-), often treating man's search for God, are usually studies of human loneliness and anguish. They include The Seventh Seal (1956), The Silence (1963), Cries and Whispers (1972), Autumn Sonata (1978), and Fanny and Alexander (1983) for which he won an Academy Award. He also wrote the screenplays for The Best Intentions (1992) and Sunday's Children (1993). His relentless probing of the internal condition of human beings would have made him a superior director of television drama. Unfortunately, he has never taken advantage of this medium, nor the medium of him.

The technically polished films of American film director **Steven Spielberg** (1946–) include Jaws (1975), Close Encounters of the Third Kind (1977), Raiders of the Lost Ark (1981), E.T.: The Extra-Terrestrial (1982), The Color Purple (1985), Jurassic Park (1993), Schindler's List (1993) for which he won an Academy Award, and Amistad (1998). He owns the Dream-Works film production company.

TELEVISION COMMERCIALS

Black-and-white television commercials are a direct application of the desaturation theory. More than a mere attention-getting device, black-and-white pictures entice us to colorize the scene in our heads and thus move psychologically closer to the event. We are made to *feel* what is going on in the commercial rather than to cognitively observe it. When, at the end of the commercial, parts of the scene or the entire scene finally appears in color, we seem oddly relieved. We are now permitted to switch back from the more demanding internal mode of perception to the customary external one, from looking *into* to looking *at* the event.

Summary

Structuring color means to use color for a specific purpose. Color has three principal functions: informational, compositional, and expressive. The informational function of color is to tell more about an object or event. Color can help to render the scene more realistically. Color can also help us distinguish among objects and establish an identification code. The symbolic use of color is part of its informational function, but symbolic associations are learned; the symbolism used must be known to the audience in order to be effective.

The compositional function of color is to help define certain screen areas and to bring the energies of pictorial elements into a balanced yet dynamic interplay. The traditional techniques of color composition—in which colors are said to harmonize best if they are close together, on opposite ends, or in a triangular configuration on the hue circle—are of little value in television and film. The constant movement of camera and object and the selective point of view of the camera render such compositional rules impractical. A more effective way of dealing with color balance and composition in the moving image is to translate the various colors into color energies and then distribute the energies within the television or film picture area so that they contribute to an overall balanced pattern. To achieve this we usually keep the background colors low-energy (less saturated colors) and the foreground colors high-energy (highly saturated colors).

The expressive function of color is to make us feel in a specific way. First, colors can express the essential quality of an object or event. Package designers use particular colors to have us associate certain feelings and attitudes with their product (white toothpaste, black perfume wrappings, and so forth). Second, color can provide drama and excitement. Colorful uniforms of a marching band, the flashing red light on a police car, or the colored spotlight on a stage are examples of this color function.

Color can also be used as the event itself. In this case, color is no longer a part of what is happening—it is the principal subject. Laser light shows and certain types of abstract painting are examples of this. Although relatively easy to produce with the aid of computers, television shows that feature abstract color patterns have not proved successful as a popular form of communication. We experience similar problems when trying to combine color and sound. Individual colors and sounds can be matched quite easily, but clusters of color and sound defy such integration.

The expressive quality of color can easily set or intensify a specific mood. Generally, warm, high-energy colors suggest a happy mood and cold, low-energy colors evoke a somber mood.

The desaturation theory suggests that by desaturating even to the point of omitting color altogether, we can entice the viewer to participate in the event, to look into rather than merely at it. Such desaturation is especially successful when we need to reveal or intensify an inner event. In this case, the low-definition color
(subdued, desaturated color scheme or single hue) and especially the low-definition black-and-white renderings deemphasize the outer appearance of things and draw attention to the inner reality of the event. The less we are concerned about outer reality, the less important color becomes.

Given this as an aesthetic context, colorizing film that was originally shot in black-and-white seems less offensive if the major portion of the film deals with external action and outer reality. But if the film depicts deep emotions and an inner reality, color will probably work against the film's aesthetic intent.

Black-and-white television commercials are a direct application of the desaturation theory. Such total desaturation renders the event low-definition, which forces the viewer into psychological involvement.

NOTES

- 1. Sergei Eisenstein, *Film Form and Film Sense*, ed. and trans. by Jack Leyda (New York: World Publishing Co., 1957), pp. 113–153.
- 2. When you deal with color energies in pictorial composition, you are actually working with vectors and the structure of the vector field. Compare the discussions of vectors in chapters 6, 8, 11, and 13.
- Conrad Mueller, et al., Light and Vision (New York: Time-Life Books, 1966), pp. 130–131.
- 4. Jack Burnham, *Beyond Modern Sculpture* (New York: George Braziller, Inc., 1967), p. 286.
- 5. László Moholy-Nagy, Vision in Motion (Chicago: Paul Theobald and Co., 1947).
- Gyorgy Kepes performed many experiments with light and color when he was head
 of the Light and Color Department of the Institute of Design in Chicago in the late
 1930s and later a professor of Visual Design at M.I.T.
- 7. Maynard Collins, Norman McLaren (Ottawa: Canadian Film Institute, 1977).
- 8. Herbert Zettl, *Television Production Handbook*, 6th ed. (Belmont, Calif.: Wadsworth Publishing Co., 1997), pp. 340–355.
- 9. Marshall McLuhan, Understanding Media: The Extensions of Man (New York: McGraw-Hill, 1964), pp. 321–322. One of McLuhan's main theories about television's intimacy is that the medium is "low-definition" and that, therefore, viewers get more involved in the presentation than if they were to see the event on the high-definition cinema screen. The success of Tony Schwartz as creator of extremely effective commercial advertising is in no small measure due to his applying McLuhan's theory of participation. See Tony Schwartz, The Responsive Chord (New York: Anchor Books, 1973).

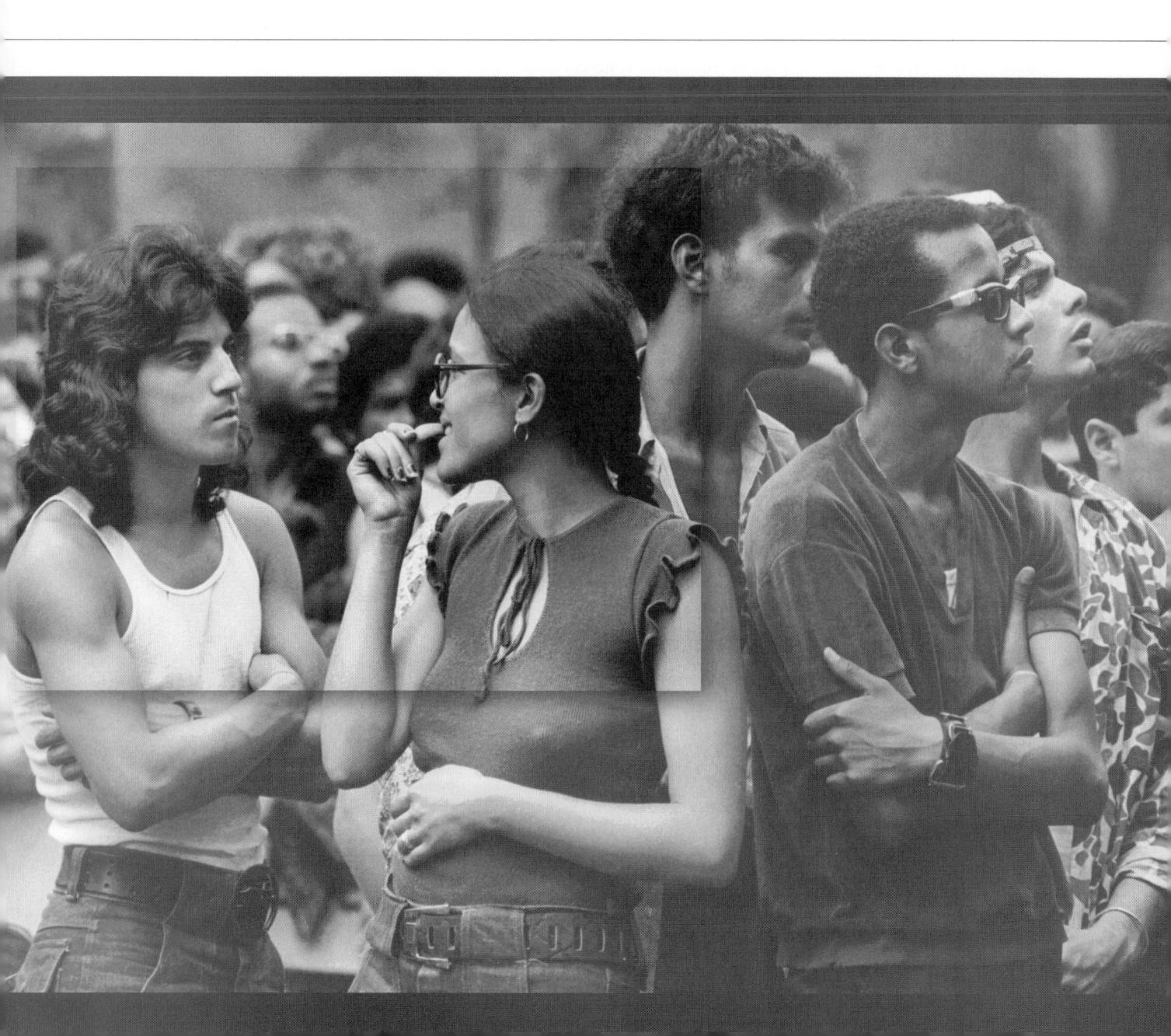

The Two-Dimensional Field: Area

OOK at the top part of the facing page. It is empty, neutral space. But, like the television, film, or computer screen, it provides a spatial field that is clearly defined by height and width. Its borders provide a spatial reference that allows us to assess the spatial relationships within the area and assert our position relative to it. Now put a coin anywhere on the empty space. Move it about. You judge each new position of the coin relative to the borders on the page. We do the same when we frame a scene for the television or film screen, or compose images on the computer screen.

The screen provides you with a new, concentrated living space, a new field for aesthetic expression. It helps you tame space. You are no longer dealing with the real space we walk through and live in every day but rather with *screen space*. You must now clarify and intensify an event within the context of screen space.

This chapter examines more closely the four structural factors of screen space: (1) aspect ratio, (2) object size, (3) image size, and (4) deductive and inductive approaches to sequencing pictures.

Aspect Ratio

Aspect ratio is the relationship of screen width to screen height. As a painter or still photographer, you have free choice in the basic orientation of your picture frame. You may want a frame that is taller than wide for the picture of a skyscraper, or a horizontally oriented format for the wide expanse of a desert landscape. You may even choose a round or an irregularly shaped boundary. In television, film, or computer displays, you do not have this format flexibility. The normal television, film, and computer screens are horizontally oriented. Why?

First of all, our peripheral vision is greater horizontally than vertically. This makes sense because we normally live and operate on a horizontal plane. To travel two hundred miles overland is nothing special; to cover the same distance vertically is a supreme achievement. A 600-foot-high tower is a structural adventure; a 600-foot-long building is simply large.

ASPECT RATIO AND FRAMING

The classical motion picture screen and traditional television and computer screens took over the classical 4:3 aspect ratio of film. Regardless of their size, they are all four units wide and three units high. **SEE 6.1** This aspect ratio is also expressed as a 1.33:1 ratio: For every unit in height, there are 1.33 units in width.

In its desire to engulf us in spectacle, the motion picture screen stretched to a wider, wraparound aspect ratio. Of the great variety of horizontally stretched aspect ratios, two formats have emerged as standards: the *wide-screen format* with a 1.85:1 aspect ratio,¹ and the *Panavision 35 format* with a wider 2.35:1 aspect ratio.² **SEE 6.2 AND 6.3** Most U.S. films are shot in the 1.85:1 wide-screen aspect

6.1 Traditional Television and Classic Movie Screen Aspect Ratio

All normal television screens and the classical motion picture screen have an aspect ratio of 4:3, which means that they are four units wide and three units high. The 4:3 ratio is also expressed as a 1.33:1 ratio: For every unit in height, there are 1.33 units in width.

6.2 Wide-Screen Motion Picture Aspect Ratio

The aspect ratio of wide-screen motion pictures is 1.85:1. This ratio provides a horizontally stretched vista and is the standard U.S. film aspect ratio.

6.3 Panavision Motion Picture Aspect Ratio

The aspect ratio of the Panavision film format is 2.35:1, which gives a wider panoramic view than the standard widescreen format.

6.4 HDTV Aspect Ratio

The HDTV (high-definition television) screen aspect ratio is 16:9 or 1.77:1, making this screen more horizontally stretched than the normal television screen. The HDTV aspect ratio can accommodate wide-screen movie formats without much picture loss on the sides.

16 units

ratio. The wider Panavision format requires an anamorphic lens to stretch the squeezed film frame for the projection on the wide screen.

HDTV (high-definition television) has a horizontally stretched aspect ratio of 16:9, or 1.77:1, a compromise that requires relatively little adjustment of any aspect ratio between the classical 4:3 (1.33:1) format and Panavision's stretched 2.35:1 view.³ **SEE 6.4**

There is some controversy, if not confusion, about just why, as early as 1889, the aspect ratio for film was set to be four units wide and three units high (1.33:1).⁴ When you look at this standard not from a technical but from an aesthetic point of view, however, the reason for this screen format is no longer so baffling.

The advantage of the 4:3 aspect ratio is that the difference between screen width and screen height is not pronounced enough to emphasize one dimension over the other. **SEE 6.5** You can frame a horizontally oriented scene without too much wasted vertical screen space, and a vertical scene without worrying too much about how to fill the sides of the screen. **SEE 6.6 AND 6.7**

The 4:3 aspect ratio is especially appropriate for the close-up and extreme close-up framing of a person. In the close-up, and especially in the extreme close-up, most of the screen area is occupied by the principal subject. **SEE 6.8 AND 6.9**

6.5 Framing Height and Width in a Single Shot

In the 4:3 aspect ratio, the difference between height and width is not so noticeable as to unduly emphasize one screen dimension over the other. It accommodates both horizontal vistas and vertical objects.

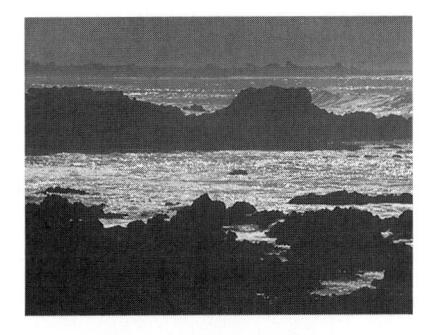

6.6 Framing a Horizontal View

The 4:3 aspect ratio can easily accommodate a horizontally oriented vista.

6.7 Framing a Vertical View

Even a vertically oriented scene can be easily framed within the 4:3 aspect ratio.

6.8 Framing a CU in 4:3 Aspect Ratio

The 4:3 aspect ratio allows us to frame a close-up without crowding the frame or leaving unused screen space.

6.9 Framing an ECU in 4:3 Aspect Ratio

The 4:3 aspect ratio can accommodate an extreme close-up without leaving undesirable screen space on the sides.

6.10 Framing an ECU in 2.35:1 Aspect Ratio

When framing a close-up or extreme closeup in the 2.35:1 Panavision aspect ratio, we are inevitably left with a considerable amount of unused screen space on either side of the subject.

When attempting the same shot within the wider aspect ratio of the motion picture screen, you are forced to deal with a considerable amount of leftover space on either side of the close-up. **SEE 6.10** As a director, you will find that in this case you have to pay much more attention to the peripheral pictorial elements or events than if you were shooting for the classical 1.33:1 aspect ratio. When moving from an establishing long shot to a close-up of the main action, the close-up does not occupy the greater portion of the screen area, as it would in the classical screen format; instead it leaves much of the surrounding event in clear view. **SEE 6.11**

Let's assume that you are directing the sidewalk café scene in figure 6.11. In this establishing long shot, you would obviously need to be concerned with all the action at the tables as well as the people standing or walking nearby. But even in a close-up of the principal event—the four men at the front table—the side

6.11 Establishing Shot in Wide-Screen Aspect Ratio

The wide-screen aspect ratio is ideal for establishing shots and vistas that stretch horizontally.

6.12 Close-up Detail in Wide-Screen Aspect Ratio

Even after moving in with the camera on the central action (in this case the front table), the peripheral action (at the side tables) still figures prominently in the composition. This means that as a director, you must concern yourself with all the action visible on the wide screen.

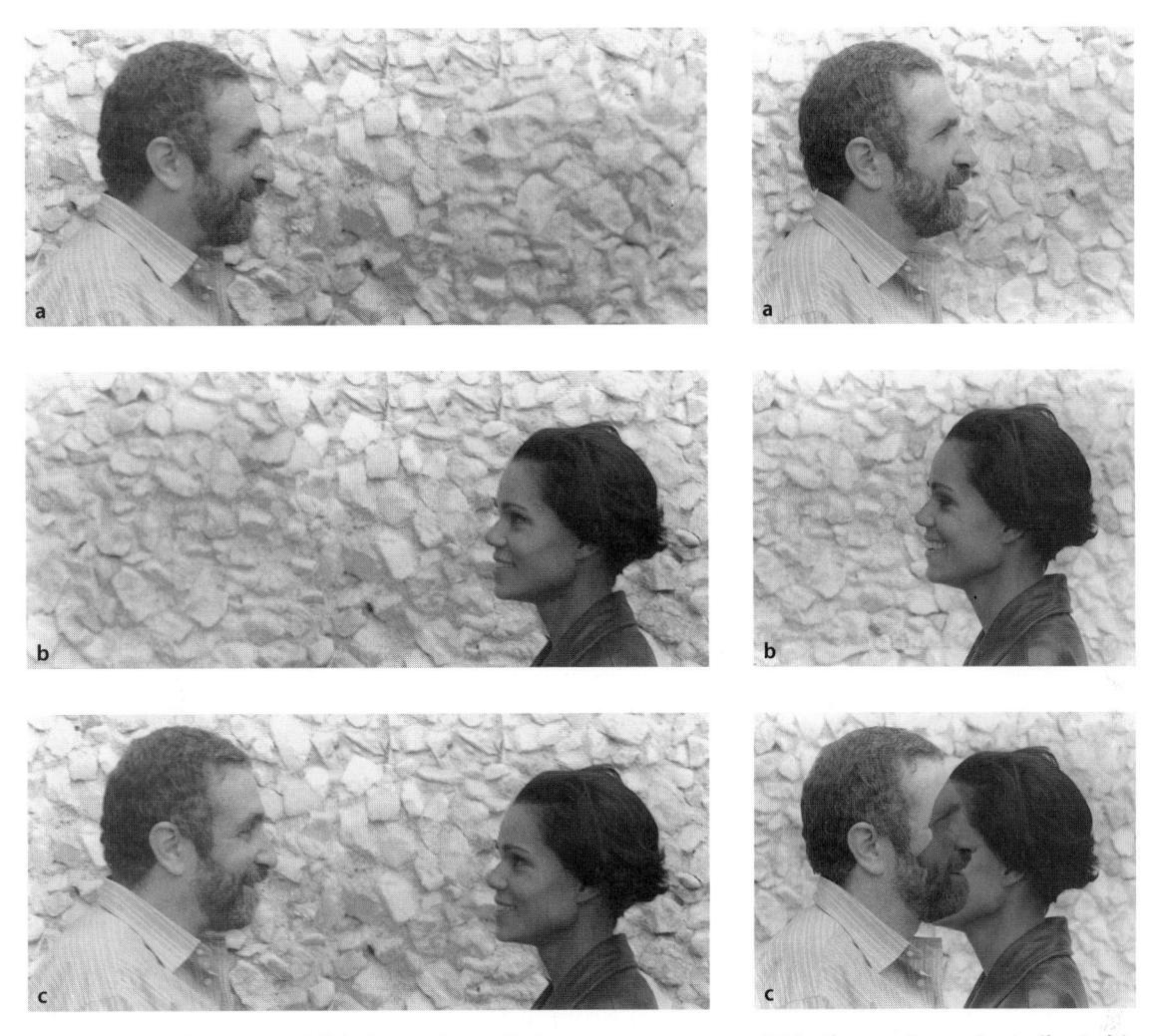

6.13 Close-up Separation in Wide-Screen Aspect Ratio
When framing one dialogue partner on screen-left in shot 1 (a) and the other on screen-right in shot 2 (b), we perceive them to be properly separated in the shot sequence. We can see the separation quite well when the two shots are superimposed (c).

6.14 Close-up Separation in Classical Aspect Ratio When framing one dialogue partner on TV-screen-left in shot 1 (a) and the other on screen-right in shot 2 (b), we perceive little position change between the dialogue partners. The crowding effect is obvious when the two shots are superimposed (c).

tables still figure prominently. **SEE 6.12** You cannot, therefore, ignore the action at these other tables. On the contrary, you need to make sure that the action at these tables is believable yet unobtrusive enough so that it does not draw the viewer's attention away from the major event.

The wide-screen aspect ratio allows you to position successive close-ups of two people talking to each other into a more extreme screen-left or screen-right position. When cutting from one close-up to another, you will perceive the people as standing apart from each other. **SEE 6.13** Such a separation is more difficult in the classical aspect ratio.⁵ **SEE 6.14**

CHANGING THE ASPECT RATIO

Since the early days of the motion picture, directors have made attempts to change the fixed aspect ratio of the screen whenever the pictorial content demanded it.

6.15 Changing Aspect Ratio Through Artificial Masking

One of the more successful masking effects occurred in the spectacular battle scene in D.W. Griffith's *Intolerance*. To intensify a soldier's fall from high atop the walls of Babylon, Griffith changed the horizontal aspect ratio into a vertical one by masking both sides of the screen.

American film producer and director **D. W.** (David Wark) **Griffith** (1875–1948) was the innovator of several filmic techniques, such as the various camera positions to change the field of view (long shots and close-ups) and the angle from which the event was filmed.

Especially in the days of the silent film, when story and concepts had to be communicated by visual means only, attempts were made to break out of the static 4:3 aspect ratio.

Masking D. W. Griffith used masking during a spectacular battle scene in his film *Intolerance*. By blacking out both sides of the screen, he changed the fundamentally horizontal aspect ratio to a vertical one to intensify a soldier's fall from high atop the walls of Babylon. **SEE 6.15**

A less obvious method of masking is filling the sides of the screen with natural scenic elements, such as buildings, trees, or furniture. This technique is especially effective when trying to frame a vertical scene within the wide motion picture aspect ratio, or when framing close-ups. **SEE 6.16**

Multiple screens The bold and highly imaginative attempts to change the aspect ratio through projecting multiple screens in the late 1920s have, unfortunately, not survived.⁶ As you will read later in this book, multiple screens still offer significant possibilities for clarifying, intensifying, and interpreting complex events.

Today the use of different aspect ratios within the main screen is especially common in television presentations. Through the use of DVE (digital video effects) equipment, we can easily create separate and discrete picture areas within the television screen, each carrying a different static or moving image. These secondary picture areas can have widely differing shapes and aspect ratios. **SEE 6.17**

6.16 Changing Aspect Ratio Through Natural Masking

Rather than artificially blocking out the sides of the wide movie screen in order to change its aspect ratio, we can use scenic objects, such as buildings, trees, and so forth, as masking devices. In this case the foreground buildings change the horizontal aspect ratio into a vertical one that dramatizes the high-rise building.

6.17 Changing Aspect Ratio in Secondary Frame

Through DVE (digital video effects), we can create many secondary picture areas within the television screen, all of which may have different aspect ratios and even variously distorted shapes.

6.18 Split Screen

So long as we are aware of the actual screen borders, we perceive the four separate screen areas as portions of a single screen rather than as four separate screens.

6.19 Matching Aspect Ratios

When showing a full frame of a wide-screen image on the normal television screen, we must leave black borders on top and bottom of the screen.

The problem with such secondary frames or masking devices is that the viewer usually remains highly aware of the basic, actual screen borders. Just look at your television set; no matter how much of the screen area is blacked out or masked with graphic elements, you can always see the screen's physical borders. Thus, you instinctively relate the events on the screen, including the masking devices or secondary frames, to the original screen border. It is an aesthetic fallacy to believe that a quad-split screen would fool the viewers into believing that they are watching four independent television screens. Under most normal situations, the viewers perceive a divided screen, not multiple screens. **SEE 6.18**

The same is true when watching a divided movie screen. We tend to relate any subdivision of the screen to its actual border, unless you walk into a totally blacked-out theater in which you cannot see the borders of the movie screen.

Moving camera A moving camera, of course, can also quite easily overcome the basic restrictions of the fixed aspect ratio. In order to show the height of a tower, for example, you can start with a close-up of the bottom of the tower and then gradually tilt up to reveal its top. Panning sideways, you can reveal an equally dramatic horizontal stretch.

Matching aspect ratios So far, the problem has been to make the wide-screen movie images fit the 4:3 aspect ratio of television. As you have undoubtedly noticed, one way is simply to cut off the image at either side of the screen. You are especially aware of this crude method of amputating picture information when letters or words are missing from subtitles or end credits. The real problem is that it often destroys the carefully worked-out compositions.

Reducing the overall size of the frame so that its width fits into the 4:3 screen creates the telltale black stripes on the top and bottom of the screen. **SEE 6.19** Even if such a technique has become fashionable in some music videos to pretend to fool you into believing that they originated as wide-screen movies, the black stripes will always signal an aesthetic problem.

One of the more sophisticated and costly techniques to adjust the wide-screen aspect ratio to the classic one of normal television is the *pan-and-scan process*, whereby the more important portions of the wide-screen frame are scanned and made to fit a new frame—the 4:3 aspect ratio of the television screen.

Obviously, such a recomposing of each frame is as much an aesthetic intrusion as reediting the whole movie. Whereas the HDTV 16:9 (1.77:1) aspect ratio will accommodate rather readily the wide-screen movie format, it will create a reverse problem when trying to show material that has been produced in the 4:3 format.

Object Size

How do you know how big an object that appears on a television or movie screen really is? You can't tell. **SEE 6.20** Because you know how big a regulation playing card actually is, you probably assume that you are seeing close-ups of three playing cards, all the same size.

Not so. These shots were of cards that differed considerably in size. **SEE 6.21** Although you now know that there are three different sizes of cards, do you know just how big they actually are? You still can't tell for sure. The smallest card, for

6.20 Interpreting Object Size: Knowledge of Object

How big are these playing cards? We don't really know. All we can do is assume that they are the same size.

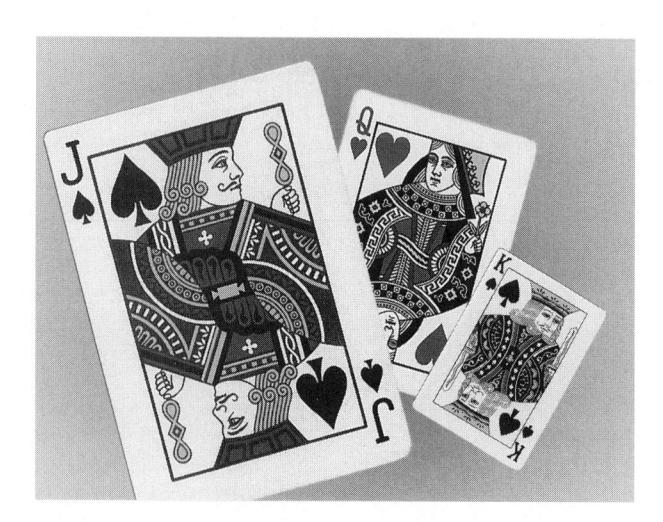

6.21 Comparison to Establish Relative Size

We now see the Jack as the largest card, the Queen as the middle-sized card, and the King as the smallest card. But do we actually know what the real size is of each card is? No, we don't. Because of our perceptual mechanism, we probably see the Jack as the oversized card, the Queen as the normal-sized card, and the King as the miniature. But couldn't the Jack be the normal-sized card, and the other two both undersized? Or perhaps the King is the normal-sized card and the other two larger than normal. We can't tell.

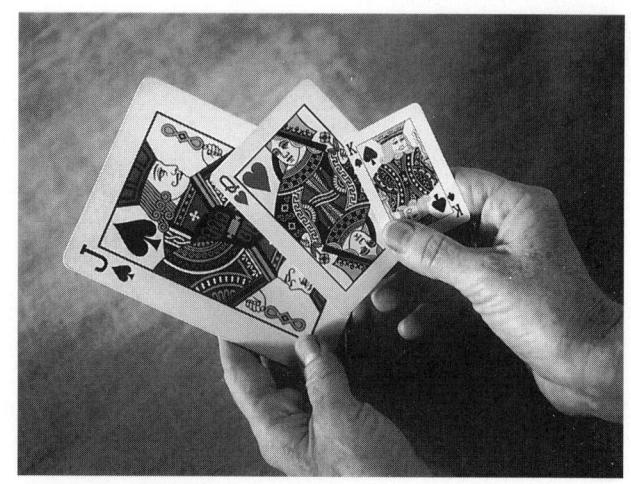

6.22 Size Reference to Human Being

As soon as we see the cards in relation to the universal reference—a human being or parts thereof, such as these hands—we can immediately judge the size of the objects. As predicted, the middle card is the normal sized one, with the Jack much larger and King much smaller than normal.

example, could be the regular-sized card with the other two being larger. Or the largest card could be the regular-sized card, with the other two being smaller. But couldn't all three of them be considerably smaller than a normal-sized card? Yes.

The only sure way of indicating actual size is to put them in the context of a universal size reference—a human being. For example, hands holding the three cards is an immediate and fairly accurate index of the cards' actual sizes. **SEE 6.22** You can now see that the shot in figure 6.20 of the smallest card (King) was actually an extreme close-up, and that of the largest card (Jack) was actually a long shot. Only the middle card (Queen) proved to be regular-sized after all.

We judge the size of objects when they appear as screen images by these major perceptual cues: (1) knowledge of object, (2) relation to screen area, (3) environmental context, and (4) reference to a person.

KNOWLEDGE OF OBJECT

If we are familiar with the object displayed on the screen, we automatically translate the screen image into the known size of the object regardless of whether the object appears as a long shot or a close-up (figure 6.20). This is why we can include small-scale models of large buildings in a shot and pretend that they are the real thing, assuming of course that they are proportional to the other objects in the scene.

RELATION TO SCREEN AREA

If we don't know the size of the object on the screen, we tend to judge size by how much screen area the object takes up. If it occupies a large portion of the screen, we perceive it as relatively large. **SEE 6.23** If it covers only a small area, we perceive it as relatively small. **SEE 6.24** But even if we know the object, we tend to feel more graphic weight when the object is shown in a close-up than in a long-shot.⁷

6.23 Screen Area as Size Reference: Close-up

If we don't know the object, we tend to judge its size by how much screen area it occupies. The more it occupies, the larger it seems. In this close-up, the plate seems large.

6.24 Screen Area as Size Reference: Long Shot In this long shot, the plate occupies relatively little screen space, so it appears to be small.

ENVIRONMENTAL CONTEXT

As in our real environment, we make continual judgments about object size by seeing the object on the screen in relation to other (usually known) objects that appear in the same shot. We seem to decide on a size standard against which the other sizes are judged and hierarchically ordered. Look at figure 6.21 once again. Even without the presence of the hands (as in figure 6.22), you probably chose the middle card as the standard (see figure 6.20b) and so called the other two cards big and small.

Cartoons operate on this principle. The close-up of a foot trampling houses, trees, bridges, and everything else in its way becomes that of a giant if we take the landscape as the norm. But if we take the foot as the standard-size reference, the landscape becomes small like the one of the unfortunate Lilliputians in *Gulliver's Travels*. As with the perception of other aesthetic phenomena, our translation of screen images into actual object size is greatly influenced by other contextual clues—in this case, by the framework of the story.

REFERENCE TO A PERSON

The most common standard for object size is the human being. Although we can on occasion make the viewer establish another standard, as in the cartoon example, we automatically take people as the norm in judging what is big or little. When objects are shown relative to the dimensions of a human being, we can immediately and directly compute their size. You don't even need to show the whole person; a hand will suffice when showing an exceptionally small thing.

Let's assume for a moment that you are asked by an advertising agency to get a tight close-up of a tiny, powerful new watch battery so that viewers can read the manufacturer's name stamped on it. Would you agree to such a shot? In the light of the theories put forth here, such a close-up would certainly prove counterproductive. A screen-filling close-up of the battery would take up so much of the picture area that we would perceive the battery as both large and heavy. A relatively simple solution might be to pull back for a long shot so that the battery is quite small relative to the surrounding screen space and then key the name of the manufacturer above or below the battery. Even more effectively, you could have someone hold it on a fingertip, using the hand as a universal size reference. You could then move in for a tight close-up, because the size relation between hand and battery is established and will remain largely intact.

Image Size

Have you ever felt ill at ease when watching a motion picture spectacle on the small television screen? Some motion pictures designed for the large Cinemascope screen do not seem to come across as well on television. Apparently, physical size has a great deal to do with how we perceive and feel about certain screen images.

The image size on a motion picture theater screen is many times larger than even the largest big-screen TV. This does not mean, however, that you see giants on the movie screen and dwarfs on the television. As with color constancy, which makes us see colors as uniform despite variations, our perception is guided by *size constancy*, which means that we perceive people and their environments as normal sized regardless of whether they appear on a large movie screen or a small television screen, in a long shot or close-up, or whether we sit relatively close to or far away from the screen. So long as we know by experience how large or small an object should be, we perceive it as its normal size regardless of screen size, relative image size, or perceived object distance.

IMAGE SIZE AND RELATIVE ENERGY

To stabilize our perceptions of our environment as much as possible, we apply size constancy, perceiving a known object as unchanging whether we are close to or far away from the object or from what angle we look at it.⁸ Yet despite our facility for size constancy, image size still influences how we feel about certain screen events. The large images that are projected on the panoramic movie screen simply feel more overpowering than a small television image. They are visually "louder" than small television pictures. When large, an image simply has more aesthetic energy than the same image does when small.

Just think of how you felt in the presence of an exceptionally large thing: a huge skyscraper, a giant ocean liner or airplane, a crowded football stadium, a towering redwood tree. You may not have felt smaller physically than in any other environment, but the largeness of the environment probably overwhelmed you somehow. The mere energy of largeness can inspire awe. Large things just do not seem to be as manageable as small things; you have less control over them, which makes them appear more powerful than small ones. This is the reason why some movies that emphasize landscape (from actual landscapes to spaceships) must be seen on the large screen to feel the total impact. Squeezing them into the small television screen reduces not only image size, but also, if not especially, event energy.

PEOPLE AND THINGS

The overwhelmingly large screen images on the horizontally stretched movie screen present a spectacle, no matter what is shown. People as well as things attain dramatic proportions, not only physically but also psychologically. The "landscape" aspect of a scene—that is, its physical environment—carries at least as much energy as the people who play in it. On the large movie screen, the simple event of a man walking down a country road becomes a grand act; on the small television screen, this remains a simple gesture.

In a movie about space exploration, the spaceship floating majestically across the giant screen most likely has as much or more impact on the viewer than the fate of the crew. But on the small television screen, the people and their actions command attention and supply the primary energy; the environment remains relatively peripheral if not unimportant. Film derives its energy from landscape as well as people; in television, it is primarily people with all their complexity who power a scene, while the landscape aspects take a back seat. Large HDTV screens will, similar to the large movie screen, favor landscape over people. 9

Deductive and Inductive Visual Approaches

The large-sized movie screen with its panoramic aspect ratio is conducive to a deductive picture sequence. In contrast, the relatively small television screen lends itself to an inductive approach to sequencing pictures.

DEDUCTIVE APPROACH

The *deductive visual approach* means moving from the general to the specific. You can, for example, start with a wide establishing shot and then get progressively tighter through a zoom or a shot series to the final close-up detail. **SEE 6.25** Such an approach is ideally suited to a large, horizontally stretched movie screen. On such a large screen, a panoramic establishing shot shows vista as well as picture detail and usually carries as much aesthetic energy as the subsequent close-ups.

Size constancy is truly a contextual phenomenon. It is the context within which we see an object that supplies us with the necessary clues for perceiving the object's actual shape and size

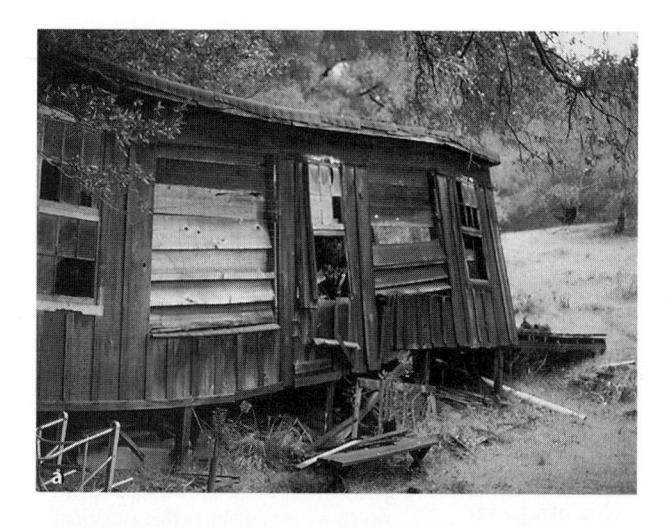

6.25 Deductive Approach

In the deductive shooting approach, we start with a wide establishing shot (a) and move progressively tighter into the event detail (b-d). This approach is especially well suited to the wide motion picture screen with its large horizontal expanse.

More than a convenient device to construct a mental map (where you see and remember how things are situated in relation to others), the establishing shot uses the "landscape" quality of film to overwhelm us with powerful images.

INDUCTIVE APPROACH

The *inductive visual approach* means that you go from details of the event to a general overview. You do not begin a shot sequence with a wide establishing shot but rather with a close-up of a significant detail. Then you follow this first close-up with other close-up shots of details that best express the intended view of the whole event. To aid the viewer in seeing the various close-ups in relation to one another, you may want to end such an inductive shot sequence with a wider orientation shot. But if you have selected the various close-ups properly so that they express the essence of the event, you may well be able to dispense with the final overview shot. The viewer will thus be enticed, if not compelled, to apply psychological closure; that is, to mentally structure the close-ups into a sensible overview or be able to mentally construct such an overview without actually seeing

6.26 Inductive Approach

In the inductive shooting approach, we select significant details that are characteristic of a whole event and present these as a series of close-ups. This encourages the viewer to mentally combine the inductive shot sequence into a whole. This shooting approach is especially well suited to the television screen.

one. ¹⁰ When you do this, the final overview shot becomes unnecessary, and you can simply end the sequence after the series of close event details. **SEE 6.26**

Although not the exclusive province of television, such an inductive approach is ideally suited for the relatively small television screen. Contrary to the wide-screen motion picture—where long vista shots can easily be as high-energy as close-ups—in television the close-up usually carries much more aesthetic energy than the long shot. In fact, one sure way of deenergizing an event is to pull back from a close-up to a long shot. Inductive shooting, therefore, allows the viewer not only to see important event detail but also to feel the full impact of the event.

Let's apply these deductive and inductive principles to shooting a brief automobile racing sequence, first for a wide-screen motion picture and then for television. When shooting deductively for film, you may decide to start with the almost inevitable establishing shot of the racecourse from a helicopter or blimp. Next you might want to show as much of the excited crowd as possible, temporarily obscured by the many cars that roar past them from one edge of the screen to the other. And then you finally move in on a two-shot of the lead car and the one in hot pursuit.

When shooting inductively for television, this scene should look quite different. For example, you might start with a close-up of the lead car's rearview mirror that reveals the desperate passing attempts of a pursuing car. Then you could show extreme close-ups of the lead driver's face, a similar shot of the second car's driver, and then the leading driver's hands on the steering wheel. Next you could do quick close-ups of one or two spectators and racecourse officials. Of course, the shot selection—and especially the shot sequence—depends entirely on the communication context, on what you consider to be the essence of the race. In any case, a good sound track with the roaring engines and the cheering of the excited crowd will help provide the viewer with the necessary "landscape" element of the race and aid in combining these individual shots into a high-energy whole.¹¹

Summary

This chapter explored the two-dimensional field, the area of the television and film screens, and some of the basic structural elements and characteristics we confront in this field. The television or film screen provides us with a new, concentrated living space—an aesthetic field in which to clarify and intensify an event. Four major structural characteristics were discussed: aspect ratio, object size, image size, and deductive and inductive visual approaches.

Contrary to the picture area in painting and still photography, which can have any shape and orientation, the television and film screens are rectangular and horizontal. The "classical" film screen and the television screen have a 4:3 (1.33:1) aspect ratio. This means that the screen is four units wide and three units high, regardless of screen size. This aspect ratio permits easy framing of horizontally as well as vertically oriented objects or scenes. All motion pictures are now shot and projected in a horizontally stretched format. The most common are the wide-screen format of 1.85:1 and the Panavision format of 2.35:1.

The television screen for HDTV (high-definition television) has a 16:9 (1.77:1) aspect ratio. This means that the screen is more horizontally stretched than the normal (4:3) television screen and similar to the motion picture wide-screen format.

Television and movie screens are horizontally oriented because our peripheral vision is greater horizontally than it is vertically, in keeping with our everyday experience of living on a horizontal plane. You can, however, change the aspect ratio of these screens. In television we can easily generate secondary screen areas that have various aspect ratios and configurations through digital special-effects equipment. In film we can either black out the sides of the screen to reduce the horizontal stretch, or fill in the sides with scenic objects to change the aspect ratio more unobtrusively.

The major clues to the actual size of an object when shown on the screen are knowledge of the object, relation to the screen area, environmental context, and reference to human beings. When we know an object, we automatically mentally translate the screen image into the actual size of the object in real life. When we don't know the object, we trend to translate the image size into actual object size as perceived on-screen. The more screen area the object takes up, the larger it seems—and vice versa. When several objects are shown on the screen, we establish a size standard and judge all other objects accordingly. The most common size reference for objects is a human being.

When shown on the movie screen, the image size of an object is many times larger than when shown on the television screen. Because of the size constancy factor, we perceive the object as equal in size. Nevertheless, the large movie image usually carries much more aesthetic energy than television images do. People as

well as things attain spectacular dimensions in film. In television human actions gain prominence, whereas the mere spectacle of things is de-emphasized.

A deductive visual approach to shooting means that we move from the general to the specific or from an overview to event detail. The deductive approach is especially appropriate for film. An inductive approach to shooting means that we show the event through a series of close-ups. We move from the specific to the general. The relatively small screen of television is especially well suited to the inductive approach.

NOTES

- The popular wide-screen aspect ratio of 1.85:1 was originally developed as the Technirama system.
- 2. The 2.35:1 Panavision 35 system squeezes the wide-screen image on a regular 35mm film frame and unsqueezes it through an anamorphic lens during the projection.
- 3. Mark Schubin, "Searching for the Perfect Aspect Ratio," paper (no. 137-61) presented at the 137th SMPTE Technical Conference (1995). See also Mark Schubin, "No Answer," *Videography* (March 1996), pp. 18–33.
- John Belton, Widescreen Cinema (Cambridge, Mass.: Harvard University Press, 1992), pp. 15–18.
- Steven D. Katz, Film Directing: Shot by Shot (Studio City, Calif.: Michael Wiese Productions, 1991), pp. 124–125.
- 6. The French film director Abel Gance (1889–1981) pioneered the showing of multiple projections to form different aspect ratios and simultaneous montage effects. In his film *Napoleon*, he used three 4:3 frames side-by-side to simulate an aspect ratio similar to today's widescreen format—a process he called Polyvision. See Belton, *Widescreen Cinema*, pp. 38–43.
- 7. Steven Acker and Robert Tiemens, "Children's Perception of Changes in Size of Televised Images," *Human Communication Research* 7, no. 4 (1981): pp. 340–346.
- 8. Irvin Rock, Perception (New York: Scientific American Library, 1984), pp. 15–31.
- 9. Herbert Zettl, "From Inscape to Landscape," *HD World Review* 3, nos. 1 and 2 (1992), pp. 40–48.
- 10. See chapter 7 for a more detailed explanation of psychological closure.
- 11. Many television commercials are shot inductively. Try to analyze them as to the shot selection and the relative ease with which you can apply closure to the shot sequence so that you perceive an entire event.

The Two-Dimensional Field: Forces Within the Screen

Nour effort to tame space aesthetically, that is, to create a picture space, we have established the television, computer, and motion picture screens as a new field of operations. The screen is our new principal frame of reference for the events occurring within it. Within this new frame of reference, highly specific field forces begin to operate that are quite different from those of a nondefined field, such as our actual three-dimensional environment.

To clarify and intensify events within the new operational spatial field, you should know something about six major types of field forces: (1) main directions, (2) magnetism of the frame and attraction of mass, (3) asymmetry of the screen, (4) figure and ground, (5) psychological closure, and (6) vectors.

Main Directions: Horizontal and Vertical

Although the television, motion picture, and most computer screens are horizontally oriented, within the screen you can emphasize either a horizontal or a vertical direction. Perhaps because we feel capable of managing horizontal space more easily than vertical, a horizontal arrangement seems to suggest calmness, tranquility, and rest. **SEE 7.1**

Vertical space, on the other hand, is harder to manage than horizontal space. Thus vertical lines seem more dynamic, powerful, and exciting than horizontal ones. **SEE 7.2**

These aesthetic principles have been applied throughout civilization. The Gothic cathedral, for example, was built with a vertical orientation to reflect the human orientation upward, toward heaven and God. **SEE 7.3** Renaissance buildings, in contrast, emphasized the importance of human endeavors and are, therefore, principally horizontal in orientation. **SEE 7.4**

Today's high-rise buildings operate much in the spirit of the Gothic cathedrals. Though their vertical orientation may have been primarily motivated by the high cost of real estate, they nevertheless reflect the contemporary human spirit, adventurous with an admirable earth-defying dynamism. **SEE 7.5**

7.1 Main Direction: Horizontal

Horizontal lines suggest calmness, tranquility, and rest. We feel normal when operating on this familiar horizontal plane.

7.2 Main Direction: Vertical

Vertical lines are more powerful and exciting than horizontal ones. The pull of gravity charges them with extra energy.

7.3 Vertical Orientation: Gothic Cathedral

The extreme vertical orientation of Gothic cathedrals and their imposing size were designed to remind people of their insignificance relative to God and to direct their spirit upward toward heaven.

7.4 Horizontal Orientation: Renaissance Building

The horizontal orientation of Renaissance buildings appropriately reflected people's renewed interest in human affairs.

HORIZONTAL/VERTICAL COMBINATION

Because of gravity and the fact that we are used to standing upright on level ground, we like to see our environment mirror our experience and be portrayed as a stable series of horizontals and verticals. In fact, most of our natural or constructed physical environment is organized into verticals that are perpendicular to the level ground. **SEE 7.6**

TILTING THE HORIZONTAL PLANE

Our sense for vertical and horizontal accuracy is so keen that we can, for example, judge whether a picture hangs straight or crooked with uncanny precision even without the aid of a level. It's no wonder that when we see a tilt to the horizontal

7.5 Vertical Orientation: High-rise Building

Modern high-rise buildings, like their earlier Gothic cousins the cathedrals, are bold and earth defying. They mirror the dynamic spirit of contemporary people.

7.6 Horizontal/Vertical Environment

A combination of horizontals and verticals reflects our everyday world. Most of our normal physical environment—the buildings we live in, our furniture, doors, and windows—are verticals perpendicular to level ground.

plane within the screen, we become somewhat disturbed, if not disoriented. Our normal and hence secure upright position on a level horizontal plane is threatened by what we perceive. As the horizon starts tilting, we lose our usually reliable and stable reference—the earth. When this happens, we desperately seek a new and more stable reference regardless of whether it makes sense. For example, when sitting in an airplane that banks sharply, we tend to assign stability to our immediate environment—the airplane—and not to the earth. Consequently, the horizon, rather than the airplane, seems to be doing the tilting.

Lacking a new stable reference, such a tilting effect may cause considerable psychophysical discomfort in us. For example, when we sit close to a large movie screen, the tilted horizon effect can, in extreme cases, cause nausea.

Simply by canting the camera and thus tilting the horizontal plane, you can easily destabilize a scene or make an otherwise uninteresting building or object look dynamic. **SEE 7.7 AND 7.8** You can also suggest the extreme physical or mental stress of people by having them operate on a tilted horizontal plane. **SEE 7.9**

In the Gothic period (roughly from 1150 to 1400), life on earth was simply a preparation for the "real life" in heaven. People lived and worked strictly *in dei gloriam*—for the glory of God. The vertical orientation of the Gothic cathedrals reflected this spirit.

The Renaissance (roughly from 1400 to 1600) with its rebirth of classical Greek architecture emphasized the importance of humanity. *In dei gloriam* was supplanted by *in hominis gloriam*. Horizontal buildings are in keeping with this new attitude of glorifying the human spirit.

7.7 Level Horizon: Stability

If you want to emphasize stability, conservatism, and reliability, you must show the building standing on level ground.

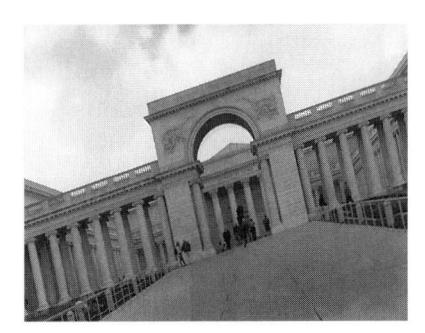

7.8 Tilted Horizon: Dynamism

If you want to suggest energy, activity, progress, and the like, you can render the scene dynamic by tilting the horizontal plane.

7.9 Tilted Horizon: Stress

By tilting the horizontal plane, you can intensify the feeling of physical or mental stress of someone running from acute danger.

Magnetism of the Frame

The borders of a picture field act like magnets: They have a tendency to attract objects near them. This *magnetism of the frame* can be so strong that it counteracts our natural reaction to gravitational pull. **SEE 7.10** Note how the black disc in the figure seems to be "glued" to the upper border in figure 7.10a. The gravitational pull comes into play only after we have moved the disc a considerable distance away from the upper border and its magnetic attraction (figure 7.10c).

The sides of the screen also exert a strong pull. **SEE 7.11** As you can see in the figure, the discs do not seem to be pulled down by gravity as you might expect; instead they are attracted by the magnetism of the frame's sides. Because the screen corners combine the magnetism from two sides, they are especially magnetic and exert a strong pull. Obviously, you should avoid compositions whose dominant lines lead directly to the corner of the screen. **SEE 7.12**

The most stable position for the disc is clearly screen-center. Here it is farthest away from the magnetic pull of the edges, and the force of the pull, however weak, is equally distributed. **SEE 7.13**

If the disc is large and wedged into the screen, it is subjected to the magnetism of all four edges. We have the feeling that it wants to burst out of the frame's confinement in order to expand. **SEE 7.14** Of course, the magnetism of

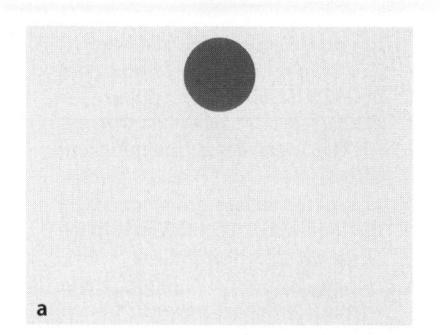

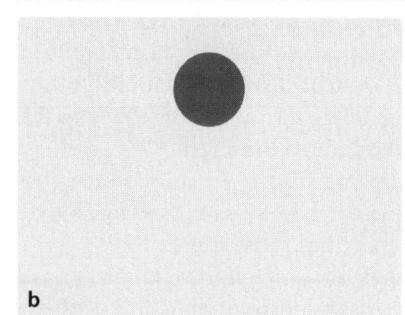

7.10 Magnetism of the Frame: Top Edge

The edges of the screen exert a strong pull on objects near them. The disc in (a) seems to be glued to the top edge despite the normal downward gravitational pull. The pull of the frame is strong enough to hold the disc up even when there is more space between the disc and the edge (b). Only when the distance between the top edge and the disc reaches a certain point does it become too great and gravity takes over (c).

The pull of the side edges is so strong that it easily overrides gravitational pull.

7.12 Magnetism of the Frame: Corners

The screen corners exert an especially strong magnetic pull.

7.13 Centered Object: Even Pull

When the disc is centered within the frame, all magnetic pulls are equalized. The disc is at rest.

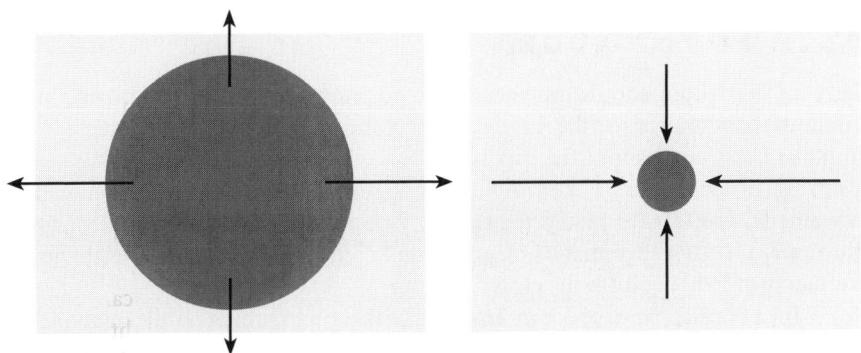

7.14 Large Disc: Expansion

When an object is wedged into the screen, it is subject to the magnetism of the entire frame and therefore tends to expand and look unusually large.

7.15 Small Disc: Compression

When the object is small enough and relatively far from the screen edges, the magnetism of the frame no longer operates. On the contrary, the space surrounding the object—in this case, the disc—compresses it to make it appear quite small.

the screen edges is not the only reason why we perceive the disc as unusually large. It also occupies a relatively large screen area that, as discussed in chapter 6 (and illustrated in figure 6.23), indicates a large-sized object. Conversely, when the disc is centered within the picture field and far from the screen edges, it is no longer subject to their magnetic pull. Rather, the concentrated "heavy" space surrounding the object also seems to compress it, making it appear smaller than it really is. **SEE 7.15**

Let's see how these principles apply when framing a shot.

HEADROOM

A close-up with too little headroom looks awkward. Why? Because the head seems to be glued to the upper screen edge. **SEE 7.16** You need to leave some headroom in order to reduce the magnetic pull of the upper screen edge. **SEE 7.17** But if you leave too much, the head is pushed down into the lower half of the frame through the combined forces of gravitational pull and the magnetism of the lower screen edge. **SEE 7.18** How much headroom should you leave? Just enough to neutralize, but not eliminate, the magnetic pull of the upper screen edge.

7.16 No Headroom

Without headroom, the attraction of the upper screen edge pulls the head firmly against it. We are as uncomfortable with such a composition as we are standing up in a room with a very low ceiling.

7.17 Proper Headroom

In order to counteract the pull of the upper screen edge, you must leave enough "breathing space," or headroom. Leave just enough space between the head and the upper screen edge to reduce the magnetic pull without eliminating it altogether.

7.18 Too Much Headroom

Here you have too much headroom. The magnetism of the frame has now capitulated to gravitational pull, so the shot looks bottom heavy.

PULL OF TOP EDGE

Leaving headroom should not become mandatory, however. Under certain circumstances you can use the magnetic pull of the upper edge to your advantage. You can learn more about the pull of the top edge of a frame by studying the paintings of old masters. For example, in his painting *The Calvary*, Antonello da Messina (c. 1430–1479) placed the figures, especially that of Christ, so close to the upper painting edge that its magnetic pull comes into action and heightens the agony of hanging from the cross. **SEE 7.19**

In a similar way, you can emphasize the precariousness of someone operating at uncomfortable heights by leaving less than normal headroom. This lack of headroom will "glue" the person to the upper edge and make him hang in space more than if you had framed him with the customary headroom. **SEE 7.20**

7.19 Using the Pull of the Top Edge

The old masters used the magnetism of the frame to intensify their messages. By reducing headroom to a minimum, the figures seem to be more suspended than if they were lower in the painting. Antonello da Messina, *The Calvary*.

7.20 Lack of Headroom for Intensification

To emphasize the precariousness of somebody working up high, you can use the magnetism of the upper edge to advantage. In this shot minimal headroom is used to maximize the pull of the upper edge.

PULL OF SIDE EDGES

The major problem that occurs as a result of the magnetic pull of the side edges is that objects that seem to be normally spaced in a long shot will often look too far apart in a tighter shot. As you can see in this establishing shot of an interview, the host and the guest seem to be sitting comfortably close to each other. **SEE 7.21** But as soon as you move in with the camera for a tighter shot, the two people now look too far apart, seemingly glued to the left and right edges of the screen. **SEE 7.22** They have become a secondary frame, emphasizing the empty center portion of the picture.

But when you want to emphasize the width of an object, such as that of a large automobile, the pull of the screen's side edges becomes a definite graphic asset. The combined pull of the left and right screen edges seems to stretch the car horizontally. **SEE 7.23** You can also use the magnetic force of a screen edge to arrest motion and keep someone glued to the spot. **SEE 7.24**

7.21 Normal Distance in Long Shot In this establishing shot, the people seem to be sitting at a comfortable distance from each other.

7.22 Edge Pull in Medium Shot
When you move in for a close-up, the people are pulled apart.
The magnetism of the side edges intensifies this separation.

You encounter a similar problem if you hang pictures at a "normal" distance from one another on a set. The edges of the screen attract the pictures. They appear, therefore, pulled apart. To make pictures look normally spaced, you must crowd them. The attraction of graphic mass (among the pictures) then counteracts, at least to some extent, the pull of the frame.

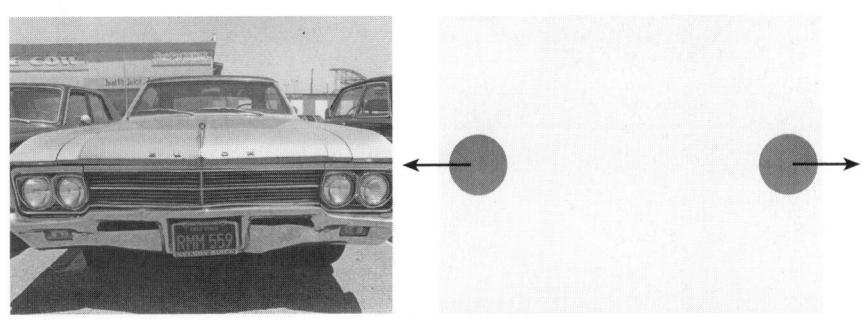

7.23 Positive Pull of Side Edges
When you want to emphasize the width of an automobile, the pull of the screen edges becomes a definite graphic asset.

7.24 Positive Pull of Side Edge
Here the pull of the frame works for you. The man has no chance to run away; the magnetism of the frame holds him firmly to the screen edge.

PULL OF ENTIRE FRAME

As pointed out in figure 7.14, all four edges pull if a disc is wedged into the picture frame. The same thing happens when you frame a close-up of a head in this way. **SEE 7.25** Because of the magnetic pull of the frame, the head seems unusually large, as if it's trying to burst out of the screen. Obviously, you should not frame a head in this fashion.² Yet you can use just such a framing technique to dramatize the large size of an object, such as this huge spotlight. **SEE 7.26**

ATTRACTION OF MASS

All screen images have a certain *graphic mass*. Usually, larger images with highly saturated colors have a larger graphic mass than smaller ones with less-saturated

7.25 Negative Pull of All Screen Edges

Unless you want to intensify the roundness of someone's head, do not frame it like this. As you can see, the pull of the frame makes the head appear so large that it appears to be bursting out of the confinement of the frame.

colors. The larger the graphic mass, the greater its *graphic weight*; that is, the "heavier" (more prominent) the image seems within the screen. Graphic mass attracts graphic mass. The larger the mass, the greater its attractive power. Also, a larger graphic mass attracts smaller ones and not vice versa. Finally, a larger graphic mass is more stable and less likely to move than smaller ones. **SEE 7.27**

7.26 Positive Pull of All Screen Edges

In this case, the magnetism of all four edges helps you emphasize the large size of this studio light.

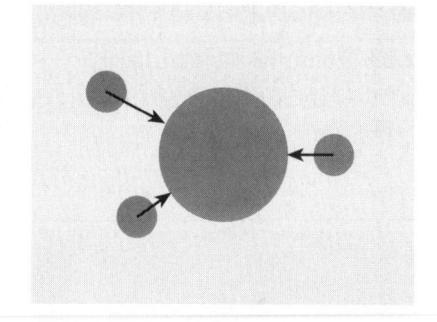

7.27 Attraction of Mass

Graphic mass attracts graphic mass: The larger the mass, the larger its attractive power. The larger graphic mass attracts the smaller one and not vice versa. A largass is also more independent than smaller masses. The larger graphic mass is also more stable (less likely to move) than the smaller ones.

Asymmetry of the Frame

We do not seem to look at the left and right sides of any screen the same way nor pay equal attention to objects that are located on either half of the screen. We carry this perceptual peculiarity over to the television or film screen, where we consider it to be one of the structural screen forces. Because the two sides of the screen seem structurally unequal, we speak of an *asymmetry of the frame*.

UP/DOWN DIAGONALS

Take a look at the following set of figures. **SEE 7.28 AND 7.29** Which of the diagonals seems to go up and which down?

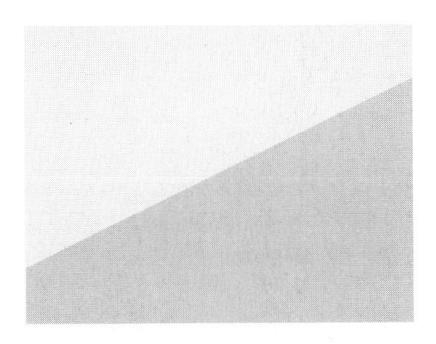

7.28 Diagonal 1

7.29 Diagonal 2

Now, look at the next set of figures. **SEE 7.30 AND 7.31** Which diagonal seems to go up and which down?

7.30 Diagonal 3

7.31 Diagonal 4

Which one do you now perceive to go up and which down?

You probably chose diagonals 1 and 4 as going up, and 2 and 3 as going down. Why we perceive a specific diagonal as going uphill and another as downhill has not been answered. Regardless of whether we learned to write from left to right, right to left, or top to bottom, or whether we are right- or left-handed, right-brained or left-brained, we seem to "read" the diagonals from left to right.

Although any movement along either slant can override this graphic up/down sensation, you can nevertheless use the up/down slants to intensify motion along the diagonals. For example, if you would like to show the ease with which a car moves up a hill, you should have the car go from left to right. This way, the uphill diagonal helps to pull the car to the top of the hill. **SEE 7.32** On the other hand, off-road vehicles, trucks, or bulldozers seem to need more power and effort

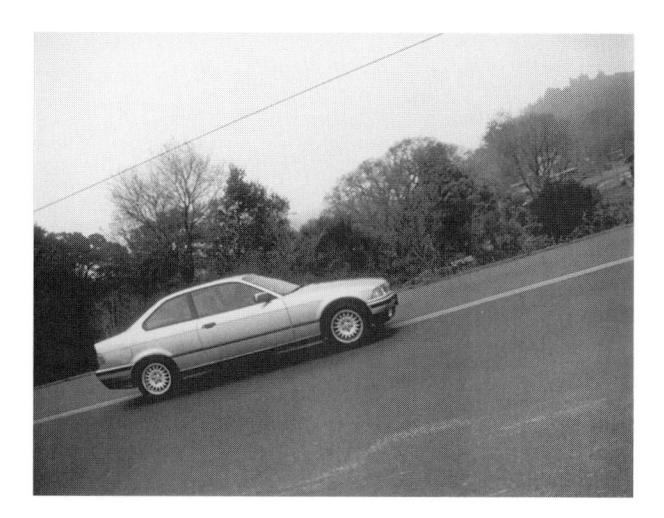

7.32 Uphill Motion Aided by Uphill DiagonalThe uphill diagonal helps pull the car to the top of the hill.

7.33 Uphill Motion Impeded by Uphill DiagonalThis truck has to overcome the graphic down-diagonal, which therefore emphasizes the truck's power.

to climb a hill from right to left than from left to right because they now have to overcome the natural flow of the graphic downhill slant. **SEE 7.33**

SCREEN-LEFT AND SCREEN-RIGHT ASYMMETRY

We tend to pay more attention to an object when it is placed on the right rather than the left side of the screen. Although considerable academic controversy exists about this aesthetic phenomenon,³ we can use the up- and downhill diagonal as a reasonable explanation of why the right picture area seems to be more conspicuous. Just as with the diagonals, we seem to feel more comfortable looking at a television or computer screen by starting somewhere in the middle, then quickly moving to the left side and finishing on the right side.⁴ See for yourself whether you feel a shift of emphasis from one person to the other when the picture is flipped. **SEE 7.34 AND 7.35**

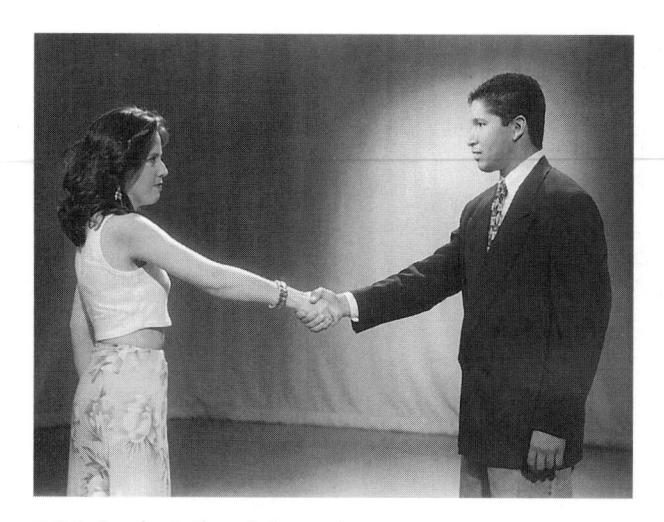

7.34 Emphasis Though Screen Asymmetry Look at this two-shot. Which person gets more attention?

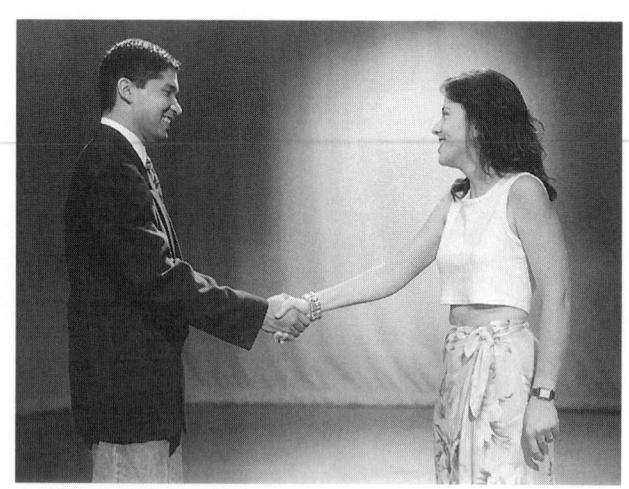

7.35 Shift of Emphasis
When the persons switch sides, we focus again on the person on the right. We tend to view the person on the left as approaching the person on the right, rather than the other way around.

You probably paid more attention to the person on the right side of the screen than the one on the left, regardless of whether you looked at the normal view (figure 7.34) or its mirror image (figure 7.35). Even their perceived actions seem to be a direct function of screen location. In both versions, it is the person on screen-left who is approaching the person on screen-right, and the person on the right responding to it.

In practice this means that if you have a choice, you should place the more important event on the right side of the screen. If, in an interview show, you consider the guest more important than the host, place the guest screen-right and the host screen-left. Most prominent hosts, however, do not want to be upstaged, and so they occupy the more conspicuous screen-right position. Why, then, do we see so many newscasters on screen-left with the less important graphic information on screen-right? Should you not put the primary information source—the newscaster—on screen-right and leave the screen-left side for the computer-generated graphic illustrations? From an aesthetic point of view, the picture is more balanced when the high-energy information source, in this case the newscaster, appears on the weaker screen-left side and the lower-energy graphic on the stronger screen-right side. From a communication point of view, though, the primary information source—the newscaster—should definitely be on the screen-right side with the illustrative information material relegated to the weaker left side. Otherwise, we run the risk of having the often crude and cryptic graphic representation of the news stories accepted as the primary message rather than the more-detailed accounts by the newscaster.

Figure and Ground

One of the most elemental structural forces operating within the screen is the figure-ground principle. As discussed in chapter 1, this is our perceptual tendency to organize our environment automatically into stable reference points against which we can assess and check the less-stable elements. Our figure-ground perception is such a natural activity and so obvious that it does not need extensive elaboration. The letters on this page and the illustrations appear as figures with the page as ground. If your book rests on a table or desk, the book

becomes the figure and the supporting table or desk, the ground.

As you can see, the figure-ground relationship is contextual and hierarchical. Depending on what you determine the figure to be, the ground will change accordingly. Contrary to the static and fixed figure-ground relationship in a painting or a still photograph, on-screen the relationship changes, as it does in real life, with the camera's particular point of view. Thus, the figure in a long shot can become the ground in a close-up.

7.36 Figure-Ground Relationship in Medium Shot

With a moving camera or a changing field of view, the figure-ground relationship alters continually. In this shot the car is the figure and the building is the background.

7.37 Figure-Ground Relationship in Close-up

When you move in for a close-up, the car's radiator grille becomes the ground for the emblem, the figure.

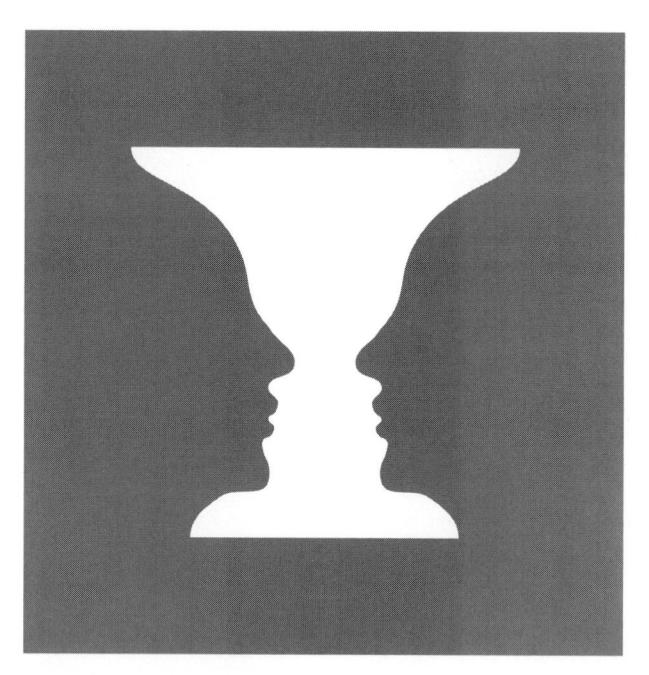

7.38 Figure and Ground

We assign figure and ground depending on what we perceive. For example, if you see a white vase here, the dark element becomes the background. But if you see two dark profiles, the white element becomes the ground. Notice how figure and ground switch characteristics, depending on which you assign to be the figure and which the ground.

7.39 Figure-Ground Reversal

If the design is simple, a designer can achieve a startling effect by having some of the ground appear as the figure. You will find it hard to consider the A and O the ground rather than a figure.

FIGURE-GROUND CHARACTERISTICS

What exactly distinguishes a figure from its ground? Look at this well-known figure-ground example. **SEE 7.38**

If you perceive the vase as the figure, the black area becomes the ground. If you take the two profiles as the figure, the white area becomes the ground. When you see the vase as figure, it takes on certain characteristics, as does the black ground. The characteristics reverse when you perceive the black profiles as the figure. Here are some of the major characteristics of figure-ground perceptions:⁵

- The figure is thinglike. You perceive it as an object. The ground is not; it is merely part of the "uncovered" screen area.
- The figure lies in front of the ground. The vase obviously lies on top of the background.
- The line that separates the figure from the ground belongs to the figure, not the ground.
- The figure is less stable than the ground; the figure is more likely to move.
- The ground seems to continue behind the figure.

Unless you possess a Zenlike state of mind that allows you to reconcile opposites, you will not be able to perceive figure and ground simultaneously. Instead you must opt for

paying attention to either the figure or the ground. At best you can oscillate between one figure-ground structure or the other.

Because of this urge to organize our environment into a series of figure-ground relationships, you can achieve especially startling effects by rendering the figure and ground purposely ambiguous or by reversing the figure-ground relationship. For example, you could design a pattern in which the viewer is coerced into perceiving parts of the ground as figure. **SEE 7.39** It is almost impossible not to see the *A* and *O* as figures although they are actually parts of the common ground—the white page. The *O* begins to disappear, however, when you cover up all the black elements surrounding the black dot in the center of the *O*. All of a sudden, the black dot switches from being the background of the white *O* to becoming a figure in its own right.

Superimposition, too, derives its strength from rendering the figure-ground relationship purposely vague. It is often difficult to see which of the two superimposed images is the figure and which is the ground. No wonder superimposition is such a popular effect when suggesting dream sequences. Through electronic matting—or *DVE* (digital video effects)—you can reverse the figure and ground at will and thus create powerful and enigmatic images. **SEE 7.40**

We are so used to seeing figures move relative to a stable ground that we maintain this relationship even if the ground moves against a stationary figure. Thus we can easily trick the viewer into perceiving a car racing through downtown streets simply by shooting the stationary car against a rear projection of moving streets. We discuss this figure-ground reversal more thoroughly in chapter 13.

The figure-ground principle also applies to the structuring of sound. We usually try to establish specific foreground sounds against more-general background sounds. Figure-ground relationships in sound structures are explored more fully in chapters 17 and 18.

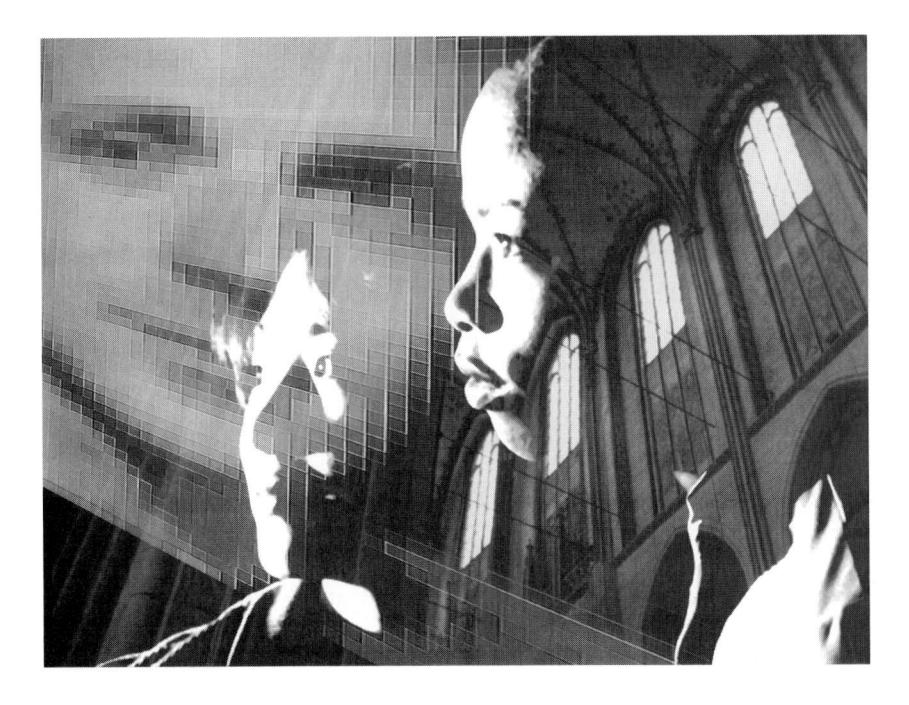

7.40 Ambiguous Figure-Ground Relationship

Through electronic special effects, you can change the figure-ground relationship in exciting and interesting ways.

Psychological Closure

As pointed out previously, in our quest for perceptual sanity, if not survival, we continually seek to stabilize our infinitely complex and often chaotic environment. One of our built-in survival mechanisms is our tendency to mentally fill in gaps in visual information to arrive at easily manageable and complete patterns and configurations. This perceptual activity is called *psychological closure*, or "closure" for short.⁶

Take a look at the random shapes in the following figure. **SEE 7.41** As soon as you see them, your perceptual mechanism automatically tries to order and group them in some sort of simple patterns. What patterns do you see in figure 7.41? Don't force yourself—let the pattern come to you. Now use a pencil to trace the most obvious connections. You probably arrived at a series of relatively simple and stable figures, such as lines, triangles, and rectangles, by

7.41 Perceiving Patterns

Look at these random shapes. You will probably find it hard not to group this random array into some kind of order.

7.42 Psychological Closure: Pattern

Most likely, you organized the shapes into a large triangle on its side at the center, a square (or rectangle) at the lower right, and a line at the bottom.

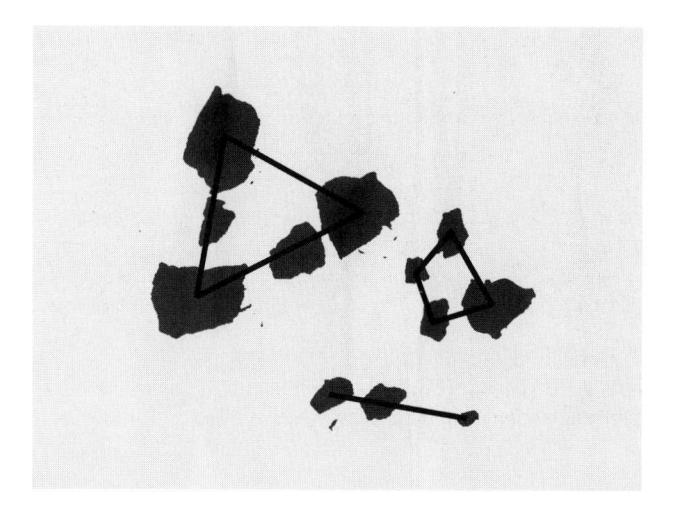

7.43 Psychological Closure: Subjective Completion

Although the page shows only three dots, you must really try hard not to perceive a triangle. Such a perceptual process is called psychological closure, or closure for short.

taking a minimum number of visual cues and mentally filling in the missing information—by applying closure. **SEE 7.42**

Let's repeat this process in a much simpler visual field. **SEE 7.43** Although the figure shows only three dots, you automatically perceive a triangle; in fact, it takes considerable effort *not* to see a triangle. As you can see, you constructed a new stable pattern—a triangle—from a minimum amount of clues—three dots.

GESTALT

The pattern that results from closure is often called a *gestalt* (German for "form," "configuration," "shape"). A gestalt is a perceptual whole that transcends its parts. As soon as you perceive a triangle (the whole) instead of the three dots (the parts), the dots have become part of the gestalt; they are no longer independent elements. This is why gestalt is often defined as a whole that is larger than, or at least different from, the sum of its parts.⁷ The relationship of the parts to the whole becomes especially apparent in a musical chord. Three notes played in sequence sound quite different when played simultaneously as a chord. **SEE 7.44** The individual elements (the three notes) have now been molded into a gestalt (the chord) and have thus surrendered their individual quality to that of the new structure.

Note that we need a certain minimum of information in order to apply psychological closure. If the information falls below the required minimum, the

7.44 Gestalt: Musical Chord

In a gestalt the individual parts, which in this case are three separate notes (a), yield their characteristics to that of the new configuration—a chord (b).

7.45 Minimum Information

You need a minimum amount of information to apply psychological closure. Notice how the seemingly random dots (a) suddenly make sense when you add enough information (b).

stimulus elements remain random, and we cannot perceive a pattern. For example, three dots are the minimum number of elements needed to perceive a triangle. One dot less would produce a line, but never a triangle. As soon as we have enough information, however, the pattern becomes immediately and inevitably apparent, and we experience an almost instant switch from chaos to order. **SEE 7.45**

HIGH- AND LOW-DEFINITION IMAGES

A high-definition image has more picture information than a low-definition image. **SEE 7.46** Figure 7.46a shows a lowest definition of a triangle, figure 7.46b a higher-definition image, and figure 7.46c the highest triangle definition. The low-definition image requires a great deal of psychological closure; the high-definition image does not.

Commercial motion pictures display high-definition images; the large screen lets you see a great amount of event detail, and the film images have high resolution. Similarly, HDTV (high-definition television), in its attempt to rival the motion picture, uses a relatively large screen area on which to project its high-definition images.

In contrast to film and HDTV, traditional television is definitely low definition. First, its picture resolution is low. The relatively few picture dots—called *pixels*—that make up the television image are like tile in a mosaic. Second, even a large television screen is small compared with a motion picture screen. Third, the *contrast ratio*—the steps between the lightest and darkest picture

7.46 Low- and High-Definition Images

The triangle in (a) has the minimum information: three dots. One dot less and you would perceive the figure as a line. The triangle in (b) has more information. You need to apply less psychological closure to arrive at the gestalt of a triangle. The triangle in (c) has the maximum information. You can see its shape without applying any closure.

Just because film and HDTV are high-definition media does not necessarily mean that their images must be high-definition at all times. In fact, we use all kinds of devices (filters, defocus effects, a limited depth of field, desaturation) to render an image low-definition. With the aid of sophisticated computer programs, we can make low-definition images high-definition by adding pixels and boosting hue, saturation, and brightness of the colors.

areas—is severely limited. Fourth, to maintain a reasonable level of aesthetic energy, the event details are normally presented as a series of close-ups rather than event overviews, as is frequently the case in motion pictures. Obviously, television viewing requires a great deal more psychological closure than watching film or HDTV. Is this innately bad, and should we try to produce images that are maximally high-definition? Not necessarily. For example, traditional television (in contrast to HDTV) derives much of its visual intensity from its low-definition images.

Precisely because low-definition images require constant psychological closure, we as viewers are required to *work* with the event—to fill in continuously missing external (form) and internal (story) information in order to make sense of the pictures and story narrative so that we can arrive at the appropriate gestalt. We no longer remain passive spectators but instead become active, perceptually hardworking participants. Thus the communication is not necessarily inhibited and may well result in a desirable intensification of the event.

The participation and intensification aspect of low-definition images has prompted many artists and communicators to render specific graphic material or commercials purposely low-definition. The black-and-white commercials and the desaturation practice discussed in chapter 5 are examples of calculated low-definition presentations. **SEE COLOR PLATES 5-8** Other examples are drawings that carry only minimumal information so as to elicit maximum psychological closure. **SEE 7.47** Low-definition fashion drawings encourage you to project how you would ideally like the clothing to look.

You should realize, however, that the constant mental activity necessary to make sense of a low-definition presentation requires much mental effort, however subconscious, from the viewer, which can lead to fatigue. This effort for closure may be one of the reasons why we find it much more tiring to watch a three-hour film on television than on the large, high-definition screen in a movie theater—even if we have the same amount of popcorn and soft drinks available.

Computer displays are usually quite low-definition and the reason for this is technical rather than aesthetic. Computer images are built pixel-by-pixel. Much like a mosaic, which looks sharper the more tiles used, a high-definition image needs a considerably larger amount of pixels than a low-definition one. Unfortunately, a higher pixel count requires more storage space and processing time. The solutions to keeping computer displays relatively high-definition are to make the image relatively small or to increase the storage capacity. Irrespective of storage capacity, however, the downloading or rendering of even a relatively simple full-screen high-definition image is time-consuming even for high-speed processors.

FACILITATING CLOSURE

A low-definition image is helpful only if it facilitates, rather than inhibits, closure. When framing a shot, you need to arrange the picture elements in such a way that they can easily be completed in the viewer's mind even in off-screen space, or else grouped into "simple" figures, that is, into recognizable patterns of basic geometrical figures. This is explored more fully in chapter 8.

7.47 Advantage of Low-Definition Images

This low-definition image compels you to apply psychological closure. In fact, you will find it hard not to "see" the line of the right side of the face, although it is not actually present.

We know that people apply psychological closure to formulate specific patterns. But is the process of psychological closure predictable? Can we predetermine the stimuli necessary for someone to perceive a particular pattern? Can we deduce any principles of psychological closure? Yes. Three gestalt psychologists—**Wolfgang Köhler** (1887–1967), **Max Wertheimer** (1880–1943), and **Kurt Koffka** (1886–1941)—helped develop three major principles of psychological closure: proximity, ⁹ similarity, ¹⁰ and continuity. ¹¹

Proximity When similar elements lie in close proximity to one another, we tend to see them together. Because of attraction of mass, we connect more readily those elements that lie closer together than those that lie farther apart.

Similarity Similar shapes are seen together.

Continuity Once a dominant line is established, its direction is not easily disturbed by other lines cutting across it.

Here we see horizontal rather than vertical lines, because the horizontal dots lie closer together than the vertical dots.

All these dots are equally spaced, yet we see horizontal lines because we tend to see similarly shaped objects together.

We see a curved line being intersected by a straight line (a) rather than four odd-shaped forms attached to each other (b).

Now we perceive vertical lines, because the vertical dots are closer together than the horizontal ones.

Here the similarity overrides the proximity. We see a triangle and a square intersecting.

Here we tend to see four narrow columns rather than three fat ones.

These three principles of psychological closure—proximity, similarity, and continuity—are all based on our desire to establish "visual rhythm." I therefore propose this overriding perceptual principle:

We tend to perceive together those elements that are easily recognizable as occurring at a certain frequency (number of similar elements) within a certain interval (distance from one another) or that pursue a dominant line.

Vectors

Probably the strongest forces operating within the screen are directional forces that lead our eyes from one point to another within, or even outside of, the picture field. These forces, called *vectors*, can be as coercive as real physical forces. ¹² Each vector has a certain magnitude or strength as to directional certainty and power. A vector, therefore, is a force with a direction and a magnitude. ¹³

A vector on the screen indicates a main direction that has been established either by implication—such as with arrows, things arranged in a particular line, or people looking in a specific direction—or by actual screen motion, such as a man running from screen-left to screen-right, or toward or away from the camera.¹⁴

For screen displays, where you must deal with implied as well as real motion, the proper understanding and handling of vectors becomes extremely important. Once you have grasped what vectors are, and how they interrelate and interact with other visual and aural elements, you can use them effectively not only to control screen directions but also to build screen space and event energy within a single frame or over a series of frames. You will find that a firm understanding of the vector theory will help you immensely in preproduction placement of cameras and in postproduction editing.

VECTOR FIELD

In structuring screen space, we no longer work with isolated vectors but instead with a *vector field*: a combination of various vectors operating within a single picture field (single frame), from picture field to picture field (from frame to frame), from picture sequence to picture sequence, from screen to screen when you use multiple screens, and from on-screen to off-screen events.

You can also find vectors in color, in music, and even in the structure of a story; in fact, a vector is any aesthetic element that leads us into specific space/time—or even emotional—directions. More complex vector fields include *external vectors*, which operate within or without the screen, and *internal vectors*, which operate within ourselves.

For the present, however, let's concentrate simply on the visual vectors that operate in on- and off-screen space of film, television, and computers.

VECTOR TYPES

If you carefully examine the various ways visual vectors operate, you are likely to find three principal types: (1) graphic vectors, (2) index vectors, and (3) motion vectors.

Graphic vectors These are created by stationary elements that guide our eyes in certain directions. The direction of a *graphic vector* is ambiguous, however. A simple line is a graphic vector, but we can scan the line from left to right or (with a little more effort) from right to left. **SEE 7.48** When we establish a point of origin for the line, we increase the magnitude of the graphic vector. Its directionality is now determined by a point of origin, but is still somewhat ambiguous. **SEE 7.49 AND 7.50** The pipe structure of a ferry boat harbor and the telephone pole and wires give basic directional orientation, but they do not unequivocally point in a single direction, hence their directional magnitude remains relatively low.

7.48 Line as Graphic Vector

A graphic vector is created by a line or by objects that are arranged so as to guide our eyes in certain directions.

b

This graphic vector has a more definite direction than those in (a), but it is still not unidirectional.
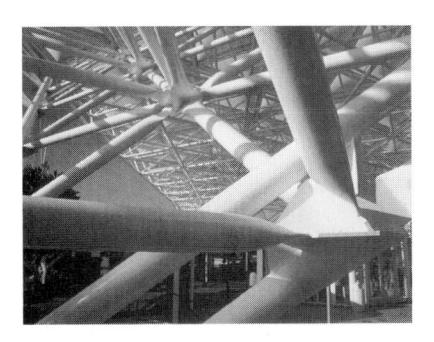

7.49 Graphic Vectors: Roof Structure This pipe structure that supports a roof generates a multitude of graphic vectors.

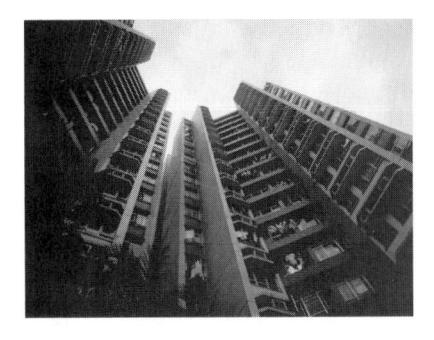

7.50 Graphic Vectors: Building
The vertical lines of this building create strong graphic vectors. The patterns formed by the windows are also graphic vectors.

Index vectors In contrast to a graphic vector, an *index vector* is created by something that points unquestionably in a specific direction. Examples are arrows or people pointing or looking in a particular direction. Index vectors include still photographs of runners or somebody riding a motorcycle. **SEE 7.51–7.54**

7.51 Index Vectors: Looking Somebody looking in a particular direction forms an index vector.

7.52 Index Vectors: Pointing
An index vector is created by anything that points unequivocally in a particular direction. Somebody pointing forms a high-magnitude index vector.

7.53 Index Vectors: Arrow
An arrow is a high-magnitude index vector.

7.54 Index Vectors: Motorcycle

Note that a still shot of a person or object in motion is not a motion vector but rather a strong index vector. Even a blurred photo suggesting movement is not a motion vector; it is still an index vector. A motion vector is created only by something that is actually moving or is perceived as moving on the screen.

Motion vectors A *motion vector* is created by an object that is actually moving or perceived as moving on the screen. Obviously, a motion vector cannot be illustrated with a still picture. You can perceive a motion vector only by watching a moving object or by perceiving it as moving on the television, computer, or movie screen. A blurred still shot of a moving object (see figure 7.54), therefore, does not represent a motion vector. It remains an index vector.

VECTOR MAGNITUDE

The magnitude of a vector is determined by its relative directional certainty and perceived directional force. *Vector magnitude* is determined primarily by (1) screen direction, (2) graphic mass, and (3) perceived object speed. Although each vector type can be strong or weak (have a high or a low magnitude), motion vectors generally have a higher magnitude than index vectors, which in turn have a higher magnitude than graphic vectors. **SEE 7.55**

7.55 Vector Magnitude

Although each vector type can be strong or weak (have a high or a low magnitude), motion vectors generally have a higher magnitude than index vectors, which in turn have a higher magnitude than graphic vectors.

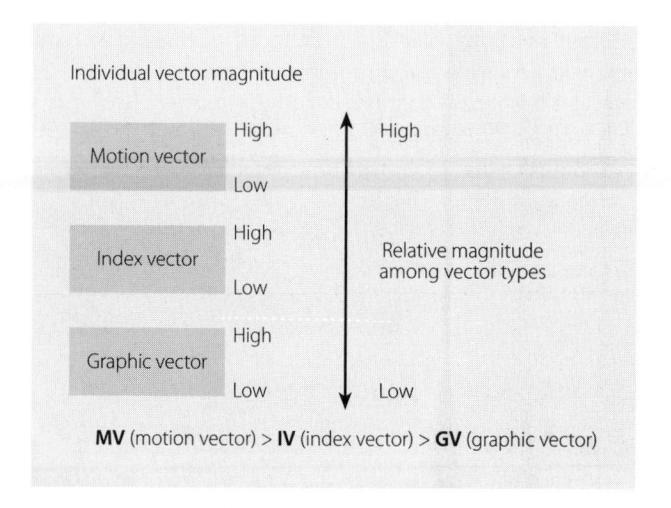

Vector magnitude and screen direction As pointed out earlier, a line indicates a general direction (horizontal, vertical, curved) but is not precise as to its direction. Such a graphic vector has, therefore, a relatively low magnitude. Such index vectors as someone pointing in a particular direction, a one-way-street sign, or a directional arrow in a parking garage have a much higher magnitude. Motion vectors have a relatively high magnitude because their screen direction is most conspicuous.¹⁵

Something moving or pointing directly toward or away from the camera results in a *z-axis vector*, so called because the vector direction follows the *z-axis*—the virtual line extending from camera to horizon. Whereas a *z-axis* index vector, such as somebody looking or pointing directly at the camera, has a very low magnitude, *z-axis* motion vectors can have a high or a low magnitude. A spaceship hurtling toward the camera definitely has a higher magnitude than the first uncertain steps of a child toddling toward the camera (representing Mother's arms). Depending on the context, a fast zoom-in or zoom-out can also produce a high-magnitude *z-axis* motion vector, although the screen motion is now implied rather than actual.

Vector magnitude and graphic mass The larger the graphic mass that is in motion, the higher its vector magnitude. As stated earlier, a large graphic mass is

less likely to be disturbed in its course than a small one. Because its directionality is more certain, its vector magnitude is higher than for small objects.

Vector magnitude and perceived object speed The faster the speed of an object, the higher its vector magnitude. This principle applies to all vector directions, including vectors that move along the z-axis. A car or jet racing across the screen, a galloping horse, a skier whizzing down a steep slope—all are strong motion vectors of high magnitude. The image of a racecar roaring down the track makes for a higher-magnitude motion vector than does a couple's leisurely stroll through the park.

VECTOR DIRECTIONS

Index and motion vectors can be (1) continuing, (2) converging, or (3) diverging. *Continuing vectors* point in the same direction. *Converging vectors* point toward each other. *Diverging vectors* point away from each other.

Continuing vectors When two or more index and/or motion vectors point in the same direction, we have continuing vectors. The continuity can be established by the same vector type (graphic, index, or motion) or by a combination of vector types. The continuity can be established in a single shot or a shot sequence. If, for example, you see two people looking in the same direction in a single shot, you have continuing index vectors. SEE 7.56 If you now show a child watching her balloon escaping into the sky, you have continuous vectors within a single shot. Both the index vector of the child's gaze and the motion vector of the balloon's ascent point in the same direction. These continuing vectors are now of mixed type: index vector (child's gaze) and motion vector (balloon's ascent). These vectors remain continuous even if you show the same event in two separate shots. For example, your first shot could show a close-up of the balloon slipping out of the girl's hand and how she looks upward with the balloon moving out of the frame. Your second shot could then show the balloon moving into the sky.

Although graphic vectors have a relatively weak magnitude (their direction is basically ambiguous), they can be continuous, especially in a shot series or in multiple screens. Let's assume that you are shooting a scene on the beach with the ocean as the background. The horizon marks a definite graphic vector that cuts across the screen at a particular spot. To ensure the necessary continuity from shot to shot, the horizon should not jump up or down in subsequent shots. The graphic vector (horizon line) must be continuous. **SEE 7.57**

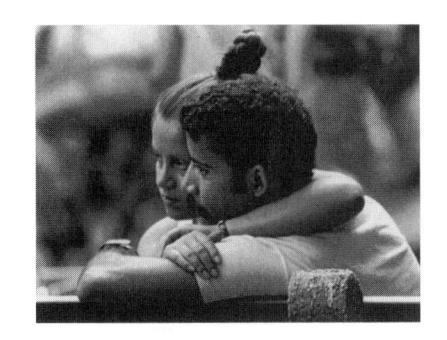

7.56 Continuing Index Vectors
Continuing vectors point in the same direction. These two people create continuing index vectors because they are looking in the same direction. If they were moving, they would create continuing motion vectors.

7.57 Continuing Graphic Vectors

Although graphic vectors are low-magnitude, which means that their direction is ambiguous, you can nevertheless see them as continuous. In this three-screen display, the horizon lines of the three shots must match to form a single graphic vector.

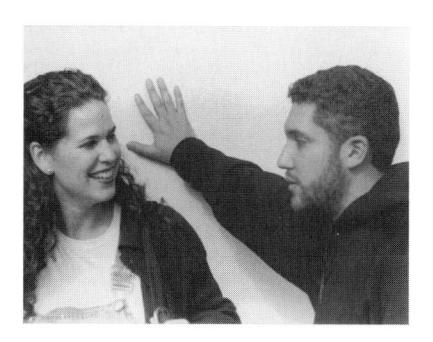

7.58 Converging Index Vectors in Two-Shot
Converging vectors point toward each other. These two people looking at each

other form converging index vectors.

7.59 Index Vector: Screen-Right
In a close-up sequence, you need to maintain the same index vectors as in the two-shot. Here the person on the left effects a screenright index vector.

7.60 Index Vector: Screen-Left
To make the index vectors converge over the shot sequence, the screen-right person must look screen-left, establishing an index vector that converges with that of the screen-left person.

Converging vectors In contrast to continuing vectors, which support each other in establishing or maintaining a specific single direction, converging vectors point toward each other either in a single shot or a series of shots. A simple conversation between two people shows converging index vectors whether you show them in a single shot or in separate close-ups. **SEE 7.58-7.60** Two cars racing toward each other represent converging motion vectors. You can also use converging vectors to increase the aesthetic energy of an event.

Diverging vectors If index or motion vectors point away from each other, we have diverging vectors. Obviously, two people pointing in opposite directions create diverging index vectors. Cars traveling in opposite directions are also examples of diverging motion vectors regardless of whether they appear in a single shot or a shot series. **SEE 7.61**

7.61 Diverging Index Vectors
Diverging vectors point in opposite directions. These two people form diverging index vectors by looking away from each other.

Sometimes when you have specific index and motion vectors (z-axis vectors that point toward or away from the camera), viewers can perceive them as continuing, converging, or diverging. In this case, the event context—and not the vectors—determines the specific vector function. For example, if you first see two people looking at each other in a two-shot and then z-axis close-ups of the two people, your mental map will most likely tell you that the z-axis vectors of the close-ups are still converging; the two people are still perceived as looking at each other. If the two-shot shows them looking away from each other, you will perceive the successive close-ups as diverging z-axis vectors; the people will continue looking away from each other. For more examples of z-axis vectors and their behavior, see chapters 8 and 15.

So far we have discussed the basic types of external (screen) vectors and their major attributes—magnitude and continuing, converging, and diverging directions. In the following chapters, you will learn more about how vectors operate within the screen, from shot to shot, or from screen to screen.

The proper manipulation of vector fields is one of the most important aspects of your quest for clarifying, intensifying, and interpreting an event for your viewers.

Summary

There are six major types of field forces: main directions, magnetism of the frame, asymmetry of the screen, figure and ground, psychological closure, and vectors.

Horizontal lines suggest calmness and normalcy. Vertical lines suggest power, formality, and strength. A combination of vertical and horizontal reflects our normal world; it follows the pull of gravity and suggests that we are standing upright on level ground. A tilted horizontal plane, therefore, implies instability or powerful dynamism in an otherwise stable, or even static, shot.

Magnetism of the frame refers to the edges of the screen and especially the corners exerting a strong pull on objects within the frame. Moreover, graphic mass attracts graphic mass (objects within the screen). The larger graphic mass is usually more stable than the smaller one. The smaller graphic mass is dependent, the larger more independent.

A diagonal going from the bottom of screen-left to the top of screen-right is perceived as an uphill slant; a diagonal from the top left to bottom right implies a downhill slant. This suggests that we tend to start at the left and finish at the right when looking at a picture field. As the destination area, the right side of the screen seems to be more prominent. We generally pay more attention to an object when it is placed on screen-right than on screen-left.

We seem to organize a picture field into a stable ground against which less stable figures operate. The figure exhibits certain spatial and graphic characteristics, the most important of which is that the figure seems to lie in front of the ground. Certain figure-ground reversals can be distracting but can also contribute to startling and expressive effects.

We tend to organize pictorial elements into a pattern of simple geometrical figures, such as triangles, squares, and the like. We can perceive such patterns, even if we have only a minimum of information, by mentally filling in the missing information—a process known as psychological closure, or closure for short. The pattern that we get through psychological closure is called a gestalt. In a gestalt, the parts have assumed a different structure than when they were independent.

A vector is a force with a direction and a magnitude. All screen events exhibit one or a combination of the three principal vectors: graphic, index, and motion.

A graphic vector is created by simple lines or stationary elements that are arranged so that the viewer sees them as lines. Although graphic vectors suggest a general direction, their actual direction is ambiguous. An index vector is created by an object that unquestionably points in a specific direction. A motion vector is created by an object that actually moves or is perceived as moving on the screen. A still photograph of a moving object is an index vector, not a motion vector.

Each vector can have a variety of magnitudes (strengths) depending on how definitely it points in a certain screen direction, its graphic mass, and perceived object speed. In general, however, graphic vectors have less magnitude than index vectors, which have less magnitude than motion vectors.

Vectors can be continuing, converging, and diverging. Continuing vectors point in the same direction either in the same shot or in a shot sequence. Converging vectors point or move toward each other. Diverging vectors point or move away from each other.

NOTES

- 1. Headroom follows the same principles as demonstrated in figure 7.10.
- 2. See also chapter 8.
- 3. This asymmetry of screen-right and screen-left—that is, whether one side of the picture draws more attention than the other regardless of picture content—has been a source of confusion and debate for some time. Alexander Dean (1893–1949), who taught play directing at Yale and was quite particular about the asymmetry of the stage, claims that the audience-left side of the stage is "stronger" than the right side since the audience has a tendency to look left first and then to the right. [Alexander Dean, Fundamentals of Play Directing (New York: Farrar and Rinehart, 1946), p. 132.] Heinrich Wölfflin (1864–1945), a prolific writer on various subjects in art history and theory, claims that the right side of a painting is "heavier" than the left. He says that we have a tendency to read over the things on the left quickly in order to come to the right side, where "the last word is spoken." He demonstrates quite convincingly with several illustrations how the character of a painting changes when its sides are reversed. [Heinrich Wölfflin, Gedanken zur Kunstgeschichte (Basel: Benno Schwabe & Co., 1940), pp. 82–96.]

Rudolf Arnheim speaks of the well-known tendency to perceive the area in the left corner of a visual field as the point of departure and thus the entire picture as organized from left to right. [Rudolf Arnheim, *The Power of the Center* (Berkeley: University of California Press, 1982), p. 37.] But then he goes on to say that "the left side of the field, corresponding to the projection areas in the right half of the brain, is endowed with special weight" and that "objects placed on the left assume special importance." Arnheim, *Power of the Center*, p. 38.]

In an experimental study, Metallinos and Tiemens come to the conclusion that there is "some evidence that the retention of visual information in a newscast is enhanced when the visual elements are placed on the left side of the screen," but that there is in general "minimal support to the asymmetry of the screen theories." [Nikos Metallinos and Robert K. Tiemens, "Asymmetry of the Screen: The Effect of Left Versus Right Placement of Television Images," *Journal of Broadcasting* 21, no. 1 (Winter 1977), p. 30.] Very much aware of the contextual nature of aesthetic communication, however, they warn that "no final conclusions can be made on the basis of mere placement of the visual elements" and that "such factors as size, color, shape, vectors (directional forces), and how individual subjects perceive these qualities must also be considered." [Metallinos and Tiemens, "Asymmetry," p. 32.]

- 4. In a more recent experiment, Sheree Josephson investigated the eye-tracking devices that chart how people scan a computer Web page. She found that people looking at various Web pages scan generally from the most attractive part of the picture (generally an image in motion) to screen-left and then to screen-right. The glance remains either at screen-right or returns to screen-center. [Sheree Josephson, "A Real Eye Opener: An Argument for Using Eye-Movement Studies to Analyze Web Sites." Paper presented at the 11th Annual Visual Communication Conference, Teton Village, Wyoming (June 1997).]
- Bruce E. Goldstein, Sensation and Perception, 4th ed. (Pacific Grove, Calif.: Brooks/ Cole Publishing, 1996), p. 187.
- 6. Irvin Rock, Perception (New York: Scientific American Library, 1984), p. 118.
- 7. Max Wertheimer, "Untersuchungen zur Lehre von der Gestalt" *Psychologische Forschung* 4 (1923), pp. 301–350. As one of the eminent members of the Gestalt school, Wertheimer introduced the Law of Prägnanz, which postulates that psychological organization can always be as good as the prevailing conditions allow. *Good* in this case means that the resulting gestalt is often symmetrical, simple, and relatively stable.
- 8. Marshall McLuhan, *Understanding Media: The Extensions of Man* (New York: McGraw-Hill, 1964), pp. 312–314.
- 9. Wolfgang Köhler, Gestalt Psychology (New York: A Mentor Book, 1947).
- 10. Max Wertheimer, "Untersuchungen zur Lehre von der Gestalt."
- 11. Kurt Koffka, *Principles of Gestalt Psychology* (New York: Harcourt, Brace, and World, 1935), pp. 106–148.
- 12. The term *vector* was first used by Kurt Lewin to refer to psychological forces; it was later used by Andrew Paul Ushenko to mean an aesthetic force. See Kurt Lewin, *A Dynamic Theory of Personality*, trans. by Donald Adams and Karl Zener (New York: McGraw-Hill, 1935); and Andrew Paul Ushenko, *Dynamics of Art* (Bloomington, Ind.: Indiana University Press, 1953), pp. 60–119.
- 13. The definition given is an aesthetic one. If you were dealing in physics (the origin of the vector concept), the definition would be that a vector is a physical quantity with both magnitude and direction.
- 14. You may want to see vectors in operation by running the interactive CD-ROM Zettl's Video Lab 2.1. Click on the editing monitor and then on the vector button on tape 4 Continuity.
- 15. Click on the camera monitor of Zettl's Video Lab 2.1 to review various applications of vectors.

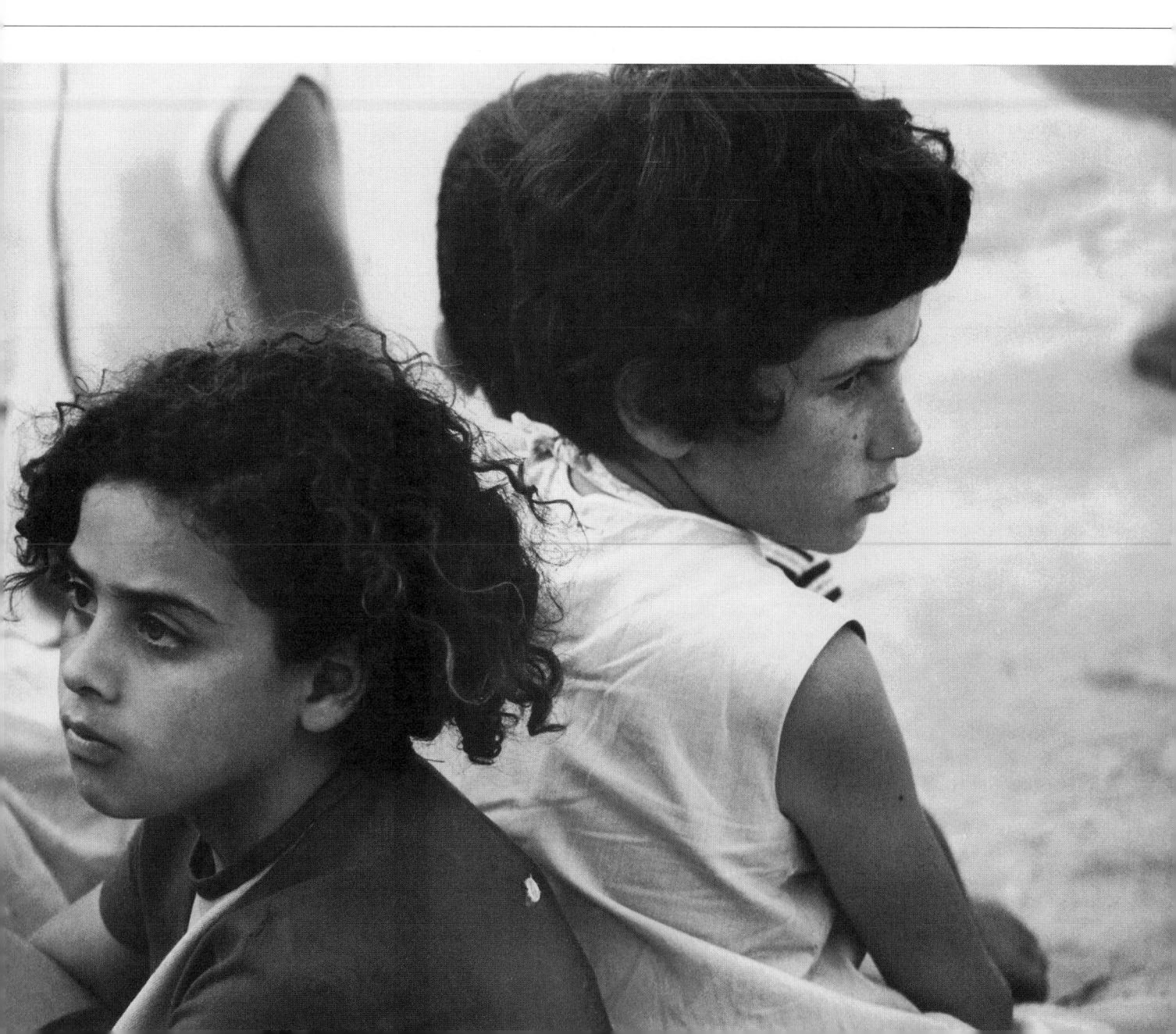

Structuring the Two-Dimensional Field: Interplay of Screen Forces

TRUCTURING the two-dimensional field means making the various screen forces work for rather than against you. This enables you to show events on the screen with clarity and impact. Painters or still photographers strive for a total composition effect in a picture. They try to arrange static pictorial elements so that they look and feel inevitably right. Once such an arrangement is achieved, the composition is finished; it will not change.

This is not so in television and film—or even on the computer screen. Most pictorial elements shift constantly within the frame and often change from one picture to the next (from shot to shot, from scene to scene, or during scrolling). Here you no longer deal with structural permanence but largely with structural change.

The old method of composition, that is, the pleasing arrangement of essentially static pictorial elements within a single frame, does not suffice for television and film. You must now think in terms of structuring a dynamic visual field and consider visual elements that move about the screen and that need to provide structural continuity between previous and following images. For example, the composition of a single shot may look wrong when you examine it by itself. **SEE 8.1** But when you see it as part of a shot sequence, its composition becomes perfectly acceptable. **SEE 8.2**

Structuring the screen space of a Web page on the computer screen presents a unique problem. Often the information does not fit the relatively small space of the monitor screen and must be moved up or down or to the sides to reveal pictures and written information. You should therefore consider even a single Web page design not as a static image, similar to a magazine page, but as partial images that maintain their structural integrity when scrolled from one segment to another. In this way their structure is influenced by their sequence, much like a brief television scene.

Does this mean, therefore, that all traditional composition principles are invalid? Not at all, but they must be adapted so that they fulfill the more-complex tasks of structuring static, moving, and sequential images within the two-dimensional field. You must now go beyond the traditional canons of good composition (area proportion, object proportion, and balance) to begin seeing the contextual interaction of the various screen forces, such as the magnetism of the frame, graphic mass, and vectors. This chapter explores the interplay of screen forces of the two-dimensional field: (1) stabilizing the field through distribution

8.1 Composition in Shot Sequence: Context Lacking
The composition in this shot is definitely wrong (the man stands much too close to the right side of the frame).

8.2 Composition in Shot Sequence: Context Provided
The position of the man makes sense as soon as you provide the proper context for such a framing as in this shot.

of graphic mass and magnetic force, (2) stabilizing the field through distribution of vectors, (3) stages of balance, (4) object framing, (5) extending the field with multiple screens, and (6) dividing the screen.

Stabilizing the Field Through Distribution of Graphic Mass and Magnetic Force

One of the most basic ways of stabilizing the two-dimensional field is to bring the forces of *graphic mass* and the *magnetism of the frame* into balance. As discussed in chapter 7, every graphic mass operating within a clearly defined two-dimensional field, such as the television, film, or computer screen, carries a specific *graphic weight*, which is somewhat akin to the actual weight of an object. Graphic weight is determined by: (1) the dimension of the object, which means how much area the object takes up relative to the total screen area; (2) its basic shape; (3) its basic orientation; (4) its location within the screen; and (5) its color. **See 8.3**

A screen object does not, however, have to display all these elements to have graphic weight. Object size alone is enough to give an image graphic

8.3 Factors Influencing Graphic Weight

Factor	Heavy	Light
Dimension	Large	Small
Shape	Simple, geometrically compact	Irregular, diffused
Orientation	Vertical	Horizontal
Location	Corner	Centered
	Upper part of frame	Lower part of frame
	Right	Left
Color	Hue: warm	Cold
	Saturation: strong	Weak
	Brightness: dark	Light

weight. **SEE 8.4** For example, the disc on the right side of the frame in figure 8.4 is obviously "heavier" (it carries more graphic weight) than the one on the left.

If objects are close enough to each other so that the attraction of mass comes into play (as explored in chapter 7), we tend to combine the graphic weights of both objects. SEE 8.5

The proximity of the object to the screen edges brings another important graphic force into play: the magnetism of the frame.

Obviously, the closer the object is to the edge of the screen, the more powerful the magnetic force will be regardless of its relative weight. However, a strong index vector, for example, can quite easily override the magnetic force of the frame. Let's look at some simple interactions of graphic weight and magnetism of the frame.

SCREEN-CENTER

The most stable position of an object is screen-center. When the graphic mass is located in screen-center, the surrounding areas and the magnetic forces of the screen edges are symmetrically distributed. **SEE 8.6**

OFF-CENTER

As soon as you move the object to one side, however, the graphic weight increases and the magnetism of the frame comes into play. The more the object moves offcenter, the greater its graphic weight—and the attraction of the frame also increases. When this happens, the picture begins to look unbalanced. **SEE 8.7**

8.4 Graphic Mass and Weight

The larger and therefore heavier graphic mass on the right side of the screen outweighs the smaller disc on the left.

8.5 Mass Attracts Mass

As in physics, in visual design graphic mass also attracts graphic mass. The attracted objects combine into a greater mass, which then has greater graphic weight.

8.6 Screen-Center Position

The screen-center position provides maximum stability.

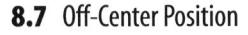

When the object moves off-center, its graphic weight increases, and the attraction of the frame comes into play.

COUNTERWEIGHTING

You can correct an imbalance of graphic weight by centering the object through camera or object movement so that the pull of the frame is equalized (see figure 8.6), or by counterweighting it with an object or other graphic element (such as a beam of light) of similar graphic weight. **SEE 8.8** As you can see, the attraction of mass caused by the two objects makes them gravitate toward screen center. The closer the objects are to each other, the more you are apt to perceive them as having a single graphic weight.

Let us now replace the abstract disc with a newscaster. The most stable position for the newscaster is obviously screen-center. Picture stability is important here to signify the newscaster's authority and credibility. **SEE 8.9**

Putting the newscaster to one side of the screen makes little sense unless you have to make room for a coanchor who sits next to the newscaster or for additional pictorial material, such as the box insert that is customarily placed above and to the side of the newscaster's shoulder. **SEE 8.10**

8.8 Counterweighting

You can achieve balance by counterweighting an object with another object of similar graphic weight. Note that attraction of mass also operates here.

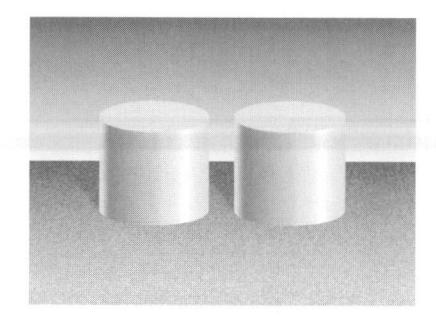

8.9 Newscaster in Screen-Center

The most stable and sensible position for a single newscaster is in screen-center, because this placement emphasizes the newscaster's credibility.

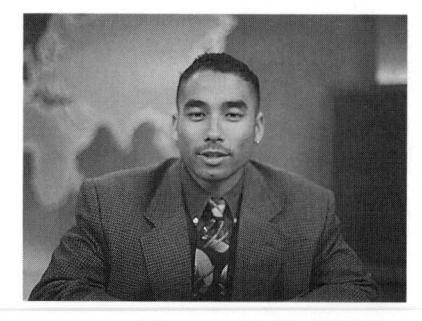

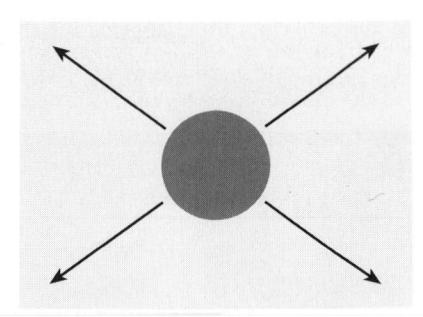

8.10 Off-Center Balance

A second newscaster or the traditional box insert necessitates the off-center positioning of the newscaster. If the new element has sufficient graphic weight, the shot will remain balanced. In this case the second anchor has ample graphic weight to maintain a balanced screen structure.

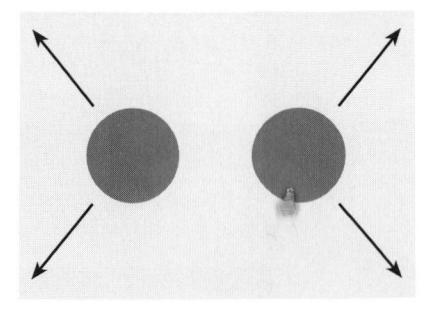

The graphic weight of a second newscaster obviously provides a symmetrical, and therefore stable, distribution of graphic weight. But even the smaller yet graphically active (visually prominent) box insert is more than enough to stabilize and balance the shot. But when you take the box insert out during the newscast, you need to once more center the newscaster to restore the original stable balance. A good camera operator can make this shift so smoothly that most viewers are unaware that this rebalancing act is taking place.

In titles and other still graphic images, however, you may want to place key elements off-center at one or the other side of the screen in order to boost the graphic tension and energy of the picture. The nonsymmetrical distribution of graphic mass and vectors are discussed more thoroughly in the section on stages of balance later in this chapter.

Stabilizing the Field Through Distribution of Vectors

When trying to stabilize the two-dimensional field, you need to focus on the distribution of vectors, which are such powerful structural elements that they usually override the lesser forces of graphic weight and frame magnetism.

STRUCTURAL FORCE OF INDEX VECTORS

Take a look at the following figure. **SEE 8.11** You will inevitably perceive the two center discs as belonging together (attraction of mass, see figure 8.8) and the upper-right disc as the isolated one (pull of screen corner, see figure 7.12).

But vectors can easily override the more subtle structural principles and cause you to perceive a different pattern. **SEE 8.12** The discs are in the same position as in figure 8.11, but now we have put "noses" on two of the discs, which create high-magnitude index vectors that establish a new relationship. Now the middle-right disc and the corner disc are strongly connected through their converging index vectors, putting the middle-left disc in isolation.² The increasing magnitude of index vectors of somebody turning from a straight-on (z-axis) shot to a profile shot has similar structural consequences.

8.11 Structure Through Attraction of Mass

The two center discs attract each other and are seen together. The disc in the upper-right corner is isolated.

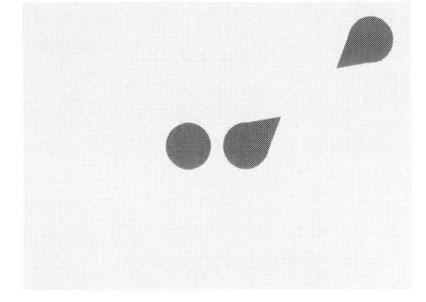

8.12 Structure Through Index Vectors

The converging index vectors now combine the right-center disc and the disc in the upper-right corner. The left-center disc is isolated.

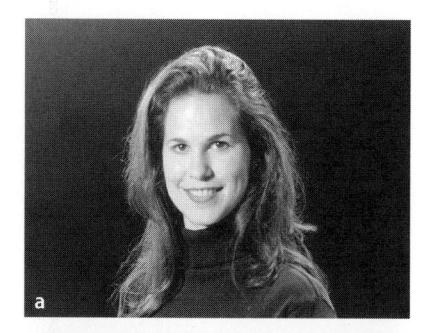

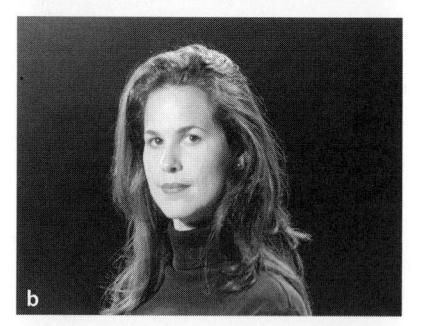

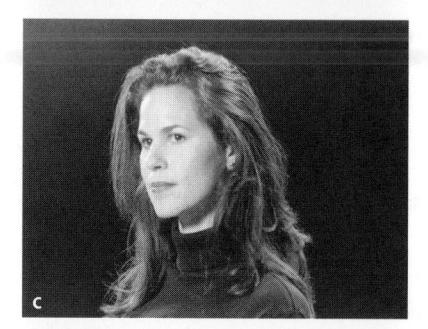

8.13 Force of Index Vector: Lack of Noseroom

The increasing magnitude of the index vector when someone gradually shifts from looking directly into the camera (z-axis vector) to looking at one of the screen edges will cause the index vector to crash into the screen edge.

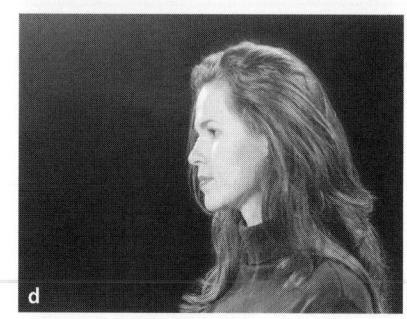

8.14 Force of Index Vector: Proper Leadroom

If you compensate for the increasing vector force by pulling the subject back to provide enough noseroom, the vector has enough space to have its force absorbed or comfortably guided through the screen border into the next shot.

LEADROOM

Imagine, for a moment, the following figure as a shot sequence. **SEE 8.13** In 8.13a the woman is looking directly into the camera (at you), generating a z-axis index vector. This vector leads along the z-axis directly into the camera. Because this z-axis index vector points directly at the viewer, its magnitude (directional force) within the screen is practically zero. You can therefore ignore the force of this index vector and stabilize the picture strictly by graphic weight and magnetism of the frame. Putting the subject in the center of the picture (maximum stability of graphic mass) with adequate headroom (neutralizing the magnetism of the upper edge) is the most logical thing to do.

But watch what happens when the subject turns her head (figure 8.13b–d). The more she looks to the side, the higher the magnitude of the index vector and the more the structural force of the vector comes into play. This index vector reaches its maximum magnitude in the profile shot (figure 8.13d). Although she has moved only her head and has not changed her basic screen position, the shot looks strangely out of balance; she seems cramped into the screen-left space with her index vector crashing into the left edge of the frame. Assuming that no other person will walk up behind her to balance the picture through graphic weight (see figure 8.2), you will now have to shift the subject more and more to screenright in order to give the index vector enough room to run its course and travel relatively unhindered to, and even through, the screen edge. This space is often called noseroom for index vectors, and leadroom for motion vectors.3

Note that you must leave more noseroom the higher the magnitude of

the index vector becomes. **SEE 8.14** The index vector is at its maximum magnitude in the profile shot; therefore, the noseroom has also reached its maximum length (figure 8.14d).

But wouldn't the index vector have a better chance of crashing through the screen edge if it originates as close to the edge as possible? Apparently not. When the index vector operates too close to the edge, it draws undue attention to the

screen edge itself. As part of a picture frame whose major function is to contain the event, the screen edge acts as final barrier to the index vector. This "short" vector and the graphic mass of the subject's head fall victim to the magnetism of the frame; both graphic forces are firmly glued to the edge and can no longer penetrate it.

Proper noseroom not only inhibits the magnetism of the frame, but also creates enough space around it to divert our attention away from the edge. Rather than deplete the vector's energy, the noseroom seems to signal clear sailing for the vector, not only through on-screen space but also—through the edge—into off-screen space.⁴

You treat motion vectors the same way. When panning with a moving object, always pan enough ahead to maintain leadroom for the motion vector to expand. If you do not sufficiently lead the moving object, the screen edge toward which the object moves will appear as a formidable barrier to the motion. All you see is where the object has been but not, as you should, where it is going. A lack of leadroom will make the motion look cramped and hampered.

Similar to the noseroom of lateral index vectors, lateral motion vectors need the most leadroom. Objects that move at an oblique screen angle need less leadroom, and z-axis vectors don't need any.

CONVERGING VECTORS

You can also balance an index vector with another converging one within the same screen. **SEE 8.15** With two people looking at each other, you achieve balance through the converging index vectors and the almost symmetrical placement of the subjects, whose graphic mass translates into just about equal graphic weight.

GRAPHIC VECTORS

Although graphic vectors as a category have relatively low magnitude, you can nevertheless use them in stabilizing the two-dimensional field. **SEE 8.16** The

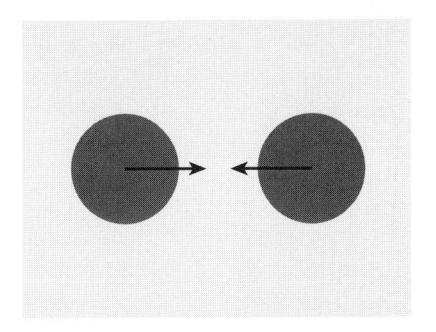

8.15 Converging Index Vectors
Converging index vectors of equal magnitude balance each other.

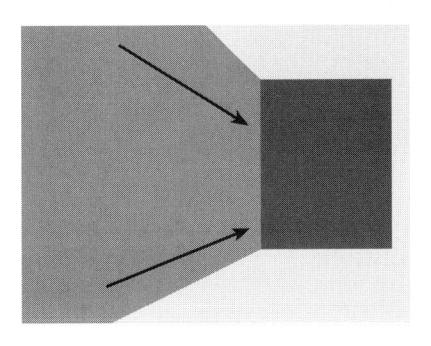

8.16 Distribution of Graphic Vectors

You can use graphic vectors to contain other graphic vectors. Here the horizontal and vertical vectors of the back building block the sloping vectors of the columns.

perspective lines of the buildings in the figure produce fairly strong graphic vectors that lead our eyes naturally, though not as directly as an index vector, from screenleft to screen-right. If you now want to prevent the vector from plunging through the right edge, to contain it properly within the screen, you can do this quite easily with other graphic vectors. In figure 8.16 the downhill vector of the entablature (on top of the columns) is arrested by the horizontal block of the back bulding.

Stages of Balance

Look back for a moment at figures 7.1 through 7.9. You will probably notice that the various structural arrangements in these illustrations do not have the same degree of balance, that is, the same degree of structural stability. Some look more

at rest, whereas others appear to have more internal tension—they look more dynamic.

Because our organism strives to obtain a maximum of potential energy and to apply the best possible equilibrium to it, as Rudolf Arnheim points out, balance does not necessarily mean maximum stability within the screen.⁵ Rather, balance can range from, or fluctuate between, stabile (stable) and labile (unstable) field structures. Thus we have three basic structural stages of balance: (1) *stabile*—stable and unlikely to change, (2) *neutral*—with some tension, and (3) *labile*—unstable and easily turning into an unbalanced composition.

STABILE BALANCE

The most stabile balance is a symmetrical structuring of visual elements. This means that identical picture elements appear on the left and right sides of the screen. More precise, the forces of graphic mass, frame magnetism, and vectors are the same, or at least almost the same, on both sides of the screen, and the horizontal/vertical screen directions are kept intact. **SEE 8.17**

NEUTRAL BALANCE

In a neutral balance, the graphic elements are asymmetrically distributed. This means that the graphic weight and the various vectors are no longer equal on both sides of the screen. Instead they are engaged in a sort of tug-of-war with one another that increases dynamic energy. **SEE 8.18**

Golden section One of the classical ways of creating a neutral balance is to use the proportions of the *golden section*—a division of the screen (or any other linear dimension) into roughly three by five units (or, more accurate 0.616:1, which translates approximately into 8 by 13 units). This means that we divide a given horizontal dimension, such as the width of this page, into a larger part (approximately three-fifths of the total width) and a smaller part (approximately two-fifths of the total width). The point where these meet is termed the golden section.

8.17 Stabile Balance

Symmetrical balance is one of the most stabile. In this picture both sides have identical graphic weights, pull of the frame, and vector distributions. The tension is low.

8.18 Neutral Balance

In a neutral balance, the dynamic energy is increased because the asymmetrical distribution of graphic elements and vectors causes some tension.

In such a division, the small and large screen areas are competing with each other, with the larger portion not quite able or even eager to outweigh the smaller one. Also, the dividing line (actual or imaginary) has not given in to the magnetic pull of one or the other screen edge, although one is definitely pulling harder than the other. The result is a less stable structure with increased graphic energy, yet the picture is still balanced. For many centuries this proportion was considered ideal and, at times, even divine.

Although the golden section is rarely applicable when dealing with moving images, it is nevertheless valuable when framing relatively static shots and designing titles and still images for the screen. For example, a title that is placed so that it divides the screen into the golden section proportion often gains dynamism and visual interest compared with one that is centered. Even when using illustrated titles, you may well arrange the major picture elements in proportions according to the golden section. This way the title gains in graphic energy without threatening the overall balance of the screen image. **SEE 8.19**

The golden section division of vertical screen space is especially effective when the vertical element (vertical graphic vector) divides a clean, horizontal vista (horizontal graphic vector). **SEE 8.20**

In a similar way, you can use a relatively uncluttered horizon (horizontal graphic vector) to divide the screen at approximately three-fifths or two-fifths of its height, thus dividing the screen horizontally into classical golden section dimensions. **SEE 8.21**

Although you may now believe that the golden section can provide area proportions that are, indeed, divine, avoid going overboard with it. For example, think twice before placing the newscaster in the golden section simply because you feel that such a graphic maneuver would create enough tension to keep the viewer watching. If the newscaster lacks dynamism in personality as well as message, even a divine screen placement will fail to improve the communication situation. Unless the newscaster's shift to the side of the screen is done to accommodate additional visual material—as pointed out earlier—the newscaster will merely look off-center.

8.19 Golden Section Applied: Titles

The left edge of the printing coincides with the golden section, providing increased visual interest. The figure balances the titles through graphic weight.

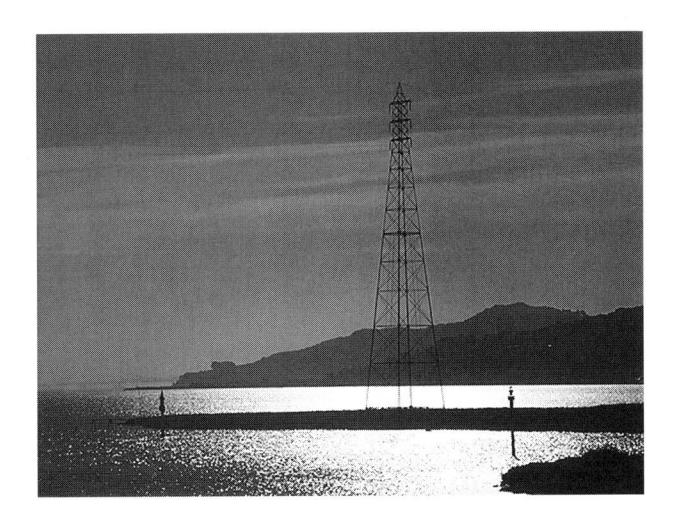

8.20 Golden Section Applied: Horizontal Division

It is especially effective to have a single vertical element divide a clean horizontal graphic vector at the golden section.

8.21 Golden Section Applied: Vertical Division

You can also use horizontal graphic vectors (such as the horizon) to divide the screen vertically at the golden section.

The Modulor The well-known contemporary Swiss-French architect **Le Corbusier** (Charles E. Jeanneret, 1887–1965) developed a proportional system that is essentially a refined version of the golden section.⁷ His system, which he called *the Modulor*, is also based on the proportions of the human figure, more specifically upon the proportions of a six-foot man.

All the Modulor proportions are presented in a gradually diminishing scale of numbers. Here, in Corbusier's diagram, all numbers are in centimeters (one one-hundredth of a meter).

The more exact Modulor dimensions are:

Harmonious Proportions The question of discovering proper proportions and using them with consistency in the various forms of art has been of major concern to artists for many centuries. The Egyptian temples and wall paintings, the Greek and Roman buildings and sculptures, the churches, palaces, and paintings of the Renaissance, the modern skyscraper, magazine layouts, and automobile design—all reveal the human preoccupation with proportional harmony. Amazingly enough, the proportions as revealed by the Egyptian and Greek temples, by a Gothic cathedral, or a Renaissance palace still seem harmonious to us today.

Obviously we have, and always have had, a built-in feeling for what proportion constitutes. But because we are never satisfied with just feeling, but also want to know *why* we feel a particular way and what makes us feel this way—mainly to make emotional responses more predictable—people have tried to rationalize about proportional ratios and to develop proportional systems. Mathematics, especially geometry, was of great help to people who tried to find the perfect, divine proportional ratio.

One charming illustration of this point is a statement by Albrecht Dürer, the famous German Renaissance painter (1471–1528). In the third book of his *Proportionslehre (Teachings on Proportions)*, he writes: "And, indeed, art is within nature, and he who can tear it out, has it. . . . And through *geometrica* you can prove much about your works." 8

Golden Section The most well-known proportional ratio is the golden section, often called the "divine proportion" or the "golden

mean." The familiar pentagram, or five-pointed star, contains a series of golden sections, each line dividing the other into a golden section proportion.

This proportion was produced by

to the Renaissance. Although the Egyptians knew about the golden section proportion and used it extensively in their architecture, sculpture, and painting, the Greeks are usually credited with working out the mathematics of this proportion and relating it to the proportions of the human figure. Later, Leonardo da Vinci, the great Italian Renaissance painter, scientist, and inventor (1452–1519), spent much time proving and making public the validity of the mathematical formula of the golden

section, (0.616:1) worked out by the Greek philosopher and mathematician **Pythagoras** as early as 530 B.C.

In the golden section, the smaller section is to the greater as the greater is to the whole. Thus:

$$\frac{BC}{AB} = \frac{AB}{AC}$$

This proportion continues ad infinitum. If you fold the BC section (on the right) into the AB section (on the left), you will again have created a golden section. Thus:

Modular units Architects and scene designers have modified golden section proportions into a modular concept. This means that a piece of scenery or prefabricated wall can be used in a variety of configurations, with, for example, two or three widths of one scenic or building unit fitting the length of another. **SEE 8.22** This makes the units easily interchangeable. With modular units, you can create a great variety of scenic structures without having to build custom units each time a new environment is required.

LABILE BALANCE

In a labile, or unstable, balance, the distribution of graphic weight, frame magnetism, and vectors are pushed to their structural limit, creating a tendency for imbalance. As viewers we sense that even the slightest change in the field structure would cause a loss of balance. This makes the graphic tension and energy quite high.

You can achieve graphic tension by overloading one or the other side of the screen with graphic weight, by not providing the vectors enough room to play out, or by constantly having high-energy vectors converge either within the shot or in a shot series. **SEE 8.23**

The easiest way to achieve more tension and move from a stabile to a neutral balance and from there to a labile balance is to tilt the horizon line. This way the customary horizontal/vertical equilibrium is disturbed enough to create tension without changing the balance of the other structural forces of graphic mass, frame magnetism, and vectors. **SEE 8.24-8.26**

Our inborn sense of equilibrium—our desire to see things stand upright on level ground—reacts so strongly to this labile balance that we try almost physically to keep the objects in the picture from slipping out of the frame and to bring the horizon line back to its normal, level position. Hence we perceive such labile types of balance as high-energy.

Whether the balance should be stabile, neutral, or labile is largely a matter of communication *context*. If you want to communicate extreme excitement, tension, or instability in relation to the event at hand, the pictorial equilibrium should reflect this instability. You may do well to choose a labile picture balance. On the other hand, if you want to communicate authority, permanence, and stability, the pictorial arrangement should, once again, reinforce and intensify this by means of a stabile balance.

8.23 Labile Balance

In a labile balance, the tension is high. With the slightest change in the distribution of graphic elements, the vectors would lead to an unbalanced picture field.

8.22 Modular Scenery

This set unit is built according to a modular concept. It can be used in a variety of ways and fits other scenic units whether used right-side up or sideways.

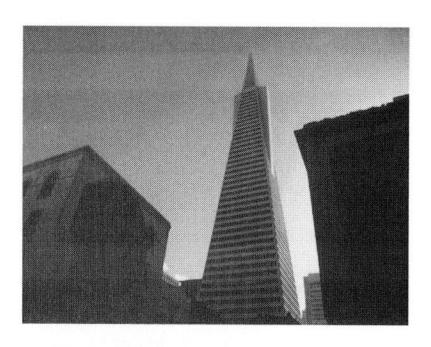

8.24 Stabile Balance
The straight horizon gives this picture a stabile (stable) balance.

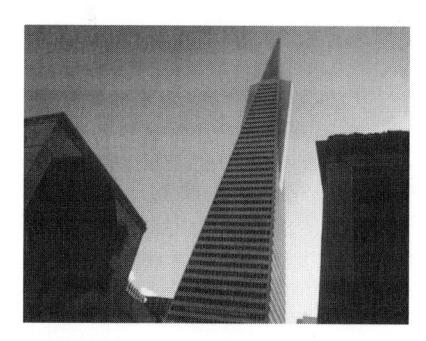

8.25 Neutral Balance
A slight tilt of the horizon gives this picture a neutral balance.

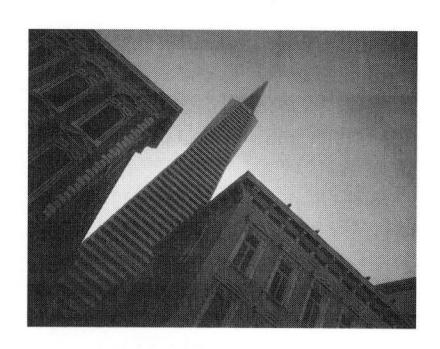

8.26 Labile Balance
A heavily tilted horizon gives this picture a labile (unstable) balance.

When working with the moving image of television and film, you must learn to "feel" the proper balance. Like a ballet dancer or champion athlete, you should be able to react to the structural demands of the moment both immediately and intuitively. The degree of balance must fit the demands of the moment. The fluctuating vector field and the constantly shifting forces of graphic weight and frame magnetism do not tolerate long and intense structural contemplations. Rather, you must sense the most effective pictorial structure and put it into operation without delay.

Object Framing

Take a breather from reading for a moment and look around. You probably notice that there is no object that you can see in its entirety unless you pick it up and look at it from all sides. Yet this limitation does not keep you from properly identifying objects or functioning as though you could see the whole environment. You simply imagine what you can't actually see and use psychological closure to complete the objects.

When you have to portray this same environment within the restricted space of a television or even a film screen, the viewer will see even less. Watching the small television screen, which favors the inductive presentation of an environment through a series of close-ups, especially taxes our facility for psychological closure. This means that you must frame object details so that the viewer can easily apply psychological closure not only within the shot but also from shot to shot. How can you do this? This section provides some answers by discussing closure within a single shot and in an extended two-dimensional field.

FACILITATING CLOSURE

To help viewers structure the two-dimensional field, try to arrange its visual content so that viewers can group and organize it into easily recognizable patterns of simple geometrical figures. **SEE 8.27-8.29** Even if you encounter visual material that is more complicated to order than in one of these illustrations, you can always look for and feature dominant graphic vectors that may give viewers some orientation in the visual jungle and help them apply closure.

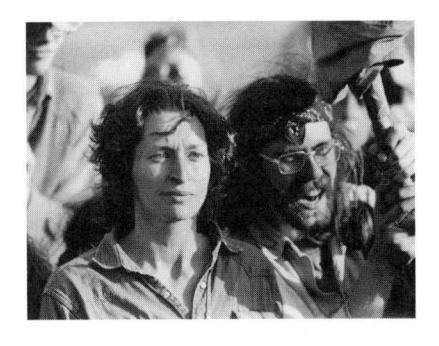

8.27 Closure into Rectangle

The graphic vectors in this picture help form the pattern of a rectangle.

8.28 Closure into Triangle

This composition facilitates closure into a triangle.

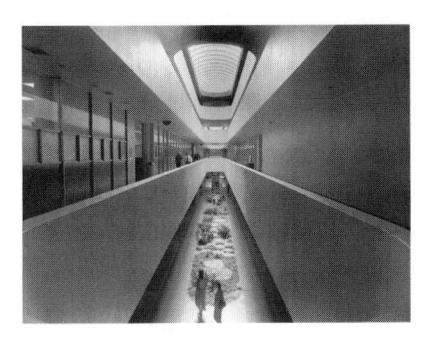

8.29 Closure into Diagonals and Triangles

The strong graphic vectors in this Frank Lloyd Wright building divide the picture into strong diagonals and triangles.

GRAPHIC CUES

When showing only part of an object or person on the screen, you must frame the object so that the viewer can easily fill in the missing parts and perceive the whole. In vector terminology this means that you arrange the vector field within the screen area so that all the vectors (graphic, index, and motion) extend easily beyond the screen area into off-screen space in order to facilitate psychological closure. **SEE 8.30** In this tight close-up, you don't see a picture of a person with the top of the head and the body cut off and think that they are missing; instead you automatically perceive a complete head and person. The reason you perceive a complete person is primarily because the shot contains enough graphic cues (graphic vectors) to provide psychological closure in the off-screen space.

PREMATURE CLOSURE

Instances do occur, however, in which improper framing can lead to premature psychological closure. *Premature closure* happens when the vector field within the frame entertains such easy closure that the image within the frame no longer stimulates us enough to extend it beyond the screen. This can occur even if only

8.30 Closure in Off-Screen Space

In this close-up, we perceive the whole person although only part of his head is actually visible.

8.31 Premature Closure

The shape of the head inevitably leads to closure into a circle. Because a circle is a highly stabile and self-contained configuration, you are no longer inclined to project beyond the frame. Hence the premature closure can cause you to perceive the head as disconnected from its body.

parts of an object or a person are shown. **SEE 8.31** The head of the subject in figure 8.31 is framed in such a way that all necessary conditions for closure exist within the frame; you automatically reduce the head to a simple, self-contained, highly stable gestalt—a circle. Practically no cues urge us to go beyond the frame. As a result, the head has become an independent unit and so it appears disconnected from its body, resting—like John the Baptist's head on Salome's platter—on the lower part of the screen edge.

NATURAL DIVIDING LINES

Similar problems of premature closure occur whenever the frame cuts off persons at any of their natural dividing lines, such as eyes, mouth, chin, shoulders, elbows, hemlines, and so forth. **SEE 8.32** When framing a shot, do not have these lines coincide with the top or bottom edge of the frame. Always try to frame a person so that these dividing lines fall either within or outside the screen edges. That way you will give viewers cues to project the image into off-screen space and apply closure to the whole person.

Objects too have natural dividing lines. **SEE 8.33** The principal graphic vectors in the houses in figure 8.33, for example, are the vertical edges of their sides, the V-shaped rooflines, the horizontal demarcation lines that divide the house into upper and lower floors, and the fences. If you frame the row of houses so that the side edges of the screen coincide with the outside-wall vectors of two houses, viewers have no need to project into off-screen space and, therefore, are made to perceive the two houses as a self-contained unit. But if you crop the picture as in the next figure, viewers are forced to extend the graphic vectors into off-screen for proper closure. **SEE 8.34** The outside walls now fall beyond the side edges of the screen, and the graphic vectors of the rooflines are added cues that lead into off-screen space. When this happens you are inclined to extend the two houses into a row of houses.

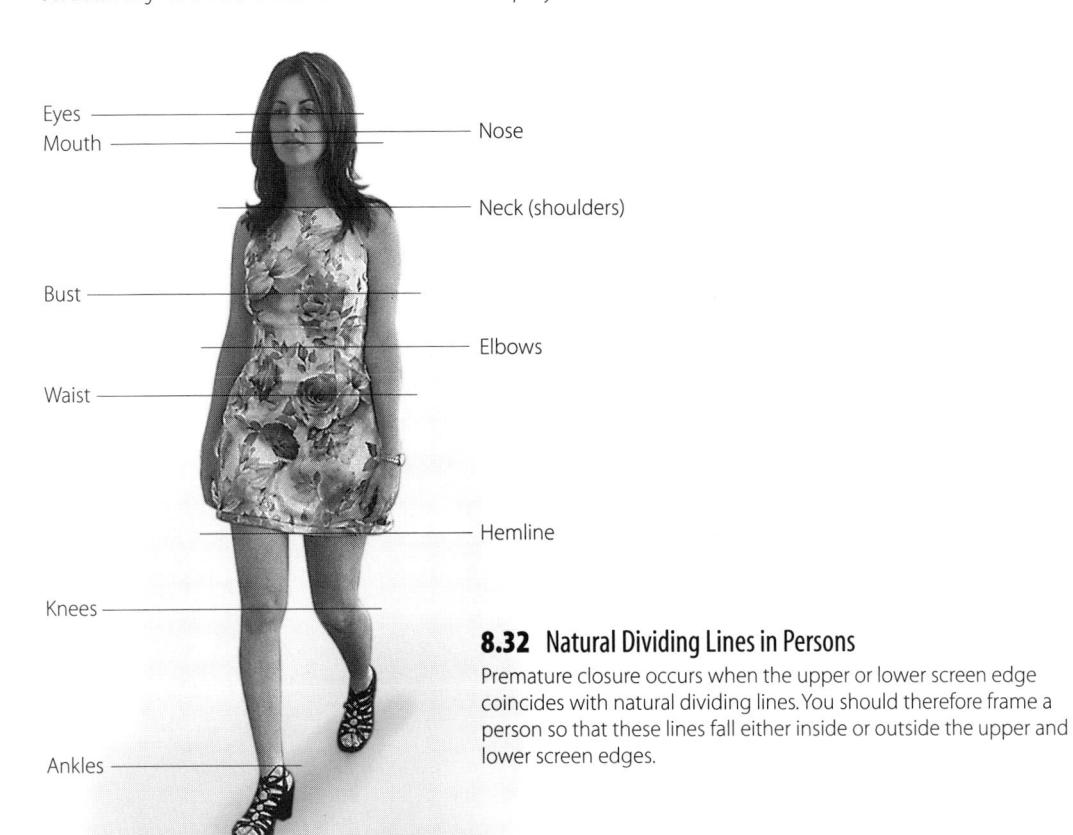

8.33 Dividing Lines Coinciding with Screen Edge

These houses are cut off at their natural dividing lines by the sides of the screen. We cannot tell whether there are only two houses or a whole row.

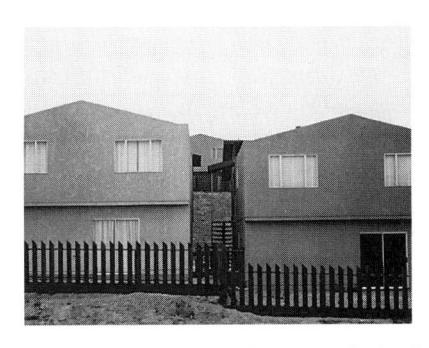

8.34 Dividing Lines Falling Outside the Screen Edge

Now that the edges of the natural dividing lines fall outside the screen edges, you are forced to apply closure outside the screen; consequently, you are more apt to perceive a row of houses.

8.35 Illogical Closure

If facilitated by the smooth continuity of vectors, we tend to group objects together into stable perceptual patterns regardless of whether they belong together. In this case, tree branches look like antlers growing out of the people's heads.

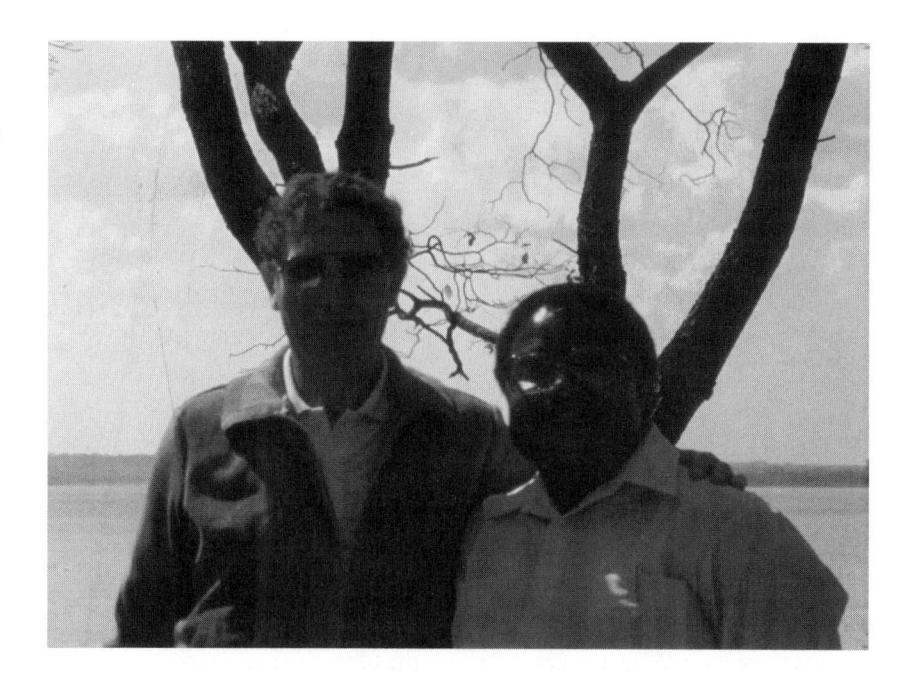

ILLOGICAL CLOSURE

Our need to make sense of the chaotic environmental and perceptual stimulus overload is so strong that we form patterns even when the visual elements that make up these patterns are illogical and obviously do not belong together. Thus we tend to group together in a single structure those visual elements that seem to provide an easy continuation of graphic vectors. Because the tree branches provide good graphic vector continuity, you perceive and form a stable configuration, regardless of the illogical content. **SEE 8.35**

To avoid this potential problem when framing a shot, you must learn to *look behind* the major focus to see if possible closure anomalies lurk in the background. Be especially alert when the scene designer puts potted plants behind interview chairs. When the camera is turned on the scene, some of the branches will almost inevitably appear to grow out of people's heads, ears, or shoulders. Similar precautions apply when shooting outside. Look behind the immediate scene you are shooting to see whether any background objects, such as telephone poles or trees, might lead to illogical closure.

Extending the Field with Multiple Screens

We live in a world of ever-increasing complexity. The various print and electronic media bombard us day and night with significant and not-so-significant information about what is going on in our neighborhood and the far corners of the world. Instant access to information is no longer a luxury; it has become a means of power. We have become information-dependent; that is, we need quick access to a large amount of varied information to function properly in our society. Whether you are shopping in a supermarket or going to the voting booth, you are asked to make choices. To make the right choices, you need to know about the various products or political candidates and be subjected to various viewpoints.

Despite its somewhat chaotic nature, the Internet makes information on practically any subject available instantly. The problem is no longer the availability of information, but access to it. Other problems are that most information is drastically streamlined to remain manageable—sound bites are but one example—and that the information is still principally delivered linearly, line by line, picture after picture. As a result, the mediated events often lack the complexity that you actually experience in everyday life. What is needed is a rethinking of the conventional television, film, and computer display techniques.

For example, the simultaneous use of several television screens could accommodate this need for increased information density and variety of viewpoints better than a single television screen. When using two television screens, you could view the interviewer and the guest more accurately than in the electronically generated frames that simulate multiple screens within the screen area of a single television receiver. In news and sports, you could watch the close-up action on one screen and the peripheral activities on one or two other screens.

Like a divided screen, multiple screens extend the field to accommodate two or more images simultaneously—not sequentially as in a shot sequence. Unlike the divided screen, however, which reduces the screen area into smaller segments, multiple screens *extend* the two-dimensional field. When properly structured, multiple screens expand and combine, like the tiles of a mosaic, into a complex yet clarified and intensified screen gestalt. The configuration and number of screens used depend entirely on the complexity and aesthetic requirements of the screen event. No doubt you are familiar with the multiscreen "towers" or "video walls" in department and record stores which, through repetition of the same image on all screens, try to match the intensity and complexity of the sound track. In this case no special attention has to be paid to a multiscreen structure. All you do is repeat the same image on all screens.

But when you intend to use the multiple screens as an expanded twodimensional field, you need to apply certain structural principles that are different from those of single-screen television. To demonstrate the major structural principles, we use a rather traditional, horizontally placed three-screen configuration very much like the triptych of the Roman writing tablet or the Gothic altar painting. **SEE 8.36**

Some of the major aesthetic principles governing the structure of the twodimensional multiscreen space include: (1) continuing graphic vectors, (2) off-screen space limits, (3) index vector combinations, and (4) z-axis vectors in three-screen space.

8.36 Horizontal Three-Screen Arrangement

A common and versatile multiscreen arrangement is three horizontally placed television sets.

132 Sight, Sound, Motion Chapter 8

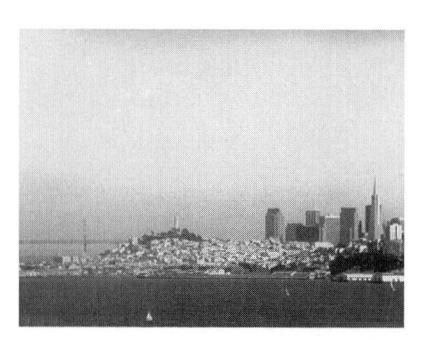

8.37 Horizon as Continuous Graphic Vector

In order for viewers to perceive the three screens as a spatial unit, you must make sure that common horizontal vectors cut the three screens at the same levels.

8.38 Horizon as Discontinuous Vectors

Graphic vectors that cut the screens at different vertical levels make it harder for viewers to perceive the three screens as a single screen space.

CONTINUING GRAPHIC VECTORS

To make the three-screen space continuous, you need to have prominent graphic vectors continuing throughout the three screens. For example, if the horizon is to be perceived as continuous across the three screens, it must cut across the same screen portion on all. **SEE 8.37** When such graphic vectors are discontinuous, viewers have a hard time seeing all three screens as continuous extended screen space. **SEE 8.38**

OFF-SCREEN SPACE LIMITS

In the three-screen arrangement, only the center screen projects into the adjacent screens. The outside, or wing, screens can project their vectors toward only the center screen, not in the opposite direction. For some reason the outside edges of the side screens seem to signal a definite spatial barrier. Contrary to a single screen, whose frame is surrounded by usable off-screen space, we tend to perceive the three-screen unit as a self-contained two-dimensional field in which the left and right outside edges represent definite spatial demarcations. The three-screen space seems closed to index and motion vectors beyond the outside edges of the wing screens. If, for example, you have a profile shot of someone in a wing screen with the index vector pointing toward the outside edge, there is no longer off-screen space where we imagine the target object to be; the person is simply looking at the edge of the screen. **SEE 8.39** In extreme cases, such vectors will cause one or both outside screens to split off from the three-screen unit to act as individual and discrete spatial fields. We then perceive three single television sets that happen to stand next to each other.

8.39 Off-Screen Limits

The index vectors of the wing screens seem to crash into the outside screen edges and isolate those screens from the center screen. The outside edges of the wing screens seem to close off-screen space to index and motion vectors.

8.40 Multi-Screen Open Space

When index and motion vectors in the wing screens point toward the center screen, they have no difficulty penetrating the inside edges and even the center screen. The three-screen unit represents open space for these vectors.

When the vectors (index or motion) point toward the center screen, however, they easily penetrate the inside borders of the wing screens and extend into, and even through, the center screen. The vectors now operate in the open space of the three-screen unit. **SEE 8.40**

INDEX VECTOR COMBINATIONS

If index vectors are continuing (in a screen-left or screen-right direction) on all three screens, we perceive the persons as looking away from each other. **SEE 8.41** When two people are shown looking at a third person in one of the outside screens,

8.41 Isolation Through Continuing Index Vectors

In this case the continuing index vectors seem to isolate the three people. All seem to be looking away from each other.

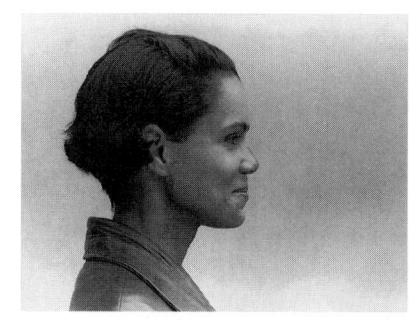

8.42 Emphasis Through Continuing Index Vectors

When two continuing index vectors converge with that of the target object, the continuing index vectors unite to focus on the target object.

8.43 Emphasis on Center Screen

The two converging vectors from the wing screens emphasize the center screen.

however, the converging index vectors seem to connect the screens into a spatial unit. The target object is obviously in the right-hand screen, which is, therefore, emphasized. **SEE 8.42** When people in the two wing screens look toward the center screen, the target object in the center receives the visual emphasis. **SEE 8.43**

If the persons in the left and center screens look at each other and the one in the right screen looks toward the outside screen edge, the converging vectors connect the left and center screens, and the right screen remains isolated. **SEE 8.44**

A similar isolation occurs even in a divided single screen, such as the box over the newscaster's shoulder. If, for example, an index vector in the box points toward the outside edge of the actual television screen, the event in the box seems

8.44 Isolation Through Diverging Index Vectors

The diverging vectors in the center and right-wing screens cause the right screen to become isolated from the other two.

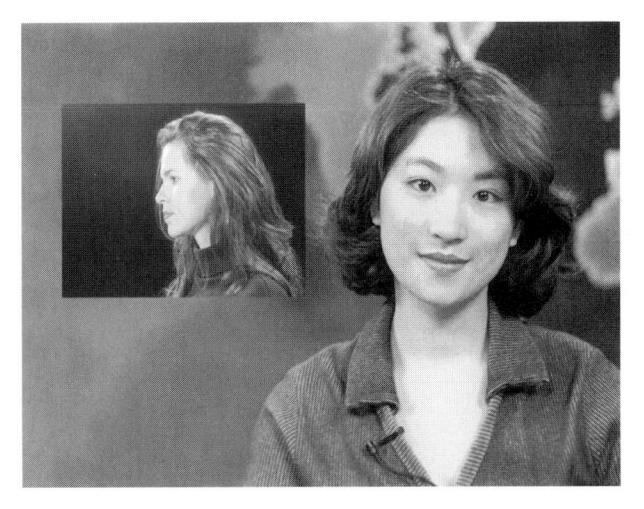

8.45 Isolation Through Outside Index Vector

Even in a divided screen, the index or motion vectors should point toward the center rather than toward the closest outside edge of the screen. If the vector points away from the center, the image looks isolated from the rest of the screen event.

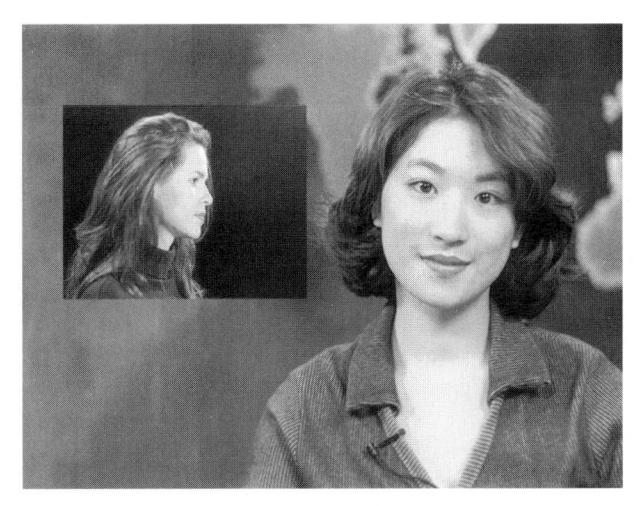

8.46 Connection Through Inside Index Vector

When the index vector points toward screen-center, the image in the box looks connected to the newscaster.

more disconnected, if not isolated, than if the index vector pointed toward screencenter. **SEE 8.45** You will therefore get a more unified screen image if the index vectors in the box point toward screen-center and not toward the outside screen edge. **SEE 8.46**

Z-AXIS VECTORS IN THREE-SCREEN SPACE

As pointed out earlier in this chapter, succeeding z-axis index vectors can be continuing, converging, or diverging, depending on the event context. But in a three-screen arrangement, this is no longer true. For example, when three people on three screens are all facing the camera and thereby creating three z-axis vectors, the three screens are no longer perceived as a unit but rather as three discrete screens. **SEE 8.47**

A similar problem occurs when two box inserts or split screens are used within a single television screen to connect interviewer and guest. If both "boxed"

8.47 Multiscreen Z-axis Index Vectors

Contrary to succeeding z-axis vectors, which can be continuing, converging, or diverging, the simultaneous display of z-axis vectors will not assume these modes. The people in the three screens all seem to be looking at the viewer but not at each other. This phenomenon also occurs in the simultaneous display of z-axis vectors in a split screen.

8.48 Split-Screen Z-axis Index Vectors

When shown simultaneously in a split-screen arrangement, the z-axis vectors of the two people isolated in their "boxes" point toward the viewer, but no longer at each other, regardless of the event context.

people look straight into their respective cameras, the two resulting z-axis vectors no longer converge, indicating that both interviewer and guest are talking to the viewers rather than to each other.¹² **SEE 8.48**

Dividing the Screen: Screens Within the Screen

Although the divided screen reduces rather than expands the principal viewing area, the basic communication purpose is similar to that of the multiscreen display—to show multiple images simultaneously rather than sequentially. You are now bombarded with more information in a shorter amount of time. It is not surprising that advertisers make frequent use of divided-screen displays. They can achieve an information density that would be hard to duplicate if the images were sequentially displayed.

Computer displays embrace the divided screen principally because of technical restrictions of limited storage space and display (processing) speeds: The smaller the picture, the less digital information is necessary. But even if the storage capacity and processing speeds are large enough for full-frame, real-time picture sequences (similar to what you see when watching television), the divided screen has the advantage of simultaneous information displays.

Fortunately, many of the aesthetic principles of multiple screens also apply to displaying smaller screens within a large screen. What you need to consider, however, is that the essential display area on the computer screen should not require either horizontal or vertical scrolling (moving the picture sideways or up and down) to see a complete picture. This is why advertising on a computer display is often done in narrow horizontally oriented strips that contain the crucial information without the need for scrolling. Also, many computer users view the

8.49 Divided Computer Screen Display

Computer displays are frequently divided into various distinct screen areas that function in the same way as the second-order screens in a television frame.

display on a smaller monitor than what the designer had available. The visual display must therefore be simple enough to be read even when its size is drastically reduced. **SEE 8.49**

Summary

Structuring the two-dimensional field means controlling the various principal forces of a shot in the two-dimensional field of the screen. The relevant processes and topics include stabilizing the field through distribution of graphic mass and magnetic force and through vector distribution; stages of balance; object framing; extending the field with multiple screens; and dividing the screen.

One of the most basic ways of stabilizing the two-dimensional field is to bring the forces of graphic mass and magnetism of the frame into balance. Each graphic mass (each object occupying a certain amount of screen area) has a graphic weight determined by the size of the object and its basic shape, orientation, and location within the screen as well as its color.

The magnetism of the frame becomes more powerful the closer an object is to the edges of the screen. The screen edges attract objects regardless of their size. The most stable position of an object is screen-center, where graphic weight and frame magnetism are symmetrically distributed. If an object is on one side of the screen, you can balance it by an object of similar weight on the other side.

One of the most important structuring processes is the distribution of vectors. High-magnitude index and motion vectors generally override such forces as graphic weight and magnetism of the frame. High-magnitude index vectors, as well as motion vectors, require deliberate framing in order to cope with their structural force and to stabilize the field. You usually do this by giving

the vector-producing object enough noseroom (for index vectors) or leadroom (for motion vectors). Although graphic vectors are of relatively low magnitude, you must arrange them so that they do not cause an imbalance in the shot.

There are three structural stages of balance: stabile (stable), neutral, and labile (unstable). The most stabile balance occurs when visual elements and forces are structured symmetrically. In a neutral balance, the graphic elements are asymmetrically distributed, which leads to a more dynamic interplay of forces. In a labile balance, the various forces are so pushed to their structural limit that the structure is close to being unbalanced. Through tilting the horizon line, you can easily go from a stabile stage of balance (horizon line parallel with the upper or lower screen edge) to a neutral stage (horizon line begins to tilt) to a labile stage (horizon line is at an extreme angle).

When framing an object so that only part of it can be seen on-screen, you need to provide enough graphic cues to facilitate psychological closure in off-screen space. This enables viewers to mentally fill in the missing parts of the object outside the frame. Premature closure occurs when viewers apply closure to the partial image within the frame, without extending the object into off-screen space. This is why having the natural dividing lines of a person or object coincide with the upper or lower screen edge should be avoided.

Illogical closure occurs when the visual elements of two nonrelated objects provide enough continuation of graphic vectors to be perceived as one configuration. This visual grouping of continuing vectors is so strong that we tend to group objects together that in fact do not belong together, such as seeing tree branches as an extension of the person standing in front of the tree.

The extended field—for example, separate screen areas within a single screen or multiple screens—requires additional structural techniques. Multiple screens extend the field simultaneously, not sequentially. Unlike a split screen, which breaks up a single screen into smaller screen areas, multiple screens expand the two-dimensional field. When properly structured, multiple screens combine and expand into a complex yet clarified and intensified screen gestalt.

If, in multiscreen structuring, a horizon line is to expand through all screens of a horizontal three-screen arrangement, for example, the graphic vectors of the horizon line must cut all screens at the same level. Otherwise viewers do not see the screens as a unit. In multiscreen configurations, the outside edges of the wing screens seem to tolerate no off-screen space, constituting definite spatial limits. Index vectors are extremely important in drawing attention to a specific screen as well as in combining the multiple screens into a single extended field. Z-axis vectors are no longer perceived as continuing, converging, or diverging when appearing simultaneously on two or three screens.

The divided screen, in which several screens are displayed simultaneously in the principal viewing area, can communicate a large amount of information within a short amount of time. Computer displays make frequent use of the divided screen. Generally, the aesthetic principles of multiple screens also apply to the divided-screen display.

NOTES

- 1. The specific structural principles and demands of a shot series are discussed in more detail in chapters 13 and 14.
- Credit for the "nose" index vector example goes to my colleague Mike Woal, who used it in his media aesthetics class in the Broadcast and Electronic Communication Arts Department at San Francisco State University.
- Leadroom seems to be the more flexible term than noseroom. See Thomas D. Burrows, Lynne S. Gross, and Donald N. Wood, Television Production, 6th ed. (Dubuque, Iowa: Wm. C. Brown Co., 1994).
- 4. Vector travel toward or through the screen edge was analyzed by Mark Borden in a paper "On the Problem of Vector Penetration" (Media Aesthetics I, Broadcast and Electronic Communication Arts Department, San Francisco State University, March 1996, unpublished).
- 5. Rudolf Arnheim, *Toward a Psychology of Art* (Berkeley: University of California Press, 1966), p. 45.
- 6. Placing the news anchor off-side in the golden section is a common practice in European television. When no additional graphic material is there to balance the shot, a beam of light or the station logo is used as a rather poor substitute. What makes this less-than-ideal composition tolerable is that the news anchor is usually presented in a rather loose medium shot and not in the tight close-ups we employ in American television.
- 7. For more information on the Le Corbusier Modulor, see Le Corbusier [Charles E. Jeanneret-Gris], *Modulor*, 2d ed., trans. by Peter de Francia and Anna Bostock (Cambridge, Mass.: Harvard University Press, 1954); and their *Modular 2* (London: Faber & Faber, 1958).
- 8. Translation by the author. The original reads: "Dann wahrhaftig steckt die Kunst in der Natur, wer sie herausreissen kann, hat sie. . . . Und durch die Geometrika magst du deine Werks viel beweisen." In Johnannes Beer, *Albrecht Dürer als Maler* (Königstein i.T, Germany: Karl Rebert Langewiesche Verlag, 1953), p. 20.
- 9. See Irvin Rock, *Perception* (New York: Scientific American Library, 1984), p. 116. Also see Max Wertheimer, "Experimentelle Studien über das Sehen von Bewegung," *Zeitschrift für Psychologie* 61 (1912): 161–265; and Kurt Koffka, *Principles of Gestalt Psychology* (New York: Harcourt, Brace and World, 1935), p. 110.
- 10. Because multiple screens are so rarely seen in film presentations, this discussion is limited to the use of multiple screens in television. However, similar multiscreen principles apply to the separate "screens" in computer Web page displays.
- 11. Most of the multiscreen material is borrowed from Herbert Zettl, "Toward a Multi-Screen Television Aesthetic: Some Structural Considerations," *Journal of Broadcasting* 21 (Winter 1977): 5–19.
- 12. Herbert Zettl, "Lost in Off-Screen Space: A Problem in Video Proxemics." Paper presented at the 11th Annual Visual Communication Conference, Teton Village, Wyoming (June 1997).

The Three-Dimensional Field: Depth and Volume

N television, film, and computer displays, as in painting and still photography, we must project the three-dimensional world onto a two-dimensional surface. Fortunately, the camera and its optical system transact such a projection automatically. It is also fortunate that we are willing to accept such a projection as a true representation of all three dimensions: height, width, and depth. **SEE 9.1**

Yet in television, film, and still photography, the third dimension of their lens-generated images is strictly illusory. By projecting the three-dimensional world onto the two-dimensional surface of the imaging device (television) or the film (cinema and still photography), the lens automatically translates all necessary depth cues to simulate depth. Synthetically constructed images of paintings and computer displays use the same basic techniques to create the illusion of a third dimension.

When examining the factors that contribute to the illusion of depth in television and film, keep in mind that it is what the *camera* sees, not what *you* see, that is important and that, contrary to painting and still photography, the viewpoint (camera position) and the event itself (objects, people) usually change even within a relatively short event sequence. Specifically, you must consider: the conventional peculiarities and techniques of projecting a third dimension on a two-dimensional screen surface; the space-manipulative properties and characteristics of lenses; the camera position and movement relative to the event; and the motion of the event, that is, the positions and movements of the event elements relative to one another.

This discussion of the three-dimensional field covers four topics: (1) the z-axis, (2) graphic depth factors, (3) depth characteristics of lenses, and (4) major graphication devices.

The Z-axis

As you probably remember from geometry, the x and y coordinates precisely locate a point in a two-dimensional plane such as the television screen. You can describe the width of the screen as the x-axis, and the screen height as the y-axis. A point within the screen can be assigned an x-value, indicating its relative position along screen width, and a y-value, indicating its position relative to screen height. **SEE 9.2**

9.1 Projection of 3-D Space onto a 2-D Plane

In traditional television and film, as in still photography and painting, we project the three-dimensional event onto a two-dimensional surface.

In the three-dimensional model, the *z-axis* is added, which describes depth. The *z-*axis value describes a point located away from the frontal plane—in our case, how far an object seems to be from the camera. SEE 9.3

Amazingly enough, the illusory third dimension—depth—proves to be the most flexible screen dimension in film and especially in television. Whereas the screen width (x-axis) and height (y-axis) have definite spatial limits, the z-axis (depth) is virtually infinite. **SEE 9.4**

Notice that without stereovision or hologram projection (as is the case with most films, television, and computer displays for the time being), we perceive the z-axis as originating from the screen and going backward. The closest object seems to lie on the screen surface; it does not seem to extend toward the viewer.² SEE 9.5

In stereovision or a hologram, the z-axis extends not only to the horizon, but also toward the viewer. The objects appear to also extend out from the

9.2 X and Y Coordinates

The x and y coordinates locate a point precisely within an area, such as the screen. A point within the screen can be assigned an x-value, indicating where it is located on the x-axis (screen width), and a y-value, indicating where it is located on the y-axis (screen height).

9.3 Three-Dimensional Model

To locate a point precisely within a described volume, the z-axis, describing depth, becomes an essential dimension. The z-value describes how far a point is located away from the frontal plane (the screen).

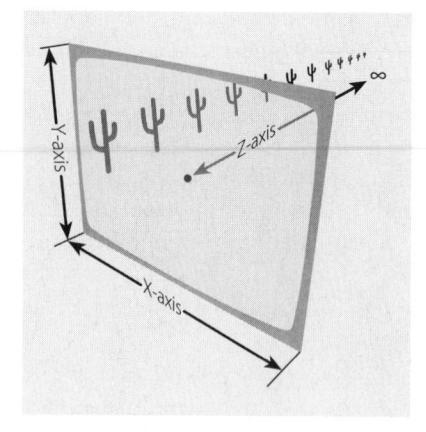

9.4 Z-axis Dimension

Although the z-axis—the depth dimension—is illusory in television and film, it is aesthetically the most flexible screen dimension.

9.5 Z-axis Direction

In normal lens-generated images, the z-axis stretches from the screen (camera lens) toward the horizon. The z-axis is bidirectional: Movement can occur from camera to horizon or from horizon to camera.

9.6 Z-axis Direction in Stereo and Hologram Projections

In stereovision and hologram projections, the z-axis points from the screen surface back toward the horizon but also through the screen toward the viewer.

screen toward the viewer; we judge their perceived distance relative to ourselves and not to the screen's surface. **SEE 9.6**

As explored in later chapters, the z-axis becomes an important element in structuring screen space and motion.

Graphic Depth Factors

But how, exactly, can we create the illusion of depth on the two-dimensional plane of the screen? **SEE 9.7** Examine the figure and try to identify the many factors that contribute to the illusion of depth on the two-dimensional surface of the page.

9.7 Graphic Depth Factors

What factors contribute to the illusion of depth in this picture?

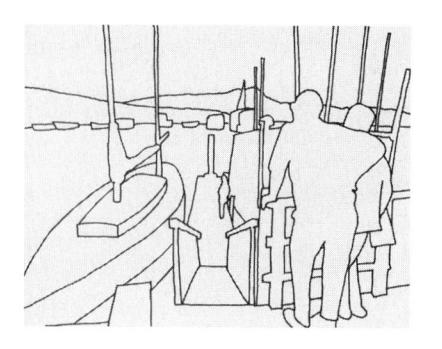

9.8

9.9

9.10

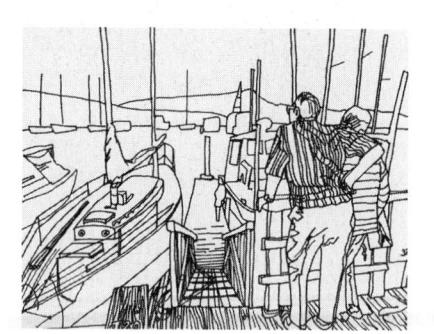

9.11

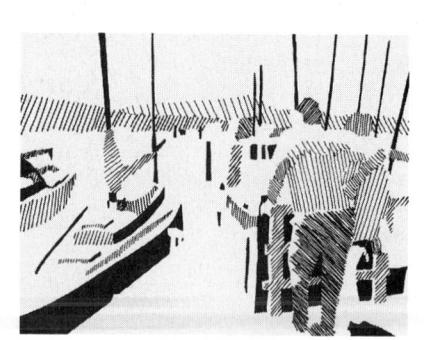

9.12

You probably noticed that some objects are partially hidden by other objects. **SEE 9.8** Also the farther away some objects are (boats, people, hills), the smaller they appear and the higher they seem to be positioned in the picture field. **SEE 9.9** Parallel lines, such as the sides of the boat and the railing and edges of the boardwalk, appear to converge in the distance. **SEE 9.10** Objects in the foreground are more clearly defined than those in the background. **SEE 9.11** And, finally, the light and shadows indicate volume, that is, the presence of a third dimension. **SEE 9.12**

Now let's name these depth cues: (1) overlapping planes, (2) relative size, (3) height in plane, (4) linear perspective, and (5) aerial perspective.

OVERLAPPING PLANES

The most direct graphic depth cue is a partial overlap. When you see one object partially covered by another, you know that the one that is doing the covering must be in front of the one that is partially covered. **SEE 9.13 AND 9.14**

Courtesy of Museo Civico di Padova.

The medieval painters relied heavily on overlapping planes to indicate depth in their work. In this detail from *The Meeting at the Golden Gate*, one of the many excellent frescoes in the Arena Chapel in Padua, Italy, by the Florentine painter and architect **Giotto di Bondone** (ca. 1267–1337), we can see how effectively overlapping planes were used to indicate depth. The only depth confusion arises from the merging halos of Joachim and Anna—caused by the fading of the contour of Joachim's halo at the point of overlap.

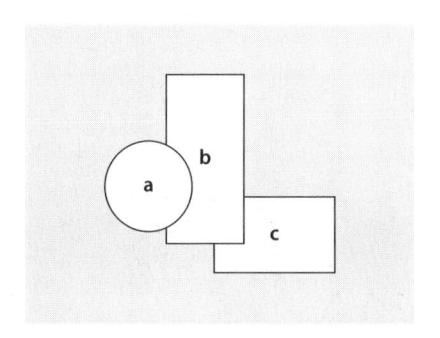

9.13 Overlapping-Planes Principle

Object (a) is partially covering object (b), which again is partially covering object (c). Although all three figures obviously lie on the same plane (this page), (a) seems to be in front of (b), which seems to lie in front of (c) but behind (a).

9.14 Depth Through Overlapping Planes

Any object that is partially blocked from our view by another object must lie behind this object. Even with other depth clues missing, we perceive a third dimension by readily assigning partially overlapping objects a "behind" or an "in front of" position.

RELATIVE SIZE

If you know how big an object is, or can guess its size by contextual clues (such as other known objects), you can tell approximately how far the object is from the camera by the size of the screen image. The larger a subject or object appears relative to the screen borders, the closer it seems to the viewer. **SEE 9.15** The smaller a subject or object appears relative to the screen borders, the farther away it seems. **SEE 9.16**

If you know that two objects are similar or identical in size, you perceive the smaller screen image as being farther away and the larger screen image as being closer. **SEE 9.17** You automatically interpret the smaller screen image of the man in the figure as being relatively far away from the woman, rather than as having an unusually small head. The more the head sizes approximate each other, the closer the subjects seem to stand to each other along the z-axis. **SEE 9.18**

9.15 Relative Size: Close-up

The larger the object appears within the screen—that is, the more area it takes up relative to the screen borders—the closer it seems to us. Appropriately, we call this a close-up.

9.16 Relative Size: Long Shot

The smaller the object appears within the screen, the farther away it seems. We call this a long shot.

In this sixteenth-century Persian painting, overlapping planes and especially height in plane serve as major depth cues.

From *Persian Painting*, text by Basil Gray, p. 77. Courtesy of Editions d'Art Albert Skira.

9.17 Interpreting Object Size as Distance: Far The man seems farther away from us than the woman, because his screen image is

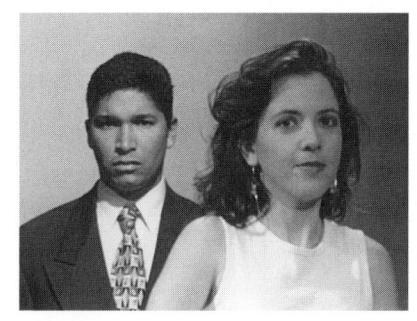

9.18 Interpreting
Object Size as Distance: Close
The man seems much closer to the woman now, because his screen image is almost as large as hers.

HEIGHT IN PLANE

considerably smaller than hers.

Assuming that no contradictory distance cues (such as overlapping planes) are evident and that the camera is shooting parallel to the ground, you will perceive an object as being more and more distant the higher it moves up in the picture field until it has reached the horizon line. **SEE 9.19** Because of the mobility of the camera, however, which causes the horizon line to shift constantly within a shot or from shot to shot, the height-in-plane distance cue is not always reliable. **SEE 9.20** The flag on the top edge of the picture in figure 9.20 seems closer than the high-rise buildings at the bottom edge of the screen. Obviously, the camera did not shoot parallel to the ground. Especially when shooting up or down a large object or building, the height-in-plane cue is no longer a valid depth indicator.

9.19 Height in Plane: Camera Parallel to Ground

In the absence of contradictory distance clues and with the camera shooting parallel to the ground, an object seems farther away the more it moves up toward the horizon in the picture plane.

9.20 Height in Plane: Camera from Below

When the camera does not shoot parallel to the ground, height-inplane depth cues are no longer valid.

LINEAR PERSPECTIVE

Linear perspective is among the more powerful and convincing depth cues. In a linear perspective, all objects look progressively smaller the farther away they are, and parallel lines converge in the distance, with the vertical and horizontal lines becoming more crowded as they move away from the observer (camera). **SEE 9.21**

All parallel lines converge and stop or vanish at the *vanishing point*, which always lies on the horizon line at eye level or camera level. **SEE 9.22**

9.21 Linear Perspective

In this architect's drawing of an Italian palazzo, all the prominent horizontal lines (graphic vectors) converge at one point. We call this perceptional phenomenon linear perspective. Courtesy of the DeBellis collection, San Francisco State University.

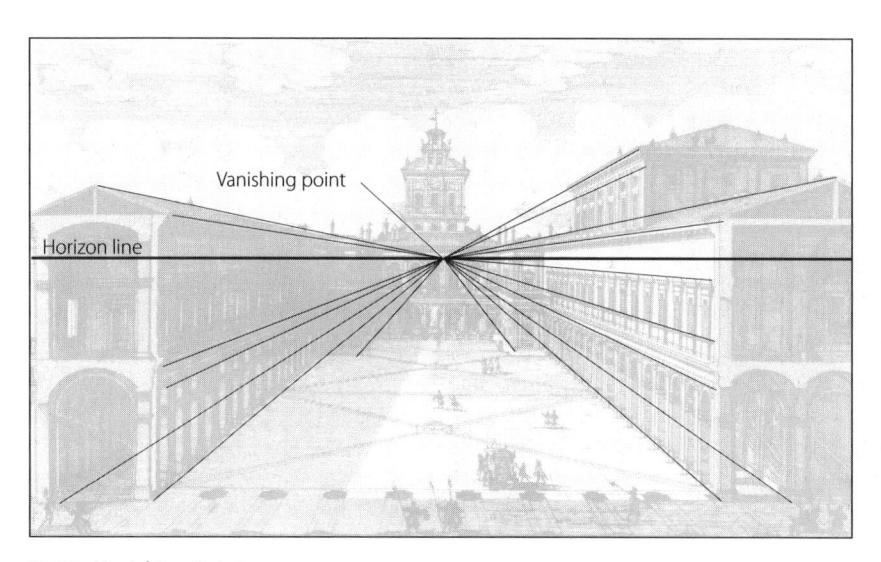

9.22 Vanishing Point

The point at which all parallel lines converge and discontinue (vanish) is aptly called the vanishing point. The vanishing point always lies on the horizon line at eye (or camera) level.

Attempts in using linear perspective to create the illusion of depth on a two-dimensional surface were made by many painters long before the Renaissance, but it was not until the first half of the fifteenth century that Italian artists established scientific laws of linear perspective, such as the horizon line and the vanishing point.

With this woodcut, one of the masters of the Renaissance, the German painter **Albrecht Dürer** (1471–1528) illustrated some of the techniques used by the artist to ensure correct foreshortening (linear perspective).

Taken from *The Complete Woodcuts of Albrecht Dürer*, edited by Dr. Willi Kurth. © 1946 Crown Publishers. Used by permission of Crown Publishers, Inc.

9.23 Horizon Line

The horizon line is an imaginary line parallel to the ground at eye level. More technically, it is the plane at right angles to the direction of gravity that emanates from the eye of the observer at a given place. If you want to find the eye level and the horizon line, simply stand erect and look straight forward. The eye level is where you do not have to look up or down.

To find the *horizon line* and *eye level*, simply stand erect and look straight forward or point the camera parallel to the ground. Assuming that your index vector runs parallel to the ground, the horizon line moves up or down with your eyes (camera) regardless of whether you are kneeling on the ground, standing on a ladder, or pointing your camera out a helicopter window. **SEE 9.23**

Now take another look at figure 9.21. Can you tell from which height the artist looked at the palazzo? Was he looking at it from the street level, sitting in a chair? Standing up? Perhaps from the balcony or window of an unseen building opposite the clock tower? If you chose the window or balcony, you estimated the artist's correct position. As you can clearly see, the parallel lines converge at a vanishing point that lies above the palazzo near the roofline of the clock tower building (see figure 9.22). The artist must therefore have looked at the building from that position.

Also note that the arches and windows of the building seem to lie closer together the farther away they are from the observer (see figure 9.21). Many painters have used this "crowding effect" or "texture" to simulate depth. **SEE 9.24** You can apply this principle just as effectively in computergenerated graphics. **SEE 9.25**

9.24 Crowding Effect Through Texture

Notice how the sunflowers appear more and more crowded the farther away they are from the camera. This crowding effect is an important depth cue.

9.25 Depth Through Crowding

In this computer-generated image, we perceive depth through the crowding effect of distant objects.

Forced perspective Because we tend to interpret convergence of lines and image size with relative distance, we can generate the impression of distance by having parallel lines converge "faster"—more readily—and make distant objects appear smaller than we would ordinarily perceive. Such an artificial forcing of linear perspective is, appropriately enough, called *forced perspective*. One of the more striking applications of such a forced perspective is the grand staircase in one of Hong Kong's luxury hotels. The wide staircase seems to curve up to the mezzanine in a long, impressive sweep. But if you actually climbed the stairs, you would notice that they gradually narrow to less than half their original width about a third of the way up. We interpret this width reduction as increased length. Fortunately, as you will discover in this chapter, we can achieve the same effect by the proper choice of lenses.

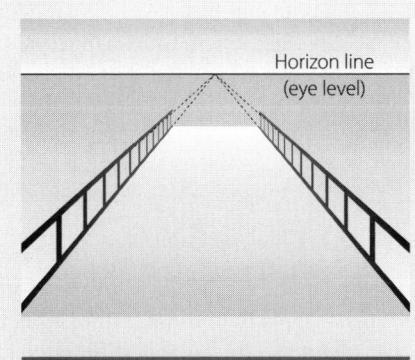

If we look down on an object, the eye (camera) level is above the object. Therefore the horizon line, and with it the vanishing point, lies above the object. We see the object—in this case the bridge—from above.

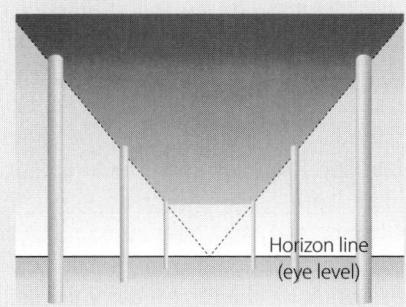

If we are below the object and look up, the eye (camera) level, the horizon line, and the vanishing point lie below the object. We see the object—the bridge—from below.

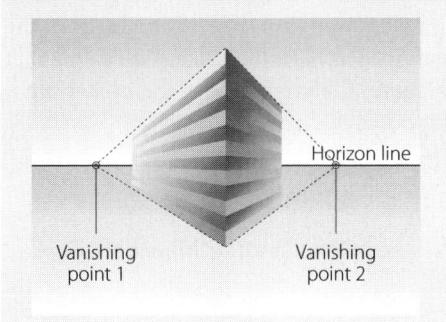

If we see two sides of a building, with one corner closest to us, we perceive two sets of converging lines going in opposite directions. We have, therefore, two vanishing points. But note that the two vanishing points lie on the horizon line; after all, we look at both sides of the building from the same eye level. This is called two-point perspective.

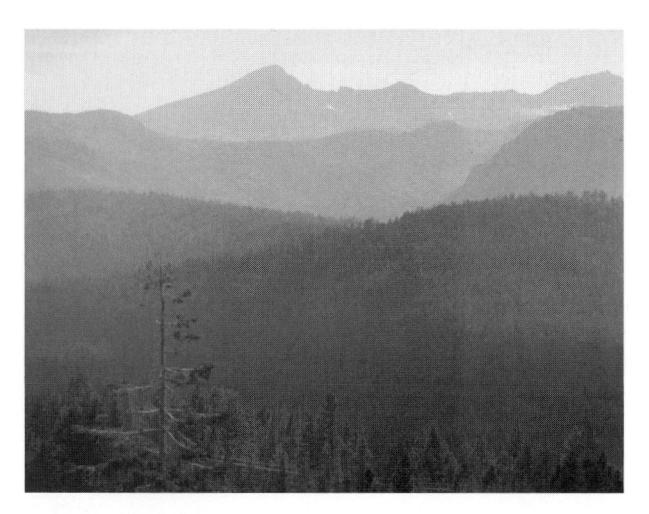

9.26 Aerial Perspective

Notice how the foreground objects in this picture are relatively sharp and dense with the background objects getting less clear and textured the farther away they are from us (or from the camera).

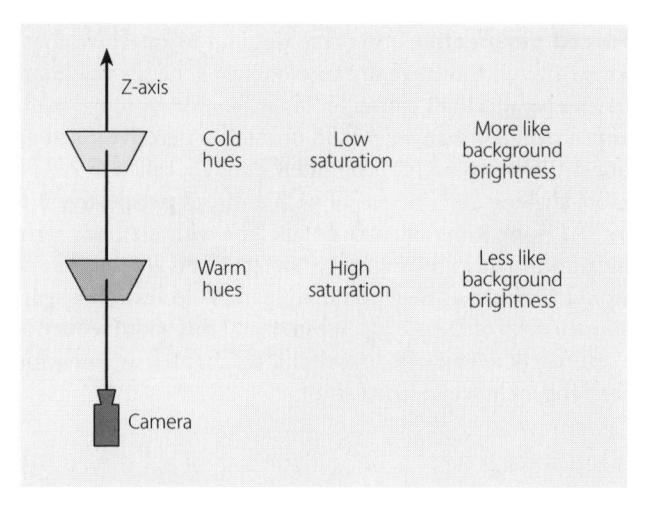

9.27 Aerial Perspective and Color

As far as aerial perspective is concerned, objects with warm, highly saturated colors that are the opposite of the background brightness seem closer to the viewer than objects with cold, less-saturated colors that are similar to the background brightness.

AERIAL PERSPECTIVE

A certain amount of moisture and dust is always in the atmosphere. We therefore see objects that are close to us somewhat more sharply than those farther away, a phenomenon known as *aerial perspective*. **SEE 9.26** In fog this difference in sharpness and image density between foreground and background is especially pronounced. Colors also lose their density and become less saturated the farther away they are from the observer (camera). Outdoors, distant colors take on a slightly blue tint.³ When creating background scenery, for example, you should paint the background objects slightly bluer and less sharp than the foreground objects. This greatly enhances the illusion of depth.

Generally, warm hues seem to advance and cold hues recede. Highly saturated colors seem closer than less-saturated colors. Assuming a fairly dark background, the brighter colors (higher position on the brightness scale) seem closer, and the less bright colors (lower position on the brightness scale) seem farther away. If the background is light (has a high degree of brightness), the darker colors seem closer and the lighter ones seem farther away. We can say that the more the brightness of an object assumes the brightness of the background, the farther away from the observer (the camera) it appears. **SEE 9.27**

DEPTH CHARACTERISTICS OF LENSES

The optical characteristics of lenses can greatly enhance or hinder the illusion of a third dimension on the television or movie screen. Moreover, your choice of lens is important in order to achieve the certain "feel" of a screen event—whether buildings or objects look squeezed or stretched out, or whether the z-axis looks long or short. Synthetic computer images generally simulate the depth characteristics of lenses in their manipulation of the third dimension.

Before discussing the psychological impact of such space manipulation, let us review the basic depth characteristics of wide-angle and narrow-angle lenses.

Although we speak of "wide-angle" (or short-focal-length) and "narrow-angle" (or long-focal-length or telephoto) lenses, these designations include the narrow- and wide-angle positions of the zoom lens. In order to bring the zoom lens to the extreme wide-angle position, you zoom all the way out. To position it in the extreme narrow-angle, or telephoto, position, you zoom all the way in. The so-called normal lens (which is somewhat in the middle of the zoom range) shows spatial relationships approximately the way we would actually see them without a camera. For emphasis we concentrate here on the extreme wide-angle and narrow-angle lens positions.⁴

The focal length of lenses influences four principal graphic depth factors: (1) overlapping planes, (2) relative size, (3) linear perspective, (4) and aerial perspective.

OVERLAPPING PLANES: WIDE-ANGLE LENS

Although the wide-angle lens does not rely on overlapping planes as much as the narrow-angle lens does, it can't avoid showing overlapping planes. Because the objects along the z-axis look stretched out more with the wide-angle lens, however, it renders overlapping planes less powerful as a depth indicator. **SEE 9.28**

OVERLAPPING PLANES: NARROW-ANGLE LENS

The narrow-angle lens does just the opposite from the wide-angle lens, making objects appear closer together along the z-axis than they really are. Because the narrow-angle lens enlarges the background objects, foreground and background objects look similar in size. Consequently, they appear closer together than they really are. Objects positioned along the z-axis look squeezed, and the z-axis itself appears shorter than you would ordinarily see.

Because of the similarity in size of foreground and background objects, overlapping planes become a major depth cue for separating one object from the other and, ultimately, separating foreground, middleground, and background objects. **SEE 9.29**

9.28 Overlapping Planes: Wide-Angle Lens
Overlapping planes are reduced in prominence, but not eliminated, by the wide-angle lens.

9.29 Overlapping Planes: Narrow-Angle Lens With a narrow-angle lens, overlapping planes become a major depth cue.

RELATIVE SIZE: WIDE-ANGLE LENS

The wide-angle lens greatly exaggerates relative size. Objects that lie close to the camera appear relatively large, whereas similar objects positioned on the z-axis only a short distance behind the close object show up in a dramatically reduced image size. **SEE 9.30** The image size of the foreground tugboat is relatively large, and the one just a short distance behind it, relatively small. This great difference in relative size is lessened only at the far end of the z-axis. Because image size is an important distance cue, we interpret this difference as meaning that the background object is farther behind the foreground object than it really is. Thus, the wide-angle lens stretches the z-axis.

RELATIVE SIZE: NARROW-ANGLE LENS

When the same scene is photographed with a narrow-angle lens, the two objects seem uncomfortably close to each other. **SEE 9.31** This is despite the fact that their actual distance is identical to that in figure 9.30. You now know why. The narrow-angle lens enlarges the background, making the second object appear close in size to that of the foreground object. We translate this similarity in size as relative closeness. The narrow-angle lens shows objects placed along the z-axis squeezed; the z-axis appears, therefore, shortened.

This squeezing effect of the long (or narrow-angle) lens is very apparent when you shoot the same row of columns with both a wide-angle and a narrow-angle lens. Using the wide-angle lens, the columns quickly diminish in size the farther away they are from the camera; they seem comfortably stretched out. **SEE 9.32** But when you shoot the same scene using a narrow-angle lens, the image size of the background columns is almost the same as the foreground columns. They now seem closer together than they really are; they no longer look graceful but instead look stiff and crowded. **SEE 9.33**

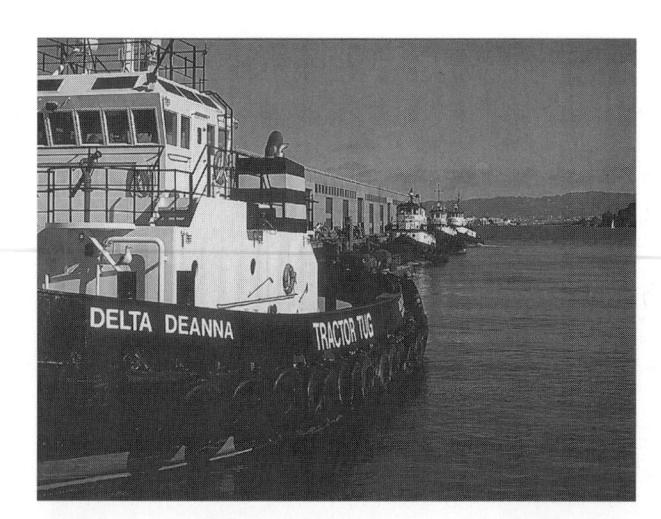

9.30 Relative Size: Wide-Angle Lens

The wide-angle lens makes objects close to the camera look relatively large and those just a short distance farther away on the z-axis look relatively small. Because relative size is an important distance cue, the tugboats look farther apart than they really are.

9.31 Relative Size: Narrow-Angle Lens

The narrow-angle lens enlarges the background image so drastically that the tugboats as well as the background hills seem much closer than in figure 9.30, although their actual positions along the z-axis have not changed.

LINEAR PERSPECTIVE: WIDE-ANGLE LENS

The wide-angle lens "accelerates" the convergence of parallel lines; that is, they seem to converge more than when seen normally, thereby giving the illusion of stretching an object or building. The z-axis space appears elongated. **SEE 9.34**

LINEAR PERSPECTIVE: NARROW-ANGLE LENS

In contrast, the narrow-angle lens inhibits the normal convergence of parallel lines and thus reduces the illusion of depth through linear perspective. It also squeezes space and makes objects appear closer than they really are. **SEE 9.35**

9.32 Stretching with a Wide-Angle Lens

This row of columns seems quite long, and the columns seem to be located a comfortable distance from one another.

9.33 Squeezing with a Narrow-Angle Lens

With a narrow-angle lens, the columns appear very close together. The space between them seems squeezed.

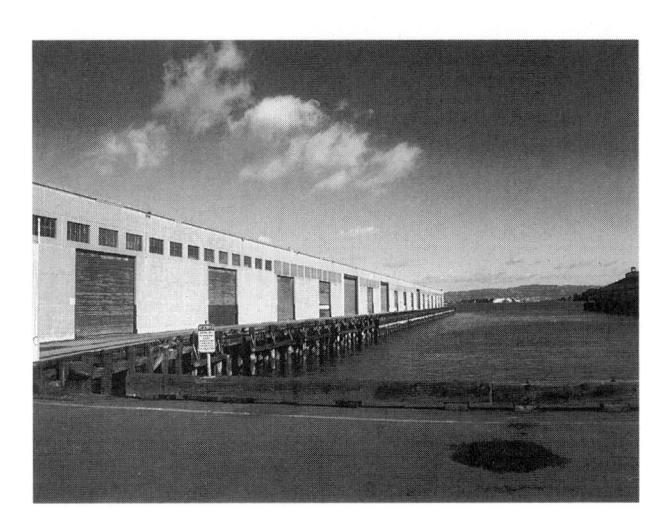

9.34 Linear Perspective: Wide-Angle Lens

The wide-angle lens makes parallel lines converge much "faster" (more drastically) than our normal vision.

9.35 Linear Perspective: Narrow-Angle Lens

The narrow-angle lens "retards" our normal expectations of parallel lines converging. The horizontal lines do not converge as readily as with a normal or wide-angle lens.

9.36 Piano Keys: Wide-Angle Lens
When shot with the wide-angle lens, the piano keys reduce drastically in size the farther they get from the camera.

9.37 Piano Keys: Narrow-Angle Lens
When shot with a narrow-angle lens, the same keys look squeezed.
The piano keys at the far side of the z-axis look almost as big as the ones that are close to the camera.

By now you should have no problems distinguishing between the wide-angle and narrow-angle shots of a piano keyboard. The wide-angle lens makes the graphic vectors of the keyboard converge much more drastically than when shot with a narrow-angle lens. **SEE 9.36 AND 9.37** The "wide-angle" keyboard looks longer, with the keys farther away from the camera looking distinctly smaller. The "narrow-angle" keyboard, on the other hand, does not seem to converge much toward a vanishing point. In fact, the keys farthest from the camera look almost as big as the ones closest to it. This makes the keyboard look short and squeezed.

ACHIEVING AERIAL PERSPECTIVE

You can achieve aerial perspective by manipulating the *depth of field*—the area along the z-axis that appears in focus—and by making use of *selective focus*, that is, focusing on only a specific area along the z-axis.

When objects are placed at different distances from the camera along the z-axis, some of them will appear in focus and some out of focus. The portion of the z-axis in which the objects appear in focus—depth of field—can be shallow or great. In a shallow depth of field, only a relatively small portion of the z-axis (or objects placed therein) is in focus. In a great depth of field, a large portion of the z-axis (or objects placed therein) is in focus. The depth of field depends on the focal length of the lens, the aperture (iris opening), and the distance from the lens to the object. Unless you move the wide-angle lens very close to the object, it gives you a greater depth of field than a narrow-angle lens.

Aerial perspective: wide-angle lens Because the wide-angle lens generates a great depth of field, it de-emphasizes aerial perspective. In a great depth of field, most of the articulated z-axis appears in focus. This means we cannot easily focus on only one spot along the z-axis while keeping the rest of the z-axis out of focus (see figure 9.36).

Aerial perspective: narrow-angle lens The narrow-angle lens has a shallow depth of field and thus emphasizes aerial perspective. Once you focus on an object using a narrow-angle lens, the areas immediately in front and in back of the object are out of focus. Even a slight position change along the z-axis of camera or object will necessitate refocusing (see figure 9.37). Although it is difficult to keep a moving object or camera in focus in a shallow depth of field, the advantage of this critical focal plane is that you can use selective focus and "rack focus" techniques to emphasize events.

Selective focus This technique allows you to select the precise portion (plane) on the z-axis that you want to be in focus, with the areas immediately in front of or behind the focused object being out of focus. Contrary to a natural aerial perspective that occurs on a foggy day where the foreground object is "in focus"—that is, more clearly visible than the background objects—the optically induced aerial perspective using selective focus allows you to focus on the foreground, with the middleground and background out of focus. **SEE 9.38** Or you can feature the middleground and leave the foreground and background out of focus. **SEE 9.39** You can also focus on the background, while the middleground and foreground remain out of focus. **SEE 9.40**

Rack focus The *rack focus* effect involves changing (racking) the focus from one location on the z-axis (the z-axis plane) to another. If, for example, you want to shift emphasis from an object to the person holding it without changing the shot (through dolly, zoom, cut, or dissolve), you can first focus on the object with the person being out of focus and then "rack through" the focus range of the lens until the person's face comes into focus, throwing the object out of focus. **SEE 9.41 AND 9.42** Obviously, you need a relatively shallow depth of field to accomplish such a rack focus effect, which means that you must use a narrow-angle lens.

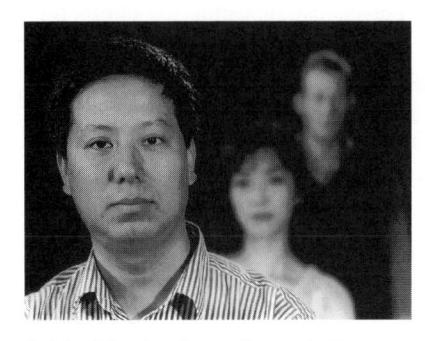

9.38 Selective Focus: Person in Front
The narrow-angle lens is used to create a shallow depth of field that allows selective focus. Note how the focus is on the person closest to the camera, with the people behind out of focus.

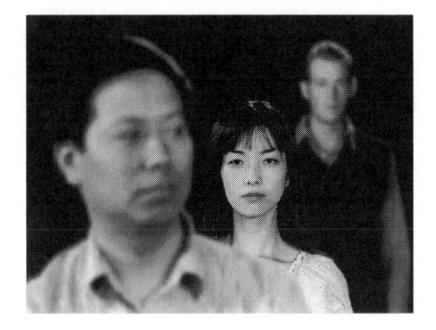

9.39 Selective Focus: Person in Middle The middle person is in focus with the foreground and background persons out of focus.

9.40 Selective Focus: Person in Back
The person farthest from the camera is in focus, with the middle and front persons out of focus.

9.41 Rack Focus Effect: Object Emphasized In this shot the focus is on the object. The shallow depth of field renders out of focus the person holding the object.

9.42 Rack Focus Effect: Person Emphasized
Emphasis is shifted from one z-axis location (object) to another
(person). Because there is such a shallow depth of field, we can shift
focus from the object closer to the camera to the one farther from
the camera by changing (racking) the camera's focus.

If you had a great depth of field (wide-angle lens and high illumination), you could just about rack through the entire focus range without noticeably affecting the focus. A rack focus effect is therefore not possible in this case. With a narrow-angle lens, on the other hand, the depth of field becomes so shallow that even a slight racking of focus shifts the focal plane from one point to another along the z-axis. This means that even a little turn of the focus handle or focus ring on the camera shifts the focus from one object to the other, even if they are only a short distance from each other along the z-axis.

You can also achieve a type of aerial perspective by using "fog filters" that render portions of the picture out of focus while keeping other portions sharp. Though the filter does not actually distinguish among different z-axis locations, but rather among picture areas that are in and out of focus, we still interpret this perceptually as changes in the picture depth. ⁶ The following table gives a summary of how lenses influence our perception of depth. **SEE 9.43**

9.43 Lens Characteristics and Depth Cues

A + sign indicates that the lens characteristic is facilitating the illusion of depth, a – sign that it inhibits the illusion of depth.

Depth Effects	Lens Position	
	Wide-Angle	Narrow-Angle
Overlapping Planes	-	+
Relative Size	+	
Linear Perspective	•	
Aerial Perspective		

Major Graphication Devices

No sooner have we learned how to create the illusion of depth on the two-dimensional plane of the television screen than we are confronted with digital techniques used to render a three-dimensional scene deliberately two-dimensional and graphiclike again. You can see such digital wizardry every time you turn on your television, regardless of program content, but these effects are most prominent in news presentations. A typical television event, such as a TV star being interviewed on her way to the Emmy Awards ceremonies, is suddenly frozen, squeezed in size, surrounded by a picture frame, and partially overlapped by another picture of the Emmy statue—very much like snapshots in a photo album.

Such a process, in which the three-dimensional lens-generated screen image is deliberately rendered in a two-dimensional, graphic- or picturelike format, is called *graphication*. Of the hundreds of graphication effects possible, we describe here three principle ones: (1) lines and lettering, (2) first- and second-order space, and (3) topological and structural changes.

LINES AND LETTERING

One of the simplest graphication devices is lines and lettering keyed over the actual full-screen image. Like the letters on this page, viewers readily perceive the stripes and letters keyed over the scene as the figure, and the images behind the letters (the actual scene) as the ground. This figure-ground relationship persists whether the ground is a static or a moving three-dimensional scene. The letters and stripes prevent the scene from pushing itself into the foreground and remind us that the scene, moving or not, is merely a picture. **SEE 9.44**

People are not immune to graphication through keyed letters and stripes. Regardless of whether people on-screen appear in a studio or a field setting, the foreground graphics inevitably relegate them to background picture space. Much like the velvet ropes in banks, movie houses, and restaurants that keep us in line, the lettering and lines prevent people on-screen from assuming foreground prominence. **SEE 9.45**

9.44 Graphication Through Letters and Lines

Letters and lines superimposed over a normal television scene become the figure, relegating the actual scene to a ground, or background, position. The scene has become picturelike, very much like a photo in a magazine. We call this process graphication.

9.45 Graphication of People

Lines and letters can also have a graphication effect on people, regardless of whether they are moving.

FIRST- AND SECOND-ORDER SPACE

One of the more popular ways of graphicating a scene is by putting it into a secondary frame, such as the box over the newscaster's shoulder. The digitally generated secondary frame clearly delineates a second picture area within the borders of the actual television receiver we watch. This technique renders the

event displayed in it as a picture similar to the pictures in newspapers and magazines. In fact, we often make the secondary frame look like a picture by containing it with a variety of borders and setting it off from the background of the primary television scene with drop shadows. SEE 9.46 Sometimes the secondary area is a large blue (chroma-key) screen with a televisionlike frame around it. SEE 9.47 It can also even be an actual large-screen television receiver placed in the studio set through which the interviewer interacts with her faraway "studio" guests. The most obvious, if not most widely used, secondary frame is the rectangular box that is keyed over the newscaster's shoulder. SEE 9.48

As you can see from figures 9.46–9.48, we now have two types of screen space: the regular television screen space as defined by its edges, and the space of the digitally created secondary frame within the television screen. We call the total screen area *first-order space*, and the secondary frame, *second-order space*. The newscaster occupies first-order space; the person or object in the box is in second-order space.¹⁰

9.46 Graphication Through Secondary Frame

A common graphication device, the secondary frame within the television screen contains a scene in much the same way as a picture that hangs on the wall.

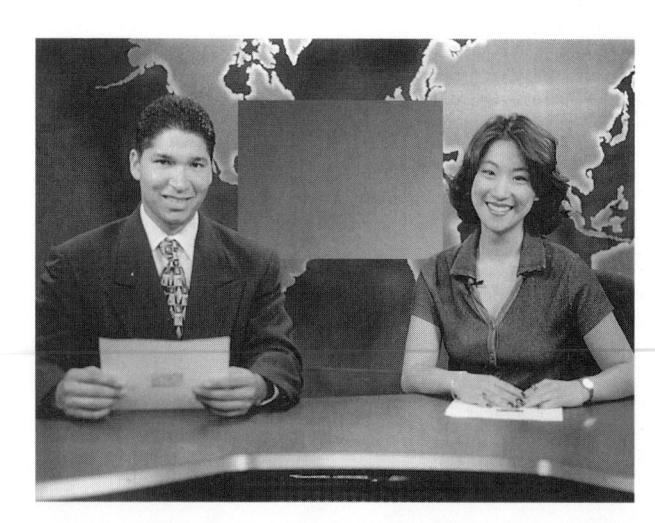

9.47 Secondary Frame: Chroma-Key Area

Often the secondary frame consists of a blue area, usually behind the newscaster or interviewer, that displays events happening away from the studio.

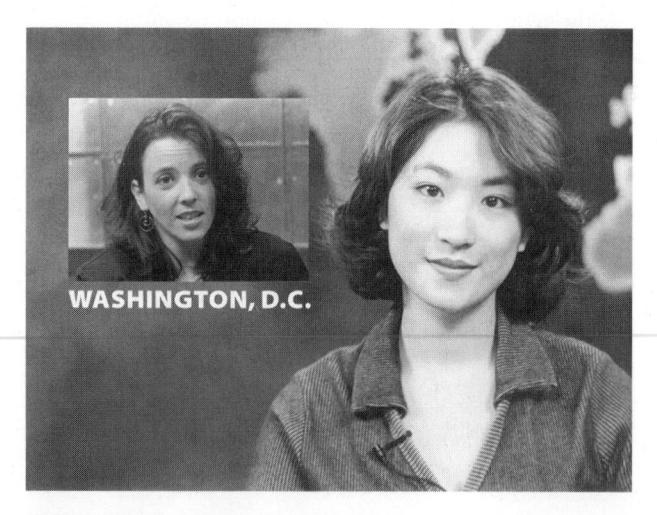

9.48 Secondary Frame: Box

Most news presentations use a secondary frame, the so-called box, that seems to be located over the newscaster's shoulder and located somewhere between the newscaster and the background of the news set.

Because the second-order frame is such a strong graphication device, we tend to perceive its content inevitably picturelike, regardless of whether the pictures are static iconic figures or lens-generated events that move. In contrast to this abstracted space, first-order space seems to become more "real." A strong possibility exists that, under certain circumstances, we may even extend firstorder space into our own space—our own living environment. At the very least, events in first-order space seem to attain a certain degree of verisimilitude and believability. On still another level, we may even perceive the people who appear in first-order space as extending into our own living space and sharing our environment and time. An example of such an extension of first-order space into our living space is when a newscaster, operating in nongraphicated firstorder space, first talks to us—the viewers—introducing the guest who is confined in a second-order box. When the anchor now turns toward the secondorder frame for the actual interview, we may well perceive, at least temporarily, the newscaster sharing our actual environment, interviewing the guest from our—the viewers'—position. SEE 9.49

Personification Such close personal contact, however much imagined, fosters familiarity and trust.¹¹ Subconsciously, we attribute to the people operating in the extended space the flesh-and-blood qualities of real people—a certain degree of *personification*.

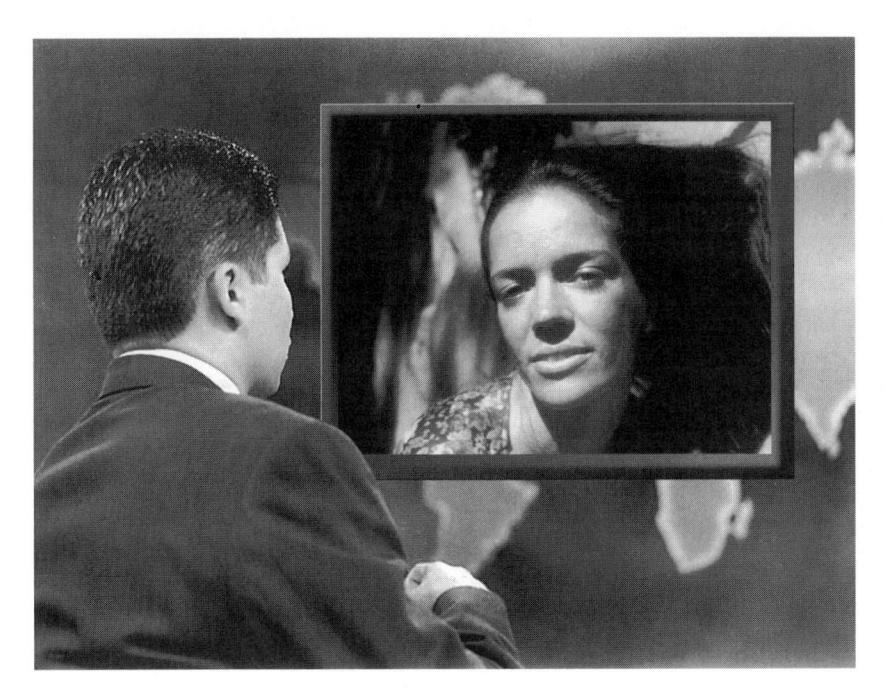

9.49 Aesthetic Personification Factor

Persons occupying nongraphicated first-order space experience a higher degree of personification from viewers than people appearing in graphicated second-order space. The host operates in first-order space; her guest appears in second-order space—the key area.

9.50 Host and Guest in Second-Order Space

When both host and guest are confined to a second-order frame, the personification factor is eliminated for both parties.

This personification effect does not take place in second-order space. The abstraction through graphication is so great that viewers inevitably consider the people appearing in second-order space as people "on the screen." Even when the second-order people are occasionally and temporarily let "out of the box" to occupy the full television screen, we still consider them as occupying second-order space so long as the full-screen display is brief. To make sure that the people appearing in second-order space are not invading first-order space, you can employ additional graphication devices in the second-order space, such as name, place, and time superimpositions. ¹²

Instead of increased graphication of the guest to effect optimal personification of the host, we find that the host is frequently put into a second-order frame during the interview. With both host and guest confined to second-order picture space, we inevitably perceive them equally far removed from us. **SEE 9.50** As a result, both are equally removed psychologically from the viewer.

TOPOLOGICAL AND STRUCTURAL CHANGES

As you have probably seen many times, through the use of *digital video effects* (*DVE*) the secondary frame sometimes changes its shape so that we see a variety of scenes as still photos that are peeled off a large stack of snapshots, or else we see a scene, very much like a magic carpet, floating off through the seemingly three-dimensional space of the television receiver. **SEE 9.51** Such a topological change to the regular television image becomes more startling the more we believed that the television-mediated event was, indeed, the real event.

Structural image changes such as mosaic and solarization effects are powerful graphication techniques that render television images picturelike. They change what we normally perceive as a three-dimensional "real" television scene into picturelike abstractions. Sophisticated computer graphics programs let

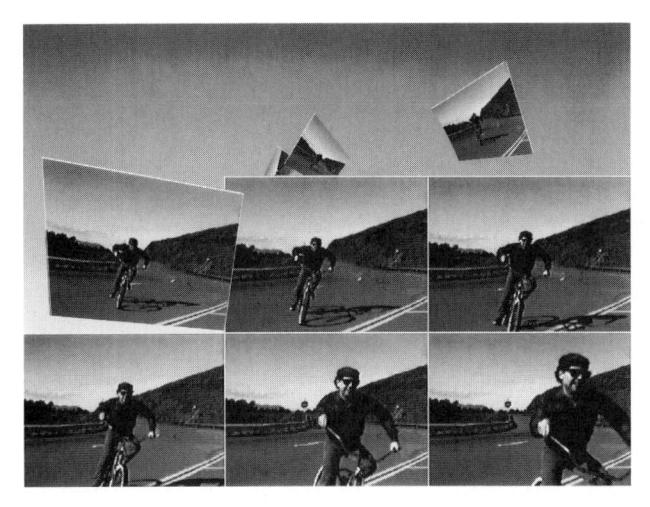

9.51 Topological Change

Through digital video effects (DVE), we can stop scenes in their tracks (called "freeze frame"), peel them off the television screen, and float them toward the horizon of first-order space. The effect is created through a topological change (change of shape) through digital manipulation.

9.52 Structural Change

We can also graphicate an image through a structural change. One popular DVE technique of this sort is the mosaic effect, in which an image is made to break up and look as though it were made up of a series of mosaic tiles.

you create a great variety of structural image changes with relatively little effort. **SEE 9.52** The problem is no longer how to achieve such effects, but when to use them. If overdone, they inhibit and muddle, rather than intensify, the intended communication.

Summary

In television, film, and computer displays, the three-dimensional world must be projected onto the two-dimensional surface of the screen. Although the third dimension is illusionary, it proves to be aesthetically the most flexible of the dimensions.

Four concepts describe the aesthetics of the three-dimensional field: the z-axis, graphic depth factors, depth characteristics of lenses, and major graphication devices.

Whereas the screen width (x-axis) and height (y-axis) have definite spatial limits, depth (z-axis) is virtually limitless. The camera is therefore much less restricted in its view and movement along the z-axis than it is either horizontally or vertically. We perceive the z-axis as originating from the screen, pointing toward the horizon. In stereovision and hologram displays, the z-axis extends toward the viewer as well.

Graphic depth factors include: overlapping planes (objects that partially overlap each other); relative size (an object positioned close to the camera projects a larger screen image than one of similar size that lies farther down on the z-axis); height in plane (assuming that the camera shoots parallel to the ground, we perceive an object that is higher on the screen as farther away from the camera); linear perspective (horizontal parallel lines converge toward a vanishing point at the eye-level horizon line; equally spaced objects appear to lie closer together the farther away they are from the camera); and aerial perspective, the foreground object in focus, with the background object out of focus. More generally, aerial perspective means selected focus on a spot along the z-axis in a shallow depth of field with the surrounding areas out of focus.

The depth characteristics of lenses are significant in the manipulation of the third dimension of a screen image. Wide-angle lenses exaggerate relative size and linear perspective; they de-emphasize overlapping planes and aerial perspective. Narrow-angle (telephoto) lenses exaggerate overlapping planes and aerial perspective, de-emphasizing relative size and linear perspective. Selective focus and rack focus effects are powerful means of articulating the z-axis and drawing attention to a specific plane along the z-axis. They are possible only in a shallow depth of field and, therefore, with narrow-angle (telephoto) lenses.

Graphication is the deliberate rendering of television-mediated events, which appear three-dimensional on the television screen, as two-dimensional, picturelike images that look like pictures in magazines or newspapers. The major graphication devices are lines and lettering, first- and second-order space, and topological and structural changes. Graphicated images and second-order space inhibit personification—the degree to which we forget that a performer is actually on-screen; nongraphicated first-order space facilitates it.

Topological changes are images whose shape is digitally manipulated. Structural changes affect the way images are built.

NOTES

- The x-, y-, and z-axes are used here in the traditional sense of the Cartesian model that quantifies Euclidian space.
- 2. Herbert Zettl, "The Graphication and Personification of Television News," in Gary Burns and Robert J. Thompson (eds.), *Television Studies: Textual Analysis* (New York: Praeger, 1989), pp. 137–163.
- 3. Technically, there is a difference between aerial perspective and detail perspective. Detail perspective refers to the gradual diminishing of detail in the distance, whereas aerial perspective refers to the more bluish tint the farther away the object is from the observer. However, we call both phenomena "aerial perspective."

Leonardo da Vinci described vividly what happens in aerial perspective:

The air tints distant objects in proportion to their distance from the eye ... Suppose several buildings are visible over a wall which conceals their basis, and suppose they all extend to the same apparent height above the wall. You wish to make one in your painting appear more distant than another. Conceive the air to be hazy, since in such air you know that distant objects like the mountains, seen through a great mass of air, appear almost blue ... Therefore paint the first building beyond the aforesaid wall in its own proper color and make the more distant building less sharply outlined and bluer, and a building that is twice as far away, make it twice as blue, and one that you wish to appear five times as far away, make it five times as blue. This rule will make it possible to tell from the picture which building is farther away and which is taller.

Leonardo da Vinci, *Trattato della Pittura* (ca. 1500), as quoted in Daniel J. Weintraub and Edward L. Walker, *Perception* (Monterey, Calif.: Brooks/Cole, 1966), pp. 25–26.

- 4. Herbert Zettl, *Television Production Handbook*, 6th ed. (Belmont, Calif.: Wadsworth Publishing Co., 1997), pp. 82–88. The interactive CD-ROM *Zettl's Video Lab 2.1* lets you do some zooming and shows you the relationship between focal length of the lens and its zoom position. Use a camcorder to do some zooming and compare focal length to what you see in the viewfinder. As a learning aide, you should always visualize the extreme zoom positions (extreme wide-angle and extreme narrow-angle) so that the distortion differences become easily recognizable.
- 5. Technically, the narrow-angle lens simply enlarges the end of the z-axis, where even with a wide-angle lens objects looked crowded and space is squeezed. This crowding effect is entirely in line with increased density of texture at the far end of the z-axis.

- 6. The interactive CD-ROM *Zettl's Video Lab 2.1* offers a good opportunity to explore depth of field and its influence on aerial perspective. Click on the camera monitor, then on Picture Depth.
- Although the normal three-dimensional scene as displayed on the television screen is not truly a three-dimensional image, we have enough depth cues to perceive it as such.
- 8. Zettl, "Graphication and Personification," p. 140.
- 9. Zettl, Television Production Handbook, pp. 340-355.
- 10. Zettl, "Graphication and Personification," pp. 157-160.
- The theory of personal space and its sociopsychological consequences has been well defined by Edward T. Hall, *Silent Language* (Garden City, N.Y.: Anchor Press/ Doubleday, 1973).
- 12. Compare the idea of Bertold Brecht's *Verfremdungseffekte*. See T. Girshausen, "Reject It in Order to Possess It: On Heiner Müller and Bertold Brecht," trans. by P. Harris and P. Kleber, *Modern Drama* 23 (1981), pp. 402–21. See also Boris Uspensky, *A Poetics of Composition* (Berkeley: University of California Press, 1973). Uspensky advances the idea of *ostranenie*—a clear separation of the stage event and the perception of such an event by the audience.

Structuring the Three-Dimensional Field: Building Screen Volume

o far we have discussed some of the basic principles and factors that help you project the three-dimensional world onto the two-dimensional television, film, and computer screens and create the illusion of depth. We now examine how to structure the three-dimensional field.

You can build screen volume by providing distinct depth planes located at different distances from the camera along the z-axis. The most basic structure of the three-dimensional field consists of a foreground (the depth plane closest to the camera, marking the beginning of the z-axis), a middleground (the depth plane marking the approximate middle of the z-axis), and a background (the depth plane farthest from the camera, marking the end of the z-axis). **SEE 10.1**

When structuring the three-dimensional field, you must—as with most other aesthetic fields—take into account the element of change, that is, the movement of the event itself, of the camera, and of the sequence of shots. A camera that dollies past a row of columns, people, and cars moving along the z-axis; a zoom; or a cut from one camera to another—all create a changing structural pattern, a changing three-dimensional field. For example, when the camera is zooming in, the foreground may disappear, the middleground takes on the role of the foreground, and the background becomes the new middleground. Or when you cut from one camera angle to another view, viewers essentially see a new z-axis with its own spatial articulation.

To structure the three-dimensional field for the screen, you need to know about four subject areas: (1) volume duality, (2) z-axis articulation, (3) z-axis blocking, and (4) spatial paradoxes.

Volume Duality

When you look at the cloudless sky from an airplane, you do not experience any depth. Empty space gives no clues to distance because nothing is either near to or far away from you. As soon as you look down and see the houses, trees, people, and cars, however, you can tell quite readily which things are closer to you and which are farther away. The various objects help define the empty space and make it possible for you to perceive the third dimension—depth. We can say that positive volumes (houses, trees, people) have articulated the negative volume of empty space.

10.1 Depth Planes

This picture is clearly divided into a foreground plane, a middleground plane, and a background plane. This threefold breakdown represents the most basic structure of the three-dimensional field.

Although the most basic articulation of the z-axis is its division into a foreground plane, a middleground plane, and a background plane, you can divide the z-axis into as many planes as you wish. But such divisions must fulfill some aesthetic purpose; otherwise the z-axis space simply looks cluttered. Josef von Sternberg, who directed Marlene Dietrich in the famous 1930 film The Blue Angel, was obsessed with articulating the z-axis space in his films with appropriate space modulators and meaningful action in order to keep "dead" z-axis planes to a minimum.

A *positive volume* has substance. It can be touched and has a clearly described mass. But a positive volume is also any screen image that has the appearance of substance. Positive volumes include such objects as trees, pillars, desks, and chairs, as well as people.

A negative volume is empty space that is somehow delineated by positive volumes. Unlimited negative space, such as the cloudless sky, constitutes negative space but not negative volume. But the interior of a room is a negative volume because it is clearly described by the positive volumes of the walls, ceiling, and floor. The hole in a doughnut is also a negative volume, but the space surrounding the doughnut is not (assuming that we ignore the larger negative volume of the room).

The interplay between positive and negative volumes is called *volume duality*. The control of volume duality—how the positive volumes articulate the negative space—is an essential factor in the manipulation of three-dimensional space and the illusion of screen depth. Designing scenery for television or film, blocking action for the camera, or simply composing a Web page or shot that shows various depth planes—all are careful and deliberate manipulations of volume duality. For example, the empty studio represents a clearly defined (by the studio walls) yet unarticulated negative volume (unarticulated space). As soon as you put people or things into the studio, such as scenery, set pieces, or furniture, you begin to modulate the negative volume of the empty studio with positive volumes, giving each scenic element its specific place and dividing the large negative volume into smaller, organically related negative volumes. Thus the positive volumes act as space modulators. **SEE 10.2**

Volume duality can vary in degree. When you stuff many objects into the studio or any other room, the positive volumes outweigh the negative ones, making the room look crowded. When negative volume outweighs the positive volume, we experience a feeling of mobility, lightness, and openness.

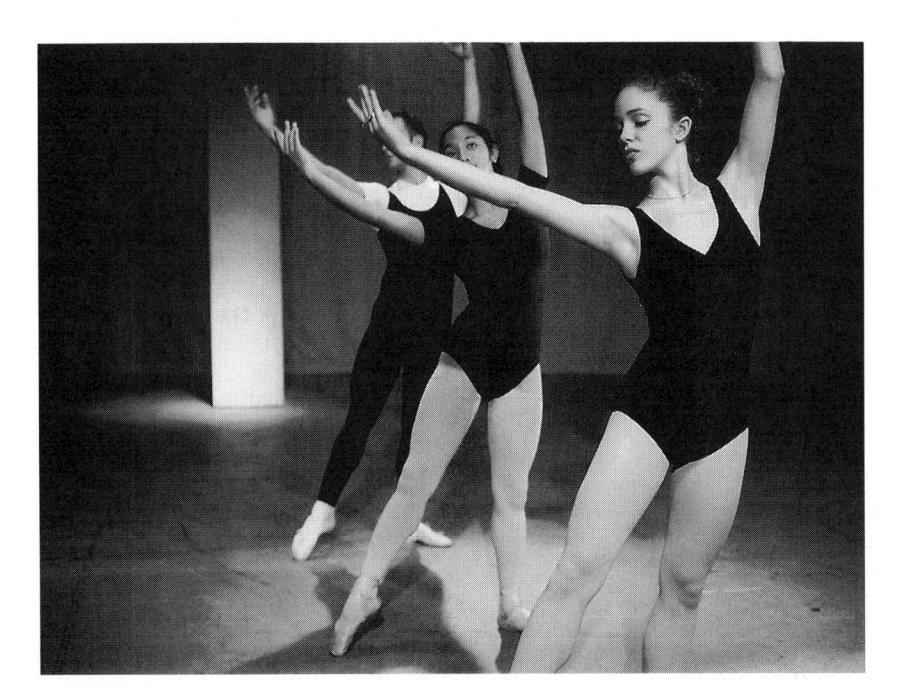

10.2 Creating Volume Duality

The negative volume of the studio space is articulated by the positive volumes of the set piece, which remains relatively stationary, and the dancers who move around and thereby change the volume duality. Because the relationship between negative and positive volume changes, we speak of dynamic volume duality.

DOMINANT POSITIVE VOLUME

Too much positive volume can confine movement and make you feel restricted, boxed in. A medieval castle is a good example of a preponderance of positive volume with relatively little negative volume. **SEE 10.3** Like modern bunkers, the heavy positive volumes protect the restricted living space inside but also inhibit freedom. It's no wonder that medieval knights broke out of this spatial confinement sporadically to engage in fierce battle with their neighbors for no apparent logical reason! Unfortunately, certain modern concrete buildings reflect this same confined negative space even if the purpose of the building is to provide as much negative volume as possible. **SEE 10.4**

10.3 Preponderant Positive Volume

Volume duality can vary in degree. When using many and/or large space modulators, the positive volume might outweigh the negative volume.

10.4 Restricted Operating Space

This garage has so much positive volume that it resembles a concrete bunker more than a parking facility. Even if negative volume predominates within this building, the exterior gives the impression that the interior space is highly confined.

If you want to re-create for the camera this sense of confined space, you need to crowd the negative volume with positive volumes—stuff things into a relatively small space. If, for example, you want to show that a crowded office is difficult to work in, confine the action area—the area in which people can move about—by placing lots of desks and file cabinets in close proximity to one another. By using narrow-angle (long-focal-length) lenses and chiaroscuro lighting as well, you can further intensify such a dominance of positive volumes.

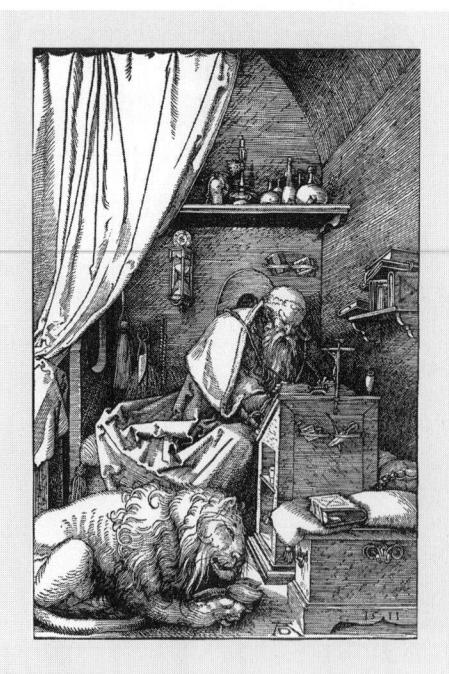

In this medieval chamber, positive volumes overpower the interior's cramped negative volume. Thick walls and solid furniture give the room a heavy, restricted look. One feels boxed in, if not imprisoned.

Taken from *The Complete Woodcuts* of *Albrecht Dürer*, edited by Dr. Willi Knuth. ©1946 Crown Publishers. Used by permission of Crown Publishers, Inc.

10.5 Preponderant Negative Volume

With only a minimum of space modulators, the negative volume remains large though highly articulated. The interior has an open, spacious feeling.

10.6 Feeling Vastness

This square has a preponderance of negative volume. The negative volume is nevertheless articulated by the people and the monument in the center. Such vast negative volumes can inspire awe. At the very least, we feel dwarfed by the space.

PREPONDERANT NEGATIVE VOLUME

A large, well-articulated negative volume invites mobility. We feel less restricted and can move about easily and breathe freely. **SEE 10.5**

Preponderant negative volumes also make us feel small in the presence of something larger, or prompt us to realize the frailty of our existence and fill us with awe. A large plaza, an empty sports stadium, or the interior of a Gothic cathedral can all cause such awe-inspiring effects. **SEE 10.6**

Too much negative volume, however, can promote a certain emptiness so that we feel alone, cold, isolated, and lost. **SEE 10.7** It's no wonder that people who work in the large, unarticulated space of modern offices put up screens and partitions or use space modulators such as file cabinets to create a less public and more personal space for themselves.

10.7 Too Much Negative Volume

An interior with too much negative space can make us feel isolated and uncomfortable. This library room is anything but cozy.

The Gothic cathedrals were deliberately built with a maximum of negative volume. The positive space modulators, such as the walls and pillars, were kept to a bare structural minimum in order to emphasize the wide expanse of the church interior. Such a vast interior space contributes greatly to making us feel both humble and reverent.

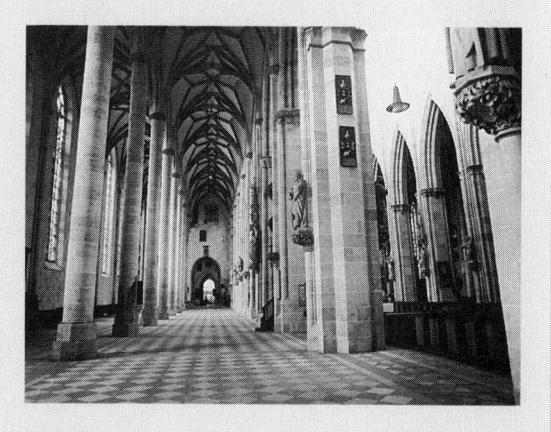

APPLICATIONS OF VOLUME DUALITY

You can see the most obvious application of volume duality for its own sake in sculptures done primarily to explore the interrelationship of positive and negative volumes. **SEE 10.8**

In scene design, volume duality is applied in an open set. *Open set* refers not to a set that is open to the public, but rather to scenery that is not continuous. The open set is not closed or boxed in by connected walls; instead it consists of only the most important parts of a room, for example, a door, some furniture, and a few separate single flats. **SEE 10.9**

10.8 Applied Volume Duality in Sculpture

This sculpture by the late English artist Henry Moore (1889–1986) shows a masterful handling of volume duality. The holes in the sculpture are so well placed and defined by the positive volumes that they attain positive spatial characteristics. As in a figure-ground reversal, the holes no longer represent nothingness—an absence of something—but rather they define a variety of negative volumes that counteract and supplement the varied positive volume. *Reclining Figure* by Henry Moore (1939). Collection of the Detroit Institute of Art. Gift of the Friends of Modern Art.

10.9 Open Set

In the open set, we modulate rather than merely describe the negative volume of the studio by the positive volumes of scenery and set properties. Modulating the negative volume means transposing it into an important scenic element. The spaces among the flats are no longer empty holes, but rather appear as solid walls much as the positive flats themselves do. Proper lighting is essential to transpose negative space into positive scenic elements.

The open-set method is especially effective for television. As pointed out previously, television builds its screen events inductively, bit by bit, close-up by close-up in a mosaic fashion. Whereas the wide motion picture screen not only allows, but frequently demands, large vistas, the relatively small television screen is most effective with intimate close-ups. A continuous set, which is often essential for large movie vistas, is superfluous for television when it involves shooting and assembling the scene inductively, close-up by close-up.

Furthermore, in a multicamera production, the open set allows free and continuous movement of cameras, microphone booms, and performers. It also permits a great variety of unrestricted points of view (camera shooting positions).

Z-axis Articulation

The z-axis is especially important in structuring television space, because the other principal spatial dimensions of the television screen—height and width—are limited compared with the larger and especially much wider motion picture screen. The camera, very much like the human eye, has no trouble looking along the z-axis all the way to the horizon. It can therefore take in a great number of objects stationed along the z-axis; it can cope successfully with even extremely fast movement without panning (horizontal camera movement) or tilting (camera looking up and down), so long as the objects are placed or move along the z-axis—that is, toward or away from the camera. The camera's horizontal and vertical field of view is, of course, much more restricted. Vertical and horizontal object motion require a great deal of camera tilting and panning, and this becomes especially difficult for the camera if the object motion is rapid. The articulation of the z-axis is therefore one of the principal factors of spatial control in television.

Articulating the z-axis means to use positive volumes along the z-axis as well as the optical characteristics of lenses so that the viewer perceives various depth planes in a specific way. By placing objects or people at various z-axis locations and by choosing a specific lens (wide-angle, normal, or narrow-angle

zoom positions), you can make the viewer perceive restricted or open space, with objects being crowded or else comfortably or agonizingly far apart.

Take a look at the three traffic situations in the following figures. **SEE 10.10-**10.12 Figure 10.10 shows a long stretch of freeway with light traffic. In figure 10.11 the traffic is slightly heavier; in figure 10.12 the traffic is fairly heavy. Actually, all three shots were taken from the same position within seconds of one another, but each shot was taken with a different lens. You probably recognized that the shot in figure 10.10 was taken with a wide-angle lens. The resulting volume duality shows preponderant negative volume. The exaggerated convergence of parallel lines and relative size make the cars appear much farther apart than they actually are. The aesthetic effect is that we perceive traffic to be rather light. The shot in figure 10.11 was taken with a normal lens. The perspective, relative size factors, and volume duality in this shot appear approximately as you would normally see them. This means that traffic conditions are reflected fairly accurately in this shot. The shot in figure 10.12 was taken with a narrow-angle (telephoto) lens. Here the volume duality shifts to a predominant positive volume. The linear perspective and relative size difference are minimized, and the parallel lines do not converge as rapidly as in the other two shots. The cars are reduced in size much less toward the background than in the wide-angle shot. Because they appear similar in size, the z-axis space seems to have shrunk, and the cars appear much more crowded than they actually are; traffic seems heavy.

NARROW-ANGLE LENS DISTORTION

The crowding of objects through a narrow-angle lens can cause a variety of interpretations. **SEE 10.13** For example, by reducing the negative space to a minimum, the various signs in figure 10.13 seem right on top of one another. The individual signs have lost their effectiveness. Instead of being carriers of specific information, they have become elements of visual pollution.

When spatially condensed by the narrow-angle lens, a row of separate columns becomes a single, massive support. With the reduction of negative space, the volume duality has given way to a mass of positive volume. **SEE 10.14** Similarly, when squeezed by a narrow-angle lens, a row of houses connotes certain psychological and social conditions, such as closeness or crowdedness with little

10.10 Wide-Angle View of Traffic

This z-axis shot, taken with a wide-angle lens, shows a preponderance of negative volume. The z-axis seems elongated, and traffic appears relatively light.

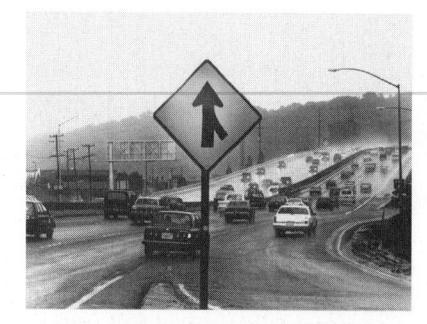

10.11 Medium-Angle View of Traffic

Taken with a medium-angle lens, the z-axis now looks slightly shorter than in figure 10.10, and traffic appears a little more congested.

10.12 Narrow-Angle View of Traffic

With a narrow-angle lens, the cars look closer together, making the z-axis look compressed.

10.13 Sign Pollution

The narrow-angle (long-focal-length) lens not only crowds these signs but also emphasizes the visual pollution.

10.14 Massive Columns

When shot with a narrow-angle lens, the pillars lose their individuality. We perceive only positive volumes.

room for expansion. Depending on the overall context, we viewers might also think of fire danger. **SEE 10.15**

Like a military uniform, the narrow-angle lens can rob people of their individuality and suggest sameness of behavior, collective goals, a high degree of persuasibility, or simply raw, irrational power. Extreme closeness can suggest danger, especially when applied to fast-moving vehicles. The danger of tailgating is highly intensified by the narrow-angle field of view. **SEE 10.16**

Shooting heavy traffic along the z-axis with an extremely long-focal-length lens (zoomed in all the way to its narrowest-angle position) crowds the vehicles even more than they really are. Such a shot readily communicates the frustration of the people stuck in rush-hour traffic. **SEE 10.17**

As with every aesthetic effect, the depth distortion through a narrow-angle lens can, of course, also work to your disadvantage. You are certainly familiar

10.15 Cramped Housing

The narrow-angle lens crowds these houses even more than they really are, intensifying their close proximity and suggesting cramped living conditions.

10.16 Tailgating

By reducing the space between the cars to a minimum, the narrowangle lens intensifies the tailgating.

10.17 Rush-hour Traffic

The crowding of the vehicles by the narrow-angle lens intensifies the rush-hour traffic.

10.18 Shrinking Distance

Even if we know the actual distance between pitcher and batter (60 feet 6 inches), the extreme long-focal-length lens (a zoom lens in its extreme narrow-angle position) shows the players as grouped fairly close together.

with the deceiving closeness of the pitcher to home plate. Because cameras must remain at a considerable distance from the action, the extreme narrow-angle lens used in the reverse-angle shot from pitcher to batter drastically shrinks the apparent distance between the two. In such a shot, we may wonder how the batter could ever hit the ball when the pitcher fires at him from such close range. **SEE 10.18**

WIDE-ANGLE LENS DISTORTION

The wide-angle lens also exaggerates size relationships. An object close to the camera appears much larger than a similarly sized object placed just a short z-axis distance away (see figure 9.17 in the previous chapter). We normally interpret this size difference as increased z-axis distance. Depending on a specific context, however, we can interpret such a size discrepancy also as exaggeration of object size. Through what Sergei Eisenstein called "conflict of volumes and spatial conflict," such distortions carry not only aesthetic but also psychological messages.²

Ordinary shots can become highly dramatic through a wide-angle lens. **SEE 10.19 AND 10.20** For example, when enlarged by the wide-angle lens, the telephone assumes much more importance (figure 10.19), and the cup is certain to contain something other than the aromatic coffee that wakes you in the morning (figure 10.20). A gesture signaling a stop is made quite forceful and authoritative when shot with a wide-angle lens. **SEE 10.21** The power of huge things, such as jet planes or trucks, is also aptly dramatized by the wide-angle shot. **SEE 10.22**

You can also use the wide-angle lens distortion to communicate intense emotional stress in a person. **SEE 10.23** Extreme facial distortions as in figure 10.23 suggest that the person is unbalanced or no longer rational or stable.

By shooting through prominent foreground pieces, the foreground acts as a secondary frame (the primary frame being the television screen), which focuses our attention on the middleground or background object. Because of the volume conflict (large foreground object and relatively small middleground or background object) and the double framing (TV screen and foreground object), the shot gains in aesthetic energy. **SEE 10.24**

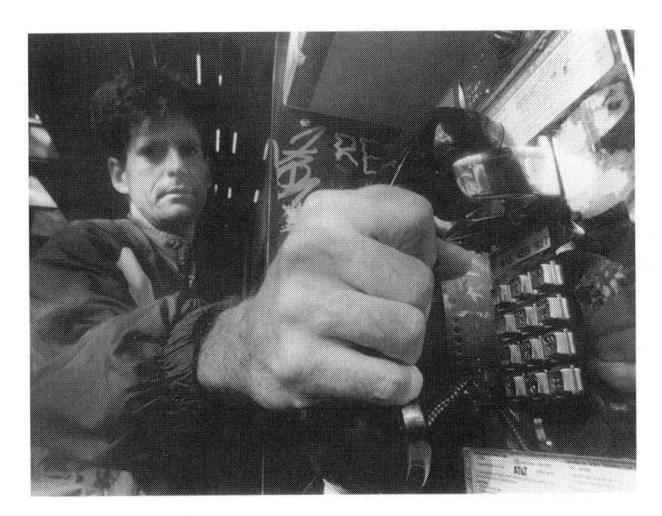

10.19 Implied Message: Importance

The distortion of relative size through the wide-angle (short-focal-length) lens implies an important telephone call.

10.20 Implied Message: Danger

The wide-angle lens distortion of this cup implies that the liquid it contains might be dangerous to drink.

10.21 Intensified Message: Stop

The wide-angle lens distortion of his hand intensifies his stop command.

10.22 Implied Message: Power

The power of this truck is intensified by the wide-angle lens distortion.

10.23 Emotional Stress

Although wide-angle lens distortions of a face are usually avoided, you can nevertheless use them to suggest extreme emotional stress or unbalance in a person.

10.24 Secondary Frame

You can focus attention on a scene by shooting through a prominent foreground piece.

10.25 Lateral Action

The relatively large lateral space of the theater stage and the wide motion picture screen make lateral action an effective blocking technique.

10.26 Z-axis Blocking

Because of the limited height and width of the television screen, action is most appropriately staged and blocked along the z-axis. Note how in this storyboard, the action moves along the z-axis.

Z-axis Blocking

Z-axis blocking means to have people placed and move primarily along the z-axis—toward and away from the camera. Such blocking is one of the major devices for effectively articulating the z-axis, creating a changing volume duality, and intensifying the illusion of a third dimension on the two-dimensional television screen.

When blocking action on the theater stage or for the motion picture screen, we usually rely more on lateral or diagonal than upstage/downstage (z-axis) motion. In fact, lateral action is generally preferred in theater because the stage is usually wider than it is deep. **SEE 10.25**

But the small television screen, with its highly limited picture field, cannot tolerate much lateral action without having the camera pan or truck along with it. Aside from the technical problems of keeping a fast-moving object properly framed, too much lateral action can become quite distracting and disorienting. Proper blocking along the z-axis eliminates much of the camera movement and places emphasis on object (and people) motion, not on camera motion.

When blocking for television, you can have the action literally weave toward and/or away from the camera along the z-axis. **SEE 10.26**

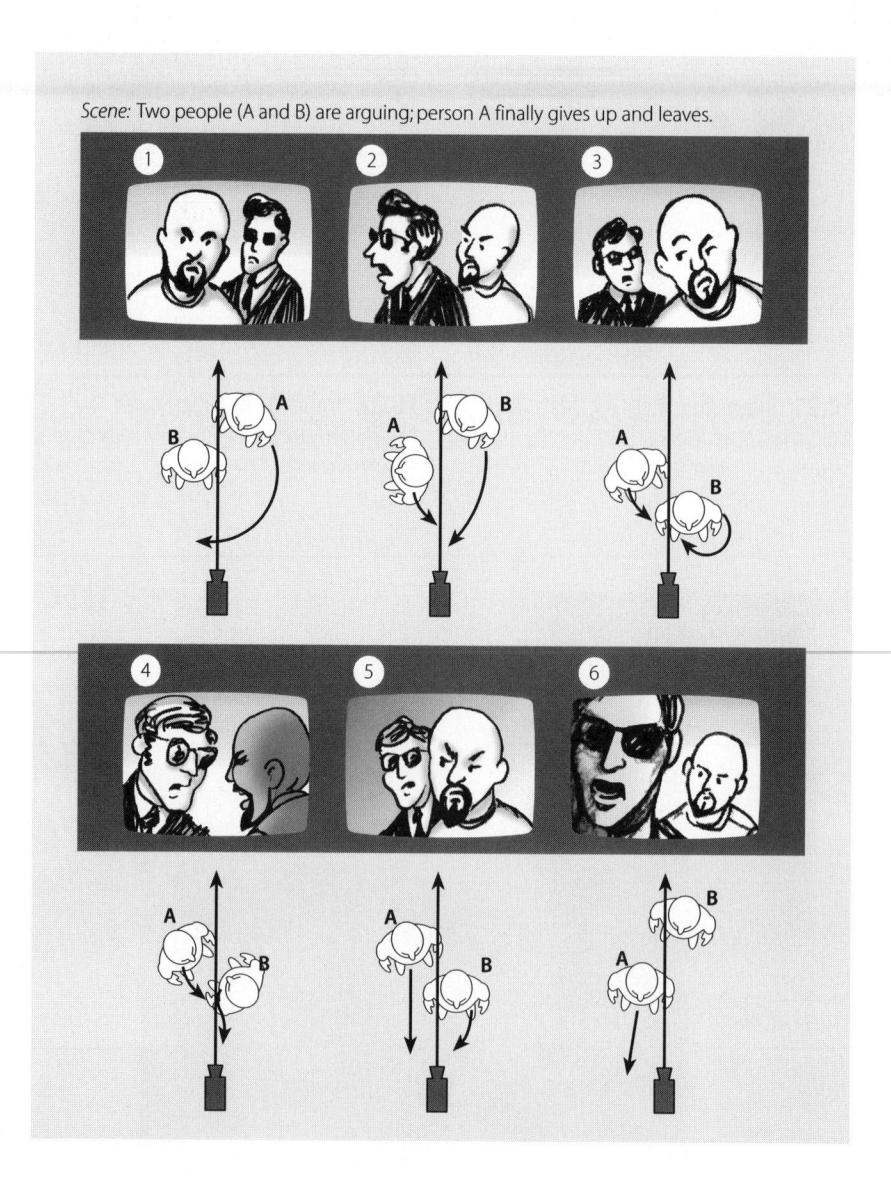

With z-axis blocking, you can manage to show a relatively large number of people interacting with one another from a single camera's point of view. **SEE 10.27** For example, you can use z-axis blocking to simulate a crowd scene with just a few people. **SEE 10.28** The same scene shot from another angle reveals how sparse the "crowd" really is. **SEE 10.29**

If you intend to use a second camera for close-ups in such a "crowd" scene, you would need to have the second camera fairly close to the first so that the z-axes of both cameras are practically identical or at least run pretty much parallel to each other. Otherwise the first camera would see the crowd along the z-axis, and the close-up camera would view them along the x-axis (see figures 10.28 and 10.29).

Good blocking for the small screen means staging an event along the z-axis for each camera. This is called *multiple z-axis blocking*. Chapter 11 explores such techniques and their aesthetic effects.

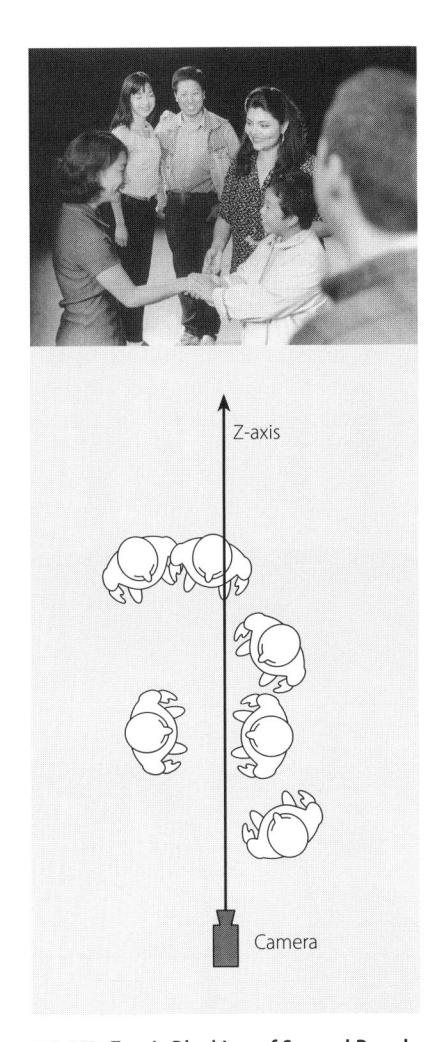

10.27 Z-axis Blocking of Several People A relatively large number of people can be

A relatively large number of people can be included in a single shot so long as they are blocked along the z-axis.

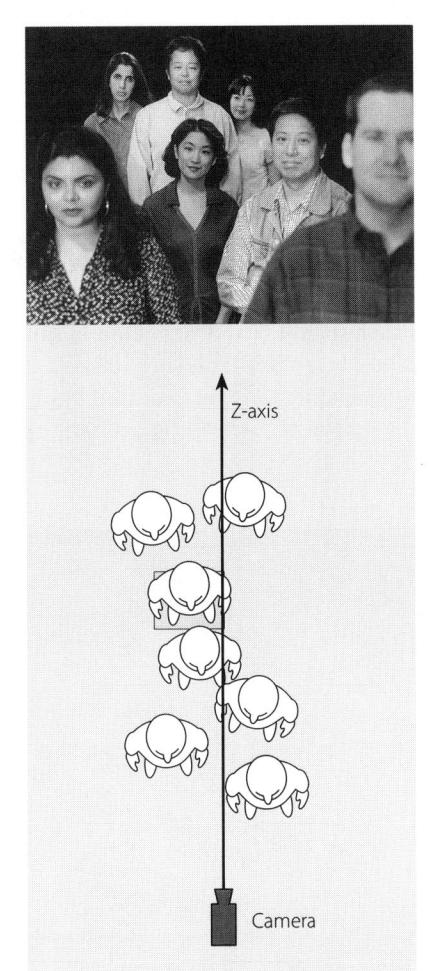

10.28 Z-axis Blocking of Crowd

A crowd scene is easily simulated on television by blocking a few people along the z-axis. Note that the overlapping planes and relative size (exaggerated by the use of a wide-angle lens) provide the necessary depth cues.

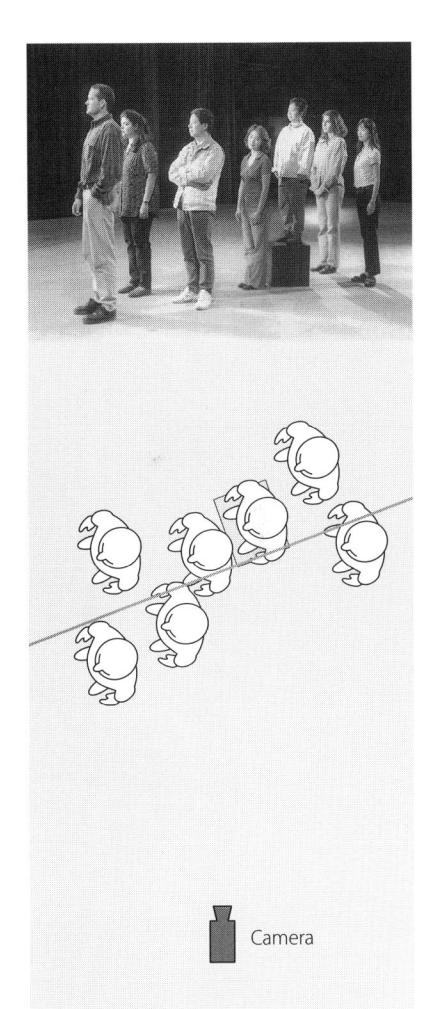

10.29 X-axis view of Same Crowd

When seen from another angle (along the x-axis), these few people are certainly not enough to simulate a crowd. This is one of the reasons why we use so many extras in crowd scenes for the horizontally stretched motion picture screen.

Spatial Paradoxes

The ready availability of digital paint programs and other *DVE* (digital video effects) may tempt you to use these effects just to liven things up a bit—to interject some motion and excitement in an otherwise dull and slow-moving show. Of course, we all know that even the most inventive effects will not alter a basically uninteresting program. Worse, such effects may unintentionally communicate fairly powerful metamessages.³ But knowing some of the aesthetic codes that underlie such effects can enable you to use them appropriately to enhance the intended communication.

SUPERIMPOSITION

A superimposition leads to an image in which the usual figure-ground relationship and the overlapping planes are largely dissolved into a complex array of intersecting images. By "supering" one image over another, the objects seem to become transparent; they no longer overlap but rather intersect, eliminating the illusion of depth. We are no longer sure which image is in front of the other. By collapsing separate viewpoints or separate events into the same two-dimensional picture plane, we change the viewer's normal perceptual expectations to give not only a more complex view of things but particularly deeper insight into the event's underlying complexity. **SEE 10.30** Because of this new structural bond, a superimposition can suggest a strong relationship between seemingly unrelated events. Thus we often use the "super" to create a surrealistic or dreamlike feeling. Supering dream images over a sleeping person's face has in fact become a structural cliché.

The use of second-order space through DVE has, inadvertently, lead to some other spatial paradoxes. One is caused by an unintentional shifting of the newscaster's box. This shift causes a figure-ground problem. The other happens through the use of an oversized second-order frame, which disturbs our normal perception of relative size.

10.30 Superimposition

The superimposition works against a clear organization of the three-dimensional field into foreground, middleground, and background. Its various intersecting planes suggest event complexity.

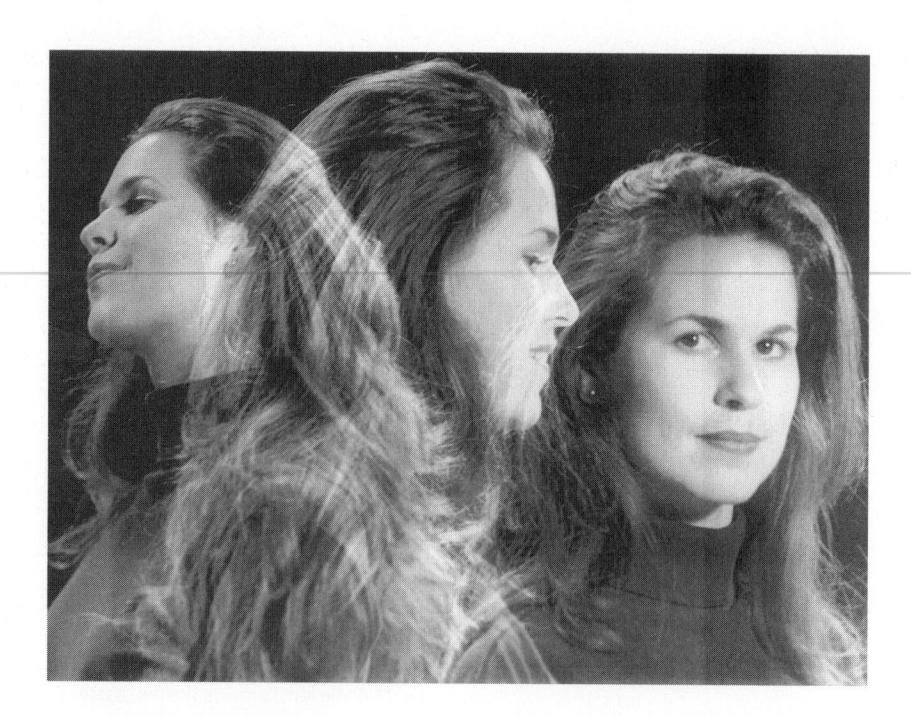
FIGURE-GROUND PARADOX

Never mind what the newscaster is saying—all we care about right now is what the newscast looks like or, more specifically, how the three-dimensional field is structured in this particular shot. When you see a close-up of the news anchor in the foreground and the keyed-in graphicated box over his shoulder, you automatically presume that the newscaster is in the foreground, the box behind the anchor's shoulder is in the middleground, and parts of the newsroom or news set are in the background. **SEE 10.31**

At first glance we seem to have a classical structuring of the three-dimensional field with a prominent foreground, a somewhat ambiguous middleground (the box seems to float somewhere between the news anchor and the back wall of the newsroom or news set), and a common background (the back of the newsroom). But structural problems occur when the news anchor leans too far toward the box or if the camera does not adjust far or fast enough for the placement of the box SEE 10.32 According to our normal perceptual expectations, we would expect the box (middleground) to be overlapped by the news anchor (foreground). But this basic spatial organization is paradoxically upset. The middleground now overlaps the foreground. Will we now perceive the box as being the foreground? Not really. Our mental map still holds on to the basic organization and tells us that the anchor is still in the foreground. Such Escher-like figure-ground reversals are no longer startling aesthetic intensifiers, but simply structural mistakes.⁴

Another startling figure-ground paradox occurs when we display a three-dimensional scene in the box that hangs within the three-dimensional environment of the news set. Will the 3D structure of the news set prevail over the one in the box or vice versa? Will we, under certain circumstances, perceive the background of the box to extend behind the background of the newsroom? Not so long as we perceive the background of the newsroom as the common ground that extends behind all foreground and middleground objects, including

10.31 Figure-Ground Organization in Newscast
In this shot the three-dimensional field is clearly organized into a foreground plane (the newscaster), a middleground plane (the box), and a background plane (the back wall).

10.32 Figure-Ground Paradox
We experience a structural paradox when the middleground plane suddenly overlaps the foreground plane.

the box. After all, we don't perceive the vanishing point of a Renaissance painting as lying behind the museum wall on which the painting hangs. But we may become somewhat puzzled, if not confused, when the action in the graphicated space of the box occurs along its own z-axis, such as a racecar moving from the background of the box to its front, or when people in the box turn around to look at events in the background. Because we see the box as graphicated second-order space that is basically two-dimensional and picturelike (even if the event in the box is moving), the people in the box seem to be staring at the background of a simulated three-dimensional space and not through the "actual" three-dimensional first-order space of the news set. Thus the box is not a window to another world that seems to lie outside of the newsroom, but rather one of the positive volumes defining the three-dimensional newsroom space.

RELATIVE SIZE PARADOX

Mostly likely you have seen interviews in which the studio host (usually one of the anchorpersons) talks to a guest who appears from a remote location on an oversized second-order screen on the news set. **SEE 10.33**

Considering that we perceive objects as smaller the farther away from us they are, you can probably spot the structural problem right away. Yes, according to the relative size principle, the image of a guest, who appears in the background, should actually be smaller than that of the host, who is located in the foreground of the first-order space of the news set. This relative size paradox makes the guest appear oversized, if not overpowering. But why would you perceive the guest as too big instead of the host as too small?

First, as relatively similar-sized objects (in this case, heads), the one in the background (guest) should look smaller than the one in the foreground (host). Second, you have probably appointed the host rather than the guest as size standard. Now you need to recall the reality aspect of first-order space compared with the graphicated second-order space. Because the host operates in the more "real" first-order space, you will use the host as the size standard rather than the guest, who appears in the less real, picturelike second-order space. Compared with the host, who has become your size standard, the guest in the background looks overly large. The sheer graphic mass of the guest's image inevitably overpowers the host even if he is functioning in first-order space. Subconsciously, you are inclined to shift the host's authority and credibility to the guest.

10.33 Relative Size Paradox

In this reversal of the relative size principle, the background figure is larger than the foreground figure. We perceive the background figure as exceptionally large.

Summary

We basically structure the three-dimensional field into various planes, or grounds, indicating z-axis placement or depth: a foreground, a middleground, and a background. In order to establish such depth planes, we must articulate the z-axis with positive space modulators—people or objects that are placed along the z-axis.

Structuring the three-dimensional field includes creating and controlling volume duality, articulating the z-axis, z-axis blocking, and dealing with spatial paradoxes.

As soon as we put things into an empty studio, we are modulating the negative volume of the studio with positive volumes. Positive volumes define space. Structuring the three-dimensional field means a careful control of volume duality—the interplay of positive and negative volumes. When positive volumes prevail, the space looks and feels crowded. Large, well-articulated negative volumes suggests mobility. They can inspire awe because of their vastness, but also suggest isolation and loneliness.

Articulating the z-axis means to use positive volumes along the z-axis and the appropriate focal lengths of lenses to create various depth planes that the viewer perceives in a specific way. Generally, narrow-angle (long-focal-length) lenses squeeze space between objects; they shorten the z-axis and make objects look crowded. Wide-angle (short-focal-length) lenses exaggerate relative size between objects close to the camera and those farther away, thereby creating the impression of increased depth and a lengthened z-axis. Extreme wide-angle lens distortions carry powerful psychological associations of intense feelings and actions.

Because of the limited height and width (y- and x-axes) of the television screen, action is best blocked along the z-axis (depth). Such z-axis blocking increases the feeling of depth, makes it relatively easy for the camera to follow, and increases the drama and aesthetic energy of the shots.

Optical and electronic special effects can create spatial paradoxes that, when used in a proper context, can carry specific meanings. A superimposition can suggest the complexity of an event and a strong relationship between seemingly unrelated events. Unintentional spatial paradoxes, however, such as those that violate figure-ground and relative size principles, can severely disturb our mental map and upset our perception of the three-dimensional structure.

NOTES

- 1. László Moholy-Nagy, Vision in Motion (Chicago: Paul Theobald Co., 1947). Moholy-Nagy discusses the various forms and applications of volume duality in detail, especially in sculpture. He distinguishes between actual positive volumes that have mass and are thinglike, and virtual positive volumes that are created by moving elements, such as a rotating flashlight.
- 2. Sergei Eisenstein, *Film Form and Film Sense*, ed. and trans. by Jack Leyda (New York: World Publishing Co., 1957), p. 54.
- Metamessages carry latent messages that the audience may decode. See Denis McQuail, Mass Communication Theory, 3d ed. (Beverly Hills, Calif.: Sage Publications, 1994).
- 4. M. C. Escher et al., *The World of M. C. Escher* (New York: Harry N. Abrams, 1972). Escher's inventive and unconventional point of view about the phenomenal world may be taken as a model for the paradoxical space manipulation through DVE (digital video effects). See also Bruno Ernst, *De Toverspiegel van M. C. Escher* (The Magic Mirror of M. C. Escher) (Munich, Germany: Heinz Moos Verlag, 1978). Even if you don't read Dutch or German, the book contains many of Escher's lesser-known drawings.

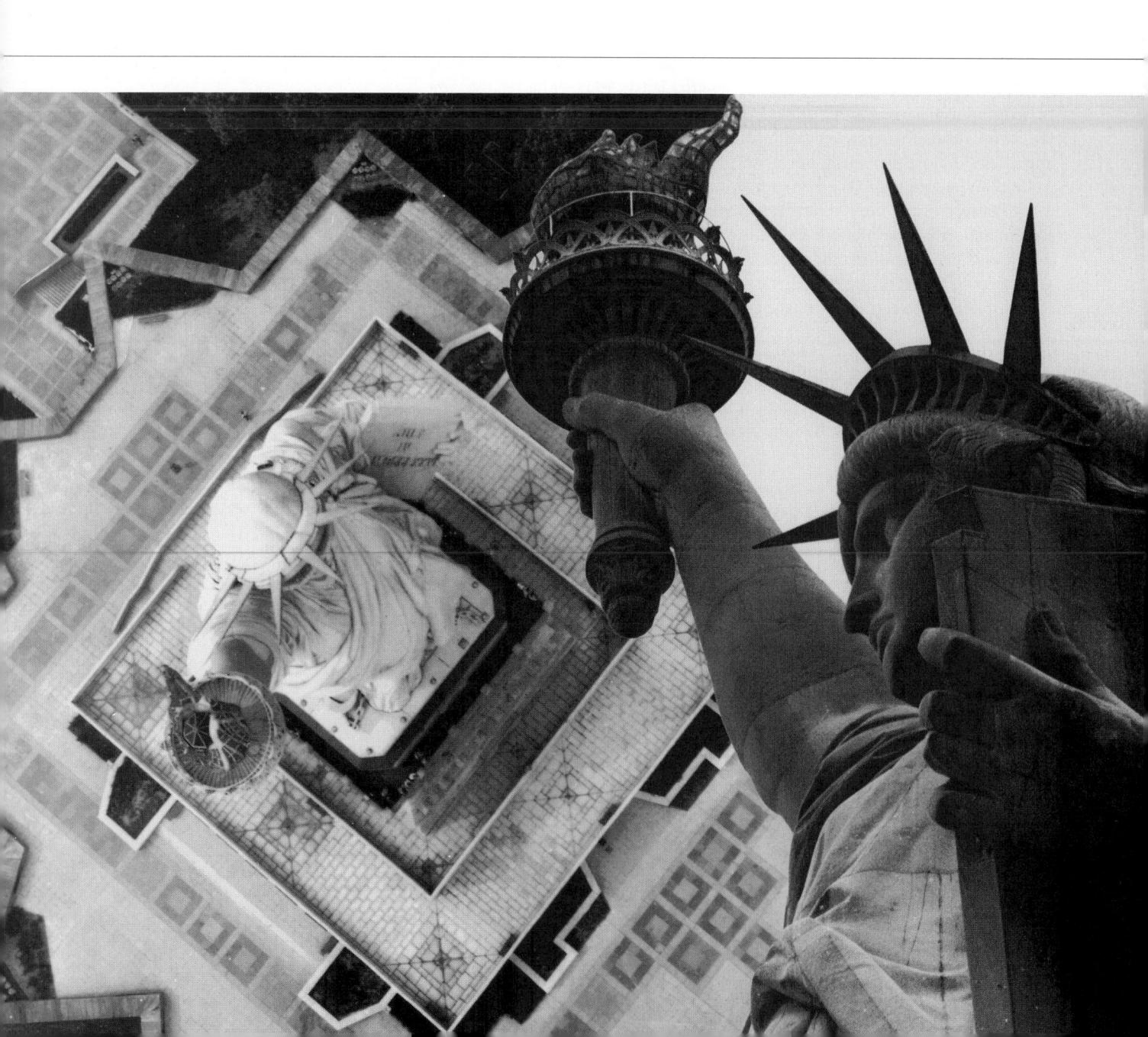

Building Screen Space: Visualization

ISUALIZATION means thinking in pictures or, more precisely, in individual shots or brief sequences. In television and film, it means thinking in screen images. For example, take a moment and visualize your mother. How do you see her? What is she wearing? What is she doing? If she were to appear on television, would you visualize her in the same way? What if she were to appear on a wide motion picture screen? Would you still visualize her in the same way?

Now visualize your favorite car. How do you see it? What color is it? What environment is it in? Is it moving or standing still? How would you visualize it for television or for motion pictures? Now do just one more exercise and visualize—that is, see as television screen images—the following shot instructions:

Video	Audio
CU (close-up) of car	Tested on the hairpin turns of the Swiss Alps, this sleek beauty holds the road exceptionally well.
CU of car	Be careful, there may be a bomb in it!
CU of car	The minister of foreign affairs has finally arrived and is greeted by the vice-president.

Exactly how did you visualize each event? You probably had some trouble actually *seeing* an image in all its detail, but most likely you had some notion of what the shots should contain and how you would like to see the events appear on the screen. Although the video instructions above each read "CU of car," you probably used a different car and a different environment for each shot. Why? Your choice was inevitably influenced by your personal experience, needs, and desires; by the context of the event; and especially by the medium—that is, whether you visualized it for television or a wide movie screen. Additional factors in your visualization are your medium skill—whether you understand the technical and aesthetic limitations and potentials of the medium (in this case television or film)—and your personal way of seeing things in general, your personal style.

Whatever prompts you to come up with specific pictures, the overriding guiding principle for any visualization should be to clarify and intensify an event for the viewer. Although event clarification and intensification usually go together, I treat them separately here to demonstrate their different visualization requirements. Here is an example of visualizing a shot for simple clarification:

Video	Audio	Visualization	
CU of can (indication of point of view)	Be sure to buy this can with the gray brand X wrapper (indication of content)	X	

All you want to do here is show the can as clearly as possible so that the viewer can learn more about brand X. To this end the can is centered within the screen, and the vector field is stable. The can is close enough so that the viewer can read the label. No attempt is made to dramatize the event.

Here is an example of intensification:

Video	Audio	Visualization
CU of can	Get away from it— it may explode!	0

In this instance, the context demands that you visualize the can in such a way as to reveal its potential danger. You must dramatize the shot, load it emotionally, create immediate impact, so you structure the vector field purposely for tension: The horizon is tilted, the mass of the can leans heavily against the frame, and the vectors of the can describe the diagonal of the frame. The vector magnitude is increased by the pull of the corners. The can is highly distorted by the wide-angle lens. The distortion of the can and its labile arrangement within the frame reflect and intensify the precariousness of the event. Within its context, the shot is properly visualized.

Storyboard

A series of visualizations is called a *storyboard*. The storyboard shows sketches or still photos of the key points of view of an event in their proper sequence. If there is audio to go with it, the audio information is written underneath the corresponding storyboard "frames." **SEE 11.1**

The storyboard is usually sketched, with the object or camera motions indicated by large arrows. Computer-generated storyboards are becoming more and more popular, mainly because they are relatively easy to produce. To tell a story, a good storyboard will show not only the visualization of individual shots, but also their sequencing.

All commercials are carefully storyboarded before they go into production. Some filmmakers (such as Stephen Spielberg), storyboard each shot for entire films.

This chapter explores the basic factors that will help you translate your visualizations into camera shots: (1) ways of looking, (2) field of view, (3) point of view (POV), (4) POV: looking up and looking down, (5) POV: subjective camera, (6) POV: over-the-shoulder and cross shooting, and (7) angles.

Ways of Looking

When working with television or film—or any other photographic medium for that matter—we need to decide on a basic approach to viewing an event. We can, for example, merely look at an event and report it as faithfully as possible, or else we can look *into* an event and try to communicate its complexity and psychological implications. We can also choose to use the technical potentials of the medium to

11.1 Storyboard

A storyboard shows the visualizations of key points of view in a progressive manner.

create an image that can exist only on the screen. Examples of creating such unique screen events are superimpositions and digital video effects. Thus we have three basic ways of looking and using the medium for optimal communication: (1) looking at an event, (2) looking into an event, and (3) creating an event.

LOOKING AT AN EVENT

When you merely want to report an event, use an approach that comes as close as possible to the point of view of an observer—someone who watches an event without much involvement. Use the camera and microphones simply to report what is going on. Most news coverage and live or live-on-tape sporting events or news events fall into this category. Looking *at* is done mainly for event-clarification. **SEE 11.2**

LOOKING INTO AN EVENT

Looking *into* an event means to scrutinize the event as closely as possible, to look behind its obvious outer appearance, to probe into its structure and, if possible, into its very essence. Looking into means communicating to the viewer aspects of an event that are usually overlooked by a casual observer and providing an insight into the nature of the event. If you were to objectively report—look *at*—two people in a lively conversation, a simple two-shot with an audio track of their conversation would suffice. But if looking *into* the event, you would use the camera to reveal the psychological implications of the conversation; the sound track may well include music or even some sound effects. Looking into not only shows *what* is happening, but *why*. It's main purpose is event intensification. **SEE 11.3**

CREATING AN EVENT

Creating an event means that you use the technical devices and potentials of the medium to build a unique screen event that depends entirely upon the medium. You can use either a lens-generated event (as seen by the camera) as the basic energy source and manipulate it through *DVEs* (digital video effects), or you can create an event entirely through digital electronics. Creating an event does not mean manufacturing an event in order to mislead the public, such as inventing and reporting a big story on a slow news day. Rather, this approach refers to building a screen event through various electronic and/or optical special effects. **SEE 11.4**

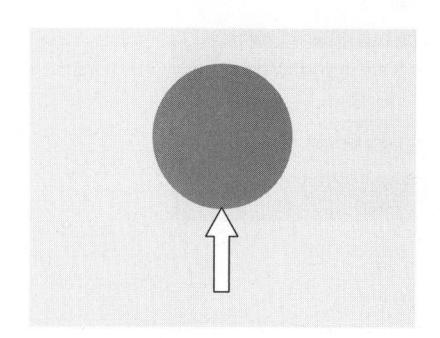

11.2 Looking At

When using the medium for looking *at* the event, we simply try to assume as neutral and objective a point of view as possible.

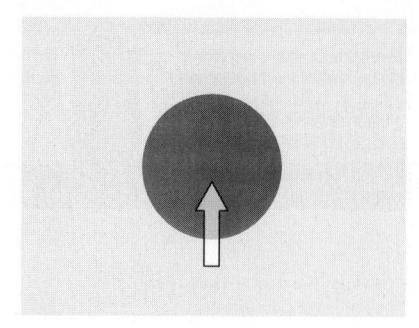

11.3 Looking Into

When using the medium to look *into* the event, we provide a deeper insight into what is going on.

11.4 Creating

In this case the medium is essential for creating a screen event. The event exists only as a screen image.

Let's use a simple action, such as placing a telephone call, and visualize the event according to these three principal ways of looking.

Event 1: Looking at All you need to do is communicate as simply and accurately as possible the action of placing a phone call. The woman walks up to the phone, picks up the receiver, inputs the number, waits for the other party to respond, and starts the conversation. You could easily cover this sequence with a single camera on a medium shot with a possible zoom-in when she makes the connection to the other party. **SEE 11.5**

Event 2: Looking into Now the event calls for intensification. You need to communicate the urgency of the call, the emotional state of the caller, and the overall tense atmosphere. The easiest way of fulfilling these communication objectives is to use tighter shots. But this means deciding which parts of the event to show in the tight shots. Do you need to show the woman walking to the phone? Probably not. You can start with a close-up view of her hand inputting the phone number. Under stress, the woman will probably call the wrong number and have to do it all over again. You may not even want to show the second attempt but instead switch to, and stay on, a close-up of her face. As you can see, your choice of shots becomes very important with this approach. **SEE 11.6**

11.5 Telephone Call: Looking At

Here the woman is simply placing a routine call. We look at it as objectively as possible. The shots for this sequence are not dramatic. They should simply tell us what is going on.

Viewers see her looking at the phone.

She picks up the handset and keys in the number.

She engages in a simple conversation.

11.6 Telephone Call: Looking Into

Now the woman is under stress. You need to let the viewer experience the event's intensity and complexity.

The close-up of the keypad action intensifies the importance of the call.

By partially blocking her face with the phone, you can emphasize the negative aspects of the phone call.

An even tighter close-up will further intensify the event.

11.7 Telephone Call: Creating

The intensification in this series of shots is achieved through selective view, close-ups, and electronic manipulation of the lens-generated image.

We start out with a normal close-up of the woman's hand making the call.

A double image now suggests the woman's extreme nervousness.

The intensity of the conversation is further enhanced by solarization.

Event 3: Creating In order to show the relative complexity and/or intensity of this event, you may use any one of the many available digital video effects such as *jogging*, whereby the motion shows a frame-by-frame advance, or such digital manipulation as solarization or mosaic effects.² Such manipulation through digital devices reveals the underlying complexity of the event and greatly intensifies it. The following figure shows how the DVE of jogging (represented by multiple images) and solarization amplify the woman's emotional state. **SEE 11.7**

Note that the series of manipulated images in figure 11.7 exists only as a screen event. Under normal circumstances we do not perceive the world in limited, highly contrasting brightness steps or as moving frame-by-frame. The event is now created by the medium, using the lens-generated or actual event—the phone call—as raw material.

Field of View

Field of view refers to how far away or close we perceive an object or a person appearing on-screen, or how much territory a shot includes. There are five traditional designations of fields of view: extreme long shot (XLS or ELS), long shot (LS), medium shot (MS), close-up (CU), and extreme close-up (XCU or ECU). **SEE 11.8-11.12**

Exactly how close is a close-up? What is a medium shot? How much territory should a long shot take in? How big should the steps—the changes in image size—be between an extreme long shot and a close-up? These field-of-view designations are relative and depend, like other viewpoint factors, largely on the context and interpretation of an event. You will be greatly aided in deciding on the basic field of view by determining as early as possible your principal way of looking—that is, whether you are using the medium to look at, look into, or create the event.

Even if you have decided on the primary approach, you can move freely among the three. But an early determination of the *principal* way of looking will help you establish a basic visual approach. Take another look at figures 11.5 and 11.6; you will notice that in the looking-at approach, each individual shot and their progressive steps are considerably looser (wider) than in the more intimate and intense looking-into approach.

Long shots and close-ups differ not only in how big objects appear onscreen (graphic mass relative to the screen borders), but also in how close they seem to us, the viewers. Close-ups seem physically and psychologically closer to

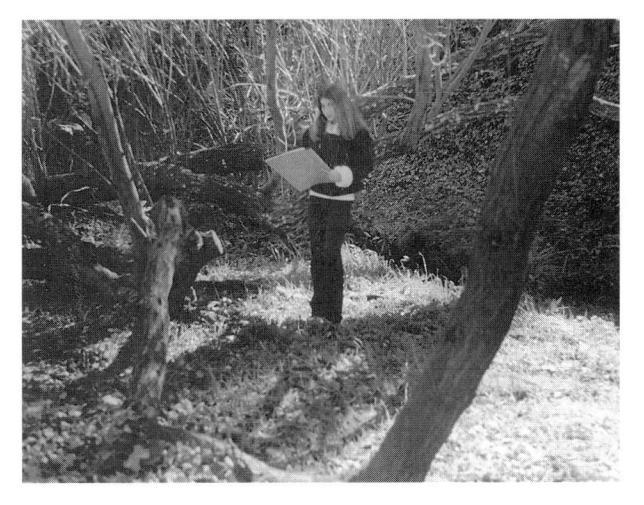

11.8 Extreme Long Shot (XLS or ELS)

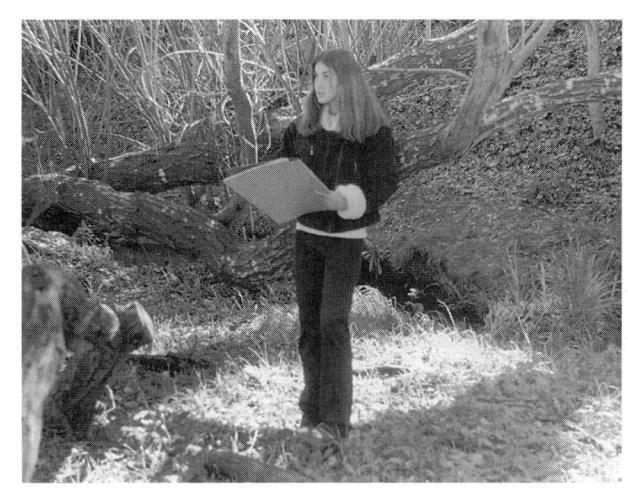

11.9 Long Shot (LS)

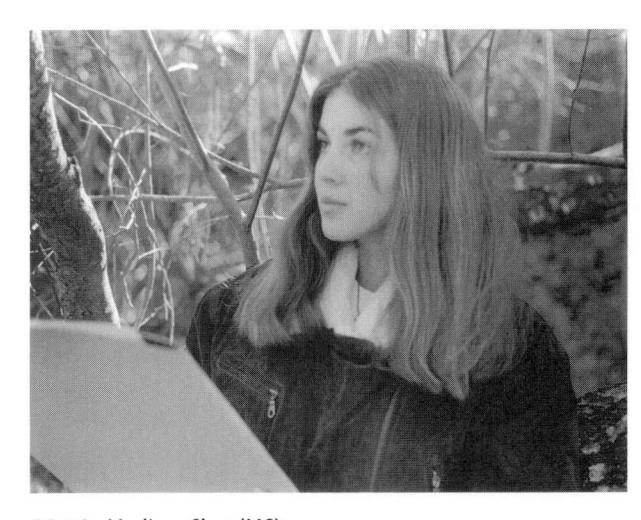

11.10 Medium Shot (MS)

11.11 Close-up (CU)

11.12 Extreme Close-up (XCU or ECU)

us than long shots.³ Because we seem to perceive variations in field of view as variations of physical and psychological distance, we seem to react to them similarly to the actual distance of people and things in everyday life. In some societies, people stand much closer when talking to one another than in other cultures, a phenomenon called proxemics.⁴ Similarly, what constitutes a close-up is not uniform throughout the world. For example, the close-ups of newscasters and even actors in dramatic productions are much wider in some parts of the world than in the United States. Such observations are all part of video proxemics—the study of how we perceive the screen space and the people operating within it.⁵

Regardless of the cultural differences of video proxemics, close-ups are innately more intimate than long shots and carry more aesthetic energy.

Point of View

Point of view (POV) has several different meanings, depending on who uses it and the situation in which it is used. Basically, it refers to the camera simulating the index vector of a particular person or persons on the screen. But it can also mean a specific character's perspective, the way a particular character sees the story unfold. In the famous Japanese film Rashomon, the same event is told from four people's differing perspectives—points of view. Visualization can be guided by an internal, psychological rather than external point of view. And, for good measure, you may detect an author's or director's point of view. Most often, all these point-of-view types, and then some, are intermixed in a single dramatic episode.

Technically, there is a difference between camera viewpoint and point of view. Viewpoint simply refers to what the camera is looking at and from where. Point of view, on the other hand, means that the camera takes on a bias of looking: It no longer describes, but comments on the event. More often than not, however, the terms are used interchangeably, sometimes referring to camera position and sometimes to its narrative involvement.

Our discussion of point of view is limited to four aspects: to (1) looking up and looking down (2) subjective camera, (3) over-the-shoulder and cross shooting, and (4) multiple z-axis blocking.

POV: Looking Up and Looking Down

For some time, kings, schoolteachers, preachers, judges, and gods have known that sitting up high had important consequences. Not only could they see better and be seen more easily, but they could also look down on people, and people had to look up to them.

Physical elevation has strong psychological implications. It immediately distinguishes between inferior and superior, between leader and follower, between those who have power and authority and those who have not. Phrases like the order came from above, moving up in the world, looking up to and down on (rather than looking up and down at), and being on top of the world are all manifestations of the strong association we make between physical positioning along a vertical hierarchy and feelings of superiority and inferiority.

The camera's viewpoint can evoke similar feelings in an audience. When we look up with the camera (sometimes called a low-angle or a below-eye-level point of view), the object or event seems more important, more powerful, more authoritative than when we look at it straight-on (normal-angle or eye-level point of view) or look down on it (high-angle or above-eye-level point of view). When we look down with the camera, the object generally diminishes in significance; it becomes less powerful and less important than when we look at it straight-on or

11.13 Prestige Through Looking Up

Statues of heroes are often mounted high, ensuring that we have to look up at—or rather up to—them.

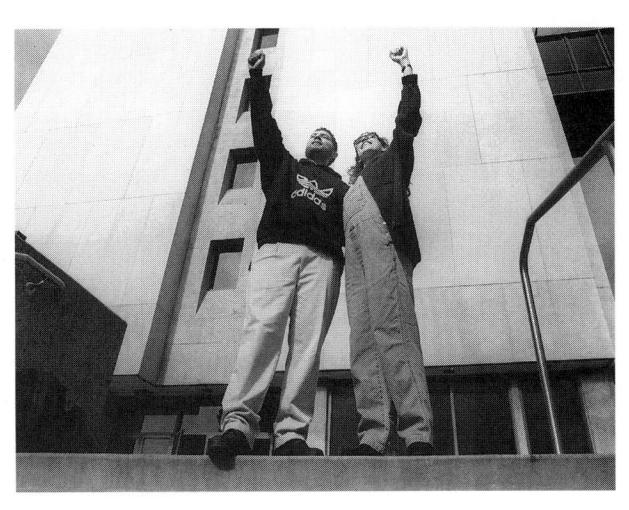

11.14 Power Through Looking Up

Speakers position themselves high enough to see their audience and, more important, make the audience look up to them. Such a superior position seems to confirm their authority and power.

11.15 Intensifying Power of Machinery

Even machines tend to gain in strength when shot from below.

11.16 Intensifying Destructive Power

Machines that are designed primarily for destruction become more menacing and powerful when shot from below.

from below. As viewers, we readily assume the camera's viewpoint and identify with its superior high-angle position (looking down on the object or subject) and its inferior low-angle position (looking up at the subject or object).⁷

Statues of famous people or heroes are either huge, such as those of the kings in ancient Egypt, or are put on pedestals to force people to look up at them or, more appropriately, up *to* them, which makes viewers assume an inferior position relative to the statue. **SEE 11.13**

When speakers address large crowds, they usually stand on fairly high platforms with the audience looking up to them. If you want to duplicate this effect and intensify the authority and power of the speaker, have the camera look up at the speaker from a below-eye-level position. **SEE 11.14**

You can emphasize the power of heavy machinery or the menace of machines designed primarily for destruction by shooting them from below. Again, as audience members we are put in an inferior position. **SEE 11.15 AND 11.16**

11.17 Point of View from Above

When shot from above, a car seems to be less dynamic or powerful than when shot from below. A moving car seems to travel at a more leisurely speed when shot from above.

11.18 Point of View from Below

A below-eye-level view of a car makes it look dynamic and powerful. The speed of a car seems slightly greater when shot from below than from above.

Even our perception of movement varies with whether we observe the motion from a low- or a high-angle position. When shot from above, a car seems to move more gently and somewhat slower than when shot from below. **SEE 11.17 AND 11.18** Note that the wide-angle lens distortion contributes greatly to the power of the above- and below-eye-level scenes.

POV: Subjective Camera

The possibility of the viewer assuming, however temporarily, the camera's viewpoint and position has prompted media people to use the camera subjectively. The *subjective camera* tries to participate in an event, rather than merely observe it. To do this, the camera can assume the role of a person who is actively engaged in the screen event, occasionally substituting for this person's eyes and actions. For example, you could show the profile of a driver of an automobile that is passed by a truck, and then have the camera take on his point of view. The viewers are invited to become, however temporarily, the driver of the car. **SEE 11.19 AND 11.20**

Or, as viewers, we may be discovered by one of the on-screen characters and forced to participate in the screen event directly from our viewing position. In this case, the camera now substitutes for our—the viewers'—eyes. This technique is explored further later in this section.

ASSUMING THE CHARACTER'S POINT OF VIEW

Because as viewers we can readily adjust to, and even identify with, the camera's point of view, we should easily be enticed to participate in the screen event through subjective camera techniques. Unfortunately, this transformation of the viewer from event spectator to event participant rarely occurs, especially if the camera is used to represent the point of view of one of the screen characters. Most often, as viewers, we remain in our seats, observing the screen event from a safe and comfortable position. We do not feel catapulted out of our chairs onto the screen to mingle with the other characters. Even in virtual-reality screen displays, which shift with our changing viewpoint, we are always aware that we are not physically

11.19 Subjective Camera: Establishing Shot When using a camera subjectively, we first show the driver of an automobile and the truck passing.

11.20 Subjective Camera: Character's Point of View When switching to the driver's point of view through the camera angle used, the viewer is supposed to assume, however temporarily, the role of the driver.

moving. The desired dislocation, in which we forsake our own perspective and position for that of the camera, is difficult to achieve and may happen more readily in scenes displayed by laser holograms and even three-dimensional displays where the z-axis extends through the screen toward us.⁸

Nevertheless, instances do occur where the subjective camera can persuade us at least to associate closely with the camera's point of view and occasionally with its action. Such involvement depends on the motivation to participate in, rather than merely observe, the event. The most effective motivational factors seem to be: (1) a strong delineation between protagonist and antagonist so that the viewer can easily choose sides or else switch back and forth comfortably between the two, (2) a highly precarious situation including physical discomfort or psychological stress, and (3) a situation in which the viewer's curiosity is greatly aroused. These are all preconditions for viewers to participate in an event psychologically (feeling of being part of the event) and occasionally even kinesthetically (reacting physically to the screen event, such as shouting approval, clapping, or moving one's arms when watching a boxing match).

Here is an example of viewers assuming the role of one of the characters in the screen event: The scene is from a boxer's story. The protagonist, a very likable fellow, is badly beaten by the antagonist, who is a despicable tough guy. When watching such a contest, we will obviously side with the good guy. It is likely that we will become so much identified with the good guy's fate that we may, on occasion, switch from psychological support (hoping he will win after all) to kinesthetic action (rooting for him). Once the viewer reaches this perceptual stage, a subjective camera treatment is more likely to succeed. The viewer will now accept more readily the shift from the objective two-shot of the fighters to the single shot showing the protagonist's point of view, perceiving it as a logical and organic intensification of the event rather than an artificial camera trick. At the very least, the viewer will feel deeply involved in the protagonist's fate when the subjective camera goes out of focus and begins to convey the defeated boxer's impaired vision.

Now you have not only motivated the viewers through a strong identification with the protagonist, but you have also presented them with a precarious physical dilemma. Will the boxer be all right? Will he be able to see again? The camera

racks slowly into focus, looking up at the happy faces of the operating team. Yes, he can see again! Because of the strong empathetic involvement of the viewer with the protagonist, the subjective camera simply underscores, but does not superimpose, the viewers' event participation.

Popular, yet rarely successful, subjective camera techniques include mounting a camera to a racecar, strapping it to a skier's helmet, or running with it through a city street. The assumption is that this type of subjective camera will make us experience what driving a racecar, skiing down a steep slope, or fleeing through a city street feels like. But unless we are highly motivated, such a position switch does not occur. Instead of participating in any of these screen events, we are more likely to watch rather dispassionately a racetrack relentlessly rushing toward the screen, snow moving up the screen with the horizon line tilting from one side to the other, or simply a cityscape jerking up and down. If you don't keep the camera parallel to the horizon, the picture shows a tilted scene, not a tilted camera. You will certainly not think that you are on a tilt while looking at the picture.

Even actual war footage shot in subjective style by extremely courageous camera operators while on the run rarely makes us experience to even a small degree the horrors of battle. This type of subjective camera may perhaps indicate the speed or relative precariousness of an event to us, but we nevertheless remain observers.

BEING DISCOVERED

If, however, the screen action is aimed directly at us in our viewing position, we feel "discovered" and, thus, inevitably linked with the screen event. Because this subjective camera technique does not require us to assume a screen position, but rather allows us to remain in our seats, we may be more inclined to accept this use of the subjective camera as a direct link between us as the viewers and the screen action. Let's say we see a sniper shooting at anything that moves. The police are inching carefully toward his stronghold. **SEE 11.21** Suddenly, he turns the gun on *us* (into the camera). This action does not require us to assume the position and point of view of the police officers; rather, we have become the direct target of the sniper and hence participants in the event. **SEE 11.22**

DIRECT-ADDRESS METHOD

The direct-address method of television, in which performers speak directly to us, the viewers, is another form of subjective camera "discovery." The difference is that this time the television performers do not really discover and surprise us; rather, they come into our home as invited guests or at least as tolerated communication partners. But as with the direct discovery technique, the communication is aimed from the screen directly at us in our viewing position, without requiring us to assume anyone else's point of view.

Television is ideally suited for such a direct-address method of communication. The relatively small screen size permits close-ups that approximate our actual experience when talking with someone. Even a tight close-up of the performer is not large enough to intimidate viewers. We accept the television medium, and most of its content, as an important and intimate part of our daily routine. We feel in close communion with our favorite performers and accept them as welcome companions. It seems perfectly natural to us that some of them tell us about the benefits of a certain brand of soap, others about the day's happenings, and still others about their troubles at the office, even if the

11.21 Subjective Camera: Being Discovered

Another way of using a subjective camera approach is to have the screen action directed toward the viewer. The objective camera view of the sniper already provides the context of a precarious situation.

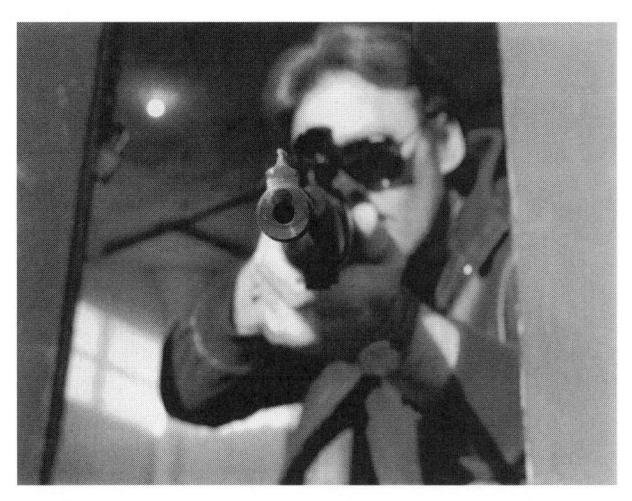

11.22 Being Discovered

When the sniper suddenly points the gun into the camera and so toward the viewer, the viewer is discovered by the screen event and is, inadvertently, forced into participation.

office happens to be the Oval Office at the White House. Good television performers are very much aware of this close relationship. They do not try to address the millions of viewers "out there in videoland," but instead communicate in a low-key, intimate way with a single viewer—you. In fact, we as viewers are so used to this close relationship with television performers that we even accept actors addressing us directly during a story and thus drawing us into their plot. We are no longer simply watching a play but are coerced into participating.

Film is quite different in this respect. We look up to film actors. They are not part of our daily lives; they represent something special. They are stars. We do not expect film actors to turn to us from time to time and include us in a conversation they are having with other actors on the screen. Indeed, we feel somewhat uncomfortable and jarred out of our fantasies and the security of the darkened, popcorn-scented environment when such an invasion of our dream world by the screen image occurs. Because as viewers we usually suffer from a slight psychological shock when being discovered watching what's happening on the big film screen, we feel more comfortable when this subjective camera technique is used for comic, rather than dramatic, reasons. As Woody Allen has demonstrated, however, even in film the screen character can establish a direct dialogue with the audience—even when the discussion is serious and pertains to deep-seated anxieties and frustrations rather than belly laughs.

POV: Over-the-Shoulder and Cross Shooting

Over-the-shoulder and cross shooting are favorite ways of structuring close-ups of two people talking to each other. Both techniques employ reverse-angle points of view to structure the close-ups of two subjects conversing. Such shots are especially effective on the relatively small television screen. In using reverse angles to show alternately the faces of one and then the other person, you can block the subjects more or less along the z-axis.

OVER-THE-SHOULDER SHOOTING

In *over-the-shoulder shooting*, the camera literally looks over the shoulder of the camera-near person at the camera-far person and vice versa. **SEE 11.23 AND 11.24** Note that in the reverse-angle shot, the dialogue partners remain in their respective screen positions.

CROSS SHOOTING

In *cross shooting*, the camera has moved past the shoulder of the camera-near person to get a tighter close-up of the camera-far person. In each shot, the camera-near person has temporarily moved into off-screen space. **SEE 11.25 AND 11.26**

11.23 Over-the-Shoulder Shot

One of the most common and frequently used reverse-angle shots in covering a conversation is the over-the-shoulder shot. In this z-axis shot sequence, we alternately see one person's face, with the other person's head and shoulder in the foreground. In this shot we are looking over the woman's (B) shoulder at the man (A).

11.24 Reverse-Angle Over-the-Shoulder Shot

Now we see the woman over the man's shoulder. Note that both people remain in the same screen position despite the reverse angle.

11.25 Cross-Shot

In cross shooting, we simply move in tighter on the person facing the camera (A). The woman (B) is now out of the shot, and we see only a close-up of the man looking in her direction.

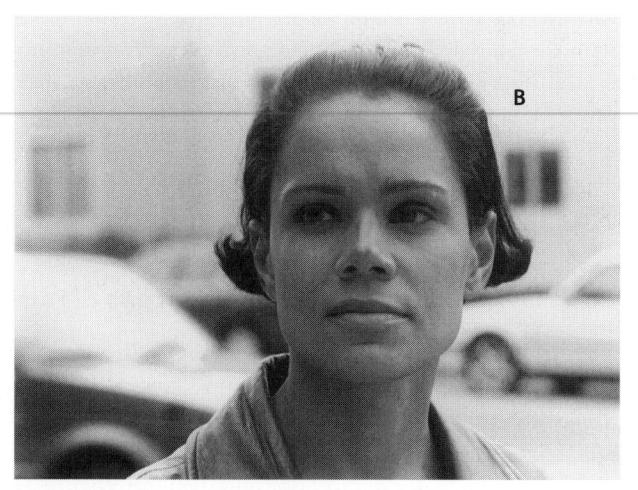

11.26 Reverse-Angle Cross-Shot

Now we have reversed camera angles to show a close-up of the woman (B) looking in the man's direction.

In both of these reverse-angle shooting techniques, we have no trouble accepting the shifting points of view so long as you keep the dialogue partners in their assigned screen positions and give each enough leadroom to facilitate the index vector penetration through the screen edge into off-screen space. We revisit the subject of screen positions in chapter 15 to explain their importance in continuity editing.

What if, in simulated cross shooting, each of two people (A and B) looks directly into the camera, creating independent index vectors? **SEE 11.27 AND 11.28**

Are you now using the camera subjectively, with the z-axis index vectors of persons A and B alternately pointing at the viewer? Not really, so long as you establish first in an over-the-shoulder shot that the two people are dialogue partners and are talking to each other (see figure 11.23). Such an establishing shot shows that the index vectors of A and B are converging rather than continuing. The succeeding cross-shots are simply seen from directly behind the off-screen person. In practical terms, the camera positions have moved from the 5 and 1 o'clock positions of figures 11.25 and 11.26 to the 6 and 12 o'clock positions for the cross-shots. **SEE 11.29**

But where has person B gone? Do we not assume that person B is sitting in our lap or at least standing somewhere between us and the screen? Again, the answer is no. In structuring the three-dimensional field, we do not perceive the z-axis, and with it person B, as extending beyond the screen toward us. If anything, we assume that person B is so close to the near (downstage or camera) end of the z-axis as to be temporarily out of the camera's field of view. Such structuring may make little sense in our real three-dimensional world, but it is perfectly acceptable and workable in the context of three-dimensional screen space.

A perceptual problem arises, however, when the z-axis index vectors are shown simultaneously rather than sequentially. Take a moment to reread the section entitled "Z-axis Vectors in Three-Screen Space" in chapter 8. As you can see in figure 8.48, the "boxed" people who pretend to be talking to each other actually seem to be addressing us, the viewers. Because there is really no cross shooting involved, we tend to perceive their index vectors as directed toward us rather than each other. Even if the sound track clearly tells us that they are talking to each other, we have a hard time reconciling the audio with the conflicting video.

11.27 Z-axis Index Vectors: Person A When two people talking with each other are positioned exactly on the z-axis, we see both people looking directly into the camera (at the viewer) in the subsequent shots. The index vector of person A is directed into the camera toward the viewer. Through the dialogue context, we perceive

A to be talking to B rather than to us.

11.28 Z-axis Index Vectors: Person B When B is shown in a z-axis index vector close-up (looking directly at the camera), by power of context we perceive B to be addressing A rather than us, the viewers.

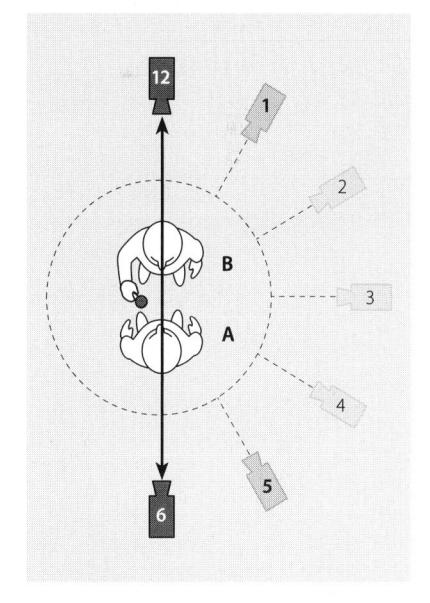

11.29 Camera Positions for Z-axis Cross-Shots

Instead of cross shooting from the customary 5 and 1 o'clock positions, the cameras have moved to the 6 and 12 o'clock positions for z-axis cross shooting.

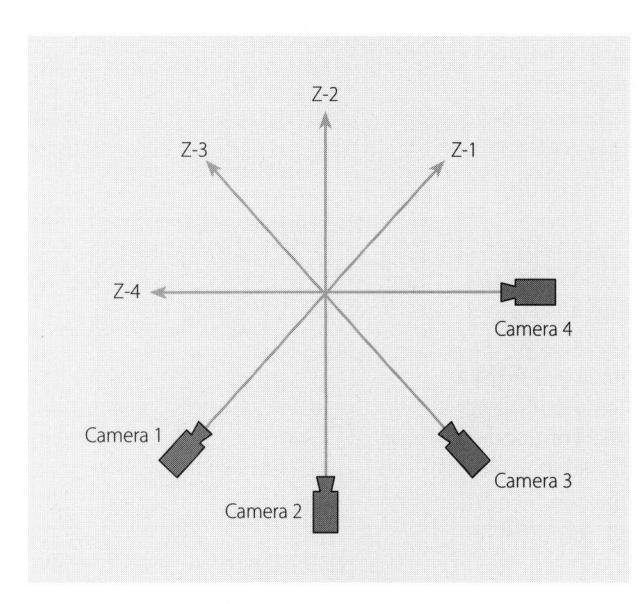

11.30 POV: Multiple Z-axis Points of View

Because each camera, or camera position, projects its own z-axis, we can build a unified screen space by combining the various points of view.

POV: Multiple Z-axis Blocking

Although each camera projects, or rather looks down, its own z-axis, you can use the z-axes of different cameras to articulate the three-dimensional field not from a single point of view (a camera with its single z-axis) but from several points of view within the context of a shot sequence. **SEE 11.30**

You will find multiple z-axis blocking especially advantageous for building screen space in multicamera productions of television dramas (especially daytime serials) and situation comedies. By making the action revolve around the z-axes of several cameras, you can shift among various points of view without losing shot continuity. In effect, each shot displays its own z-axis blocking. **SEE 11.31**

Angles

When we shift the camera's viewpoint, we create a variety of *angles*, a distinct vector field that can help us clarify and intensify a particular screen event. Although we have already

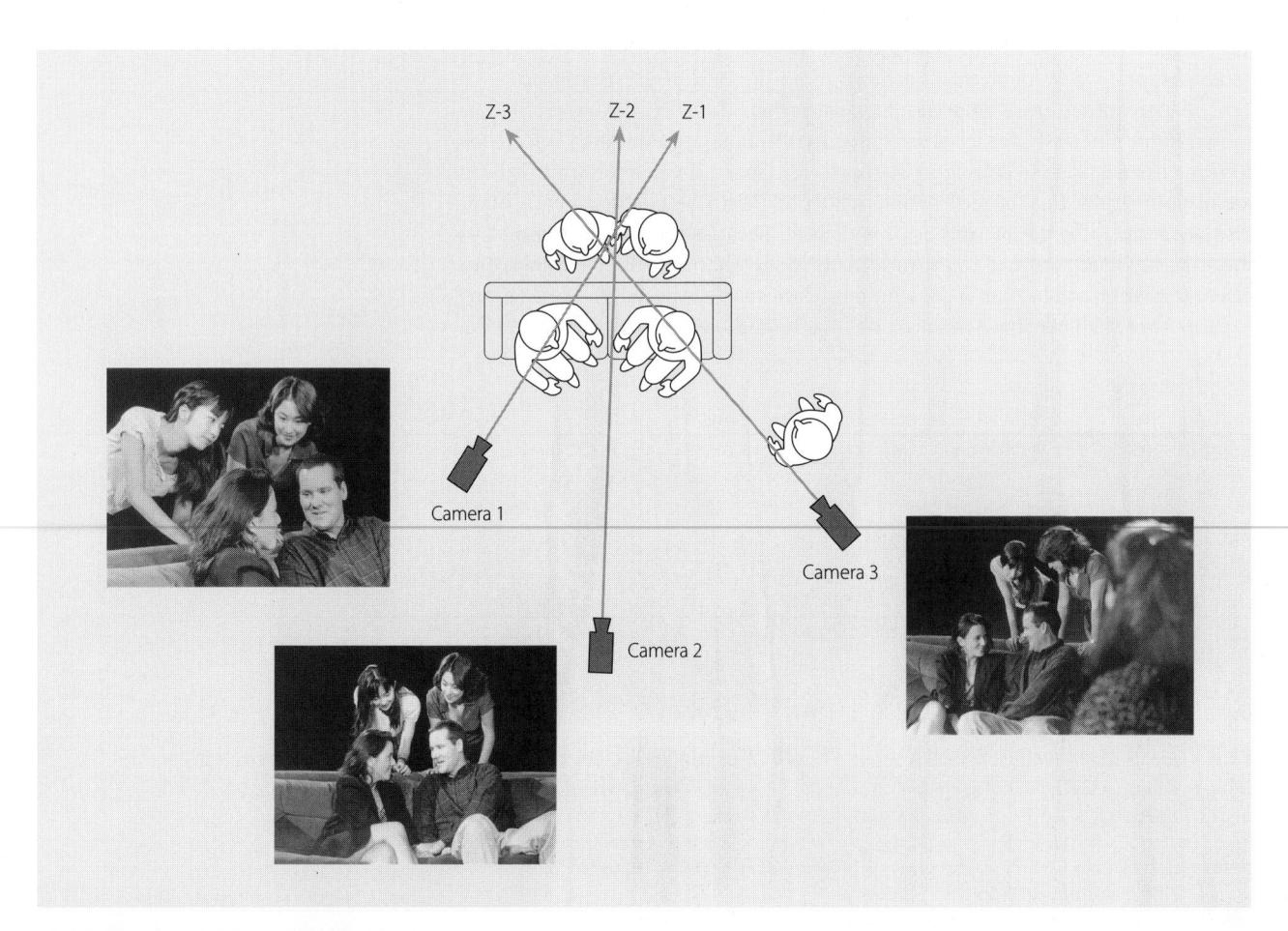

11.31 Applied Multiple Z-axis Blocking

Each of the three cameras used in this scene projects its own z-axis. The action is blocked for each individual z-axis of the three cameras used. When combined, you achieve shot continuity while maintaining the desirable z-axis blocking.

explored the various aesthetic implications of certain shooting angles (such as the looking-up and looking-down camera positions), we take another brief look at angles here in terms of their usefulness in building effective screen space: (1) for vector continuity, (2) for multiple viewpoints, (3) for point-of-view clarification, (4) for event intensification, and (5) for style setting.

ANGLES FOR VECTOR CONTINUITY

When you shoot a scene out of sequence for postproduction, a change of angles between shots will generally avoid jerky action during postproduction editing. **SEE 11.32**

If you do not change the angle between shots, any slight misalignment from shot to shot will show up prominently. The so-called *jump cut*, in which a misaligned object seems to jump or jerk from one screen position to another, is a direct consequence of slight but significant misalignments of camera-to-object from one shot to the next. We discuss the jump cut more extensively in chapter 14.

ANGLES FOR MULTIPLE VIEWPOINTS

By changing angles from shot to shot, you introduce directional shifts that are perceived as a change in viewpoint rather than positional jumps. Like the cubist painters, you are helping the viewer see an object or event from various positions, thereby providing a more complete and intensified screen space than would be possible without such angles.

The relationship between shifts of viewpoint through camera angles and the variable viewpoints in cubist paintings shows up especially in the display of simultaneous screen space, such as superimpositions, electronic matting, or multiple screens. By showing various angles of an object simultaneously, you create a unique vector field that can exist only as screen space. Because in our real space/time environment we cannot be in two or more places at once, we can observe real events from only one viewpoint at a time. But when you use the unique potentials of the medium, a simultaneous display of various viewpoints provides a new visual reality that permits the viewer to experience the whole complexity of an event all at once. The new vector structure can transcend the original event, creating a new, synergetic field of experience that, though based on an original event, communicates a greatly increased amount of aesthetic energy. **SEE 11.33**

11.32 Angles for Vector Continuity
The most elementary use of camera angles is to provide vector continuity in a series of shots.

11.33 Simultaneous Angles

When you show the various shooting angles simultaneously, such as in a superimposition, you create a new visual event that lets viewers experience it from various points of view, very much like in a cubist painting.

11.34 Index Vector Angles

When a tall person talks to a shorter person, the camera needs to be positioned at a height resembling the eye level of the person doing the looking. The camera has to assumethetall person's index vector and inthereverse angle, the shorter person's index vector.

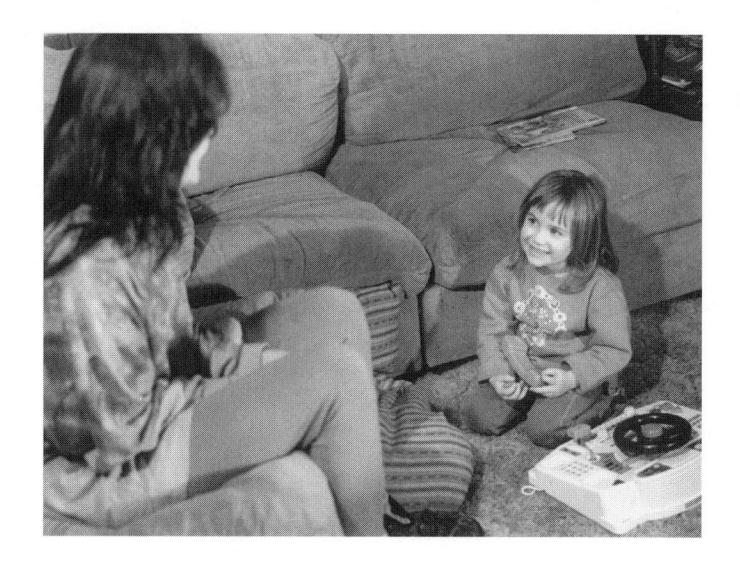

ANGLES FOR POINT-OF-VIEW CLARIFICATION

An important use of angles is to clarify and reinforce the point of view of the people appearing on-camera, that is, at what and in what direction they are looking. The camera angle is basically dictated by the direction and angle of the index vector.

When a tall person talks to a shorter one, the tall person obviously looks down at the shorter person, and the short person up at the taller one. You will notice, however, that many times the camera angle does not seem to change whether it assumes the point of view of the short or the tall person. Such a discrepancy is especially noticeable in close-ups, where the camera seems to be adjusted to the eye level of the person being looked at rather than to the one doing the looking. The following figures show the general angles of the index vectors of a tall person talking with a shorter person. **SEE 11.34**

When the tall person is shown in a subsequent close-up, the camera should assume the shorter person's point of view. This means that the camera needs to be adjusted to the eye level of the shorter person looking up at the tall person. We see the tall person from below her eye level. **SEE 11.35** When cross shooting to a close-up of the shorter person, the camera needs to be adjusted to the higher eye level of the tall person looking down. The camera is now above the shorter person's eye level. **SEE 11.36**

ANGLES FOR EVENT INTENSIFICATION

As with wide-angle lens distortion, you can use angles to intensify an event or to reveal the underlying feelings of a person in a particular situation. Take a look at the following series of figures. As you can clearly see, the camera angles intensify the dancers' upward movement. When the dancers are in a relatively low position, the camera looks down at them. **SEE 11.37** As they rise and begin to reach up, the camera moves to eye level. **SEE 11.38** At the peak of their upward movement, the camera looks at the dancers from a very low position and frames them along the screen diagonal. **SEE 11.39** The camera's point of view and the tilted angle make a simple movement look dramatic.

11.35 Point of View: Shorter Person

In reverse-angle shooting, the camera height and angle need to be adjusted to the eye level and index vector of the person doing the looking. When the child looks up at the woman, the woman is seen from a below-eye-level position.

11.36 Point of View: Tall Person

When a close-up of the child is shown, the camera needs to be adjusted to the height and index vector direction of the woman. The woman (camera) looks down at the child.

11.37 From Above: High Angle

Angles can intensify an event. In this shot sequence, for example, angles add intensity to the dancers' upward movement. We begin by looking at them from above, emphasizing their low position.

11.38 Eye Level: Normal Angle

This new angle is about at eye level, with the camera following their upward movement.

11.39 From Below: Low Angle

Now the camera has taken a low position, looking up at the dancers and thus intensifying their upward movement.

11.40 Long Shot
The lack of different camera angles makes the same dance sequence less dramatic even if we move from a LS to a CU.

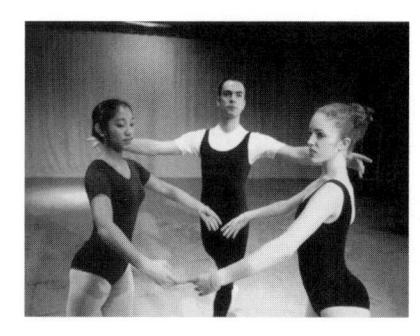

11.41 Medium Shot

Moving in tighter on the action helps viewers see better but does not intensify the upward movement.

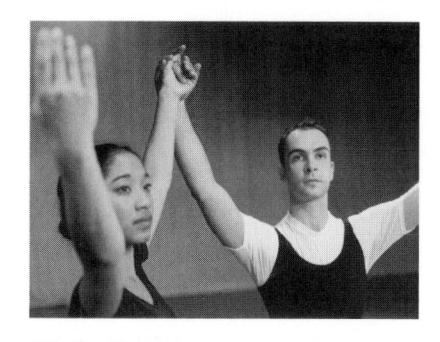

11.42 Close-up Even a close-up is not as dynamic as when looking up at the subjects.

Even if you change the field of view from a medium shot to a close-up, the absence of angles makes the same dance movement somewhat less dramatic. **SEE 11.40-11.42**

To demonstrate how you can use camera angles as point of view to reveal and perhaps even intensify a person's attitude and feeling in a specific situation, let's go downtown and observe a variety of people entering an exclusive, expensive department store for women.

Here is what we observe:

Event 1 A woman does some browsing in an expensive department store, because she has some time to kill before her champagne luncheon with the other women from her club. She enters the store swiftly and surely, much like entering a supermarket. She knows where to go. She knows that the sales staff are here to serve *her*.

Event 2 Another woman, who cannot afford to shop in such an expensive store, has saved up some money to buy a present for her friend, who is more impressed by fancy labels than product quality. She enters hesitatingly, does not quite know what to say to the hostess who greets her at the entrance, and feels quite embarrassed by the cool stares of the salespeople.

Event 3 A little girl wanders into the store. Her mother is busy talking to a friend outside the store. She simply wants to look at all the wonderful things in the store.

Now try to visualize these three events. How do the different attitudes and feelings of the women and the girl influence the camera viewpoints? What are the predominant angles? Without telling you specifically how to visualize these three events, let me simply describe one possibility for deciding on camera viewpoints and angles.

Event 1 The woman pays the cab driver, walks quickly to the store, and enters without hesitation as though the doors were nonexistent. She gives the hostess (store manager?) a polite smile and proceeds to the elevator. She is obviously doing a routine thing. The shooting angles, therefore, should comply with the routine character of the event. They too are normal and routine with a minimum of viewpoint shift; the vector field is stable. Angles should contribute more to the clarification than to the intensification of

this event. The camera objectively follows the woman's actions; no attempt is made to shift to the woman's point of view.

Event 2 This woman walks by the store once or twice before entering, pretending to study the window displays. We see her from inside the store, looking through the window. Even the building appears threatening to her. Camera looks up at the building. She finally gathers enough courage and enters. The door still in hand, she sees the smiling hostess. We see a close-up of the hostess's forced smile from the woman's POV (point-of-view). The camera pans slowly, revealing the huge store (wide-angle lens distortion) and the other salespeople, all bearing similar forced smiles. Again, this sequence is shot from the woman's POV and approaches a subjective camera technique. Depending on whether you want her to gradually gain more confidence or become progressively more ill at ease, the angles should either stabilize or become more acute and labile.

Event 3 We see the little girl from above as she walks to the door. From inside the store, the camera watches the girl trying to open the heavy doors. She walks inside. Shift to girl's point of view (low camera position looking up at people and things). This will emphasize the girl's fascination with the store and its people. Shift back to hostess's point of view, looking down at the girl. If the girl becomes more and more captivated by all the wonders of the store, the camera may switch more frequently from the girl's point of view to close-ups of the girl's face looking here and there. If the girl becomes frightened, however, the viewpoints would become more and more subjective (the girl's point of view) and the angles more acute (tilted horizon line, wide-angle distortion).

One word of caution, however: Avoid becoming angle crazy. If your basic visualization is determined by a simple looking-at context, keep the angles and points of view to a minimum. There is no need to shoot a newscaster from below eye level, then from above, then from her left, and then from her right, especially if all she is doing is reading the weather report.

A dull, uninteresting speech will not become more exciting even if you use many extremely varied angle shots. As a matter of fact, with your visual acrobatics, you will probably destroy the little information the speaker has to give to the audience. But if, on the other hand, you want to emphasize the menacing power of a demagogue, you may very well want to cover his speech from various extreme angles.

ANGLES FOR SETTING STYLE

Even when the event context, the thematic implications, and the actions and attitudes of the on-camera people dictate to a large extent the basic use of angles, you still have wide latitude in which angles to use and how to use them. Your visualization is finally determined by your basic aesthetic concept of the event and your knowledge of the technical and aesthetic requirements and potentials of the medium through which you communicate the event. While recognizing the usual determinants for camera angles set forth here, you may still choose different angles in order to satisfy your own sense of style. But as with all good things, your style should remain subtle. It should not draw attention to itself but should become yet another element in the totality of aesthetic communication. Like your handwriting, your shooting angles should not become the communication; instead they should simply be a reflection of your personality and aesthetic sensitivity.

Summary

Visualization means thinking in individual pictures or brief shot sequences. It refers to imagining how a camera would see a particular event from a specific point of view. Visualization is principally guided by the event context, your personal insight into the event, and your skills in using the medium of television or film to clarify and intensify the event for a particular audience.

A series of visualizations is called a storyboard. It shows sketches or still photos of an event's key points of view in their proper sequence and can include corresponding audio information.

The basic visualization factors are: ways of looking, field of view, point of view (POV), looking up and looking down, subjective camera, over-the-shoulder and cross shooting, and angles.

We can use the medium to look at, look into, or create an event. Looking at means to observe an event as objectively as possible. Looking into means to scrutinize an event as closely as possible and to provide the viewer with insights into the event. Creating means to use the medium to create images that can exist only as a screen event.

Field of view describes how far away or close we perceive an object or a person appearing on-screen. The usual shot designations of the field of view range from an extreme long shot (XLS or ELS) to an extreme close-up (XCU or ECU).

Point of view can mean that the camera substitutes for a character's index vector; it also refers to a camera's bias of looking—that the camera no longer describes, but comments on the event from a specific perspective. Viewpoint refers to what the camera is looking at and from where.

When the camera takes a looking-up position with respect to an object, person, or event (sometimes called a low-angle position), the object or person seems to be more powerful than when the camera looks at the event straight-on (eye level) or down (high-angle position). When the camera takes a looking-down position, it assumes a superior point of view, making the object, person, or event look less powerful.

Subjective camera means that the camera no longer observes an event but participates in it. One subjective camera technique is to have the camera temporarily assume the point of view of one of the screen characters. Subjective camera supposes that the viewer will identify with this screen character. Another type of subjective camera is when the viewer is discovered by one of the screen characters (the camera). The attention and action of the character is then aimed directly at the viewer (the camera), thus forcing the viewer to participate in the screen event.

The direct-address method, in which a television performer or actor speaks directly to the viewer (the camera), is another form of subjective camera technique. Although common and readily accepted by the viewer in television presentations, it is not often used in motion pictures.

In over-the-shoulder shooting, the camera looks over the shoulder of the camera-near person at the person facing the camera. We usually see parts of the shoulder and head of the camera-near person and the face of the camera-far person. When cross shooting, we go to a tighter shot that moves the camera-near person entirely out of the shot into off-screen space, leaving only a close-up view of the camera-far person.

In multiple z-axis blocking, the action is arranged so that the z-axis of each camera is properly articulated. When cutting from one camera to another, the z-axis blocking is preserved but looks at the event from a different viewpoint.

Angles are useful for facilitating vector continuity, multiple viewpoints, point-of-view clarification, event intensification, and style setting.

Varying angles from shot to shot will generally avoid jump cuts. By displaying different angles (through a superimposition or multiple screens, for example), we can make an event more complex.

When intended for point-of-view clarification, the angles are dictated by direction and angle of the index vectors of people appearing on-camera. When a tall person looks at a shorter one, the camera must assume the tall person's point of view and vice versa.

When used for event intensification, angles can reveal the underlying attitudes or feelings of a person in a particular situation.

Finally, angles help to set style. Like handwriting, camera angles can reveal the personality and creative trademark of the television or film artist.

NOTES

- There are various software programs available that contain a standard vocabulary for storyboard creation.
- 2. See Herbert Zettl, *Television Production Handbook*, 6th ed. (Belmont, Calif.: Wadsworth Publishing Co., 1997), pp. 340–355.
- 3. Steven D. Katz, *Film Directing Shot by Shot* (Studio City, Calif.: Michael Wiese Productions, 1991), p. 260.
- 4. The anthropologist E. T. Hall cataloged personal distance in various cultures. See Edward T. Hall, *Silent Language* (Garden City, N.Y.: Anchor Press/Doubleday, 1973).
- I have coined the term *video proxemics* as the basis for an ongoing study that compares the actual distance of people talking to each other in various cultures to the relative closeness of their news anchors.
- 6. This idea of showing varying points of view of the same event is powerfully expressed in the Japanese novel *In a Bush* by Ryunosuke Akutagawa, which was popularized by Akira Kurosawa in his classic film *Rashomon* (1950).
- 7. Although proven successful over many centuries and in various situations by practical application, the psychological implications of looking up and looking down have not been substantiated by early experimental research. Studies in this field are not conclusive and are, in fact, sometimes contradictory. The problem seems to lie more in the measurement tool than in the pragmatic evidence. The difficulty of measuring such subtle psychological effects is probably why such studies have not been done in quite some time. See Robert K. Tiemens, "Some Relationships of Camera Angle to Communicator Credibility," *Journal of Broadcasting* 14 (1965): 483–490; M. Mandell and D. L. Shaw, "Judging People in the News—Unconsciously: Effect of Camera Angle and Bodily Activity," *Journal of Broadcasting* 17 (1973): 353–362; Thomas A. McCain, Joseph Chilberg, and Jacob Wakshlag, "The Effect of Camera Angle on Source Credibility and Attraction," *Journal of Broadcasting* 21 (1977): 35–46; and Hans M. Kepplinger and Wolfgang Donsbach, "The Influence of Camera Angles and Political Consistency on the Perception of a Party Speaker," ed. by Jon Baggaley and Patti Janega, *Experimental Research in TV Instruction* 5 (1982): 135–152.
- 8. Refer back to chapter 9 how we perceive the z-axis extension in formal screen displays and in stereovision and hologram projections.

The Four-Dimensional Field: Time

HE study of the four-dimensional field—the various theories and applications of time and motion within the context of television and film—is one of the most important steps in this discussion of various aesthetic fields. After all, the basic structure of television and film is the *moving* image. As in real life, change is the essence of the four-dimensional field. Television and film demand the articulation and manipulation not only of a spatial field but also of a space/time field. Structuring the four-dimensional field means achieving a spatial/temporal order.

The concept of vectors and vector fields includes the time element. Vector fields in television and film are not static but rather are continually changing either within a shot or from shot to shot. A vector is created not only by a stationary arrow that points in a particular direction but also by one that flies off the bow toward its target.

Let us now lay the groundwork for structuring the four-dimensional field by discussing some of its most basic elements: the theories and modes of time and motion.

The Importance of Time

Humans have always been concerned with time. We are born and die at a certain time. We experience recurring phenomena that suggest the passage of time: day and night, the months, the seasons. We experience periods of activity and inactivity and of bodily wants and needs and their satisfaction. We learn how to record the past, and we live in the present. We try to predict the future and cheat human mortality; at least we try to prolong our life span as much as possible. We construct theories and beliefs that suggest another life after death. In all, we seek to manipulate, to control, time.

In our efficiency-oriented society, time has become an important modern commodity. Time has gone far beyond its former spiritual and ethereal importance. Today time has attained a new existential significance. Time is money. Time salespersons and time buyers bargain shrewdly for the price of various segments of broadcast time. They have tables that list the price of time. Some of the rate cards for broadcasting time point out that no time is "sold in bulk."

Time is an essential factor in measuring the worth of work. Efficiency is assessed not only by what you do but also by how fast you can do it. We build machines that break down or at least become inefficient at a particular time, and we accelerate this carefully calculated obsolescence with periodic style changes. When traveling we are now inclined to measure distances not by spatial units but by units of time: It is three hours to Europe and three days to the moon.

Computers that perform the most intricate calculations with incredible speed, various new discoveries in physics, and space travel have all contributed to a new space/time concept. At least they have demanded of us a new, intense, and unprecedented awareness of time. In recent years we have graduated from a highly mobile society to an electronic one in which much of the actual movement is not carried out so much by people as by electronically coded information. We get impatient if our computer takes just a few seconds longer

than expected to retrieve a highly specific piece of data from the inconceivably vast information pool on the Internet. In the context of such an electronic society, time and motion have become almost the essence of life. In any event, it is high time, so to speak, that we learn to function properly and effectively within this new space/time environment and reconcile old values with the new social and psychological requirements of our "now" generation.

Small wonder, then, that the new time concept—this "now" factor—has prominently entered all fields of the arts. We can find artists trying to manipulate time and motion in such nonmotion arts as painting, sculpture, and still photography as well as in the more obviously time-and-motion—based arts of theater, dance, and music.

Painters, for example, cope with this new time/motion dynamism in various ways. As mentioned in chapter 11, the cubists painted a scene from several points of view to create the impression that the observer is moving from one point of observation to another or is viewing the object from various points of view simultaneously. **SEE 12.1** Other painters invite an empathic time response by letting us feel the motion and force of their brush strokes or through letting us see successive frozen moments of a moving object. **SEE 12.2 AND 12.3**

Some painters are so fascinated with time and motion that they create a variety of vibrating patterns to simulate movement. Whereas the factors of time and motion in various types of cubistic or abstract-expressionist paintings are relatively hidden, they are unavoidable in paintings designed to influence directly our perceptual mechanism. **SEE 12.4** When looking at figures 12.1 through 12.3, you need to reconstruct the aspects of time and motion cognitively—by thinking about them. But in the paintings that influence your perceptual mechanisms, called "op-art," the illusion of motion is generated physiologically through a planned disturbance of the eye/brain system.

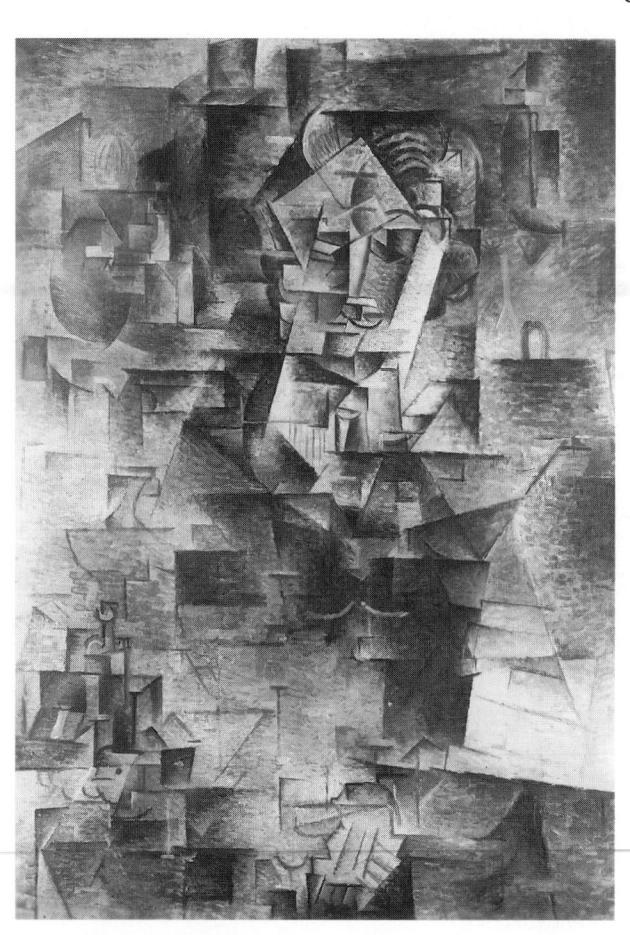

12.1 Time in Cubist Painting

This cubist painting by Picasso shows various sides of the object simultaneously. It implies a shift in viewpoint, that is, the viewer's moving about the object. Also the pattern of this painting suggests a certain rhythm, which we can easily sense as a type of motion. *Daniel-Henry Kahnweiler* by Pablo Picasso (1910). Oil on canvas, 39%" x 28%". Gift of Mrs. Gilbert W. Chapman. Courtesy of The Art Institute of Chicago.

12.2 Implied Motion in Abstract Expressionism

In this abstract-expressionist painting by the American painter Franz Kline (1910–1962), we experience an immense sense of motion. We can literally relive and move with the energy of the powerful brush strokes. *Bigard* by Franz Kline (1961). Oil on canvas, 92" x 68". Collection Carter Burden, New York.

12.3 Simulated Motion Through Multiple Object Positions

The French painter Marcel Duchamp (1887–1968) shows frozen elements of motion in this painting, which closely resembles timelapse photography. *Nude Descending a Staircase, No. 2,* by Marcel Duchamp (1912). Oil on canvas. 58" x 35". Courtesy of the Philadelphia Museum of Art: The Louise and Walter Arensberg Collection.

12.4 Simulated Motion Through Optical Vibrations

Some contemporary painters are so time-conscious that they create a variety of vibrating patterns that seem actually to move. *Blaze 1* by Bridget Riley (1962). Courtesy of Richard L. Feigen & Co., New York.

12.5 Simulated Motion Through Time-lapse Photography In time-lapse photography, a moving object is frozen in several successive positions, simulating its progression in time.

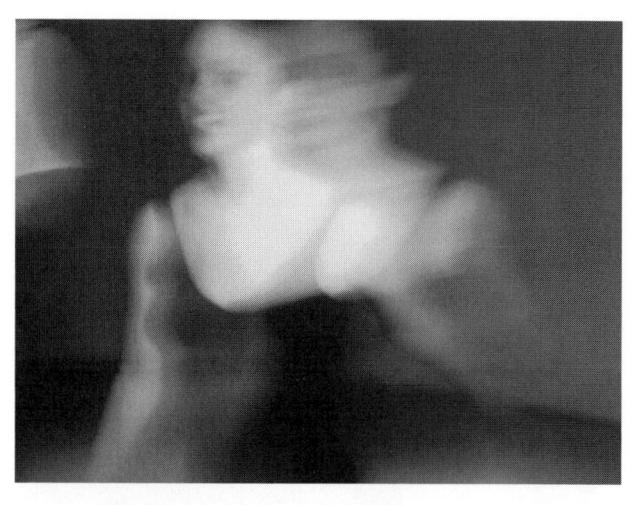

12.6 Simulated Motion Through Blurring
A slow shutter speed or a zoom with the shutter open causes a moving object to blur. We tend to interpret this blurred image as object motion although the actual photograph shows the object at rest. Note, however, that the blurred photo of the dancer shows not a motion vector but an index vector.

Still photographers try to communicate motion through time-lapse strobe effects or through blurring the moving object. **SEE 12.5 AND 12.6**

Sculptors, who heretofore simply arrested motion in one still pose, now create works that actually move. Such kinetic sculptures can take many forms, from mobiles or machinelike constructs whose only purpose is to generate motion to contraptions created solely for the purpose of watching them decay. **SEE 12.7 AND 12.8**

The ultimate instrument with which to express now-consciousness is television. This medium allows for clarification and intensification of an event while the event is occurring. What's more, an almost unlimited number of widely dispersed people can experience this clarified and intensified event simultaneously. It's no wonder that this medium holds such a fascination for us.

What Is Time?

We do not know what time is. All we really know is how to experience time in the form of duration, recurring phenomena, cycles, rhythm, and motion. We can measure time. We live, love, have children, suffer, and die with it and through it, but we do not exactly know what it is. J. T. Fraser, who devoted his scholarly career to the study of this subject, still calls time "the familiar stranger." We get different answers to the seemingly simple question of what time is, depending on whom we ask. The philosopher gives us one set of answers, the physicist another. Artists may be concerned only with the aspect of time that best suits them in their quest to clarify and intensify experience within a specific medium, such as television or film. And this is exactly what we will do: select and discuss those aspects of time and motion that seem most relevant to our media—television and film—and that help us best in understanding and structuring the four-dimensional field.

"Time is a fable and mystery: it has ten thousand visages, it broods on all the images of the earth, and it transmutes them with a strange, unearthly glow. Time is collected in great clocks and hung in towers, the ponderous bells of time throng through the darkened air of sleeping cities, time beats its tiny pulse out in small watches on a woman's wrist, time begins and ends the life of every man, and each man has his own, a different time."

—Thomas Wolfe

12.7 Kinetic Sculptures

Sculptors, who heretofore simply arrested motion in one immobile pose, are now creating works that actually move. The American Alexander Calder (1898–1976) was one of the foremost kinetic sculptors, producing a great variety of mobiles. *Big Red* by Alexander Calder (1959). Sheet metal and steel wire. 114" long. Collection Whitney Museum of American Art. Gift of the Friends of the Whitney Museum of American Art.

12.8 Time in Conceptual Art

Some artists create events merely to demonstrate the close connection between art and life, to show that art is merely a process (including the fighting of bureaucracy) bracketed by time. The Bulgarian-born artist Christo (born Christo Javacheff in 1935) battled numerous county agencies and landowners before he could erect his gigantic 24-mile-long and 18-feet-high *Running Fence* in Marin County, California, only to have it dismantled two weeks later. Christo is especially famous for wrapping buildings, bridges, and even islands with plastic or woven material. Photo by Irene Imfeld.

Types of Time

First of all we must distinguish between the time that the clock records and shows and the time we feel. We have all experienced an endlessly long five minutes, whereas at other times an hour seemed to pass in seconds. Obviously, the time we feel does not always correspond with the time we measure. The time we measure by the clock is called, appropriately enough, *clock time* or *objective time*. The time we experience is called *subjective time* or *psychological time*. A time also exists that regulates our body functions and determines when we feel alert and when we feel tired. This third type is called *biological time*. In structuring the four-dimensional field for television and film, we are primarily interested in the first two types—objective and subjective time.

"Space-time stands for many things: relativity of motion and its measurement, integration, simultaneous grasp of inside and outside, revelation of the structure instead of the facade. It also stands for a new vision concerning materials, energies, tensions, and their social implications."

-László Moholy-Nagy

OBJECTIVE TIME

Objective time is what an accurate clock reports. It is measured by observable change—some regularly recurring physical phenomenon, such as the movement of stars, the revolution of the earth around the sun, or the moon around the earth. Day and night cycles as well as the seasons of the year are also manifestations of objective time. Humans invented more-manageable devices to measure objective time, such as the hourglass, whose displacement of sand from top to bottom measures the passage of a certain amount of time, or the clock, which is constructed to produce some kind of regular motion. The periodic motion is then shown by the hands or the digital readout. Despite Einstein's theory, which holds that even objective time changes depending on how fast clocks travel relative to an observer, in our ordinary day-to-day life, the most fundamental conditions of a clock are that its recurring events (the movement of its hands or its electronic oscillations) be regular and uniform. So far the most accurate device we have to

measure objective time is the atomic clock, which uses the cesium atom. This atom oscillates 9,192,631,770 times per second.⁶

SUBJECTIVE TIME

Subjective, or psychological, time is "felt time." Regardless of what the clock says, you may experience an activity or event as being short or long. Whereas using clock time you can measure the duration of an event rather precisely, with subjective time such estimation is more elusive and often confusing.

Perceived duration How long, then, is an event that we experience? Just think of some examples of when you have experienced "short" and "long" periods of subjective time. A fifty-minute lecture on time may seem endless, whereas surfing the Internet for the same amount of time may somehow seem much, much shorter to you. To the casual observer, a chess game may seem exceedingly slow; but to those playing the game, time seems to fly, or rather the flow of time seems peculiarly absent. When waiting for a person we love, time seems to crawl, but when with that person, the point of departure seems to come all too soon.

Common experience seems to tell us that the more involved we are in an event, the shorter the event's duration seems to be; and the less involved we are, the longer the duration seems to be. But certain controlled studies seem to contradict this theory. For example, when asked to recall the duration of a roller-coaster ride or an especially action-packed segment of a film, subjects of the experiment generally overestimated the actual clock time of the event. You have probably experienced fun-filled weekends that seemed like a week's vacation in retrospect, or else felt the absence of time during the ecstasy of love, the unreality of death, or in moments of extreme beauty or terror. In such moments we seem to feel the instantaneousness of eternity, or perhaps more accurately, the timelessness of total involvement. How can this be?

Duration as vertical vector The confusion about the relative length of subjective time is mainly due to our erroneous assumption that it is somehow a subgroup of objective time. In order to understand the fundamental differences between objective (clock-measured) and subjective (psychological) time, it might be best to think of them as two entirely different concepts.

Although we organize our lives by the clock in terms of keeping appointments, getting up at a certain time whether we like it or not, or tuning in to a certain program, we actually experience time more by the *quality* of what we do, that is, by whether and how much we are interested in what we are doing and by how much we are affected by what we perceive. We read the clock, but we experience time. The major difference between objective clock time and subjective psychological time is that clock time is measured *quantitatively*, and subjective time is perceived and processed *qualitatively*.⁸

The clock moves along, measuring recurring periods (hours, minutes, seconds), independent of how we actually experience the succession of events. We speak of a certain "amount" of time—of hours, minutes, and seconds. An appropriate representation of clock time is a horizontal *time vector*. **SEE 12.9**

Subjective time, however, is qualitative. We use this time concept to express our relative involvement in an event and, with it, our relative awareness of time. Counting the degree of involvement or how much we are aware of a certain duration in seconds, minutes, and hours thus makes as little sense as using a yardstick to measure the weight of a person. Unfortunately, in our efficiency-oriented society, we seek to measure, rather than to enjoy, quality. We rate the

value of a van Gogh painting by how many millions of dollars were spent for its purchase, and the value of a person on a ten-point scale. It's no wonder that we tend to measure subjective time as though it were clock time. Instead we need to look at subjective time as going into depth rather than progressing horizontally. We can best visualize this "deep time" as a vertical vector indicating greater or lesser intensity. **SEE 12.10**

When waiting, you are usually not highly involved in the act of waiting, which is merely a necessary condition for the anticipated event to occur. Because it is something you would like to have pass as quickly as possible, you probably find yourself looking at your watch frequently. Checking the clock time helps to bring structure to the rather amorphous time experience of waiting. You seek comfort in the regularity of the clock, but in this case the clock is also the bearer of bad news; what felt like a half-hour wait might turn out to be only ten minutes of elapsed clock time. Because you are so much aware of objective time (wishing it to be as short as possible before the anticipated event occurs), the subjective time vector is no longer vertical but instead runs almost parallel with the horizontal clock time vector. **SEE 12.11**

But when riding a roller coaster, you are probably much more intent on hanging on for dear life than worrying about how much clock time it takes to get from one end to the other. Here the time vector has become more vertical and gained considerably in magnitude, indicating that you are involved in riding the roller coaster and less aware of clock time. As indicated earlier, we seem to have no perception of either objective time or subjective time (perceived duration). To call such moments timeless is more accurate than to say that time stands still. In such a case, the subjective time vector stands at true vertical and has gained so much magnitude that its point no longer occupies any space on the horizontal time vector. It has reached a zero point in time.

Why, then, do studies show that we overestimate the actual duration of an intense or especially crowded event rather than underestimate it? Should not an intense or crowded event seem shorter to us than it really was because of our involvement? Considering the previous arguments, the answer should be yes. The problem seems to arise in our trying to translate subjective time (felt duration) into objective (clock) time after the experience. In doing so, we are inclined to substitute the horizontal vector magnitude (clock time period) for the perceived magnitude of the vertical vector (intensity of experience). That is, we change the vertical vector into a horizontal one. In this switch we simply use the magnitude, or length, of the vertical vector as the magnitude (length) of the horizontal one. Hence, we erroneously interpret the high-magnitude vertical vector of an intense experience as an equally high-magnitude

12.9 Horizontal Vector of Objective Time

The progression of objective, or clock, time is represented by a horizontal vector. Objective time is quantitative.

12.10 Vertical Vector of Subjective Time

The intensity of subjective time is represented by a vertical vector. This "deep time" is qualitative.

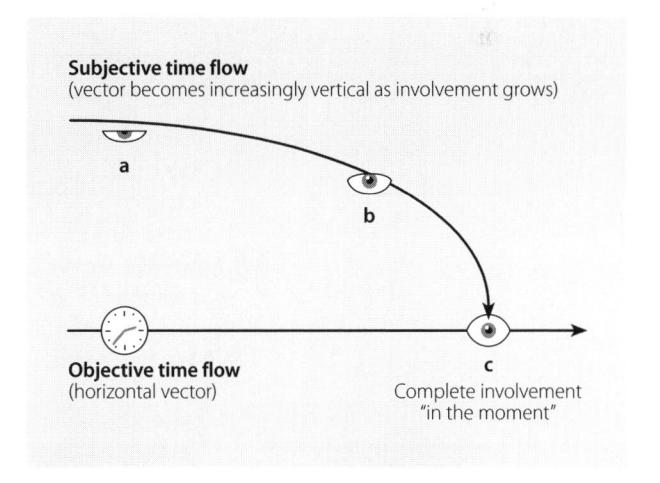

12.11 Zero Point of Horizontal Time Vector

When uninvolved in an event, the subjective time vector runs almost parallel with objective time (a). But the more involved we get in an event, the steeper the subjective time vector becomes (b). When totally involved in an event, the subjective time vector no longer occupies any space on the horizontal objective time vector (c). The subjective time vector has reached a zero point in time.

12.12 Parallel Time Vectors

When asked to estimate the elapsed clock time of an event, we translate the magnitude of the vertical subjective vector (degree of event involvement) into an equally strong horizontal (clock time) vector. The deeper the vertical vector, the longer the recalled duration of the event.

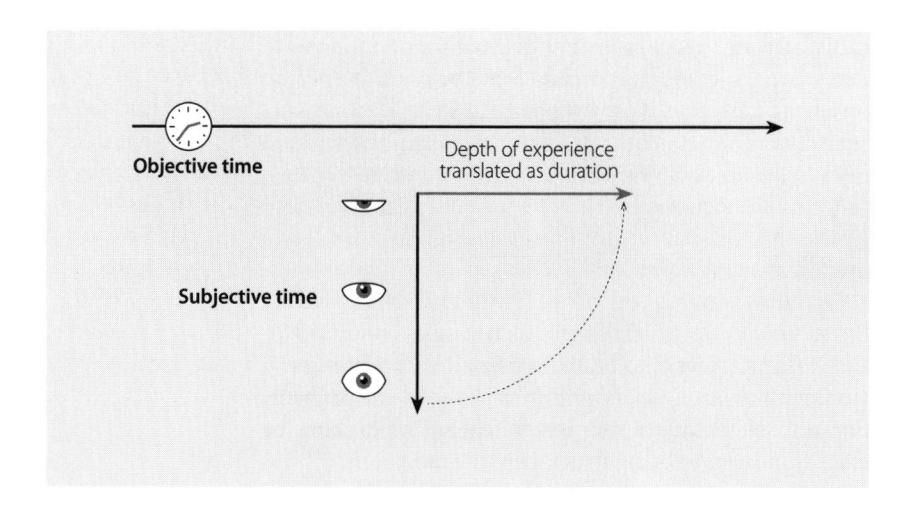

horizontal vector—more elapsed clock time. Thus we remember being on the roller coaster longer than we actually were. **SEE 12.12**

Vector magnitude of subjective time It may be helpful at this point to repeat and list the major factors that influence the magnitude of the subjective time vector—that is, whether you experience an event as "brief" or "long." These factors are: (1) event intensity, (2) event density, and (3) experience intensity.

Event intensity Some events seem to carry more energy than others. The relative energy and significance we perceive about an event is a measure of *event intensity*. A herd of stampeding cattle has more energy than a single cow grazing, or a person running has more than someone sleeping. Usually, we respond to a high-energy event more readily than to a low-energy event, especially if the event bears no specific significance for us. Thus a high-energy event is more likely to involve us more than is a low-energy event and, consequently, to increase the magnitude of the subjective time vector. The high energy can make the event more intense for us, involve us more, and thereby distance us more from clock time. As a result, our estimation of clock time will be distorted.

Event density The relative number of event details that occur within a brief clock time period constitute *event density*. Thus a high-energy event is one in which many things occur within a relatively short time. For example, if you watch a three-ring circus performance, more things are going on at the same time than you can watch. A movie or television sequence with many shifts of point of view, location, or angles is also a high-density event. A ten-second commercial that includes many different close-up shots is another example of a high-density event. We tend to interpret such a rapid assault on our senses as event density and are, therefore, more apt to be stimulated by such a rapid-fire presentation than by a less dense shot sequence. If the high-density event has any kind of beat to it, such as the beat generated by the rhythmic cuts in a commercial, we tend to interpret the faster rhythm as faster speed than if the cutting rhythm of a commercial is less dense (and therefore slower), even though the actual running time of the two commercials may be exactly the same.

Experience intensity *Experience intensity* refers to the number of relevant experiences we go through either simultaneously or in rapid succession and to the relative depth or impact such events have on us. You have probably experienced overwhelming moments when, waking up at night, all your problems, both large
and small, seem to converge on you at the same time with tremendous intensity. Experience intensity commonly depends to a great extent on the *relevancy* of the event: The more relevant the event is for you, the more intense your involvement in it is likely to be. Waiting to see whether your chess partner has discovered the trap you set for her is nothing like the empty waiting period discussed earlier. Because you are now totally involved, waiting for your partner to make a move is a high-intensity experience. Taking an exam or playing in a tennis final are equally involving, high-intensity experiences. Experience intensity is less dependent on the relative energy or density of the event and more dependent on how much the event means for you. As mentioned earlier, low involvement means more awareness of clock time; high involvement means less awareness of clock time. That we usually experience a high-intensity event as having no time or sometimes as lasting an eternity is one of the paradoxes of subjective time.

BIOLOGICAL TIME

One type of subjective time operates quantitatively, which means it tells us when to do certain things. All living things seem to have a biological clock built into them. Migrant birds return when their biological clock says it is time to do so, regardless of the prevailing weather conditions back home. Some plants open and close according to their biological clock time, not because it is night or day or hot or cold.

You probably have awakened many times just before the alarm clock went off. Your biological clock told you when it was time to get up. The biological clock is set by habit. If you gradually change sleeping and waking hours, the biological clock resets itself to the new schedule. But if you change a schedule abruptly, your biological clock keeps on ticking faithfully according to the old time schedule. This can be quite annoying or exhausting, especially during travel, when it is commonly referred to as "jet lag." When everyone is ready for bed in the new location, you start feeling wide awake and alert. And when your biological clock tells you that it is the time you normally go to bed, the people in the new location, whose biological clocks are set differently, are ready and eager to start a new day. This type of biological time upset is called circadian cycle (or rhythm) desynchronization. Fortunately, your biological clock will adjust after a while to the new working and sleeping rhythm.

Although biological time does not directly help to structure the four-dimensional field, it nevertheless contributes to the readiness of the viewers to respond properly to mediated communication. If they are dead tired when watching our program, we will certainly have a more difficult task arousing their aesthetic sensitivities than if they are wide awake. In television you should at least consider adjusting programming to the general waking and sleeping habits of your audience. You should also be sensitive to the general mood and receptiveness of the audience as dictated by the biological clock. In midmorning, when the audience is wide awake and full of energy, it may tolerate, if not demand, a higher-energy program than late at night, when the biological clock of the viewers tells them to relax and be comfortable.

Time Direction

Everyday experience in life gives us ample evidence that time moves relentlessly forward, that the past precedes the present, and the present, the future. We experience birth before death, and we move from cause to effect. In our world entropy seems to work only in one direction, from an organized system to a loss

of organization, from a high information level to a low one.¹¹ We have, therefore, come to believe that the flow of time is irreversible, that the "arrow" of time—the time vector—moves in only one direction.

Live television is inevitably tied to this unidirectional time vector. Once an event is recorded on videotape or film, though, you are no longer tied to the past/present/future flow of time nor to the cause/effect principle. You can now change the direction of the time vector of the screen event in any way you desire.

To understand the potentials of such time vector shifts, let us now take a brief look at the past/present/future division of time and its relevance to television and film.

PAST/PRESENT/FUTURE

Based on our ordinary experience, we divide the time continuum into the past, the present, and the future. **SEE 12.13**

We remember the past and have proof of it. Historians and archaeologists make a profession of verifying the past. We may have photographs, films, videotapes, or even old letters to substantiate our own past. We anticipate the future and try to predict it as much as possible. We are eager to know what the weather will be like tomorrow, who will win the election, and how our production will turn out. Both past and future are really addresses in the time continuum: Martin Luther King Jr. was assassinated on April 4, 1968; I will have my final examination on May 21. As you can see, we can accurately pinpoint time in the past and in the future. **SEE 12.14**

The present is more elusive. When is now? Right now! When? Whoops, your "now" just passed. Now you are still thinking about it, but it has not yet come about. Too late, it has again eluded you. It is already past.

Can we pinpoint and freeze the now so that it becomes a spot in time, a specific instant in the time continuum? Or is it something that continuously comes and goes in a constant flux, always lost somewhere between the "not yet" and the "has been"? We gain help in answering these puzzling questions from an unexpected source.

SAINT AUGUSTINE AND THE PRESENT

Fifteen centuries ago Saint Augustine felt that the rigid division of time into past, present, and future was incorrect because whenever we speak of the past or the future, we do so in the very present, our very present, right now. Therefore, he claimed, there can be only a *present of things past*, a *present of things present*, and a *present of things future*.¹² Augustine points out, "the present has no space," at least not on the normal horizontal time vector that envisions time as an orderly progression from past to future.¹³

THE PRESENT AS SUBJECTIVE TIME

The present has no place in our consciousness. The paradox of the present is that it is the only time in which we live, yet it remains outside our perceptual grasp. This state of affairs probably reminds you of the problem we had with trying to fit subjective time into the horizontal time vector. In fact, you do better if you think of the present not as objective time but rather as subjective time. As a subjective time phenomenon, the present no longer has "space"—a quantity, an address in the horizontal time continuum, but rather a quality. This no-space present is similar to our zero-time concept of total involvement—the virtual absence of time-consciousness.

12.13 Past/Present/Future

The time continuum is usually divided into past, present, and future.

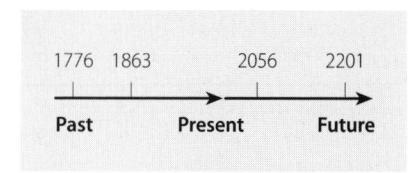

12.14 Addresses in Time

We can accurately pinpoint specific epochs, or addresses, in the past and future.

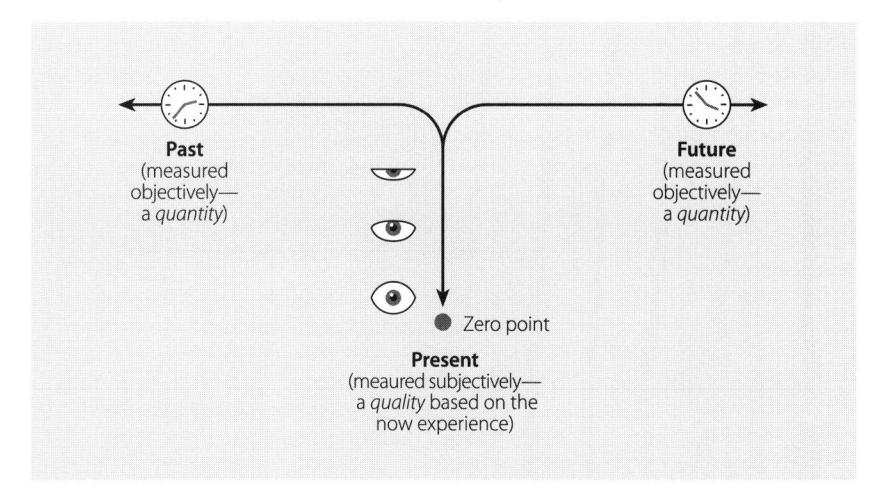

12.15 Present as Zero-Time Quality

We cannot pinpoint the elusive present as we can the past and the future. It is more fruitful to consider the present as subjective rather than objective time. As such, we experience it qualitatively (according to the relative intensity of the moment) rather than quantitatively (duration of the moment).

As part of qualitative time, the present becomes less mysterious. You should no longer try to fix the relative length of the present or when or where it is but rather perceive it as a vertical time vector. As such, it is merely the state in which you receive constant and unadulterated experiences. Once you become consciously aware of these experiences, you define the past. While anticipating them, you define the future. Thus the zero point acts, indeed, as the ever-present zero point of experience that divides the past and the future. **SEE 12.15**

TRANSCENDING TIME

Contrary to the Western concept of time, the followers of Eastern spiritual traditions to transcend the from/to, cause/effect direction of the time vector into a liberation from time altogether. In this higher state of consciousness, the time vector changes from its horizontal direction to a vertical one; it transcends from a quantitative mode to a qualitative one. As a quality rather than a quantity, time no longer measures cause/effect progression, but has given way to the simultaneous coexistence of all events. As such the "flow of time" has lost its meaning. ¹⁴ In the absence of meditation, you may experience such an absence of time occasionally through extreme emotional conditions, such as overwhelming love or terror. Paradoxically, each of such timeless moments contains eternity. ¹⁵

Time Vectors in Live Television

The objective time vectors of an actual event and the televised event are inevitably tied to each other when the telecast is live. Live television means that the event and the telecast of the event are happening simultaneously. Broadcasters speak of such programs as occurring in "real time," that is, the time of the actual event. At this point you might argue that technically no true simultaneity occurs between actual event and televised event. For example, when the television signal is distributed via satellite, we can experience a time delay of almost half a second between event origin and reception. ¹⁶ When the picture

St. Augustine (A.D. 354–430), Bishop of Hippo (present-day Algeria), was one of the truly original thinkers. Throughout his *Confessions*, he apologizes frequently to God for being so bold as to having his own deep thoughts about creation and the many aspects of the human condition. Some think that his insightful writings are his "soul's journey to grace." His analysis of time and his emphasis of the "now" place him as one of the earliest forerunners of existentialism.

finally gets from the downlink (the satellite signal receiver on the ground) to the broadcast station, it is digitized and briefly stored by a synchronization device before videotaping or transmission.¹⁷

Aesthetically, however, such minor time delays do not constitute a recording of the event. Even if the televised event is slightly delayed by signal processing and distribution, it cannot free itself from the "real time" of the actual event and must follow its flow. But though you may have no control over the length of the actual event and its flow, you can still influence how "fast" or how "slow" viewers perceive the televised event. That is, you can control the subjective time of the televised event. In such cases, it seems as though the objective and subjective time vectors are marching to different drummers. Let's take a closer look at objective and subjective time vectors in a live television presentation.

LIVE TELEVISION AND OBJECTIVE TIME VECTORS

In the context of objective time vectors—that is, the "real time" of the actual event—the live telecast is totally event-dependent. The only control you have over clock time in the coverage of a live event is the starting and end times of the telecast, and when you temporarily cut away for commercials or other announcements. But as much as you may want to know the outcome of a football game, for example, you cannot speed it up or slow it down electronically. If you show brief recordings of the live pickup (such as instant replays), you will miss out on the progression of the game during this time period. A possibility of doing both is, of course, to show the live image and the recorded playback simultaneously on a split screen or on multiple screens. You may also choose to have the cameras look at something more interesting than the main event action, such as close-ups of the audience instead of the players on the field. Such cutaways, however, will not influence the actual clock time duration of the main event.

This event-dependency has interesting aesthetic consequences: The televised event has the same "open future" as the real event. This means that even if the outcome of the real event is predictable, it is not predetermined. As in real life, the unexpected can occur at any time. More so, such an event-dependency allows us as viewers to participate in the process of becoming; it involves us in the event and affords us a glance at the continual creation of the world, however humble its scale. Bound by time and closeness to the actual event, the television audience of the live transmission may well lose some of its usual heterogeneity and become a more closely knit social aggregate. Perhaps when millions of people watch the same live event on television, we may come closer to achieving a true global community than through world politics.

LIVE TELEVISION AND SUBJECTIVE TIME VECTORS

Recall the earlier suggestion that the present is not so much a fixed address in the time continuum as a mode of subjective time. As such, viewers perceive a live event more in terms of relative involvement than as the passing of time. As producers we have no control over the direction of the objective time vectors in a live telecast, but we can still influence the magnitude of the subjective time vector, that is, the degree of involvement and participation in the event. Changes in the field of view (within the usual range from extreme long shots to extreme closeups), shifts in points of view (various angles, above- and below-eye-level camera positions), instantaneous editing (switching) rhythm, and the manipulation of other appropriate aesthetic elements, such as lighting and sound, can all contribute to a higher magnitude of the vertical subjective time vector (deeper viewer

involvement). For example, a close-up of the action, the careful selection of event details, and high-energy colors and sound all contribute to a higher-energy screen event than would a continuous long shot of the action.

But with this in mind, should you always try to achieve maximum event energy regardless of the actual nature of the event and your communication intent? What if the event is basically low-energy? There are several different schools of thought on this topic. One school defends a minimum of event manipulation by the medium, advocating that the televised event should primarily be a simple reflection of the original event. The other defends event manipulation by the medium on the basis that the medium itself is an integral part of the event and that the televised event by its very nature is different from the actual event.

Which school of thought is right? Both are. As discussed in chapter 11, the relative amount of medium manipulation depends principally on your communication intent—that is, on whether you use the medium for looking at, looking into, or creating the event.

Looking at When looking at an event, the medium should intrude as little as possible. In this case, television should reflect the live event as directly as possible. This means the objective time of the actual event and that of the televised event are identical. The subjective time vector is also similar to that of the actual event. In such circumstances you should follow the rhythm of the actual event as closely as possible in your medium event, along with all its low-energy and high-energy points.

Looking into When looking into an event, you should use the medium to look closely, to probe, to reveal both its external and internal structure. Television now becomes more than a neutral spectator. Through clarification and intensification techniques, the medium manipulates the energy of the event. It is not unusual, therefore, that with the looking into approach, the subjective time vector of the televised event attains a higher magnitude than that of the actual event.

Creating When creating, the only event that counts is the screen event. Now the actual occurrences merely serve as raw material for the screen event, even if they take place simultaneously. Although in a live telecast you cannot change the direction of the objective time vector—the order of event segments—you can still change their rhythm. Assuming that your communication intent does not go against communication ethics, you can generate an event density that is quite different from that of the actual event. For example, fast cutting and tight close-ups may well give a relatively low-energy awards show the appearance of a high-energy extravaganza.

Time Vectors in Recorded Television and Film

As soon as an event is recorded on videotape, on some other electronic recording device, or on film, it has become a record of the past. As such it is totally free from the relentless unidirectional flow of time. Now you have the opportunity to construct your own event time with its own objective and subjective time vectors. If you want, you can put the end of the actual event at the beginning of your screen event, and the middle at the end. You can change an especially slow portion of the actual event into a fast one and vice versa through editing. As you can see, the television or film event is largely medium-dependent.

Although editing constitutes a major phase of film production, not all television recordings require, or even tolerate, editing. In the context of editing for manipulating objective and subjective time, you may do well to take a

closer look at the various types of television recordings and their intended communication objectives: live-on-tape and instant replays.

LIVE-ON-TAPE

Live-on-tape means that the live telecast is recorded for unedited playback at a later time. This technique is almost always used to have the program start at the same hour in different time zones. The audience is usually told that it is a "live" telecast recorded for delayed playback. But then it isn't really a live telecast anymore, since the major criterion—the simultaneity of actual and televised events—no longer applies. Does it matter? What if the viewer doesn't know that it has been recorded and believes that it is, indeed, a live telecast? We'll address this tricky subject by looking at the relative magnitude of the subjective time vector and the factor of aesthetic entropy.

Vector magnitude If you are totally unaware that the screen event is a delayed version of a live telecast, your involvement may well be as intense as if you were watching a truly live telecast. Still, because your aesthetic experience is based on a perceptual fallacy, it becomes rather precarious. You are fooled into a pseudoexperience of becoming, of changing with the event, of experiencing the living present when actually you are presented with a record of the past in which the outcome of the event is at this point predetermined.

As soon as you become aware that the program is a recording, the subjective vector magnitude inevitably decreases. Even if you are still very much interested in the event, chances are you distance yourself from the televised event; you tend to change from highly involved event participant to slightly less involved event viewer. Your relative involvement in the live-on-tape telecast is also greatly affected by knowing the outcome of the actual event while watching it on television. For example, if you have heard on the radio the final score of a football game before watching the live-on-tape telecast, you will probably react quite differently to the presentation than your friend, who does not know the outcome of the game. While he may get very excited about a last-second field goal attempt, you may get annoyed by all the media hoopla (close-ups and announcer's screaming), knowing full well that the kick will fall short and the game will be lost. As you can see, the very same screen action can produce subjective time vectors of entirely different magnitudes, depending on whether the viewer knows the outcome of the event. Once you know the outcome, you are hard-pressed to maintain interest during the slow periods of the game.

Aesthetic entropy As soon as you have recorded the present, aesthetic entropy sets in. The recording of the event becomes subject to your attitude changes, depending on how far removed in time you are from the event and the context that may change over time. In most cases, the subjective vector magnitude gradually decreases in intensity; you become less and less involved in the event. "Time heals" is the popular but correct interpretation of the entropic process of a particularly unpleasant or sad event.

In television and film, you can combat this energy loss by editing before reshowing. Condensing an event into its highlights through editing is often a necessary reenergizing procedure when the event is replayed at a later date. Because of this entropy factor, there is some justification to the "hot news" concept. With few exceptions, news events are important only within their immediate time context. When the recorded news gets communicated as soon after the actual event as possible, the recorded event still lives off the energy of the original event. The longer you wait, however, the less relevant the recorded event becomes and

the more rapidly the event energy dissipates. But does this mean that every recorded television event or every film automatically becomes obsolete with time? What about "classic" movies and television shows?

It seems that classic films or television programs—or any other pieces of high-quality art—resist aesthetic entropy because they carry universal messages (in form and content) that are not easily rendered useless by contextual changes dictated by history or personal attitudes. Thus they remain meaningful to us despite the passage of time. ¹⁸

INSTANT REPLAYS

Instant replays are live-on-tape recordings of event highlights that are played back immediately after they have occurred in the actual event. Although instant replays are quite informative, they still constitute an aesthetic discrepancy. Because most sports telecasts fulfill a looking-at function—that is, they try to reflect the actual event as much as possible—the rhythm of the screen event approximates the rhythm of the actual event. But instant replays interrupt the flow of the actual event and create an event rhythm all their own. You could argue that commercials do the same—they represent an aesthetic discrepancy as far as event flow is concerned unless they are inserted in such natural event breaks as time-outs. Instant replays become even more of an aesthetic paradox during a live telecast if they occur at important moments in the live event. In this case, you must again revert to instant replay to show the missed action. If you are not careful, you may wind up showing more event time as a recording than live. Of course, instant replays are a great asset for audience members and referees who may want to analyze a particular action in order to pass immediate judgment on it.

Time Vectors in Edited Videotape and Film

The time vectors in edited videotape and film are independent of the actual event and are a *construct* of the screen event. Through editing you can change the time order of past, present, and future. For example, a flash-forward will interrupt the normal cause/effect development of a story and provide viewers with a brief glimpse of a future event. In a flashback, the cause/effect time vector of the story is interrupted by flashes of past events. Or you may want to reverse the usual time vector of the screen event altogether and have the effect occur before the cause. For example, when you want to chart the growth of a plant, you will most likely follow the horizontal time vector and show its development from seed to fruit-bearing maturity to decay. After internalizing an event, however, you may no longer "see" it in quite this order. You might first think of the plant in full bloom, then how the fruit tasted, then how someone prepared the soil and planted the seedling. Obviously, the logical, unidirectional time vector no longer applies. What you are now doing is editing by emotion, that is, creating a high-magnitude vertical vector.¹⁹

The subjective time vector yields to equally high manipulation. As pointed out earlier, you can take an originally high-energy and involving event and render it low-energy and rather neutral. Or you can take a low-energy event and make it highly dramatic and involving.

Does this mean that after an event is recorded on film or television we no longer have to worry about possible aesthetic differences between the two media? Not at all. As you will see in the following chapter, time and motion are the principal factors that determine the structural uniqueness of each medium and contribute to the aesthetic differences between the two.

Summary

We distinguish among three types of time: objective time (clock time), subjective time (psychological time), and biological time. Objective and subjective time are especially important for television and film. Objective time is what the clock says; it can be measured quantitatively. Subjective time is felt duration; it is perceived and processed qualitatively. Objective time is a horizontal vector that indicates quantity. Subjective time is a vertical vector that indicates our relative involvement in an event and the relative absence of any objective time-consciousness. The more involved we are in an event, the less aware we are of clock time passing, which we interpret in retrospect as having a short duration. If we are not involved in an event, we become aware of clock time and tend to interpret such awareness as long event duration.

The magnitude of the vertical vector of subjective time (degree of involvement and how much or little we are aware of clock time) is influenced by event intensity, event density, and experience intensity. Biological time operates quantitatively, which means that it regulates our behavior according to an internal clock time.

We experience time as going in one direction: from past, to present, to future. And though we can establish past and future events as "addresses" on the time continuum, we cannot do this with the present. When we are conscious of the present, it has already occurred or has not yet happened. Aesthetically, we therefore consider the present as belonging to subjective rather than objective time. Subjective time is qualitative rather than quantitative. Thus, the present is a vertical time vector.

Live television means that the actual event and the televised event are happening simultaneously. The televised event is inevitably tied to the objective time vector of the actual event. The live telecast is event-dependent; that is, it is bound by the progression of the actual event.

Through various production techniques, we can clarify and intensify the original event, although in live television we remain tied to the time flow of the actual event. The degree of manipulation of the subjective time vector depends on whether we use the medium to look at, to look into, or to create the event.

As soon as an event is recorded on videotape or film, the screen event becomes medium-dependent. When this happens, the objective as well as the subjective time vectors are open to medium manipulation. The two basic types of event recordings are live-on-tape and instant replays.

Instant replays are the live-on-tape recording of especially important event actions and their immediate replay. They are highly informative and valuable for quick analysis of the event action. But because they interrupt the time flow and rhythm of the actual event, they represent a basic aesthetic discrepancy.

When an event is recorded for postproduction editing, the screen event is totally independent of the objective and subjective time vectors of the original event. The screen event now becomes a new construct with its own objective and subjective times.

NOTES

- 1. Remy Lestienne, *The Children of Time: Causality, Entropy, Becoming,* trans. by E. C. Neher (Urbana, Ill.: University of Illinois Press, 1995). See also Joshua Meyrowitz, *No Sense of Place* (New York: Oxford University Press, 1985).
- J. T. Fraser, Time, the Familiar Stranger (Amherst: University of Massachusetts Press, 1987).

- 3. John Boslough, "The Enigma of Time," *National Geographic* 177 (March 1990): 109–132.
- 4. Thomas Wolfe, The Web and the Rock (New York: Grosset and Dunlap, 1938), p. 626.
- László Moholy-Nagy, Vision in Motion (Chicago: Paul Theobald and Co., 1947), p. 268.
- 6. Paul Davies, *About Time: Einstein's Unfinished Revolution* (New York: Touchstone, 1996), pp. 21–24. See also Boslough, "Enigma of Time," pp. 112–116, 121–126. Still one of the best popular explanations of Einstein's relativity of time is the chapter on the Einstein revolution in Samuel A. Goudsmit and Robert Clairborne, *Time* (New York: Time-Life Books, 1961), pp. 144–165.
- 7. Philip Kipper, "Time Is of the Essence: An Investigation of Visual Events and the Experience of Duration." Paper presented at the Conference on Visual Communication, Alta, Utah, 1987.
- 8. Henri Bergson, *Time and Free Will*, trans. by F. L. Pogson (New York: Harper Torchbooks, 1960), pp. 197–198. The difference between quantitative and qualitative time is further discussed in Stephen C. Pepper, *World Hypotheses* (Berkeley: University of California Press, 1970), p. 242. See also Robert M. Pirsig, *Zen and the Art of Motorcycle Maintenance* (New York: William Morrow and Co., 1974).
- 9. The term *zero-time* for a high-magnitude subjective time vector was suggested by Philip Kipper, San Francisco State University.
- 10. Circadian comes from the Latin circa ("about") and dies ("a day"), referring to the approximate day/night cycles of biological clocks.
- 11. David Park, *The Image of Eternity* (Amherst: University of Massachusetts Press, 1980) pp. 51–53. There is no reason, however, why the arrow of time could not go in the opposite direction. See Davies, *About Time*, pp. 197–232.
- 12. Saint Augustinus, *The Confessions of St. Augustine*, book XI, sec. x–xxxi (Chicago: Henry Regnery Co., 1948), p. 196.
- 13. Saint Augustine, Confessions, p. 196.
- 14. Fritjof Capra, *The Tao of Physics*, rev. ed. (Boulder, Colo.: Shambhala Publications, 1991).
- 15. Jürgen Rausch, "Ökonomie unserer Zeit," in Hans Jürgen Schultz (ed.), *Was der Mensch braucht* (Stuttgart, Germany: Kreuz Verlag, 1979), pp. 384–394. In the conclusion of his article on the philosophy of time, Rausch says: "It is the mystery of time that eternity can fit into it" (p. 394).
- 16. Often a television signal is sent up to and received from two satellite links traveling a total of 89,200 miles. Even at the speed of light, such travel takes almost half a second (0.4795 second).
- 17. The device is a frame store synchronizer, which stores one complete video frame at a time in order to synchronize its scanning cycle with other video sources that are not synchronized through nondigital devices.
- 18. For a discussion of the seeming discrepancy between entropy in nature and negative entropy in art, see Rudolf Arnheim, *Entropy and Art* (Berkeley: University of California Press, 1971).
- 19. Walter Murch, *In the Blink of an Eye: A Perspective on Film Editing* (Beverly Hills, Calif.: Silman-James Press, 1995), pp. 17–20.

The Four-Dimensional Field: Motion

HE previous chapter explores time as an important element in the four-dimensional field. This chapter takes a closer look at one of the most obvious manifestations of time—motion. It is primarily the various aspects of motion that help us define the four-dimensional field in media aesthetics and also distinguish between the fundamental structural differences of television and film. Indeed, the differences in motion may well be the key to each medium's unique aesthetic requirements and potentials.

This chapter examines five major areas: (1) motion and media structure, (2) motion paradox, (3) z-axis motion, (4) slow motion, and (5) accelerated motion.

Motion and Media Structure

In order to uncover one of the fundamental structural differences between film and television, we consult two rather unlikely sources: the Greek philosopher Zeno of Elea and the French philosopher Henri Bergson. Their ideas about time and motion prove quite helpful in demonstrating the differences between film motion and television motion.

ZENO AND FILM

Like most Greek philosophers, Zeno tackled the problem of time by analyzing motion. He saw motion basically as an infinite number of "frozen" positions in space. Applying rigorous logic, he developed the by-now celebrated and often refuted paradoxes of motion. These paradoxes all try to prove that motion is impossible and only an illusion. His basic argument can best be illustrated through stroboscopic, or strobe, photography of motion.

Let us assume that you are showing Mr. Zeno how a strobe works. Because Zeno is fond of archery (he explains several of his motion paradoxes using the motion of arrows), you have the subject you are photographing draw a bow. For your first shot, you set the strobe to three light flashes per second. **SEE 13.1** The subsequent print reveals three static images of three different bow positions. **SEE 13.2** Next you set the strobe to five and then to seven strobes per second. The photographs show five and seven static bow positions. **SEE 13.3**

13.1 Three Static Positions Through Strobe

With the strobe light set to three flashes per second, we see three static positions of the moving objects (bow and arrow).

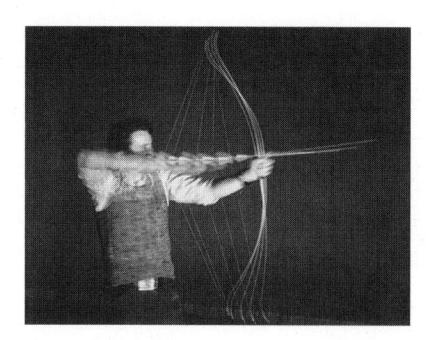

13.2 Five Static Positions Through Strobe

With five strobe flashes per second, we see five static positions of the moving objects.

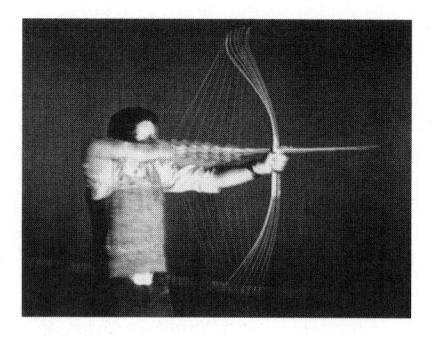

13.3 Seven Static Positions Through Strobe

Seven flashes show seven static positions of the moving objects. The faster the strobe light flashes, the more snapshots (static images) of the moving object we get, and the closer together the images are.

Zeno is excited and asks if you can have the strobe go much faster, say, a thousand times per second. The resulting photograph shows, as predicted, one thousand static positions. Zeno puts forth his ultimate request: to have the strobe flash infinitely fast during the motion of drawing a bow. Because you don't want to disappoint him, you set the strobe speed to infinity and ask the subject, who by now is getting somewhat tired, to draw the bow one last time. Sure enough, the print faithfully shows an infinite number of static positions, each one lying infinitely close to the next. Zeno is clearly ecstatic. You have proved his assumption that motion is merely an infinite number of static positions. "But how can we get from one of the infinite static positions to the other?" Zeno asks. Because between the two lies another set of infinite positions, logically, we can't seem to get there. Motion is impossible—or at least it is an absurdity.

Despite this rather impressive logical proof that motion is impossible, you invite Zeno to get out of his chair and follow you to your film and television screening room. On the way, he studies various photographs you have taken of dancers. He is mildly interested in a blurred photograph, which seems to prove that the dancers were, indeed, in motion when the picture was taken. **SEE 13.4**

Basically, **Zeno** asserted that if a thing moves, it moves either where it is or where it is not. It cannot move where it actually is, however, because there it is at rest. Where it is about to move toward, it is not as yet. Because the thing cannot exist where it is not, it cannot possibly move there either. Therefore, he concluded, motion is impossible.

Here is one of his paradoxes that is especially relevant to our discussion of the basic structural unit of film: So long as anything is in a space equal to itself, it is at rest. An arrow is in a space equal to itself at every moment of its flight and therefore also during the whole of its flight. Thus the flying arrow is at rest.

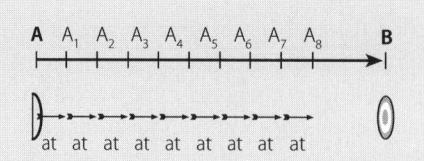

At position 1 (beginning of its flight), the arrow occupies space from A to A1; at position 2, it occupies space from A1 to A2; at position 3, the space from A2 to A3, and so on ad infinitum. At every instant of its travel path from A to B, the arrow is actually at rest. The arrow is always at a particular point. This concept of motion is, therefore,

referred to as the "at-at" theory of time. But how can it then be in motion? How, for example, can we get the arrow from static position 1 to static position 2, especially since the positions lie infinitely close together? Motion, therefore, is an absurdity. So concludes Zeno. Fortunately, nobody shot an arrow at him to disprove his point.

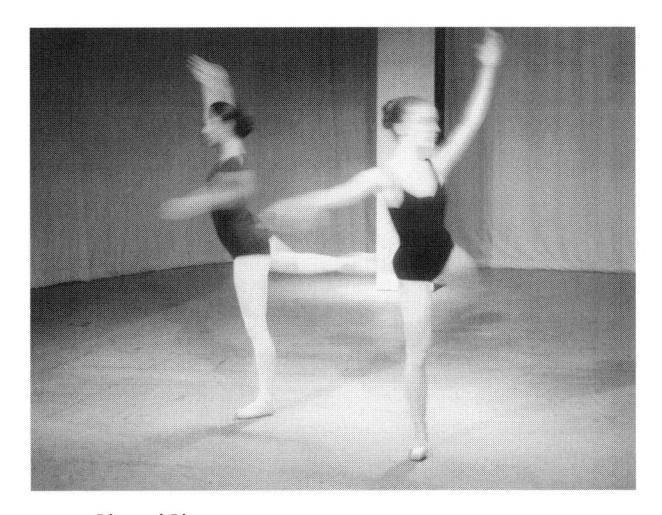

13.4 Blurred Photo

Even a blurred photo of an object or subject in motion is only a great number of overlapping static positions, in this case of the two dancers. The photo does not show actual movement.

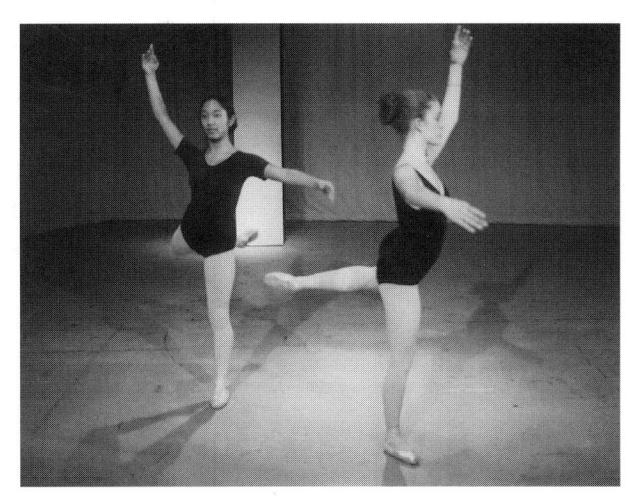

13.5 Arrested Motion

When the shutter speed is increased, we perceive single static positions of the dancers.

His defense is that the picture actually shows several static positions simultaneously and that you are not observant enough to see the infinite number of static positions within the blurred image.

Zeno points to the next photo of the same dancers, which you had taken with a higher shutter speed. Now the dancers appear at rest. Their motion—that is, their travel through space—was evidently so small during the brief period of exposure that to the camera their motion was undistinguishable from a person at rest. **SEE 13.5** He claims that this photograph is further proof that objects that appear in motion are actually at rest at various points in space and time.

You are beginning to understand why Zeno has so much interest in film. Much like strobe photography, film photography involves taking a great number of snapshots of a moving object. Each of the snapshots, or frames, shows the object at rest, so that when you hold and enlarge a single film frame, you cannot tell whether the object was stationary or in motion when the picture was taken. After seeing a film, Zeno is more than pleased. You have provided him with further and more impressive validation of his theory that motion is only an illusion. In turn, he has helped us gain fundamental insights into the structure of film.

BASIC STRUCTURAL UNIT OF FILM

Film motion, like that of Zeno's arrow, is an illusion. Film does not move, but makes us see things that move in our minds. The only actual motion in film occurs when the projector pulls frame after frame in front of the light source. During this motion, the screen is blacked out, and we are not allowed to witness the pulldown of each frame. As soon as a film frame reaches the gate, it stops temporarily and the projector light is allowed to shine through that frame to project it onto a screen. Assuming a projection rate of 24 frames per second, we could conceivably use twenty-four slide projectors and fire them one at a time within one second. The net effect would be exactly the same as that of the "moving" film. Thus, you can think of film as a great number of slides glued together for easier projection. Film motion is created by showing a number of static positions in sequence, each of which is slightly advanced from the previous position. **SEEE 13.6**

object at rest.

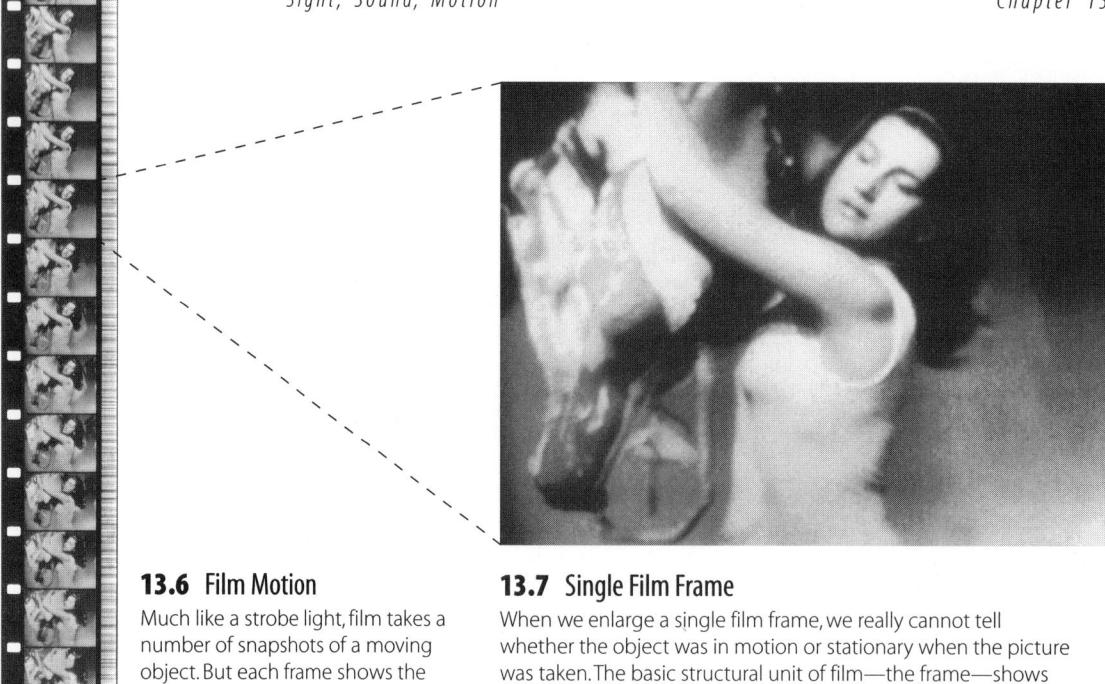

the object at rest.

In film the projected image is always at rest. The important thing to remember is that the basic structural unit—the film frame—shows the object at rest regardless of whether the object is in motion or not. **SEE 13.7** Please realize that we are talking about the *basic aesthetic structure* of film, not how we perceive film motion through persistence of vision.

"AT-AT" MOTION OF FILM

Just like Zeno's arrow, which occupies an "at" position during every stage of its flight, every frame of film shows an "at" position in the time continuum, a snapshot of part of the motion. **SEE 13.8** Thus the "at-at" theory, adopted from Zeno's concept of motion, consists of a series of static "at" positions in space and time, each differing to some degree from the previous one. The more the "at-at" object positions change from shot to shot, the faster we perceive the object movement to be. **SEE 13.9** The less the position change is from frame to frame, the slower we perceive the object to move. **SEE 13.10**

Because in film, motion is broken down into a series of small, discontinuous, static increments (frames), we can examine and control each of these frozen instances of motion. We can leave them in their original sequence or we can change them around. We can add some, cut some out, or put in some parts from an entirely different event. Because in film we deal with recorded "at-at" instances rather than an uninterrupted fluid action, we have full control over how we want the film action to be perceived. Thus we have control over the very structure of the four-dimensional field of film. The following two chapters cover the various possibilities and principles of motion structure in film and videotape.

BERGSON'S MOTION

Contrary to Zeno, who saw motion as a series of discrete, static positions and time as a string of discontinuous immobile moments, Henri Bergson contends that motion is a dynamic process, a duration with continuous flow of time, which he called *durée*.²

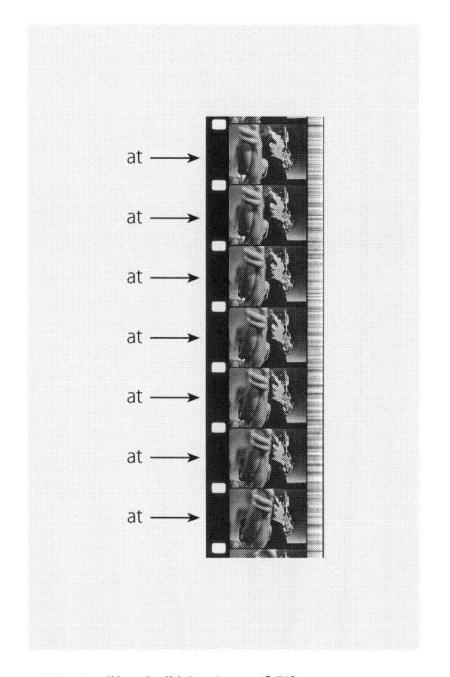

13.8 "At-At" Motion of Film Each film frame shows a specific "at" position of the object motion.

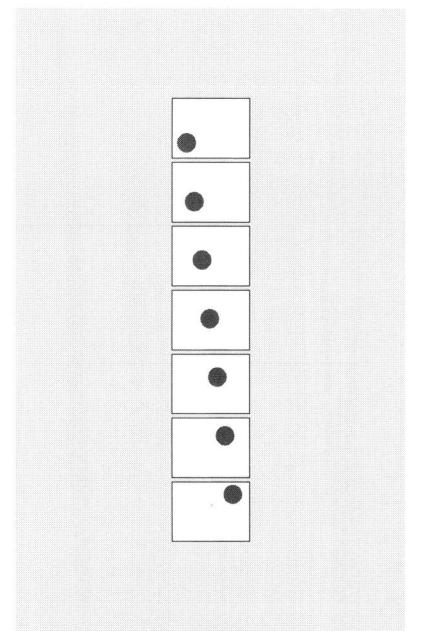

13.9 Faster Object Motion
If the "at-at" positions of a moving object differ greatly from frame to frame, viewers perceive the object as moving relatively fast.

13.10 Slower Object Motion
If the "at-at" positions of a moving object differ to only a small degree from frame to frame, viewers see the object as moving relatively slowly.

So far as the infinite number of static positions of Zeno are concerned, Bergson sees things differently, believing that motion is an indivisible, continuous succession of states driven by a neutral (internal) flow.³ In the case of the bow and arrow, Zeno would argue that the arrow never hits the target because it cannot move from one static position to the other. In contrast, Bergson says that the arrow simply flies from bow to target in a single continuous motion during which the arrow is never in one specific position at any given moment during its flight.

French philosopher **Henri Louis Bergson** (1859–1941) dealt with the problem of time, free will, and the whole of human existence. "Take the flying arrow. At every moment, Zeno says, it is motionless for it cannot have time to move, to occupy at least two successive positions, unless at least two moments are allowed it. At a given moment, therefore, it is at rest at a given point. Motionless in each point of its course, it is motionless during all the time that it is moving.

"Yes, if we suppose that the arrow can ever 'be' in a point of its course. Yes, again, if the arrow, which is moving, ever coincides with a position, which is motionless. But the arrow never 'is' in any point of its course. The most we can say is that it might be there, in this sense, that is passes there and might stop there. It is true that if it did stop there, it would be at rest there, and at this point it is no longer movement that we should have to do with. The truth is that if the arrow leaves the point A to fall down at the point B, its movement AB is as simple, as indecomposable, in so far as it is movement, as the tension of the bow that shoots it. As the shrapnel, bursting before it falls to the ground, covers the explosive zone with an indivisible danger so the arrow which goes from A to B displays with a single stroke, although over a certain extent of duration, its indivisible mobility. Suppose an elastic stretched from A to B, could you divide its extension? The course of the arrow is this very extension; it is equally simple and equally undivided. It is a single and unique bound."

13.11 Bergson's Theory of Motion

In contrast to Zeno, who conceived of a moving object as occupying a great number of static "at" positions (a), Bergson contended that the motion of an object is indivisible and simply goes from one point at the beginning of a movement to another point at its end (b).

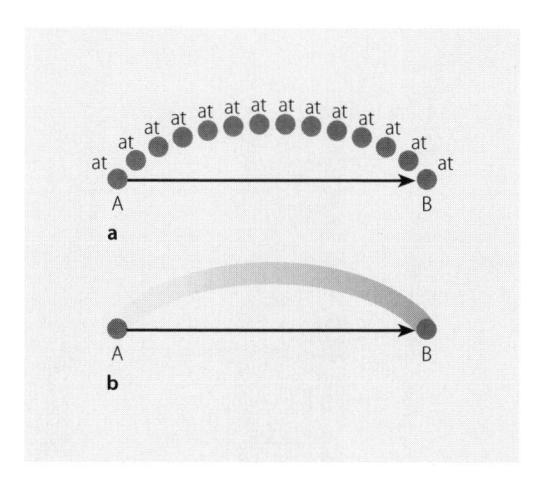

In effect, Bergson replaces Zeno's "at-at" theory of motion with a "from-to" theory of motion, which says that the motion of an object simply goes from one point to another at the end of the movement in one uninterrupted sweep. **SEE 13.11**

BASIC STRUCTURAL UNIT OF TELEVISION

After the elation of having his theories confirmed by film, Zeno is less pleased while watching a live football game on television. Somehow the way the image is formed does not seem to fit his "at-at" theory. Instead of seeing discrete pictures of arrested motion, similar to still photographs of various stages of "at-at" positions, he now perceives only a great number of dots that mysteriously light up and quickly decay again. Much to Bergson's delight, Zeno mutters something about having to think about the whole thing some more, shakes his head, and quickly walks back into the past.

The reason Zeno was so upset was that the basic structural unit of television (which includes all forms of analog and digital video, as well as computer displays) is quite different from that of film. Contrary to the basic unit of film—the frame, which you can hold, enlarge, reduce, project, and store in a box very much like a slide—the basic structural unit of television—the video frame—is always in motion.

THE PROCESS IMAGE OF TELEVISION

The television image⁵ is in a continuous flow, an image in flux, a process, even when it displays an object at rest. Regardless of whether it is analog or digital, the color television image relies on constantly moving electron beams for its existence. Because the mosaiclike dots of the television screen light up only temporarily and change their brightness according to how hard they are hit by the electron beams, the television image is never complete. While some of the screen dots are lighting up, others are already decaying. **SEE 13.12** Like Bergson's continuously moving arrow, it is never at rest but is in a continuous state of change.

But what about television frames? Can you not identify them by numbers and work with them in editing similar to film frames? Yes, but even the television frame can exist only through process, through the constantly scanning beams of the many dots that make up the frame. Even when we display a freeze-frame, in

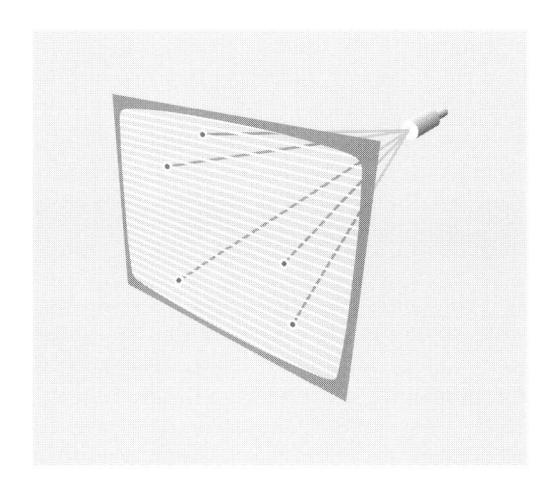

13.12 Process Image of Television

The basic unit of television—the television frame—is not a snapshot of an "at" position in the time continuum like a film frame; rather, it is an image in motion.

which a moving object is temporarily arrested when in a specific "at" position, the electron beams must be constantly and repeatedly "reading" the screen along prescribed scanning lines or a prescribed mosaic pattern in order to make the image visible. Regardless of its mode, the mosaiclike television image is truly a process image.⁶ **SEE 13.13**

DIGITAL VIDEO

In digital video you may presume that Zeno and Bergson are coming a little closer together. Each digital image is made up of many individual picture units—called *pixels*—each of which has its own "at" computer address. In digitizing lensgenerated images (such as a television image), the computer samples a certain amount of picture details and translates them into individual values (numbers). In synthetic image creation, the software program creates a number of pixels that, when put side-by-side, form an image. These "at-at" addresses can then be stored

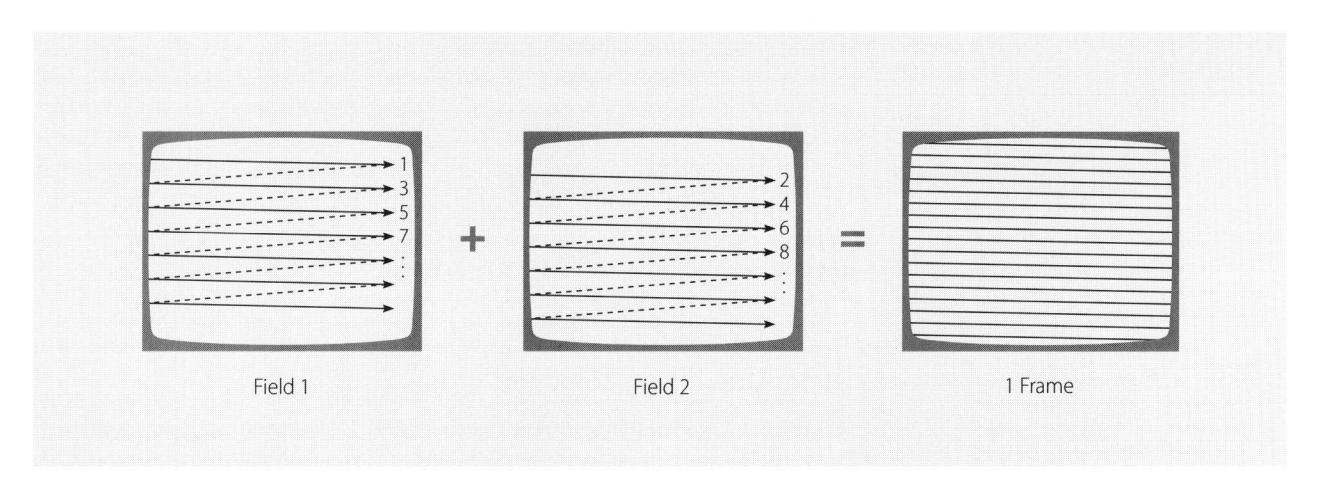

13.13 Television Scanning

In the basic television image creation, the electron beams first scan all odd-numbered lines from left to right, then all even-numbered lines. This is called interlaced scanning. The scanning of all odd-numbered lines constitutes a field; when all even numbers have been scanned, you have a second field. Both fields make up a complete television frame.

by the computer and retrieved on command. Zeno could be pleased if the pixels were visible by themselves, but they are not; they are merely magnetic charges. In order to make them visible, these charges must be scanned, very much like in analog television, by constantly moving electron beams (see figure 13.13). Depending on how hard they are hit by their respective electron beams, the dots on the television screen are in a constant flux; like analog television, the digital television frame is always in motion and always fragmentary. Bergson's theory of motion and digital television are still congruous.

Structurally, film has a certain historic permanency, much like a painting or a photograph. The television image, on the other hand, has an electronic immediacy regardless of whether it is live or videotaped, analog or digital. An isomorphic relationship, a structural similarity, exists between the evanescence of the scanning process and the fleeting "now" of the present.

PROCESS IMAGE OF LCD AND PLASMA DISPLAYS

Although technically ultimately more complex, both liquid crystal display (LCD) and plasma systems operate much like billboards that display their image by activating a great number of lightbulbs. The display screens of both LCD and plasma systems consist of a great number of pixels that can be individually activated by an electric charge or an ultraviolet light. Because they do not need electron beams to activate the pixels, they can be very thin. A laptop computer display is an LCD. Now we have a third type of image structure. So long as nothing moves, all necessary image pixels remain activated and display a relatively stable picture that is very similar to a pointillist's painting or the color dots of a magazine picture. If something moves, the various dots light up and decay in rapid order similar to that of the television image. It is no longer a static display, but has become a process image. As you can see, Zeno and Bergson are shaking hands.

FILM ON TELEVISION

But what happens when we show films on the television screen? After all, a large audience no longer views films in the theater but through a videocassette on the television screen. Do we not in these cases encounter basic structural discrepancies between film and television?

As discussed in chapter 6, screen size has a definite influence on how we perceive and interpret the various "landscape" (environmental) and "people" aspects of a film. In a less obvious way, the basic structural differences between film and television can influence considerably how we perceive films on television.

When a film is shown on television or dubbed onto videotape, the static frames of film are transformed into the scanning process of the television image. The "states of being" of the film frames change into the "processes of becoming" of the electronic television frames. Such a transformation is aesthetically quite acceptable if the main emphasis of the film was on character rather than plot, on *inscape* rather than *landscape*. The process of human existence and the process image of television are congruent. But if the film relies heavily on landscape, on environment, and on linear plot development rather than character development, its translation into a basically nervous and fleeting television image no longer seems appropriate. When shown on television, such films lose their grandeur. As you can see, landscape films suffer when shown on television not only because of their size reduction but also because of the structural change of the medium.

HIGH-DEFINITION TELEVISION

Large-screen projections of *high-definition television* (*HDTV*) are an aesthetic paradox. The large screen size and its wide-screen aspect ratio invite a landscape approach to the material shown, similar to that of wide-screen cinema. Also, contrary to the traditional low-definition television image, the high-definition television image is much closer in picture quality to that of 35mm film.⁸ But its images are nevertheless created by the television scanning process, which, as we have just discussed, is quite different from the static "at-at" positions of film frames.

Due to the similarity in image size and quality of HDTV to film, landscape films or television programs in which the environment plays a major role will suffer little if at all when shown as a large-screen television projection. Assuming a high-definition image quality, the more-hidden structure of the television scanning process will not interfere, even on a subtextual level. In addition, the process image of television will be a great asset when people-oriented material appears on a large screen. Inscape films and television programs attain an electronic immediacy without sacrificing the basic energy derived through sheer screen size.

The large high-definition screen invites spectacle, in which the myriad digital video effects will have a field day. Because the electronic effects need no longer be translated into the film medium, they obtain an uncanny aesthetic aliveness and presence.

The emphasis on environment, outer action, and special effects may well influence the basic dramatic structure of television plays. The large screen, with its potential for spectacle, invites us to write plot-oriented rather than character-oriented stories. Very much in the tradition of action films, the characters' actions will now be driven by outer circumstances and the environment in which the event takes place, rather than springing from inner conflicts. As explored in chapter 17, the sound track must now be equally high-definition, which means that it has to match the aesthetic energy of the pictures.

What will get lost in such a projection is television's intimacy—our considering television as part of our routine home environment and the typically

close personal space that exists between the television performer and the viewer. In the home-theater context, we become more event spectators than event participants, regardless of the basic nature of the material presented.

Motion Paradox

Motion is a change of position of one object in relation to another. If we stand still and watch a thing move, we see it change its position from a "before" to an "after" position. But if you move *with* the object at the same speed, you may not perceive any motion. For example, if you ride in an airplane, you are in motion relative to the more stable earth; but when sitting in your seat, you are at rest relative to the plane itself. **SEE 13.14** When you walk toward the front of the plane, the motion relationships become more complex. You are moving relative to the people in their seats. You are also moving even faster than the plane relative to the earth as you walk toward the cockpit. **SEE 13.15** Such a *motion*

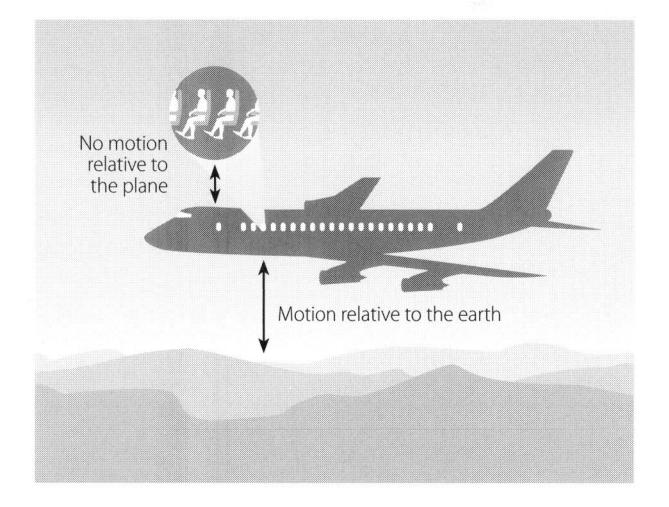

13.14 Motion Paradox: Object at Rest and in Motion In reference to the airplane, the person inside is at rest.

But in reference to the earth, the person is in motion.

13.15 Motion Paradox: Relative Speed

When walking toward the front of the airplane, the passenger moves relative to the airplane and faster than the airplane relative to the earth.

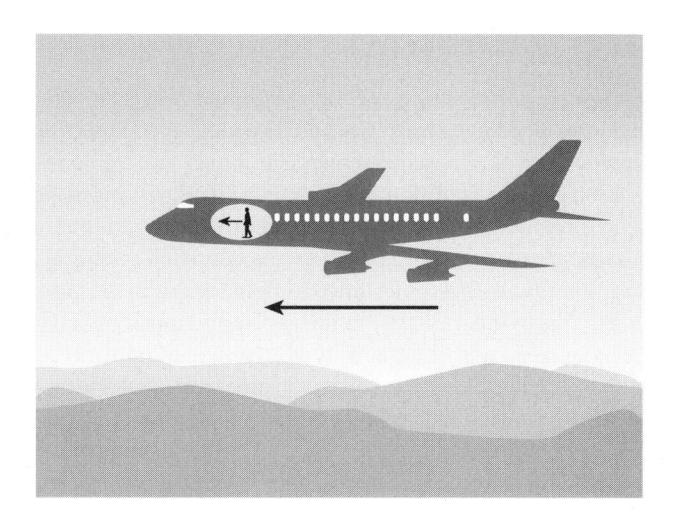

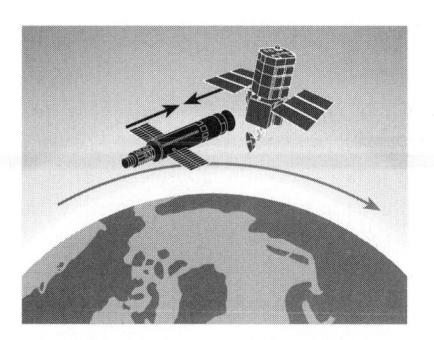

13.16 Motion Paradox: Zero Speed Even when moving at great speeds relative to the earth, these spaceships

move very slowly and, when docked, not

at all relative to each other.

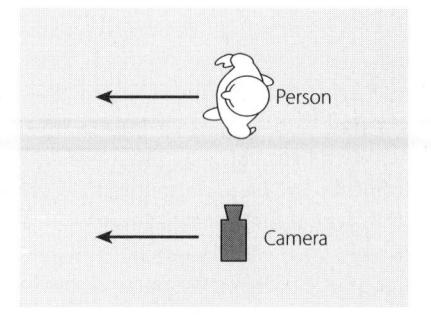

Perceived Zero Speed
When the camera travels at the same speed as the object, we cannot detect object motion in an unarticulated space.

13.17 Motion Paradox:

paradox occurs whenever an object is in motion and simultaneously also at rest.

Regardless of how fast a spaceship is traveling relative to the earth, its motion approaches zero relative to another spaceship during docking. **SEE 13.16** The same motion paradox occurs if the camera trucks with a moving object at identical speeds. Assuming that the space is unarticulated and that the camera is handled extremely smoothly, you will not notice any object movement on the screen. **SEE 13.17**

This, then, is the *motion paradox*: An object can be in motion and at rest at the same time. The *aesthetic motion paradox* is that an object can be in motion and perceived at rest, or at rest and perceived in motion.

FRAMES OF REFERENCE

Whenever you perceive motion, you automatically establish a frame of reference by which you judge the direction of the vector and its relative speed. This frame of reference is basically a *figure-ground* relationship. As explained in chapter 7, the figure is less stable than the ground. You normally perceive a moving object

relative to its immediately more stable environment. What you do, in effect, is to establish hierarchical relationships of dependence.¹⁰

The most basic frame of reference for motion is the television or motion picture screen. Assuming a plain background, such as a cloudless sky, you perceive the motion of an airplane against the edges of the screen. **SEE 13.18**

Within the screen, the larger object (ground) usually serves as a frame of reference for the motion of the smaller one (figure). For example, the walls of your room are the stable frame of reference for you moving about your room. Or if you show someone walking along a downtown street, the houses—and not the edges of the television or movie screen—become the primary stationary reference for the motion of the person. **SEE 13.19** But if you now show a fly buzzing around that person's head, as viewers we most likely judge the motion of the fly against the relatively more stable person, even if he or she is in motion, rather than against the houses. The person, and not the row of houses, has now become the immediate frame of reference for the fly. **SEE 13.20**

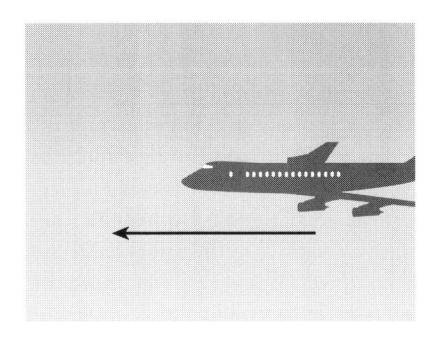

13.18 Screen as Frame of Reference In the absence of other spatial clues, the screen becomes the basic frame of reference for object motion. Thus we judge the airplane's motion by its position change

relative to the frame.

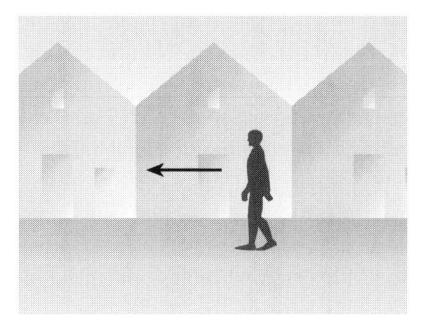

13.19 Houses as Frame of Reference When looking at a man walking along the street, the houses and not the screen become the stable reference against which we judge the man's motion.

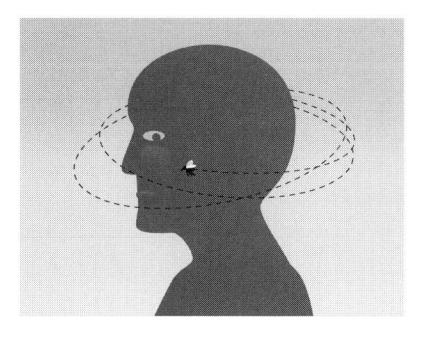

13.20 Person as Frame of Reference When a fly buzzes around the same man's head, we judge the motion of the fly not against the houses but against the immediately more stable reference—his head.

FIGURE-GROUND REVERSAL

Sometimes the motion paradox can play tricks on us, especially when we are confused about which object is doing the moving. Most likely, you have experienced such motion relativity when sitting in a train alongside another train. Instead of seeing the other train as moving out slowly, you may perceive your train, which is still waiting for its departure, as rolling backward. The same figure-ground reversal can occur when you sit in your car next to a large bus, waiting for the stoplight to turn green. When the bus inches forward, trying to get a jump on you, you may feel as though your car is rolling backward even though your foot is on the brake. **SEE 13.21**

Because our figure-ground frames of reference are so strong when perceiving motion, we do not give them up easily. This is why you can simulate object motion on the screen by having the object (figure) remain stationary and the background (ground) in motion. **SEE 13.22**. For

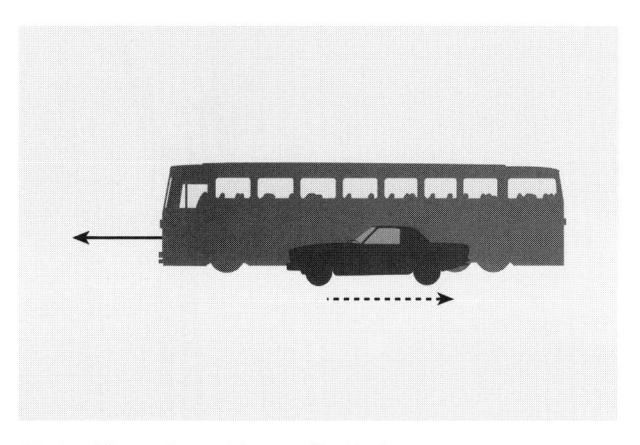

13.21 Figure-Ground Reversal in Motion

When both a car and a bus are temporarily stationary, and then the bus begins to inch forward, the car's driver may think that the car is rolling backward.

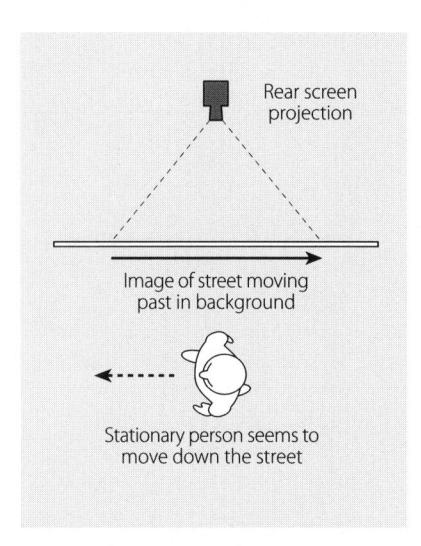

13.22 Figure-Ground Reversal

If you show a person stationary in front of a rear-projection or a blue screen (for chroma keying) that displays a moving street, viewers perceive the person (figure) doing the moving against the seemingly more stable ground (the street) even if they know about the figure-ground reversal.

example, we automatically translate a shot of a stationary car shown against an electronically keyed "moving" street scene as a car racing through the city streets. Once again, our immediate frame of reference for motion is the city streets, which we perceive as the stable ground against which the less stable figure—the car—is moving. In our perpetual quest for a stable environment, we simply cannot admit perceiving the street as doing the moving behind a stationary car.

Although we accept quite readily the figure-ground reversal within the motion frames of reference, in some cases we might become confused and actually perceive the ground as doing the moving. For example, if you begin a sequence with a subjective dolly shot down an empty street, as viewers we use the screen as the immediate reference. Consequently, the houses and the street seem to be doing the moving rather than the camera, which represents a person walking down the street. In this case, you would first need to establish the immediate reference—the person walking down the street—before switching to the subjective camera point of view. By first showing the person walking along the street, you establish the street as the stable ground and the person as the moving figure. As viewers we carry this frame of reference over into the next shot.

As mentioned in chapter 11, there are some instances in which even though we know which object is doing the actual moving, we are not willing to let reason overrule perception. Let's revisit the racecar example from chapter 11. With a television camera mounted behind the driver during a race, we don't perceive the car as doing the moving, but rather the racetrack. Why? Isn't the racetrack the more stable ground and the car the less stable figure? Yes. However, this is a perfect example of the motion paradox. Even if the car is traveling at 200-plus miles per hour relative to the racetrack, it is not moving at all relative to the camera. All you see is the driver's head bobbing and his arms handling the steering wheel and the gearshift. Because the car remains immobile relative to the camera, its screen image remains equally immobile relative to the screen borders. The stable image of the car has now become the stable reference against which you judge the changing screen image—the racetrack.

Z-axis Motion

The perceived speed with which an object moves toward or away from the camera along the z-axis is greatly determined by the lens (zoom lens positions) you use. Recall from chapter 9 that the specific focal length of a lens has a great influence on the relative size of an object. Because we automatically interpret object size into relative distance, we perceive a small screen image of an object as farther away from the camera than a larger screen image of the same object.

When we show a series of shrinking circles in sequence, we perceive them not as getting smaller but as moving along the z-axis away from us. The reverse is true when the circles get bigger. **SEE 13.23**

PERCEIVED OBJECT SPEED: WIDE-ANGLE LENS

A wide-angle lens exaggerates the perceived z-axis speed, or the speed with which an object appears to move toward or away from the camera. With a wide-angle lens, an object moving away from the camera gets rapidly smaller even when it traveled a relatively short distance along the camera-near end of the z-axis. We therefore perceive this rapid change in image size as increased z-axis speed. The wide-angle lens boosts the magnitude of the z-axis motion vector. **SEE 13.24**

Once the object reaches the far end of the z-axis, the same amount of travel no longer causes the rapid change in object size; the object seems to move more slowly toward the horizon.

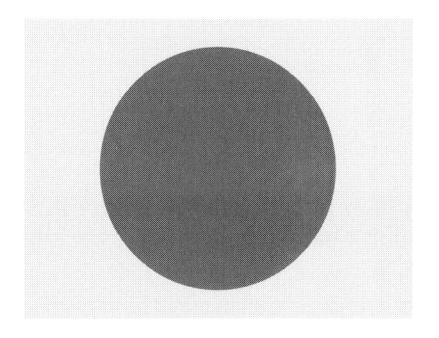

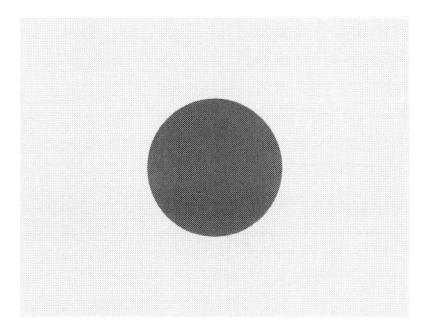

13.23 Simulated Z-axis Motion

When shown in sequence (through film or computer animation), we would perceive these circles not as getting smaller but as a single circle moving along the z-axis away from us. If played backward, the circle would seem to be coming toward us.

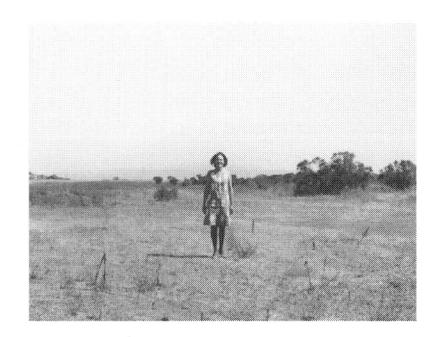

13.24 Z-axis Motion Vector: Wide-Angle Lens

When using a wide-angle lens, the image size of this person walking toward the camera along the z-axis changes considerably. We interpret this change as meaning that she is moving relatively fast.

13.25 Z-axis Motion Vector: Narrow-Angle Lens

When using a narrow-angle lens, the image size of the woman moving along the z-axis does not change very much even though she is covering the same distance at the same speed as in figure 13.24. We perceive this similarity of image size as her moving relatively slowly.

PERCEIVED OBJECT SPEED: NARROW-ANGLE LENS

When using a narrow-angle lens, however, the image size of the person changes only very slightly, even though she is covering the same distance in the same amount of time. We interpret this small change in image size as reduced speed. **SEE 13.25** The z-axis motion vector now has a relatively low magnitude.

The deceleration effect of the narrow-angle lens (discussed in chapter 10) can be used to virtually eliminate the feeling of movement along the z-axis and can, as you will see in the next section, even be used for a slow-motion effect.

PERCEIVED CAMERA SPEED: WIDE- AND NARROW-ANGLE LENSES

Because of the exaggerated change in object size when using a wide-angle lens, the dolly speed of a camera is usually exaggerated. When dollying past objects placed along the z-axis, the object image grows more quickly the closer the camera gets to it; meanwhile background objects more or less maintain their image size.

Theoretically, with a narrow-angle lens the perceived dolly speed is much slower than the actual camera speed. Unless you have an elaborate rail tracking system, a special camera mount, a Steadicam, or electronic image stabilizers, it is very difficult, if not impossible, to achieve a smooth dolly with a narrow-angle lens. Even if you do achieve a smooth dolly, the shallow depth of the long-focal-length lens will make it difficult to maintain focus.

Slow Motion

We say an event is in *slow motion* when it appears to be moving considerably more slowly on the screen than it would normally while being photographed. But an object in slow motion does not seem to simply move more slowly than usual; rather, it seems to be moving through a denser medium than air, which appears to cushion the effect of gravity and make the motion "woolly and soft." Slow motion introduces a feeling of surreality. The motion vector no longer obeys the physical laws of gravity to which we are accustomed, and its direction seems to be more labile.

What, then, are the principal factors that distinguish slow motion from something simply moving a little more slowly than normal? One is frame density; the other is absence of gravity.

FILMIC SLOW MOTION: FRAME DENSITY

Frame density refers to the sampling rate. A high sampling rate of the actual motion divides an action into considerably more frames than the normal 24 frames per second. If you divide the shot of a moving object into 24 individual frames during one second of its travel and then project these 24 frames within the same time span of a second, the screen motion of the object will closely approximate the real object motion (assuming that you do not distort the motion optically or through a moving camera). But if you increase the sampling rate by speeding up the film while photographing the moving object—let's say to 48 frames per second—and then play them back at the customary 24 frames per second, the object appears to be moving much more slowly. This object has to go through 48 rather than 24 "at" positions to reach the end of its movement. SEE 13.26 The more "at" positions you use for the breakdown of a moving object, the smaller the progression of the object's location becomes from frame to frame. And the more minute the progression of the object is from frame to frame, the slower the object motion is that we perceive on the screen.

SLOW MOTION IN TELEVISION: PLAYBACK SPEED

Television slow motion is something of a paradox. First, unlike film, television creates its slow motion not in the shooting phase but during the playback. Second, the slower the tape speed, the fewer frames are scanned within a time unit, such as one second. A time base corrector or frame store synchronizer, which are electronic devices that temporarily store the electronic picture information until a stable electronic frame is attained, will prevent a picture breakup during slow

playback speeds. ¹² But then, after recording this slow-motion mode for normal-speed playback, each of the frames is rescanned a number of times before moving on to the next one. Third, because the basic unit of television is not a frozen moment but a changing process, we cannot manipulate it quite so easily as we can the fixed unit of the film frame.

Nevertheless, the density principle still applies to the creation of slow motion in television. The multiple scannings of each frame during normal-speed playback increase the frame density similarly to film. But then, the playback does not increase the "at" positions as does film. Unless you use a computer that generates more "at" positions among the original frames, the playback shows fewer "at" positions than regular television motion. And though the difference between the motions is hard to detect by simply looking at it, television motion does not feel quite the same as film motion; somehow it seems to lack the "wooly" density of film. Some HDTV (high-definition television) and DTV (digital television) systems, however, employ a different way of creating a television frame that allows more "at-at" positions even during very slow playback, thus making the slow motion appear as dense and seamless as that of film.¹³

Freeze-frame A freeze-frame shows *arrested* motion, not a picture of no motion. It picks a specific "at" position and repeats it for the duration of the freeze. You can think of a freeze-frame as the ultimate frame density: The object remains in precisely the same position from frame to frame, regardless of whether you use film or television.

Slow motion through narrow-angle-lens distortion Because there is hardly any size change of an object moving along the z-axis, the long-focal-length lens can simulate a slow-motion effect. For example, if you were to place a camera at the far end of the track opposite the starting blocks of a 100-meter sprint, an extremely long-focal-length lens would practically eliminate the z-axis motion of even a world-class runner. What you would get is an aesthetic incongruity: While you would see the runner's body in full-speed motion, his z-axis progress would appear in slow motion.

ABSENCE OF GRAVITY

As mentioned previously, an object in slow motion seems strangely free of gravity. Like astronauts in outer space, slow-motion objects appear weightless and their direction seems unpredictable. A good example of the directional uncertainty of the slow-motion vector is when you watch the slow-motion replay of a fumble during a football game; the ball rolls and bounces agonizingly slowly and without much apparent sense of direction. This frame-dense atmosphere lets you see, and especially feel, why the players trying to recover the fumble have little chance for success. Because the forces of gravity do not seem to operate in slow motion, as viewers we would not be too shocked or even too surprised if, after a bad pass, the ball suddenly floated right back into the quarterback's hands. ¹⁴ The slow-motion effect generated by the long-focal-length lens lacks this absence of gravity, mainly because it lacks the frame density of standard slow motion.

AESTHETIC EFFECTS OF SLOW MOTION

Depending on the event context, you may perceive slow motion in various, sometimes contradictory ways. Most often, slow motion is used to intensify the agony of getting somewhere. For example, if you try to intensify the last seconds of two people running toward each other for a long-awaited embrace, slow motion can prolong their actual meeting and intensify their anticipation. But you can

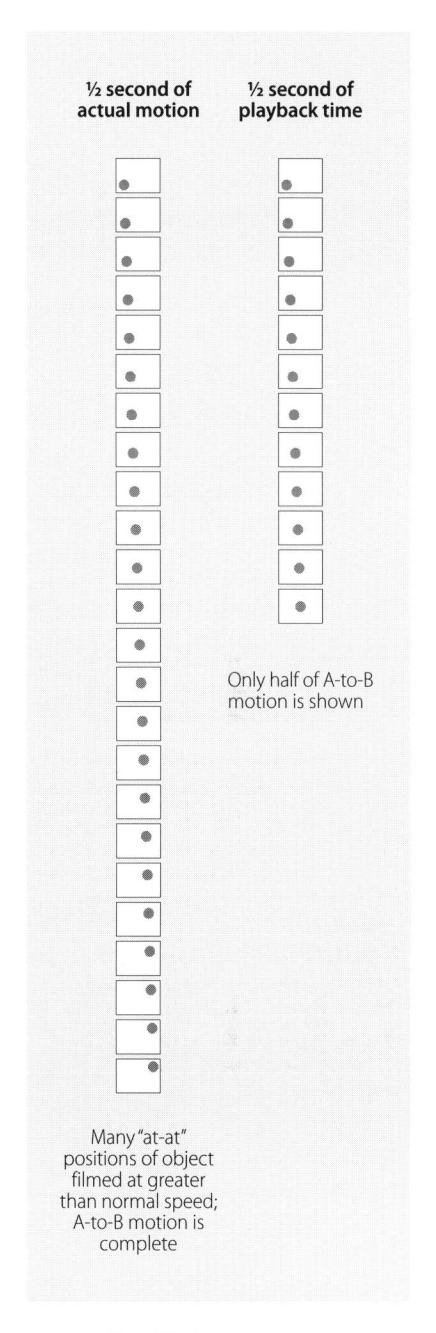

13.26 Slow Motion

In film we achieve slow motion by increasing the number of "at" positions of a motion during the actual filming. When played back at normal speed, the motion now has to go through more "at" positions. It is perceived as slow motion.

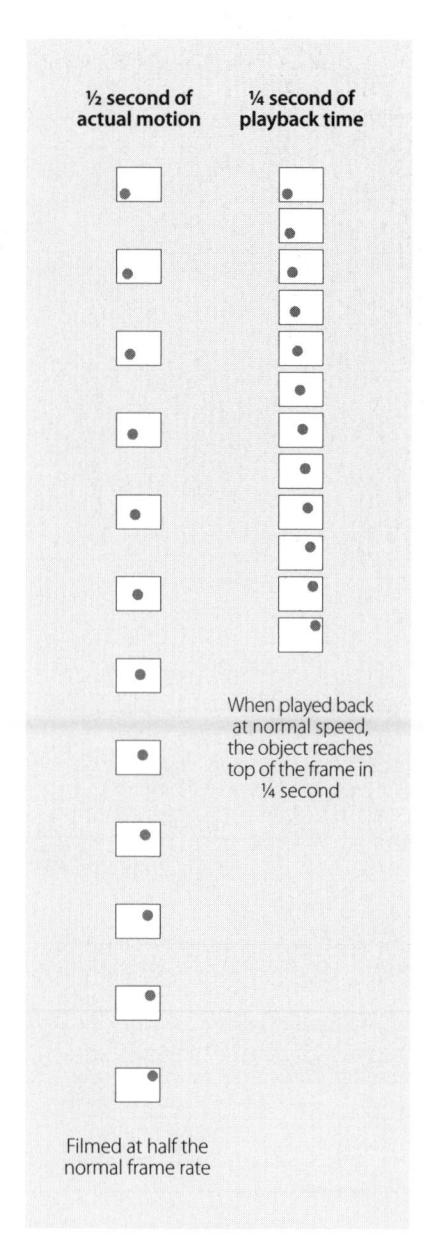

13.27 Low Sampling Rate in Accelerated Motion

In accelerated motion we reduce the number of "at" positions. The object seems to leap from one "at" position to the next, as though traveling through a thinner atmosphere.

also use slow motion to signal increased speed. Switching to slow motion during a downhill ski race does not indicate that the champion downhill skier has slowed down; rather it exhibits her skill and intensifies her speed.

When used in news events, slow motion can introduce a feeling of menace. To use slow motion to show somebody being lead into a courtroom implies that the person is guilty. A harmless grin can turn into an eerie grimace.

Accelerated Motion

Like slow motion, accelerated motion has its own aesthetic feel. It shows the object not merely faster than normal but also more erratic, more jumpy. The comic energy of many cartoons and silent movies is based on accelerated motion. For example, accelerated motion can turn a person's normal walk into a jerky, frenzied event in which the person seems driven along the street by an unseen force and pulled around the corners as if by a giant rubber band. When shown in accelerated motion, objects sometimes seem to be self-propelled, shooting unpredictably through the low-density atmosphere that offers little if any resistance to their movement. For some reason, accelerated motion seems to trigger laughter more often than awe. Perhaps accelerated motion seems so comic because, contrary to moving slowly, it is far beyond our actual experience.

FILMIC ACCELERATED MOTION: FRAME DENSITY

Like slow motion, accelerated motion is less a matter of relative speed than a function of frame density. In accelerated motion the original event is divided into relatively few "at" positions, each differing considerably from the other.

SEE 13.27 We sample fewer steps in accelerated motion than in slow motion. 15

Let us assume that you want to show the unfolding of a rose, which takes about 24 hours. To show the process in its normal motion, you would need to have a camera run for 24 hours. But you can also decide to sample the total process and shoot one frame every 15 minutes, leaving out all the intermediate steps. Thus in a 24-hour period, you would end up with 96 frames that show the unfolding of the rose from beginning to end. When played back at regular speed of 24 frames per second, the total unfolding process would take only 4 seconds. Note that the film did not simply run faster through the gate, but that your sampling rate was rather low—that is, you picked only relatively few "at" positions of the total process. While in slow motion, the frame density is quite high; in accelerated motion, the frame density is low.

ACCELERATED MOTION IN TELEVISION: PLAYBACK SPEED

Unlike film, accelerated motion in television normally occurs not through sampling of wider "at-at" positions when videotaping an event in motion, but in the playback phase. Nevertheless, the low-density effect is similar to that of film, because in the fast-playback mode the tape moves faster past the playback mechanism, causing a wider gap between the "at-at" positions of the event motion than during regular speed. As a result, you perceive a lower frame density and, with it, the erratic self-propelled quality of accelerated motion.

You can also use *jogging* as a low-density dramatic device. The term refers to a rather abrupt position change from one "at" position to the next, similar to the position jumps of an object in stroboscopic photography. Jogging shows up as jerky slow motion, and you create it by the slow, frame-by-frame playback

speed of the videotape. When used correctly, the jogging effect can be highly dramatic. For example, visualize a scene in which a man and a woman are engaged in a polite and controlled argument that grows increasingly intense. Would he like another cup of tea? No, but she would. While pouring herself some tea, we suddenly see her jerk forward from one "at" position to the next and then return to normal speed and, therefore, smooth action. The jogging sequence reveals her inner emotional state—her extreme tension—and suggests that she is getting close to losing control.

To achieve low-density accelerated motion in the television shooting phase, you must proceed very much as you do in film: You control the density in the actual shooting process. For example, to show the rose unfolding through accelerated motion, you could shoot a very brief segment ("at" position) of the unfolding process every 15 minutes or so and edit the various segments together in postproduction. Assuming normal playback speed, the unfolding process could be shown in less than 10 seconds. Because the reduced sampling rate will cause a low frame density, the rose unfolds not only faster than in actual time, but it also discloses its inner drive to reveal its beauty.

You can use accelerated motion not only for comic but also for dramatic effects. One of the most striking examples of the dramatic use of low-density accelerated motion appears in Sergei Eisenstein's "Odessa Step Sequence" from his film *Battleship Potemkin*.¹⁶ In a brief scene, he shows the death of a woman fatally shot by advancing soldiers. He intensifies her death by eliminating all nonessential frames from her fall, causing the woman not only an external, but also an internal, collapse. When she jerks to the ground in this low-density atmosphere, we have no doubt that she has met death.

Slow and accelerated motion are effective devices for structuring objective and subjective time. Slow motion can not only give us a "close-up of time," 17 prolonging duration, but also hurry us along and rush us through time. Accelerated motion can produce a comic effect by hurling us, roller coaster—like, through the event. But it can also show a catastrophic change of inner structure. The time manipulation has transcended into a structural change.

Summary

Zeno's and Bergson's time theories seem quite appropriate to explain the unique use of time and motion in film and video. They are also useful to point out the basic structural differences between the two media. Zeno claims that motion is actually an illusion, because the moving object seems basically at rest at any of the finite points along its path. This "at-at" theory corresponds closely with film, in which motion is dissected into a number of snapshots. Each of these snapshots (frames) shows the object at rest. Thus, the basic structural unit of film—the frame—shows the object at rest. When these frames are shown in rapid succession, we perceive the object as moving, but the motion is strictly illusory.

Contrary to Zeno, Bergson believed that motion is a dynamic process, a continuous flow of events. Bergson contended that the motion of an object is indivisible and that the object simply goes from its starting point continuously to the finish. This time concept is very similar to the process of video images, which are created by continuously moving electron beams that scan a great number of dots—called pixels—on the television screen. Regardless of whether the video signals are analog or digital, the projected video image is never at rest but rather is in a continuous state of change. The basic structural unit of video—the video frame—is in continuous flow; it is an image in flux—a process image. Liquid crystal displays (LCDs) and plasma displays generate their images through activating pixels by an electric charge. The image is stable (filmlike) when nothing moves, but processlike (videolike) when motion occurs.

Structurally, film has historic permanency, much like a photograph or a painting. Television presentation has an electronic immediacy. It has an isomorphic relationship to the fleeting character of the present moment.

When film is shown on television, the series of static film frames are translated into electronic television frames that are always in the process of becoming. When televised, films that rely heavily on landscape as dramatic agents seem to lose their grandeur through reduction in size as well as the electronic nervousness of television.

Large-screen projections of HDTV (high-definition television) are capable of communicating the high energy of landscape material as well as the inscape aspects of people-oriented programs. Television's intimacy, however, is largely lost in the process.

The basic motion paradox is that we can be in motion and at rest at the same time, depending on how the motion is judged. We judge motion against frames of reference in which we perceive the moving object (figure) against its immediately more stable environment (ground). Our tendency to perceive a figure moving against the more stable ground is so great that we maintain this figure-ground relationship of motion even if a figure-ground reversal occurs in which the ground moves behind a stable figure.

Perceived z-axis motion is greatly influenced by the focal length of the lens. The wide-angle lens accelerates z-axis motion; the narrow-angle lens slows it down.

The principal factors that distinguish slow motion from something merely moving slowly are frame density and absence of gravity. Frame density refers to the number of frames into which an event is divided. In filmic slow motion, the event is divided during filming into a greater number of "at" positions (frames) than when filming the event at normal speed. In television, slow motion occurs during playback, not during the photographing process. Television reduces the number of "at" positions during slow-motion playback, which are then rescanned during regular playback. A freeze-frame shows a repetition of a specific "at" position. A narrow-angle lens retards the progress z-axis motion and creates a special type of slow motion. Objects shown in slow motion seem to be freed from the laws of gravity, so they appear to be weightless and to lack directional certainty.

In filmic accelerated motion, the frame density is low with an omnipresent gravity that seems to pull in all directions. Accelerated motion shows the object as moving not only faster, but also more erratically than normal. A faster-than-normal playback of a videotape does not contain a lower frame density; in fact, it shows more "at" positions at a faster rate. Consequently, it has a different aesthetic effect than filmic accelerated motion.

NOTES

- 1. Some of the most famous of Zeno's paradoxes of motion are well explained in Robert Audi (ed.), *The Cambridge Dictionary of Philosophy* (Cambridge, Mass.: Cambridge University Press, 1995), pp. 865–866.
- 2. Henri Bergson, *Creative Evolution*, trans. by Arthur Mitchell (New York: Modern Library, 1944), pp. 324–341. Although Bergson uses film to explain some of his theories, his general theory of *durée* and the concept of becoming is much more closely related to the medium of television than to that of film. See *Creative Evolution*, pp. 330–335. Also see David Park, *The Image of Eternity* (Amherst: University of Massachusetts Press, 1980), p. 43. Park refines the idea of duration by saying that it is not the flow of time that we perceive but rather the flow of events.
- 3. Bergson, Creative Evolution, p. 331.
- 4. Bergson, Creative Evolution, pp. 335-336.

- 5. The term *television* is used here to include all forms of video, nonbroadcast, and broadcast presentations. It also implies such transmission techniques as cable, fiber optics, microwave, DBS (direct broadcast satellite), and the usual VHS and UHF channels.
- 6. Herbert Zettl, *Television Production Handbook*, 6th ed. (Belmont, Calif.: Wadsworth Publishing Co., 1997), pp. 62–64.
- 7. The term inscape was coined by Gerard Manley Hopkins, a British poet (1844–1889).
- 8. At some of the annual conventions of the National Association of Broadcasters, Sony demonstrated comparison tests of the relative resolution of 35mm film and HDTV videotape. Even to educated critical observers, no discernible differences of resolution showed up between the two media. The noticeable difference was in the luminance. Film still showed a higher number of subtle grayscale steps than HDTV.
- 9. Herbert Zettl, "From Inscape to Landscape: Some Thoughts on the Aesthetics of HDTV," *HD World Review* 3, nos. 1 and 2 (1992): 40–48.
- 10. The hierarchical relationships of dependence were developed by Karl Duncker, "Über induzierte Bewegung," *Psychologische Forschung* 12 (1929): 180–259.
- Rudolf Arnheim, Art and Visual Perception (Berkeley: University of California Press, 1974), pp. 372–409.
- 12. Zettl, Television Production Handbook, pp. 263-264.
- 13. These HDTV and DTV systems create a television frame through progressive rather than interlaced scanning. In the normal television system, three electron beams scan first all odd-numbered lines every 1/60 second, then jump back to the top of the screen and scan all even-numbered lines in the next 1/60 second. These two incomplete scans, called "fields," make up the complete television frame. In progressive scanning, the electron beams scan all lines sequentially and deliver a complete frame every 1/30 second. The advantage of progressive scanning is that it produces better picture resolution than interlaced scanning. The problem with progressive scanning, however, is that we perceive especially bright picture areas as a flicker at the relatively low "refreshrate" (when one complete frame changes to the next). Most computer monitors operate with progressive scanning that have a much higher refreshrate, such as 60 frames per second or higher. Similarly high refreshrates are difficult to achieve in broadcast television because they would require an exceptionally large bandwidth.
- 14. German filmmaker Leni Riefenstahl used this technique decades ago to intensify her highly ideological view of the 1936 Olympic Games in Berlin during Hitler's regime. She showed the perfect birdlike dives of her chosen athletes in slow motion and then had one go backward, from the water to the diving board. Because the divers seem to defy gravity, the casual observer is hardly aware of this directional switch.
- 15. I received generous help in the discussion of accelerated motion from my colleague Philip Kipper. The idea of "sampling" in this context is entirely his.
- See Sergei Eisenstein, Film Form and Film Sense, ed. and trans. by Jack Leyda (New York: World Publishing Co., 1957).
- 17. This apt expression comes from Vsevolod Illarionovich Pudovkin (1893–1953), Russian filmmaker and theorist, whose theories were published in Ivor Montagu (ed. and trans.) Film Technique and Film Acting (New York: Grove Press, 1960).

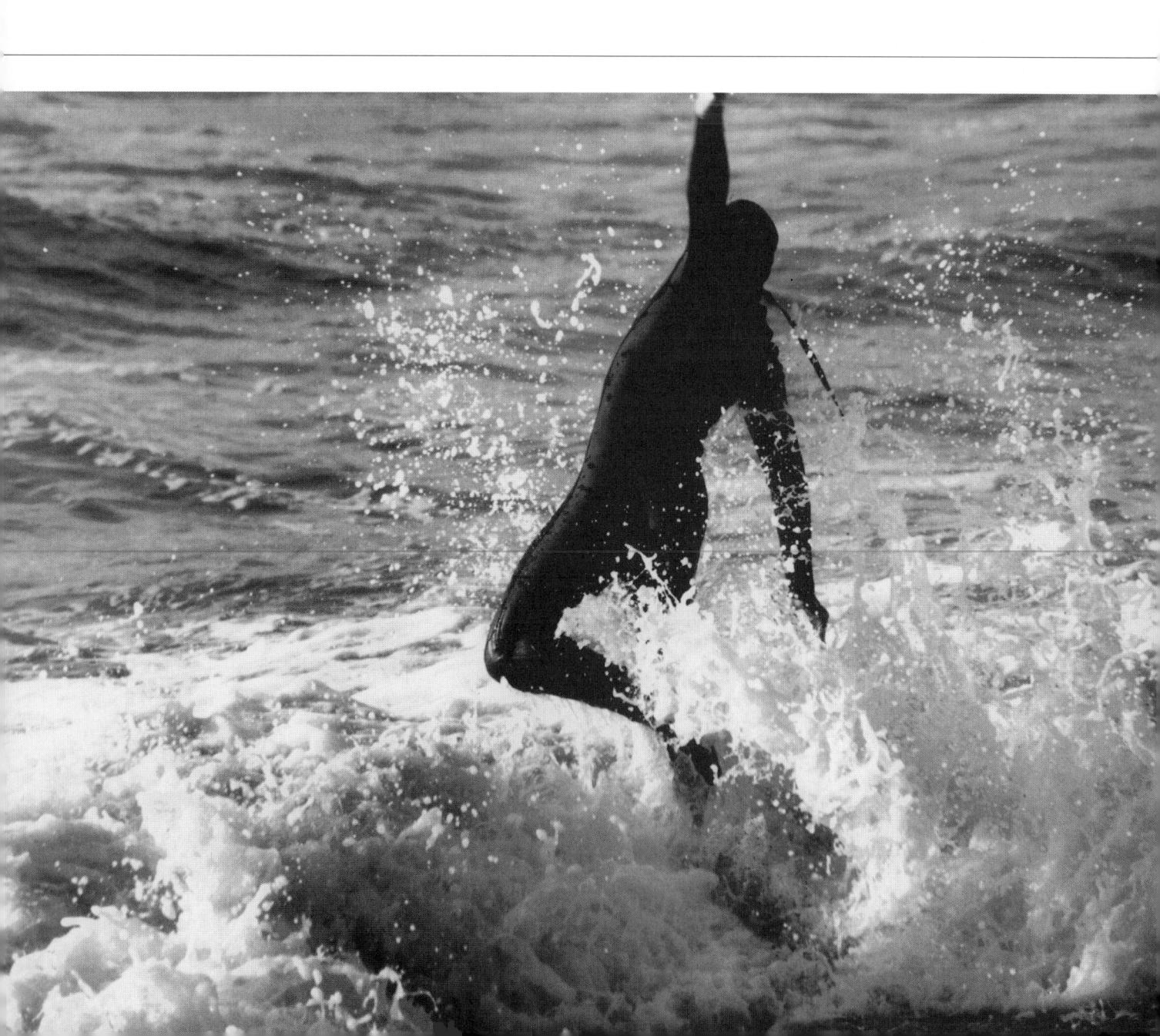

Structuring the Four-Dimensional Field: Timing and Principal Motions

LTHOUGH the various time theories discussed in chapters 12 and 13 are important for explicating one of the major structural differences between television and film, they are also an important factor in learning and understanding the processes of timing and structuring the three principal motions. This means that after all this time theory, you are in for an application of some of it. This chapter explores (1) types of objective time: timing, (2) types of subjective time: pace and rhythm, and (3) principal motions and their functions.

Types of Objective Time: Timing

The selling of time and the use of time in scheduling are important aspects of television programming and operations, but these considerations fall outside of the parameters of the four-dimensional aesthetic field. Here we concentrate on the various aspects of timing as it relates to the aesthetics of television and film. *Timing* usually means the control and manipulation of objective time; however, it also includes the structuring of subjective time.

Objective time deals with all clock time events of a show, such as how long or short a television show runs, how long the scenes are, or what time span the show covers. Subjective time control means that we are more concerned with influencing the duration the viewer feels than with actual clock time. You will find that objective and subjective time manipulations overlap. For example, at times you will have to juggle objective time, not so much to structure clock time, but to achieve optimal event density; and event density will, in turn, influence subjective time. You may want, for instance, to shorten a scene here or lengthen one there to establish a specific overall pace and especially an appropriate event rhythm. The following classifications of objective and subjective time are meant to facilitate timing and the analysis of the four-dimensional field.

To keep things manageable and make time useful in structuring the four-dimensional field for television and film, we distinguish among six different types of objective time: (1) clock time, (2) running time, (3) sequence time, (4) scene time, (5) shot time, and (6) story time.

CLOCK TIME

Clock time determines the precise "at" position in the objective time continuum. Although all types of objective time are measured by the clock, clock time has come to mean a precise spot—an "at" on the dial. Clock time indicates when an event happens. The motion picture you want to see begins at 7 P.M. and ends at 9:10 P.M. A television program schedule lists the beginning times when the various programs start, implying when the preceding one ends. A television program log lists the clock times in a second-by-second breakdown. When somebody asks you what time it is, your answer refers to clock time. When the tower clock strikes midnight in a mystery movie, it also designates clock time. As you can see, clock time refers to an "at" position in the time continuum regardless of whether we deal with real time (what your watch says) or fictional time (the pretended clock time in a film or television show). **SEE 14.1**

RUNNING TIME

Running time indicates the overall length of a program. For example, this film has a running time of 2:15 hours, or this television commercial runs only 10 seconds. **SEE 14.2** Generally, television programs have a shorter running time than motion pictures. The major aesthetic reason for this difference is that watching television is often perceptually more demanding than watching a film. The relatively low-definition mosaic image of television plus the typically inductive visual approach requires more attention from viewers and more psychological closure activity than the high-definition, deductively shot motion picture. Television has a less narrative structure than film, which normally tells a story that has a beginning, a middle, and an end. Television is more fragmented; similar to the Internet, it offers a great amount of widely differing information that can be chosen by the viewer. The remote control that invites "channel surfing" only adds to this fragmentation. Other, more practical reasons for shorter programs are that they allow a greater program variety during a broadcast day and, with it, more commercial advertising than with fewer, but longer, programs.

14.1 Clock Time

Clock time signifies the "at" position of an event on the time continuum.

14.2 Running Time

The running time indicates a from-to position on the time continuum. It specifies the overall length of an event or event segment.

SEQUENCE TIME

A sequence is the sum of several scenes that compose an organic whole. Each sequence has a clearly identifiable beginning and end. In a film on the life of Pablo Picasso, for example, his "Blue Period" from 1901 to about 1904 and his involvement with cubism (1907 to 1921) would be separate sequences. When you start your stopwatch at the beginning of the sequence and stop it at the end, you have the sequence time. To keep you properly confused, some people call the clock time duration of a sequence the "running time" of a sequence. **SEE 14.3**

SCENE TIME

A *scene* is a small, clearly identifiable organic part of an event. It is usually defined by action that plays in a single location within a single story time span. For example, watching Picasso doing some sketches of a bullfight would constitute a scene. *Scene time* is the clock time duration of a scene. **SEE 14.4**

SHOT TIME

A *shot* is the smallest convenient operational unit in a film or television show. It is the interval between two transitions, for example, from when you press the *record* button on a camcorder to when you press the *stop* button, or from cut to cut, or a dissolve, for example. *Shot time* measures the actual clock time duration of a shot. **SEE 14.5**

14.3 Sequence Time

Sequence time is a subdivision of running time. It shows the length of an event sequence.

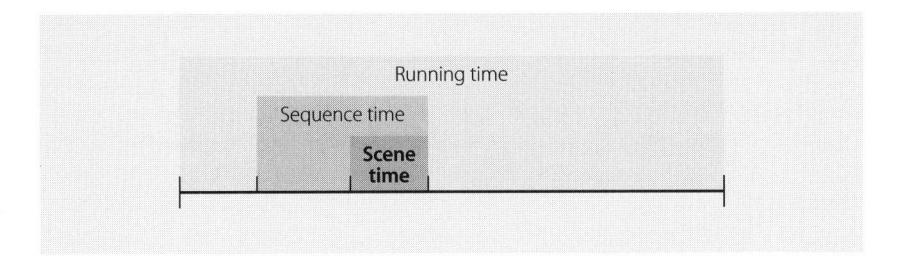

14.4 Scene Time

Scene time shows the length of a scene. It is a subdivision of sequence time.

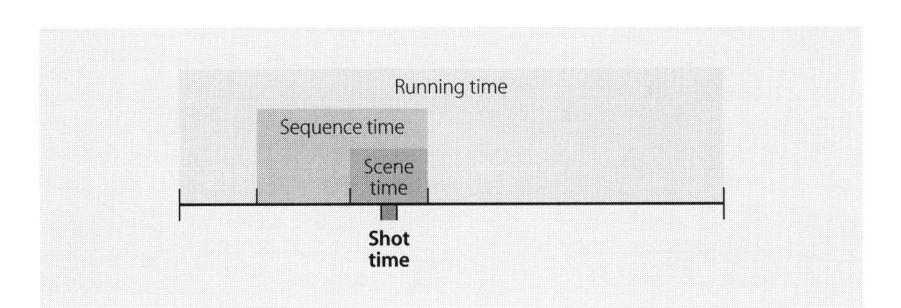

14.5 Shot Time

Shot time is the length of one shot. As a subdivision of scene time, shot time represents the shortest usable objective timing in a television program or film.

Let's construct a shot sequence for a scene in which we observe Picasso starting a new painting. Note that the sequence is shot inductively for television, which means that we see basically a series of close-ups.

Shot 1: CU (close-up) of Picasso's hands putting a new, blank canvas on the easel (shot time: 3 seconds)

Shot 2: CU of his hands squeezing paint on a palette (shot time: 2 seconds)

Shot 3: CU of Picasso's face (shot time: 5 seconds)

Shot 4: Tight O/S shot watching Picasso put the first lines on the virgin canvas (shot time: 4 seconds)

As you can see, the brief scene (total scene time: 14 seconds) is made up of a series of shots, each of which has its own time. Can you visualize this sequence—that is, feel its timing? Are the shots too fast for you or too slow? With some practice you will find that you can mentally time your shots, scenes, and sequences so accurately that you waste a minimum of your actual working time (clock time) in the editing suite.

STORY TIME

Story time shows the objective time span of an event as depicted by the screen event. For example, if in our videotape on Picasso we depict his entire life from his birth to his death, the story time spans ninety-two years (from 1881 to 1973). With few exceptions, story time and running time are independent of each other. You may, for example, choose to show a weeklong period in your life in the first 30 seconds of your television show or spend the entire one-hour running time on it. **SEE 14.6** Or you may want to synchronize running time and story time and depict a one-hour period in someone's life in exactly one hour. But if you televise a nonfictional event live or make a live-on-tape recording of such an event, story time (the period of event development) and running time (the time you devote to its coverage) are synchronous and, therefore, identical. For example, if you devote one hour to the live telecast of the Thanksgiving parade, story time (the various floats and bands that pass before the cameras during this hour), and the running time of the telecast are inevitably the same. In such a case, story time and running time are dependent upon each other.¹

14.6 Story Time

Story time is fictional or developmental time. It shows the period of the screen event. Story time usually moves from one calendar date to another or, less often, from one clock time in the story to another. Story time is largely independent of the running time. For example, it could take up to 10 minutes of running time for the twenty years of Picasso's youth, but devote the remaining 45 minutes of running time to the three years of his Blue Period.

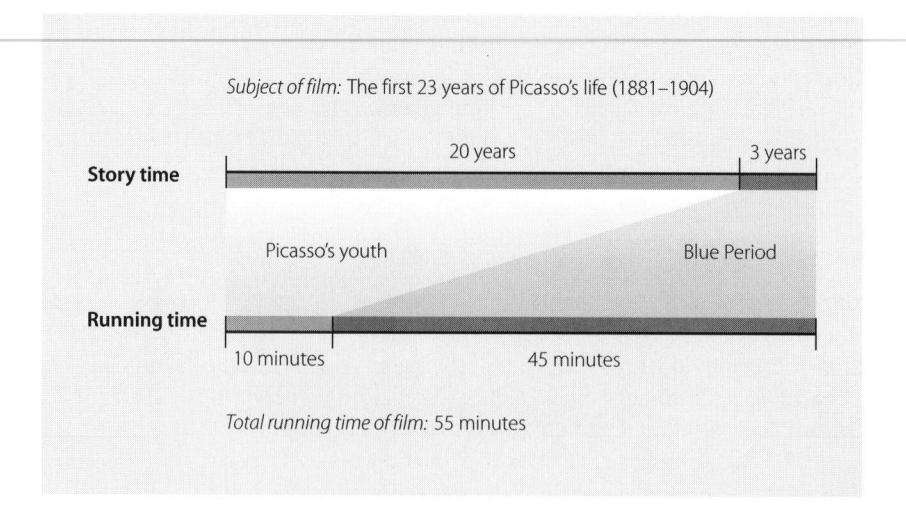

Types of Subjective Time: Pace and Rhythm

As indicated in chapter 12, the term *subjective time* contains a paradox. We judge the felt duration of an event not by the clock but rather by how aware or unaware we are of the passage of clock time during and after the event. Instances do occur, however, where the manipulation of subjective time requires an acute awareness of time. This paradox is explored further later in this chapter.

Considering the relativity of subjective time, can you ever use it as a reliable element in structuring the four-dimensional field? Yes, but not in a truly scientific way. Because it is more dependent on feeling than measurement, you need to approach the control of subjective time using intuition and considered judgment rather than logic.

Subjective time is usually categorized into pace, tempo, rate, and rhythm. Pace refers to the perceived speed of the overall event; tempo and rate, to the perceived duration of the individual event sections; and rhythm, to the flow within and among event segments. At first glance, such a variety of subjective time divisions seems quite advantageous for managing the perceived duration of a screen event. In practice, however, they prove more confusing and bothersome than helpful. We therefore limit the subjective time categories here to pace and rhythm.

PACE

As stated, *pace* refers to the perceived speed of an event, that is, whether we feel the event to drag or to move along briskly. Different event sections, such as scenes or sequences, can have their own paces, and so can an entire show. We usually consider a fast-paced scene to be one in which many things happen one after the other, with fast dialogue and rapid action. It is a high-density event. A slow-paced event moves less rapidly in story development, dialogue, and action. You will probably wonder at this point whether trimming a few seconds off a dance number in a music video, cutting some lines here and there to render the dialogue a little tighter, or replacing one of the slower songs with a more upbeat one is not more a manipulation of objective time, the horizontal time vector, than subjective time, the vertical time vector. In a way, this is true. Although pace belongs to the subjective time category because it is not judged by the clock, you can control it by manipulating the horizontal time vector (making an event shorter or longer or increasing its density.

Slow and accelerated motion are especially useful tools in governing pace. Slow motion, as a close-up of time, seems to interrupt pace temporarily, rather than slow it down, very much like holding your breath for a while. Accelerated motion does the opposite; it seems to lurch through time, giving pace a temporary push. Pace appears to be out of breath for a while. As you can see, pace does not remove us from an awareness of time. It simply regulates our perception of the flow of time—whether the flow feels fast or slow, regular or irregular.

RHYTHM

Rhythm refers to the flow within and among event segments (shots, scenes, sequences) and to a recognizable time structure—a beat. It is determined by the pace of the individual segments and how these relate to one another. Although individual scenes might consist of fast-paced shots, this does not guarantee a smooth flow from one scene to the next.

Very much like the bars in musical notation, the overall rhythm is frequently determined more by the transitions between shots, scenes, and sequences; by the

beat created by the shot or scene times; and by the rhythm of the music than it is by the pace of the individual segments. For example, straight cuts between the shots of a fast-paced car chase will probably produce a much more exciting and appropriate rhythm than dissolves or fancy wipes would. But when establishing a slow rhythm that matches the slow pace of a solemn event, such as a funeral, you may prefer dissolves over staccatolike cuts. Establishing a rhythm is high on the list of priorities for editors. Even if the visual cutting does not establish an obvious rhythm, a rhythmic sound track will provide the necessary beat. The structural function of sound and music is explored in chapter 17.

As with the structuring of the color field, the control of pace and rhythm requires sensitivity and experience. The stopwatch alone should not be your sole guide in assessing pace. But even though we don't have scientifically precise criteria for evaluating pace and rhythm, their role in structuring the four-dimensional field is no less important than that of the clock.

Principal Motions and Their Functions

In television and film, we are confronted with many different movements. The performers move about, the camera dollies and trucks along with the action, and movement is also created by the shift of viewpoints through cutting. Let's label and order these motions so that you can work with them more easily when structuring the four-dimensional field. There are three principal motions: (1) primary motion, (2) secondary motion, and (3) tertiary motion.

Primary motion is event motion. It always occurs in front of the camera, such as the movements of performers, cars, or a cat escaping a dog.

Secondary motion is camera motion, such as the pan, tilt, pedestal, boom, dolly, truck, or arc. Secondary motion includes the zoom, although only the lens elements, rather than the camera itself, move during the zoom. Still, aesthetically, we perceive the zoom as camera-induced motion.³

Tertiary motion is sequence motion. This is the movement and rhythm induced by shot changes—by using a cut, dissolve, fade, wipe, or any other transition device to switch from shot to shot. All three types of motion are important factors in structuring the four-dimensional field.

PRIMARY MOTION AND FUNCTIONS

It is called "primary" because this is the principal indicator of an object's dynamics—whether the object is in motion or at rest. Although primary motion refers to the actual motion of an object or event in front of the camera, its function is always judged from the camera's point of view. For example, no primary motion is intrinsically an x- or z-axis motion. It becomes so only in proximity to the camera. The same primary motion can be an x-axis motion or a z-axis motion, depending on whether it occurs laterally to the camera or toward and away from it. **SEE 14.7**

In previous chapters, we have repeatedly discussed the advantages of z-axis motion and blocking for the small television screen and the dramatic effects you can achieve with this motion. But z-axis blocking does not mean that you cannot use a limited amount of x-axis motion or primary motion that occurs at an oblique angle. Especially when used for a larger-screen format with a wider aspect ratio (such as a wide motion picture or HDTV screen), lateral motion can be highly effective. When shooting a wide-screen movie, a battle scene in which the soldiers come from either side of the screen and clash in the middle is probably more spectacular than if they were charging along the z-axis. On the small television
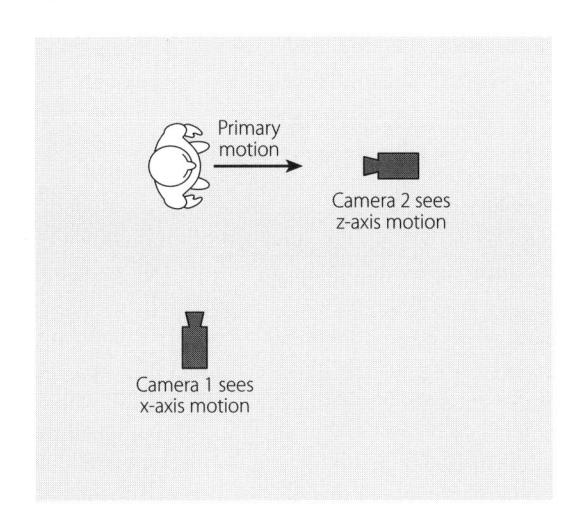

14.7 Primary Motion and Camera Proximity

Depending on the relative camera position, we can see the same primary motion as x-axis movement or z-axis movement.

screen, however, such a long shot remains largely ineffective. At best, the laterally blocked battle lacks energy; more often, it looks absurd.

Whatever screen format you use, your first concern is the natural flow of the action—before manipulating it for the camera. Ideally, you should not force the action to fit the camera position, but instead place the camera so that it can capture the normal flow of "event traffic."

Nevertheless, you need to adjust the event traffic to fit the camera, especially if you desire a specific intensification effect. For example, you may want to have the actor speed up or slow down for the camera. Close-ups always need a slowdown of the speed with which we normally do things. For example, trying to follow on a close-up the lifting of a telephone receiver from its cradle to the caller's ear can be a frustrating experience unless the whole action is slowed down considerably. You will find that trying to keep up with lateral action is also difficult, especially on a fairly tight shot.⁵ You need to slow the person down, even if the scene calls for a quick exit. Simply tell the actor to make her steps shorter. The increased number of steps maintain the feeling of rushing; the smaller steps slow down the action. Or you may have to tell her to walk in a wider arc when circling the sofa simply to stay in the camera's view. In any case, you should preserve for the viewer the feeling that primary motion is inherent in the event and not dictated by the medium. Primary motion is principally event-dependent.

Although all screen motion is finally medium-generated, we seem to sense a difference between event-generated primary motion, such as watching a dancer on the screen, and medium-generated primary motion, such as cartoons or even more-realistic digital video creations of object motion. Somehow, when videotaping or filming actual object motion, the lens-generated motion seems to belong intrinsically to the object. When creating object motion through animation or computer-generated sequences, the motion seems to belong more to the medium; that is, the motion seems to superimpose itself on the object rather than to spring from it. Overcoming such subtle disparities between lens-generated and computer-generated fluency has been a major problem for special-effects people.⁶

A similar problem occurs when live action of people and things is coupled with the motion of models. Because models are usually built on a small scale, their speed needs to be adjusted to that of the live action. To get some idea of the problem of matching speeds, hold a pencil vertically on your desk. Pretending that it is a huge tree, let it crash onto the desk. The "crash" took only a fraction of a second. A real tree would certainly take quite a bit longer to fall. To make the fall

of the tree model (the pencil) believable, you obviously need to slow it down. By how much is the problem of synchronizing model and actual speeds.

SECONDARY MOTION AND FUNCTIONS

Secondary motion—the motion of the camera and the motion created by zooming—is medium-dependent. This means that camera motion is basically independent of event motion. Unfortunately, this independence of primary motion can seduce inexperienced camera operators into believing that it is the moving camera that is important rather than the event motion. We are all too familiar with the wild and unmotivated camera moves and fast zooms that characterize almost every amateur videotape or film.

The problem with unmotivated secondary motion is that it draws attention to itself and away from the event. Instead of contributing to the clarification and intensification of an event, it muddles its depiction. Nevertheless, secondary motion fulfills several important functions: (1) to follow action, (2) to reveal action, (3) to reveal landscape, (4) to relate events, and (5) to induce action.

To follow action When you are trying to follow a football player with the camera, you need to pan the camera to keep him in the shot. When a performer stands up and the camera is on a fairly close shot of her, you need to tilt up to keep her in the frame. When you are on a close-up of the host and you want to include the guest in a two-shot, you need to dolly or zoom out unless you cut to another shot. Following action is one of the most natural and least obtrusive uses of secondary motion.

To reveal action A rather dramatic use of secondary motion is to reveal action gradually or to emphasize event detail. For example, you may create considerable tension in the viewer by not showing the accident scene right away but by first showing the horrified face of an onlooker and then, rather than cutting to it, doing a slow pan that traces her index vector right to the accident. Another example of creating tension through revealing action is to follow a skier hurtling down an icy slope (secondary motion to follow action) but then pan ahead to reveal the treacherous crevasse that lies in the skier's path (secondary motion to reveal an event). Will he be able to stop in time once he sees it? (No, but he managed to jump over it.) In this example, you used secondary motion as a proven dramaturgical device: to let the audience in on what the hero has yet to discover.

To reveal landscape A similar application of the revealing function is to show landscape in a dramatic way. For example, you can pan along a mountain range, or tilt up along the awesome height of an office building to discover smoke pouring out of one of the top-floor windows. Showing the mountain range or the building in long shots would be much less dramatic.

To relate events Through secondary motion you can establish a connection between seemingly unrelated events or draw attention to a specific event detail. Thus, depending on the event context, secondary motion can imply meaning. Let's take a courtroom scene, for example. First we see a close-up of the defendant (a man), who stares at something or someone. But rather than cut to the target of his index vector, the camera pans rather quickly over to it: a woman in the jury box, who meets the defendant's glance ever so briefly, trying to look as inconspicuous as possible. Somehow, they know each other but don't want anybody else to know that. Nevertheless, the secondary motion that followed the man's index vector gave them away and revealed their connection to the audience.

Here, the primary function of the secondary motion is not to reveal an event but rather to connect two events—the man and the woman.

You may have noticed that the difference between revealing an event (following an index vector to the accident) and relating events (following the man's index vector to see the woman) is not determined by the pan itself but by the event context. However, a very fast pan (called a "swishpan") from one event to the other usually establishes quite readily a relationship between the two events. For example, a swishpan from a fire to the street signs of the nearest intersection will tell viewers where the fire is happening.

To induce action Sometimes you may want to simulate object motion by moving the camera or zooming on a still picture. In this case, the secondary motion induces a motion vector. For example, by panning in a wavelike motion against the index vector of the picture of a ship, the ship seems to be moving relative to the screen. The problem with such induced motion is that figure (the ship) and ground (the sea) both do the moving instead of only the figure. Hence, the viewer will usually remain aware of the moving camera and not accept the induced vector as primary motion.

We classify zooming as secondary motion, although normally the camera remains stationary during the zoom. The reason for this classification is that, for the inattentive viewer, the zoom looks similar to a dolly. As a matter of fact, there is a tendency even among experienced production people to substitute the zoom for a dolly. Whereas the basic function of the zoom and dolly may be similar—to change the field of view in a continuous move—there is a significant aesthetic difference between the two motions.

Zooming When doing a fast zoom-in and zoom-out, the object seems to hurl along the z-axis toward the screen or else shoot toward the background as if self-propelled. Fast zooms create induced motion vectors of high magnitude. The reason we perceive the object as flying toward—and sometimes even through—the screen at the viewer is that all space modulators along the z-axis are quickly enlarged. And because we interpret a continuous enlargement of an object not as getting bigger but as coming closer, we see the objects coming toward us during a zoom. When they get smaller during a zoom-out, we perceive them as receding into the background (see figure 13.23 in the previous chapter). Because the camera does not move during a zoom, there is no perspective change between the various space modulators along the z-axis. The objects seem to be glued together during the entire zoom. **SEE 14.8** Zooms make us perceive object motion even if we know that the object is stationary. Because of this, you must be especially careful with fast zooms; viewers can easily become annoyed when bombarded with objects hurtling toward them.

Dollying When dollying, the camera perspective, and with it the volume duality between the space modulators, changes continuously. The objects close to the camera quickly grow in size when the camera dollies past them, with background objects remaining relatively unchanged. Because this change of perspective is close to what we would be seeing when walking past the space modulators, we tend to identify with the moving camera, perceiving the space modulators as part of the stationary environment. Hence, we seem to be moving into the scene rather than having the scene come to us. A dolly-out works on the same principle except that now we are moving out of, instead of into, the scene. **SEE 14.9** A zoom simulates primary (object) motion with the viewer in a solidly stationary position. A dolly faithfully reflects secondary (camera) motion. It invites the viewer to assume the camera's point of view and walk with it into or out of the scene.

14.8 Perceived Motion During Zoom
A zoom-in seems to bring the object to the screen.
Because the camera does not move, the camera perspective remains the same throughout the zoom.

14.9 Perceived Motion During Dolly When dollying in, we seem to move with the camera into the scene. Because of the moving camera, we experience a continuous changing perspective of the space modulators.

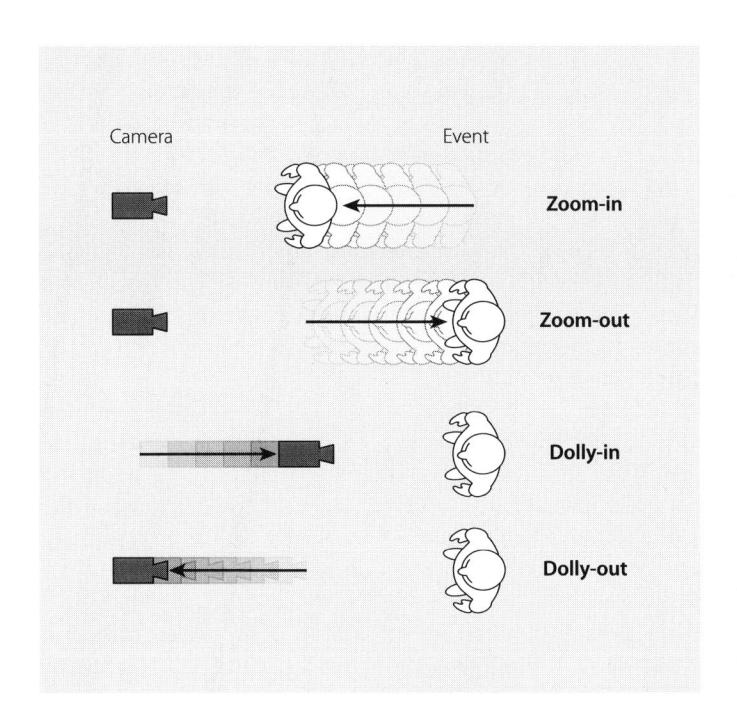

14.10 Zoom Versus Dolly

A zoom-in brings the event toward the viewer; a zoom-out moves the event away from the viewer. A dolly-in takes the viewer to the event; a dolly-out leads the viewer away from it.

Zoom versus dolly The aesthetic difference between a zoom and dolly is important enough to emphasize it one more time. When zooming in on an event, the event seems to come toward you. When zooming out, the event seems to move away from you. A fast zoom-in hurls the object toward you; a fast zoom-out pulls it away from you. During a dolly-in, you will seem to be moving with the camera toward the event. In a dolly-out, you seem to be moving with the camera away from the event. **SEE 14.10**

TERTIARY MOTION

Tertiary motion is sequence motion. Through a change of shots, we perceive a movement of progression, a visual development. The important aspect of tertiary motion is not so much the vector field of the individual shot but the *moment of change*—the relationship of vector fields from shot to shot. As with bars in music, the various transition devices act as important structural elements in the overall development of the television show or film without drawing too much, if any, attention to themselves. Their basic and common purpose is to provide the necessary link from shot to shot. Transition devices and the lengths of shots determine the basic beat and contribute to the rhythm of the various sequences and the overall pace of the show. They guide the viewer's attention and feeling and supply structural unity.

Digital electronics have provided us with such a great variety of transition effects that you may well wonder what to do with them all. Many of them are so interesting and so easily produced that it is hard not to use them regardless of their appropriateness. But how can you tell whether a transition device is appropriate? When, for example, should you use a cut rather than a dissolve? Or what is a good use for a special effect that makes the picture shrink, tumble, and zoom through screen space? There are no simple answers to these questions. Yet by studying the screen presence of the major transition devices—that is, how they look and how we perceive them—you may get a clearer idea of when and how to use them effectively. Let us therefore examine the screen presence and

major aesthetic functions of the following transitions and transition groups: (1) the cut, (2) the dissolve, (3) the fade, and (4) special transitional effects.

The cut The *cut* is an instantaneous change from one image to another. As a transition device, the cut does not exist. Because it occupies neither screen time nor space, it is invisible. We are simply aware of the change itself, that one image has been instantly replaced by another. Cutting most closely resembles changing visual fields by the human eye. Try to scan things in front of you. Notice how your eyes "jump" from place to place, neglecting the in-between spaces. You are not smoothly panning the scene but are instead "cutting" from place to place. The filmic cut does the same thing.

Despite its nonexistence, we treat the cut as though it were a visible transition device much like the dissolve or wipe. We speak of a "smooth cut" or a "jump cut" even though we know that it can't be the cut that is smooth or that is doing the jumping. What we really mean by a smooth cut is that the vector fields of the previous and following shots have the expected continuity. The more continuity in object direction, speed, on- and off-screen location, color, and general vector magnitude (the perceived intensity), the less aware we are of the cut. When these vector fields are less continuous, we become more aware of the change from shot to shot. **SEE 14.11 AND 14.12** When looking at figures 14.11 and 14.12, try to see them as a sequence of shots rather than simply two adjacent still pictures.

Cutting is the simplest and, when done right, the least obtrusive way of manipulating screen space, time, and event density. The principal spatial functions of a cut are: (1) to continue action from shot to shot, (2) to follow or establish a sequence of objects or events, (3) to change viewpoint or locale, and (4) to reveal event detail.

When manipulating time, a cut can indicate the passage of time or a change among past, present, and future. It can also indicate simultaneous events. In fact, we have become so used to seeing the cut used to show that events in different locations happen simultaneously that we no longer need the famous "meanwhile-back-at-the-ranch" reminders. Rhythmic cutting can establish a beat, which to a large extent determines the pace of the scene, segment, or overall show.

Rapid or slow cutting not only establishes an event rhythm but also regulates the density of an event. For example, if you have many cuts within a scene, you increase event density. Thirty-second television commercials that contain more than thirty cuts are good examples. Especially when cutting between converging vector fields and inductively sequenced close-ups, such dense screen events bristle with intensity. **SEE 14.13** Even as seasoned television viewers, we could not take such sensory bombardment for long. Slower cutting between less intense shots and continuing rather than converging vectors will reduce event density and make an event seem more tranquil.

The jump cut If the camera or the photographed object is not in the exact position when repeating a take, or if the following shot is not sufficiently different in field or angle of view, the image seems to "jump" within the screen. **SEE 14.14** Not too long ago, video and film editors considered a *jump cut* an aesthetic mistake and immediately discarded it. But now we have accepted the jump cut as a part of our aesthetic arsenal. It was made acceptable and even popular by people who edit news interviews. Because of constant deadline pressures and demands for ever shorter running times for news items, the videotape editor eliminated most of the interview except for a few highlights and then simply strung the remaining shots together without concern for the resulting jump cuts. Eventually, we accepted the spatial jumps and translated them accurately into time jumps. After all, the relatively minor positional jumps are manifestations of large "at" position jumps

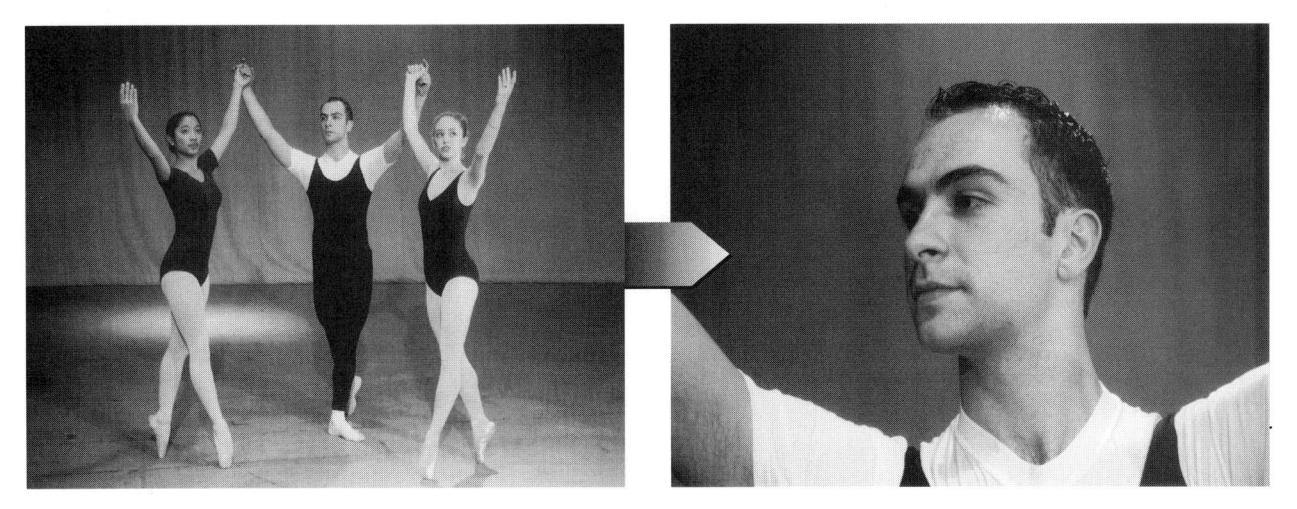

14.11 Smooth Cut

We consider a cut as smooth if there is continuity in object direction, speed, on- and off-screen location, color, and general vector magnitude between the two shots.

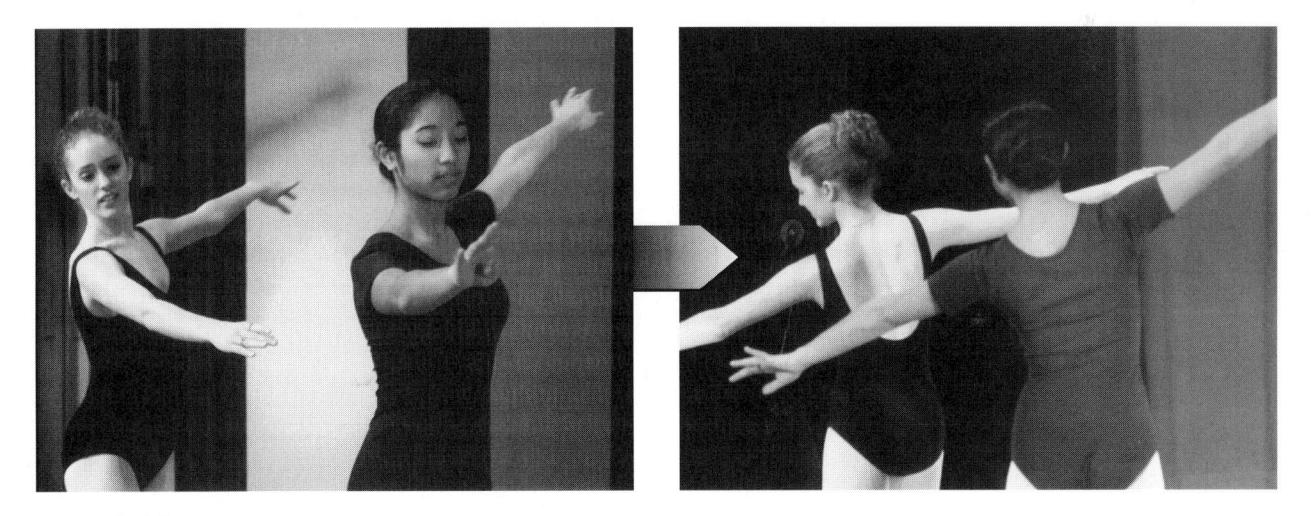

14.12 Bad Cut

This cut is considered less smooth, because the direction of the object motion changes too abruptly from shot to shot while the field of view remains too similar.

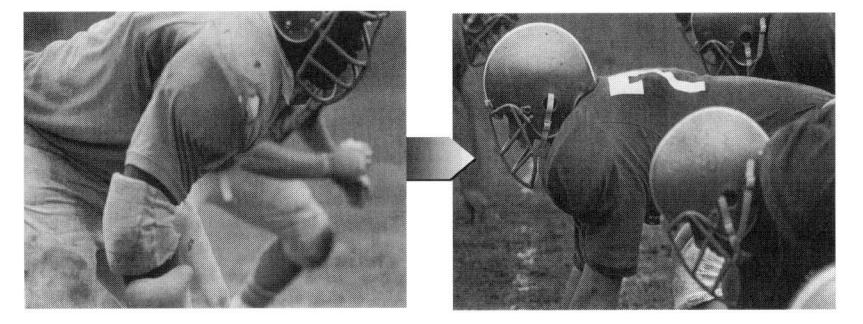

14.13 Converging Vectors to Increase Energy

Cuts between converging vectors can contribute to a high-intensity screen event.

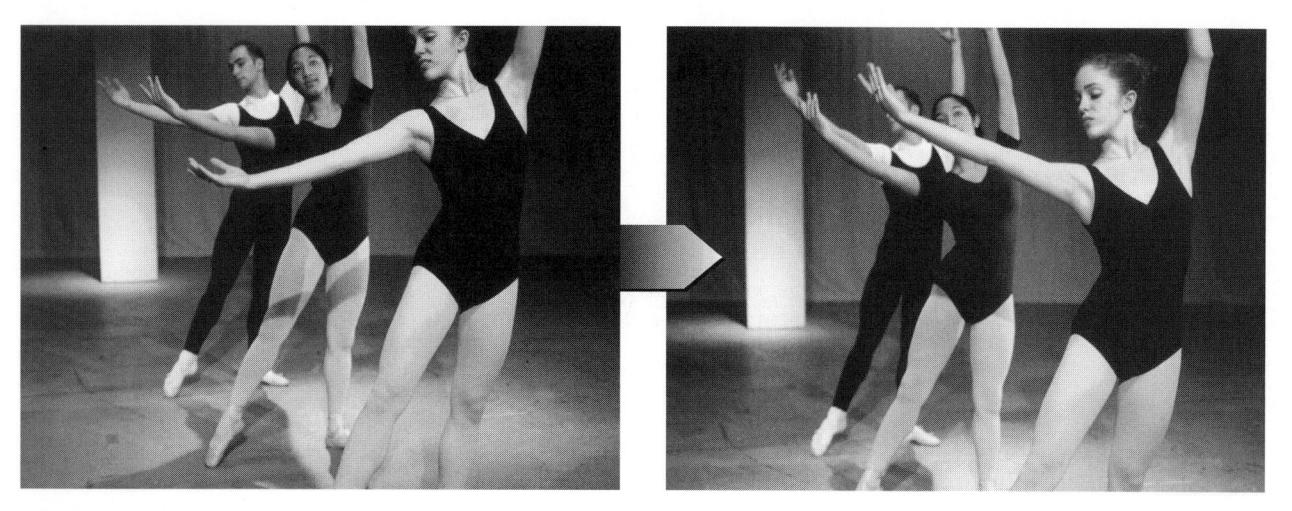

14.14 Jump Cut

In a jump cut, the person seems to jump from one screen location to the next. Though jump cuts are generally undesirable, you can use them to signal a jump in time or else extreme emotional stress.

along the horizontal time vector. In order to make the jump cut less abrupt and more acceptable to the viewer, many editors use the "soft cut" as a transitional device. The soft cut is similar to a fast dissolve that briefly overlaps the two images and thus somewhat blurs the "jump" between the preceding and following image.

The jump cut can also function as a powerful intensification device. For example, you can use the jump cut in a dramatic scene similar to the *jogging* device to signal extreme emotional stress (see the discussion of accelerated motion in chapter 13). The cut violates the expected smooth continuity and jolts our perceptual complacency. At the same time, it manifests the character's psychological "jumps" and compels us in a shorthand way to take notice of his or her progressively labile emotional state of mind.

The dissolve The *dissolve* is a gradual transition from shot to shot in which the two images temporarily overlap. In contrast to the cut, which itself is invisible, the dissolve occupies its own screen space and time **SEE 14.15** A dissolve can be long or short, depending on the time that the images from the preceding and following shots overlap. The dissolve has its own visual structure, albeit a temporary one. In a slow dissolve, the visual structure becomes more prominent; in a quick dissolve, the transition has more of the characteristics of a soft cut.

During the overlap, the dissolve creates a new vector field that consists of the vectors of the preceding and following shots. **SEE 14.16** In many cases this overlap of vectors produces a field in which the direction of the individual vectors is greatly muddled and their magnitude drastically reduced if not eliminated altogether. The temporary directional confusion of the vectors and the resulting reduction of their magnitude make the dissolve appear as a rather smooth, legato transition. A dissolve never ends a shot—it simply blends into a new one. It's no wonder that the dissolve is such a favorite transition device whenever sequence fluidity is desired.

A dissolve can also cause some confusion about the figure-ground relationship of the overlapping shots; that is, which of the two shots is supposed to be on top and which on the bottom. At the beginning of the dissolve, the first shot maintains its own figure-ground organization. In the middle of the dissolve, both shots yield their figure-ground organizations to that of the temporary third

14.15 Dissolve

In a dissolve the image of the preceding shot temporarily overlaps that of the following shot. The dissolve occupies its own screen time and space.

14.16 Third Vector Field of Dissolve

In a dissolve the vector field of the preceding and following shots overlap temporarily, forming a third vector field that occupies its own screen space and time.

A cut usually generates a staccato rhythm; dissolves generate a legato rhythm. Staccato means that there is emphasis on each note: Each note appears as a separate, strong entity.

In a legato passage, the notes blend into one another; there are no breaks between them. They appear as a unified passage.

vector field, which, because of the overlap, remains ambiguous as to which shot is the figure and which is the ground. By the end of the dissolve, the second shot gains control of its own figure-ground organization. This temporary figure-ground confusion makes us take notice and gives the dissolve its high visibility. You have probably figured out that a superimposition is simply a dissolve stopped midway.

The main aesthetic functions of the dissolve are: to provide smooth continuity, to influence our perception of screen time and event rhythm, and to suggest a thematic or structural relationship between two events.

The dissolve aids continuity. Because you create an ambiguous vector field in the middle of a dissolve, you can provide some continuity of shots even if the shots would not cut together well. In an emergency, for example, you can bridge the gap between an extreme long shot and an extreme close-up without losing the viewer's orientation.

A word of warning is in order here: The ready availability of dissolves in television and their ability to camouflage gross sequencing mistakes may entice you to use more dissolves than cuts for every type of show. Avoid this temptation. They may be safer than cuts, because they cushion vector discrepancies from shot to shot, and they may feel somewhat smoother, but using too many dissolves is certain to destroy the crispness and rhythmic clarity of a sequence. Like too much pedal in piano playing, the indiscriminate use of the dissolve muddles the scene. Think of dissolves as a special effect and treat them as such.

The dissolve can also act as a time bridge. Although the cut and even the jump cut have largely replaced the dissolve in indicating a change of locale or a passage of time, dissolves are still an effective and reliable way of bridging time intervals. For example: a lone survivor of a shipwreck, floating in a rubber dinghy; dissolve to a slightly closer shot of the dinghy. This will indicate that some time has passed with no change of circumstances. The dissolve is especially appropriate when you want to show the connection between an event that happened in the distant past and one that occurred more recently. Example: young boy running through his hometown fields; short dissolve to a professor in a lecture hall at a large university, speaking on the influence of one's youth on adult behavior.

The dissolve greatly influences event rhythm. The legato linkage between shots reduces rhythmic accents and interconnects event details to form a smooth time entity. A slow dance sequence, a religious service, the solemn pace of a funeral—all are probably better served by dissolves than cuts between shots. Dissolves make these events feel less frantic while preserving their emotional intensity.

Dissolves can also suggest thematic or structural relationships, even between two unrelated events. Example of thematic relationship: street crowded with people; dissolve to crowded cattle. Example of structural relationship: outfielder jumping to catch the ball; dissolve to leaping dancer.

The fade In a *fade*, the picture either goes gradually to black (fade-out) or appears gradually on the screen from black (fade-in), signifying, much like a theater curtain, a definite beginning or end of a sequence. The fade is not a true transition device; rather, it defines the duration (running time) of the individual event sequences or of the event itself. Again, try to avoid fades between shots unless you want to indicate the end of one event and the beginning of another. To keep the viewer's avid attention and to maintain the high-energy pace of a show, use cuts rather than fades. Sometimes you may want to use a quick fade-out followed immediately by a fade-in of the next shot—also called a "cross-fade" or a "dip-to-black"—as a more obvious indication of a scene or sequence change than a cut would provide.

Special transitional effects *Digital video effects (DVE)* provide a great number of transitional choices. The image may freeze, shrink, tumble, stretch, flip, glow—or do all these things and more simultaneously. Still another shot may freeze, expand into a mosaiclike image, undergo an imperceptible metamorphosis, and shrink into a normal-sized second shot as if nothing had happened. The various special-effects software available for desktop computers make such transitional effects readily accessible. Because most of these effects are visually exciting, you may be tempted to use them indiscriminately; but use them judiciously so that

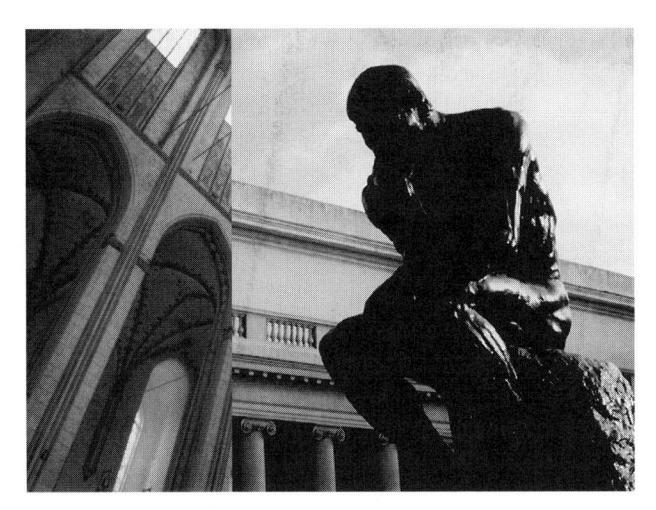

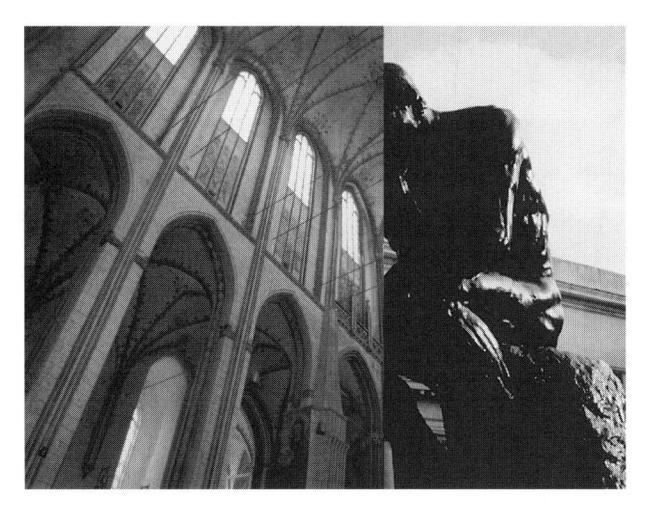

14.17 Wipe In a wipe the first image yields to the second.

they aid rather than hinder you in clarifying, intensifying, and interpreting messages for an intended audience.

Most of these electronic effects have such an unabashed screen presence that we can hardly call them transitions; rather they are interconnecting shots. Contrary to the cut, such effects operate largely independently of the vector fields of the two shots they connect. For example, in a *wipe*, the new image seems to push the old one off the screen, although, technically, it merely moves aside to reveal the new shot. The wipe has no reverence for vector continuity or structural or thematic relationships. **SEE 14.17** The more-complex effects may graphicate the images of the previous and/or following shots, or create their own images that may or may not be based on the preceding and following shot, scene, or sequence.

Similar to the fade, these obvious electronic effects signify the end of one sequence and the beginning of the next. Unlike the fade, however, these effects can be more transient. The wipe, for example, does not put a stop to a shot sequence but simply advances it in a rather impudent way. Others mark—much as space modulators do—the scenes and sequences of the event. They lead us from one space/time environment to another or, more often, from one event to a quite different one.

Commercial spots perform a similar structural function. In daytime serials, for example, they have become important dramaturgical devices to separate scenes and sequences. When writing for television, you should consider commercial breaks as part of the total show development so that you can use them to function as structural "markers" and periods of relief, just as the intermission does in a theater performance. The "glow and flow" trend in television, whereby one show or commercial rolls into the next one as seamlessly as possible (to keep its audience), puts special emphasis on connecting the show segments not only thematically, but also aesthetically through congruous vector structures.

Again, you may be lured into using these effects just because they look interesting and are so easy to produce, but don't use anything except a cut unless the effect contributes to the clarification and intensification of the visual sequence and is appropriate to the content, look, and pace of the program material. For example, to freeze the champion ski racer during a high-speed turn and have the

graphicated image tumble away toward the snow-covered mountains might be an appropriate way of ending the race coverage. But to use a similar graphication technique for a skier who has been badly hurt would communicate bad taste, if not gross insensitivity.

Summary

Timing is the control of time in television and film. The control of both objective and subjective time is an essential element in structuring the four-dimensional field.

There are six types of objective time in television and film: Clock time depicts the actual, measurable time when an event happens. The television log lists clock times, that is, the beginning and ending times of shows or show segments. Running time indicates the overall length of a television show or film. You can use it to express the length of a show segment as well. Sequence time is a subdivision of running time that measures the length of a sequence—the organic cluster of scenes. Scene time is a subdivision of sequence time and indicates the length of a scene. Shot time measures the duration of a shot; it is the smallest convenient operational unit in a film or television show. Finally, story time is the fictional time depicted by the screen event. If somebody's life is shown from birth to death, the span of this lifetime, rather than length of the show, is the story time.

Timing refers to the control of all these times so that they form a dynamic, rhythmically stimulating pattern. Timing also includes the control of the subjective time categories of pace and rhythm. Pace refers to the perceived speed of an event or an event segment. We speak of the slow pace of a drama or the exceptionally fast pace of a musical. Rhythm refers to the flow within and among the event segments. It is determined by the pace of the individual segments and how they relate to one another.

The principal motions are primary, secondary, and tertiary.

Primary motion is event-dependent and includes everything that moves in front of the camera. Its function is always judged from the camera's point of view. On the small screen, primary motion along the z-axis is preferred over lateral motion. On the wide movie or HDTV screen, lateral motion, especially when blocked as converging motion vectors, can be highly effective.

Secondary motion is the motion of the camera and the motion simulated by camera zooms. It is medium-dependent. The principal functions of secondary motion are: to follow action, to reveal action, to reveal landscape, to relate events, and to induce action.

We define the zoom as secondary motion, although normally the camera remains stationary during the zoom. In a zoom-in, the object gets progressively larger and the camera seems to bring the object toward the screen. In a zoom-out, the object gets progressively smaller and seems to move away from the screen. In contrast, a dolly-in takes the viewer into the scene; a dolly-out propels the viewer away from the scene.

Tertiary motion is sequence motion. It is determined by the specific use of one or several of these transition devices: the cut, the dissolve, the fade, and special transitional effects.

The cut is an instantaneous change from one image to another. The cut itself does not exist because it does not occupy its own screen time and space. It is used to manipulate and construct screen space, screen time, and event density. Smooth cuts occur when the vector fields of the preceding and following shots provide continuity. A jump cut shows the object in a slight yet sudden position

change. You can use this technique to indicate a jump in time or to intensify an especially emotional event.

The dissolve is a gradual transition from shot to shot, in which the two images temporarily overlap. The major functions of the dissolve are to provide continuity, influence our perception of screen time and event rhythm, and suggest a thematic or structural relationship between two events.

The fade is a gradual appearance or disappearance of a screen image. The fade signals a definite beginning or end of a show, sequence, or scene.

Through digital electronics, many special effects such as a wipe are available as transitional devices. Such digital video effects (DVE) have such a strong screen presence that they are more like interconnecting shots than pure transitions. Much like space modulators, they mark the scenes and sequences and lead from one space/time environment to the next or from one story segment to another.

NOTES

- 1. Story time and running time are seldom identical in film. One of the more impressive exceptions is the French film *Rififi* (1958) by Jules Dassin, which shows a bold burglary in its actual time from beginning to end. Yes, the culprits get away!
- 2. In his "Rule of Six" for editing, Walter Murch puts rhythm as third in importance for making a cut. See Walter Murch, *In the Blink of an Eye: A Perspective on Film Editing* (Beverly Hills, Calif.: Silman-James Press, 1995), p. 18.
- 3. Herbert Zettl, Video Basics 2 (Belmont, Calif.: Wadsworth Publishing Co., 1998), p. 92.
- 4. Refer to chapters 9, 10, 11, and 13 for the various z-axis explanations and discussions.
- 5. If available, you can set up three monitors side-by-side in multiscreen fashion and connect them to three side-by-side cameras. Have the two wing cameras zoomed out and the center camera zoomed in. When somebody walks along the x-axis of the three cameras, you will see how the close-up view of the center camera dramatically increases object speed.
- 6. Overcoming the difference between lens-generated and computer-generated motion proved to be a major obstacle in the preproduction of Steven Spielberg's *Jurassic Park*.
- 7. Herbert Zettl, *Television Production Handbook*, 6th. ed. (Belmont, Calif.: Wadsworth Publishing Co., 1997), pp. 340–355.

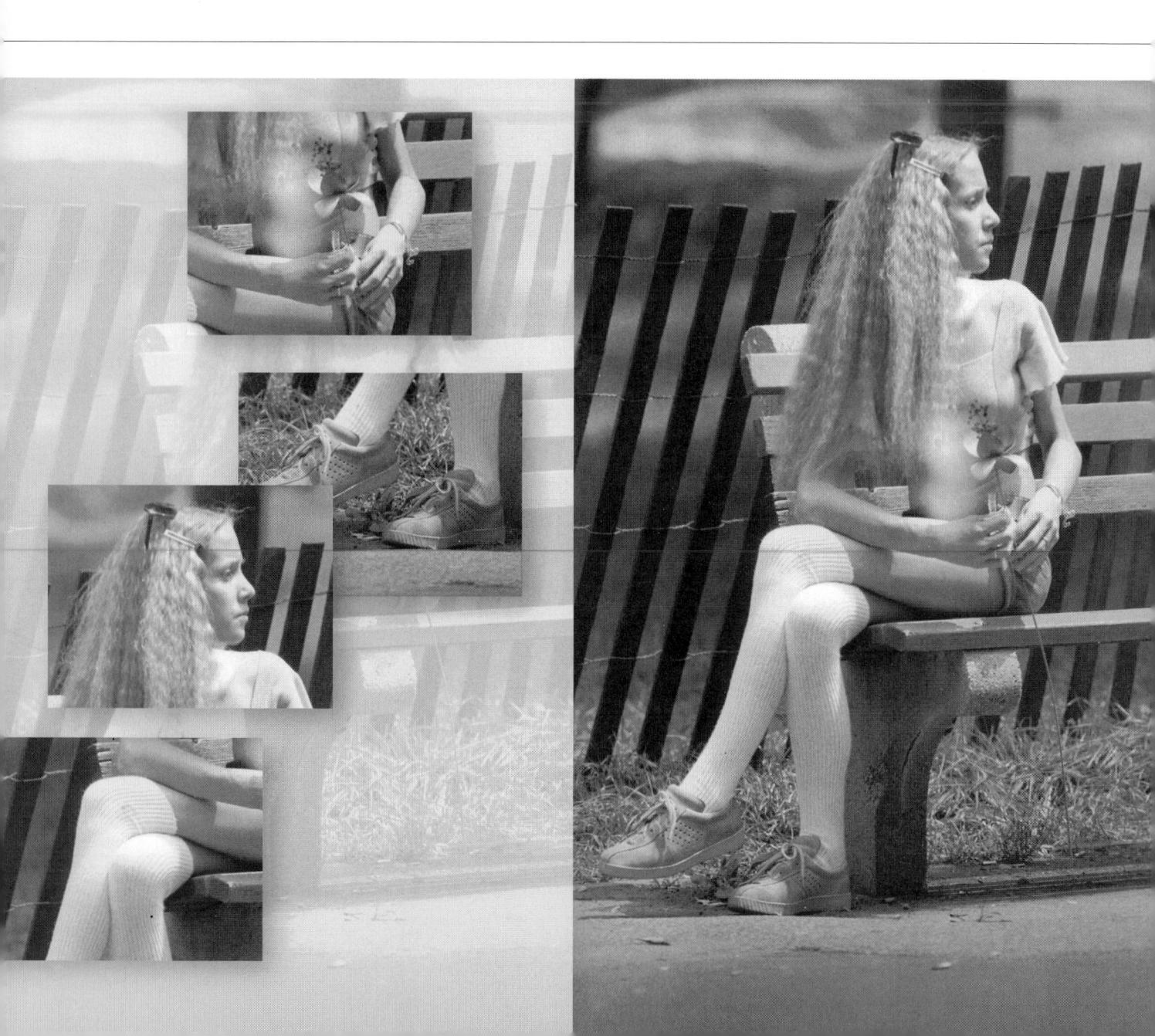

Structuring the Four-Dimensional Field: Continuity Editing

DITING involves selecting and sequencing those parts of an event that contribute most effectively to its clarification and intensification. Thus editing means building a screen event. What parts of the event you select and how you build the screen event depend on many contextual factors: what you want to say, why and to whom, and especially how. Your decisions of what to use and what not, what to emphasize and what not, and exactly how to put everything together for the screen are influenced by your communications intent, the target audience, the medium requirements, and your personal style.

Sometimes you will find that you have to make such decisions almost instantly while the television show is going on. Live television, for example, frequently demands immediate decisions and action which, despite careful preproduction preparation, you could not have anticipated. Much of television editing is done in the control room while the show is in progress. Interview shows, sports remotes, and daytime serials are all shot with a multicamera setup. The editing is done by selecting the most effective shots from the continuous video feed from these cameras and other video inputs, such as videotape inserts or computer-generated images. This selecting and sequencing of shots while the televised event is in progress is called *switching* or *instantaneous editing*.¹

At other times, you will need to deliberate on just which part of the prerecorded material to select and where to place it in the overall show. The more deliberate selection and ordering of prerecorded material is called *postproduction editing*. This process is similar for television and film, especially since much postproduction editing of film is done electronically with nonlinear computer systems.² Regardless of whether you are engaged in switching or postproduction editing, the aesthetic principles of editing are identical for both techniques: the clarification, intensification, and interpretation of an event. *Continuity editing* concentrates on the structuring of on- and off-screen space and on establishing and maintaining the viewer's mental map. When driving to a specific location, you are establishing a mental map that you follow on the way back. You do the same when watching television or a motion picture. The *mental map* helps you make sense of where things are, where they are going, or where they are supposed to be in on- and off-screen space. Continuity editing concerns itself primarily, but not exclusively, with the clarification of an event.

When reading and thinking about editing, you should realize that editing procedures are as much audio-dependent as they are video-dependent. This means that you will have to consider sound (dialogue, sound effects, music, and natural environmental sounds) as important an influence on your editing decisions as the pictorial vector field. For clarification's sake, however, we concentrate here on the visual practices of editing as part of structuring the four-dimensional field. Sound structures and their relation to visual structures are discussed in chapters 17 and 18.

Specifically, continuity editing is concerned with selecting and putting together shots that cohere in terms of: (1) graphic vector continuity, (2) index vector continuity, (3) the index vector line, (4) motion vector continuity, (5) the motion vector line, and (6) special continuity factors.

You may think that this is a big order to fill—and indeed it is. Most postproduction editing takes much longer than the actual recording of the event. Although there is no recipe that guarantees success every time you edit, a thorough knowledge of the basic editing principles will make you secure in your judgment and will ultimately free you to act more intuitively without abandoning artistic control.

Graphic Vector Continuity

Although graphic vectors generally have a low magnitude—which means that they are relatively ambiguous as to specific direction—you must nevertheless consider them when trying to achieve continuity from shot to shot. Especially when shooting a scene with a prominent background line, maintain the horizon at the same screen height in subsequent shots with the same or similar field of view. In a multiscreen presentation, such graphic vector continuity is essential if you want viewers to see the horizon line as continuous across all horizontally positioned monitors. **SEE 15.1**

In interior shots you must be equally aware of such prominent graphic vectors as the back of a couch or a windowsill in the background. Unless you change camera height and angle of view, such lines must continue from shot to shot.

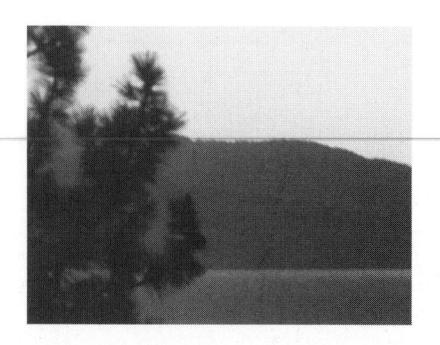

15.1 Graphic Vector Continuity

In a series of shots with the same or similar field of view, the graphic vector of the horizon line should lie at the same screen height from shot to shot, or from screen to screen in multiscreen presentations.

Index Vector Continuity

The continuity of vectors from shot to shot applies regardless of whether the vectors are continuing, converging, or diverging index or motion vectors. Continuity principles of *index vectors* apply to on-screen space, but also extend into off-screen space. They help establish an important part of the viewer's mental map.³

CONTINUING, CONVERGING, AND DIVERGING INDEX VECTORS

As you recall, *continuing vectors* point in the same direction, *converging vectors* point toward each other, and *diverging vectors* point in opposite directions.

Continuing index vectors Once you show a woman looking left in a medium shot, we as viewers expect that person to continue looking left in the succeeding close-up, assuming that she is still focused on the same object. This formation of our mental map is in line with our actual daily experiences and our constant need for a stable environment. **SEE 15.2** The same continuity principle applies if you are showing in the medium shot two people looking screen-left at the same object. If you then cut to individual close-ups, the direction of the index vectors must be maintained for each person. **SEE 15.3**

15.2 Continuing Index Vectors

When cutting from a medium shot (a) to a close-up (b), the index vectors in both shots should point in the same screen direction.

15.3 Continuing Index Vectors: Two-Shot.

If a two-shot establishes two continuing index vectors (a), the index vectors must continue into the subsequent close-ups (b and c).

Converging index vectors The continuity principle of continuing index vectors applies in a similar way to converging and diverging index vectors. If, in a two-shot, you show two people talking to each other, you must maintain the converging index vectors in the following close-ups. **SEE 15.4–15.6** Note that there are several possibilities for keeping the index vectors converging.

When you show a medium shot of a speaker and close-ups of audience members, you must preserve the original index vector convergence between audience and speaker by having all audience members look in the same direction. **SEE 15.7**

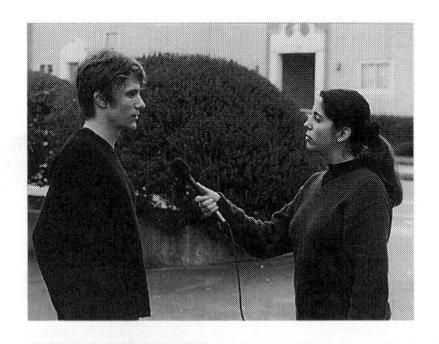

15.4 Converging Index Vectors: Two-Shot Profile

Index vectors that converge in a two-shot should continue this convergence in subsequent close-ups.

15.5 Converging Index Vectors: Oblique Angles

The convergence of established index vectors can vary from the two-shot. Here the index vectors converge at oblique angles.

15.6 Converging Index Vectors: Over-the-Shoulder Shot

This follow-up sequence suggests converging vectors through over-the-shoulder close-ups.

Diverging index vectors In a similar way, if you establish converging vectors by having two people look away from each other, you need to carry over the diverging vectors into the succeeding close-ups.

INDEX VECTOR-TARGET OBJECT CONTINUITY

The continuity of index vector to target object is especially important if you have a person looking at something in one shot and then show the target object in the following shot. As viewers we will remember the direction of the index vector and construct a cognitive mental map of where the target object should be positioned relative to the index vector.

On-screen continuity To maintain the viewer's mental map, you must match in the second shot the camera's viewpoint and the resulting object position of the first shot. For example, if you show a child looking up and screen-right, the target object should appear in approximately the same screen position in the subsequent close-up. What you need to do is follow the index vector of the child in shot (a) and extend it the same way into shot (b). This extension leads unquestionably to the upper-right corner of the frame. **SEE 15.8**

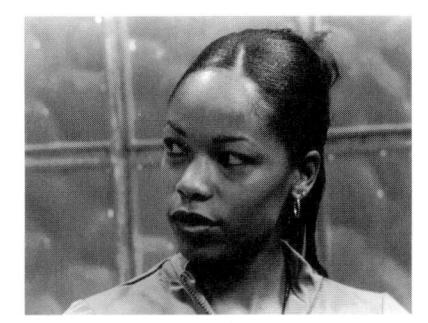

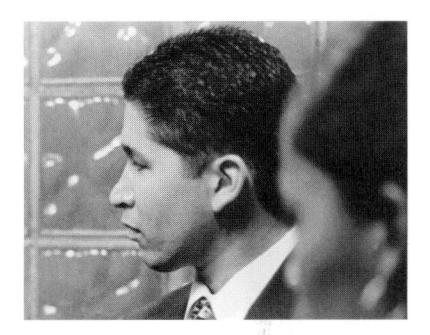

15.7 Converging Index Vectors: Audience and Speaker

Separate close-ups of a speaker and audience members must produce converging index vectors if viewers are to perceive speaker and audience as looking at, rather than away from, each other.

15.8 Index Vector—Target Object Continuity

The strong index vector in (a) influences the screen position of the target object in (b). The girl's index vector points to the upper-right screen corner in (a). The target object is correctly positioned at the end of the extended index vector in the vicinity of the upper-right corner in (b).

Shot 1 — Person A

Shot 2 — Person B

Shot 3 — Person A

Shot 4 — Person C

15.9 Implied Screen Positions

You can use index vectors to help viewers construct a cognitive map of the off-screen space that shows the position of people and things.

Off-screen continuity The mental map requirements for index vector—target object continuity extend quite readily into off-screen space. If in one shot you have someone looking at something outside the screen, the follow-up shots need to show the object in such a screen position that viewers can perceive the two shots as a single, simultaneous event. The position of the target object is obviously greatly influenced by the direction of the index vector in the previous shot.

For example, in showing two people watching a tennis match, for example, their index vectors will tell the viewers where the ball is going without showing the actual game. When you finally show the tennis player, however, make sure that the target object (the ball) is indeed at the end of the extended index vector of the spectators' glance. This is especially important when you shoot out of sequence for postproduction. In the same manner, if you show someone looking at something and then let the viewer see what the person is looking at, you must match the camera's viewpoint in the second shot with that of the person in the first shot.

You can facilitate the viewer's creation of such a map by setting up a series of index vectors. Take a look at the series of shots at left and try to construct a map of where the people pictured are located in real space. **SEE 15.9**

If you placed person A in the middle, person B at camera right (A's left), and person C at camera left (A's right), you constructed the proper cognitive map of their actual positions. **SEE 15.10**

BAC positioning If you were to use the same seating arrangement for an interview, you would run into serious problems maintaining the established screen positions. With the host (person A) in the middle of the two guests (persons B and C), you switch A's position every time you cut to a two-shot during the interview. **SEE 15.11**

15.10 Actual Screen Positions

The actual positions of the people concur with those implied by the index vectors in figure 15.9

15.11 BAC Positioning
With the host (A) in the middle, cutting to two-shots (BA and AC) will switch the position of the host.

A simple solution to this problem of position continuity is to change the BAC arrangement to an ABC one. By putting the host (person A) on one side and the guests (B and C) on the other, the index vectors between the host and his guests will remain properly converging even in separate close-ups. Host and guests will maintain their screen positions and not upset the viewer's mental map of on- and off-screen space. **SEE 15.12**

SUCCESSIVE Z-AXIS INDEX VECTORS

Recall that *z-axis vectors* point toward or away from the camera. Whether you perceive two successive *z-axis* vectors as continuing, converging, or diverging

15.12 ABC Positioning

By placing the host (A) to one side of the guests (B and C), the subsequent close-ups maintain the screen positions of host and guests and their converging index vectors.

15.13 Successive Z-axis Vectors: Continuing

If you establish in a single shot that two people are looking in the same direction (a), viewers perceive successive z-axis close-up shots as continuing vectors (b and c). The two people look at the same target object.

depends on context. For example, if you show two people looking at something in shot 1 and then show each person in a z-axis close-up in shots 2 and 3, we perceive them not as looking at us (the viewers) but at the target object. We see their index vectors as continuing in the successive close-ups. **SEE 15.13**

When you have two people talking to each other in shot 1 and then have each one looking directly into the camera to create z-axis index vectors in shots 2 and 3, the converging index vectors are carried over to the successive z-axis close-ups. **SEE 15.14**

If shot 1 now shows the two people looking away from each other, we continue the diverging directions of their index vectors from the establishing shot in the subsequent z-axis close-ups; we perceive them as looking away from each other. **SEE 15.15**

The Index Vector Line

The vector line is also called "the principal vector," "the line of conversation and action," "the one-eighty" (for 180 degrees), or simply "the line." You can establish extending converging index vectors. **SEE 15.16** The vector line is important for maintaining the established vector continuity in close-ups and especially for keeping an object in the same screen area from shot to shot. The vector line will also aid you in camera placement for proper shot sequencing. When using a multicamera setup, you will immediately see in the preview monitors when a camera is in the wrong place. But when you shoot with a single camera for postproduction editing, mistakes in camera placement are not so readily apparent and usually show up only during editing, when they may or may not be fixable. Assuming you have a skilled editor who can finesse a workable solution, such mistakes are nevertheless time-consuming and labor-intensive to remedy and are invariably more easily and effectively dealt with during the shooting phase than during postproduction editing. "Fixing it in post" should be reserved for unavoidable and unforeseen complications—and not considered a safety net for careless camera placement by a negligent director. Observing the rules of the vector line will help you place cameras in optimal shooting positions and avoid such mistakes.

15.14 Successive Z-axis Vectors: Converging

When the context establishes converging vectors, viewers perceive the successive z-axis vectors as converging.

15.15 Successive Z-axis Vectors: Diverging

If you establish in a single shot that two people are looking away from each other, viewers perceive the subsequent z-axis close-ups as diverging z-axis vectors.

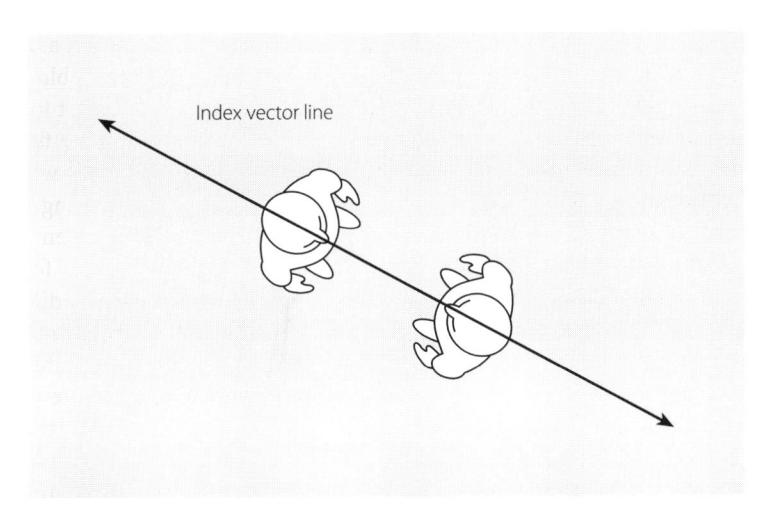

15.16 Index Vector Line

The vector line is created by extending converging index vectors.

CAMERA PLACEMENT FOR CROSS SHOOTING

When cross shooting a conversation, you need to keep both cameras on one or the other side of the vector line. Such a camera setup will maintain the converging index vectors in the successive close-ups of the two people. **SEE 15.17**

If you cross the vector line and place one camera to its left and the other to its right, you will get continuing rather than converging index vectors. Despite the established context of the converging index vectors, we would no longer perceive the two people as talking to each other but rather as talking to a third (unseen) party. **SEE 15.18**

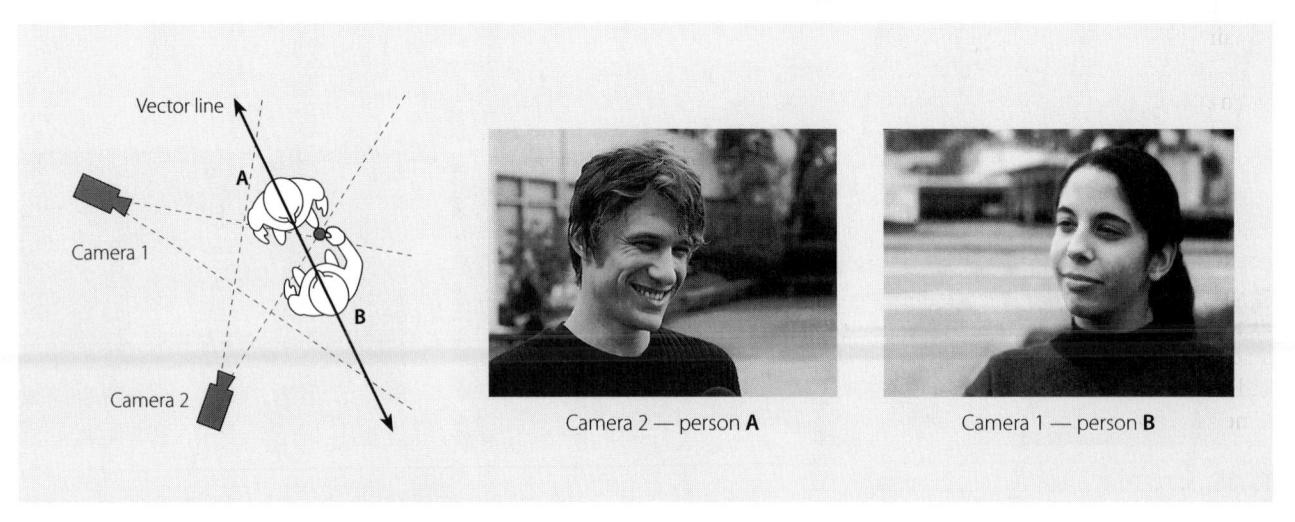

15.17 Camera Placement: Cross-Shot Sequence

To maintain converging index vectors when cross shooting, both cameras need to be on the same side of the vector line.

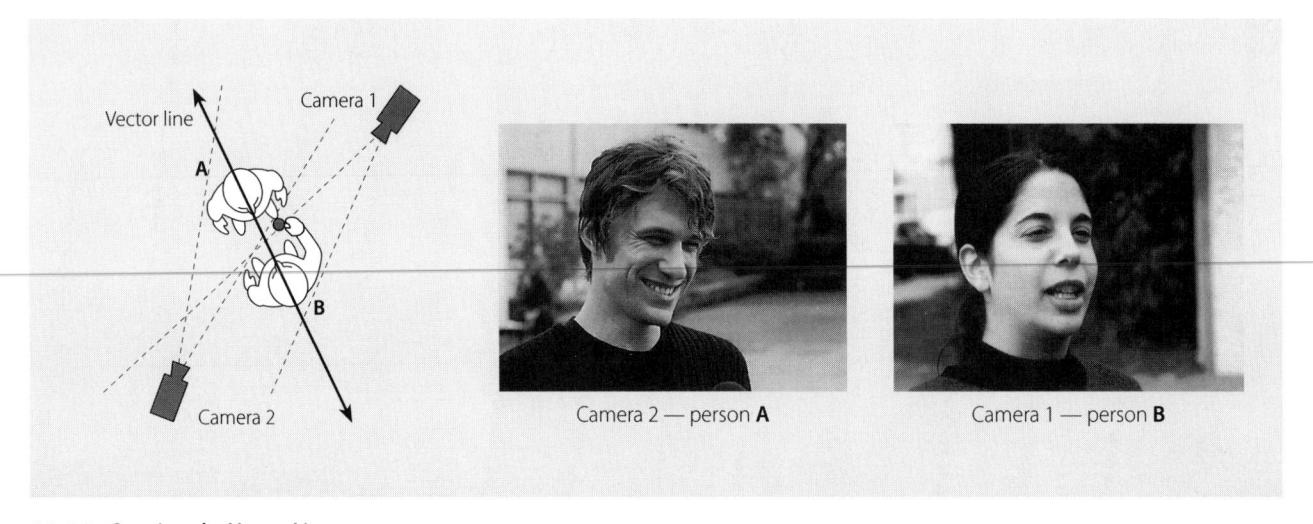

15.18 Crossing the Vector Line

If you place the cameras on both sides of the vector line during cross shooting, the people will appear to be talking away from each other toward someone else.

CAMERA PLACEMENT FOR OVER-THE-SHOULDER SHOOTING

When placing cameras for an over-the-shoulder (O/S) shot sequence, you cannot cross the vector line but must keep the cameras on one or the other side of it. **SEE 15.19**

Visualize, for a moment, how you would see persons A and B in the viewfinder from the camera 1 position in figure 15.19 as well as from the camera 2 position. Now check your visualization against the next figure. **SEE 15.20** As you can see, by keeping both cameras on the same side of the victor line, you maintain the converging index vectors, but especially the screen positions of persons A and B. Person A still appears on screen-left in both shots, and person B remains in the screen-right position.

Now go back to figure 15.19 and visualize the positions of persons A and B when cutting from camera 1 to camera 3. Would the index vectors of A and B still converge? Would A and B remain in the same screen positions in both shots?

Yes, their index vectors still converge in both shots. No, they will not remain in the same screen positions. By placing camera 1 and 3 on both sides of the vector line, you would show the people playing musical chairs and jumping from one side of the screen to the other. **SEE 15.21** Such a sudden position change can be quite confusing to viewers, who rely on relatively stable screen positions of major objects in their effort to make sense of the inductively presented screen space. Once their mental maps established a screen-left position for person A and a screen-right position for person B, they expect the people to appear in the same positions in subsequent shots.

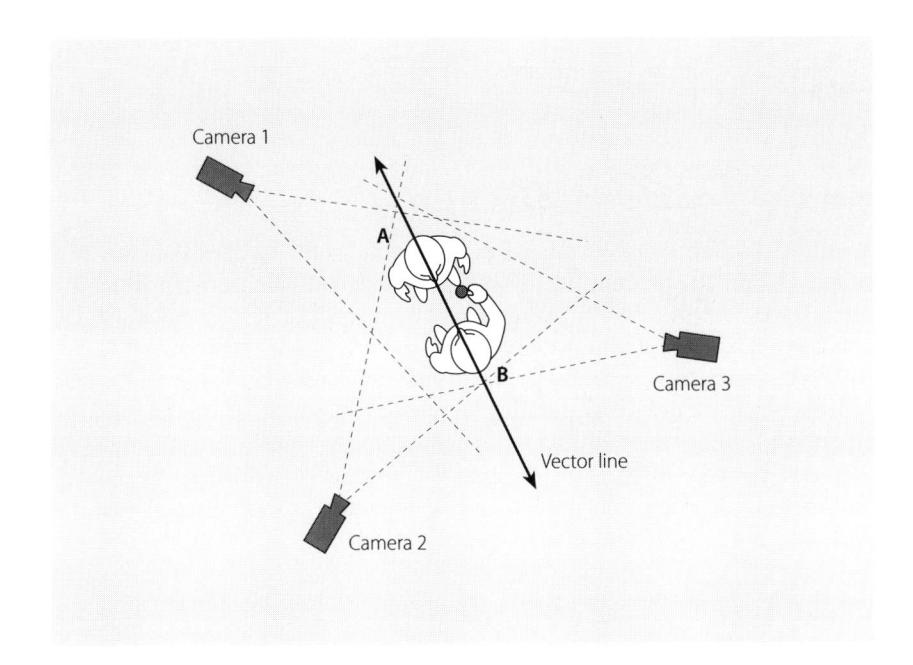

15.19 Camera Placement: 0/S Sequence

Which cameras would you use to provide position continuity when cutting from one over-the-shoulder shot to the other?

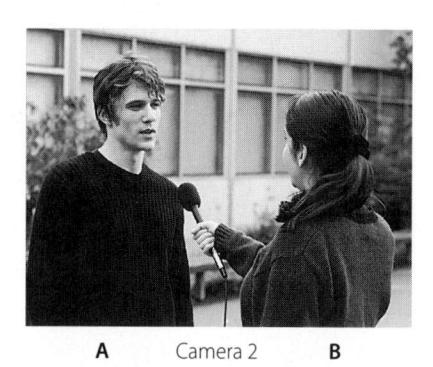

A Camera 1 B

15.20 Cameras 1 and 2: 0/S Views

By keeping both cameras on the same side of the index vector line, cameras 1 and 2 provide the proper vector continuity. Both A and B remain in their previous screen positions.

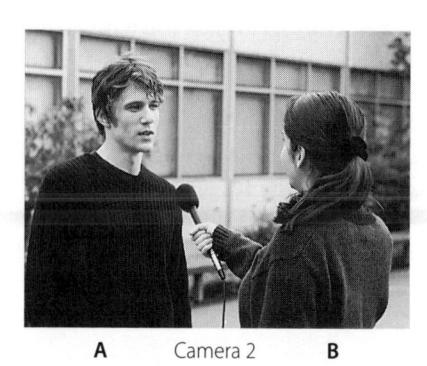

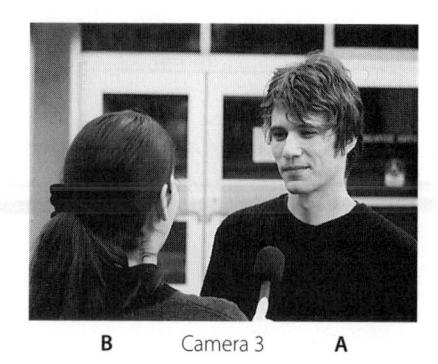

15.21 Cameras 1 and 3: 0/S Views

Cameras 1 and 3 shoot from opposite sides of the vector line. As a result, the people will jump into each other's screen position during the cut.

Z-AXIS POSITION CHANGE

A similar position switch occurs when you cut from the front to the back of a couple (A and B) standing side-by-side. **SEE 15.22** Although their continuing z-axis index vectors (camera 1) are carried over into the next shot (camera 2), A and B will reverse screen positions.

This problem occurs most frequently when videotaping weddings. It seems appropriate to attempt cross shooting between a two-shot of the couple and the official performing the wedding, or to videotape the couple from the front as they walk down the aisle, and then from the back once they have passed the camera, but when you later try to edit the two shots together, you will discover that the bride and groom switch positions.

How can you avoid such a position reversal? One solution is to exclude the couple in your first cross-shot close-up of the official. Once you have interspersed this neutral z-axis shot, you can then show the couple from the back. With such a neutral *cutaway*, our mental map will be much more willing to accept the position switch. If the couple walks toward you, avoid cutting to a shot from the back. Or you may want to try to pan with the couple as they walk past the camera so that the position change occurs within a single shot. When you then cut to a shot of them walking away, you have already established the position change in the previous shot.

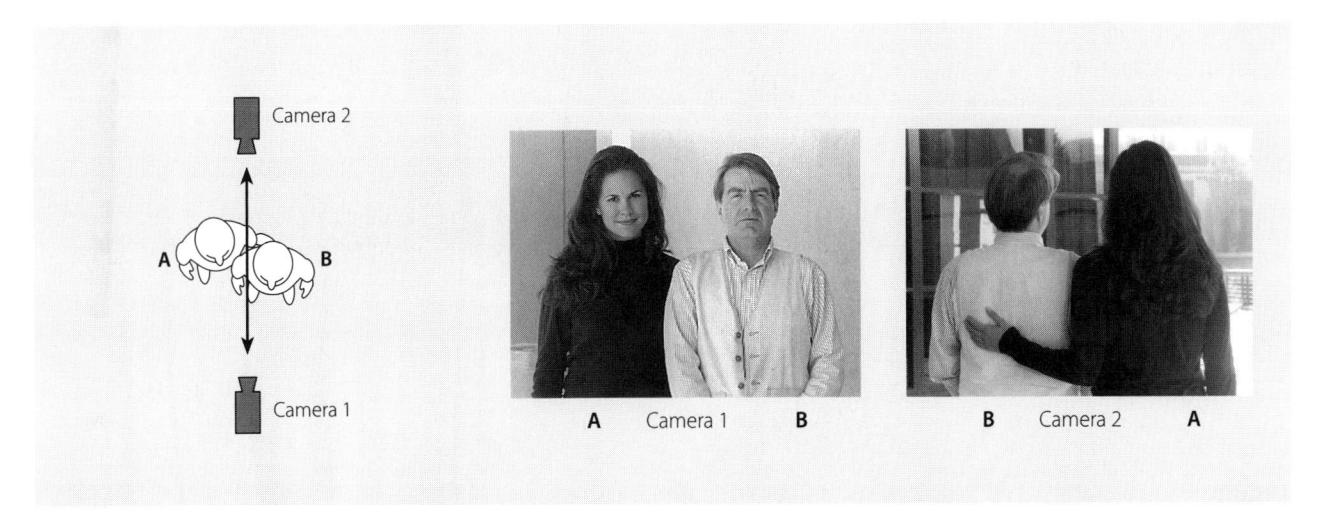

15.22 Z-axis Position Change

When cutting from a front z-axis shot to a back z-axis shot of two people standing side-by-side, the positions of the two people will be switched.

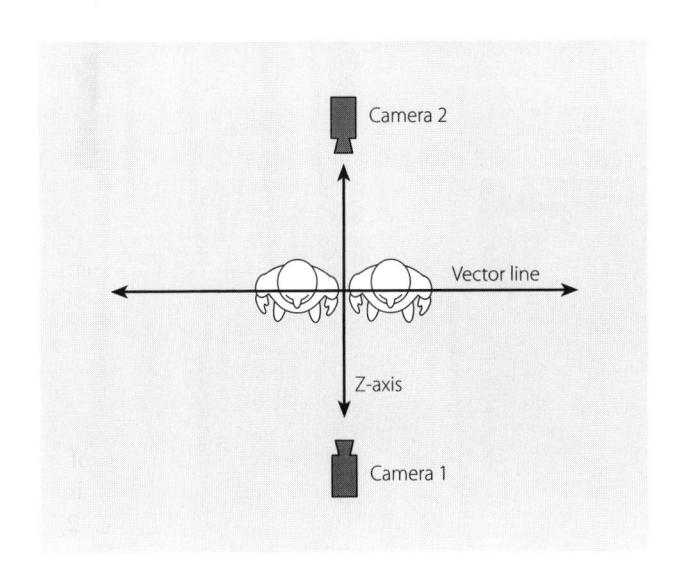

15.23 Establishing the Vector Line: Wedding

Occasionally, establishing the proper vector line can be somewhat difficult. In this case, the vector line is not established by the z-axis, but by the line extending through the two people standing side-by-side (x-axis).

ESTABLISHING THE INDEX VECTOR LINE

In certain situations it is not always easy to decide on the vector line or exactly where to place the cameras. In the wedding example, you would think that the z-axis (the aisle) would be the appropriate vector line and that you had your cameras placed on both ends of it, but not crossed it. But the actual vector line was really formed by the two people standing next to each other, rather than by where they were looking. **SEE 15.23** As you can see, you *did* cross the vector line by positioning cameras in front and in back of the couple.

Now try to imagine the vector line between an audience in a large auditorium and the speaker on stage, or between a concert audience and the orchestra. Where should the cameras go so that the audience is looking at the speaker rather than away from him? **SEE 15.24** Which two of the three cameras

15.24 Establishing the Vector Line: Speaker

A speaker facing his audience forms a vector line that extends from the speaker to the audience. One of the three cameras is in the wrong position for maintaining converging vectors during cutting.

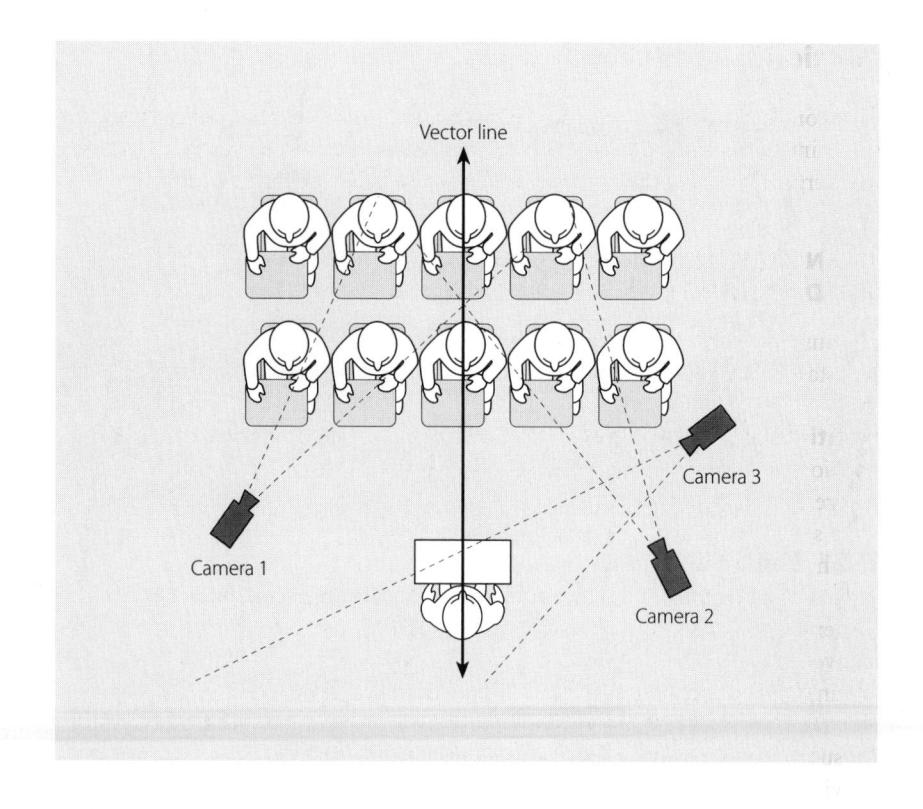

Camera 3 (correct)

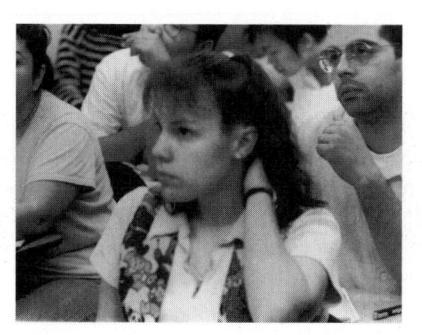

Camera 2 (correct)

Camera 1 (incorrect)

15.25 Camera Views

As you can see, cutting between cameras 2 and 3 maintains the converging index vectors. Cutting to camera 1 between speaker and audience would have them both looking in the same direction. Camera 1 has crossed the index vector line and is in the wrong position.

in figure 15.24 would you use for proper sequencing, that is, for maintaining the converging index vectors between audience members and the speaker?

Yes, cameras 2 and 3 are both on the right side of the vector line and in the correct position for showing converging vectors in a close-up sequence of audience members and speaker. If you were to take camera 1, which has crossed the line, the close-up of the audience member and that of the speaker would show continuing, rather than converging, index vectors. The audience members and the speaker would appear to be looking at a third party rather than at each other. **SEE 15.25**

Motion Vector Continuity

The continuity principles for *motion vectors* are similar to those of index vectors. Like index vectors, the continuity of motion vectors includes continuing, converging, and diverging vectors and extends into off-screen space.

CONTINUING, CONVERGING, AND DIVERGING MOTION VECTORS

Because of their high general magnitude, motion vectors play an important part in establishing and maintaining the viewer's mental map.

Continuing motion vectors As with index vectors, you must continue motion vectors in subsequent shots so that the direction of the moving object is preserved. **SEE 15.26** (Remember, we cannot show an actual motion vector in a still photograph. A motion vector is created by a moving object off and on the screen.)⁴

When you show the traditional yellow cab pursuing the black limousine, for example, their motion vectors must continue in the same direction. If you converge, rather than continue, the motion vectors, viewers see the two cars as fleeing from or racing toward each other, not one following the other.

Continuing vectors are also important for preserving a principal direction in subsequent scenes or event sequences. For example, if you show someone driving from San Francisco to New York, the car should continue in the same screen direction after a stopover during the trip, even if you have changed the direction of the motion vector from time to time during the car's actual travel.

15.26 Motion Vector Continuity

Although you can't show a motion vector on a printed page (motion vectors are created only by a *moving* object or image), you must make sure that the motion vectors are continuing (moving in the same direction) from shot (a) to shot (b).

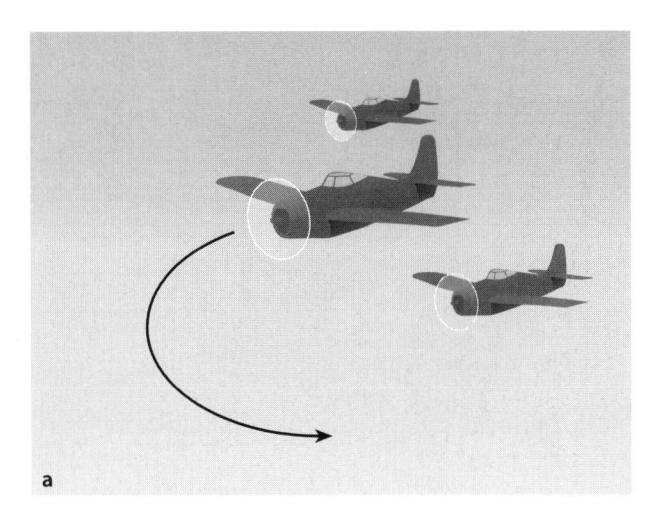

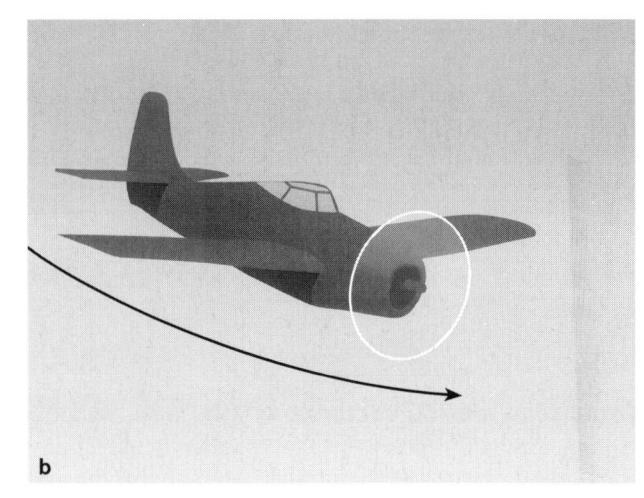

15.27 Directional Change

When the moving object changes its direction within a shot (a), the next shot must show the object moving in the direction it left the screen (b).

If the moving object changes direction within the screen, you need to continue its motion vector in the next shot in the direction it left the screen, that is, at the end of the shot and not necessarily in the direction where it began. **SEE 15.27**

In special cases, you can use converging vectors to indicate continuing motion. If you have established the travel direction of a prominent, easily recognizable object, such as a train or an isolated person, you can have the motion vectors converge without destroying their motion continuity. Converging motion vectors often increase the force of the motion (the vectors collide), thereby raising the energy, if not the tension, of the event. **SEE 15.28** But do not use converging vectors to indicate continuing motion of the object if motion is not easily recognizable or if you mix the motion vectors of several objects.

15.28 Converging Vectors Continue Motion

If we have an easily recognizable object, we can use converging vectors to intensify its motion. Even though the vectors are converging, we accept them as continuing.

15.29 Converging Motion Vectors Collide

The converging motion vectors of shots that show different speeding trains indicate that they are moving toward each other.

Converging motion vectors If the context signals disaster, the converging motion vectors of two speeding trains in subsequent shots indicate that they are racing toward each other. **SEE 15.29** Again, be reminded that these pictures represent index rather than motion vectors, but with a little imagination you should be able to perceive them as shots in which the trains are moving.

If in the context of two people trying to meet, you show a man walking screen-right and, in the next shot, a woman walking screen-left, we expect the two people to meet eventually. **SEE 15.30**

Diverging motion vectors Diverging vectors operate on the same principle as converging vectors. By simply showing the two people first in the context of bidding good-bye rather than trying to meet each other, we interpret the subsequent close-ups of the two people walking in opposite screen directions as diverging, rather than converging, motion vectors. **SEE 15.31** Note that here we have the same two people in similar shots as in figure 15.30, but the new context forces us to interpret them as walking away from rather than toward each other.

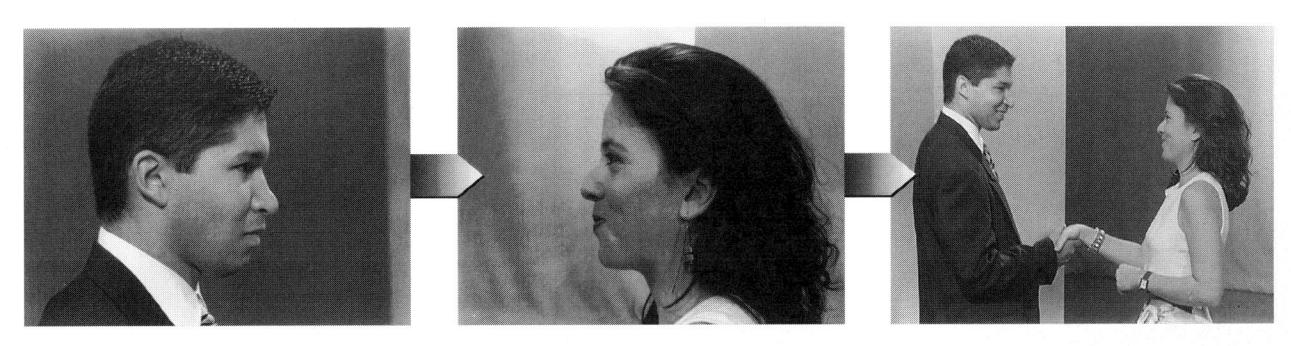

15.30 Converging Motion Vectors: Meeting

If we expect the two people to meet, we interpret the motion vectors in the close-ups as converging.

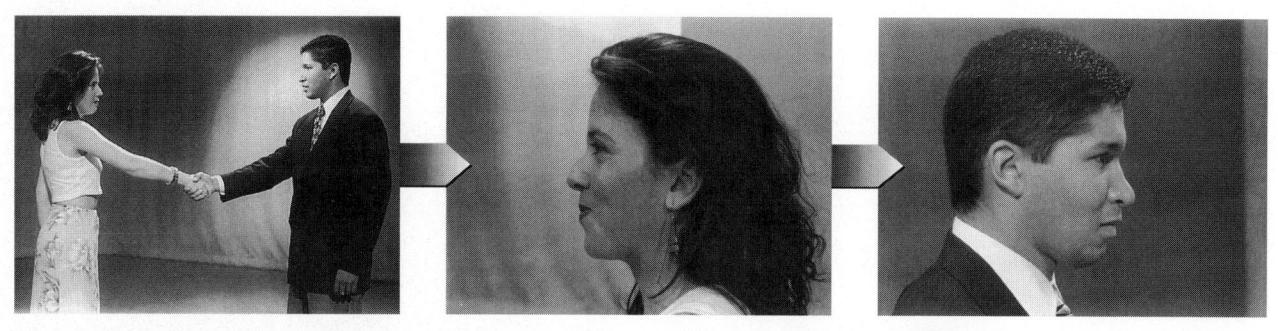

15.31 Diverging Motion Vectors: Departure

If we establish in a single shot that the two people are saying good-bye, we interpret the same motion vectors in the close-ups as diverging.

This perceptual switch of motion from converging to diverging through context is only a small indication of the manipulative power of editing.

Z-AXIS MOTION VECTORS AND CONTINUITY

Objects that move toward or away from the camera produce a z-axis vector. Because they don't move toward a screen edge, they, like z-axis index vectors, have zero directionality, so we perceive vector continuity regardless of their direction in the subsequent shot. **SEE 15.32** Figure 15.32 shows cuts from a z-axis motion vector to a screen-left (a-b) and a screen-right (a-c) motion vector as continuing.

As a matter of fact, you can pretend that the converging vectors of a man in a wheelchair are continuing and pointing in the same direction by placing a zero-directionality cutaway (students walking) between the two shots. **SEE 15.33**

15.32 Continuing Motion Through Zero Directionality

If you show a person moving toward the camera, you can cut either to a screen-left (a–b) or a screen-right (a–c) motion vector while maintaining the motion continuity.

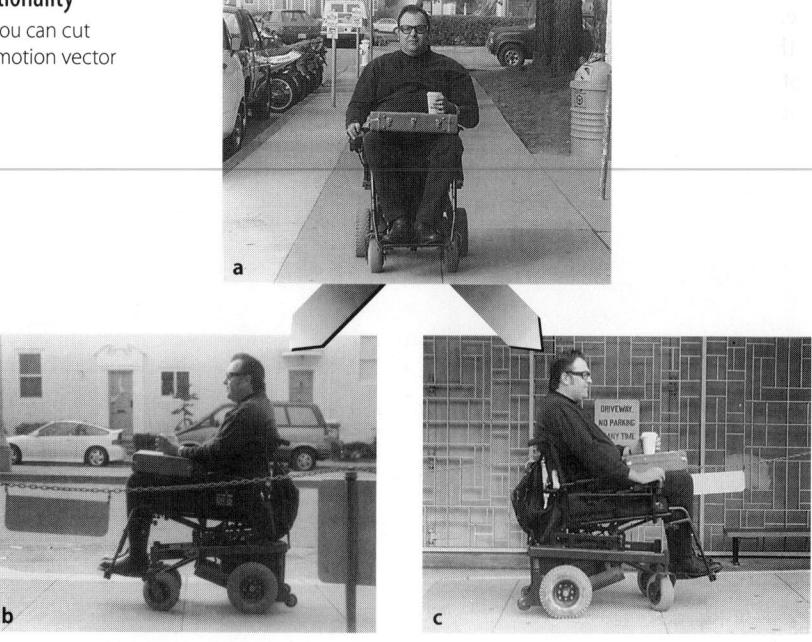

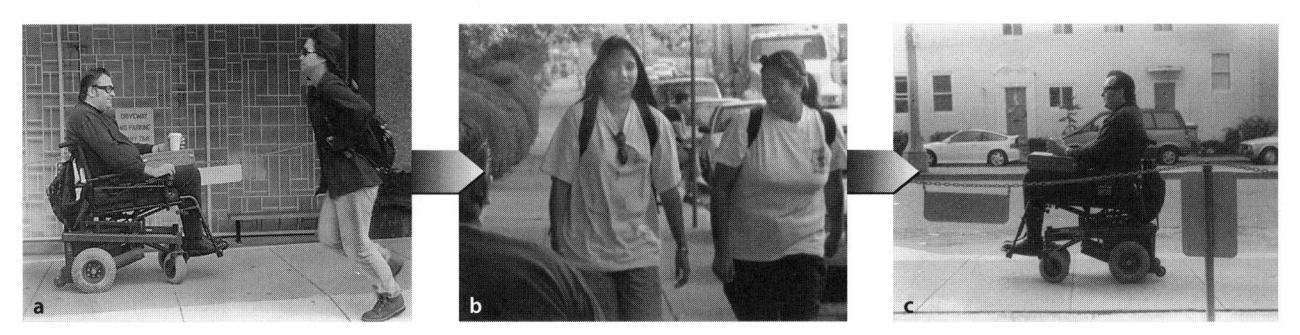

15.33 Zero-Directionality Cutaway

Viewers can perceive converging index or motion vectors as continuous if a zero-directionality (neutral) image (b) is used as a cutaway (cut between the vector reversal of a and c).

A cutaway does not have to have a zero directionality to act as a link between shots that otherwise would not cut together well, that is, between shots whose individual vectors are not continuous. But the cutaway needs to be thematically related.

When using a single camera in a production, always make sure to videotape or film several such cutaways of sufficient lengths. Your editor will be most grateful when trying to establish continuity between shots whose vectors do not provide the desired continuity.

The Motion Vector Line

The motion vector line is similar in function to the index vector line. Establishing the principal direction of a motion vector helps you place the cameras so that vector continuity is maintained.

ESTABLISHING THE MOTION VECTOR LINE

With the exception of z-axis vectors, all other motion vectors describe a vector line. You achieve motion vector continuity only if you place the cameras on one or the other side of the motion vector line. **SEE 15.34** To maintain the principal motion in a shot sequence, you must place the cameras on the same side of the motion vector. **SEE 15.35**

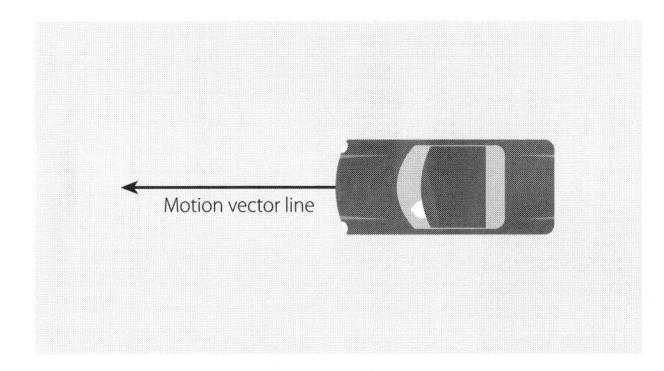

15.34 Motion Vector Line

An extended motion vector forms a vector line.

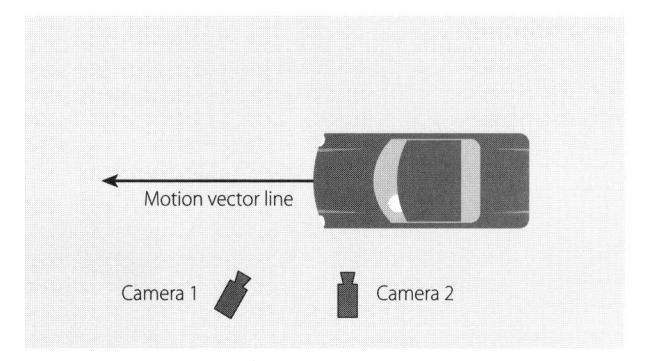

15.35 Camera Placement: Motion Vector Continuity

To maintain the continuity of the motion vector, both cameras must be positioned on one or the other side of the motion vector line. You may cross the motion vector line if the cameras are placed relatively close together and in such a way that they are practically shooting along the z-axis. By cutting from one camera to the other, you show the moving object from oblique angles (from slightly camera-right to slightly camera-left), but you do not reverse the action. **SEE 15.36**

If cameras are placed on opposite sides of the motion vector line, you reverse the motion vector when cutting from one to the other. **SEE 15.37**

You may find that in some sporting events the cameras are placed on opposite sides of the field and so opposite sides of the principal vector line. Cutting to the camera that is across the line reverses the action. Even if such cameras are generally used only for instant replays, the motion reversal is still aesthetically wrong and perceptually confusing. Once viewers have established a screen-right direction for one team and a screen-left direction for the other, however unconsciously, they expect these directions to be maintained in all subsequent shots regardless of field of view. Telling viewers that they are seeing a "reverse-

15.36 Camera Placement: Z-axis

The cameras may cross the motion vector line so long as they are close to the z-axis position. The resulting shots merely show the moving object from a slightly different z-axis point of view.

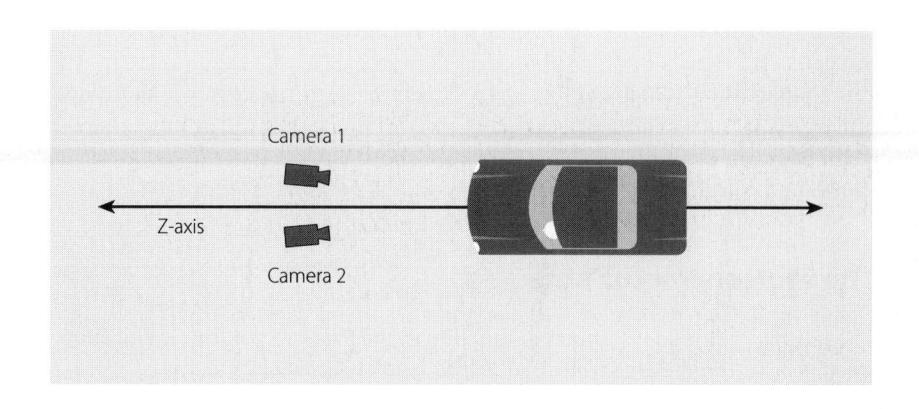

15.37 Crossing the Motion Vector Line

Placing the cameras on opposite sides of the motion vector line will reverse the vector direction with each cut.

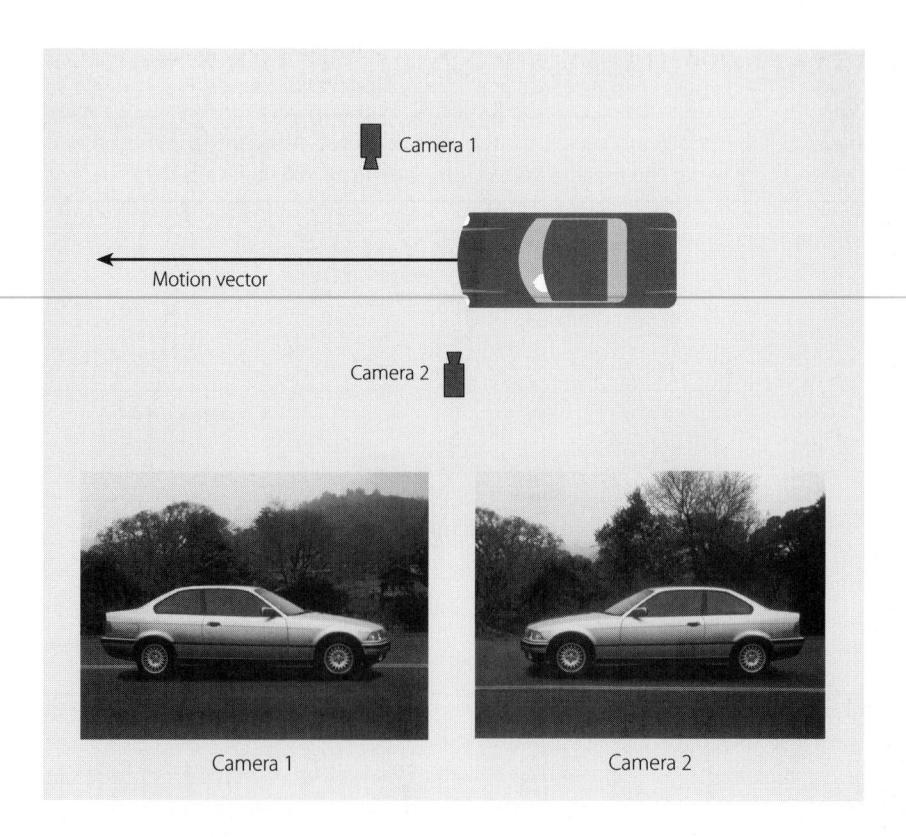

angle shot" may provide them with a rational explanation for the motion vector reversal, but it will not eliminate their mental map confusion.

MOTION AND INDEX VECTOR LINES

Reverse-angle shooting of two people sitting next to each other in an automobile presents an especially tricky vector problem because you have to consider both an index vector line and a motion vector line for camera placement. **SEE 15.38** If you establish an index vector line along the converging index vectors of the two people conversing and place the cameras accordingly on one side of this vector line (cameras 3 and 4), you will preserve the relative screen positions of the two people in cutting from camera 3 to camera 4. **SEE 15.39** But in doing so, you have also inadvertently placed these two cameras on the opposite sides of the motion vector line. As you have just seen, such camera placement causes a motion reversal.

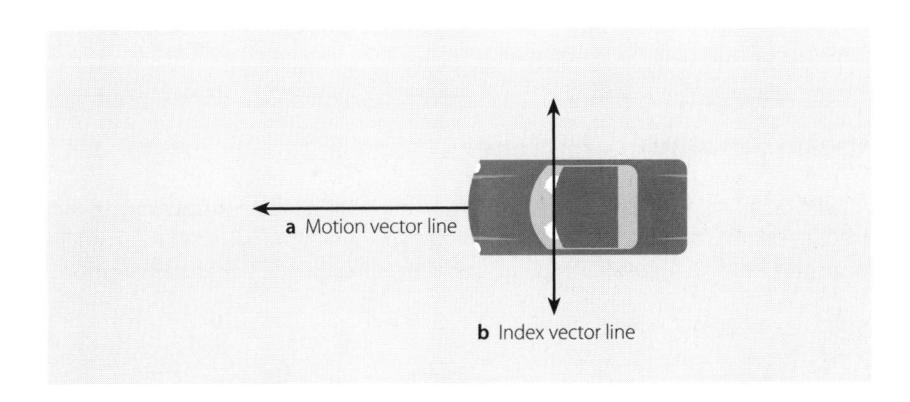

15.38 Index and Motion Vector Lines

When shooting a conversation between driver and passenger in a moving car, you must deal with two vector lines: the motion vector line of the car (a) and the index vector line of the two people talking (b).

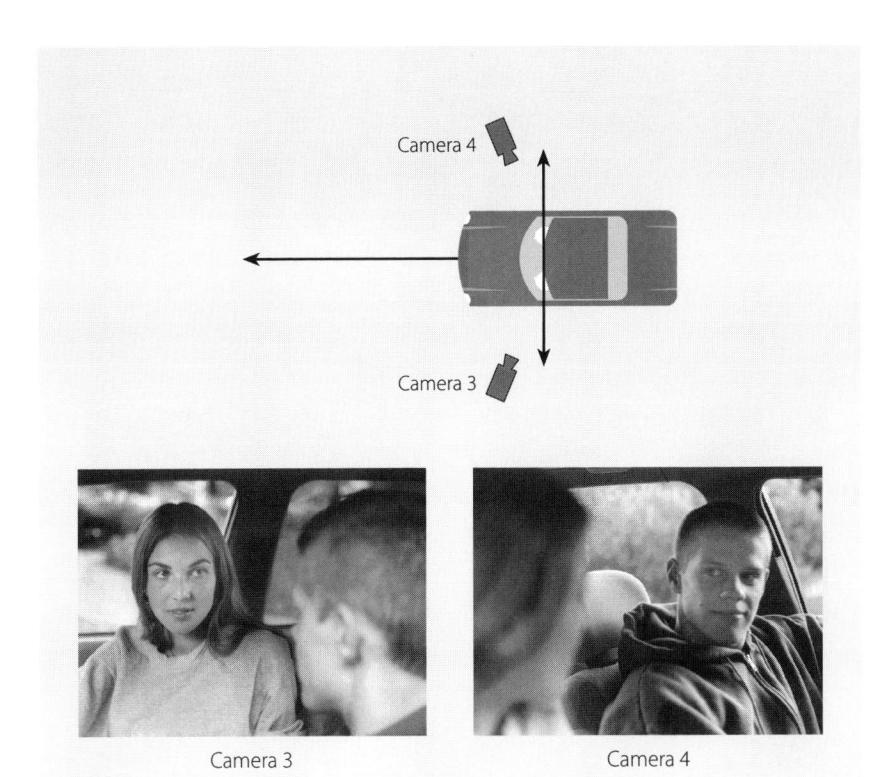

15.39 Camera Placement: Index Vector Line

By keeping cameras 3 and 4 on one side of the index vector line, the positions of the people in the car are preserved, but the car moves in opposite directions each time you switch between the two cameras.

Many directors and editors seem to accept this motion reversal as an unavoidable consequence of trying to maintain screen positions to push the story forward. But, contrary to the wedding scene, where the z-axis motion vectors were of zero magnitude, the moving car now establishes a high-magnitude screenleft motion vector. This high-magnitude vector should override the principle of screen positions. You should not reverse the direction of the car simply because one or the other person is doing the talking. The usual argument is that, if we can't see much of the landscape and keep to a close-up of the two people, their screen direction reversal should not bother us too much. The problem is, however, that even if we can follow the story, our mental map remains confused.

What can you do? One way out of this dilemma is to place a camera in a z-axis position (camera 2). A cut from camera 3 (which shows a screen-left motion vector) to camera 2 (which shows the neutral z-axis vector) will then not reverse the direction of the motion vector and we will readily accept the second shot as a continuing motion vector. **SEE 15.40**

Better yet, you can place both cameras (1 and 2) in the z-axis position and shoot through the windshield. Such a camera setup maintains the screen positions of the driver and the passenger and looks more realistic than when shot from the driver and/or passenger side. **SEE 15.41**

Special Continuity Factors

Finally, there are a few special continuity factors that need attention during the production phase. Observing these will make your postproduction editing much more efficient and enjoyable and will avoid needless headaches and frustration.

15.40 Camera Placement: Z-axis

By placing camera 2 directly in front of the car, the individual shots maintain the established screen positions as well as motion vector continuity. The car does not change directions when cutting from camera 3 to camera 2.

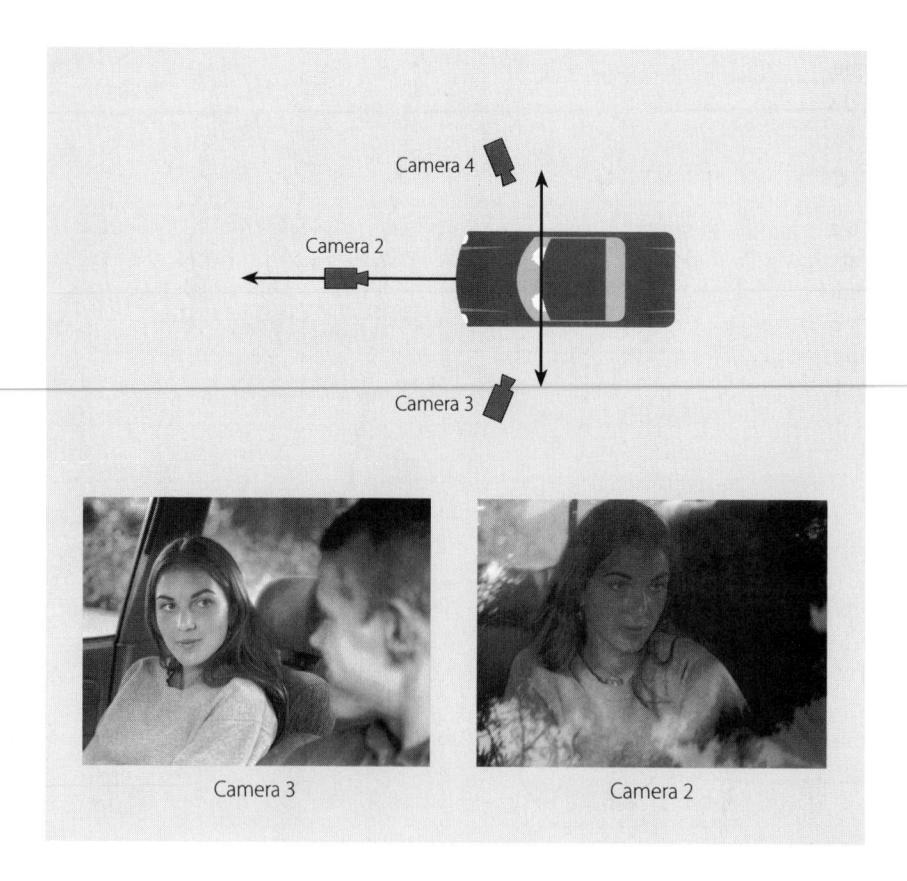
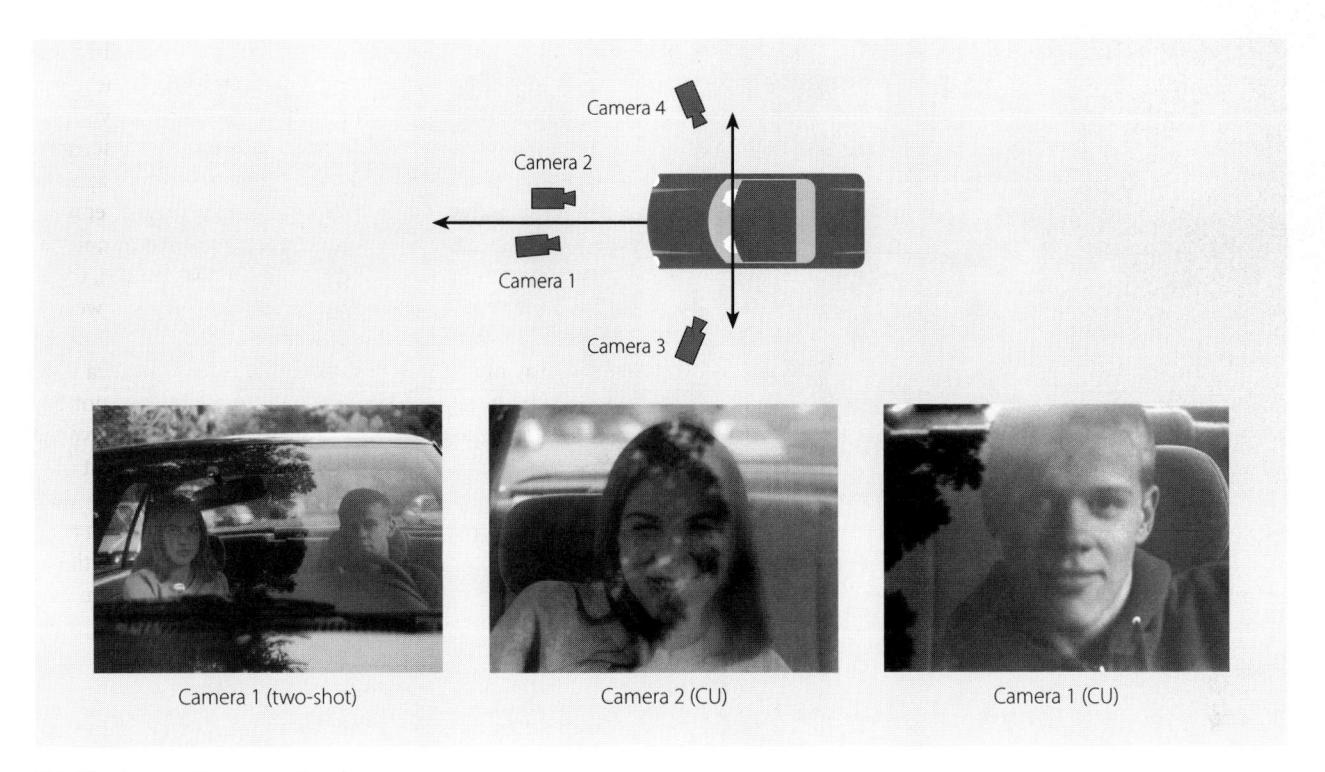

15.41 Camera Placement: Z-axis

By placing cameras 1 and 2 close together in the z-axis position, the through-the-windshield shots provide maximum continuity of screen positions and motion vectors.

The special continuity factors are: (1) action continuity, (2) subject continuity, (3) color continuity, and (4) continuity of environment.

ACTION CONTINUITY

To ensure maximum continuity of action, you should try as much as possible to cut *during* the action, not before or after it. When you cut just before or after the action, you accentuate the beginning or the end of a motion vector rather than its continuity. For example, if you cut from a shot that shows the hostess getting up from her chair to a medium shot of her standing, you need to cut while she is getting up and not after she is already standing. This means that you must let her move partially out of the frame in the first shot and then have her move into the frame in the following shot.⁵

When cutting during a secondary motion (pan, tilt, zoom, or the like), you need to continue the secondary motion in the next shot. If you are panning with a moving object, you should have the second camera panning in the same direction before cutting to it. If the camera is not panning during the second shot, the motion vector will look oddly disturbed. When cutting from a shot in which the object is at rest to one in which the object is in motion, the object seems to accelerate suddenly and lurch through the frame. When cutting from an object in motion to a shot in which it is at rest, the object seems to have come to a sudden halt as if hitting a brick wall. Such action continuity is especially important when building a screen event in postproduction from prerecorded bits and pieces of an event.

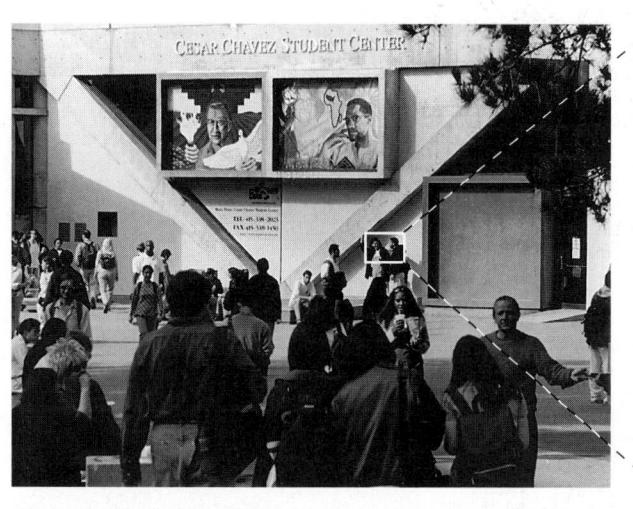

15.42 Subject Continuity

If you cut from an ELS (extreme long shot) to an ECU (extreme close-up), viewers are not always able to verify that the person in the ECU was, indeed, part of the ELS.

SUBJECT CONTINUITY

If, for example, you cut from an extreme long shot of a group of people to an extreme close-up, the viewer may not be able to tell whether the person shown in the close-up was, indeed, part of the original group. **SEE 15.42** You should also avoid extreme angles that do not show any subject relationship between shots.

COLOR CONTINUITY

One of the persistent problems in postproduction editing is maintaining continuity of color. When trying to edit a show, you may suddenly find that the star is wearing a red dress in the long shot, but a purple or pink one in the close-up. Obviously, the colors should be continuous unless you change the event to a different place or time. Color matching in postproduction is time- and energy-consuming as well as costly. You can avoid expensive color matching in postproduction by paying particular attention to the lighting and white balance of the cameras before you record the event or event details.⁶

CONTINUITY OF ENVIRONMENT

A scene should reflect the same environment and appearance from shot to shot. For example, if you show a person in a medium shot just about to sit down in his chair, he needs to wear the same tie in the long shot. Such continuity problems are practically nonexistent in live or live-on-tape coverage of an event, but when you shoot a scene over a period of time such obvious continuity mistakes can occur quite easily. Make a special effort to watch whether the background remains the same during subsequent takes. Nothing is more annoying than having books disappear, or multiply, in a background bookcase, or having the scenery change merely because the director or floor manager did not bother to watch the continuity requirements of the background as much as those of the foreground event. When shooting outdoors, the changing weather is always a continuity hazard. A cloudless sky in a two-shot of two people talking but then dramatic cumulus clouds in the subsequent close-ups from the same camera position does not make for good continuity.

The next chapter discusses editing principles that are based not so much on continuity as on emotion and impact.

Summary

Editing means selecting those parts of an event that contribute most effectively to its clarification and intensification. The selected parts are then used to build a screen event. Instantaneous editing or switching refers to selecting and combining shots while the televised event is in progress. Postproduction editing means deliberately selecting and sequencing prerecorded material into a unified whole. Continuity editing concentrates on structuring on- and off-screeen space and on establishing and maintaining a cognitive mental map in the viewer. Specifically, continuity editing is concerned with graphic vector continuity, index vector continuity, the index vector line, motion vector continuity, the motion vector line, and special continuity factors in terms of action, subject, color, and environment.

Graphic vector continuity refers to being aware of prominent lines and having them continue from shot to shot.

Continuity principles apply to continuing, converging, and diverging vectors in on- and off-screen space. Index vector—target object continuity must be maintained in successive shots. The target object in shot 2 should be placed at the extension of the index vector in shot 1.

BAC positioning, which places the host between two guests, will cause position jumps in subsequent two-shots of host and guest. An ABC arrangement, which places the host at one side and the guests on the other, provides better index vector and position continuity in close-ups.

To preserve converging index vector continuity in cross-shots of a conversation, the cameras must be kept on the same side of the index vector line. The same camera placement relative to the index vector line is necessary to preserve screen positions in over-the-shoulder shots of a conversation.

When placing cameras both in front and in back of two side-by-side people, their shots will reverse the people's established screen-left and screenright positions.

The continuity principles of motion vectors are similar to those of index vectors. Crossing the line with cameras will reverse the motion vector. Z-axis motion vectors provide continuity to any subsequent direction of motion vectors.

A smooth cut requires that you cut during—not after—the action (primary motion) and that, when the camera moves in one shot, it must move in the second. Cuts from extreme long shots to extreme close-ups are to be avoided if the subject cannot be recognized in both shots. Continuity in colors and in the general environment (background) are also important factors to consider.

NOTES

- 1. Herbert Zettl, *Television Production Handbook*, 6th ed. (Belmont, Calif.: Wadsworth Publishing Co., 1997), pp. 322–337.
- 2. Zettl, Television Production Handbook, pp. 299-302.
- 3. Herbert Zettl, *Video Basics 2* (Belmont, Calif.: Wadsworth Publishing Co., 1998), pp. 242–257.
- 4. Because we can't show a motion vector in a book, you may want to review the various continuity principles of editing in *Zettl's Video Lab 2.1* interactive CD-ROM (Belmont, Calif.: Wadsworth Publishing Co., 1997). Click on the camera monitor, then on tape 5 Screen Forces; and on the editing monitor, tape 5 Location Procedures.
- 5. Zettl's Video Lab 2.1 editing monitor, tape 7 Cutting Procedures.
- See the section on white-balancing in Zettl, Television Production Handbook, pp. 133–135. Also run Zettl's Video Lab 2.1 lights monitor, tape 5 Color Temperature.

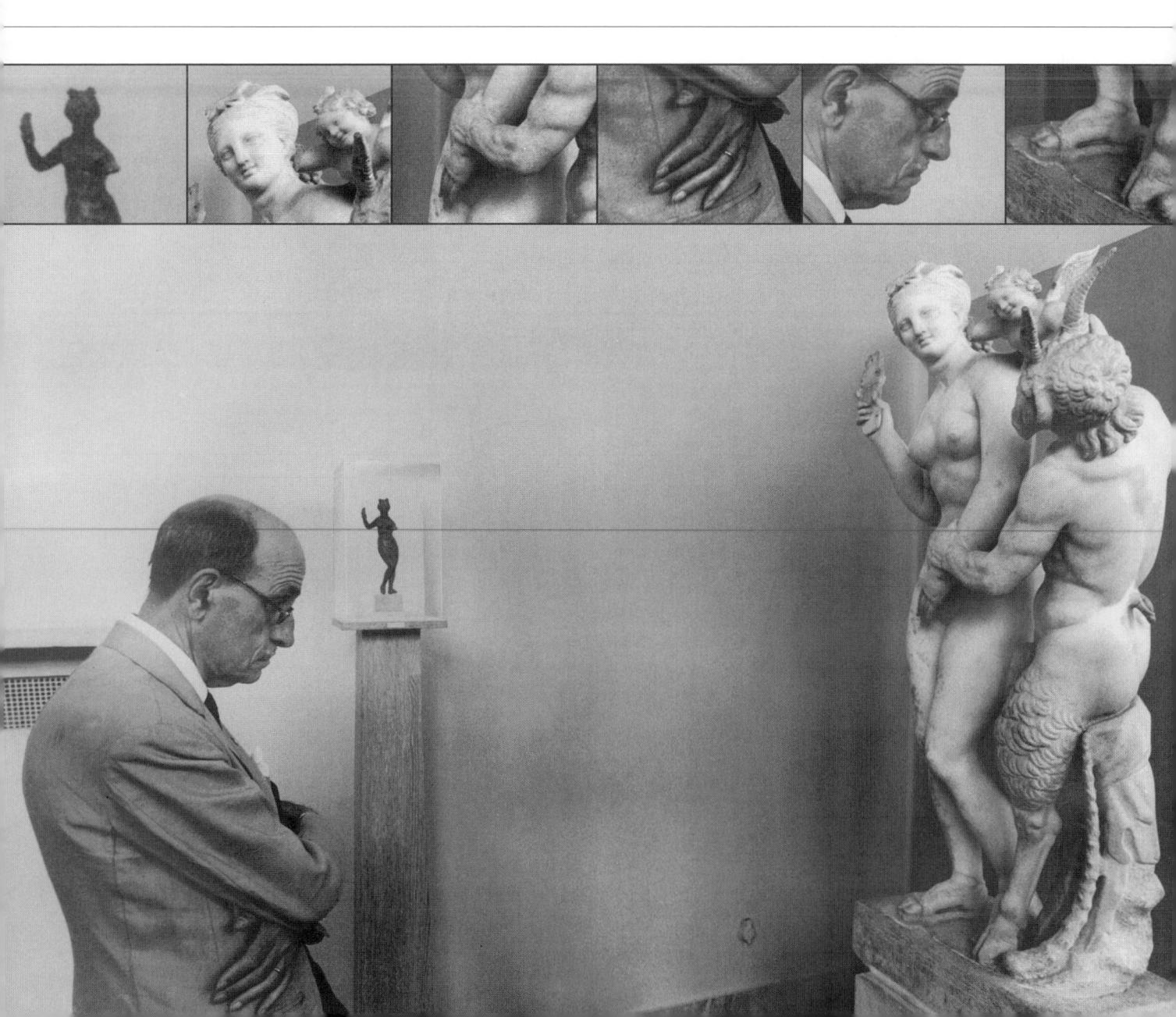

Structuring the Four-Dimensional Field: Complexity Editing

OMPLEXITY editing is used primarily to intensify an event and reveal its complexity. Now you are not so much concerned with providing continuity as with probing the depth of the event. Complexity editing communicates the inner relationships and energy of an event and stresses the event's principal moments. In this type of editing, your selection and sequencing of shots is now guided more by story and emotion—by what people do, what drives them to do it, and how they feel about what they do.

Complexity editing tends to affect subjective, rather than objective, time. While progressing by necessity along the horizontal vector of running time, complexity editing establishes an inner rhythm, a vertical vector. In fact, what you are dealing with are inner rather than outer vectors—an emotional rather than a spatial vector field.¹

Without intending to confuse you, complexity editing may or may not adhere to the principles of continuity editing. In any case, continuity now takes a backseat.² For example, in order to show the inner confusion of a troubled person, you may very well cut between cameras that are positioned on opposite sides of an index or motion vector. The resulting flip-flop reversal of screen directions is now intended, because it represents a visual interpretation of the person's labile emotional condition. But the new priorities for an edit do not mean that we can now throw all the principals of continuity editing out the window. Poor continuity can well wreck the intended emotional effect. Whenever you can, you should apply the principles of continuity and keep the viewer's cognitive mental map intact. Yet in complexity editing, your main focus is establishing and maintaining an affective map in the viewer.³

The basic building block of complexity editing is the montage, which literally means a setting together; in our case, of various event details. In the context of media aesthetics, *montage* is the juxtaposition of two or more separate event images that, when shown together, combine into a larger and more intense whole—a *gestalt*. Montage is a kind of filmic shorthand that quickly reveals or creates certain event aspects and ideas. Whereas the classic montage of the silent film era consisted of a brief series of quick cuts, showing segments of a single event or of different events, the modern view of montage has become more inclusive. Today montage implies the construction of a narrative—a story—as well as a series of shots, scenes,

or even sequences that create a vertical vector field—a clarification and intensification of emotions.

Although possible montage combinations are numerous, they all seem to cluster into three broad categories: (1) metric montage, (2) analytical montage, and (3) idea-associative montage.

Metric Montage

The *metric montage* is a rhythmic structuring device. In its purest form, it consists of a series of related or unrelated images that are flashed on the screen at more or less equally spaced intervals.⁴ You can create a metric montage simply by cutting the videotape or film to equal, or nearly equal, shot lengths, regardless of content, continuity, or color within the individual shots. You thus give tertiary motion a beat and, with it, structure.

A good metric montage should allow you to clap your hands with the rhythm of the tertiary motion. **SEE 16.1** A variation on the metric montage is the accelerated metric montage, in which the shots become progressively shorter. Your clapping to the cuts becomes progressively faster. You can use the accelerated metric montage to lead up to, or punctuate, a particular high point in a scene. **SEE 16.2**

Because it supplies a basic rhythm, you can use the metric montage as a structuring device for all other types of montage, or, for that matter, in all types of editing.

16.1 Metric Montage

In a metrically controlled montage, all shots are equally long. A metric montage provides an even tertiary motion beat.

16.2 Accelerated Metric Montage

In an accelerated metric montage, the shots get progressively shorter. The tertiary motion beat accelerates toward the end of the montage.

16.3 Analytical Montage

The two types of analytical montage are sequential and sectional.

Analytical Montage

In *analytical montage*, you analyze an event as to its thematic and structural elements, select the essential elements, and then synthesize them into an intensified screen event. The two basic types of analytical montage are sequential and sectional. **SEE 16.3**

SEQUENTIAL ANALYTICAL MONTAGE

To achieve a sequential analytical montage, you condense an event into its key developmental elements and present these elements in their original cause-effect sequence. The sequential montage moves from event-time 1 (t_1) to event-time 2 (t_2) . **SEE 16.4**

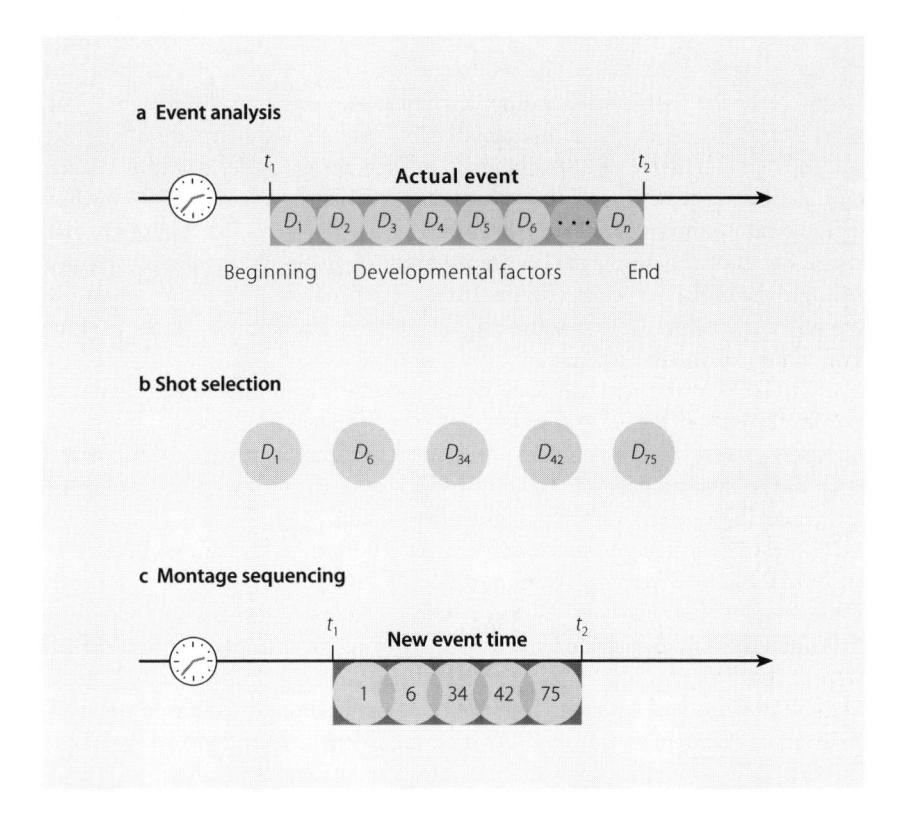

16.4 Sequential Analytical Montage

The sequential analytical montage tells a story in shorthand fashion. It presents event highlights (developmental elements) in the actual cause-effect sequence of the original event.

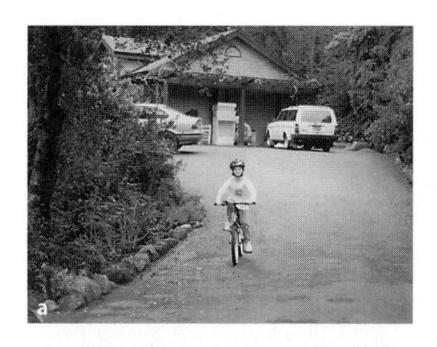

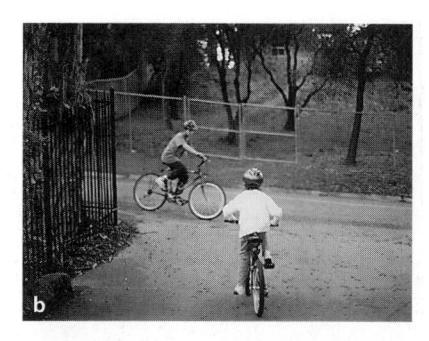

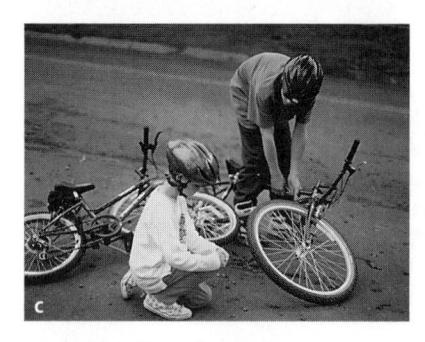

16.5 Main Event Implied

Note that in many sequential montages, the main event or main theme is implied rather than shown. Here the actual accident is not shown; only its development (a–b) and consequence (c–d) are.

One of the characteristics of an analytical montage is that the main event or its major theme is frequently implied but not shown or made otherwise explicit. Take the theme of a small bicycle mishap, for example. **SEE 16.5** We see a girl riding her bike down a driveway toward the street (figure 16.5a). At that very moment, another cyclist crosses her path (figure 16.5b). These are the "cause" parts of the montage. The fourth shot shows the bikes tangled and the little girl holding her knee (figure 16.5c). Fortunately, the collision wasn't serious. Both riders were unhurt (figure 16.5d). The last two shots are the "effect" part of the montage.

Notice that the accident itself is not shown; it is left up to the viewer to imagine. This montage is a type of low-definition rendering of an event (we show only a few parts of the event) that requires the viewer to apply psychological closure to fill in the missing parts. Thus you have engaged, if not forced, the viewer to participate in the event, rather than merely watch it.

Because the sequential montage is time bound by the cause-effect time vector of the actual event, you cannot reverse or change in any way the time order of the selected event essences. All you can do is condense the event and intensify it through this condensation. This t_1 to t_2 sequence is, of course, an important element in editing for plot development and narrative continuity.

To impress you with the importance of maintaining the natural order of the event in a sequential montage, let's do some switching of individual elements. The first shot sequence shows montage units in their proper order: proposal, marriage, first baby, second baby. **SEE 16.6** But by placing only a single shot in a different position, we drastically alter the meaning of the montage. Now the story sequence reads: proposal, first baby, second baby, and finally marriage. **SEE 16.7**

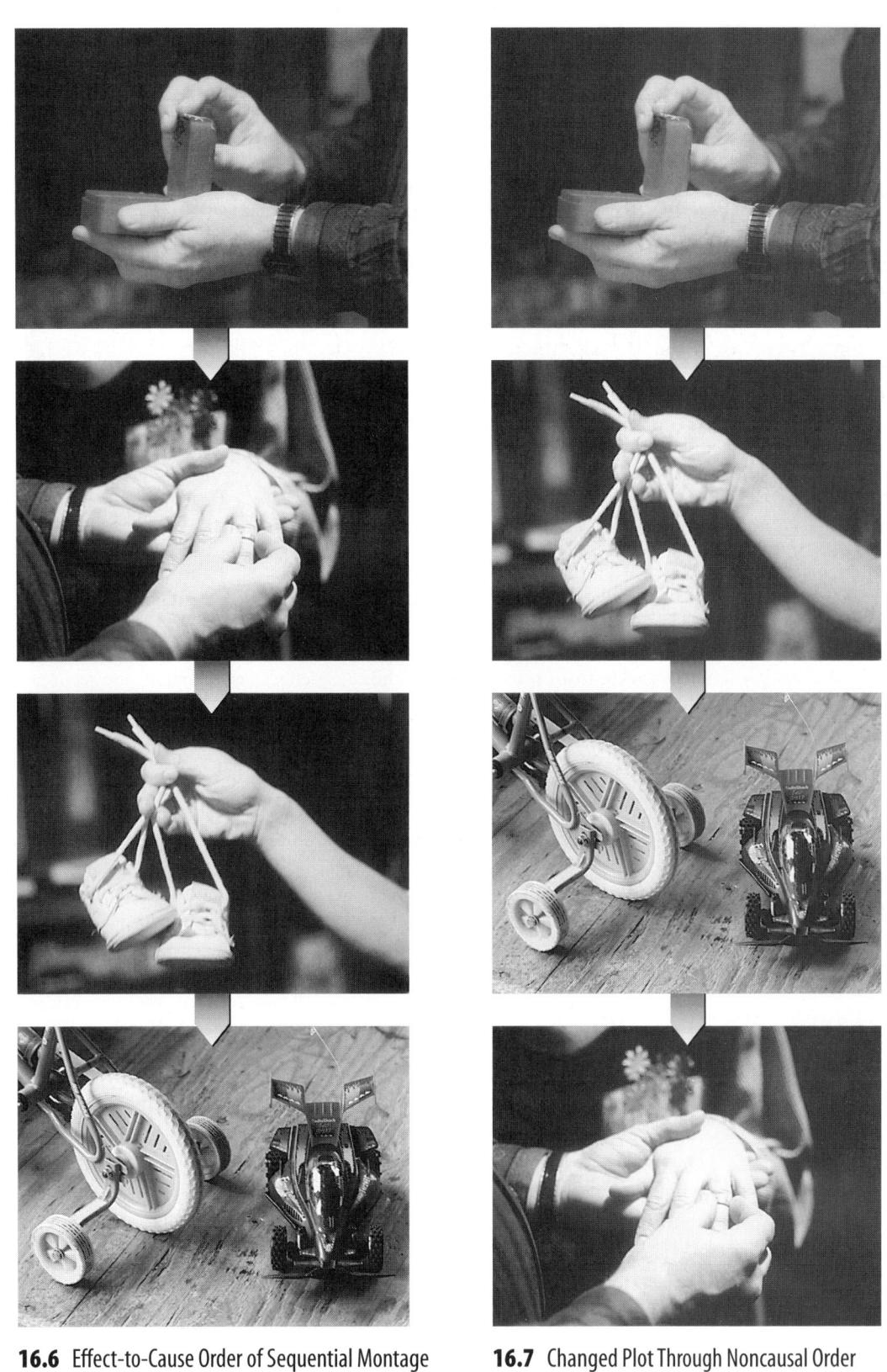

Because the sequential montage moves from event time 1 to event time 2, the selected shots must be sequenced in the order of the original event. In this montage, we imply the logical sequence of proposal, marriage, first baby, and second baby.

The meaning of the montage can change dramatically when the original event sequence is not maintained in the montage. Now the sequence suggests a proposal, the birth of the first baby, the second baby, and then marriage.

16.8 Sectional Montage

In the sectional montage, the event sections are not arranged along the horizontal time vector (event progression) but rather along the vertical one (event intensity and complexity).

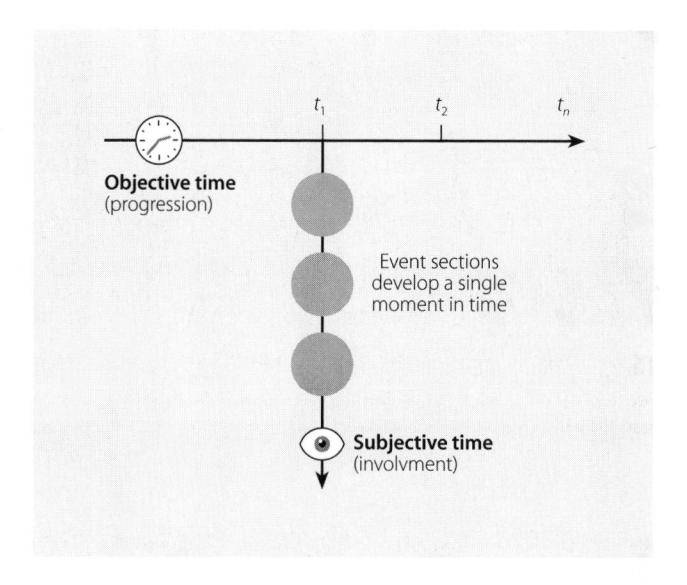

SECTIONAL ANALYTICAL MONTAGE

The sectional analytical montage temporarily arrests the progression of an event and examines an isolated moment from various viewpoints. It shows the various sections of an event and explores the complexity of a particular moment. Rather than moving from t_1 to t_2 to show the cause-effect development, the sectional montage stops the temporary event progression to examine significant event sections. We no longer move along the horizontal objective time vector but rather along the vertical subjective time vector. By examining a t_1 to t_1 development, the sectional montage reveals the complexity of the event—the intensity, emotional power, and quality of the moment. **SEE 16.8**

Because the sectional montage is independent of the cause-effect progression of time, shouldn't the order of shots or scenes be of little consequence in telling the basic story? Yes, to a certain extent. For example, if your intent is to show the tension of the moment just before the pitch with the bases loaded, it matters relatively little if you start the series of quick cuts with the pitcher, the batter, or some fans in the stands. The order of shots are important, however, if you want to establish point of view. The first shot or scene in a sectional montage can set the tone of the piece, its context, or, at least, suggest the intended emphasis. Both of the following sectional montages tell the same basic story: a teacher trying to communicate information to a less than enthusiastic student. **SEE 16.9 AND 16.10**

But take another look at the montage sequences and try to detect the difference of implied point of view. Even though the three shots in each montage contain admittedly minimal information, you probably notice that in the first sectional montage (figure 16.9) the emphasis is more on the student than the teacher, whereas in the second montage (figure 16.10) it is the other way around. In the first montage, you are more likely to side with the student, who has to put up with a boring lecture. In the second montage, it is the teacher who deserves some sympathy for trying to instill knowledge in a student who would rather be doing something else.

In a single-screen presentation, a brief sectional montage is usually presented as a series of rhythmically precise shots. This means that while you aesthetically freeze a moment—remaining at event-time 1 throughout the shot series—you nevertheless take up running time while presenting the sectional montage, shot after shot. The tight metric rhythm to the shot series indicates to the viewer that

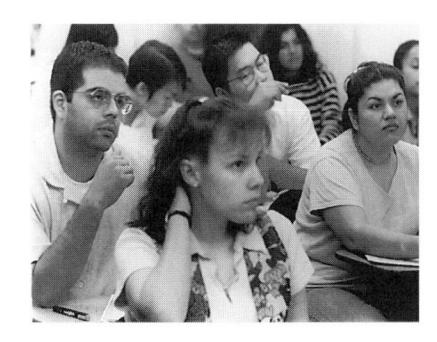

16.9 Sectional Montage Order: Student POV

Because we move vertically rather than horizontally in time, the order of shots does not signify an event development. Starting with the student, however, establishes a student point of view.

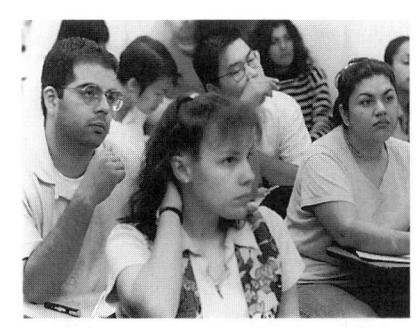

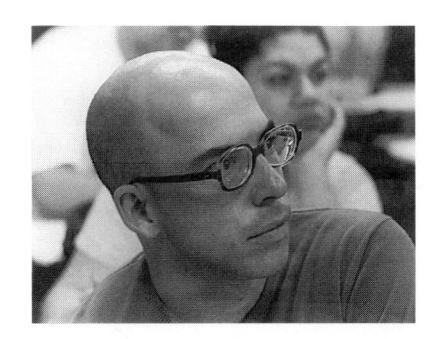

16.10 Sectional Montage Order: Teacher POV

By starting the montage with the teacher, we have now shifted to the teacher's POV.

you are not just showing a screen version of an actual event but that you have constructed something special, something inherently filmic.

Indeed, we often engage in a similar quick scanning of event details in our everyday life. Picture yourself eating alone in a restaurant. Even if you are mainly concerned with your food, every once in a while you will probably glance up and look at various "shots," such as of the waiter skillfully balancing a tray, a couple looking into each other's eyes, people anxious to catch the hostess's eye, and so forth. This series of impressionistic "close-ups" is very similar to a sectional montage, contributing to your perception of the restaurant's ambience.

But isn't such a montage approach similar to the inductive approach to sequencing? Yes, it is. The inductive approach, discussed in chapter 6, is merely an extension of the analytical montage. All montage types are basically condensed inductive approaches to sequencing.

Sectional montages are sometimes presented simultaneously as a series of split-screen images or on multiple screens. Because we are dealing with the various aspects of a single moment, such simultaneous presentations are actually more appropriate than the sequential presentations of event details. Such multiscreen montages were used in films as early as 1934, when the French filmmaker Abel Gance demonstrated his "triptych polyvision" technique with the three-screen film *Napoléon Bonaparte*.

Although this technique, which film biographer David Thomson dismisses as "silly" and an example of "lavish indecision," was unsuccessful in cinema, it could fare much better in television. Multiple video screens could serve as an

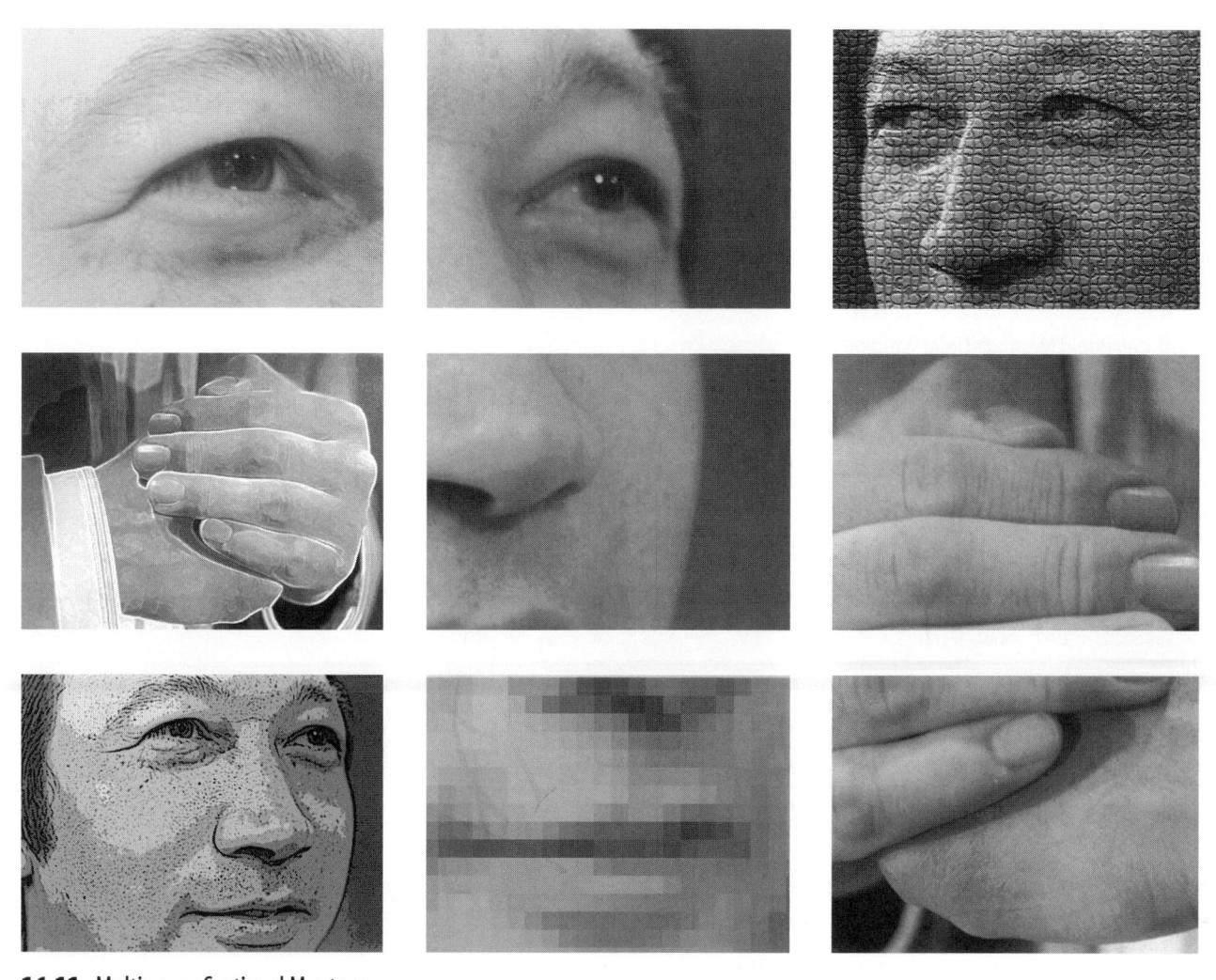

16.11 Multiscreen Sectional Montage

A multiscreen presentation is the ideal vehicle for the sectional montage. The multiple screens display the various event aspects at the same time.

organic framework for the sectional montage. By extending the mosaic pattern of the single television image, multiple images could, in a sectional montage, reveal the complexity of the moment all at once. Through the simultaneous presentation of event details, you can generate a new structure—a new, complex point of view that would probably not occur during a sequential presentation of the same event details. In this case, the sectional montage acts more like a musical chord in which the three notes take on a gestalt quite different from playing them one by one. **SEE 16.11** Such multiscreen structures and their juxtaposition have become an important design element in computer displays of Internet Web pages.

Idea-Associative Montage

The *idea-associative montage* juxtaposes two seemingly disassociated images in order to create a third principal idea or concept. This montage creates a *tertium quid*, a third something, that is not contained in either of the montage parts. Like

16.12 Idea-Associative Montage

The two types of idea-associative montage are the comparison montage and the collision montage.

the analytical montage, the idea-associative montage has two subgroups: comparison and collision montage. **SEE 16.12** The idea-associative montage was created and developed into a high art in the days of silent film to express ideas and concepts that could not be readily shown in a narrative picture sequence. Just think how difficult it would be if you had to do a daily newscast with pictures only. Despite all sorts of montage effects available, television could not exist without the often maligned "talking heads." The advent of sound did not really harm the art of film, as early filmmakers and critics claimed, but it helped strip the idea-associative montage of its glaring conspicuousness.⁶

COMPARISON MONTAGE

The comparison montage consists of succeeding shots that juxtapose two events that are thematically related in order to express or reinforce a theme or basic idea. It is also used to generate a specific feeling in us. A comparison montage compares similar themes as expressed in dissimilar events. An example of a comparison montage would be: shot 1—run-down shack; shot 2—abandoned automobile. The intended tertium quid,—the overall theme—is the idea of inevitable decay. **SEE 16.13** Or you may show a hungry person looking for food in a garbage can in shot 1, followed by a hungry dog looking through garbage in a back alley in shot 2. The resulting idea or theme is the desperation and social degradation of being poor.

One word of caution, however. In the early days of filmmaking, such devices were considered clever. For example, an early silent film juxtaposed the image of a political leader with shots of a preening peacock to communicate the leader's excessive vanity.⁷ Although such visual juxtapositions may have been appropriate in the days of silent film, today they seem rather crude if not ridiculous.

Nevertheless, when used skillfully, the comparison montage can influence our perception in ways similar to those of optical illusions. Some theories suggest that the comparison montage has an inevitable influence on our perception of the main event, similar to optical illusions. The Russian filmmaker and theorist Lev Vladimirovich Kuleshov (1899–1970) conducted several experiments on the aesthetic effects of montage. To demonstrate the power of juxtaposition and context, Kuleshov interspersed the unchanging and expressionless face of the great Russian actor Ivan Mosjukhin with unrelated shots of different emotional values: a child playing, a plate of soup, a dead woman. Through the power of montage, the audience thought they saw Mosjukhin change his facial expression according to the juxtaposed event.⁸ The montage had engendered what Kuleshov called an "artificial landscape," a "creative geography."

16.13 Comparison Montage

In a comparison montage, we compare thematically related events in order to reinforce a general theme. In this case, the juxtaposition of a run-down shack and an old bus reinforces the broad theme of decay.

Television commercials still make frequent use of comparison montages because they must get complex messages across in a short time. You may, for example, see a powerful new sports car racing down a windy road, juxtaposed with quick cuts to the cast shadow of a jet plane. The intended theme: The sports car is just about as fast as the jet. Or you may see the graceful and quietly elegant movements of a tiger dissolve in and out of a smoothly running luxury car. The intended theme: The luxury car has the strength, agility, and grace of a tiger. As you just noticed, these new comparison montages are no longer a juxtaposition of alternating shots but rather occur within the same shot. It is the close thematic relationship that makes it possible to compare the two principal montage elements within a single shot.

At this point you may feel that viewers will reject such obvious montages as unabashed persuasion devices. If viewers were as knowledgeable as you are about media aesthetics, you would probably be right. But for the casual and uncritical viewer, even such an overt persuasive device may go unnoticed.

You could create a less obvious, but no less effective, comparison montage by comparing a specific event with the sounds of another. For example, a slightly more subtle way of creating the *tertium quid* of swiftness and speed might be to eliminate the jet's shadow and simply keep the sound of the jet in flight as the second element of the comparison montage. As explored in chapters 17 and 18, the element of sound is a principal and indispensable aspect of media aesthetics.

COLLISION MONTAGE

In the *collision montage*, you take two opposite events and collide them in order to express or reinforce a basic idea or feeling. Thus, instead of comparing a hungry man with a hungry animal, you would juxtapose the shot of the hungry man looking through a garbage can with a shot of a well-nourished glutton stuffing himself. The collision montage now generates its *tertium quid* through conflict.

To use conflict as a structural device is nothing new in many areas of aesthetics, including drama, poetry, painting, dance, music, or the collision montage in film and television. Conflict creates tension—an essential element for any aesthetic experience. The aesthetic use of conflict is closely related to our dualistic existence between life and death, or any other process that exists only by

16.14 Collision Montage

In the collision montage, we put opposite images together in order to generate a new idea. The juxtaposition of new and old suggests the inevitable decay of machines if not their built-in obsolescence.

oscillating between the absolutes of beginning and end. In the example of the comparison montage, we juxtaposed a run-down shack with an abandoned car to emphasize the idea of decay or entropy (see figure 16.13). In a collision montage, you would need to choose opposite images to generate the same idea. **SEE 16.14**

Whereas the collision montage is a powerful filmic device, it is, unfortunately, an equally obvious one, so be extremely careful how and when you use it. If the montage becomes too obvious, you will annoy rather than enlighten or emotionally involve the sensitive viewer.

There are, however, techniques you can use to render the collision montage less obvious. Let's assume that you have chosen a collision montage to illustrate the idea of environmental awareness, that indiscriminate building of tract houses will destroy the beauty of open spaces. You could juxtapose shot 1, an open field covered with wildflowers, with shot 2, the same space now barren and covered with tightly spaced, look-alike houses. Or, in the same shot, you could show a field with wildflowers and then have a bulldozer enter the shot, ruthlessly plowing the earth and cutting through the flowers with its gigantic blade. For good measure, you can mix the sound of the bulldozer with various sounds of frantic building, such as hammering, buzz saws, trucks, and so forth.

The strength—but also the weakness—of the montage is that it is filmic in nature; that is, it is a purposely synthesized event. This means that idea-associative

Haiku poetry often works on the collision montage principle. In its rigid minimalist structure it implies a larger picture or concept than its lines actually contain. Here are some examples of Haiku poetry written by Erika Zettl. © 1996 Erika Zettl.

Waterlily

Held Captive

From its small prison The singing canary holds Its keeper captive The waterlily Growing in murky water Stands unpolluted

Hibiscus Blossom

Flaming hibiscus Opens its timeless splendor For just one brief day French Garden

Bushes, manicured Planted in rows and patterns Wanting to grow free montages are a deliberate juxtaposition of fixed event elements, or cells, in order to produce a specific effect or energy level. It is a deliberate sequencing device very much in line with the basic "at-at" structure of film. Although we usually try to avoid drawing the viewer's attention to the editing process, the montage is meant to be perceived as a medium-induced statement. A montage is intended to interrupt the natural flow of the event. As you have seen, such event synthesis—Kuleshov's "artificial landscape"—is especially apparent in the two forms of idea-associative montages (comparison and collision) in which two seemingly disassociated, separate events are juxtaposed to generate a *tertium quid*.

In television the montage is somewhat of a paradox. At the most fundamental level, the evanescent and fleeting nature of the basic structural unit of television—the television frame—works against the "at-at" juxtaposition of images. When television is used live, or in a live-like manner in which the medium is largely event-driven, you can use all except idea-associative montages. But when television is used in a basically filmic way—that is, when the various event details are recorded out of sequence for later postproduction editing—there is no reason not to use idea-associative montages. The ease with which we can create, store, retrieve, and assemble digitized television images has made the montage a viable postproduction technique even in television.

As with the comparison montage, you can use multiscreen video to show simultaneous collision montages that juxtapose such opposites as hot/cold, fast/slow, high-energy/low energy, color/black-and-white, peaceful/violent, pristine nature/crowded city. You can also use the montage effect in multiple screens by simply commenting on the complexity of a situation. Such polyphonic structuring is discussed more thoroughly in chapter 18.

When working on the layout of Internet Web pages or CD-ROM programs, you need to take care that the multiple "screens" on the computer page (or the text and the advertising) do not inadvertently create collision montages. The juxtaposition of a motorcycle ad with the promo for a movie whose main virtue is spectacular explosions would, however incidentally, create a *tertium quid* not entirely favorable to motorcycle safety. The possibility for unintentional collision montages is increased by the necessity to scroll through information. Even if a

Sergei Eisenstein developed a rather complex theory of film montage, which was designed to show not only the primary theme and action of an event but also its more subtle overtones. Because of their historical importance, I briefly describe here the major types of Eisenstein's filmic montage. You will notice that I have borrowed or adapted some of Eisenstein's categories for our rhythmic control methods (metric and vectorial, which Eisenstein calls "rhythmic"). Eisenstein describes five basic methods of montage: (1) metric, (2) rhythmic, (3) tonal, (4) overtonal, and (5) intellectual.

Metric Montage: The criterion for the metric is the "absolute lengths" of the film pieces.

Rhythmic Montage: In the rhythmic montage, the content within the frame determines the lengths of the pieces. It is the movement within the frame that impels the montage movement from frame to frame. (In other words, graphic, index, and motion vectors lead to the cut and determine the vector field of the total montage.)

Tonal Montage: Here montage is driven by the characteristic emotional sound of the piece—of its dominant. Tonal montage reflects the degree of emotional intensity. For example, the tilted

horizon would be part of a tonal montage, indicating the instability of the scene.

Overtonal Montage: The overtonal montage derives from a conflict of the principal tone of the piece (dominant) and the overtones. A comparison or a collision montage would fit into Eisenstein's overtonal montage category. The principal tone of the montage (peace—conference table) is juxtaposed with an overtonal concept (war—A-bomb explosion). An overtonal montage also occurs when the basic montage has more-subtle overtones, such as changes in lighting and the like. For example, the high-key lighting of a happy party scene turns into predictive low-key lighting while the party is still going on. Such predictive lighting is one of the aesthetic factors that can turn a tonal into an overtonal montage.

Intellectual Montage: "Intellectual montage is montage not of generally physiological overtonal sounds but of sounds and overtones of an intellectual sort: that is, conflict-juxtaposition of accompanying intellectual affects." What this means is that intellectual montage is based on the content—the theme—of the scene. The montage is controlled cognitively. It requires closure by intellect, not just by emotion or intuition.

single computer page displays images that in combination are reinforcing the basic message, scrolling may inadvertently "edit" images into a montage that carries an unintended meaning.

Visual dialectic The aesthetic principle upon which the visual conflict of the collision montage is based is called the *visual dialectic*. The concept of dialectic in film and television is important not only to the collision montage but also to the structure of the four-dimensional field. But what exactly is the concept of dialectic? The ancient Greeks used the dialectical method to search for and, they hoped, find the truth. Through debate and logical argument, they juxtaposed opposing and contradictory statements and ideas in order to resolve apparent contradictions into universally true axioms. For example, the Greek philosopher Heraclitus (ca. 540–ca. 480 B.C.) explained that everything is inevitably undergoing change and that the existence of opposites suggests a universal system in which any changes in one direction are ultimately balanced by

similar changes in the other. According to Heraclitus, all existence is based on strife, and unity is nothing more than a temporary balance of opposing forces. You probably notice the similarity between this theory and our vector theory of structuring various aesthetic fields.

Much later, the German philosopher Georg W. F. Hegel (1770–1831) based his whole theory of idealism on a similar dialectic: Every being is juxtaposed by a not-being that resolves itself into a process of becoming. In the spirit of Heraclitus, Hegel considered the ideal as well as the process of life as the result of a continuing "war of opposites." ¹⁰

Specifically, Hegel's dialectic consists of a thesis that is always opposed by an antithesis that ultimately results in a synthesis. This synthesis, then, represents a new thesis. It, in turn, is opposed by a new antithesis that again results in a new synthesis. This process repeats itself over and over again, always striving toward the "ideal," an objective spirit, absolute reason. **SEE 16.15**

Synthesis

Antithesis

New idea: social injustice

Shot 1 Shot 2

Hungry man overeating

b

Eisenstein eagerly took to the Hegelian dialectic, because it served not only his aesthetic but also his political and his own personal aims to have a system that legitimately deals with conflict—that needs conflict for progress. "For art is always conflict," he says, "(1) according to its social mission, (2) according to its nature, (3) according to its methodology."

The dialectical theory was, indeed, applied to social conflict quite successfully by **Karl Marx** (1818–1883), German writer and social philosopher. Marx boldly replaced the Hegelian "idealism" with the more concrete and then-relevant materialism. In his basic theory, Marx felt that history is nothing but a continuing conflict among economic groups, notably between social classes. He proposed that the thesis—the bourgeoisie (capitalist class)—must be opposed by the antithesis—the proletariat (workers)—in order to synthesize the two opposing classes into the ideal classless society in which every single member has, theoretically, equal rights. As we could witness with the breakup of communism, such theories do not always work in practice.

16.15 Dialectic Principle

In its most basic form, the dialectic principle states that by juxtaposing a thesis (any statement or condition) with its antithesis (counterstatement or opposite condition), we can arrive at a synthesis in which the two opposing conditions are resolved to a higher order statement or condition (a). The idea-associative collision montage is a direct application of this dialectic principle (b).

Some filmmakers, such as the late Russian film theorist and director Sergei Eisenstein, used the dialectic not only as the basic structural and thematic principle of montage but also as the basic syntax of an entire film. Eisenstein juxtaposed shots in a dialectical manner (colliding opposite ideas to create a synthesis—a tertium quid) and also scenes and entire sequences. The whole film, then, represents a complex visual dialectic. But such a formulaic application of the visual dialectic can easily drain the aesthetic energy of the screen event and render it dull and listless. On the other hand, indiscriminate use of the visual dialectic in film as well as in television can easily become an aesthetic sledgehammer. The advantage of the vector theory over the dialectic approach to structuring the four-dimensional field is that vectors need not collide in order to produce energy. The vector field is more versatile; it includes a visual dialectic but is not dependent upon it.

Summary

Complexity editing is used to intensify an event and reveal its complexity and to generate feeling. The selection of shots is principally guided by the emotional tone of the piece rather than vector continuity.

The basic building block of complexity editing is the montage. A montage is the juxtaposition of several separate event images that, when shown together, combine into a larger and more intense whole. There are three basic montage categories: metric montage, analytical montage, and idea-associative montage.

Metric montage consists of a series of event images that are flashed on the screen in more or less equally spaced intervals. The metric montage creates a tertiary motion beat, one of the chief characteristics of any montage. The metric montage is an especially useful structural device for analytical montage.

In the analytical montage, we analyze a single event as to its thematic and structural essentials and then synthesize the selected pieces into a brief, rhythmically precise series of shots. There are two types of analytical montage: sequential analytical montage and sectional analytical montage.

A sequential montage strings together major developmental factors of an event in their natural sequence in order to show, in shorthand style, the cause-effect development of an event.

A sectional montage temporarily arrests the progression of an event and examines the isolated moment from various viewpoints. It explores the complexity of an event.

In the idea-associative montage, we juxtapose seemingly disassociated events in order to reinforce or generate a specific idea or overall theme, often called the *tertium quid* (third something). The two idea-associative montage types are the comparison montage and the collision montage.

In the comparison montage, we compare two similar themes by juxtaposing images from different events. Example: a hungry man going through a garbage can—a hungry dog looking for food. Theme: the desperation and social indignation of being poor.

In the collision montage, we show two dissimilar themes together in order to create the new statement. The collision montage represents a visual dialectic in which one idea is juxtaposed with an opposing idea. Both ideas are ultimately synthesized into a new idea—the *tertium quid*. The visual dialectic is based on the Hegelian dialectic of thesis-antithesis-synthesis.

NOTES

- 1. Steven D. Katz, *Film Directing: Shot by Shot* (Studio City, Calif.: Michael Wiese Productions, 1991), pp. 259–275.
- 2. Walter Murch, *In the Blink of an Eye: A Perspective on Film Editing* (Beverly Hills, Calif.: Silman-James Press, 1995), pp. 15–20, 32–43.
- 3. Herbert Zettl, "Contextual Media Aesthetics as the Basis for Media Literacy," *Journal of Communication* (Winter 1998), pp. 1–15.
- 4. Sergei Eisenstein, *Film Form and Film Sense*, ed. and trans. by Jack Leyda (New York: World Publishing Co., 1957), pp. 72–73.
- 5. David Thomson, *A Biographical Dictionary of Film*, 3d ed. (New York: Alfred A. Knopf, 1994), pp. 273–274.
- 6. See the comments by Siegfried Kracauer, *Theory of Film: The Redemption of Physical Reality* (New York: Oxford University Press, 1960), pp. 102–111.
- 7. This comparison montage is used by Eisenstein in his 1928 film *Ten Days That Shook the World*. See also John Fell, *Film: An Introduction* (New York: Praeger Publishers, 1975) pp. 87–89.
- 8. Lev V. Kuleshov, *Kuleshov on Film: Writings by Lev Kuleshov*. Select., trans., and ed. by Ronald Levaco (Berkeley: University of California Press, 1974).
- 9. David Thomson, Dictionary of Film, p. 409.
- 10. Georg W. F. Hegel, *The Phenomenology of Mind*, trans. by F. P. B. Osmaston (New York: Macmillan, 1931).
- 11. Eisenstein, *Film Form*, pp. 38–39. Also see the section entitled "A Dialectic Approach to Film," pp. 45–63.
- 12. Eisenstein, Film Form, p. 46.

17

Ó

The Five-Dimensional Field: Sound

OUND in various manifestations (dialogue, music, and sound effects) is an integral part of television and film. It represents the all-important fifth dimension in the total field of applied media aesthetics.

In film, for some time, sound was considered an additional element to an already highly developed, independent visual structure. A considerable amount of time elapsed before the "talkies" were accepted aesthetically as constituting a medium in its own right. Broadcast television, on the other hand, was born as an audiovisual medium. Sound was as essential to the television message as the pictures. Unfortunately, the various media terms such as *film, motion pictures, cinema, television*, or *video* do not incorporate the audio concept. This neglect may have caused some people to believe that sound is either an unnecessary or a nonessential adjunct of the visual fields of television and film. Far from it. Sound is an indispensable element in television and film communication.

In this chapter we consider five major aspects of the five-dimensional field: (1) sound and noise, (2) television and film sound, (3) literal and nonliteral sound, (4) sound functions, and (5) aesthetic factors.

Sound and Noise

Both *sound* and *noise* are audible vibrations (oscillations) of the air or other material. Aesthetically, the distinguishing factor between sound and noise is its communication purpose. Sound has purpose; it is organized. Noise is essentially random. The same audible vibrations can be sound at one time, noise at another. Let's assume that you hear a big crash outside while reading this chapter. You run to the window, or outside, to see what is happening. The crash was noise. It happened unexpectedly and interrupted your activities. Now let's assume that you are working on a sound track. The scene shows a car running a stoplight and crashing into another car. At the precise moment of impact, you use the recording of a crash. What was noise before has now become sound. The crash sound fulfills an important function within the overall structure of your television show or film. In short, it has purpose. Similarly, what we usually consider a beautiful sound, such as a Mozart piano sonata, can become noise if it doesn't fit the pattern of your activities. If, just as you are trying to think

of an appropriate musical theme for your television show, a neighbor starts practicing Mozart, the sonata becomes noise because it interferes with the other melodies you are trying to listen to in your head.

You will find, however, that even the critical literature on audio considers all audible vibrations sound regardless of whether they occur randomly or as purposeful communication.

TELEVISION AND FILM SOUND

Almost from its very beginnings, television sound and pictures were picked up, processed, and broadcast simultaneously. Live television obviously did not permit any postproduction doctoring of sound. But even now, when we have sophisticated computerized video and audio postproduction facilities available, we generally record and broadcast sound and pictures together. The "sweetening" of sound—improving the quality of the recorded audio mix—or more-extensive sound postproduction is done only in more-ambitious television projects as part of the total postproduction activities.

In contrast to television, film "learned to talk" much later in its development. By the time sound was added to film, its visual aesthetics had been firmly established and highly refined. It seems natural that for some time respectable filmmakers and theorists believed that sound was a detriment, rather than an asset, to the art of the film. Film, then, was a *visual* medium, and sound was at that time a foreign element that did not always fit the established visual syntax. The Russian filmmaker and theorist V. I. Pudovkin clearly recognized the basic problem of adding sound to a tightly structured visual field: "Usually music in sound films is treated merely as pure accompaniment, advancing the inevitable and monotonous parallelism with the image." 3

Although by now television and film are firmly established as audiovisual media, some important distinctions remain between television and film sound.

TELEVISION SOUND

You may have heard that television is primarily a visual medium and that you should therefore avoid as much as possible "talking heads"—that is, shots that show people talking instead of illustrating what they are talking about. This is a great misconception. First, television is definitely not a predominantly visual medium; it is an audiovisual medium. Silent television is inconceivable from an informational as well as an aesthetic point of view. Second, nothing is wrong with "talking heads" so long as they talk well. You will notice that the majority of television programs have people talking.

Why, then, is sound so important in television? Let's answer this important question by focusing on four major reasons: (1) reflection of reality, (2) low-definition image, (3) production restrictions and technical limitations, and (4) audio/video balance.

Reflection of reality In television, sound is one of our primary, if not essential, communication factors. Television programming is predominantly reality based. This means that television shows draw on real events, such as news, sports, documentaries, interviews, and talk shows, or on fictional events that reflect some aspect of reality, however much distorted, such as daytime serials, police shows, or situation comedies. Because all these events happen within a space, time, and sound environment, we cannot simply ignore or even neglect the audio portion of such television-mediated events. It is often the sound track that lends authenticity to the pictures and not the other way around.

Low-definition image Television pictures are, of necessity, low-definition.⁴ This means that the size of the television screen is relatively small, the picture resolution is relatively low, and the contrast ratio and color palette are reasonably restricted. Contrary to film, where we often move deductively from overview to event detail, television normally builds its overview inductively using a series of close-ups. We need sound for essential or supplemental information. The visuals alone are usually not enough to tell the whole story. Just try to follow a television show by watching the pictures with the sound turned off. It will be difficult, if possible at all, for you to understand what is going on even though the story may be highly visual. On the other hand, you will have little trouble keeping abreast of what is happening on-screen by listening to the audio portion only. Television audio normally has a higher relevant information density than television video does.

We also need sound to give coherence and structure to the inductive picture series. For example, we frequently use music not only to establish a specific mood but also to facilitate closure to the picture sequence and make viewers perceive individual shots as a unified whole. Besides tertiary motion (editing motion), this important rhythmic structure is supplied by sound. Why, then, you may ask, do we not have higher-quality television audio?

Production restrictions and technical limitations Certain production and technical limitations reduce the quality of television sound. First, in many daily routine television productions, the sound is picked up and recorded on videotape simultaneously with the pictures, regardless of whether the show is done live, live-on-tape, or videotaped for postproduction editing. Although technically we have the capability of sound sweetening—pulling the sound off the videotape, improving its quality, and putting it back again with the picture portion—relatively few routine shows enjoy such a postproduction luxury.

Second, the simultaneous audio/video pickup of sound means that all major moving and stationary sound sources must be covered with microphones. In such studio-produced programs as daytime serials and situation comedies, the microphones must be kept out of the picture. Consequently, the audio pickup is inherently restricted, even if you use high-quality microphones. The outdoor conditions for ENG (electronic news gathering) and EFP (electronic field production) are generally less than ideal for good sound pickup. It is difficult to separate ambient sounds and wind noise from the planned sound, which means that these extraneous sounds often get amplified along with the desired sounds.

Finally, the sound reproduction systems in most television receivers are severely limited in their frequency and amplitude (loudness) response. The speakers in the television set often point away, rather than toward, the viewer-listener. It seems likely that any effort to improve the reproduction quality of television sound would be embraced by the public with great enthusiasm, but this has not been the case. Simply improving the quality of the sound without a similar improvement in the picture portion does not lead to an improved viewer-listener experience.

Audio/video balance Why has high-fidelity, stereo television sound not received the enthusiastic public acceptance originally predicted? Have we become so aesthetically insensitive that we accept bad television sound as an inevitable given?

On the contrary. It is precisely our aesthetic sensitivity that detects—and rejects—an imbalance between the low-definition video portion and the high-definition stereo audio track and their relative aesthetic energies. You may have heard telecasts of concerts in which the audio portion is transmitted

simultaneously with the television pictures via an FM radio channel. The idea is to provide optimal audio quality during the television viewing. Unfortunately, the high-quality sound portion diminishes the low-definition picture portion to the insignificant, if not ludicrous. The television screen and its images seem to shrink from the onslaught of all the high-energy sound. Like any sensitive viewer-listener, you will probably try to reduce the volume, and perhaps even the frequency response of the sound, to bring it more into balance with the low-definition video images. You may even find that, finally, you need to switch back to the low-definition television sound in order to achieve the proper energy balance between pictures and sound.

Television with stereo sound invites similar problems with defining video space, which is addressed later in this chapter.

When the screen size increases, however, and the video images become more high-definition, such high-fidelity audio not only is appropriate, but it actually becomes necessary for the proper balance of aesthetic video and audio energies and the spatial matching of pictures and sound. Again, you would be painfully aware of an energy imbalance if the large, high-resolution video images of an *HDTV* (high-definition television) projection were matched with a single-channel, low-quality sound track. To achieve the proper energy balance between video and audio now, you must resort to equally high-definition (high-volume and high-fidelity) sounds. Also, the large screen of HDTV projection not only tolerates sound separation, but demands it—similar to the wide motion picture screen.

FILM SOUND

Although film has been firmly established as an audiovisual medium for some time now, in many instances the visual field still appears to dominate film presentations. Sometimes the high-definition film image and the deductive sequential structure (moving from overview to event details) are so well suited to tell a story pictorially that, indeed, the sound can be, as Siegfried Kracauer remarked, occasionally casual and the dialogue embedded in visual contexts.⁵

In *landscape* films, the dialogue is often separated, but not interrupted, by an overwhelming and exciting visual sequence. For example, you can splice in any number of large-screen landscape scenes between the slow-moving dialogue of two cowboys riding through a Montana valley without sacrificing story flow or event energy. But when the same movie appears on television, the large, high-definition film images are reduced to small, low-definition television images. In this transformation, the overpowering landscape shots are most susceptible to energy loss. The resulting low-energy landscape shots no longer serve as plausible bridges for the various dialogue segments and so cannot carry the story. As a consequence, we become very much aware of the long pauses between the dialogue elements. Though the slow film dialogue appeared natural in conjunction with the high-energy landscape images on the large screen, on television it seems spotty and uneven.

Do not be misled into thinking, however, that because the landscape images of film can take over a storytelling function, you can neglect the aesthetics of film sound. The contrary is true. Because the high-definition film images carry so much aesthetic energy regardless of content, the sound must be equally high-definition. Technically, this means that sound requires at least as much attention in production and postproduction as the visual portion.

Surround-sound, which literally surrounds the motion picture audience with a superhigh-fidelity sound system, is one attempt to achieve such an energy balance between pictures and sound. To achieve such high-quality film sound, it is usually manipulated and edited separately from the picture, or it is reproduced

and added to the visual portion in the often highly complex sound postproduction activities.⁶ In film production, the visual and audio portions are always manipulated separately and then "married" (printed together on the same filmstrip) only at the last moment.

In the more-ambitious high-budget television productions, the sound pickup and postproduction techniques are very similar to those of film. Almost all television production centers, and especially the postproduction houses, have extensive facilities for sound design and sweetening in which the sound is created or manipulated separately and later married to the edited video portion.⁷

Literal and Nonliteral Sounds

When you listen carefully to the sounds of a television show or a motion picture, you probably hear some form of speech, such as dialogue or narration over a scene, and some *ambient* sounds—the environmental sounds in which the scene plays—such as traffic, the pounding of the surf, or the whine of a jet engine. Inevitably, you will also hear some music and, depending on the story, sounds that are neither speech, environmental sounds, nor music but whose presence inevitably affects us in how we feel about what we see. Despite the great variety of sounds used in television and film, we can group them into two large categories: literal and nonliteral.

Literal sounds include forms of speech and the environmental sounds. *Nonliteral sounds* include most background music and other sounds that seem to influence our feeling in some way. Let's take a closer look at these sound categories.

LITERAL SOUND

Literal sounds are referential, which means that they convey a specific literal meaning and also that they refer you to the sound-producing source. When you listen to a conversation, for example, you learn what the people say and how they say it. You become familiar with the conversation's literal meaning. The sounds of rush-hour traffic are also referential—they refer you directly to the sound-producing source: buses, cars, motorcycles. Literal sounds are sometimes called "diegetic" sounds because they occupy "story space."

Literal sounds can be source-connected or source-disconnected. They are source-connected when you see the sound-producing source while simultaneously hearing its sound. For example, you see a close-up of a mother talking to her child and hear her at the same time. **SEE 17.1** When you then switch to a close-up of the child while still hearing the mother talk, the literal sound has become source-disconnected. **SEE 17.2** Source-connected sounds are on-screen sounds; that is, the sounds emanate from an on-screen event. Source-disconnected sounds are off-screen sounds; the sound-producing source is located somewhere in off-screen space. When you hear source-disconnected literal sounds, you will, however subconsciously, refer back to and visualize the actual sound-producing source.

NONLITERAL SOUND

Nonliteral sounds are not intended to refer to a particular sound source or to convey literal meaning. They are deliberately source-disconnected and do not evoke a visual image of the sound-producing source. Nonliteral sounds include the boings, hisses, and whams in a cartoon that accompany the incredible feats of the cartoon character, the romantic music during a tender love scene on the beach, or the rhythmic theme that introduces the evening news. Music is the most

17.1 Source-Connected Literal Sound

When we hear a sound and see the sound-producing source on the screen at the same time, the literal sound is source-connected. We see and hear the woman talk.

Sound MOTHER: (continuing) "... but you must put your things away."

17.2 Source-Disconnected Literal Sound

When we see something other than the sound-producing source, the literal sound is source-disconnected. Here we see the child listening to her mother talk, which means the mother's words (literal sound) are now source-disconnected.

frequently used form of nonliteral sound. **SEE 17.3** Nonliteral sounds are also called "nondiegetic," occupying nonstory space.

LITERAL AND NONLITERAL SOUND COMBINATIONS

Most often, literal and nonliteral sounds are combined in the same scene. Assume for a minute that we see the mother and her son walking along the beach. We hear their dialogue (literal, source-connected), the pounding of the surf (literal, source-connected), a jet plane overhead (literal, source-disconnected). When their conversation turns to the recent funeral of Grandma, music comes in to underscore the sad memories (nonliteral). Such a mixture of literal and nonliteral sounds communicates what the event is all about and how it feels. It "shows" the outside and the inside of the event simultaneously.

A mix of literal and nonliteral sounds can also increase the magnitude of the screen event's total vector field, that is, the energy of the screen event. For example, the shrill, nervous sounds (nonliteral) that accompany the sounds of squealing tires (literal) of a car that has lost its brakes on a steep, winding road will certainly boost the precariousness of the event. We take up such aesthetic functions later in this chapter.

THE IMPORTANCE OF CONTEXT

You will find that the same sound can be literal or nonliteral, depending on the visual context. Here is the context for a literal sound interpretation: a concert of a difficult contemporary piece. We see close-ups of the conductor, the string basses, and the various percussion instruments that create unusual pounding sounds (literal, source-connected). We see one of the audience members hold her ears as if to protect herself from the relentless rhythms (literal, source-disconnected). We cut back to the conductor, who is accelerating the beat (literal, source-disconnected).

17.3 Descriptive Nonliteral Sounds

From the following list, choose some factors and try to "listen" to them. Then pick nonliteral sounds (sound effects or music) that best describe each selected item.

Factor	Aspect	Variable		
Space	Distance	Far, near, infinite		
	Size	Small, large, inflated, huge, microscopic		
	Shape	Regular, irregular, found, square, jagged, slender, fat, wide, narrow		
	Height	High, tall, low, short		
	Volume	Large, small		
Time	Seasons	Summer, autumn, winter, spring		
	Clock time	High noon, morning, evening, dusk, dawn, night		
	Subjective time	Boring, fast, exciting, accelerated		
	Motion	Fast, slow, dragging, graceful, clumsy		
Light	Sun	Bright, overcast, strong, weak		
	Moon	Soft, brilliant		
	Searchlight	Moving, blinding		
	Car headlights	Passing, approaching, blinding		
Quality	Weight	Heavy, light, unbearable, shifting, increasing		
	Texture	Rough, smooth, polished, coarse, even, uneven		
	Consistency	Hard, soft, spongy, solid, fragile, dense, loose		
	Temperature	Hot, cold, warm, cool, heating up, cooling down, freezing, glowing		
	Personality	Stable, unstable, cheerful, dull, alive, sincere, insincere, powerful, rough, effeminate, masculine, weak, strong, pedantic, careless, romantic, moral, amoral		
	Feeling	Funny, tragic, sad, frightened, lonely, panicky, happy, solemn, anxious, loving, desperate, hateful, sympathetic, mean, suspicious, open, guarded		
Event		Sports, church service, graduation ceremony, thunderstorm, political campaign, funeral, death, birth, lovemaking, running, cars in pursuit		

Now switch to the visual context of a psychiatric ward. A patient is sitting with the psychiatrist, calmly and intelligently answering a variety of questions (literal, source-connected). But then one particular question triggers something in the patient. We see a close-up of him trying to hide his panic and silently struggling for answers. During this close-up shot, we hear music coming up, getting louder, with string basses and percussion instruments creating pounding rhythms. Yes, the music is identical to the piece we heard in the concert hall. But now the music is nonliteral. In the context of the psychiatric ward, we don't visualize the sound-originating instruments, but instead we perceive the music as a reflection of the patient's state of mind. The different context has changed the function of the sound track. We have moved from an information function (what the new piece of music sounds like) to a purely emotional one.

Functions of Sound

Before reading about the major functions of television and film sound, you should realize that many of these functions overlap and largely depend on the communication intent of a scene and the visual context in which the sounds operate. The treatment of sound, like cooking, also depends not only on a good mix of basic ingredients and principles but also to a great extent on an overall feel for balance. Effective sound mixing requires an understanding of, and sensitivity to, the contextual use of the other four aesthetic fields. Nevertheless, television and film sound have the following major functions: (1) information, (2) outer orientation, and (3) inner orientation.

Information Function of Sound

The information function of sound is to communicate specific information verbally. In our verbally oriented society, a word is often worth a thousand pictures. Just try to use pictures to explain concepts with a high level of abstraction, such as justice, freedom, grammar, process, efficiency, or learning. Or try to express, using just screen images, the following simple communication: telling a friend over the telephone that she should meet you at the library next Wednesday at 9:30 A.M. To get the point across in pictures, you would probably resort to scribbling a message on a notepad by the telephone or using some other ingenious way to display the message in writing. It is certainly easier to simply deliver the message in some form of speech.

The forms of speech most often used in television are: (1) dialogue, (2) direct address, and (3) narration.

DIALOGUE

A dialogue is a conversation between two or more persons. We also use the term *dialogue* if one person is speaking while the other is listening or even when one person speaks to himself or herself. Because thinking out loud is actually conversing with oneself, it is still a form of dialogue, but now we call it internal dialogue.

Dialogue on television is the chief means of conveying what the event is all about (theme), developing the story progression (plot), saying something specific about the people in the story (characterization), and describing where, when, and under what circumstances the event takes place (environment, context). You may have noticed that the opening dialogue in daytime serials recounts what has happened before, tells where the story is now, and suggests where it might be going. This same sequence also introduces new characters. All this information is contained in a few lines of carefully crafted dialogue.

Good dialogue seems to come naturally. It often sounds like a tape recording of a randomly observed conversation. As most writers will confirm, however, good dialogue is meticulously constructed to sound and feel natural yet communicate a maximum of information. **SEE 17.4**

DIRECT ADDRESS

Direct address means that the performer speaks directly to us from her or his screen position. We are no longer passive observers but have become active dialogue partners, even if the dialogue is one-sided. The direct-address method provides for optimal information exchange. People on television tell us what to watch, what to buy, what to think, what to feel, and how to behave. We do not think it unusual to have, within a relatively brief time span, a former astronaut

17.4 Context and Dialogue Variables

The important thing to watch in dialogue is that it operates within a fairly consistent pattern

Context Variables		Dialogue Variables			
Гуре	Examples	Word Choice	Sentence Structure	Rhythm	
Education	High	Wide vocabulary range	Precise syntax	Lucid, fluid	
	Low	Limited vocabulary	Double negatives, etc.	Hesitant, uneven	
Occupation	Special	Specialized vocabulary depending on occupation	Involved, depending on occupation (lawyer, college professor)		
	General	General vocabulary			
Region	Country	Country-flavor dialect	Simple	Relatively slow	
	City	Specific city slang		Fast	
	Geographic	Southern, Eastern, etc.		South: legato; East: staccato, etc.	
Locale	Office	Formal, businesslike	Precise syntax	Fast	
	Bar	Informal	Mixed, relaxed structure	Uneven	
	Courtroom	Extremely formal	Highly formal and involved	Precise, even for judges and lawyers; uneven for defendants	
Time	Period	Vocabulary depending on period (century)	Old language structure		
	Morning		New language, simpler	Faster	
	Night			Slower	
Partner	Friend	Familiar, less formal	Informal	Relaxed	
	Stranger	Formal, general	Formal	Uneven	
	Superior	Formal	Formal		
	Inferior	Less formal	Less formal		
Situation	Familiar	Common words	Short, relaxed	Even	
	Unfamiliar	Formal	Precise	Uneven	
	Emergency	Essential words only	Incomplete	Uneven (staccato)	
Attitude	Calm	Large vocabulary	Fairly precise	Even, flowing	
	Excited	Limited vocabulary	Less precise	Fast, staccato	
	Tense	Limited vocabulary	Short	Staccato	
	Hysterical	Often nonsensical	Illogical	Uneven	

tell us about the virtues of a candy bar, an ordinary househusband speak about the power of a new detergent, and the president of the United States describe his difficulty balancing the budget. Television is ideally suited for the direct-address method. The relatively small screen and the alive structure of the image provide the immediacy necessary for such personal "dialogue." What the on-screen dialogue partners say to us is usually of immediate concern. Because this (one-sided) conversation also takes place in the most familiar surroundings possible—our home—it carries a high degree of intimacy.

Not so in film. We go to the movie theater, take our place with other people in an auditorium, and wait until the opening frames reveal a construct of "historical" images—a reconstructed world to dream by. Marshall McLuhan quite rightly observed that in motion pictures, "We roll up the real world on a spool in order to unroll it as a magic carpet of fantasy." We want to look at or be engulfed

by the images of film, but we have little inclination to participate in the screen event. As spectators, we want to remain anonymous. Thus we are apt to become uncomfortable, if not annoyed, when the dream image on the large-sized movie screen all of a sudden turns around, looks at us, and addresses us directly. We feel discovered, caught in the act of observing. Perhaps worse, the film hero has become mortal, a psychological equal. We are subjected to the painful experience of hearing the emperor admit that he is, indeed, naked.

All of this does not mean, however, that you cannot or should not use the direct-address method in film. You should realize, however, that it takes more to make this method successful than having the actor turn toward the camera for part of the dialogue. The direct-address method in film is a dramaturgical device that requires a specific approach to plot and character and a sensitivity to how audiences react. Woody Allen showed us that it is possible to establish a close personal relationship between screen character and audience and to make it believable. But there are few Woody Allens around.

NARRATION

Narration can be on- or off-camera. It is another efficient method of supplying additional information. The narrator usually describes an event or bridges various gaps in the continuity of a screen event. Most television documentaries rely heavily on narration to fill in needed information.

Again, the spoken word is often much more effective in advancing a plot than pictures are. Instead of showing the hands of a clock madly spinning to indicate elapsed time, the narrator can simply say that twenty hours later the situation has not changed. As with direct address, we seem to feel more comfortable with narration on television than in films. We are psychologically more prepared to have someone talk to us (either on- or off-screen) on television than on film. This is why in film you still see written information to indicate extreme changes in time and locale.

Samuel L. Clemens (better knows as Mark Twain) comments on such literary pitfalls in constructing dialogue in his delightful essay on Fenimore Cooper's literary offenses. He accuses Cooper of having violated in *Deerslayer* eighteen of the nineteen rules of literary art. Of the eighteen literary requirements, these three are of special interest to us:

They require that when the personages of a tale deal in conversation, the talk shall sound like human talk, and be talk such as human beings would be likely to talk in the given circumstances, and have a discoverable meaning, also a discoverable purpose and a show of relevancy, and remain in the neighborhood of the subject in hand, and be interesting to the reader, and help out the tale, and stop when the people cannot think of anything more to say....

And:

They require that when the author describes the character of the personage in his tale, the conduct and conversation of that personage shall justify said description...

Here is how Clemens introduces a dialogue example from Cooper's *Deerslayer*: "In the *Deerslayer* story he lets Deerslayer talk the showiest kind of book-talk sometimes, and at other times the basest of base dialects. For instance, when some one asks him if he has a sweetheart, and if so where she abides, this is his majestic answer: 'She's in the forest—hanging from the boughs of the trees, in a soft rain—in the dew on the open grass—the clouds that float about in the blue heavens—the birds that sing in the woods—the sweet springs where I slake my thirst—and in all the other glorious gifts that come from God's Providence!' And he preceded that, little before, with this: 'It consarns me as all things that touches a fri'nd consarns a fri'nd.'" 9

Outer Orientation Functions of Sound

The outer orientation functions of sound are similar to those of light. They include orientation (1) in space, (2) in time, (3) to situation, and (4) to external event conditions.

As with other elements in the various aesthetic fields, the outer orientation functions of sound often overlap; one sound can fulfill several functions, depending on the event context. For clarity's sake, however, we discuss here each of the major functions separately.

SPACE

Specific sounds can help us reveal and define the location of an event, its spatial environment, and off-screen space.

Location Certain sounds identify a specific location, provided that the audience is familiar with those environmental sounds. If, for example, you accompany the close-up of a young woman with such outdoor sounds as birds singing, a rustling brook, and barking dogs, she is obviously somewhere in the country. You have no need for a cumbersome establishing shot; the sounds will take over this orientation function. Now think of the same close-up accompanied with sounds of typical downtown traffic: car horns, automobile engines, trucks, people moving about, a patrol car's siren, a hotel doorman's taxi whistle, buses pulling up to the curb and moving away. The young woman is now in the city. Specific nonliteral sounds, such as electronic hums and beeps, can even locate her in outer space.

In film and large-screen HDTV, you need to take care that the sound comes from approximately the screen position of the sound-producing source. For example, if you show the main character talking on screen-left, her sound should also come from screen-left and not from screen-right or even from the middle of the screen. Fortunately, stereo sound makes it possible to move the sound anywhere along an on- and off-screen x-axis (horizontal) position. Surround-sound extends the sound through a series of speakers to the sides and back of the audience and, when done well, occupies even limited z-axis positions. All too frequently, however, it has a tendency to become independent of the screen event. Instead of supporting each other synergistically, the sound and screen event now vie for attention, similar to what we experience at sound-and-light shows.

In normal-screen television, a stereo separation of sound is less successful. Due to the limited width of the television screen, the built-in speakers are not separated enough to achieve the desired illusion of sonic depth and width. Unless your speakers can be properly separated or you wear earphones or sit exactly in the right place, you will not be able to tell the direction from which the various sounds are coming. We simply cannot discriminate such minute horizontal sound separations. If, for example, you try to match the sounds of two people talking to each other from extreme screen-left and screen-right positions, you will find that a similar x-axis sound separation is unconvincing. Even if you were to separate the loudspeakers and place them far enough apart to achieve sufficient sound separation between left and right, the sounds would be located so far in the left and right off-screen space that they would appear separated from their source—the people on the screen.

Binaural audio, a stereo recording technique that simulates as best as possible how we actually hear, is more accurate in pinpointing x-axis and even z-axis on-and off-screen position. ¹² Early television sound experiments have shown that binaural sound is especially effective not only in defining locations along the on-and off-screen x-axis but also along the on- and off-screen z-axis. ¹³ You can hear

Not every media theorist is in agreement with the directional function of off-screen sound. For example, Christian Metz thinks that a sound source in itself is never "off" because sound is either audible or it doesn't exist. He comments: "When it exists, it could not possibly be situated within the interior of the rectangle or outside of it, since the nature of sounds is to diffuse themselves more or less into the entire surrounding space: sound is simultaneously 'in' the screen, in front, behind, around, and throughout the entire movie theatre." Considering the long history of spatial articulation through stereo sound, this argument is surprisingly naive.11

someone walking right through the screen toward you and even past you along the z-axis. Unfortunately, this aural three-dimensionality is not supported by a similarly extended three-dimensional video space. Unless the vector fields of the visuals are carefully coordinated with the binaural sound, the sound portion remains oddly removed from the pictures and does not lead to the expected heightened spatial awareness of the audiovisual screen event. Also, the technical recording and reception requirements (the need to wear earphones) makes this stereo technique impractical for normal television viewing.

As pointed out before, the horizontal, x-axis positioning of sound through stereo audio gains importance as soon as the television screen size increases. The large-screen HDTV projections not only benefit from such horizontal sound separation but also demand it for all sound functions. In the treatment of sound, as with other aesthetic elements, large-screen television has very similar requirements to those of film.

Environment You can use various sounds to indicate the specific spatial characteristics of an environment. For example, you can indicate whether a person is in the small confined space of a telephone booth or the large space of an empty warehouse simply by manipulating the sound reverberations. More reverberation occurs in a large room than a small one. Outer space is another matter and is usually suggested through novel sustaining, often computer-generated, complex sounds. Simply by switching sounds from expansive to restricted space, you can support or suggest the perceptual switch of what the astronauts see through the porthole to what they feel about their tight living quarters.

Off-screen space Sound expands the on-screen event to off-screen space. Even if you show only a close-up of two people in a restaurant, you can easily communicate the spatial environment of the restaurant through typical restaurant sounds (people talking, soft music, sounds of clattering dishes). Just by hearing a door open and close, we assume that people are either coming or leaving. When the door is open, you can expand the off-screen space even more by bringing in some traffic sounds. You are now operating with layers of literal off-screen sounds.

To suggest that the two people we see talking with each other in a close-up are part of a larger convention group, you can have them wear the traditional name tags. The more convincing clue, however, is to add to their dialogue off-screen sounds of people talking, drinking coffee, laughing, and so forth.

TIME

Like lighting, sounds are a powerful indicator of clock time and the seasons. We readily associate typical sounds with morning, noon, evening, night, summer, or winter. Try to listen to these sounds. Typical morning sounds are the alarm clock, the shower, or the coffee maker. Outside, the morning sounds may include the newspaper being delivered, the garbage truck pulling up, somebody having trouble getting the car started in the cold morning air, or the first bus rattling by. An evening or night in the country inevitably has cricket sounds, the rustling of trees in the evening breeze, the distant barking of a dog, subdued television sounds, and voices and laughter coming from the neighbors. At night you can add the hooting of an owl for good measure.

Different cities and neighborhoods have their own specific sounds. A creative sound track contains many universal sounds we are all familiar with and which we can easily associate with a specific place or time, but it also has sounds that are unique and that differentiate one particular event from all the others. For example, the coffee maker may be so old that it makes a strange hissing sound, the garbage

collector may whistle operatic arias while emptying the cans, and the newspaper may hit the door with a big thump instead of quietly landing on the lawn.

Snow acts as an acoustic dampener; everything is more quiet when it snows than in summertime. Even if there is no snow, winter sounds are generally more subdued than summer sounds.

SITUATION

Sounds can describe a specific situation. You may, for example, indicate that everything is not going according to plan by accompanying the close-up of the chief surgeon's stoic face with the sound of the patient's irregular breathing. Or, in another event, dogs barking madly outside will indicate that someone is coming. Literal sounds are especially helpful to extend the visual field of the small television screen. If, for example, we see a close-up of a woman telephoning and hear the literal (source-disconnected) sound of a baby crying, we don't have to see the baby to know that it is close by and in need of attention.

Predictive sound You can use *predictive sound* very much like predictive lighting to signal an upcoming situational change. For example, you can indicate the imminent danger of a forest fire by gradually and very softly sneaking in the sounds of fire engines while the video still lingers on the carefree campers preparing to cook their freshly caught trout. Or you may show a successful party with all its laughter, occasional tears, and serious and not-so-serious conversations. As an additional sound layer, there is party music, which may be perceived as literal (coming from the host's record player). But suddenly and almost imperceptibly, the music changes to a rather ominous mood (now it is definitely nonliteral), preparing the audience for a coming mishap.

Leitmotiv A specific use of predictive sound is the *leitmotiv* (German for "leading motif"). A leitmotiv is a short musical phrase or specific sound effect that signals the appearance of a person, action, or situation. Its basic dramatic function is that of allusion (reference). Like the bell that caused Pavlov's dog to salivate, the leitmotiv "leads" the audience to expect a specific recurring phenomenon. For example, if you hear heavy breathing every time you see the psycho killer, you expect to see the bad guy again when you hear the heavy breathing, even if the story as told by the screen images makes his appearance rather unlikely. Note that a leitmotiv is effective only if used repeatedly to signal the same event. You need to build up the connection between leitmotiv and event before you can exercise its predictive power.

EXTERNAL CONDITION

Sound can indicate whether something is big or small, smooth or rough, high or low, old or new, fast or slow. Which particular sounds to use depends on the structure of the other aesthetic fields, especially the relative complexity and magnitude of their vector fields. Such video/audio matching tasks are explored in chapter 18.

An example of using nonliteral sounds for describing a certain external event condition is the sudden flooding of a ship's engine room. To express this dangerous condition in literal sounds, you would probably use the rushing and gurgling of the water entering the ship, engine sounds, the sailors' excited voices, the shouted commands, and the clanging of tools against the metal hull. Or you may choose such nonliteral sounds as a thumping that gets more and more "squeezed" the higher the water rises, or music that rhythmically and harmonically

The leitmotiv is usually credited to the German composer and poet Richard Wagner (1813–1883), who used it extensively in his operas. But the leitmotiv had been used long before Wagner by many composers, notably by German-Austrian composer Wolfgang Amadeus Mozart (1756–1791) in his opera Cosi fan tutte and German composer Carl Maria von Weber (1786–1826) in his opera Der Freischütz.

reflects the rushing and rising water, the desperate pounding of the engines, and the confusion and panic of the crew.

Creative sound people are ingenious in combining natural and synthesized sounds to get just the right combination to create the appropriate condition. The sound tracks of extraterrestrial stories especially display the virtuosity of such sound designers.¹⁴

Inner Orientation Functions of Sound

The inner orientation functions of sound include those related to: (1) mood, (2) internal condition, (3) energy, and (4) structure.

MOOD

Music is one of the most direct ways of establishing a certain mood. Music can make us laugh or cry, feel happy or sad. It seems to affect our emotions directly without first being filtered through our *ratio*—our rational faculties. This is one of the reasons why we so readily accept music as part of a scene regardless of whether the presence of music makes any story sense. In relation to the visual screen event, music certainly appoints a persuasive context that engenders an audio/video Kuleshov effect.

Happy music can underscore the overall happy context of the screen event; sad or ominous music will do the opposite. Even if the visual part of a scene expresses a neutral or positive atmosphere, accompanying ominous music will override the visual cues and forewarn the viewer-listener of an impending disaster. As a matter of fact, if you show a relatively neutral scene, such as a mother kissing her children good-bye and then driving off to work, different types of music can shape our specific perception of this event. With upbeat music, we tend to interpret the scene as a happy one; the mother and the children will have a good day. If accompanied by haunting music, we will perceive the identical scene as foreboding and fear that something will happen either to the mother or to the children.

Obviously, we can also create or underscore mood by a variety of nonmusical sounds (usually synthesized or otherwise electronically distorted sound) or a combination of music and nonmusical sounds.

INTERNAL CONDITION

Sounds can express a variety of internal conditions, such as an unstable environment (often in conjunction with the contextual visual clue: the tilting of the horizon line) or a person who feels calm, excited, or agitated. For example, to reveal the fear and panic of sailors in the flooded engine room, you could put yet another layer of "internal fear" sounds on top of the sounds that depict the squeezing of space. You may also recall the earlier example of the use of the frame-by-frame "jogging" effect to reveal a woman's incredible inner tension while calmly pouring tea. You can intensify the woman's inner state considerably by combining the brief visual "jogging" montage with sustained, piercing, dissonant sounds.

ENERGY

Music and other nonliteral sounds, such as electronic hisses, whistles, and whines, can provide or increase the aesthetic energy of a scene. Again, the immediate way in which sound affects our emotions is a perfect tool for establishing or supplementing the energy of the screen event. Cartoons, for example, rely heavily on music and sound effects as an energy source. In a cartoon, there is no such thing as the villain simply plunging toward the earth;

"If the music draws away or diverts from the dramatic shape, line, or impulse, it doesn't fit the film. If it understates the case, it will be a disappointment. And if it overstates a particular situation along the way, it will cause a problem of balance or a distortion of the dramatic line. On the other hand, if the music connects with the film in terms of dramatic shape and meaning, bringing out various aspects in a corroborative manner without overdoing it, the music begins to fit the film. How this is done in each situation is the basic question—the most important question for all film music composers."16

—George Burt, The Art of Film Music

he is literally driven into the ground by the accompanying sound effects. In a slightly more subtle way, car chases are often energized by frantic music, as are scenes in which people run from or toward disaster. Internal energy is just as easily expressed or supplemented by music. Even if you show a rather static scene of two people staring at each other, appropriate music will reveal their inner state and the general energy level of the scene.

People have used music and sound effects as energizing elements in many areas of the performing arts for quite some time. The high energy of an African dance is primarily dictated and communicated by pounding drums. When the long Greek plays threatened to lose energy and the audience's attention despite the tragic battles of gods and mortals, flute players were called onstage to keep things moving. Some 2,500 years later, it is a rare play that does not make heavy

use of music and sound effects not only to underscore the mood of various scenes but also to add aesthetic energy. The various sounds accompanying video games are based on the same aesthetic principle.¹⁵

STRUCTURE

Probably one of the most important, though least conspicuous, functions of sound is to establish or supplement the rhythmic structure or the visual vector structure of the screen event. You may discover that, despite great care, your editing has little structural coherence and lacks a precise tertiary motion beat. Such problems frequently occur during continuity editing, when the vector continuity rather than rhythm is the major criterion for the cut. In this case, a highly rhythmic sound track will help establish a precise tertiary motion beat even if the visual editing is rhythmically uneven. The sound rhythm acts like a clothesline on which you can "hang" shots of various lengths without sacrificing rhythmic continuity. **SEE 17.5**

When sound rhythms and picture rhythms parallel each other, the total structure becomes unified and stable. **SEE 17.6** Be careful, however, that the beat does not become too regular for too long a period of time; this can make the total rhythmic structure become monotonous and boring.

An interesting rhythm is not the one that has parallel tertiary motion and sound track beats, but rather one that is slightly syncopated. In such a picture/sound counterpoint, the editing and sound rhythms run parallel for a while but then shift to a contrapuntal structure in which a relatively fast video editing sequence is juxtaposed with the slow beat of the sound track, or a relatively slow picture sequence with a fast sound rhythm. **SEE 17.7**

This juxtaposition of fast and slow video and audio rhythms is simply another application of the dialectic principle, which is based on putting opposing elements side-by-side. Sensitively applied, such an audio/video dialectic will increase the complexity of the screen event without impairing its communication clarity. You can also analyze the relative magnitude and complexity of the visual vector field and match it with a sound vector field of similar or opposing characteristics. This aspect of structural matching is discussed in chapter 18.

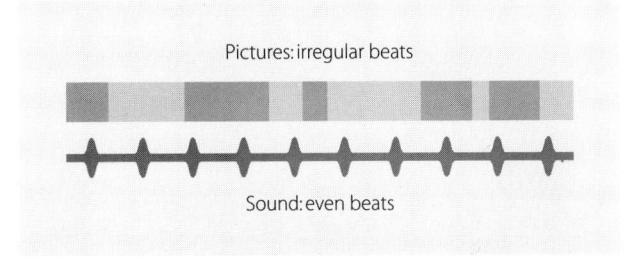

17.5 Irregular Picture Sequence Structured Through Sound

In an irregular picture/sound structure, an uneven picture rhythm (uneven editing beat) is usually combined with a prominent, even sound beat.

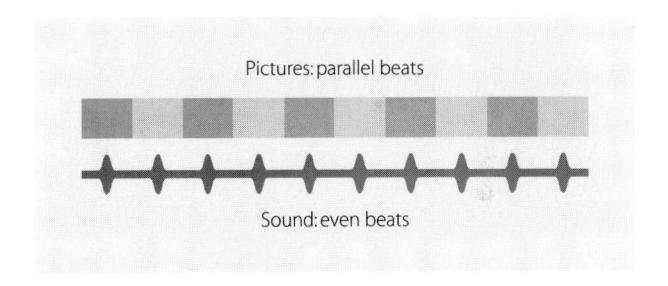

17.6 Parallel Picture/Sound Structure

In a parallel structure, the tertiary motion of the picture portion (editing beat) is accompanied by an identical beat in the sound portion. Thus, picture and sound rhythms match.

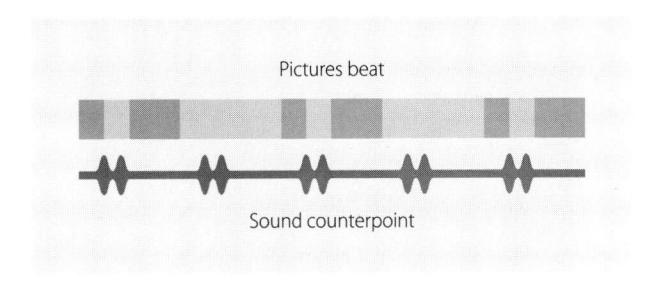

17.7 Picture/Sound Counterpoint

In a picture/sound counterpoint, the rhythm of the video portion (editing beat) relates to the sound rhythm contrapuntally. This can mean that a relatively fast video beat is juxtaposed with a rather slow sound beat or vice versa.

Aesthetic Factors

Even if you are not a sound expert, you need to be aware of three basic aesthetic factors in the treatment of sound: (1) figure-ground, (2) sound perspective, and (3) sound continuity.

FIGURE-GROUND

The figure-ground principle, according to which we organize our visual environment into a mobile figure and a relatively stable background, also applies to sound. ¹⁷ In sound design, *figure-ground* means that you choose the important sounds to be the figure, while relegating the other sounds to the background. For example, in an outside news report, you need to emphasize the reporter's voice over the ambient sounds of the fire engines and other rescue equipment. The reporter's voice functions as figure and the environmental sounds as ground.

The same figure-ground principle applies when you show two people whispering dear thoughts in each other's ears while standing at a busy downtown street corner. In a long shot, the visual figure-ground relationship between the couple, the other people, and the cars on the street is indistinct. The visual aspect of cars and people rushing by the happy couple is equally prominent. Consequently, you can mix the couple's voices liberally with traffic and other ambient (environmental) sounds. **SEE 17.8**

But as soon as you take a close-up of the couple, you establish a much clearer visual figure-ground relationship. Now the couple stand out as the figure from the out-of-focus street, and viewers expect the sound to follow suit. Regardless of what the actual volume relationship may be between traffic sounds and the couple's voices, their whispering must now become the sound figure, and the traffic sounds, the ground. **SEE 17.9**

You have surely noticed that this figure-ground principle of sound is identical to that of aerial perspective. In both cases, we "focus" on a particular visual or aural plane, while rendering the other picture and sound elements as "out-of-focus" background (see chapter 9). This figure-ground control is possible, however, only if you have separated the various sound "planes" during the sound pickup and recorded them on different tracks.

SOUND PERSPECTIVE

Sound perspective means that you match close-up pictures with "close" sounds, and long shots with sounds that seem to come from farther away. Close sounds have more presence than far sounds. *Presence* is a sound quality that makes you feel as though you were close to the sound source.

Sound perspective also depends on the figure-ground relationship. When we see the happy couple in a long shot standing on the busy street corner, we should hear their voices as coming from equally far away. On a close-up, however, we want to have their voices come from a closer distance. The "close-up" sound must have considerably more presence than the sounds in the long shot.

As you probably noticed, most routine television productions, such as news, interview shows, game shows, and documentaries, do not bother with sound perspective. In many cases, the talent wear lavaliere mics that are fixed to some piece of clothing and therefore do not change the distance from sound source (mouth) to microphone during field-of-view changes (such as a cut from a long shot of all the guest in an interview show to a tight close-up of one of the guests). Because in such cases the perceived distance between long shot and close-up is relatively small, the lack of sound perspective is not detrimental to the overall effect.

Couple's voices

Traffic and pedestrian sounds

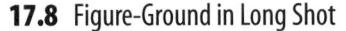

In a long shot, the figure-ground relationship between a prominent foreground sound and background ambient sounds is purposely de-emphasized. In this case, the traffic and pedestrian sounds are as audible as the couple's whispers.

Couple's voices more prominent than

95万,上于1967年,1977年,1986年,1987年,1987年,1987年,1987年,1987年,1987年,1987年,1987年,1987年,1987年,1987年,1987年,1987年,1987年,19

traffic and pedestrian sounds

17.9 Figure-Ground in Close-up

In a close-up, the traffic sounds are relegated to ambient background sounds, and the quiet whispering of the couple is emphasized as the sound (close-up sound).

SOUND CONTINUITY

Sound continuity means that the sound maintains its intended volume and quality over a series of edits. As with visual vector continuity from shot to shot, we expect a similar continuity of sound vectors. For example, if you cross cut between close-ups of two people talking with each other, their voices should not change perceptively either in volume or presence during the cutting sequence. You can most easily achieve continuity by keeping the background sounds as even and continuous as possible. So long as you maintain an even level of ambient (background) sounds, viewers will perceive the foreground sounds as continuous regardless of whether they change somewhat in volume, quality, and presence from shot to shot.¹⁸

The same aesthetic principle operates in the first aesthetic field. Despite a cluttered set that has a great variety of brightly colored foreground pieces, you can achieve some sort of visual continuity by keeping the background evenly illuminated and painted with a uniform color of low saturation. As you can see, the basic principles apply in some way to all five aesthetic fields; they are, at least to some degree, dependent upon one another. This interdependency of aesthetic elements in the various fields is the main characteristic of applied media aesthetics.

Summary

The five major aspects of the five-dimensional field are: sound and noise, television and film sound, literal and nonliteral sound, sound functions, and aesthetic factors.

Sound and noise are both audible vibrations of the air or some other material. The difference is that sound has communication purpose; noise is random and unwanted. In television, sound is especially important because much of the programming is reality-based, and we experience the world as an audiovisual environment. The low-definition, inductively presented television pictures also need sound as an important informational supplement. Production restrictions, such as low-fidelity speakers and the simultaneous pickup of sound with the pictures, render television sound low-definition. With respect to energy matching between television pictures and sound, the low-definition television sound seems more appropriate to the low-definition image than high-definition, high-energy sound would.

Film and large-screen HDTV sound have a higher fidelity than normal television sound, which is important when matching audio and video energies on the large screen. HDTV and certain television programs use postproduction sound techniques that are similar to those of film.

Literal sound is referential. It conveys specific meaning and refers to the sound-originating source. Literal, or diegetic, sounds can be source-connected (we see what is making the sound) or source-disconnected (we see something else while hearing the sound).

Nonliteral, or nondiegetic, sounds do not carry a particular meaning or point to a sound source. They are deliberately source-disconnected. Some sounds (such as music) can be literal or nonliteral, depending on the visual context.

Sound has three basic functions: information, outer orientation, and inner orientation.

The information function of sound includes all forms of speech, such as dialogue, direct address, and narration. Dialogue is the major form of speech in film, with direct address used only on special occasions. In television all three forms of speech are common.

The outer orientation functions of sound include orientation in space, in time, to situation, and to external event conditions.

Sound can identify a particular location (downtown, country) and the relative position of the sound source on the x-axis of wide motion picture screen. It can indicate spatial characteristics of an environment (large empty hall, small constricted space) and events that happen in the off-screen space. We readily identify specific sounds with a particular clock time or season. Sound can also give clues as to the prevailing situation. Predictive sound means that certain sound changes or repeated sound phrases (leitmotiv) can signal an upcoming event. Sound can also give clues to, or reinforce, the external condition of an object or event, such as big or small, fast or slow.

The inner orientation functions of sound include mood, internal conditions, energy, and structure.

Music is one of the most efficient aesthetic elements to create a specific mood or describe an internal condition. Music and nonliteral sounds are often used to provide additional energy for a scene. One of the most important functions of sound, especially for television, is to supply or supplement the rhythmic structure or the vector structure of the visual field.

The aesthetic factors include the figure-ground principle, sound perspective, and sound continuity. Figure-ground means that some sounds are treated as the more prominent foreground sounds (figure) while others are kept in the background (ground). Sound perspective refers to how close we perceive a sound to be; close-ups should sound closer than long shots. Sound continuity means that the sound should maintain its intended volume and quality over a series of related shots.

NOTES

- 1. See the comments on the effect of sound on montage in chapter 16.
- 2. D. W. Griffith was quite despondent about the use of sound in cinema and the resulting loss of power of the montage. He begged to "give us back our beauty." See David Thomson, *A Biographical Dictionary of Film*, 3d ed., (New York: Alfred A. Knopf, 1994), p. 273. Also note the comments by Rudolf Arnheim, "A New Laocoön: Artistic Composites and the Talking Film," in his *Film As Art* (Berkeley: University of California Press, 1957), pp. 199–230. Also see Elisabeth Weis and John Belton (eds.), *Film Sound: Theory and Practice* (New York: Columbia University Press, 1985).
- 3. V. I. Pudovkin, *Film Technique and Film Acting*, ed. and trans. by Ivor Montagu (New York: Grove Press, 1960), pp. 310–311.
- 4. Marshall McLuhan, *Understanding Media: The Extensions of Man* (New York: McGraw-Hill, 1964), pp. 311–314.
- Siegfried Kracauer, Theory of Film: The Redemption of Physical Reality (New York: Oxford University Press, 1960), pp. 104–106.
- 6. Walter Murch, the sound designer for Francis Ford Coppola's film *Apocalypse Now*, says that at a certain point there were 160 tracks for the film. See Frank Paine, "Sound Mixing and *Apocalypse Now*: An Interview with Walter Murch," in Weis and Belton, *Film Sound*, p. 359.
- Stanley R. Alten, Audio in Media, 4th ed. (Belmont, Calif.: Wadsworth Publishing Co., 1994), pp. 52–57.
- 8. David Bordwell and Kristin Thompson, "Fundamental Aesthetics of Sound in the Cinema," in Weis and Belton, *Film Sound*, pp. 197–199. See also Vinay Shrivastava, *Aesthetics of Sound*, (Dubuque, Iowa: Kendall/Hunt Publishing Co., 1996).
- 9. Bernard De Voto (ed.), *The Portable Mark Twain* (New York: Viking Press, 1946), pp. 542–543, 553.
- 10. McLuhan, Understanding Media, p. 284.
- 11. Christian Metz, "Aural Objects," in Weis and Belton, Film Sound, pp. 157–158.
- 12. Alten, Audio in Media, pp. 376-377.
- 13. Benjamin P. Wilson, "The Design, Application and Evaluation of Stereophonic Television: A Production Model." Master's thesis, San Francisco State University, San Francisco, 1980.
- 14. Mark Mancini, "The Sound Designer," in Weis and Belton, Film Sound, pp. 361–368. Also see Shrivastava, Aesthetics of Sound, pp. 49–58, and George Burt, The Art of Film Music (Boston: Northeastern University Press, 1994). In this highly informative though quite technical book, film composer and teacher Burt demonstrates in a number of examples how a film composer conceives and structures film music. On the other side of the fence, Theodor Adorno feels that "despite all the talk, film music has up to now not seen any influx of truly new impulses." Theodor Adorno and Hans Eisler, "Komposition für den Film," in Theodor Adorno, Gesammelte Schriften 15 (Frankfurt am Main, Germany: Suhrkamp Verlag, 1976), p. 89 (translation by the author). Adorno was clearly caught between his Marxist ideology and his reverence for classical music. Shrivastava provides a good summary of the Marxist approach to film sound; see his Aesthetics of Sound, pp. 177–224.
- See Herbert Zettl, *Television Production Handbook*, 6th ed. (Belmont, Calif.: Wadsworth Publishing Co., 1997), p. 254. See also the delightful description of the role of music in Greek plays as quoted by Ernest Lindgren, *The Art of Film* (New York: Macmillan Co., 1963), p. 134.
- 16. Burt, Art of Film Music, p. 5.
- 17. See the section on figure-ground in Chapter 7.
- 18. Zettl, Television Production Handbook, p. 254.

Structuring the Five-Dimensional Field: Sound Structures and Sound/Picture Combinations

N structuring the five-dimensional field, we take a closer look at (1) elements of sound, (2) basic sound structures, (3) sound structures and dramaturgy, and (4) picture/sound combinations. When talking about sound, we will have to consider not only its physical characteristics, such as the frequency of a sound, but also its psychological characteristics, such as how high or low we perceive a tone to be. Unfortunately, as with color, neat physical formulas for sound use do not always translate into equally neat perceptions. Our definitions are, therefore, often based on perceptual rather than strict physical phenomena and processes.

Fortunately, in structuring the five-dimensional field, you can apply many of the basic structural principles developed and used in music as well as those of the other aesthetic fields discussed in this text. For example, even if you don't read music, you can look at musical notation simply as another type of vector structure. When translated into graphic, index, and motion vectors, musical notation can describe a line, a direction, a movement, and horizontal and vertical vectors.

Elements of Sound

When you strike a single piano key, blow into a trumpet, or draw the bow across a violin string, you can hear five distinct attributes, or elements, of sound: (1) pitch, (2) timbre, (3) duration, (4) loudness (dynamics), and (5) attack/decay.

PITCH

Pitch indicates the relative highness and lowness of a sound measured against an agreed-upon scale. The pitch of a tone is perceived and measured by its frequency—its vibrations per second. A high-pitched tone vibrates with a higher frequency than a low-pitched tone. The generally accepted pitch standard is the A above middle C, called A prime (A'). It vibrates 440 times per second, which is expressed as 440 Hz (hertz, the international unit of frequency). **SEE 18.1**

18.1 Pitch

You can recognize the pitch of a tone by its relative position on the staff. Note that a higher octave of a tone is exactly twice its frequency; the lower octave is half its frequency.

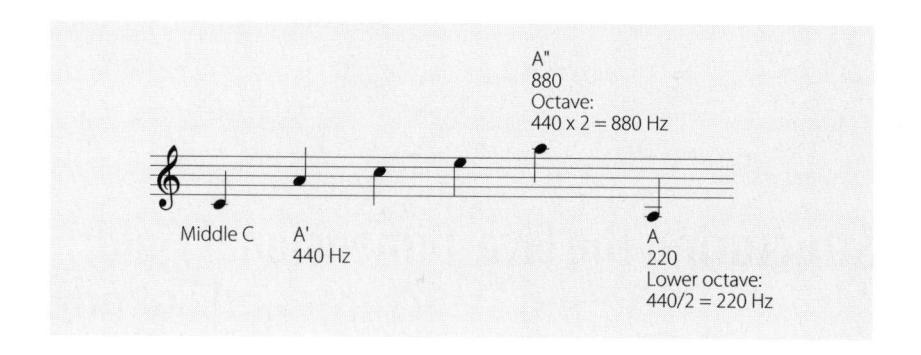

TIMBRE

Timbre (rhymes with amber) describes the tone quality or tone color. The timbre of a tone tells you whether it is produced by a clarinet or a violin. Technically, the timbre of a sound is created by the kind and relative number of overtones. Overtones are a number of frequencies with which a sound-producing source vibrates in addition to its fundamental frequency—the one that we hear as a specific pitch.

All overtones have a higher pitch than the basic tone. You don't hear the individual overtones as higher pitches in combination with the basic tone, however. Rather, you perceive the overtones more like a superimposition, as a more complex, richer tone than one without any or with fewer overtones. The following figure illustrates the formation of overtones. **SEE 18.2**

18.2 Timbre

When you pluck a violin string, it moves back and forth between fixed points (the upper end of the fingering board and the bridge) in a wavelike pattern. The crest of the wave moves in one direction, and the valley comes back from the opposite direction. Practically, the whole string appears to be moving up and down. The number of such up-and-down movements of the string per second determines its basic frequency (hertz) and pitch. This fundamental frequency is the tone's first "harmonic." Because the vibration of the string as drawn in this illustration has no other vibrations superimposed on it, it has no overtones.

The violin string also vibrates simultaneously in separate sections. In this illustration each half of the string vibrates twice as fast as the total string, which is an exact octave of the basic frequency. This octave is the second harmonic and represents the first overtone.

The more sections of the string that vibrate in multiples of the basic frequency, the more numerous and the higher the harmonics become. Although you may not be able to hear each overtone separately, you perceive the sum of these overtones as a richer sound.

The frequency of the fundamental tone—and those frequencies that are simple multiples of the fundamental tone, such as double, three times, or six times the frequency of the fundamental—are called *harmonics*. Thus the fundamental tone (the one that determines the pitch) is the first harmonic. The second harmonic may be a frequency twice as fast as that of the fundamental. This second harmonic, then, represents the first overtone. Because it has a frequency twice that of the fundamental tone, it is an octave higher. The second and all subsequent harmonics have a progressively higher frequency than the fundamental tone. Let us assume that the fundamental tone (first harmonic) vibrates at a frequency of 440 Hz. You would hear an A', the normal A you hear when an orchestra tunes up. If the first overtone (second harmonic) vibrates at 880 Hz, which is twice the frequency of the fundamental, you would hear a tone that is an octave higher than the fundamental. If the second overtone (third harmonic) vibrates at three times the frequency of the fundamental, you would hear a 1,320 Hz tone, which is a very high E.

The point to remember is that a rich, full sound has many overtones; a thin or hollow sound has few overtones. Some instruments, such as the flute, produce sounds with fewer overtones than the violin or cello. The human voice has more overtones than most instruments. When computers were first used to synthesize the human voice, it was the lack of sufficient overtones that gave the voice its infamous monotone "computer-speak" quality.

DURATION

Duration refers to how long you hear a sound lasting. **SEE 18.3** You may perceive very short bursts of a tone or a rather long, continuous one. Most musical instruments permit some control of sound duration, like the bow that one pulls across the strings at various speeds or piano pedals that one depresses or releases. In musical notation there are specific symbols that determine the relative duration of various sounds.

LOUDNESS (DYNAMICS)

The *loudness* of a tone is its apparent strength as we perceive it. You can play a tone of a certain pitch and timbre either loudly or softly. Essentially, when you have to hold your ears while listening to music, the sounds are loud; when you

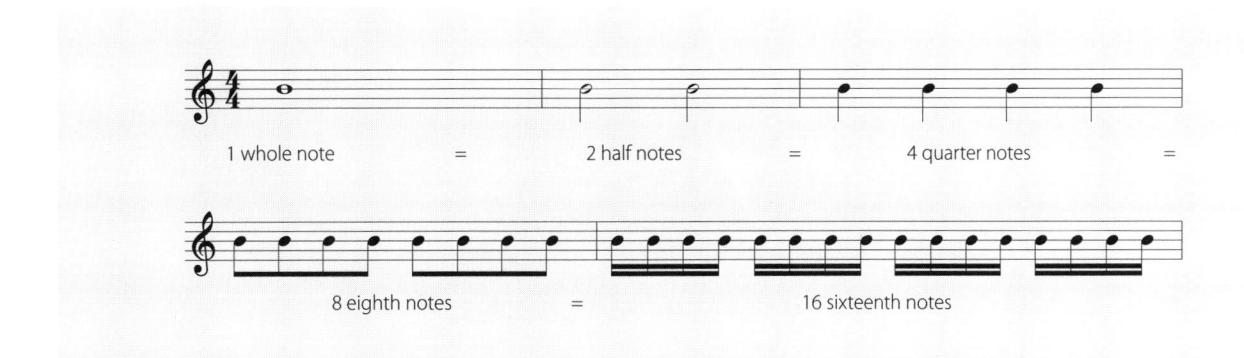

18.3 Duration

In musical notation the duration of a tone is precisely determined by a specific symbol, such as whole notes, half notes, quarter notes, eighth notes, and so forth.

18.4 Loudness (Dynamics)

In musical notation the loudness of a tone is roughly indicated by symbols such as these. The electronic volume control on an your audio console ultimately affords, of course, more loudness variations.

have to strain to hear them, they are soft. Loud sounds have a high magnitude; soft sounds, a low one. The variations of perceived strength are the dynamics of the sound.¹ **SEE 18.4**

ATTACK/DECAY

The attack or decay of a sound is part of its dynamics and duration. *Attack* means how fast a sound reaches a certain level of loudness. The time it takes for the sound to reach the desired maximum loudness is sometimes called rise time. The sound remains at slightly fluctuating sound levels for some time before it gets softer and finally dies away. The time it remains at the high levels of loudness is called the sustain level; the sustain level is sometimes called duration. From the point the tone starts to get softer until we can no longer perceive it is called its *decay*. The whole process, from initial attack to final decay, is called the sound envelope or, simply, *envelope*. The envelope, then, represents the total sound duration and not just its sustain level. **SEE 18.5** Much like timbre, the stages of the sound envelope, such as the attack phase, have some influence on how we perceive a specific tone.²

Both attack and decay can be fast or slow. In vector terminology a fast attack means that the sound vector achieves its maximum magnitude quickly. **SEE 18.6** In a slow attack, it will take the sound vector some time to get up to its maximum strength (loudness). **SEE 18.7** The sustain level is how long the vector maintains

18.5 Sound Envelope

The basic sound envelope consists of attack, initial decay, sustain level, and final release.

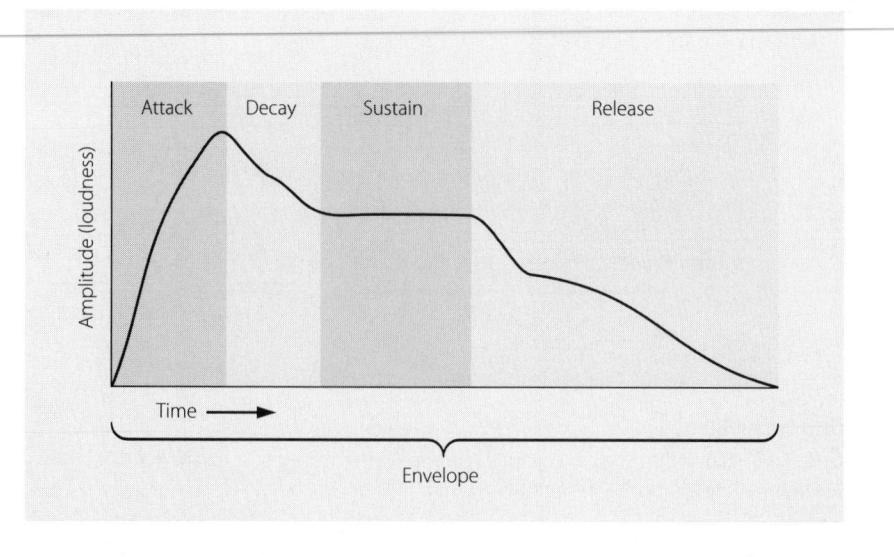

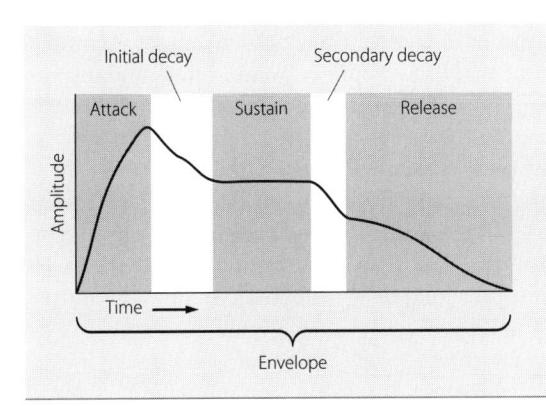

A more precise envelope shows a more drastic initial decay and a secondary decay before the release phase. Note, however, that different instruments produce different envelopes. Much like timbre, all stages of the envelope influence the characteristics of a sound to a certain extent.

at a relatively steady high-magnitude level. When its magnitude starts to decrease, the sound has entered its decay phase. If the sound vector drops from its high magnitude to zero relatively quickly, the sound has a fast decay. **SEE 18.8** When it takes some time for the vector to lose its strength, the sound has a slow decay. **SEE 18.9** In musical language, *crescendo* stands for attack (change from soft to loud) and *diminuendo* for decay (change from loud to soft).

Not all instruments have the same control over the sound envelope (duration and dynamics from attack to final decay). As a violin player, for example, you would have maximum control over the attack time, the sustain level, and the decay time. Depending on how you use the bow, you can produce a fast or slow attack, a short or long sustain level, and a fast or slow decay. When playing the piano,

18.6 Fast Attack

In a fast attack, the sound gets loud quickly; the rise time is short. We have a high-magnitude sound vector.

18.8 Fast Decay

In a fast decay, the sound dies quickly. We have a high-magnitude sound vector.

18.7 Slow Attack

In a slow attack, the sound takes a while before it reaches the desired loudness; the rise time is slow. We have a low-magnitude sound vector.

18.9 Slow Decay

In a slow decay, the sound fades more gradually. We have a low-magnitude sound vector.

18.10 Fast and Slow Acceleration

- a A fast attack (acceleration) creates a high-magnitude vector.
- **b** A slow attack (acceleration) creates a low-magnitude vector.

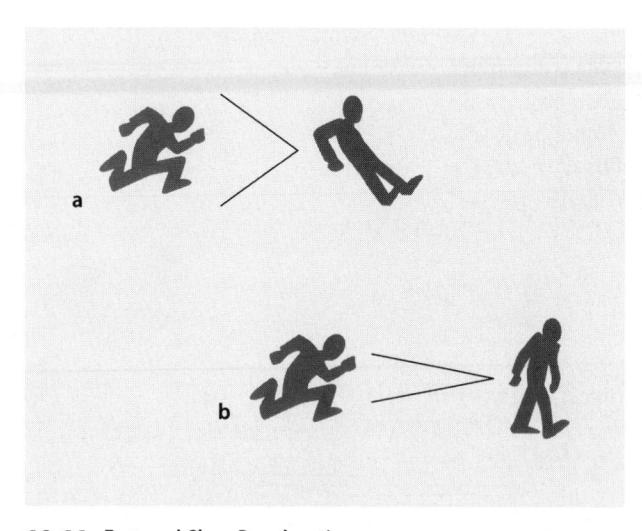

18.11 Fast and Slow Deceleration

- **a** Fast deceleration (fast decay) produces a high-magnitude vector.
- **b** Slow deceleration (slow decay) creates a low-magnitude vector.

however, you have control over the dynamics of the tone (its loudness or softness) but not over its attack and sustain level. The only control you have is over the decay period. When you press the sustain pedal, the sound takes more time to fade; the pedal stretches the decay. The dampening pedal shortens the decay; the tone dies more quickly. When playing the drums, you are at the mercy of the instrument for the whole envelope. You can strike it only softly or hard, to produce a soft or loud bang, but you have no control over attack or sustain levels.

Actually, the decay of sound is also influenced by the acoustics of the room. In a fairly "live" acoustical environment, the decay is slower (more reverberations) than in a rather "dead" environment (fewer reverberations). Also, the control of the various elements of the sound envelope is especially important if you electronically synthesize various sounds and sound combinations.

When you combine picture and sound vectors, you can match the attack and decay variables of both vector types. For example, a visual motion vector can reflect a variety of attack and decay modes, depending on how fast it reaches or loses a specific maximum magnitude. If an object accelerates to a specific speed quickly, you have a motion vector with a fast attack (or fast rise time); if it accelerates more gradually, you have a slow-attack motion vector. **SEE 18.10** If it decelerates quickly, its magnitude drops equally quickly, and you have a fast-decay motion vector. If the object motion decelerates more gradually, it produces a slow-decay motion vector. **SEE 18.11** The advantage of translating sound into a variety of vectors is explored more fully later in this chapter.

Basic Sound Structures

This discussion of sound structures is not meant to be exhaustive. Rather, it is intended to aid you in dealing effectively with the sound portion of a television or film production and especially in developing, or deciding on, a sound track that not only supports the video portion but

also combines with it synergistically to become an organic, maximally effective whole. To achieve this, you should try to translate musical elements and structures into various types of sound vectors whenever possible. Seeing music in terms of sound vectors means you can, for example, deal successfully with the basic notation of a musical piece even if you don't read music. More important, vectors allow you to compare sound with pictures and find relationships between sound and pictures that would otherwise not have been so evident. Vectors convey more readily than any other aesthetic factor the contextual nature of media aesthetics.

Let us now take a closer look at the following basic sound structures: (1) melody, (2) harmony, (3) homophony, and (4) polyphony.

18.12 Melody

Melody moves as a horizontal sound vector in a linear fashion. Each tone leads to another until they become an entity—a tune.

MELODY

A *melody* is a series of musical tones arranged in succession. Like a sequential series of shots, a melody is a sequential series of specific sounds that has a logic in its progression and that forms a tune. Melody forms a horizontal vector. **SEE 18.12**

Like life itself, a melody is constantly progressing and is complete only when it has ended. You experience the various steps of progression, but you can only remember the total melody—the tune. You should note that the logic of melodic progression differs among various cultures. For example, the traditional melodies of Middle Eastern or Far Eastern songs are much more subtle in their progression than are Western melodies.

All melodies are based on specific scales. In Western music there are major and minor scales, chromatic and diatonic scales, and whole-tone and twelve-tone scales. They differ basically in the number of steps and the interval between the steps within an octave (when the tone repeats itself higher or lower on the scale). **SEE 18.13–18.17**

Arnold Schönberg (1874–1951), Austrian-German composer, established the twelve-tone system as a useful compositional device. He taught in Berlin and at the University of California, Los Angeles.

18.13 Chromatic Scale

In the chromatic scale, an octave is divided into twelve equal steps, with the twelfth tone being the octave (double the frequency of the fundamental). It consists entirely of half-tone intervals.

18.14 Major Diatonic Scale

In the diatonic scale, an octave is divided into eight steps, with the eighth tone being the octave (double the frequency of the tonic—the first tone). The steps are not equal, with half steps between the third and fourth, and the seventh and eighth tones. The diatonic scale is what we (in Western music) normally use in melodic and harmonic structures. Generally, a major scale expresses a positive, normal, practical mood.

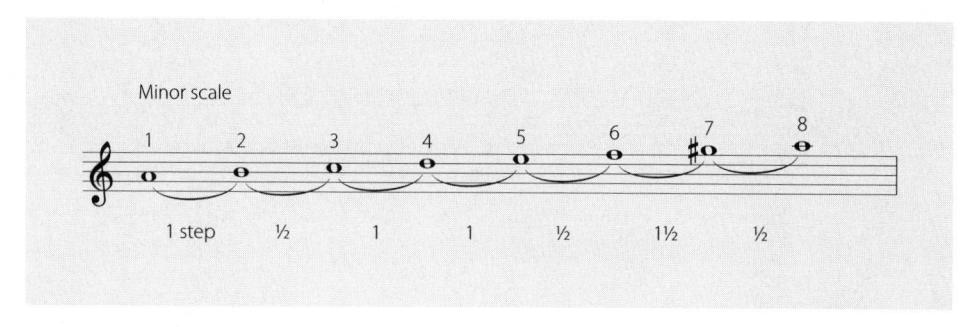

18.15 Minor Diatonic Scale

In the minor diatonic scale, the eight steps are not equal. There is a half step between the second and third tones, and the fifth and sixth tones. In the ascending minor scale (which is illustrated here), there is an additional one-and-a-half step between the sixth and seventh tones, and half a step between the seventh and eighth (octave) tones. The minor scale reflects a sad, mysterious, haunting, less definite mood.

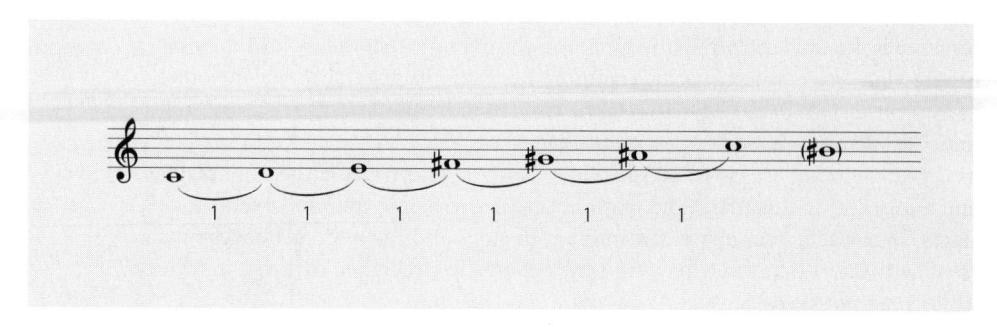

18.16 Whole-Tone Scale

The whole-tone scale uses full steps between all seven intervals.

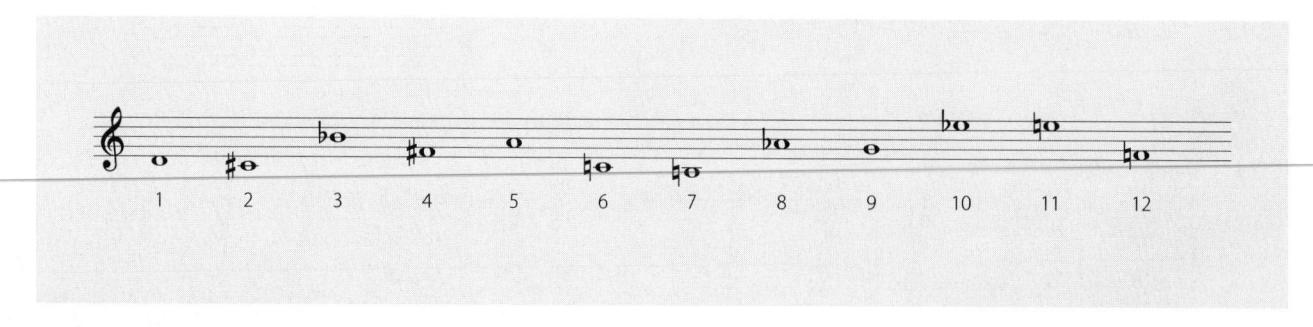

18.17 Twelve-Tone Scale

Some composers simply regard the twelve tones of the chromatic scale as equal and arrange these notes in some form regardless of the specific intervals. Because there is a total of twelve notes in a scale before the notes begin to repeat themselves as an octave, the individual row can contain twelve notes. The structuring of such sets of twelve notes has become known as the twelve-tone system.

18.18 Harmony

A harmonic structure is created by simultaneous tones. Whereas melody consists of horizontal sound vectors, harmony consists of vertical ones.

HARMONY

Whereas a melody consists of horizontally successive notes, *harmony* is a vertical combination of simultaneously played notes. Melody is linear and forms a horizontal vector; harmony is nonlinear and forms a vertical vector. Contrary to the melody, which you can perceive only incompletely in its development, you can hear harmony in its totality all at once. Melody leads somewhere; harmony is there. It has always arrived. The harmonic combination of sounds is called a *chord*. **SEE 18.18**

The magnitude of the vertical sound vector depends on various factors, principally the relative density and texture of the chord (the number of notes in the chord and how close together they are), its perceived tension (consonant, pleasant sounding, or dissonant, consisting of tones that do not blend together well), and its tension relative to the melody. Generally, the higher the chord density, texture, and tension, the higher the vector magnitude. **SEE 18.19**

HOMOPHONY

Homophony means literally "alike sounding" (Greek homo means "the same"; phonos means "sound"). In music, homophony refers to the structure in which a single predominating melody is supported by corresponding chords. The chords act like pillars (vertical vectors) that hold up the melody bridge (horizontal vector). **SEE 18.20** In a homophonic structure, only the horizontal vector of the melodic line is independent. You can re-create its logic by simply whistling a tune. **SEE 18.21** But the accompanying chords are dependent upon the melody; they cannot stand alone—and playing them without the melody makes no sense. The chords do not lead to a satisfactory musical closure. **SEE 18.22**

18.19 Harmonic Density

Chords can vary considerably in their complexity. We speak of relative chord density or sound texture. To play this chord on the piano, you would have to press all the white and black keys between the highest and lowest notes of the chord. From "Pentatonic" by P. Peter Sacco, by permission of the composer.

In traditional music, harmonic structures must adhere to strict rules. The simplest harmonic structure consists of two tones that are played simultaneously. Chords consist of three or more simultaneous tones.

Two simultaneous tones equal an interval.

The basic unit of the traditional harmonic structure is the triad, a combination of three tones.

Vertical, harmonic structures are usually built from the same scale in which the melody operates (that is, the chords have the tonality of the melody), but the melody and the chords may also operate in different keys or outside of any predetermined scale (as in twelve-tone structures, for example).

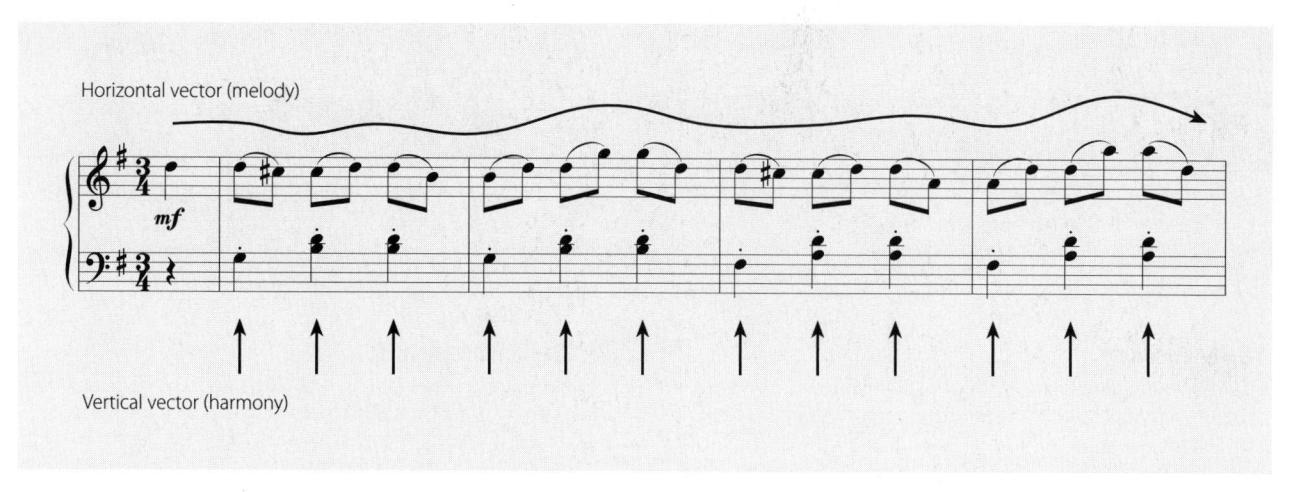

18.20 Homophony

In a typical homophonic structure, the leading melody is supported by a parallel chord accompaniment. When we translate the written music of this waltz in G major by Franz Schubert into vectors, we can see how the horizontal vector of the melody is supported by vertical vectors.

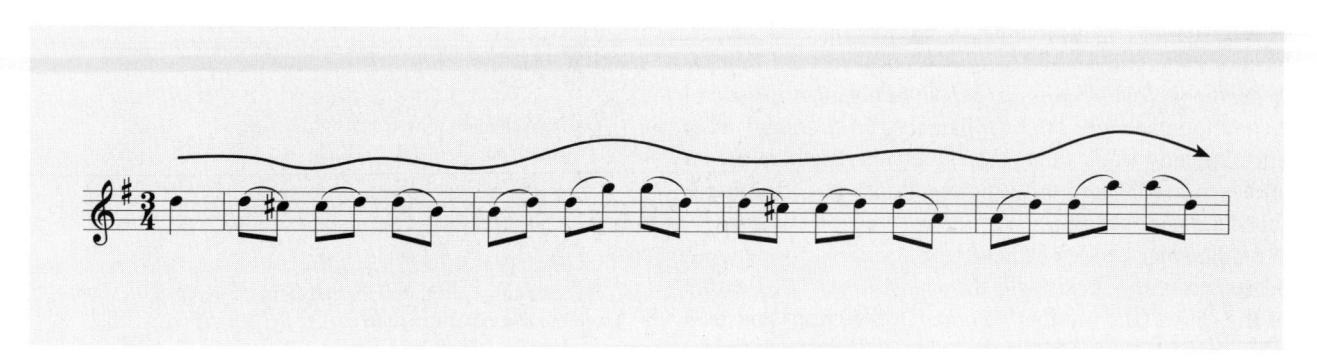

18.21 Melody

In a homophonic structure, the melodic, horizontal vectors are independent. The melody can exist by itself.

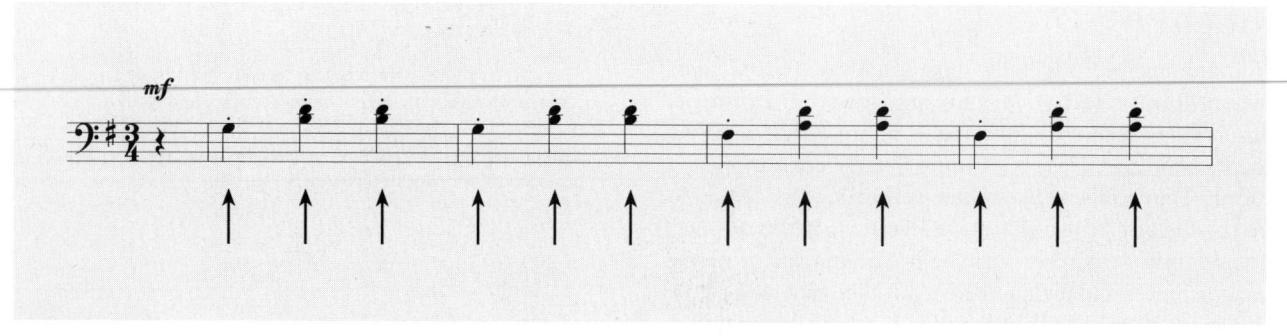

18.22 Chords

In a homophonic structure, the accompanying chords are dependent on the melody. They are dependent vertical vectors; that is, they need the melody to form a gestalt.

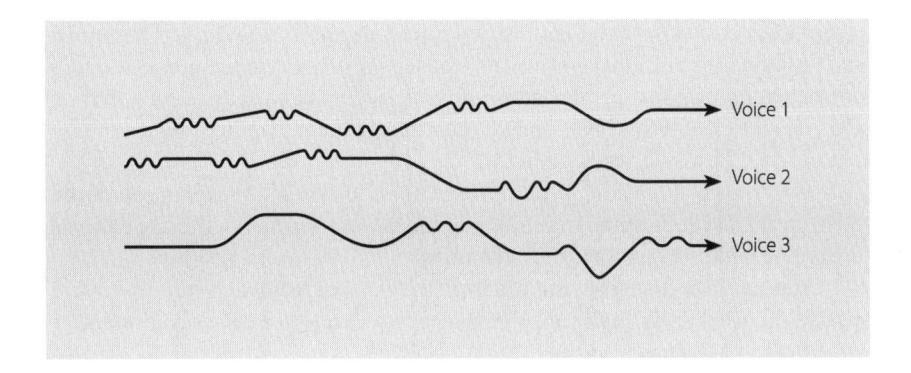

18.23 Polyphony

In a polyphonic structure, each voice (horizontal vector) is basically independent; that is, each voice has its own logical melodic development.

POLYPHONY

In musical terminology, *polyphony* refers to two or more melodic lines that, when played together, form a harmonic whole. Unlike homophonic structures, where a single dominating melody is accompanied by supporting chords, polyphonic structures are composed of multiple, equally dominating voices (melodies or horizontal vectors). No single voice is relegated to a supporting role; each runs its own course, sometimes dominating the other voices and sometimes seemingly assuming a subordinate role. When played separately, each voice forms a self-sufficient entity. **SEE 18.23** When played together, the various horizontally independent voices form a vertical, harmonic structure. Vertical vectors are formed incidentally through planned juxtaposition and interaction of the horizontal vectors of the various voices. The various voices must make sense not only horizontally (melodic development) but also vertically (harmonic development). **SEE 18.24**

Counterpoint Most polyphonic music is written in *counterpoint*—a specific polyphonic technique in which the individual notes and melodic lines are set against each other. It emphasizes an encounter among the various voices, a vectoragainst-vector structure. We use counterpoint to achieve a certain structural tension, a high-energy field. By contrasting the various horizontal vectors of the independent voices in a calculated way, we also create vertical vectors of varying complexity and magnitude.

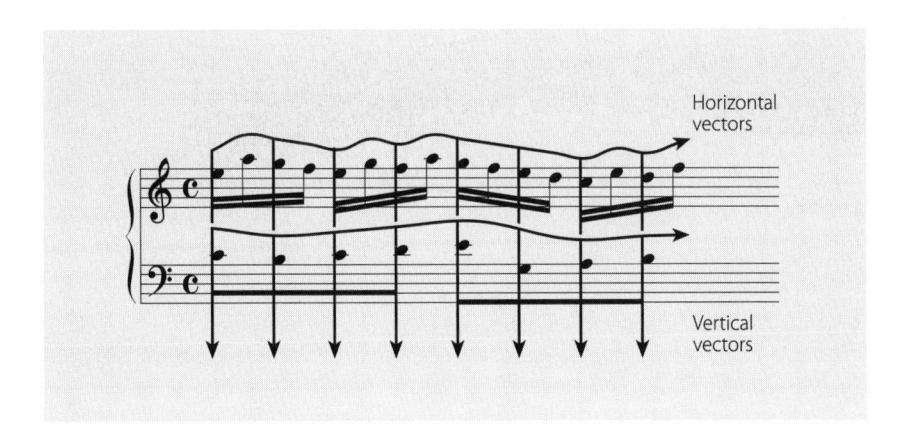

18.24 Horizontal and Vertical Structure

Although in polyphonic music the individual voices are basically independent, they nevertheless connect vertically and form a tight harmonic structure.

Counterpoint means punctum contra punctum, Latin for "point against point." In the first half of the fourteenth century, when the term counterpoint first appeared, punctum (point) was synonymous with nota (note). Punctum contra punctum means, therefore, nota contra notam—note against note. In the terminology of media aesthetics, we can define counterpoint as vector contra vector.

Although counterpoint in music is limited to specific melodic and harmonic juxtapositions, for our purposes we can broaden the concept to include techniques for creating tension that involve other aesthetic elements, such as vectors, timbre, pitch, dynamics, and rhythm. Some of these techniques are quite similar to those employed in the visual aesthetic fields.

Contrapuntal tension is primarily achieved by having the direction of the voices go against each other. In the language of media aesthetics, the voices act as converging and diverging vectors. **SEE 18.25**

You can also contrast the pitch of the various voices. While one voice operates in a relatively high range (treble), the other voice develops in a lower range (bass). **SEE 18.26**

You can achieve a contrast between voices by using timbre. One voice may be played by the violin, the other by the flute. **SEE 18.27**

Contrasting dynamics create various tensions even in a single melody (playing parts of it loud and others soft), but they are especially effective when they occur between voices. For example, part of the upper voice is loud while the lower voice is soft; then the lower voice is played louder than the upper one. This use of contrapuntal dynamics draws attention to different parts (usually the theme) very much as a close-up or even an index vector does. **SEE 18.28**

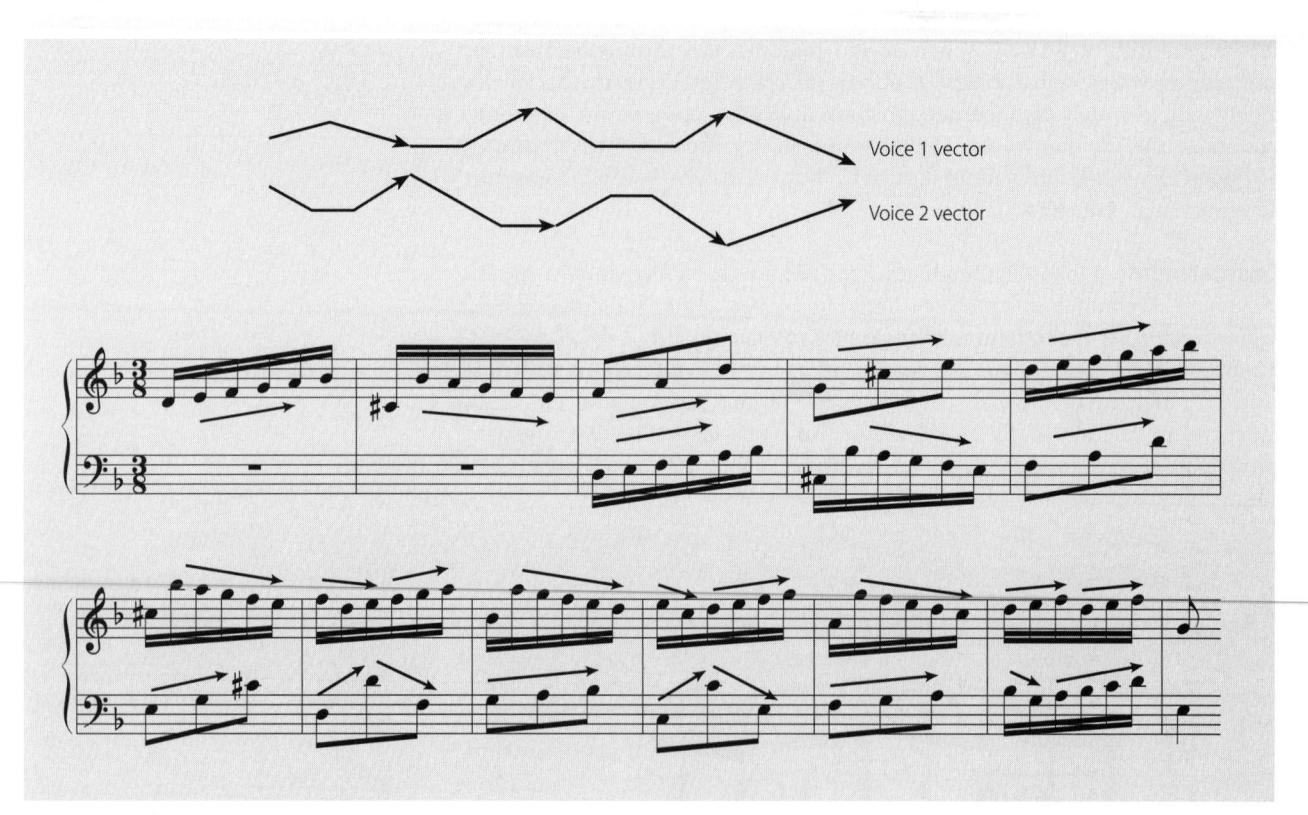

18.25 Tension Through Vector Direction

To achieve the desired contrapuntal tension, we can contrast the direction of the horizontal vectors, such as converging and diverging vectors. While one melody line (voice) is going down, the other one is going up and vice versa. We have, in effect, converging and diverging vectors (and some continuing ones that run parallel to each other). From *Inventio IV* by J. S. Bach, by permission of Edwin F. Kalmus, Publisher of Music.

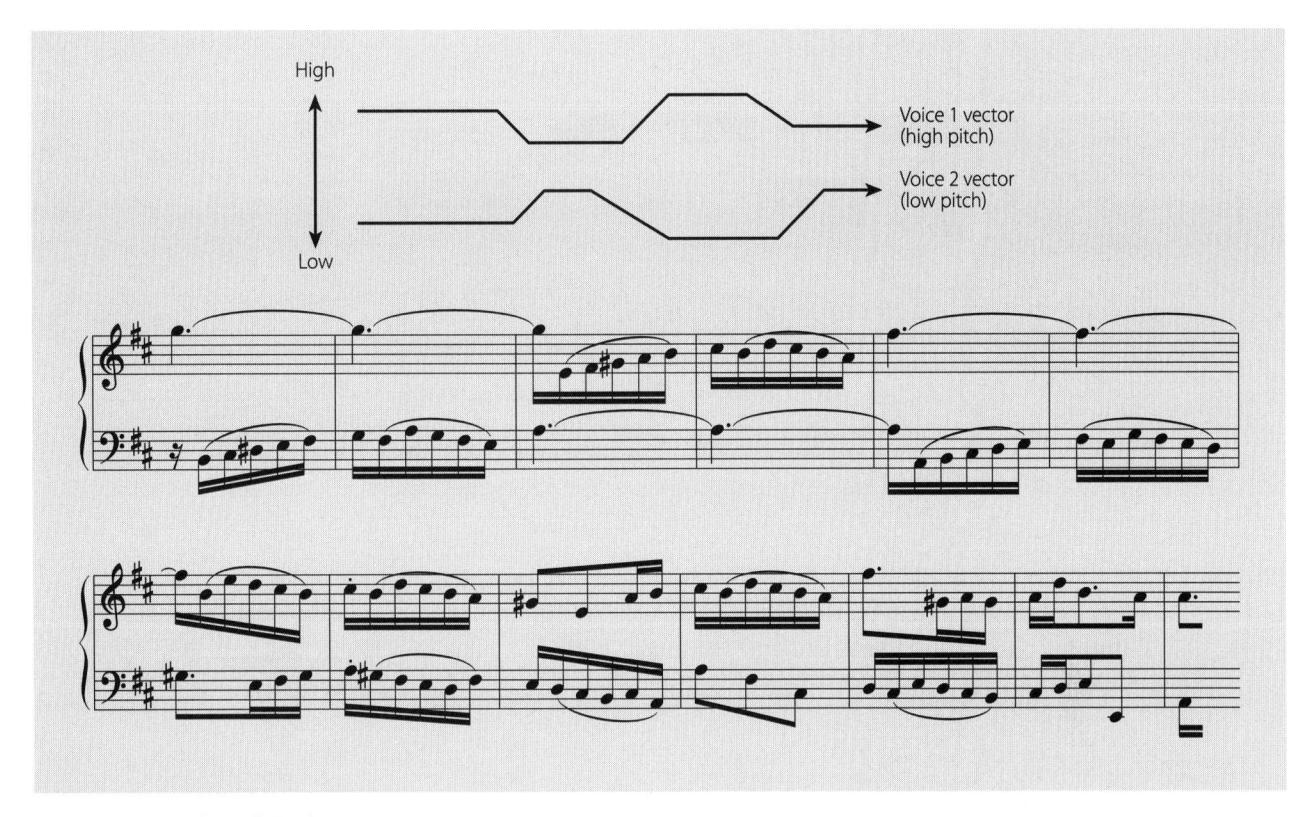

18.26 Tension Through Pitch

We can create contrapuntal tension through a contrast in pitch. In this example, the first voice operates in a relatively high range (treble), while the other voice progresses in a lower range (bass). From *Inventio III* by J. S. Bach, by permission of Edwin F. Kalmus, Publisher of Music.

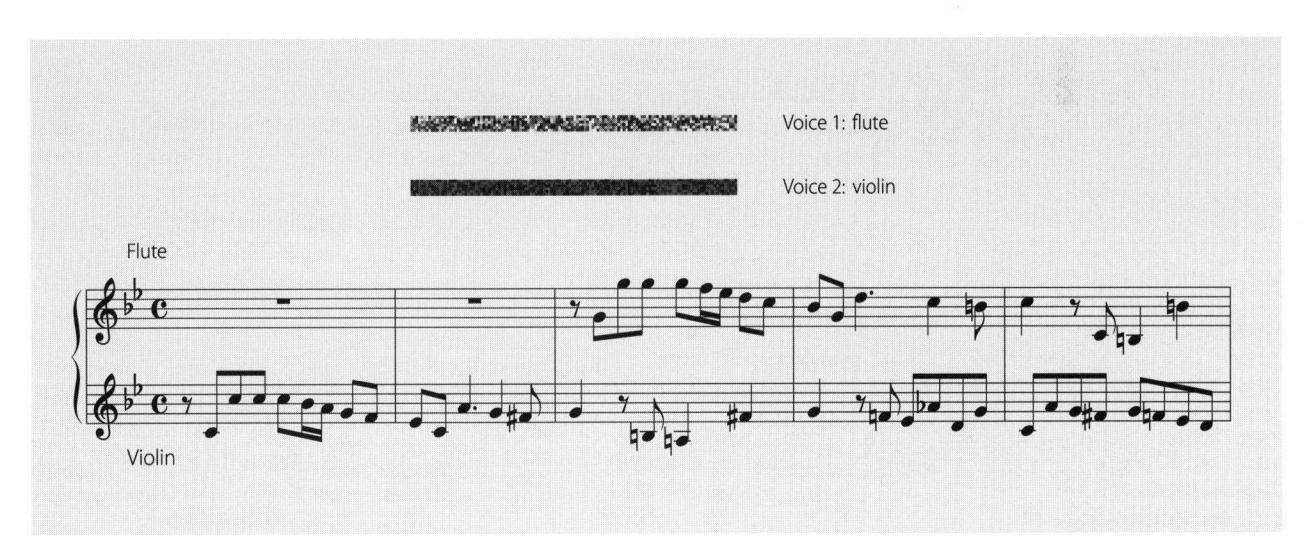

18.27 Tension Through Timbre

We can create contrapuntal tension by giving each voice a distinct timbre. This piece relies primarily on timbre for contrast. One voice is played by the flute, the other by the violin.

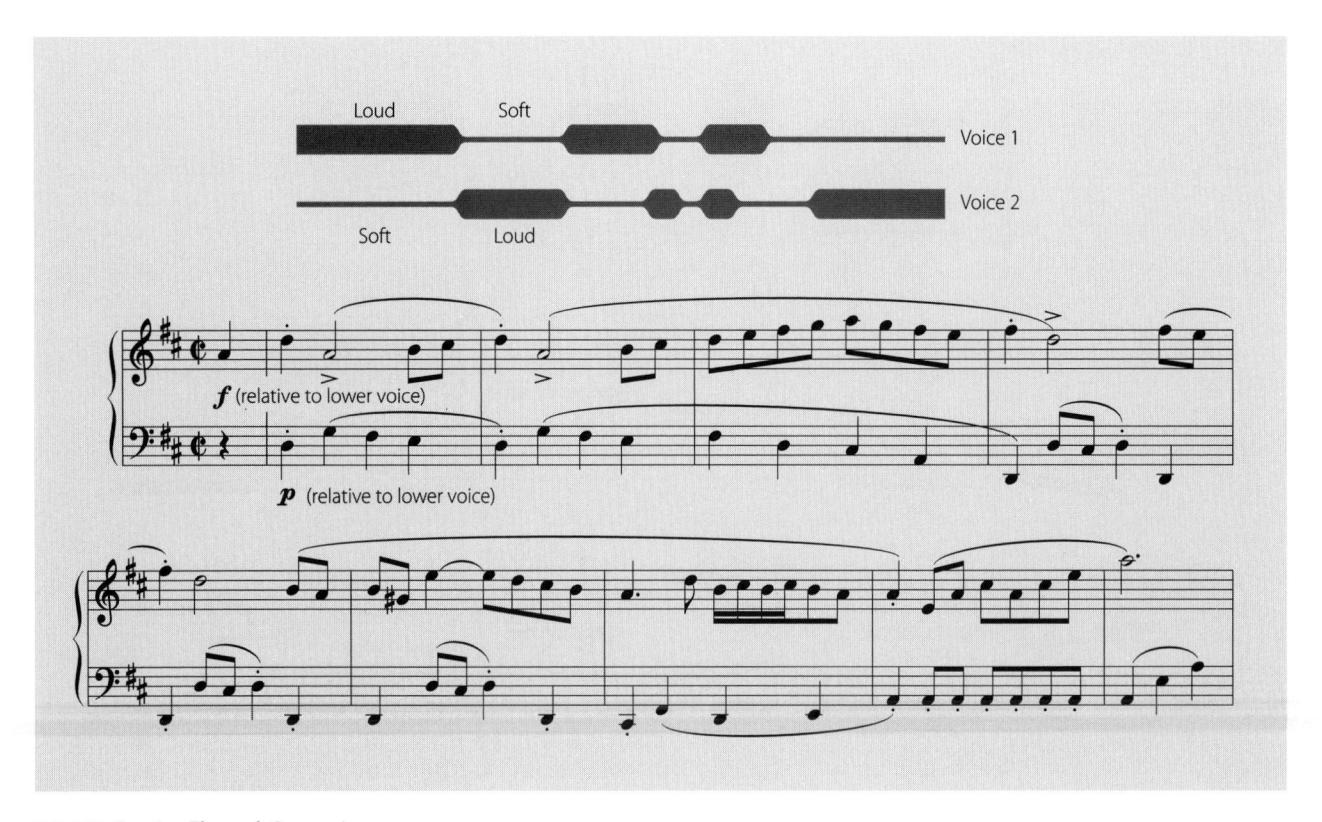

18.28 Tension Through Dynamics

We can create contrapuntal tension by contrasting the dynamics of the various voices. Here dynamics are contrasted. One voice is rather loud (theme); the other (counterpoint) is much softer and less obtrusive. In effect, we have a juxtaposition of sound vectors of varying magnitudes. From *March in D Major* by J. S. Bach.

A rhythmic contrast is similar in effect to a dynamic one. While one voice is progressing quickly, the contrapuntal voice is slow, or the other way around. You can give one voice a sharp staccato beat and set it against another that proceeds in a more continuous, legato, line. **SEE 18.29**

Contrapuntal Structures Widely used contrapuntal structures are imitation, the canon, and the fugue. All of these musical forms use the polyphonic principle in which each voice develops independently of the others, yet plays against the others in highly calculated ways.

Imitation One of the most common elements of contrapuntal structure is *imitation*, wherein a short theme or subject is stated in one voice and then repeated verbatim or in a slightly changed form in the other voice or voices while the first voice continues on its way, providing the counterpoint to the imitated theme. **SEE 18.30** Most contrapuntal structures use some form of imitation.

The canon The canon, or "round," is the purest and most obvious form of imitation. Not only is the theme repeated verbatim by the other voices, but also the entire melody. The harmonic (vertical) structure is created by a phasic shift of the identical melodies; that is, each one starts a little later than the voice immediately above. **SEE 18.31** Familiar canons, such as "Three Blind Mice" and "Row, Row, Row Your Boat," work on the total-imitation principle.

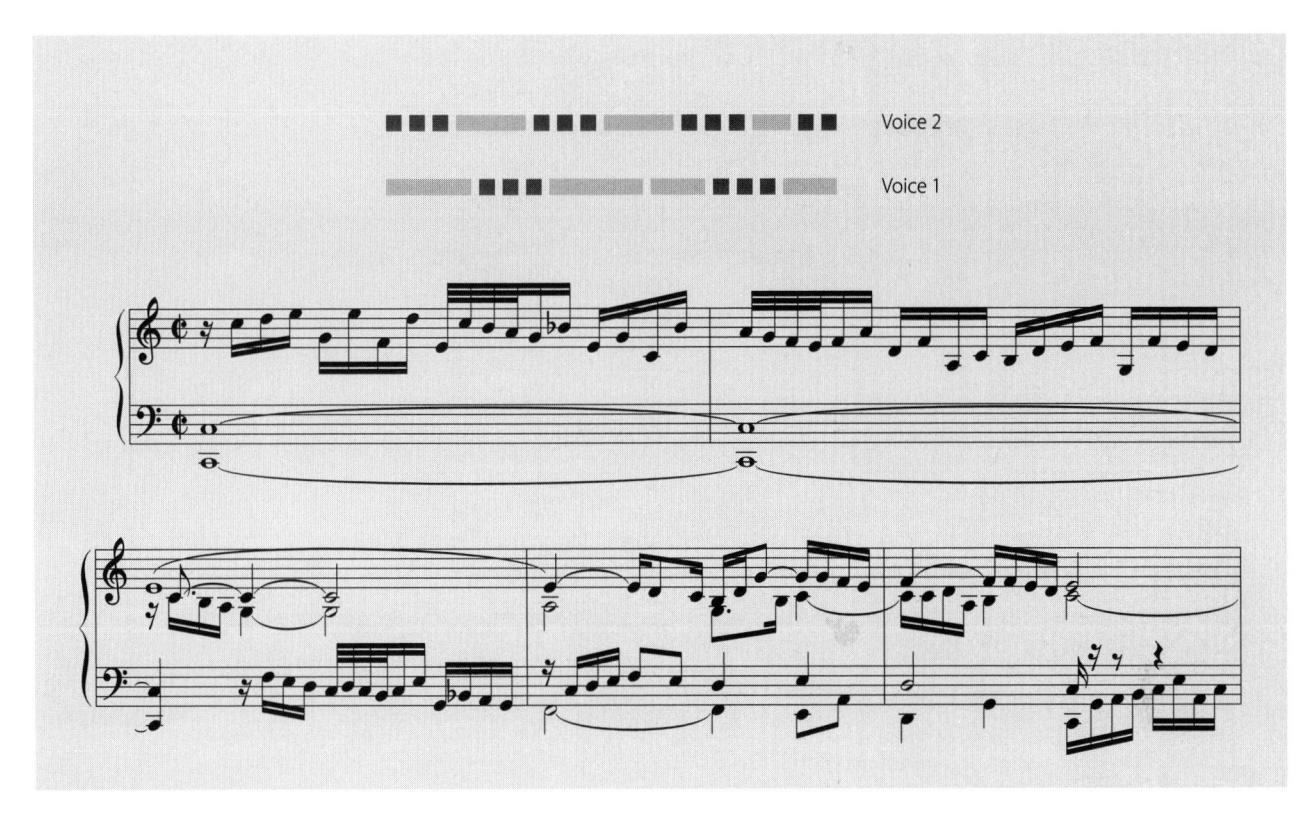

18.29 Tension Through Rhythm

One of the favorite techniques of creating tension in a polyphonic structure is to juxtapose different rhythms among the various voices. While one voice is progressing quickly, the contrapuntal voice is slow; while one has a sharp staccato beat, the other proceeds as a continuous legato line. From *The Well-Tempered Clavier* by J. S. Bach.

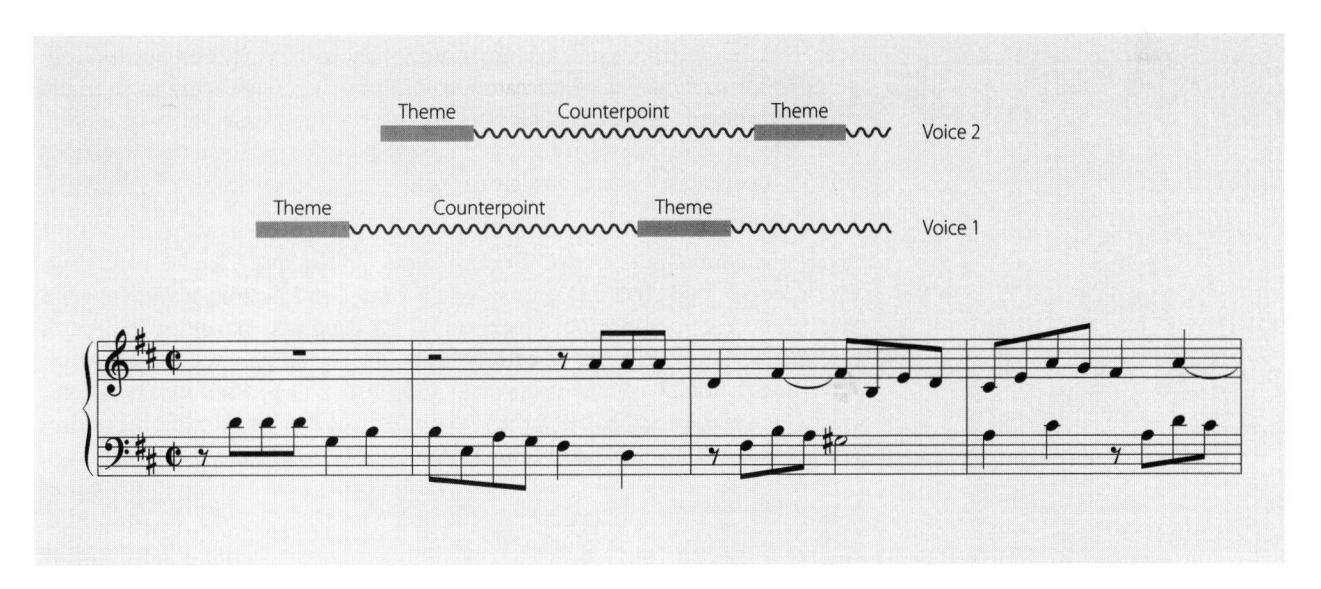

18.30 Imitation

One of the key elements of a polyphonic structure is imitation. A theme or short phrase is repeated verbatim one by one in the other voices. In this example, the theme is stated in voice 2 and then imitated in a different pitch in voice 1. From *The Well-Tempered Clavier* by J. S. Bach.

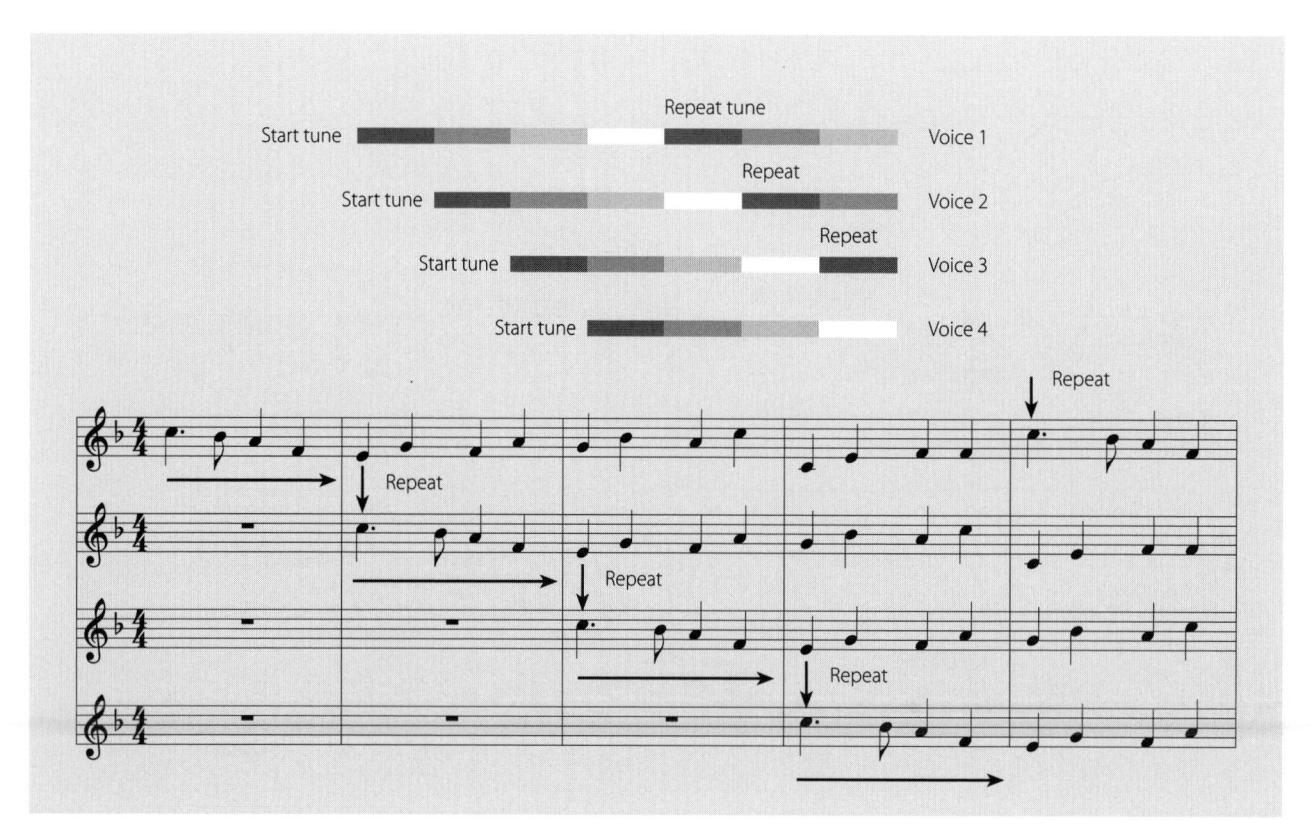

18.31 Canon

In a canon (or round), the complete tune is repeated by phasing. One voice starts the tune, and the others carry the same tune at staggered intervals. Note how the same subject is stated in one voice and then repeated verbatim in the others. The harmonic (vertical) structure is achieved through a phasic shift of the identical melodies.

Simple repetitions of the same subject without varying counterpoints can get quite boring, however, which is why masters of polyphony, such as the German composer Johann Sebastian Bach (1685–1750), vary not only the counterpoint from voice to voice (the horizontal vectors that continue the theme in the various voices) but also occasionally the theme itself.³

The fugue One of the most intricate contrapuntal structures is the fugue. In a fugue (the word comes from the Latin fugere, "to run away, to flee"; and fuga, which means "flight"), a theme or subject is chased and flees from voice to voice throughout the composition. The theme is imitated and expanded in each of the voices, relating vertically at each point to form a complex yet unified whole.

The theme in a fugue is normally introduced all by itself in one specific voice (such as the middle voice), then in another (the top voice), while the middle one proceeds on its own, providing the necessary counterpoint. The theme then finally appears in the third voice (the bottom one), with the other two voices continuing on their ways, providing the necessary counterpoint for each other and for the third voice. **SEE 18.32** When the theme has been introduced once by all the voices, we have the first exposition. The theme is then imitated, varied, and expanded throughout the voices in a rather free-flowing way. This part, where the composer is showing off, is called the episode. When the theme is clearly introduced again, we have another exposition, and when it is imitated again throughout the other voices, another episode. Normally several expositions and episodes occur in a single fugue.

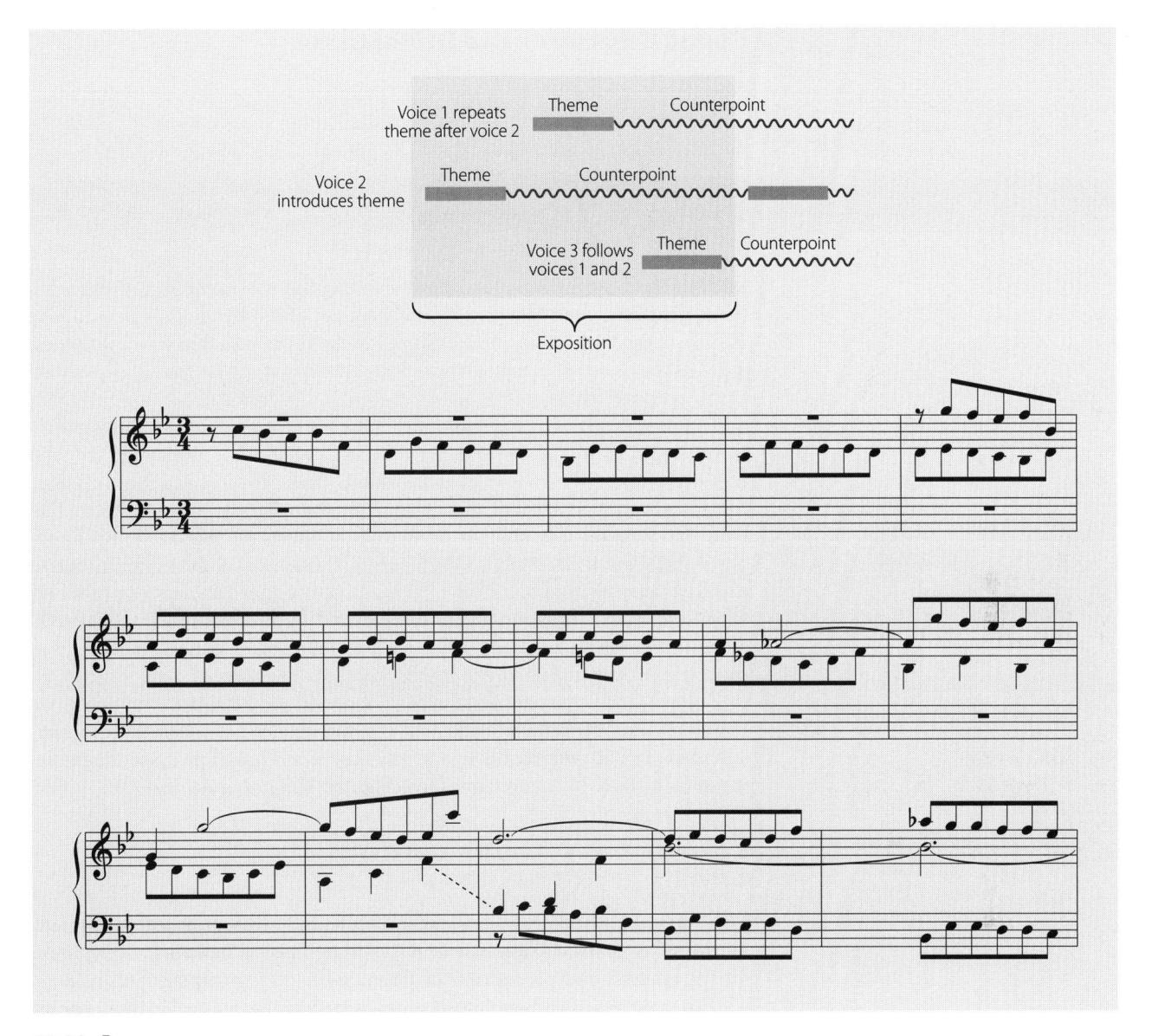

18.32 Fugue

After the theme has been introduced once by all the voices, the exposition is finished. The theme is then imitated, varied, and expanded throughout the voices. This is called an episode. When the theme is clearly introduced again in each voice, we have another exposition. There may be several expositions and episodes in a single fugue. Thus the subject "flees" throughout the composition. In most fugues the theme (subject) is introduced by itself and then repeated in the various voices. In this example, the theme is first introduced in voice 2, then imitated in voice 1, and finally repeated in voice 3. From *The Well-Tempered Clavier* by J. S. Bach.

In the complex fabric of a contrapuntal vector field, the vertical vectors (the harmonic chords as formulated when we read the various independent melodic voices vertically at any given point) act as important structural agents. They hold the horizontal voice lines together and give the seemingly independent voices their necessary structural dependence. Essentially, the vertical vectors represent space/time modulators, explicating the spatial (harmonic) as well as the temporal (melodic) relationships and interdependence of the individual voices. The vertical vectors tell us where the individual voices have been, where they are going, and how they fit together.

Sound Structures and Dramaturgy

Now that you know the basic sound structures, let's compare them to the major dramaturgical elements. In this context, *dramaturgy* means the art of dramatic narrative composition and its representation in film and television plays.

SOUND ELEMENTS AND DRAMATURGICAL PARALLELS

Pitch and timbre contrasts of voice play an important part in choosing the various major characters for a film or television play. For example, you may want to cast the role of the villain with an actor who has a high-pitched, thin (few overtones) voice, or the role of a friendly grandmother with an actor who has a low-pitched, rich (many overtones) voice.

To use various dynamics among the characters of a play is just as important. Some characters are simply "loud" in whatever they say or do, even when they are trying to be as unobtrusive as possible. Others are more quiet and introspective. Assigning such general behavioral dynamics to characters does not mean that the loud character can't be quiet at times and the quiet one lose her temper and occasionally get loud. But a predominant juxtaposition of dynamics sharpens each character without being too obvious. When you read a script or a novel or when you watch a television play or film, try to determine the general behavioral dynamics of each character and see if the writer uses these dynamics in a contrapuntal way, and, if so, how this is achieved.

The "loud" character usually has a more erratic behavioral rhythm than the quiet one. You can see again that the various aesthetic elements interact contextually with one another and that their combination determines the magnitude of the vertical vector of the character (his or her depth).

SOUND STRUCTURES AND DRAMATURGICAL PARALLELS

Much like the sound elements, the major sound structures also have their dramaturgical parallels. You may find that using musical structures as the basis for the analysis and production of films and television dramas will help in analyzing scripts, in casting, in designing preproduction strategies, and even in visualizing key shots and scenes.

Melody and plot Plot is very much like the melodic structure. They both form horizontal vectors. One thing happens after another and especially leads to the other in some kind of logic. The magnitude of both plot and melodic vectors depends on how much tension there is in the progression of the individual elements (action or notes). Despite the surprises in the expected progression, which builds tension, the development of successful plot as well as melody must inevitably lead to closure—to a complete story or tune.

Melody and sequential analytical montage The sequential analytical montage is built upon a melodic structure. As explained in chapter 16, the sequential montage moves horizontally and logically in a cause-effect fashion from one event segment to the next and to the next and so forth until all elements lead up to the final gestalt—the montage.

Harmonic structure and character Harmonic structure applies to character. You can compare the vertical (harmonic) vectors of a chord to the depth and "texture" of a character in a play. A shallow, stereotyped character who thinks, feels, and acts in a predictable way has a low vertical vector magnitude. Like a more complex chord, a more complex character has more elements (intellectual and emotional) that interact simultaneously at any given moment.

Chords and sectional analytical montage Because the sectional montage does not progress in time, but explores a single moment from various points of view, the *sectional analytical montage* has a vertical rather than a horizontal vector structure. The different event aspects shown within a single moment are more like a chord in which several notes are played simultaneously.

Good writing and its visualization in television and film have usually both—a strong melodic structure (story and plot development) and an equally strong harmonic one (complex characters and layers of deeper meaning).

Homophonic structure and character You can detect such homophonic structures not just in music but also in many television plays and films where a single strong character dominates the play or show series, with all the other actors merely providing support. Such plays or program series are usually named after the main character, such as "The Ron Compesi Show," just in case you failed to notice who stars in the show.

Polyphonic structure and plot Again, to use an analogy, you may have noticed that the more-complex television programs and films employ a polyphonic structure in order to advance several plots simultaneously. The daytime serials have at least three "voices" (plots) running parallel. The plots (horizontal vectors) are seemingly independent of each other, yet they relate vertically through the interacting characters and, often, through some common environment in which all inevitably meet from time to time (the ranch house, the estate, the police station, the hospital, or even the jail).

When translating the musical structure of the fugue into a dramaturgical one, you will again find parallels. For example, you could establish a particular theme by having a suspicious-looking man repeat the same thing (such as making a particular phone call) in different locations (voices). Each time, the contextual environment will give the same phone call different meanings (counterpoint). Or you could have different people witness the same event from different points of view and then report these different viewpoints.

Picture/Sound Combinations

Even if you are successful in structuring the picture field and the sound field independently, you cannot expect to arrive at a meaningful audiovisual structure simply by adding the two together. Rather, you must learn to combine the video and audio vector fields so that they form a synergistic structure. Such an audio/video combination requires you to hear the screen event while visualizing and sequencing it and to see it while working with the sound. You should try to conceive and develop the video and audio vector fields together as much as possible.

But exactly how should you combine the pictures and sound so that they form such a synergistic unit, a maximally effective picture/sound gestalt? No easy

recipe exists. Each case has its own specific requirements. However, the following structural principles can act as general guidelines: (1) homophonic structures, (2) polyphonic structures, and (3) montage.

HOMOPHONIC STRUCTURES

Much like the homophonic structure in music, where a single dominant melody is supported and undergirded by accompanying chords, you can support the video portion step-by-step with appropriate sound, or the audio track with appropriate pictures. Take as an example the scene in which a car had lost its brakes and is careening down a steep mountain road. The accompanying audio track consists of such literal sounds as squealing tires and nonliteral nervous music. This picture/sound combination represents a typical homophonic structure. The visuals (car without brakes) dominate the scene and tell the principal story. Literal and nonliteral sounds are precisely in step with the visual event, properly intensifying it from moment to moment. **SEE 18.33**

18.33 Homophonic Video/Audio Structure

In a homophonic structure, the audio track (consisting of literal and nonliteral sounds) is in step with the visual event. Each audio event runs parallel to its corresponding video event.

Many music videos illustrate their sound tracks with accompanying pictures in a homophonic fashion. The lyrics of the song, or at least its major literal themes, are supported at each step by pictures with similar meanings.

POLYPHONIC STRUCTURES

In a polyphonic picture/sound structure, pictures and sound seem to develop independently as "melodic" lines, yet combine vertically into an intensified audiovisual experience. For example, some music videos show pictures that do not in any way parallel the lyrics of the song. The pictures seem to tell their own story (often of the principal singer's psychological frustrations) and are relatively independent of the meaning of the lyrics. While the song proclaims tender love, the pictures may show surprisingly violent scenes. The vertical structure is achieved through strong parallel rhythms of the pictures (tertiary motion rhythm) and sound.

Three of the more notable polyphonic audiovisual techniques are (1) phasing, (2) multiple texts, and (3) multiple screens.

18.34 Phasing

In phasing, the audio track of one scene (as scene 1 for example) extends into the next scene (scene 2) or changes to the next scene (scene 2) while the video portion still shows the previous scene (scene 1).

Phasing In phasing, the video and audio portions are not tightly synchronized—they are somewhat out of phase. Either the picture precedes the sound event or vice versa, or picture and sound are thematically out of phase, at least for a while. In phasing, the sound is asynchronous to the picture. **SEE 18.34**

Flashbacks are a good vehicle for this phasing technique. Imagine, for example, a mountain climber surprised by a snowstorm on an especially difficult part of the climb. We see him trying to reach a ledge where he can find temporary shelter. We hear the howling storm, the sounds of his crampons, his heavy breathing (homophonic literal sound). Suddenly, these natural sounds switch to a conversation the mountain climber had with his friend before embarking on this difficult climb. The friend warns about the fickle weather and the dangers of avalanches. Then the sounds switch just as suddenly to the laughter of the climber's children. Finally, we switch back to the literal sounds of the climb.

While the video tells the story progressively (the climber's efforts to stay alive), the audio is out of phase. It shifts occasionally to the past (friend's warning and children's laughter).

Phasing lends itself especially well to various space/time transitions. Here is an example:

Video	Audio
Tight 2-shot: Larry and	Larry
Barbara in front of the library.	Don't you want to go to a movie tonight? You can't study all the time.
ECU of Barbara.	Barbara
	Perhaps.
Zoom back to reveal entrance to the movie theater. Larry hands her the ticket.	

Now the video has jumped ahead of the audio to the "effect" phase, while the accompanying sound (Barbara's reply) still lingers in the "cause" phase. If you now switch the phasing and have the audio progress to the effect phase with the video still lingering in the cause phase, you deal with *predictive sound* (see chapter 17).

Multiple texts Multiple texts are two or more dialogue tracks that run simultaneously or in a phasing mode. You can use multiple texts for single-screen presentations or, more common, for multiscreen productions. The following is an example of multiple texts playing simultaneously with a single-screen scene.

Video	Audio
2-shot of couple.	Track 1 (main text)
	She: How did it go today?
	Track 2 (slightly delayed subtext)
	She: I don't really care.
CU of man.	Track 1
	He: Oh, pretty well!
	Track 2 (slightly delayed)
	He: What do you care, anyway?
	Track 3 (simultaneous with 2)
	She: Liar!

As you can see from the multiple dialogue, the two people do not quite feel as civilized toward each other as they pretend in the main dialogue track (track 1). Such a multiple-text technique is a rather obvious communication device and needs to be treated with some discretion and deftness. Depending on how much of the event complexity you want to communicate, you can emphasize either track one, two, or three, or you can play them all together at equal volume. If you play all tracks at the same time and the same loudness, the audience will no longer be able to follow exactly what is being said. Instead of communicating specific information, you will be providing the audience with a fabric of speech sounds that may reflect the complexity of the moment better than any single track could.

You can also emphasize a specific track by running its volume relatively high while keeping the other tracks at a much lower volume. In effect, you are applying the figure-ground principle. By emphasizing track 1, you communicate primarily the "outer" event—a woman asking a man how the day went for him. But if you now emphasize track 2 or 3, you shift from an outer-event orientation (plot) to an inner one (feeling). You add to the horizontal vector (event progression) a vertical one (event complexity). The advantage of such multiple texts is that you can provide the event complexity through sound while keeping the visual event relatively simple and straightforward.

Multiple screens You can achieve a truly polyphonic structure by using multiscreen presentation techniques. Each screen can pursue a different story (voice) that relates to the others thematically or through the interaction of characters. Each screen may have its own sound track, or you can use an identical sound track for all three (or however many screens you have). Sometimes the various sound tracks get muddled into a dialogue fabric, but they allow the audience to associate with one or another phrase, sentence, or uttering.

If you construct the dialogue tracks of the various screens so that they are sequential rather than simultaneous, the audience will be better able to follow the meaning of each voice. For example, if you have a three-screen setup, the person on the left screen may ask, "How do you feel?" and the person on the right screen may answer "Fine," while the person in the middle screen may simply listen. Thus, you can establish a relationship among the three screen events even if the scenes are not connected as to event location and event time.

Because the dialogue in the various screens is narratively connected, we tend to connect the visual events on the separate screens, however different they may be. You probably noticed that the dialogue that stretched over the three screens was presented in a phasing mode.

As with the single-screen presentation technique, there is a limit to how many dialogue tracks we can discriminate among, even in multiscreen presentations. When played simultaneously, the tracks might lose their informational function and yet blend into a sound configuration that serves as a powerful emotional intensification device. You may want to experiment with arranging the video and audio tracks of multiscreen presentations in a fuguelike way in which you have a particular theme "fleeing" from screen to screen, with the other screens and especially the other audio tracks providing varying contrapuntal contexts. **SEE 18.35**

MONTAGE

Although the *montage* was originally developed as a sophisticated pictorial statement, the audiovisual montage is no less powerful. Let's take a quick look at the four principal montages—sequential, sectional, comparison, and collision—and list some of the possibilities of picture/sound montage combinations.

Sequential analytical montage The sound portion of a visual *sequential analytical montage* normally consists of literal sounds and/or music that follows the visual sequences. For example, if your sequential montage depicts somebody rushing to the airport, you simply accompany each shot with its appropriate sound track: traffic, car horns, running and breathing sounds, crowd sounds in the airport terminal, beeps at baggage security, the starting up of the jet engines. You simply "cut" from one environmental sound detail to the next. By adding a rhythmically

Left screen (present time)

Audio

Sound: Telephone.

He: "Hello. Great... no this is fine.

Yes, I agree... Very happy."

She: "Who is it, honey?

Let me hear it.
This is so much fun...

Oh, please..."

Center screen (two years later)

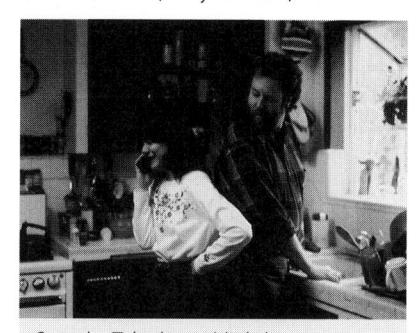

Sound: Telephone (slightly later than left screen).

She: "Hello.Yes.Why?

No.OK...OK...Why not? OK... What?"

He (interrupting):

"Can't you ever ignore that damned phone? Get off the line and give me a hand with these dishes."

Right screen (five years later)

Sound: Telephone (slightly later than center screen).

Boy: "Dad, the phone is ringing."

He: "Let it ring."

She is no longer present.

All three sound tracks are phased to overlap to some extent.

18.35 Multiscreen Sound Tracks

In this example of polyphonic dialogue, the three screens display a time shift. The left screen represents the present, the center screen two years later, the right screen five years later.⁴

precise music track, you will not only facilitate the visual continuity of the montage but also intensify its rhythmic structure.

Sectional analytical montage If the sectional analytical montage explores different environments, you can simply cut with the visuals from one sound environment to the next. For example, if you show a quick sectional montage of a young woman exploring various downtown shopping areas, you once again accompany each shot with the sound characteristic of the location depicted. As in the sequential montage, you can "cut" from one sound environment to the next, such as sounds of a department store; the quiet yet intense sales pitch of a jeweler; the noisy coffeeshop environment. This time the sound is not supporting the progression of the event but rather the mosaiclike environment. The sound portions contribute to the vertical, rather than horizontal, vector. But you could also choose to run a continuous sound track of a single event, such as the sounds of the department store, throughout the montage. Although basically a contrapuntal treatment (an uninterrupted sequence of literal sounds versus quick discontinuous visual cuts), such an audio/video juxtaposition can provide much needed montage continuity. Rhythmically precise music can fulfill the same structural function.

Idea-associative comparison montage In the *comparison montage*, you choose sounds that are congruent to the event. If the event is romantic, you choose romantic music. Violent visuals are intensified by violent sounds. In a comparison montage, the literal and nonliteral sounds are similar in meaning and feeling to what you see on the screen.

Video	Audio
CU of politician, whose	Actual speech. Crossfade to
speech becomes more and more emotional.	schoolchildren reciting a patriotic poem in chorus.

The *tertium quid*—the main idea—of the montage is that the politician is spouting shallow slogans no better than the thoughtless babble of children. Here is another example of a comparison montage:

Video	Audio
MS of shooting gallery in an amusement park.	Natural, literal sounds.
CU of boy taking aim.	Seque into actual war sounds.

Idea-associative collision montage In a *collision montage*, the accompanying sound track is contradictory in meaning and feeling to what you see on the screen. When perceived together, however, they intensify the visual scene or produce a *tertium quid*, a third major idea, that grows out of the audio/video contradiction.

For example, in order to intensify an especially violent scene, you may counter the visuals with soft, romantic music as counterpoint. Or by accompanying an especially tender love scene with violent sounds, you may hint at the underlying menace of the relationship.

Some audio/video collision montages might look like this:

Example 1:

Video	Audio
CU of slum areas.	Narrator describing the wealth and historical significance of the city.

Example 2:

Video Audio

Attack helicopter with rockets blazing.

Soft, romantic music.

Example 3:

Video Audio

Couple drinking coffee in sidewalk café.

Romantic music changing into dissonant chords mixed with synthesized high-pitched hisses.

In the slum montage, the narration will certainly intensify the terrible conditions of the slums. The overriding message is the blindness of the city council, whose members still don't seem to realize that their city is in deep trouble. In the helicopter montage, the soft, romantic music sharpens the cruelty of war. And in the coffee-drinking scene, trouble is brewing.

The audiovisual collision montage is no less obvious than the visual collision montage. You need to be extremely cautious about how and when to use it. If, for example, you have a scene in which a veteran is sitting in front of a cozy fire, recalling some of his war experiences, you may achieve a startling collision montage by subtly changing the peaceful crackling of the fire into the menacing sounds of machine guns.⁵ But to accompany pictures of starving people with rowdy drinking songs does not intensify the scene; it merely reflects the writer's or director's bad taste.

The audio/video collision montage can produce comic effects with relatively little effort. All you need to do is use literal sounds that go against our expectations. The sleek racecar that sounds like an old truck, the glamorous soprano who sings her aria in a deep bass voice, or the lion that meows like a kitten are well-known collision montage clichés.

Picture/Sound Matching Criteria

As pointed out earlier, ideally you should conceive pictures and sound together as a unit, trying to see and hear the screen event simultaneously as an aesthetic whole. In practice, however, such a complete preconception of the whole event is rarely possible. Even if the sound portion of your show consists mainly of literal, source-connected sounds, you will most likely need additional sounds to intensify the total screen event.

You will probably find that you think in pictures first and then try to locate the appropriate supporting sounds, such as background music. Or you may find yourself with a piece of music, such as a popular new song, for which you need to find appropriate visuals. But what specific types of music should you use? What if your "unfailing" instinct fails you just when you need it most? What you obviously need are more-reliable criteria for selecting the appropriate music for the more-common video events. There are four basic picture/sound matching criteria: (1) historical-geographical, (2) thematic, (3) tonal, and (4) structural.

HISTORICAL-GEOGRAPHICAL

Historical matching means that you match pictures with music that was created in approximately the same historical period. For example, you would match the picture of a Baroque church with the music of Johann Sebastian Bach; an eighteenth-century scene in Salzburg, Austria, with music by Mozart; a scene from the 1960s with music by the Beatles; or the brand-new hotel with music by a contemporary composer.

Geographical matching means that you select music that is typical of the geographical area depicted in the scene. You could, for example, match a scene that plays in Vienna with a waltz, a scene in Japan with traditional koto music, or one in the American south with New Orleans jazz.

Once again, a word of warning: Matching the sights and sounds of historical periods does not automatically make for effective and smooth picture/sound combinations. For example, the precise, carefully structured music of Bach does not necessarily fit the light, flamboyant Baroque architecture. Also, geographical matching is such an obvious aesthetic device that it might annoy or even insult the sensitive viewer. For example, to introduce an interview show featuring a famous scholar from China with what we consider to be typical Chinese music, or the ambassador from Austria with a waltz, would certainly offend the guests and annoy the viewers. On the other hand, if you do a documentary on Tibet, you might as well have Tibetan music under the opening scenes and titles.

THEMATIC

When using *thematic matching* for video and audio, you select sounds that we are accustomed to hearing at specific events or locales. For example, when we see the interior of a church, we probably expect organ music. Or when you show a football stadium full of people, marching-band music is the thematically correct choice.

TONAL

Tonal matching requires sounds that fit the general tone, that is, the mood and feeling of the event. If you show a sad scene, the music should be sad, too. Similarly, you can match a happy scene with happy sounds. Romantic music that engulfs the lovers embracing tenderly in the moonlight is another familiar example of tonal audio/video matching. The difference between thematic and tonal matching is that in thematic matching you choose music that you normally associate with the event; in tonal matching, the music is selected according to how the event feels.

STRUCTURAL

When using *structural matching*, you parallel pictures and sound according to their internal structure. For example, take a look at the following figures and see whether you can "hear" them. **SEE 18.36–18.38** How did you do with "listening" to these pictures? Could you assign each picture a specific type of music? Did they sound different from one another?

Now go back and try to identify some of the specific pictorial characteristics that prompted you to select a certain type of music. Was it the direction and arrangement of dominant lines within the pictures? Their relative harshness or softness? The graphic weight, degrees of balance, the relative shadow falloff? You probably went more by how the pictures felt to you, and whether they were round, soft, hard, brassy, simple, or complex, than by a careful vector analysis. Most likely, that was all you needed to match accurately the video and sound structures. Nevertheless, even with your intuitive approach, you applied—however quickly and subconsciously—a series of vector analyses and comparisons. What you were actually doing was analyzing the visual vector fields and constructing aural vector fields of similar characteristics.

But when your aesthetic instincts fail you, or if the matching task becomes a little too complex for quick guessing, you need to apply specific criteria to analyze the video or audio vector fields for possible compatibility. To isolate the dominant structural element within a picture or picture sequence and grasp the overall structural tendency (simple, complex, directional, confused) is not always an easy

18.36 Structural Matching 1 How does this picture sound? Loud or soft? Fast or slow? Does it have a simple or a syncopated beat?

18.37 Structural Matching 2
Compare the sound of this picture to that of figure 18.36. Do you "hear" a difference? Try to verbalize this difference. What audio characteristics can you isolate that are unique to this picture?

18.38 Structural Matching 3 What specific sound characteristics does this picture have? Does it sound different from figures 18.36 and 18.37? What specific sound vector field would you have to create to match the visual vector field of this illustration?

task. Sometimes a picture or picture sequence just does not seem to "sound" right, or it seems so indistinct that any number of musical structures could fit it equally well or badly. In such a situation, you must muster the patience to analyze the picture sequence step-by-step according to the major aesthetic criteria developed throughout this book: light, color, space, time, and motion. You should then be able to establish primary connections between the major visual vector fields or dominant aesthetic elements and similar aural ones.

Exactly how does such a structural analysis work? And how can you translate pictorial characteristics into music? There is no single or simple answer. Structural matching, as with any other type of matching criteria, depends on many contextual variables, such as the desired overall effect, what immediately preceded the picture sequence and what follows it, or whether or not you intend to create montage effects.

The following table shows how you might approach a structural analysis of the video and its translation into musical terminology for audio matching. In fact, this table is an apt summary of the major elements of the five aesthetic fields and how they might relate to one another. **SEE 18.39**

18.39 Video/Audio Structural Analysis

Aesthetic Element	Video		Audio	
		Directional		Staccato
	Type	Nondirectional	Rhythm	Legato
	MORNES KIMMOR	High-key		Major
Light	Mode	Low-key	Key	Minor
	all published by the second	Fast		High-contrast (loud-soft)
	Falloff	Slow	Dynamics	Low-contrast (even)
	Energy	High	Dynamics	Loud
	Energy	Low	Dyriamics	Soft
	Hue	Warm	Pitch	High
Calan	nue	Cool	Pitch	Low
Color	Catalination	High	Timbre	Brass, strings
	Saturation	Low	Timbre	Flutes, reeds
	Delaharan	High	Dominion	Loud
	Brightness	Low	Dynamics	Soft
	Screen size	Large	Dynamics	Loud (high energy)
		Small		Soft (low-energy)
	Graphic weight	Heavy (close-ups)	Chords and beat	Complex (accented)
	Graphile Height	Light (long shots)	Chords and beat	Simple (unaccented)
	General shape	Regular	Sound shape	Consonant
	General shape	Irregular	(timbre, chords)	Dissonant
	Placement of objects	Labile (high tension)	Chord tension	High (dissonant)
	within frame	Stabile (low tension)	Chora terision	Low (consonant)
	Texture	Heavy	Chords	Complex
	lexture	Light		Simple
	Field density (number of	High	Harmonic density	High
Space	elements in single frame)	Low	Transforme desistey	Low
	Field density (number of successive elements within given period	High	Melodic density	High
		Low		Low
	Field complexity in single frame or shot Field complexity in successive frames or shots	High	Melodic or contrapuntal density	High
		Low		Low
		High		High
		Low		Low Definite
	Graphic vectors	High magnitude	Melodic line	
		Low magnitude		Vague
	Index vectors	High magnitude	Melodic progression	Definite
		Low magnitude		Vague

18.39 Video/Audio Structural Analysis (continued)

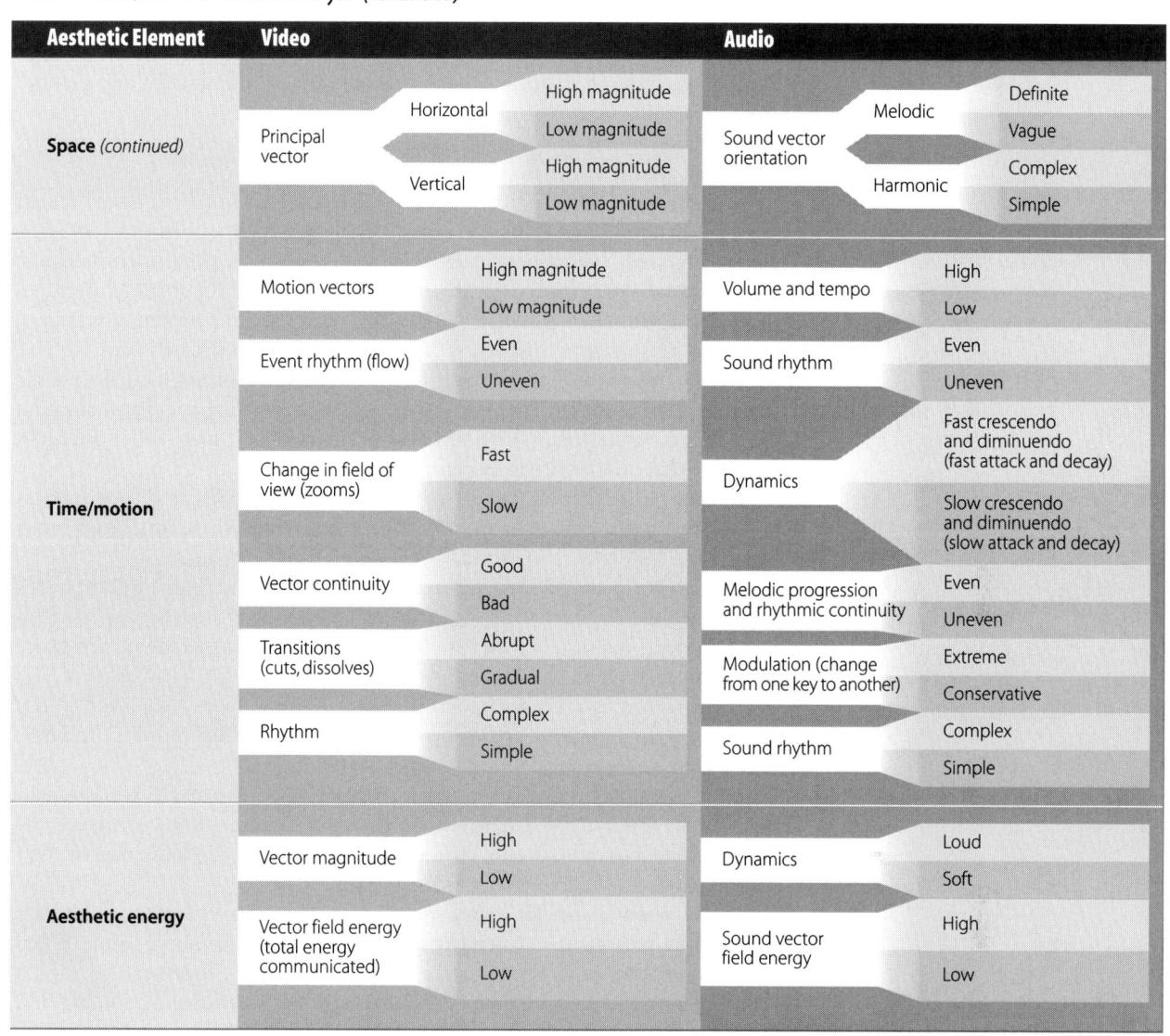

To witness the structural power of music, take any video sequence you have at hand and run some arbitrarily selected music with it. You will be amazed at how frequently the video and audio seem to match structurally. You simply expect the visual and aural beats to coincide. If they do not, you apply psychological closure and make them fit. Only if the video and audio beats are, or drift, too far apart do we concede to a structural mismatch—but then only temporarily.

Also, when watching a television show or a film without sound, you will become surprisingly aware of the visual structure, especially of tertiary motion. Tertiary motion shows up with undue prominence without the benefit of the accompanying sound track. When watching the same sequence with sound, however, it appears much smoother. Assuming that the sequence is edited properly, you may not even be conscious of the tertiary motion employed. Again, the organic structural power of music greatly facilitates the pictorial vector flow.

Summary

In structuring the five-dimensional field, we concern ourselves with elements of sound, basic sound structures, sound structures and dramaturgy, and picture/sound combinations.

The elements of sound, or basic sound attributes, include pitch, timbre, duration, loudness (dynamics), and attack/decay.

Pitch refers to the relative highness and lowness of a sound measured against an agreed-upon scale. The pitch of a tone is perceived and measured by its frequency. Timbre describes the tone quality or tone color, whether a certain note is played by the violin or the clarinet. Timbre depends on the amount of overtones that vibrate with the fundamental tone. Duration refers to how long a sound can be heard. The loudness (dynamics) of a tone is its apparent strength as we perceive it. You can play a tone either loudly or softly. The variations of loudness are the dynamics of the sound. The attack/decay is a part of the dynamics and duration of a sound. Attack means how fast a sound reaches a certain level of loudness. Decay means how fast a sound becomes inaudible.

The period during which a tone remains at its maximum loudness is called the sustain level. A sound envelope includes the whole tone from initial attack to final decay.

The basic sound structures include melody, harmony, homophony, and polyphony.

Melody is a series of musical tones arranged in a consequent succession. A melody forms a horizontal vector.

Harmony is a vertical combination of simultaneously played notes. Harmonic combinations of three or more tones are called chords. Harmonic structure forms a vertical vector.

Homophony refers to a musical structure in which a single, predominant melody is supported by corresponding chords. In a homophonic structure, the melodic line (horizontal vector) can stand alone, but the chords (vertical vectors) make sense only in the presence of the melody.

Polyphony stands for "many voices" and refers to two or more melodic lines (horizontal vectors) that, when played together, form a harmonic whole. When played separately, each voice forms a self-sufficient entity. Together, they form a vertical harmonic structure. Most polyphonic music is written in counterpoint, which means that the elements of various voices (vector direction, pitch, timbre, dynamics, rhythm) are countering each other so as to produce structural tension. Imitation, a commonly used structural element in polyphony, means that a short theme of one voice is repeated in the other voice or voices. The canon (round) is a direct imitation. The fugue introduces a theme that appears in different voices.

The sound structures are closely related to dramaturgical structures. Melody is closely related to plot through consequent progression. Harmonic chords are similar to complex characters and sectional montage. Homophonic structure features a dominant character. Polyphonic structure features multiple plots or points of view and is a structural model for multiscreen presentations.

The picture/sound combinations should form a synergistic structure in which picture and sound reinforce each other. In homophonic combinations, the picture dominates and is supported by sound or vice versa. In polyphonic combinations, picture and sound seem to develop independently as melodic lines, yet they combine vertically into an intensified audiovisual experience. Multiple texts refer to several sound tracks that are run simultaneously or in a phasing mode.

Pictures and sound can be combined according to the montage principle. In the sequential analytical montage, the sound simply accompanies the video of

the montage elements. In the sectional analytical montage, the sound either follows the picture elements or creates a general sound environment characteristic of the montage scene. In the idea-associative comparison montage, the literal and nonliteral sounds are similar in meaning and feeling to the visual event. In the collision montage, the accompanying sound track is contradictory in meaning and feeling to the visual event.

There are four basic picture/sound matching criteria: historical-geographical, thematic, tonal, and structural. In historical matching you select music that was played in the historical period of the visual event. Geographical matching means that the music chosen has its origin in the geographical area depicted. In thematic matching you select sounds that you expect to hear at a particular event or locale. When using tonal matching, you choose sounds that fit the general tone—or the mood and feeling—of the pictorial event.

Structural matching means that we parallel pictures and sound according to the internal structure, that is, their specific vector fields.

NOTES

- 1. The background music you often hear in elevators, doctor's waiting rooms, and supermarkets has a drastically limited range of dynamics. The music sounds equally soft throughout and, therefore, is highly unobtrusive. All other elements (melody, timber, harmony, rhythm) are kept intact.
- Stanley R. Alten, Audio in Media, 4th ed. (Belmont, Calif.: Wadsworth Publishing Co., 1994), p. 30.
- 3. Listen to a relatively simple polyphonic composition (such as J. S. Bach's *Two-Part Inventions*) and follow the theme throughout the piece. Note the counterpoint that works opposite the theme or the slight variations of the theme itself when it is reintroduced in each of the two voices. If you are a skilled listener, follow the themes in Bach's *The Well-Tempered Clavier* and in his fugues.
- 4. The basic idea for the telephone conversation was developed by students in my seminar in experimental production.
- 5. This sound effect was used in Francis Ford Coppola's Apocalypse Now (1979).

Epilogue

ow that you have studied the five aesthetic fields, take some time to reflect on some of the major points in each field. Think especially of how these points, and the whole fields, interrelate contextually. Note that every one of the various theories of the five contextual fields can be applied to actual production problems or the analysis of television shows and films. *Sight Sound Motion* provides you with the tools to predict, to a certain extent, how the various aesthetic elements operate in a variety of contexts and what effect they have on the viewer. The knowledge of applied media aesthetics is, therefore, an indispensable prerequisite for effective and efficient preproduction, production, and postproduction activities. In analysis it provides you with criteria that help you reconstruct how and why certain aesthetic factors were used.

You have now reached a level of sophistication that allows you to combine aesthetic intuition and feeling with the precise knowledge of how the various aesthetic elements and fields operate and interact with one another. By tempering your feeling with knowledge and your knowledge with feeling, you realized the first and most important prerequisite for becoming truly media-literate.

Glossary

- **"at-at" theory** Adapted from Zeno's concept of motion, consisting of a series of static "at" positions in space and time, each differing to some degree from the previous one. Film shows a specific "at" position in each frame.
- **above- and below-eye-level key light positions** The principal light source (key light) strikes from above or below the object's eye level.
- **accelerated motion** Object motion on the screen appears faster than normal. In film, the division of object motion into relatively few "at" positions, each differing considerably from the other. The frame of density is low. In television, the videotape moves faster than its normal speed during playback.
- **achromatic** Its basic meaning is *without chroma* (color). Usually, it refers to totally desaturated colors (having no hue) that show up white, black, and various shades of gray (brightness steps). The grayscale is an achromatic scale ranging from white to black.
- **additive color mixing** The mixing of colored light. Usually the mixing of the light primaries—red, green, and blue.
- **aerial perspective** Three-dimensional emphasis by means of selective focus in a shallow depth of field. Only a relatively short section of the z-axis is in focus, with all else out of focus.
- **aesthetic energy** The energy we perceive from aesthetic phenomena, such as color, sound, and motion. Can be expressed as vector magnitudes.
- **aesthetic motion paradox** An object can be in motion and perceived at rest, or at rest and perceived in motion.
- **ambient sounds** Background sounds that normally occur in a specific environment.
- **analytical montage** The selection of key elements of a single event (analysis) and their proper sequencing (synthesis).
- **angles** Variety of camera viewpoints.

- **applied aesthetics** The branch of aesthetics that deals with sense perceptions and how to influence them through fundamental image elements, such as light, space, time/motion, and sound.
- **applied media aesthetics** Same as applied aesthetics except that its focus is on television, film, and other electronic audiovisual media.
- **area proportion** The harmonious interrelation of various screen areas.
- **articulating the z-axis** To place objects or people along the z-axis to serve as three-dimensional space modulators.
- **aspect ratio** The relationship of screen width to screen height; 4:3 (1.33:1) for regular TV screen; 16:9 (1.77:1) for HDTV, and between 1.85:1 and 2.35:1 for wide motion picture screens.
- **asymmetry of the frame** The right and left sides of the video screen are unequal in visual prominence. The right side is said to command more attention than the left.
- **attached shadow** Shadow that is on the object itself. It cannot be seen independent of (detached from) the object.
- **attack** The speed with which a tone reaches a certain (usually maximum) level of loudness.
- **back light** Illumination from behind the subject and opposite the camera.
- **background light** Illumination of the set pieces and backdrops. Also called *set light*.
- **balance** Relative structural stability of objects or events within the screen. Specifically, the distribution of vectors and graphic weight into stabile, neutral, and labile pictorial structures.
- **biological time** An internal clock that tells us when to feel awake or tired. A type of subjective time that is measured quantitatively (when to do certain things).
- **brightness** Sometimes called *value*, brightness indicates how light or dark a color appears in a black-and-white photograph. Technically, brightness is one of the three major attributes of color that indicates how much light is reflected from a colored surface.
- **cameo lighting** Lighted objects set off against a plain, dark background. Foreground figures are illuminated with highly directional light, and the background remains unlighted.
- **canon** The purest and most obvious form of musical imitation. Both the theme and the melody are repeated verbatim by the other voices. Also called *round*. See *imitation*.
- **cast shadow** Shadow produced by an object and thrown (cast) onto a surface (part of the object itself or another surface). The cast shadow may be object-connected (cast shadow touches the object producing it) or object-disconnected (cast shadow does not touch the object producing it). The cast shadow can be independent of the object (appear detached from the object causing it).

- **chiaroscuro lighting** Lighting for light/dark contrast (fast falloff) to emphasize volume and specific areas.
- **chord** The simultaneous playing of three or more musical tones. Two tones played simultaneously constitute an interval. The chord forms a vertical sound vector.
- chroma See saturation.
- **clock time** See *objective time*. Also the "at" position in the time continuum when an event occurs.
- **collision montage** An idea-associative montage that collides opposite events in order to express or reinforce a basic idea.
- **color** Specific wavelengths within the visible light spectrum, which we interpret as various hues.
- color attributes The three color sensations: hue, saturation, and brightness.
- **color constancy** Perceiving a color as uniform despite variations.
- **color energy** The aesthetic energy we perceive from a color; the relative energy a color emits within its contextual field.
- **color harmony** Colors that go well together. Specifically, the balanced energy of colors. Color harmony is most easily achieved with high-energy colors (figure) set off against a low-energy color background (ground).
- **color temperature** The relative bluishness or reddishness of light, measured in Kelvin degrees. Bluish light has a high color temperature; reddish light, a low one. The television camera must be adjusted to the color temperature of the prevailing light. See *white balance*.
- **comparison montage** An idea-associative montage that compares seemingly disassociated, yet thematically related, events in order to establish or reinforce a basic idea.
- **complexity editing** The building of an intensified screen event from carefully selected event essences. The various montages belong to the complexity-editing category.
- **computer-generated image** Pictures and sound created synthetically by the computer. Normally used to distinguish from lens-generated images (television, film, still cameras).
- **context** The environment in which we perceive and evaluate specific perceptual phenomena. Every single aesthetic element operates within, and is dependent upon, the context of all others.
- **contextualism** A branch of philosophy that includes, rather than excludes, the environment (context) in the process of clarifying, intensifying, and interpreting experience.
- **contextualistic aesthetics** How the various fundamental aesthetic elements (light and color, space, time/motion, and sound) operate in various contexts and in relation to one another. See *contextualism*.
- **continuing vectors** Vectors that succeed each other in the same direction.

- **continuity editing** The assembly of shots that ensure vector and vector field continuity. Its principal function is the clarification of an event.
- **converging vectors** Vectors that point or move toward each other. They usually energize an event.
- **counterpoint** A specific polyphonic technique in which the various voices (horizontal vectors) encounter each other. In media aesthetics the musical counterpoint of note against note is expanded into vector against vector.
- **cross shooting** Similar to over-the-shoulder shooting except that the person close to the camera is out of the shot. See *over-the-shoulder shooting*.
- cut The instantaneous change from one shot (image) to the next.
- **cutaway** A shot of an object or event that is peripherally connected with the overall event and that is neutral as to screen direction. Used to intercut between two shots in which the screen direction is reversed.
- **decay** The speed with which a sound fades to where it can no longer be heard.
- **deductive visual approach** Moving from an overview to event detail. A deductive method stresses the analysis and breakdown of a complete television show, film, or computer display into its major aesthetic elements.
- **density** The relative number of film or television frames used to depict the motion of an object. Also the number of events happening within a given time unit.
- **depth of field** Area along the z-axis that is in focus. In a great depth of field, objects located along the z-axis at different distances from the camera are in focus. In a shallow depth of field, only objects that lie within a short section of the z-axis are in focus; all others are out of focus. It is dependent on the focal length of the lens, the lens aperture, and the distance from camera to object.
- **desaturation theory** The more desaturated the colors of a scene, the more internal it becomes and the more the viewer is compelled to participate in the scene. A color desaturation renders the scene low-definition.
- **dialectic** The juxtaposition of opposing or contradictory statements or events in order to resolve the contradictions into universally true axioms or an event synthesis (new event or idea).
- **digital video effects (DVE)** Visual effects created by a computer or other digital effects video equipment.
- **dissolve** A gradual transition from shot to shot, in which the two images temporarily overlap.
- **diverging vectors** Vectors that point or move in opposite directions.
- **dramatic agent** Any object or action within a scene that contributes directly to its intensification.
- **dramaturgy** The art of dramatic narrative and composition. More generally, the whole structure of a play; the total orchestration of dialogue, action, and various aesthetic elements.

- **duration** The running time of a scene, sequence, or total film or television show. In music, refers to how long we perceive a sound.
- **DVE** See digital video effects.
- **editing** Selecting significant event details and sequencing them into a comprehensive whole.
- **encoding** To translate an idea into a message for a specific communication medium.
- **envelope** The total duration of a tone, from initial attack to final decay.
- **event** An actual happening or any person or object used for aesthetic manipulation. In media aesthetics, the term *event* refers to anything within the camera's view.
- **event density** The relative number of event details that occur within a brief clock time period. Can also be used to describe the complexity of an event.
- **event energy and intensity** The relative energy and relative significance we perceive about a specific event.
- **experience intensity** The number of relevant experiences to which we are subjected simultaneously or in rapid succession, and their relative depths.
- **external vectors** Forces with a direction and magnitude operating outside of us; event vectors.
- **eye level** The plane parallel to the ground emanating from the eye of the observer. Eye level and the horizon line lie on the same plane, regardless of how high the observer is from the ground.
- **fade** The gradual appearance of a picture from black or its disappearance to black.
- **falloff** The speed (degree of change) with which the brightest part of an object turns into dense shadow. Fast falloff means that the lighted area changes abruptly into dense shadows. Slow falloff means that a very gradual change takes place from lighted area to shadow area, or that very little, if any, contrast exists between light and shadow areas. No falloff means that the object is lighted equally on both sides of the camera.
- **field of view** The territory a shot includes; ranges from extreme long shot (ELS) to extreme close-up (ECU).
- **figure-ground principle** Our tendency to organize a scene into figures that lie in front of a ground. In doing this, we perceive the ground as being more stable than the figures. In sound design, figure-ground means that you choose the important sounds to be the figure, while relegating the other sounds to the background.
- **fill light** Additional light on the opposite side of the camera from the key light, used to illuminate shadow areas and thereby reduce falloff. Usually accomplished by floodlights.
- **first-order space** Television space as defined by the borders of the television screen (x- and y-axes) and the illusory z-axis.

- **flat lighting** Omnidirectional illumination from no particular single source. The falloff is slow or nonexistent.
- **forced perspective** An exaggerated linear perspective, making us perceive parallel lines converging more drastically than in normal vision. Wide-angle lenses create a forced perspective.
- **frame density** The sampling rate of a motion, that is, the number of "at" positions used to divide a single motion.
- **from-to** Describes an uninterrupted motion from beginning to end.
- **fugue** A musical theme or subject stated first in each of the voices (usually four) and then restated verbatim or in a slightly changed form at various times in all voices. The theme is virtually chased from voice to voice throughout the fugue, relating vertically to the counterpoints of the other voices.
- **gel** Generic name for color filters put in front of spotlights or floodlights to give the light beam a specific hue. *Gel* comes from *gelatin*, the filter material used before the invention of much more heat- and moisture-resistant plastics. Also called *color media*.
- **geographic matching** Sound and pictures originate in the same geographical area.
- **gestalt** A complete configuration that we perceive through psychological closure. The perceived pattern is generally different from and often more complete than the sum of its parts. In a gestalt all elements operate in relation to the whole.
- **golden section** A classic proportional system in which the smaller section of a line is to the greater as the greater is to the total length of the line.
- **graphic depth factors** Factors that create the illusion of depth on a two-dimensional surface (without the use of motion). The major ones are overlapping planes, relative size, height in plane, linear perspective, aerial perspective, and light and shadow.
- **graphic mass** A precisely defined screen area, such as a person, object, or abstract wipe pattern, that is seen as a figure against a ground. The more screen area the figure occupies, the heavier its graphic mass.
- **graphic vector** A vector created by lines or by stationary elements arranged in such a way as to suggest a line. Although graphic vectors are ambivalent as to precise direction, they do indicate a directional tendency, such as horizontal, vertical, or curved.
- **graphic weight** The relative lightness or heaviness we perceive from a specific graphic mass.
- **graphication** The deliberate rendering of a television-mediated event as a two-dimensional, picturelike image that assumes the characteristics of a magazine illustration.
- harmonics Overtones that are simple multiples of the fundamental tone.
- **harmony** Elements that go together well. In music, a number of chords or vertical sound vectors.

- **Hegelian dialectic** A thesis (basic argument) that is opposed by an antithesis (counterargument), ultimately resulting in a synthesis (resolution or new, more insightful argument).
- **high-definition** A high-resolution picture (consisting of a great number of pixels), or high-fidelity sound.
- **high-definition television (HDTV)** A television image with an aspect ratio of 16:9 that has a much higher resolution (1,125 lines) than the ordinary television image (in the United States, 525 lines).
- **high-key lighting** High overall light level; general, nonspecific, bright lighting; slow falloff, usually with a light background. Has nothing to do with the vertical position of the key light.
- historical matching Sound and pictures originate in the same historical period.
- **homophony** A musical structure in which a single predominant melody is supported by chords. The melody can stand on its own; the chords cannot.
- **horizon line** The line formed by the actual horizon or an imaginary line parallel to the ground at eye level. More technically, the plane at right angles to the direction of gravity that emanates from the eye of the observer at a given place. The horizon line is always at the eye level of the observer regardless of how high the observer is relative to the ground.
- **hue** The actual color of an object—red, green, blue, and so on.
- **idea-associative montage** Juxtaposes two seemingly disassociated images in order to create a third principle idea or concept. Operates on the dialectical principle in which one idea (thesis) is opposed by another (antithesis), leading to a new idea (synthesis)—a *tertium quid* (third something).
- **illogical closure** Occurs when nonrelated visual elements provide enough cues for psychological closure regardless of whether the resulting gestalt is logical in content.
- **image elements** The fundamental aesthetic elements of television and film: light and color, two-dimensional space, three-dimensional space, time/motion, and sound.
- **imitation** A short musical theme or subject stated first in one voice and then repeated verbatim or in a slightly changed form in the other voice(s) while the first voice continues.
- **index vector** A vector created by something that points unquestionably in a specific direction.
- **induced motion vector** A motion vector created by secondary (camera) movement on a static event to simulate primary (event) motion.
- **inductive visual approach** Moving from event detail to others to create the overall event in the perceiver's mind. The inductive method requires psychological closure. As a method, it advocates the careful study of each image element without and within its structural field and other contexts.
- **inertia** The tendency of a body at rest to remain at rest, and of a body in motion to remain in motion. The greater the mass of an object, the greater its inertia.

inscape All events that characterize an internal condition—how people feel rather than what they do.

instantaneous editing See switching.

internal vectors Forces with a direction and magnitude operating within us, such as feelings, empathic responses, and so forth.

jump cut An image that jumps slightly from one screen position to another during a cut.

key light The apparent principal source of directional illumination falling upon an area or subject. Also refers to high- or low-key lighting (light or dark background).

keying A secondary image that is electronically cut into the base picture. Also called *matting*.

kicker Kicker light; directional light that is positioned low and from the side and back of the subject.

labile See balance.

landscape The setting in which the action takes place rather than the people who function in this setting. It may refer to the actual setting—city street, mountains, desert—as well as a broad, outer action, such as a huge battle scene, a space spectacular, and so forth. It refers to outer events (car chase) rather than inner events (people expressing their love for each other).

leadroom The space in front of a person or object moving toward the edge of the screen. See *noseroom*.

leitmotiv "Leading motif," a short musical phrase that denotes a specific event. When repeated, it signals an upcoming event. Its basic dramatic function is that of allusion (reference).

lens-generated image The photographic image projected by the lens onto the imaging device (film, charge-coupled device in video).

light Radiant energy that behaves commonly as electromagnetic waves.

lighting The control of light for the purpose of manipulating and articulating the perception of an event.

lightness How light or dark we perceive various brightness steps (actual light reflectance).

limbo Any set area that has a plain, light background. Often confused with flat lighting.

linear perspective Horizontal parallel lines converge toward the distance at the vanishing point, which lies on the eye-level horizon line. Vertical lines (such as windows) crowd progressively toward the vanishing point. An important graphic technique to create the illusion of three-dimensional space on a two-dimensional surface.

literal sound Referential sound. It always refers to its originating source (sound of a baby crying alludes to the image and presence of a baby).

- **loudness** The apparent strength of a tone as we perceive it (magnitude of a sound vector). Technically, the amplitude of the sound wave.
- **low-definition** A low-resolution picture (consisting of relatively few pixels), or low-fidelity sound.
- low-key lighting Low overall light level. Selective lighting with fast falloff.
- **magnetism of the frame** The pull the frame (screen edges) exerts on objects within the frame (screen).
- **mass** All the matter a body contains. It is characterized by the object's perceived size, shape, volume, and weight.
- **melody** A series of musical notes arranged in succession, forming a tune. Melody is a horizontal sound vector.
- **mental map** Tells viewers where things are or are supposed to be on- and off-screen.
- **metric montage** A number of shots of identical or similar length that create a definite tertiary motion beat—a rhythm. The content of the shots is less important than shot length.
- **metric rhythm control** The application of metric montage to create a tertiary motion beat.
- **moiré effect** Color vibrations that occur when narrow, contrasting stripes of a design interfere with the scanning lines of the television system.
- **montage** The juxtaposition of two or more separate event details that combine into a larger and more intense whole—a new gestalt.
- **motion paradox** An object can be in motion and at rest at the same time. Also, the figure is perceived as doing the moving even if it is only the ground that is actually in motion.
- **motion vector** A vector created by an object actually moving in a specific direction or an object that is perceived as moving on the screen. A photograph or drawing of an object in motion is an index vector but not a motion vector.
- **multiple z-axis blocking** To block the z-axis of each camera with space modulators (people, objects) so that when switching from one camera to the next, each shows an articulated z-axis.
- **natural dividing lines** Graphic vectors that occur at prominent points of a body, such as the horizontal ones formed by the eyes, the bottom of the nose, the mouth, the shoulders, the knees, the hemline, and so forth.
- **negative volume** Empty space that surrounds, or is described by, positive volumes. A definite empty space, such as the inside of a room, that is articulated by positive volumes, such as the walls.

neutral See balance.

noise Random audible vibrations of the air ("sounds" without communication purpose). Also any random signal in a circuit, such as video noise (picture interference). Video noise is also referred to as *artifacts*.

- **nonliteral sound** Does not refer to the sound-originating source. The most common nonliteral sound is music, assuming that the context does not deal with the performance of this music.
- **noseroom** The space in front of a person looking or pointing toward the edge of the screen. See *leadroom*.
- **object proportions** The process of translating screen images of objects into their actual size and their interrelation with their environment.
- **objective color perception** Sometimes used to refer to the colors we see that are actually present.
- **objective time** The time measured by the clock. Quantitative measure of time intervals in which observable change occurs. Also called *clock time*.
- **off-screen space** The space immediately surrounding the television, computer, or motion picture screen.
- **on-screen space** The space actually contained within the borders of the television, computer, or motion picture screen.
- **open set** A set whose background scenery is not continuous. The open set consists of sections of interiors not connected by a common background.
- **over-the-shoulder shooting** The camera looks over the camera-near person's shoulder (shoulder and head included in shot) at another person.
- **overtones** The number of frequencies with which a sound-producing source vibrates in addition to its fundamental frequency.
- **pace** The perceived speed of an event: whether the event seems to move along quickly or whether it seems to drag. Although pace belongs to subjective time, it is treated quantitatively; we speak of slow and fast pace.
- **pan-and-scan** The selection through horizontal panning and cutting of sections of the wide-screen image to fit the narrower 4:3 aspect ratio of the traditional television screen.
- **personification** To perceive the person (usually a news anchor) operating in first-order space as a real person who shares the viewer's psychological, if not physical, space.
- **phasing** The sound portion of an event is either ahead of or trails the corresponding picture portion.
- **pitch** Indicates the relative highness or lowness of a sound measured by frequency (hertz).
- **pixel** Short for *picture element*. The smallest single picture element with which an image is constructed. Also refers to the light-sensitive elements on an imaging device in a television camera that translate light into an electrical picture signal.
- **point of view (POV)** Camera simulates the index vector and field of view of a particular screen character. It makes the audience associate with what the character sees and feels. See *subjective camera*.

- **polyphony** The combination of two or more melodic lines (horizontal vectors) which, when played together, form a harmonic whole (vertical vectors).
- **positive volume** Objects that have substance and can be touched and weighed. Objects with a certain amount of mass.
- **postproduction editing** The assembly of recorded material after the actual production.
- **POV** See point of view.
- **predictive lighting** Light changes from one mood to another, signaling an impending occurrence.
- **predictive sound** Sound change or specific sound combinations that signal an impending occurrence. See *leitmotiv*.
- **premature closure** Applying psychological closure on account of on-screen cues and so neglecting to project the image into off-screen space.
- **presence** A sound quality that makes you feel as though you were close to the sound source.
- **primaries** Basic colors that, when mixed, render almost all other colors. The primaries cannot be achieved by mixing. The additive (light) primaries are red, green, and blue. The subtractive (paint) primaries are magenta (bluish red), yellow, and cyan (greenish blue).
- **primary motion** Event motion in front of the camera.
- **psychological closure** Taking a minimal amount of clues and mentally filling in nonexistent information to arrive at stable, easily manageable patterns.
- psychological time See subjective time.
- **rack focus** The shift of emphasis from one z-axis plane to another by changing (racking through) optical focus from one object to another in a shallow depth of field.
- **Rembrandt lighting** A type of chiaroscuro lighting in which only highly selected areas are illuminated while others are kept purposely dark; features fast falloff.
- **rhythm** How well a scene or show flows. Indicates the variety of pacing of the individual shots and the scene in general, and how well the parts relate to each other sequentially.
- **running time** Objective time measure. Indicates the overall length of a television show or film. It indicates the "from-to" span in the time continuum.
- **saturation** The color attribute that indicates color richness—the strength of the color.
- **scene** A clearly identifiable, organic part of an event. It is a small structural (action) or thematic (story) unit, usually consisting of several shots.
- **scene time** The actual clock time length of a scene.

- **screen space** The space as contained within the borders of the screen or the cumulative screen space of a shot sequence or multiple screens. See also *sequential screen space*.
- **secondary motion** Camera motion, including pan, tilt, pedestal, crane or boom, dolly, truck, arc, and zoom.
- **second-order space** A clearly defined space within the television screen (such as the box over the newscaster's shoulder), the screen space of a television set within first-order space, or any other clearly defined framed space on the television screen.
- **sectional analytical montage** Arrests, temporarily, the progression of an event and examines an isolated moment from various viewpoints. It explores the relative complexity of an event.
- **selective focus** Emphasizing an object in a shallow depth of field through focus, while keeping its foreground and background out of focus.
- **selective seeing** Our tendency to see only such events and event details as we are interested in and/or that seem to confirm our perceptual expectations and prejudices. Often, and quite inaccurately, called *selective perception*.
- **selective sound** Works on the figure-ground principle. We select the most relevant sound as the figure, while relegating all other sounds to the ground (background).
- **sequence** The sum of several scenes that compose an organic whole.
- **sequence time** The clock time of a sequence.
- **sequencing** Assembling shots so that they form a unified whole. Sequencing is achieved through editing.
- **sequential analytical montage** The sequencing of major event details in the cause-effect order of the actual event.
- sequential screen space The vector fields as they relate from shot to shot.
- **shot** The smallest convenient operational unit in television and film. It is the interval between two distinct video transitions, such as cuts, dissolves, and wipes.
- **shot time** The actual clock time duration of a shot.
- **side light** Usually directional light coming from the side of the object. Acts as additional fill light and provides contour.
- **silhouette lighting** The background is evenly lit, with the figures remaining unlighted. The figures reveal only their contours.
- **simultaneous screen space** The total screen space of multiple screens or several distinct picture areas (second-order spaces) within the television screen.
- **size constancy** The perception of the actual size of an object regardless of the distance and angle of view.

- **slow motion** Screen motion that shows the event move more slowly than its actual primary motion. In film, the division of motion into relatively many "at" positions, each one differing little from the next. The frame density is high. In television, it is achieved through slower-than-normal playback speed.
- **sound** Purposeful audible vibrations (oscillations) of the air.
- **sound continuity** Maintaining the intended volume and quality of sound over a series of edits.
- **sound perspective** A close-up picture is accompanied by a close-up sound, and a long shot, by a farther-away sound. A close-up picture is accompanied by a sound with more presence (appears to come from nearby) than the sound for a long shot (appears to come from farther away).
- **sound texture** The relative complexity of a harmonic structure (complexity of vertical sound vectors).
- **source-connected sound** Hearing a sound and seeing the sound-originating source at the same time. For example, to show a close-up of a speaker and hear her speak.
- **source-disconnected sound** Hearing a sound and seeing a picture that shows something other than the sound-producing source.
- **stabile** See balance.
- **story time** Spans the period of a story told in a television show or motion picture. It moves from a specific calendar date to another or from one clock time to another.
- **storyboard** A series of sketches of the key visualization points of an event, with the corresponding audio information given below each visualization.
- **structural matching** Pictures and sound are matched according to their internal structure and their dominant vector fields.
- **structural unit of film** The film frame that shows the frozen moment ("at" position) of an event.
- **structural unit of television** A "frame" that is in continuous flow and in the process of becoming and decaying; an image in flux.
- **structural visual rhythm** A beat created by recognizable recurring visual elements.
- **subjective camera** The camera assuming the role of an event participant; it no longer looks at but rather participates in the event.
- **subjective color perception** Stimulation of our color perception apparatus by means other than looking at actual colors. Mixing separate and distinct colors in our heads into new ones.
- **subjective time** The duration we feel; a qualitative measure. Also called *psychological time*.

- **subtractive color mixing** The mixing of color pigments (paint) or filters. The filters subtract (block) certain colors while passing others. Usually, the mixing of paint primaries—magenta (bluish red), yellow, and cyan (greenish blue).
- **switching** A change from one video source to another during a show or show segment with the aid of an electronic switcher. Also called *instantaneous editing*.
- **synthetic environment** Electronically generated setting either through chroma key or computer.
- tertiary motion Editing rhythm (beat) induced by regular shot changes.
- **tertium quid** The "third something"—a third (new) idea resulting from a montage.
- **thematic matching** The video event is accompanied by sounds we ordinarily associate with the event, such as the interior of a cathedral and organ music, or a football game and crowd sounds.
- **timbre** Describes the tone quality or tone color. Depends on the amount and combination of overtones.
- **time vector** The horizontal direction of time from past to future as we normally experience it.
- **timing** The control of objective and subjective time.
- **tonal matching** The video event is matched with sounds that express the general tone or mood of the event, such as lovers and romantic music, or sporting events and cheering.
- value See brightness.
- **vanishing point** The point at which all parallel lines seem to converge and discontinue (vanish). The vanishing point always lies at eye level on the horizon line.
- **vector** In media aesthetics, a perceivable force with a direction and a magnitude. In mathematics, a physical quantity with both a magnitude and a direction.
- **vector field** A combination of various vectors operating within a single picture field (frame), from picture field to picture field (from frame to frame), or from screen to screen (multiple screens).
- **vector line** An imaginary line created by extending converging index vectors or a motion vector. In order to preserve shot continuity, all cameras must be either to one or the other side of this line. Also called *principal vector*, *line of conversion and action, the one-eighty,* and, simply, *the line.*
- **vector magnitude** The degree of the directional force of the vector; the amount of energy we perceive. A high-magnitude vector is a strong vector; a low-magnitude vector is a weak one.
- **viewpoint** What the camera is looking at and from where.
- **virtual reality** Computer-simulated environment with which the user can interact and which changes according to the user's command.

- **visual dialectic** Any juxtaposition of visual opposites; can be opposing aesthetic elements (size, color, vectors), ideas, or conditions.
- visualization Mentally seeing a key image or images in a sequence.
- **volume duality** The interplay between positive and negative volumes. Any articulation of negative space by positive space modulators.
- white balance The adjustment of the three color signals in the video camera to show a white object as white regardless of the relative color temperature of the light that illuminates the object.
- wide-screen format The most common aspect ratio used for wide-screen film—1.85:1. This means that for every unit of screen height, there are 1.85 units of screen width. The traditional television aspect ratio of 1.33:1 is considerably narrower.
- **wipe** The transition in which a second image, framed in some geometric shape, gradually replaces all or part of the first one.
- **z-axis** The axis in the coordinating system that defines depth. Also, the imaginary line that extends from the camera lens to the horizon.
- **z-axis blocking** Arranging the event (people and things) along the z-axis or in close proximity to it.
- **z-axis motion vector** Motion along the z-axis (toward or away from the camera).
- **z-axis staging** Arranging scenery and set pieces along the z-axis.
- **z-axis vector** An index and motion vector that points or moves toward or away from the camera.
- **zero time** A high-magnitude subjective time vector that occupies only a spot (practically zero length) on the objective time continuum.

Bibliography

Acker, Steven, and Robert Tiemens. "Children's Perception of Changes in Size of Televised Images," Human Communication Research 7, no. 4 (1981). Adorno, Theodor, and Hans Eisler. "Komposition für den Film." In Theodor Adorno, Gesammelte Schriften 15. Frankfurt am Main, Germany: Suhrkamp Verlag, 1976. Alten, Stanley R. Audio in Media, 4th ed. Belmont, Calif.: Wadsworth Publishing Co., 1994. Arnheim, Rudolf. "A New Laocoön: Artistic Composites and the Talking Film." In his Film As Art. Berkeley: University of California Press, 1957. -. Art and Visual Perception: The New Vision. Berkeley: University of California Press, 1974. —. Entropy and Art. Berkeley: University of California Press, 1971. -. New Essays on the Psychology of Art. Berkeley: University of California Press, 1986. —. The Power of the Center. Berkeley: University of California Press, 1982. —. Toward a Psychology of Art. Berkeley: University of California Press, 1966. Audi, Robert (ed.). The Cambridge Dictionary of Philosophy. Cambridge, Mass.: Cambridge University Press, 1995. Augustinus, Saint. The Confessions of St. Augustine, bk. XI, sec. x-xxxi. Chicago: Henry Regnery Co., 1948.

- Barker, David. "It's Been Real': Forms of Television Presentation." *Critical Studies in Mass Communication* 5 (1988): 42–56.
- Barr, Tony. Acting for the Camera, rev. ed. New York: Harper Perennial, 1997.
- Becker, Samuel L., and L. C. Roberts. *Discovering Mass Communication*, 3d ed. New York: HarperCollins, 1992.
- Beer, Johnannes. *Albrecht Dürer als Maler*. Königstein i.T., Germany: Karl Rebert Langewiesche Verlag, 1953.
- Belton, John. Widescreen Cinema. Cambridge, Mass.: Harvard University Press, 1992.
- Berger, John. About Looking. New York: Vintage Books, 1992.
- Bergson, Henri. *Creative Evolution*. Trans. by Arthur Mitchell. New York: Modern Library, 1944.
- Bergson, Henri. *Time and Free Will*. Trans. by F. L. Pogson. New York: Harper Torchbooks, 1960.
- Biocca, Frank (ed.). *Television and Political Advertising*. Hillsdale, N.J.: Lawrence Erlbaum Associates, 1991.
- Birren, Faber. Color in Your World. New York: Collier Books, 1962.
- Borden, Mark. "On the Problem of Vector Penetration." Broadcast and Electronic Communication Arts Department, San Francisco State University. March 1996. Unpublished.
- Bordwell, David, and Kristin Thompson. *Film Art: An Introduction*, 5th ed. New York: McGraw-Hill, 1996.
- ——. "Fundamental Aesthetics of Sound in the Cinema." In Elisabeth Weis and John Belton (eds.), *Film Sound: Theory and Practice*. New York: Columbia University Press, 1985.
- Boslough, John. "The Enigma of Time." National Geographic 177 (March 1990).
- Bruner, Jerome S., and A. L. Minturn. "Perceptual Identification and Perceptual Organization." *Journal of General Psychology* 53 (1955): 21–28.
- Burch, Noel. Theory of Film Practice. New York: Praeger Publishers, 1973.
- Burnham, Jack. Beyond Modern Sculpture. New York: George Braziller, Inc. 1967.
- Burrows, Thomas D., Lynne S. Gross, and Donald N. Wood. *Television Production*, 7th ed. Boston: McGraw-Hill Companies, 1998.

- Burt, George. The Art of Film Music. Boston: Northeastern University Press, 1994.
- Capra, Fritjof. *The Tao of Physics*, rev. ed. Boulder, Colo.: Shambhala Publications, 1991.
- ——. The Turning Point. Toronto: Bantam Books, 1983.
- Chrisholm, Brad. "On-Screen Screen." Journal of Film Video 41, no. 2 (1989): 14–24.
- Christians, Clifford G. (ed.), and Mark Fackler. *Media Ethics: Cases and Moral Reasoning*, 5th ed. New York: Longman Publishing Group, 1997.
- Collins, Maynard. Norman McLaren. Ottawa: Canadian Film Institute, 1977.
- Compesi, Ronald, and Ronald Sherriffs. *Video Field Production and Editing*, 4th ed. Boston: Allyn and Bacon, 1997.
- Davies, Paul. About Time: Einstein's Unfinished Revolution. New York: Touchstone, 1996.
- Dean, Alexander. Fundamentals of Play Directing. New York: Farrar and Rinehart, 1946.
- De Voto, Bernard (ed.). The Portable Mark Twain. New York: Viking Press, 1946.
- Dondis, Donis A. A Primer of Visual Literacy. Cambridge, Mass.: MIT Press, 1973.
- Duncker, Karl. "Über induzierte Bewegung." Psychologische Forschung 12 (1929).
- Edman, Irwin. Arts and the Man. New York: W. W. Norton & Co., 1939, 1967.
- Eisenstein, Sergei. *Film Form and Film Sense*. Ed. and trans. by Jack Leyda. New York: World Publishing Co., 1957.
- Epstein, Edward J. *News from Nowhere: Television and the News.* New York: Random House, 1973.
- Epstein, William. *Perceiving Events and Objects*. Hillsdale, N.J.: Lawrence Erlbaum Associates, 1994.
- Epstein, William, and Sheena Rogers (eds.). *Perception of Space and Motion.* San Diego, Calif.: Academic Press, 1995.
- Ernst, Bruno. *De Toverspiegel van M. C. Escher* (The Magic Mirror of M. C. Escher). Munich, Germany: Heinz Moos Verlag, 1978.
- Escher, M. C., et al. The World of M. C. Escher. New York: Harry N. Abrams, 1972.
- Evans, Ralph M. The Perception of Color. New York: John Wiley and Sons, 1974.

- Fell, John. Film: An Introduction. New York: Praeger Publishers, 1975.
- Festinger, Leon. A Theory of Cognitive Dissonance. Evanston, Ill.: Row, Peterson, and Co., 1957.
- Fineman, Mark B. *The Nature of Visual Illusion*. Mineola, N.Y.: Dover Publications, 1996.
- Foss, Bob. *Filmmaking: Narrative and Structural Techniques*. Beverly Hills, Calif.: Silman-James Press, 1992.
- Fraser, J. T. (ed.). *The Voices of Time*. Amherst: University of Massachusetts Press, 1981.
- Fraser, J. T. *Time, the Familiar Stranger*. Amherst: University of Massachusetts Press, 1987.
- ——. Of Time, Passion, and Knowledge, 2d ed. Princeton, N.J.: Princeton University Press, 1990.
- Gadamer, Hans-Georg. Hermeneutik I, Wahrheit und Methode: Grundzüge einer philosophischen Hermeneutik. Tübingen: J. C. B. Mohr, 1986.
- -----. Truth and Method. New York: Seabury Press, 1975.
- Galitz, Wilbert O. *The Essential Guide to User Interface Design: An Introduction to GUI Design.* New York: John Wiley and Sons, 1997.
- Giannetti, Louis. *Understanding Movies*, 7th ed. Englewood Cliffs, N.J.: Prentice-Hall, 1995.
- Gibson, James J. *The Ecological Approach to Visual Perception*. Hillsdale, N.J.: Lawrence Erlbaum Associates, 1987.
- Girshausen, T. "Reject It in Order to Possess It: On Heiner Müller and Bertold Brecht." Trans. by P. Harris and P. Kleber. *Modern Drama* 23 (1981): 402–21.
- Goldstein, Bruce E. *Sensation and Perception*, 4th ed. Pacific Grove, Calif.: Brooks/Cole Publishing, 1996.
- Gombrich, E. H. The Image and the Eye. Ithaca, N.Y.: Cornell University Press, 1982.
- Goudsmit, Samuel A., and Robert Clairborne. *Time*. New York: Time-Life Books, 1961.
- Gregory, R. L., and J. Harris (eds.). *The Artful Eye.* New York: Oxford University Press, 1995.
- Gregory, R. L. Mirrors in Mind. San Francisco: W. H. Freeman and Co., 1996.

- Hahn, Lewis Edwin. A Contextualistic Theory of Perception. University of California Publications in Philosophy, vol. 22. Berkeley: University of California Press, 1939.
- Hall, Edward T. Silent Language. Garden City, N.Y.: Anchor Press/Doubleday, 1973.
- Handell, L. T., and A. T. Handell. *Intuitive Light: An Emotional Approach to Capturing the Illusion of Value, Form, Color, and Space.* New York: Watson Guptill Publications, 1995.
- Hegel, Georg W. F. *The Phenomenology of Mind*. Trans. by F. P. B. Osmaston. New York: Macmillan, 1931.
- Holman, Tomlinson, and Gerald Millerson. *Sound for Film and Television*. Boston and London: Focal Press, 1997.
- Hyde, Stuart. *Television and Radio Announcing*, 8th ed. Boston: Houghton Mifflin Co., 1998.
- ——. "Idea to Script: Conceptualization and Writing for the Electronic Media." Unpublished manuscript, 1998.
- Itten, Johannes. *Design and Form: The Basic Course at the Bauhaus*. Trans. by John Maas. New York: Van Nostrand Reinhold Co., 1963.
- Josephson, Sheree, "A Real Eye Opener: An Argument for Using Eye-Movement Studies to Analyze Web Sites." Paper presented at the 11th Annual Visual Communication Conference, Teton Village, Wyoming (June 1997).
- Kandinsky, Wassily. *Point and Line to Plane*. Trans. by Howard Dearstyne and Hilla Rebay. New York: Dover Publications, 1979. (The work was originally published as *Punkt und Linie zu Fläche* in 1926 as the ninth in a series of fourteen Bauhaus books edited by Walter Gropius and László Moholy-Nagy.)
- Katz, Steven D. *Film Directing: Cinematic Motion*. Studio City, Calif.: Michael Wiese Productions, 1992.
- ——. Film Directing: Shot by Shot. Studio City, Calif.: Michael Wiese Productions, 1991.

Kepes, Gyorgy. Language of Vision. Chicago: Paul Theobald, 1944.

Kepes, Gyorgy (ed.). Education of Vision. New York: George Braziller, 1965.

———. The Man-Made Object. New York: George Braziller, 1966.

——. *The Nature and Art of Motion*. New York: George Braziller, 1965.

- -----. Sign, Image, Symbol. New York: George Braziller, 1966.
- ——. Structure in Art and Science. New York: George Braziller, 1965.
- Kepplinger, Hans M., and Wolfgang Donsbach. "The Influence of Camera Angles and Political Consistency on the Perception of a Party Speaker." *Experimental Research in Instruction* 5. Ed. by Jon Baggaley and Patti Janega. Montreal: Concordia University, 1982.
- Kipper, Philip, "Time Is of the Essence: An Investigation of Visual Events and the Experience of Duration." Unpublished paper presented at the Conference on Visual Communication, Alta, Utah, 1987.
- Knopp, Lisa. Field of Vision. Ames, Iowa: University of Iowa Press, 1996.
- Koffka, Kurt. *Principles of Gestalt Psychology*. New York: Harcourt, Brace, and World, 1935.
- Köhler, Wolfgang. Gestalt Psychology. New York: A Mentor Book, 1947.
- Kracauer, Siegfried. *Theory of Film: The Redemption of Physical Reality.* New York: Oxford University Press, 1960.
- Kramer, Arthur F., Michael Coles, G. H. Logan, and D. Gordon (eds.). *Converging Operations in the Study of Selective Attention*. Washington, D.C.: American Psychological Association, 1996.
- Kuleshov, Lev V. *Kuleshov on Film: Writings by Lev Kuleshov*. Selected, trans., and ed. by Ronald Levaco. Berkeley: University of California Press, 1974.
- Langer, Susanne K. Feeling and Form. New York: Charles Scribner's Sons, 1953.
- Le Corbusier. *Modular*, 2d ed. Trans. by Peter de Francia and Anna Bostock. Cambridge, Mass.: Harvard University Press, 1954.
- Modular 2. Trans. By Peter de Francia and Anna Bostock. London: Faber and Faber, 1958.
- Lestinenne, Remy. *The Children of Time: Causality, Entropy, Becoming.* Trans. by E. C. Neher. Urbana, Ill.: University of Illinois Press, 1995.
- Lewin, Kurt. *A Dynamic Theory of Personality.* Trans. by Donald Adams and Karl Zener. New York: McGraw-Hill, 1935.
- Linden, George. *Reflections on the Screen*. Belmont, Calif.: Wadsworth Publishing Co., 1970.
- Lindgren, Ernest. The Art of the Film. New York: Macmillan Co., 1963.

- Lopuck, Lisa. Designing Multimedia: A Visual Guide to Multimedia and Online Graphic Design. Berkeley, Calif.: Peachpit Press, 1996.
- Lüscher, M. *The Lüscher Color Test*. Trans. and ed. by Ian Scott. New York: Pocket Books, 1971.
- Mancini, Mark. "The Sound Designer." In Weis and Belton, Film Sound: Theory and Practice, 1985.
- Mandell, Theo. *The Elements of User Interface Design*. New York: John Wiley and Sons, 1997.
- Mandell, M., and D. L. Shaw. "Judging People in the News—Unconsciously: Effect of Camera Angle and Bodily Activity." *Journal of Broadcasting* 17 (1973): 353–362.
- Madsen, Roy Paul. Working Cinema: Learning from the Masters. Belmont, Calif.: Wadsworth Publishing Co., 1990.
- Marcus, Aaron. *Multimedia Interface Design*. Studio book and CD-ROM. New York: Random House, 1997.
- Mathias, Harry, and Richard Patterson. *Electronic Cinematography.* Belmont, Calif.: Wadsworth Publishing Co., 1985.
- Mathias, Harry. "A Sensible Look at HDTV for Motion Picture Production and Special Effects." In John F. Rice (ed.), *HDTV*. New York: Union Square Press, 1990, pp. 253–285.
- McCain, Thomas A., Joseph Chilberg, and Jacob Wakshlag. "The Effect of Camera Angle on Source Credibility and Attraction." *Journal of Broadcasting* 21 (1977): 35–46.
- McLuhan, Marshall. *Understanding Media: The Extensions of Man.* New York: McGraw-Hill, 1964.
- McLuhan, Eric, and Frank Zingrone (eds.). *Essential McLuhan*. New York: Basic Books, 1995.
- McQuail, Denis. *Mass Communication Theory*, 3d ed. Beverly Hills, Calif.: Sage Publications, 1994.
- Messaris, Paul. Visual Literacy: Image, Mind, and Reality. Boulder, Colo.: Westview Press, 1994.
- ——. Visual Persuasion. Thousand Oaks, Calif.: Sage Publications, 1997.
- Metallinos, Nikos, and Robert K. Tiemens. "Asymmetry of the Screen: The Effect of Left Versus Right Placement of Television Images." *Journal of Broadcasting* 21 (1977): 21–33.

- Metallinos, Nikos. *Television Aesthetics*. Mahwah, N.J.: Lawrence Erlbaum Associates, 1996.
- Metz, Christian. "Aural Objects." In Weis and Belton, Film Sound: Theory and Practice, 1985.
- Meyrowitz, Joshua. No Sense of Place. New York: Oxford University Press, 1985.
- Millerson, Gerald. *The Technique of Lighting for Television and Film*, 3d ed. Boston and London: Focal Press, 1991.
- ——. *The Technique of Television Production*, 12th ed. Boston and London: Focal Press, 1990.
- Mitchell, William J. The Reconfigured Eye. Cambridge, Mass.: MIT Press, 1992.
- Moholy-Nagy, László. Vision in Motion. Chicago: Paul Theobald and Co., 1947.
- Mueller, Conrad, et al. Light and Vision. New York: Time-Life Books, 1966.
- Murch, Walter. *In the Blink of an Eye: A Perspective on Film Editing*. Beverly Hills, Calif.: Silman-James Press, 1995.
- Newcomb, Horace (ed.). *Television the Critical View*, 5th ed. New York: Oxford University Press, 1994.
- O'Neill, Catherine. You Won't Believe Your Eyes. Washington, D.C.: National Geographic Society, 1987.
- Ornstein, Robert. Multimind. New York: Anchor Books/Doubleday, 1989.
- Paine, Frank. "Sound Mixing and Apocalypse Now: An Interview with Walter Murch." In Weis and Belton, Film Sound: Theory and Practice, 1985.
- Park, David. The Image of Eternity. Amherst: University of Massachusetts Press, 1980.
- Pepper, Stephen C. *Aesthetic Quality: A Contextualistic Theory of Beauty.* New York: Charles Scribner's Sons, 1938.
- ------. The Basis of Criticism in the Arts. Cambridge, Mass.: Harvard University Press, 1945.
- ———. *Principles of Art Appreciation*. New York: Harcourt, Brace, 1949.
- ——. World Hypotheses. Berkeley: University of California Press, 1942, 1970.
- Perlmutter, Martin. "The Language of Television." In Richard P. Adler (ed.), *Understanding Television*. New York: Praeger Publishers, 1981.

- Pirsig, Robert M. Zen and the Art of Motorcycle Maintenance. New York: William Morrow and Co., 1974.
- Pudovkin, V. I. *Film Technique and Film Acting*. Trans. and ed. by Ivor Montagu. New York: Grove Press, 1960.
- Rausch, Jürgen. "Ökonomie unserer Zeit." In Hans Jürgen Schultz (ed.), *Was der Mensch braucht*. Stuttgart, Germany: Kreuz Verlag, 1979.
- Rabiger, Michael. *Directing: Film Techniques and Aesthetics*, 2d ed. Boston and London: Focal Press, 1997.
- Rock, Irvin. Perception. New York: Scientific American Library, 1984.
- Russel, Francis, and the editors of Time-Life. *The World of Dürer* 1471–1528. New York: Time-Life Books, 1967.
- Schramm, Wilbur, and Donald F. Roberts (eds.). *The Process and Effects of Mass Communication*, rev. ed. Urbana, Ill.: University of Illinois Press, 1971.
- Schubin, Mark. "No Answer." Videography (March 1996): 18-33.
- ——. "Searching for the Perfect Aspect Ratio." *SMPTE Journal* (August 1996): 460–478. Originally presented as paper no. 137-61 at the 137th SMPTE Technical Conference (1995).
- Schwartz, Tony. Media, the Second God. New York: Anchor Books, 1983.
- ——. The Responsive Chord. New York: Anchor Books, 1973.
- Shrivastava, Vinay. *Aesthetics of Sound*. Dubuque, Iowa: Kendall/Hunt Publishing Co., 1996.
- Smith, Thomas G. *Industrial Light and Magic: The Art of Special Effects.* New York: Ballantine Books, 1986.
- Solso, Robert L. *Cognition and the Visual Arts* (Cognitive Psychology series). Cambridge, Mass.: MIT Press, 1996.
- Taylor, Frank A. Color Technology. London: Oxford University Press, 1962.
- Thomson, David. A Biographical Dictionary of Film, 3d ed. New York: Alfred A. Knopf, 1994.
- Tiemens, Robert K. "A Visual Analysis of the 1976 Presidential Debates." Communication Monographs 45 (1978).
- ——. "Some Relationships of Camera Angle to Communicator Credibility." *Journal of Broadcasting* 14 (1965): 483–490.

- Timberg, Bernard, and David Barker (eds.). "The Evolution of Encoding Research." *Journal of Film and Video* 14, no. 2 (1989): 3–14.
- Toffler, Alvin. The Third Wave. Toronto: Bantam Books, 1981.
- Tovee, Martin J. An Introduction to the Visual System. New York: Cambridge University Press, 1996.
- Uspensky, Boris. *A Poetics of Composition*. Berkeley: University of California Press, 1973.
- Ushenko, Andrew Paul. *Dynamics of Art.* Bloomington, Ind.: Indiana University Press, 1953.
- Vision, Gerald. *The Problems of Vision: Rethinking the Casual Theory of Perception*. New York: Oxford University Press, 1997.
- Vlastos, Gregory. "Zeno of Elea." *The Encyclopedia of Philosophy*, vol. 7. New York: Macmillan Publishing Co. and the Free Press, 1967, pp. 369–379.
- Ward, Peter. *Picture Composition for Film and Television*. Boston and London: Focal Press, 1996.
- Weintraub, Daniel J., and Edward L. Walker. *Perception*. Monterey, Calif.: Brooks/Cole, 1966.
- Weis, Elisabeth, and John Belton (eds.). *Film Sound: Theory and Practice*. New York: Columbia University Press, 1985.
- Wertheimer, Max "Experimentelle Studien über das Sehen von Bewegung." Zeitschrift für Psychologie 61 (1912), pp. 161–265.
- ------. "Untersuchungen zur Lehre von der Gestalt." *Psychologische Forschung* 4 (1923).
- Whittaker, Ron. *Television Production*. Mountain View, Calif.: Mayfield Publishing Co., 1992.
- ——. Video Field Production, 2d ed. Mountain View, Calif.: Mayfield Publishing Co., 1996.
- Willats, John. Art and Representation: New Principles in the Analysis of Pictures. Princeton, N.J.: Princeton University Press, 1997.
- Wilson, Benjamin P. "The Design, Application and Evaluation of Stereophonic Television: A Production Model." Master's thesis. San Francisco State University, 1980.
- Wingler, Hans M. *The Bauhaus*. Trans. by Wolfgang Jabs and Basil Gilbert. Cambridge, Mass.: MIT Press, 1969.

Wolfe, Thomas. The Web and the Rock. New York: Grosset and Dunlop, 1938. Wölfflin, Heinrich. Gedanken zur Kunstgeschichte. Basel: Benno Schwabe and Co., 1940. Wurtzel, Alan, and John Rosenbaum. Television Production, 4th ed. New York: McGraw-Hill, 1995. Zettl, Herbert. "Contextual Media Aesthetics as the Basis for a Media-Literacy Model." Journal of Communication 48 (1998): 81-95. —. "From Inscape to Landscape: Some Thoughts on the Aesthetics of HDTV." HD World Review 3, nos. 1 and 2 (1992). —. "The Graphication and Personification of Television News." In Gary Burns and Robert J. Thompson (eds.), Television Studies: Textual Analysis. New York: Praeger, 1989. -. "Lost in Off-Screen Space: A Problem in Video Proxemics." Paper presented at the 11th Annual Visual Communication Conference, Teton Village, Wyoming (June 1997). -. Television Production Handbook, 6th ed. Belmont, Calif.: Wadsworth Publishing Co., 1997. ---. "Toward a Multi-Screen Television Aesthetic: Some Structural Considerations." Journal of Broadcasting 21 (1977): 5–19.

Publishing Co., 1997.

-. Zettl's Video Lab 2.1. Interactive CD-ROM. Belmont, Calif.: Wadsworth

Photo Credits

Cooperative Media Group: 9.51

Lara Hartley: 7.9, 11.21, 11.22, chapter 14 p. 244, 15.28, 15.29

Daniel Hubbell: portrait p. viii, 7.51, 7.61, 8.48

Ideas to Images: 8.49 Irene Imfeld: 12.8

Steve Renick: 7.20, 7.23, 8.27, 11.16

Chris Rozales: 8.18, 8.23 W. Eugene Smith: 3.7

John Veltri: chapter 1 p. 2, 1.1, 1.5, 1.10, chapter 2 p. 16, 2.9, 2.10, 2.11, 2.12, 2.14, 2.17, 2.18, 2.19, 2.20, 2.23, 2.25, 2.26, 2.27, chapter 3 p. 32, 3.1, 3.2, 3.3, 3.4, 3.5, 3.6, 3.12, 3.13, 3.14, color plates 17, 19, and 20, chapter 6 p. 72, 6.7, 6.13, 6.14, 6.19, 6.20, 6.21, 6.22, 6.23, 6.24, chapter 7 p. 88, 7.5, 7.7, 7.8, 7.21, 7.22, 7.24, 7.25, 7.33, 7.34, 7.35, 7.36, 7.37, 7.40 profiles, 7.52, 7.54, 7.56, 7.57, 7.58, 7.59, 7.60, chapter 8 p. 114, 8.1, 8.2, 8.13, 8.14, 8.15, 8.16, 8.17, 8.28, 8.29, 8.31, 8.37, 8.38, 8.39, 8.40, 8.41, 8.42, 8.43, 8.44, 8.45, 8.46, 8.47, chapter 9 p. 140, 9.14, 9.15, 9.16, 9.17, 9.18, 9.19, 9.38, 9.39, 9.40, 9.41, 9.42, 9.45, 9.46, 9.47, 9.48, 9.49, 9.50, 9.52, chapter 10 p. 164, 10.1, 10.2, 10.10, 10.11, 10.12, 10.15, 10.16, 10.17, 10.19, 10.20, 10.21, 10.22, 10.23, 10.24, 10.27, 10.28, 10.29, 10.30, 10.31, 10.32, 10.33, chapter 11 p. 182, 11.5, 11.6, 11.7, 11.8, 11.9, 11.10, 11.11, 11.12, 11.14, 11.17, 11.18, 11.19, 11.20, 11.23, 11.24, 11.25, 11.26, 11.27, 11.28, 11.31, 11.32, 11.33, 11.34, 11.35, 11.36, 11.37, 11.38, 11.39, 11.40, 11.41, 11.42, chapter 12 p. 206, 12.5, 12.6, chapter 13 p. 224, 13.4, 13.5, 14.11, 14.12, chapter 15 p. 264, 15.2, 15.3, 15.4, 15.5, 15.6, 15.7, 15.8, 15.9, 15.10, 15.11, 15.12, 15.13, 15.14, 15.15, 15.16, 15.17, 15.18, 15.20, 15.21, 15.22, 15.25, 15.26, 15.30, 15.31, 15.32, 15.33, 15.39, 15.40, 15.41, 15.42, chapter 16 p. 290, 16.6. 16.7, 16.9, 16.10, 16.11, 16.14, chapter 17 p. 306, 17.1, 17.2, 17.8, 17.9, chapter 18 p. 326, 18.35, 18.36, 18.37, 18.38

Erika Zettl: 8.35

Herbert Zettl: 1.2, 1.6, 1.7, 2.1, 2.2, 2.4, 2.5, 2.8, 2.13, 2.15, 2.16, 2.21, 2.22, 2.24, 3.11, 3.16, color plates 15b and 16, chapter 5 p. 62, 6.2, 6.5, 6.6, 6.8, 6.9, 6.10, 6.11, 6.12, 6.16, 6.17, 6.18, 6.25, 6.26, 7.1, 7.2, 7.3, 7.6, 7.16, 7.17, 7.18, 7.26, 7.32, 7.40 (cathedral), 7.45, 7.49, 7.50, 7.53, 8.9, 8.10, 8.20, 8.21, 8.24, 8.25, 8.26, 8.30, 8.32, 8.33, 8.34, 9.7, 9.20, 9.24, 9.26, 9.28, 9.29, 9.30, 9.31, 9.32, 9.33, 9.34, 9.35, 9.36, 9.37, 9.44, 10.3, 10.4, 10.5, 10.6, 10.7, p. 170 (cathedral), 10.9, 10.13, 10.14, 10.18, 11.13, 11.15, 13.1, 13.2, 13.3, 13.24, 13.25, 14.8, 14.9, 14.13, 14.14, 14.15, 14.17, 15.1, 15.37, 16.5, 16.13

Index

asymmetry of the screen, 89, Angles. See Camera angles Α 97-99, 110-112, 122-125 Animation. See Cartoons ABC positioning, 271 color harmony, 65 Applied media aesthetics of colors, 58-59, 67-68 Above-eye-level lighting, 28-29, and context and perception, 5-10 190-192, 200-203 contextual, 5 and contextualism, 4-5 converging vectors, 110, 279-281 Abstract painting, 11-12, 67, 199, defined, 3-4 208-209 and energy, 58-59, 65-66, and medium, 10-11 320-321 Abstraction, deductive and inductive. method of presenting, 11-13 entropy, 220-221 11 - 12fields. See Light; Motion; Sound; Area Accelerated motion, 240-241 Space; Time and aspect ratio, 73-80 Achromatic axis, 50 and lens distortion, 194-196 deductive and inductive Acker, Steven, 87 and lighting, 19 approaches to, 83-86 and image size, 82-83 media, applied, 3-13 Acoustics. See Sound and object size, 80-82 and motion paradox, 234 Action areas, lighting of, 40, 44, 166, and slow motion, 239-240 Area proportion. See Screen space 168 and sound, 322-323, 304 Action continuity, 287 Arnheim, Rudolf, 31, 57, 61, 112, 139, and video/audio structural 223, 243, 325 Additive mixing of color, CP10, analysis, 355 CP11, 51-52, 59 Articulating the z-axis, 165–166, Akutagawa, Ryunosuke, 205 171-175, 181 Additive primaries. See Light Alten, Stanley R., 325, 357 primaries Artificial masking, 78 Ambient sounds, 311, 322 Adorno, Theodor, 325 Aspect ratio, 73-80 Amistad, 69 changing, 77-80 Aerial perspective, 150, 154-156 and framing, 74-77 Amplitude. See Loudness Aesthetic entropy, 220-221 matching, 79-80 Analytical montage, 293-298, 304, Aesthetics Asymmetry of the screen, 89, 97–99, 344–345. See also Montage applied media, 3-4, 11-13 110-112, 122-125

At-at theory of motion, 228–230, labile, 125-126 Cameo lighting, 39, 43, 44. 241, 302 See also Lighting neutral, 122-124, 126 Atomic clock, 212 stabile, 122, 126 Camera stages of, 122-126 angles, 198-203, 205, 274-277, Attached shadows, 20-21, 38, 42-43. See also Lighting; Shadows Barker, David, 15 and color television, 51, 54-56 Attack/decay, 327, 330-332. Baroque period, 38, 351 and cross shooting, 274 See also Sound Battleship Potemkin, 241 lens, and depth, 150-156 Attraction of mass, 96 Bauhaus, 12, 26, 68 lighting for, 44 Audi, Robert, 242 and over-the-shoulder shooting, Beer, Johnannes, 139 Audio/video balance, 309-310 195-196, 275-276 Below-eye-level lighting, 28–29, position of, 141, 176, 190–192, Augustine, Saint, and time, 216-217, 190-192, 200-203 204, 272-276 223 Belton, John, 87, 325 proximity, 250-251 Autumn Sonata, 69 Bergman, Ingmar, 69 and rack focus, 155-156 and selective focus, 154-156 Bergson, Henri, 223, 228–230, 242 В subjective, 192-195, 204 Bergson's theory of motion, 228–230, See also Lens 241 BAC positioning, 270-271 Candlelight, 36 Best Intentions, The, 69 Bach, Johann Sebastian, 343, 357 Canon, musical form, 340-342 Bigard, 209 Back light, 33-34, 44. See also Capra, Fritjof, 223 Lighting Binaural audio, 317 Caravaggio, Michelangelo Merisi da, Background Biological time, 211, 215, 222 aerial perspective of, 150, 154-156 Blaze 1, 209 Cartoons, 82, 240, 311, 320 cameo lighting of, 39, 43-44 Blocking, z-axis, 176–177, 198 chiaroscuro lighting of, 33, 35–39, Cast shadows, 21-22, 31 Blue Angel, The, 166 43-44 and cameo lighting, 39 color, 55-56 Borden, Mark, 139 and clock time, 27 flat lighting of, 39-41, 44-45 Bordwell, David, 325 and flat lighting, 39-40 and graphic vector continuity, 266 and interior scenes, 27 Boslough, John, 223 and high-key lighting, 28 See also Shadows Brecht, Bertold, 163 and lateral movement, 176 Castel, Louis-Bertrand, 68 Brightness, of color, CP5, 49-50, 59 light, 33-34, 44 Cathedrals, Gothic, 67, 90, 91, 124, and limbo lighting, 41 Bruner, Jerome S., 14 170 linear perspective, 147–149, Burnham, Jack, 71 153-154, 172 CD-ROM, 302 Burns, Gary, 162 and low-key lighting, 28 Cesium atom, 212 Burrows, Thomas D., 139 and selective focus, 154-156 Chiaroscuro lighting, 33, 35–39, 43, silhouette lighting of, 41–42, 45 Burt, George, 320, 325 See also Foreground; Chilberg, Joseph, 205 Middleground C Chords, musical, 102, 335-337, 345, Baggaley, Jon, 205 356 Balance of objects in frame Calder, Alexander, 211 Christians, Clifford G., 15 and counterweighting, 118-119 Calvary, The, 94

Christo (Javacheff), 211 Collins, Maynard, 71 and sound, 67-68 spectral, 48, 59 Chroma. See Saturation of color Collision montage, 300-304, 349-351, 357. See also Montage spill, 54 Chroma-key background, 55 subtractive mixing of, CP13 Color Chromatic scale, 333 surface reflectance of, 54, 59-60 additive mixing of, CP10, CP11, Chromaticity diagram, CP1 CP12, 51-52, 59 surrounding, 55-56 attributes of, 49-50, 52, symbolism of, CP18, 64 Cinemascope, 82-83 brightness of, CP5, 49-50, 59 and television, 50-51, 54-56, 59 Clairborne, Robert, 223 cold, 57-58, 60 temperature of, 54-55, 57-58 Clemens, Samuel L., 316 compatibility, 50, 59 tints and tones of, 49, 56 Clock time, 27, 211–212, 222, 246 compositional function of, 65-66 and video/audio structural analysis, 354-355 Close Encounters of the Third Kind, 69 constancy of, 56-57 visible spectrum of, 48, CP1 Close-ups continuity of, 288 warm and cold, 54-55, 57-58 and aspect ratio, 75-77 defined, 47-48 and white-balancing, 55 and Cinemascope, 82-83 and desaturation theory, CP20-CP23, 68-70 and continuity, 267-271, 288 Color Purple, The, 69 energy, CP19, 58-59, 65-66 and cross shooting, 196, 274-275 Colorizing film, 69 environmental, 54 and depth of field, 151-154, Colour-Music: The Art of Light, 68 170-171 expressive function of, 66-68 Commercials, 12, 50, 70, 214, 256, and field of view, 188-190, 204 and feelings, 57-58 261, 300 filters, 48, 50-53 and figure-ground, 99 Communication graphic weight of, 116 and image size, 82-83, 86 mass, 3, 12-13 and index vectors, 267-273 harmony, 65 model of, 10 and leadroom, 120-121 hues of, CP2, CP6, 49, 58 purpose of, 10-11, 308-309 informational function of, 63, and lighting intensity, 30 CP16, CP17 responsibility in, 12–13 and montage, 297 and sound, 307 juxtaposition of, CP14, CP15, 56, and noseroom, 120-121 58,65 Comparison montage, 299-300, 304, and object size, 80-82, 85 and light, 18, 54 350. See also Montage and over-the-shoulder shooting, mixing, 48, 50-53, 59 Complexity editing, 291-304 models. See Chromaticity and relation to screen area, 82 and graphic vector continuity, 266 diagram; Munsell color system and sound, 311, 317-318 and index vector continuity, mood, establishing with, 57-58, 267-278 and space orientation, 171, 177 68,70-71and subject continuity, 250-255 and motion vector continuity, Munsell system of, 61 279-286 visualization of, 183–184, 187, perception of, 48-50, 53-57 247-248 Composition physiological perception of, 48 and wide-angle lens distortion, color, 65-66, 70 primaries, CP9, 51 76-77, 174-175 two-dimensional, 115-138 as principal event, 67 Closure Conceptual art, 211 psychological factors of, 49-54 facilitating, 126-127 relativity of, 47, 53-54, 59 Cones (eye), 48, 59 illogical, 130, 138 saturation of, CP3, CP4, Constancy, color, 56-57 premature, 127-128, 138 CP20-CP23, 49, 58 Content, and aesthetics, 11-12 psychological, 101-105, 111

simultaneous contrast of, CP14, 56

Context

communication, and balance, 140–141

and dialogue variables, 314–315 and motion paradox, 265–266, 274

visualization of, 183-184

Contextualism

and applied aesthetics, 4-5

and color, 57

and perception, 5-10

Continuing vectors, 109, 112, 131–133, 266–267. See also Vectors

Continuity

and closure, 105

and dissolves, 258-260

and psychological closure, 101–105, 111

and shooting angles, 199

of sound, 323-324

Continuity editing, 265-289

and action continuity, 287

and continuity of environment,

288

and graphic vector continuity, 266

and index vector continuity,

267-278

and motion vector continuity,

279–286

and sound, 323

and subject continuity, 288

Continuous set, 171

Contrapuntal music, 340-343

Contrast, in lighting, 22, 24, 56

Contrast falloff, 24

Converging vectors, 109–110, 121, 135, 256–257, 268, 272–273,

279–281. See also Vectors

Cooper, Fenimore, 316

Coppola, Francis Ford, 357

Corbusier, Le (Charles-Edouard Jeanneret), 124, 139 Costumes, and color energy, 76

Counterpoint, in music, 321, 337–340, 356

Counterweighting objects in frame, 118–119

Crescendo, 331

Cries and Whispers, 69

Crossfade, 350

Cross shooting, 195-197, 274

Crowding effect, 248

Cubist painting, 199, 208

Cutaways, 276

Cutting (image change), 155, 165, 252, 256–259, 262. See also

BAC positioning; Transitional

devices

D

da Messina, Antonello, 94

da Vinci, Leonardo, 20, 40, 124, 162

Daniel-Henry Kahnweiler, 208

Dassin, Jules, 263

Davies, Paul, 223

Daytime lighting, 26–27, 31. *See also* Light source; Lighting

De Voto, Bernard, 325

Dean, Alexander, 112

Dearstyne, Howard, 15

Decay of sound, 327, 330–332. *See also* Sound

Decoding messages, 11

Deductive abstraction, 11

Deductive visual approach, 83-84, 87

Deerslayer, The, 316

Defocus effect, 104

Density, frame, 238, 240, 242

Depth of field, 141–162, 166, 181. *See also* Z-axis

Desaturation theory of color, CP20–CP23, 49, 68–70

Descriptive nonliteral sound, 313

Diagetic sounds, 312, 324

Dialectic principle, 303-304

Dialogue, 307, 314-315, 324

and multiple texts, 348

Diatonic scales, 333-334

Digital video effects (DVE), 100, 160–161, 178, 181, 231–232,

260–262. *See also* Transitional

devices

Dimenuendo, 331

Direct-address method, 194–195,

314–316, 324

Directional forces. See Vectors

Directional function of lighting, 36

Dissolves, 155, 258–260. *See also* Transitional devices

Distance. See Depth of field

Distortion, lens, 172-175

Diverging vectors, 110–111, 281–282.

See also Vectors

Dollying and zooming, 155, 238, 250, 253–255, 262

Donsbach, Wolfgang, 205

Downlink, television, 218

Dramatic agent, lighting as, 30

Dramaturgy, and sound, 344-345

DreamWorks film production company, 69

Duchamp, Marcel, 209

Duncker, Karl, 243

Duration of sound, 329, 356.

See also Sound

Durée, 228

Dürer, Albrecht, 124, 148

DVE. See Digital video effects

Dynamics. See Loudness
psychological closure in, 101–105,

111

energy of, 218-219

E	intensity of, 187–188, 191,	Field forces
	200–203, 205, 214, 219	asymmetry of screen, 89, 97–99,
Editing, 69, 221. <i>See also</i> Complexity editing; Continuity editing	live transmission of, 185, 217–219	110–112, 122–125
	looking at, 186–187	figure-ground, 99–101, 111, 179–180, 181
Edman, Irwin, 4, 14	pace and rhythm of, 249–250, 260 recorded, 216	and magnetism of frame, 92–96,
EFP (electronic field production), 309	slow motion, 238–240	116–119
	subjective time of, 211–215, 222,	main directions of, 89-91, 111
8½, 30	249–250	and psychological closure,
Einstein, Albert, 211, 223	synthesis of, 303-304	101–105, 111
Eisenstein, Sergei, 64, 71, 181, 241, 243, 302–303, 305	viewer participation in, 192	and vectors, 106–112
	Experience intensity, 214–215	Field of view, 188–190, 204
Eisler, Hans, 325	Expressive function of color, 63,	and aspect ratio, 86–91 and z-axis articulation, 171–175
Electromagnetic waves, 17–18	66–68, 70	See also Close-ups; Long shots;
Electronic field production, 309	External condition, sound for,	Medium shots
Electronic news gathering, 309	319–320	Figure-ground paradox, 179–181
Ellipsoidal spotlight, 19	Eye, and color perception, 48, 59	Figure-ground relationship, 6,
Encoding messages, 11		99–101, 234–236
Energy	F	and dissolves, 258–259
of color, 58–59, 67–68	Error lighting of 29 20 26 27	and sound, 322–323
and image size, 94	Faces, lighting of, 28–29, 36–37. See also Close-ups	Fill light, 33–34, 37, 44
of light, 17–18	Fackler, Mark, 15	controlling, 23–24
and sound, 309–310	Fades, fade-outs, 260, 263. See also	See also Lighting
ENG (electronic news gathering),	Transitional devices	Film
309	Falloff, 22–24	aesthetics of, 10, 13, 228, 241, 302
Entropy, aesthetic, 220–221	and cameo lighting, 39, 43–44	aspect ratio of movie screen, 74
Envelope, sound, 330–331	and chiaroscuro lighting, 33,	and balance in frame, 116–117, 122–126
Environment, and sound, 318.	35–39, 43–44	and color, 53–54
See also Ambient sounds	controlling, 23–24	colorizing, 69
Ernst, Bruno, 181	and daytime lighting, 26–27	communication functions of,
Escher, M. C., 181	fast, 22–25, 36, 44 and flat lighting, 39–41, 43, 45	10–11, 17, 307
E.T.: The Extra-Terrestrial, 69	slow, 22–25, 36, 44	complexity in, 291–292
Ethics, and aesthetics, 12-14	See also Lighting; Shadows	cuts, 155, 165, 252, 256–259, 262 direct-address method in,
Evaluation, formative, 4	Fanny and Alexander, 69	194–195, 314–316
Evans, Ralph M., 60	Fast motion, 240–241	editing, 69, 221-222. See also
Events, screen		Complexity editing; Continuity
complexity of, 265, 291–292	Fell, John, 305	editing
creating, 186–188	Fellini, Federico, 30	image elements of, 11, 13–14 and motion, 227–228, 238–241,
density of, 214	Festinger, Leon, 14	242

Film (continued) running time of, 246 shot time in, 247 slow motion in, 238-240 sound in, 308, 310-311, 356-357 structural unit of, basic, 227–228 on television, 219-222, 232 tertiary motion in, 250, 255-262, time/motion image element, 11, 13-14, 207-211 time vectors in, 219-222 vectors in, 106-109 viewer/performer relationship in, 192-194 Zeno's theories and, 225-227 Film Form and Film Sense, 64 Film frames accelerated motion in, 240-241 and natural dividing lines, 128 - 130slow motion in, 238-240 Zeno's theories and, 225-227 Film lighting, 17–18, 42–45 Film screen. See Screen space Film sound, 308, 310-311, 356-357 Film-style lighting, 44 Filmic time, 216, 256 Filters, light, 48, 51-53. See also Lighting; Lighting instruments First-order space, 158 Five-dimensional field, 307-324. See also Sound Flags, 44 Flashback, flash-forward, 221, 347 Flat lighting, 33, 39–41, 43–45. See also Lighting; Lighting instruments Floodlights, 19, 23-24, 43 Fluorescent lighting, 55. See also Indoor lighting Focus, selective, 154-156. See also

Depth of field

Forced perspective, 149 Foreground aerial perspective, 150, 154-156 color, 55-56 and lens distortion, 172-175 and linear perspective, 147-149, 153-154, 172 selective focus of, 154-156 See also Background; Middleground Form follows function, 12 Four-dimensional field, 207–222 and complexity editing, 291-304 and continuity editing, 265–289 primary motion, 250-252, 262 secondary motion, 252-255, 262 tertiary motion, 255-263 and timing, 245-250 Frame asymmetry of the, 89, 97–99, 110-112, 122-125 counterweighting objects in, 118-119 density, 238, 240, 242 diagonals in, 97-98 freezing the, 230-231, 239, 242 headroom in, 93 magnetism of the, 89, 92-96, 116-119, 125, 137 and natural dividing lines, 128-130 pull of edges of, 94-96 of reference, 234-235 secondary, 78, 158-159, 174-175 Framing, 74–77, 126–130 and natural dividing lines, 128-130 and secondary frame, 78, 158-159, 174-175 Fraser, J. T., 210, 222 Freeze-frame, 230-231, 239, 242 Fresnel spotlights, 19, 30. See also Lighting; Lighting instruments

Fugue, musical form, 342-343, 356

Future time, 216, 222, 256. See also Time, Time vectors G Gadamer, Hans-Georg, 14 Gance, Abel, 87, 297 Gels, lighting, 48 Geographical matching, 351–352, 357. See also Matching criteria Gestalt, 102-103, 105, 291 and complexity editing, 291-304 object framing, 74-77, 126-130 television image, 104 video/audio, 345 Giotto di Bondone, 144 Girl Before a Mirror, 10 Gobos, 44 Golden section, 122–124, 139 Goldstein, Bruce E., 14, 60, 113 Gothic cathedrals, 67, 90-91, 124, 170 Goudsmit, Samuel A., 223 Graphic depth factors, 143-156, 161 Graphic mass, 96, 116-119, 137 Graphic vectors, 106-112, 121-122, continuing, 109, 112, 132, 266 converging, 110, 112 direction of, 109-112 diverging, 110, 112 magnitude of, 108-109, 112 off-screen space limits of, 132-133 See also Linear perspective; Vectors Graphic weight, and balance, 96, 116-119, 122, 125, 137 Graphication devices, 157-162 first- and second-order space, 158-160, 162, 178 lines and lettering, 157, 162

topological and structural

changes, 160-162

Inner orientation Gravity, absence of, in slow motion, Homophony sound structure, 335-336, 345-346, 356. See also 239 of light, 17-18, 28-31 Picture/sound combinations of sound, 320-321 Grayscale steps, CP7, CP8, 49 Hopkins, Gerard Manley, 243 Inscape vs. landscape films, 232, 242 Griffith, D. W., 78, 325 Horizon line, 91, 148 Instant replays, 221–222 Gropius, Walter, 12, 15 Horizontal plane, 89-91, 105-106 Instantaneous editing, 265, 289 Gross, Lynne S., 139 depth cues, 109, 146 Intellectual montage, 302. Gulliver's Travels, 82 tilting of, 9, 90-91 See also Montage vanishing point, 147 Intensity, creating, 104, 187-188, 191, Н Hue, of colors, CP2, CP6, 49, 58. 200-203, 205, 214, 219 See also Color Interior lighting, 26–27, 30, 266. Hahn, Lewis Edwin, 14 Hyde, Stuart, 14 See also Light source; Lighting; Haiku poetry, and collision montage, Lighting instruments Hz, 327. See also Sound 301 Interlaced scanning, 243 Hall, Edward T., 163, 205 Internal condition, and sound, 320 ı Harmonic structure, 345 Internal dialogue, 314 Harmonics, 329 Idea-associative montage, 298-304, Internet Web pages, 115, 302 350, 357. See also Montage Harmony, 335, 345, 356. See also Interviews, positioning subjects in, Color harmony; Homophony Image elements, of TV and film, 11 270-271 sound structure; Polyphony **Images** Intolerance, 8 HDTV. See High-definition television fundamental elements of, 11 Isolation through diverging vectors, Headroom in frame, 93 high- and low-definition, 103-104 134-135 size of, 82-83, 94 Hegel, Georg W. F., 303, 305 Itten, Johannes, 12, 26, 31 and sound, 345-355 Hegelian dialectic, 303 static, 225-226 Height, screen, 141-142, 161 J Imitation in contrapuntal structures, Helmholtz, Hermann L. F. von, 68 340-341 Janega, Patti, 205 Heraclitus, 303 Incandescent lighting, 55. See also *Iaws*, 69 Indoor lighting Hertz, 327. See also Sound Jeanneret-Gris, Charles E., 124, 139 Index vectors, 106–107, 112, 119–122, High-definition images, 103-104 138, 148, 200, 205, 253, 327 Jogging, 240-241, 258, 320 High-definition television (HDTV), combinations of, 131, 133-135 74–75, 103–104, 233, 243, 310, Josephson, Sheree, 113 continuity of, 109-110, 267-278 Jump cut, 199, 256-258. See also z-axis, 197 High-fidelity stereo sound, 309-310 Transitional devices See also Vectors High-key lighting, 28, 31, 41, 43, 45. Jurassic Park, 69, 263 See also Lighting; Lighting Indoor lighting, 26–27, 54–55. See also Lighting; Light source instruments Historical matching, 351-352, 357. Inductive abstraction, 11-12 K See also Matching criteria Inductive visual approach, 84-86 Kandinsky, Wassily, 11-12, 15 Hitler, Adolf, 12, 243 Informational function Katz, Steven D., 87, 205, 305 Homophonic video/audio structure, of color, 63-64, 70 346, 354-355

of sound, 314-316

Kepes, Gyorgy, 68, 71

single- and multiple-camera, 44

Kepplinger, Hans M., 205 narrow-angle, 150-156 single, 19-20, 27, 35 and perceived object speed, sunlight, 18-19, 26, 47, 59. See also Key lights, 28, 31, 33-34, 37, 41, 236-238 Light; Lighting instruments 43-44. See also Light source; Lighting; Lighting instruments and rack focus, 155-156 Lighting wide-angle, 150-156 Kicker lights, 33-34, 37. See also Light above and below eye level, 28-29 source; Lighting; Lighting Lestienne, Remy, 222 back, 33-34, 44 instruments cameo, 39, 43-44 Leviant, Isia, 56, 61 Kinetic sculptures, 211 chiaroscuro, 33, 35-39, 43-44 Lewin, Kurt, 113 King, Martin Luther Jr., 216 and clock time, 27 Light for color television, 53-56, 59 Kipper, Philip, 223, 243 and brightness, 22-24, 26 contrast in, 22 Klee, Paul, 12 and color, 18, 54 daytime, 26-27, 31 Klein, Adrian Bernard, 68 and color mixing, 50-53, 59 fill, 23-24, 33-34, 37, 44 contrast, 22 Kline, Franz, 209 for film and TV, 17-18, 42-45 edge, 23 Koffka, Kurt, 105, 113, 139 and filters, color, 48, 51–53 and falloff, 22-24, 26 flat, 33, 39-41, 43-45 Köhler, Wolfgang, 105, 113 functions of, 18-24, 36-38, 40-41 fluorescent, 55 Kracauer, Siegfried, 305, 310, 325 hard, 24 functions of, 18-24, 36-38, 40-41 Kuleshov, Lev Vladimirovich, 299, and inner orientation, 17–18, gels, 48 305 28 - 31high-key, 28, 31, 41, 43, 45 nature of, 17-18, 30-31 Kurosawa, Akira, 205 incandescent, 55 organic function of, 36 inner orientation of, 17-18, and outer orientation, 24-27 28 - 31primaries, 51-52, 59 intensity control of, 19, 28, 30 purposes and functions of, 18 La Dolce Vita, 30 interior lighting, 26-27, 30 and shadows, 19-24 key, 28, 31, 33-34, 41, 43-44 La Tour, Georges de, 36-37 shows, 67, 70 limbo, 41 Labile balance, 122, 125-126, 138 soft, 24 low-key, 28, 31, 35, 43, 45 Landscape vs. inscape films, 232, 242 surface reflectance of, 54 media-enhanced and mediaand video/audio structural Langer, Susanne, 14 generated, 42-43 analysis, 354 Laser light shows, 67, 70 for mood and atmosphere, 18, 22, See also Light source; Lighting 28-31, 35-36 Lateral action on stage and screen, Light source nighttime, 26-27, 31 above and below eye level, 28-29 outer orientation of, 17, 24-27, 31 LCD, process image of, 232 for chiaroscuro lighting, 36-37 photographic principle of, 33 Le Corbusier. See Corbusier as dramatic agent, 28-30, 35, 37, predictive, 29-31 40-41 Leadroom, 120-121, 138 Rembrandt, 38, 43-44 for indoor lighting, 26-27, 30 Legato rhythm, 259-260 seasonal, 27, 31 for lighting faces, 22-23, 25, set, 33-34 Leitmotiv, 319 28-29, 35-37 setups, 34, 37 Lens moving, 30 and shadows, 19-31, 42-43 aerial perspective of, 150, 154-156 outdoor, 18, 26, 54-55 side, 33-34 depth characteristics of, 150–156 predictive, 29-30 silhouette, 41-43, 45 distortion, and z-axis, 172-175 and shadows, 19-24, 27

Eisenstein's theory of, 302

Media, 3, 11–14. See also Film; and space orientation, 19, 24, Low-definition images, 103-104, 309, Television 30 - 31, 35324 for tactile orientation, 24-26 Media aesthetics, applied, 3-15, 225 Low-key lighting, 28, 31, 35, 43, 45 techniques of, standard, 33-34 Media-enhanced and -generated LS. See Long shots time orientation of, 26-27 lighting, 42-43 Lucas, George, 15 triangle, 33 Medium as stuctural agent, 10-11 See also Film lighting; Light; Medium shots, 95, 172, 350 Television, lighting for M and field of view, 188-190 Lighting instruments, 30 and figure-ground, 99 McCain, Thomas A., 205 background lights, 39-41, 44-45 Meeting at the Golden Gate, The, 144 McLaren, Norman, 68 back lights, 33-34, 44 Melody, as sound, 333-334, 344 as dramatic agents, 30-31 McLuhan, Eric, 15 and homophony, 335-336 ellipsoidal spotlights, 19 McLuhan, Marshall, 10, 15, 71, 113, fill lights, 23-24, 33-34, 37, 44 and polyphony, 337-343 325 See also Music; Picture/sound and filters, 48 McQuail, Denis, 181 combinations flags, 44 Magnetism of the frame, 89, 92–96, Messaris, Paul, 15 floodlights, 23-24, 43 116-119, 125, 137 Fresnel spotlights, 19, 30 Metallinos, Nikos, 112 Main directions of the screen, 89–91. and gels, 48 See also Horizontal plane; Metamessages, 178 gobos, 44 Vectors; Vertical plane Metric montage, 292, 302, 304. key lights, 28, 31, 33-34, 37, 41, Major diatonic scale, 333 See also Montage Makeup, 55 Metz, Christian, 317, 325 kicker lights, 33-34, 37 Mancini, Mark, 325 Meyrowitz, Joshua, 15, 222 scoops, 19, 43 side lights, 33-34 Mandell, M., 205 Middleground, 165-166, 174 spotlights, 19, 23-24, 34, 43 Mannerist (post-Renaissance) Millerson, Gerald, 31 strobe lights, 226-228 period, 38 Minor diatonic scale, 334 television, 17-18, 42-45, 53-56, 59 Marx, Karl, 303 Minturn, A. L., 14 See also Light; Light source; Masking, 78 Lighting Mitchell, William J., 45 Mass Limbo lighting, 41 Mixing of color. See Additive mixing attraction of, 96 of color; Subtractive mixing of Lindgren, Ernest, 325 graphic, 96, 115-119, 137 Linear perspective, 147–149, motion of, 233-234 Modular (Le Corbusier), 124 153-154, 172 Mass communication, 3, 12-13 Moholy-Nagy, László, 12, 14–15, 68, Liquid crystal display (LCD) images, 71, 181, 223 Matching criteria (picture/sound) 232 Moiré effects, CP15, 56 historical-geographical, 351-352, Literal sound, 307, 311-313, 323-324 357 Monochrome television, 50, 63 Long shots, 76, 82, 95, 188–190, 204, structural, 352-255, 357 Montage thematic, 352, 357 analytical, 293-298, 304, 344-345 Looking at and looking into events, tonal, 352, 357 186-187, 219 collision, 300-304, 349-351, 357 See also Picture/sound comparison, 299-300, 304, 350 Loudness, 309, 329-330. combinations See also Sound

Mathias, Harry, 60

Montage (continued)	Movies. See Film	Narrow-angle lens, 151–156, 171–172
idea-associative, 298–304, 350,	Moving light source, 30	and aerial perspective, 155–156
357		and depth of field (z-axis),
intellectual, 302	Mozart, Wolfgang Amadeus, 319	150–151
metric, 292, 302, 304	MS. See Medium shots	distortion of, 172–174, 181
overtonal, 302	Mueller, Conrad, 71	and linear perspective, 153–154,
rhythmic, 302	Multiple cameras, 44, 177, 274–275,	156 and overlapping planes, 151, 156
sectional analytical, 296–298, 304, 345, 350, 357	277–278, 284–287	and relative size, 152, 156
sequential analytical, 293–295,	Multiple screens, 130–136	and traffic density, 172
304, 344, 349–350, 356	z-axis vectors in, 135–136	Natural dividing lines, 128–130
tonal, 302	Multiple texts, 348, 356	
Montagu, Ivor, 243	Multiple z-axis blocking, 177, 198	Negative volume, 165–166, 169–170, 181. <i>See also</i> Volume duality
Mood and atmosphere, establishing, 28, 320	Multiscreens, 130–136, 138, 348–349, 356	Neutral balance, 122-124, 126, 138
and color, 57–58, 68, 70–71	Munsell, Albert H., 61	Newborn Child, The, 36–37
lighting for, 18, 22, 28–31, 35–36	Munsell color system, 61	Newton, Sir Isaac, 68
and shadows, 22, 28–30	Murch, Walter, 223, 263, 305, 325	Nighttime lighting, 26–27, 31.
and sound, 320, 324	Music	See also Light source; Lighting
tonal matching, 302	canon, 340–342	Noise, 307–308, 323. See also Sound
Moore, Henry, 170	chords, 102, 335–337, 345, 356	Nondiegetic sounds, 312, 324
Mosaic effect, 160, 231	and counterpoint, 321, 337-340,	Nonliteral sound, 311–313, 319,
Mosjukhin, Ivan, 299	356	323–324
Motion	contrapuntal, 340–343	Noseroom, 120–121, 138
accelerated, 240–241	effects, 320–321	Notan lighting. See Flat lighting
at-at theory of, 228-230, 241, 302	energy, 320–321 fugue, 342–343, 356	Nude Descending a Staircase, 209
Bergson's theory of, 228–230, 241	harmony, 335, 345, 356	
in film, 227–228	homophony, 335–336, 345–346,	0
and media structure, 225–233	356	
paradox, 225–227, 233–236, 242 pictures. <i>See</i> Cinemascope; Film	and mood, 320, 324	Object-connected and -disconnected shadows, 21
primary, 250–252, 262	notation, 327, 329, 330	
principal, 250–262	and pitch, 327–328, 339, 356	Object framing, 126–130, 137
secondary, 250, 252–255, 262	and picture/sound matching, 345–357	Object size, 80–82
slow, 238–240, 242	polyphony, 337–343, 345–349,	height in plane, 146
tertiary, 250, 255–262, 355	356–357	relative, 145, 152
and time, 230–233, 245–250, 262	terms, and colors, 67-68	Objective time, 27, 211–212, 222, 246. <i>See also</i> Time
vectors, 108, 279–286 z-axis, 236–238, 282–284		Off-center position, and graphic
Zeno's theory of, 225–227, 241	N	weight, 117, 127–128, 132–133,
See also Vectors	Napoléon Bonaparte, 297	318
Movie screen aspect ratios, 74		Off-screen space limits, 132–133
movie selecti aspect fatios, 74	Narration, 316, 324	Old Woman Reading, 38

Open set, 170–171	Kandinsky approach to, 11–12	Photographic principle, 33
Optical illusion, 8–9	and overlapping planes, 144, 146	Photography color filters, 48, 50–53
Orientation	Persian, 146	
horizontal, 89–91, 105, 111	pointillism, 52	principles, 33
vertical, 89–91, 105	Rembrandt lighting, 38, 43–44	and shutter speed, 210, 227
Orientation and lighting, 24–30	Pan-and-scan process, 79	and third dimension, 141
inner, 17–18, 28–30, 31	Panavision, aspect ratio of, 74-75, 86	time and motion, 210, 225–227
outer, 24–27, 31	Paradox	time lapse, 210
spatial, 24, 31	figure-ground, 179–181	Picasso, Pablo, 10, 208, 248
tactile, 24–26, 31	motion, 225-227, 233-236, 242	Picture/sound combinations,
time, 26–27, 31	Parallel lines, 144, 172	345–357
Orientation of sound	Park, David, 223, 242	counterpoint structure, 321 gestalt of, 345
and external condition, 319–320, 324	Past (time), 216, 222, 256. See also Time; Time vectors	homophonic structures, 346, 354–355
inner, 320–321, 324	Patterson, Richard, 60	irregular structure, 321
outer, 317–320, 324 situational, 319, 324	Pawlik, Johannes, 60	matching criteria, 351–355, 357
spatial, 317–318, 324	Pedestal (camera motion), 250	montage, 349-351, 356-357
time, 318–319, 324	Pentagram, 124	parallel structure, 321
Ornstein, Robert, 14	Pepper, Stephen C., 14, 223	polyphonic structures, 345–349, 356–357
Outdoor film, 53	Perception	and rhythm, 321
Outdoor light, 18, 26, 53–54	of color, 48–50, 53–57	Picturization. See Complexity
Over-the-shoulder shooting,	and context, 5–10	editing; Continuity editing
195–196, 275–276	of depth cues, 171–172	Pirsig, Robert M., 223
Overlapping planes, 144–145, 151	and figure-ground phenomenon,	Pitch, 327–328, 339, 356
Overtonal montage, 302.	179–181 and light, 48	Pixels, 104, 231–232
See also Montage	of psychological closure, 101–105,	Plasma display images, 232
Overtones, and timbre, 328.	111	Plot, 314, 345
See also Sound	of size constancy, 82-83, 86	Point of view
	See also Linear perspective	camera angles for, 200–201
P	Performance rhythm, 249–250, 262–263	looking up and looking down, 190–192
Pace of timing, 249, 262	Persian painting, 146	subjective camera, 192–195
Paine, Frank, 325	Personification, 159–160	Pointillists, 52
Paint primaries, CP9, 51	Perspective	Polyphony, 337–343, 345–349,
Painting	aerial, 150, 154–156	356–357. See also Picture/
abstract, 11–12, 67, 199, 208–209	forced, 149	sound combinations
chiaroscuro, 35–39	linear, 147-149, 153-154, 172	Polyvision, 87
cubist, 199, 208	sound, 322, 324	Positive volume, 166–168, 181.
and deductive abstraction, 11	two-point, 149	See also Volume
and inductive abstraction, 12	Phasing of video and audio, 347	Posterization, 43

Postproduction editing, 265, 272, 287-289, 308-309, 311, 324. See also Complexity editing; Continuity editing

Predictive lighting, 29–31. See also Light source; Lighting; Lighting instruments

Predictive sound, 319

Present (time), 216, 222, 256. See also Time; Time vectors

Primary colors, CP9, 51. See also Color

Primary motion, 250-252, 262. See also Motion

Prism, 18, 47

Progressive scanning, 243

Prometheus: The Poems of Fire, 68

Proportion. See Aspect ratio; Golden section; Screen space

Proportionslehre, 124

Proximity, and closure, 105

Psychological closure, 101-105, 111 and complexity editing, 291-304 and gestalt, 102-103, 105, 291 facilitating, 126-127 illogical, 130, 138 and object framing, 74-77, 126 - 130premature, 127-128, 138

Psychological time, 211-215, 222, 249-250

Pudovkin, Vsevolod Illarionovich, 243, 308, 325

Pythagoras, 124

R

Rack focus, 155-156 Raiders of the Lost Ark, 69 Rashomon, 10, 192 Rausch, Jürgen, 223

Rebay, Hilla, 15

Reclining Figure, 170

Reflection of light, 54. See also Light; Light source; Lighting

Reflection of reality, 308

Relative size, 145-146, 161 and lenses, 152-153, 156 paradox, 180

Rembrandt lighting, 38, 43–44. See also Light source; Lighting; Lighting instruments

Rembrandt van Rijn, 38

Renaissance, 20, 38, 90-91, 124, 148

Responsibility, as communicator, 12-14

Reverse modeling, 28

Rhythm

and accelerated motion, 240-241 counterpoint, 321, 337-340, 356 cutting for, 256, 315 and dissolves, 260

of events, 219, 249-250, 262, 292

and montage, 302 of sound, 321, 324

structural, 321, 324

and tension, 341

of timing, 249–250, 262–263

visual, 105

See also Music; Sound

Rhythmic montage, 302. See also Montage

Riefenstahl, Leni, 243

Rififi, 263

Riley, Bridget, 61, 209

Roberts, Donald F., 15

Rock, Irvin, 87, 113, 139

Rods (eye), 48,

Round, music form, 340-342, 356

Running time, 246, 262. See also Time

S

Saturation of color, CP3, CP4, CP20-CP23, 49, 58. See also Color

Scales, in melodies, 333-334

Scanning, TV, 231, 243

Scene pace, 249, 262

Scene time, 245, 247. See also Time

Scenery, in open set, 170–171

Schindler's List, 69

Schlemmer, Oskar, 12

Schönberg, Arnold, 333

Schramm, Wilbur, 15

Schubert, Franz, 336

Schubin, Mark, 87

Schultz, Hans Jürgen, 223

Schwartz, Tony, 71

Scoops, 19, 43. See also Lighting instruments

Screen images

blocking, 176–177, 198

Cinemascope, 82-83

deductive visual approach to, 83-84, 87

depth cues for, 141-162, 166, 181

and dissolves, 155, 258-260 and fades, 260, 263

high- and low-definition, 103-104

inductive visual approach to,

84-86

mass of, graphic, 96, 115-119, 137

and motion, 250-263

multiple, 78-79, 135-136

and psychological closure,

101-105, 111

simultaneous screen space, 199

size of, 82-83, 94

and sound, 345-355

television, 11

visualization of, 183-205

Screen-left and screen-right, 98-99, 120-122, 269, 317 Screen presence, 261 Screen space, 73-86 and aspect ratio, 73-80 asymmetry of, 89, 97-99, 110-112, 122-125 attraction of mass in, 96 borders, 73, 79 center, 117-119 figure-ground phenomenon, 6, 99-101, 234-236 Golden section, 122-124 graphic weight in, 96, 116-119 height of, 141-142, 161 horizontal, 89-91 lateral action on, 176 and magnetism of the frame, 92-96, 116-119 main directions of, 89-91 and multiple screens, 78-79, 135 - 136and object size, 80-82 off-screen limits, 132-133 screen-left and screen-right, 98-99, 120-122, 269, 317 screens within, 136-137 split, 78-79, 135-136, 138 stability of objects in, 116-119 two-dimensional, structuring, 115-138 vectors as directional forces in, 106 - 111vertical, 89-91 See also Screen images; Television screen Screen width, 141-142, 161

Scriabin, Alexander N., 68 Seasons, lighting for, 27, 31. See also Light; Lighting; Lighting instruments

Screens, multiple, 130-136, 138,

348-349, 356

Second-order space, 158

Secondary frame, 78, 158-159, 174-175

Secondary motion, 250, 252-255, 262. See also Motion

Sectional analytical montage, 296-298, 304, 345, 350, 357. See also Montage

Selective focus, 154-156. See also Depth of field

Selecting seeing, 6–7, 13

Sequence motion. See Tertiary motion

Sequence pace, 249, 262

Sequence time, 247. See also Time

Sequential analytical montage, 293-295, 304, 344, 349-350. See also Montage

Set light, 33-34

Seurat, Georges Pierre, CP12

Seventh Seal, The, 69

Shading. See Falloff

Shadow gradient. See Falloff

Shadows

attached, 20-21, 28, 38, 42-43 background, 26, 38 cast, 21-22, 27 and chiaroscuro lighting, 33, 35-39, 43-44 and color television, 57 as definers of space and shape, 19-20 and falloff, 22-24 and fill light, 23-24, 33-34, 37, 44 and nighttime lighting, 26–27 object-connected and -disconnected, 21

Shaw, D. L., 205

Shot time, 247-248, 262. See also Time

Shots, 183, 247-248, 262 length of, 247-248 rhythm of, 249-250 sequence of, 247-248

Shrivastava, Vinay, 325

Side light, 33-34

Silence, The, 69

Silhouette lighting, 41–43, 45. See also Light source; Lighting; Lighting instruments

Similarity, and closure, 105

Simultaneous contrast, 56

Single-camera lighting, 44

Situational sound, 319, 324. See also Sound

Size constancy, 82-83, 86

Skin, lighting for, 25, 53

Slow motion, 238-240, 242. See also Motion

Smith, Thomas G., 15

Smith, W. Eugene, 35

Solarization effect, 43, 160

Sound

aesthetic factors in, 322-323, 324 ambient, 311, 322 attack or decay of, 327, 330-332 and audio/video balance, 309-310 and color, 67-68 and context, 312-313, 315 continuity of, 323, 324 decay or attack of, 327, 330-332 dialogue as, 314-315, 324, 348 direct address as, 314-316, 324 and dramaturgy, 344-345 duration of, 329 and energy, 320-321 envelope, 330-331 and figure-ground principle, 322-324 in film, 308, 310-311 and flashbacks, 347 functions of, 317-321, 324 and harmony, 335, 345 high-fidelity stereo, 309-310 historical and geographical

matching to pictures, 351-352

Sound (continued) and homophony, 335-336, 345-346 images and, 345-355 informational, 314-316, 324 inner orientation of, 320-321, leitmotiv, 319, 324 literal, 307, 311-313, 323-324 and location, 317-318 loudness of, 309, 329-330 and melody, 333-334, 344 and mood, 320, 324 and multiple texts, 348, 356 narration as, 316, 324 and noise, 307-311, 323 nondiegetic, 312, 324 nonliteral, 311-313, 324 outer orientation of, 317-320, 324 perspective of, 322, 324 phasing of, 347 pickup, 309, 324 and pictures, 345-355 pitch of, 327-328 and polyphony, 337-343, 345-349 predictive, 319, 324 and psychological closure, 102 situational, 319, 324 source-connected and -disconnected, 311 and structure, 321, 352-355 "sweetening" of, 308, 311 technical limitations of, 309 for television, 308-310, 324 thematic matching to pictures, 352 timbre of, 328-329 and time and seasons, 318-319, tonal matching to pictures, 352 vectors, 330-332 See also Music; Rhythm

Space first-order, 158-160, 162, 178 modulators, 166, 169-171, 253-255 off-screen, 127, 318 orientation, 317-320 second-order, 158-160, 162, 178 and time, 211 See also Negative volume; Positive Volume Spanish Wake, 35 Spatial orientation, 24 Spatial paradoxes, 178-180 Special effects, 260-261 Spectral colors, 48, 59 Speech, 203, 310-311, 314-316 Spielberg, Steven, 69, 263 Split screen, 78-79, 135-136, 138 Spotlights, 19, 23-24, 34, 43. See also Lighting; Lighting instruments Stabile balance, 122, 126 Static images, 225-226 Sternberg, Josef von, 166 Story time, 245, 248, 262. See also Time Storyboards, 184-185, 204 Strobe flashes and motion, 226–228. See also Lighting instruments Structural agent, medium as, 10–11 Structural analysis, video/audio, 353-355 Structural changes, 160-162 Structural matching of sound and pictures, 352-355, 357 Structural rhythm, 321, 324 Style, angles for, 203 Subject continuity, 288 Subjective camera, 192–195, 204

Subjective time, 211–215, 222, 249-250. See also Time Subtractive mixing of color, CP13, 52, 59 Sunday Afternoon on the Island of La Grande Jatte, CP12 Sunday's Children, 69 Sunlight, 18, 23-24, 26-27, 47, 59 Superimposition, 100, 178, 199 Surface reflectance of color, 54, 59-60 Swishpan, 253 Switching, 265, 289 Symbolism of color, 64 Synthesis, 303 Tactile orientation, 24-26, 31 Taylor, Frank A., 60 Technirama system, 87 Telephoto lens. See Narrow-angle lens Television accelerated motion in, 240-241 aesthetics of, 4, 11-13, 218 and balance in frame, 116-117, 122-126 and Bergson's theory, 229-232 cameras, 51, 54-56 and color, 50-51, 54-56, 59 commercials, 12, 50, 70, 214, 256, 261, 300

communication functions of,

direct-address method in,

194-195, 314-316, 324

3, 12-13, 307

digital, 231-232

editing, 69, 221

film on, 219-222, 232

frame, 74-76, 78, 230

image size, 82-83, 94

freeze frame on, 239 lateral action on, 176 Timbre, 328-329, 338-339. See also Sound high-definition (HDTV), 74-75, and magnetism of the frame. 89, 92-96, 116-119, 125, 137 103-104, 233, 243, 310, 324 Time main directions of, 89-90, 111 image elements of, 11 biological, 215 and image size, 82-83 screen-left and screen-right, bridge, 250 98-99, 120-122, 269, 317 lighting for, 17–18, 42–45, 53–56, clock, 27, 211-212, 222, 246, 262 Television sound, 308-310, 324 direction of, 215-217 live transmission on, 217-219, 222 Television time, 217–222. importance of, 207-210 low-definition image of, 103-104, See also Time motion and, 230-233 309, 324 Tension objective, 27, 211-212, 222, monochrome, 50, 63 245-248 and converging vectors, 110, and motion, 207, 225, 230-232, 279-281 orientation, 26-27, 31 238-239, 240-241 and counterpoint, 337-340, 356 past/present/future, 216, 222, 256 multiscreen, 78-79, 135-136 and golden section, 123 psychological. See Subjective time process image of, 230-232 and labile balance, 125 running, 246, 262 and psychological closure, through sound, 338-341 scene, 245, 247, 262 103-104 sequence, 247, 262 recorded, 219-222 Tertiary motion, 250, 255-262, 355 shot, 247-248, 262 replays, 221-222 Tertium quid, 298-300, 304 and sound, 318-319 running time of, 246 Texts, multiple, 348, 356 story, 245, 248, 262 scanning, 231 Theater stage, lateral action on, 176 subjective, 211-215, 222, 249-250 shot time in, 247-248 Thematic and video/audio structural slow motion in, 238-239 analysis, 355 function of dissolves, 259 sound in, 308-310 See also Time vectors function of lighting, 37, 40-41 structural unit of, 230 Time-lapse photography, 210 matching, 352 and tilting technique, 90-91, 125-126, 171, 250 rhythm control, 260 Time/motion image element, time vectors in, 217-222 11, 13-14, 207-211 Thompson, Kristin, 325 vectors in, 106-111 Time vectors Thompson, Robert J., 162 viewer/performer relationship in, in edited videotape and film, Thomson, David, 297, 305, 325 192-194 221-222 Three-dimensional field Television screen in live TV, 217-219, 222 building screen volume in, aspect ratio of, 74-77 in recorded TV and film, 219-222 165 - 181asymmetry of, 89, 97-99, Timing, 245–248, 262. See also depth and volume in, 141–162 110-112, 122-125 Motion; Pace of timing; Time z-axis in, 141-143 attraction of mass, 96 Tints and tones of colors, 49, 56 See also Depth of field; Volume; figure-ground paradox, 179-181 Z-axis Tonal matching, 352, 357 and golden section, 122-124, 139 Tiemens, Robert K., 87, 112, 205 Tonal montage, 302. and graphic weight, 96, 116-119, See also Montage 122, 125, 137 Tilting technique, 90–91, 125–126, horizontal orientation of (x-axis), 171, 250 Tones and tints of colors, 49, 56 141-142, 161 Timberg, Bernard, 15 Topological changes, 160-162

Transitional devices	V
cutting (image change), 155, 252, 256–259, 262	165, V/A. <i>S</i>
digital video effects (DVE), 1	00, Value.
160–161, 178, 231–232, 260–262	Vanish
dissolves, 155, 258-260	Vector
fades, fade-outs, 260, 263	and
jump cut, 199, 256–258	
wipes, 261, 263	and
Triad (harmonic structure), 335	and
Triangle lighting, 33	and
Twain, Mark, 316	and
Twelve-tone scale, 334	stal
Two-dimensional field	strı
and asymmetry of the frame,	See
89, 97–99, 110–112, 122–1	25 Vector
and balance, 122-126, 137	Vector
and divided screens, 136-137	ang
extending with multiple screen 130–136	ens, and
and figure and ground, 6, 99-	con
234–236	con
and graphic mass and magne	
force, 116–122	as d
horizontal and vertical	
orientations, 89–91	dire
and magnetism of the frame, 89, 92–96, 116–119, 125, 1	dist
and object framing, 126–130,	dive
and psychological closure,	and
101–105, 111, 126–128	gra
stabilizing, 116–122	ind
structuring, 115–138	
and vectors on screen, 106–11	12, and
See also Area	mag
Joe moo Hed	mo
	sou
U	stru
	tim

Up/down diagonals, 97-98 Ushenko, Andrew Paul, 113 Uspensky, Boris, 163

See Video/audio See Brightness ning point, 147, 161 fields, 106 d camera angles, 198–203, 205, 274-277, 289 d continuity editing, 266–286, 289 dissolves, 258–260 d multiple screens, 130–136 d screen space, 106 oilizing, 116–122 acturing, 115 also Vectors line, 272-278

les for vector continuity, 199 balance, 122-126, 138 tinuing, 109–112, 131–133, 199, 266–267 verging, 110–112, 121, 272-273, 279-281 lirectional forces in screens, 106-111 ections of, 109–111, 132 tribution of, 119–122 erging, 110–112, 272–273 event intensification, 200-203 phic, 106-107, 121-122, 132, 266 ex, 107, 119–122, 133–135, 267-278 induced action, 253 gnitude of, 108-109, 220, 222 tion, 108, 250-262, 279-286 nd, 330-332 ictural force of, 119-122 e, 217–221, 222 types of, 106-108 and z-axis motion, 236-238, 282-284 See also Vector fields

Vertical plane, 89–91, 105 Video flashbacks, 221, 347 proxemics, 190 tape, 219-222 See also Transitional devices

Video/audio combining, 345-351, 356 gestalt of, 345 matching criteria, 351-355, 357 phasing of, 347 structural analysis, 353-355 See also Picture/sound combinations

Viewpoint. See Field of view Visual dialectic, 303-304 Visualization, 183-205

Volume

conflict of, 174 and dollying, 253-255 duality, 165–171, 253–255 negative, 165-166, 169-170, 181 and open set, 170-171 positive, 166-168, 181 and z-axis blocking, 165, 176-177, 198, 250

W

Wagner, Richard, 319 Wakshlag, Jacob, 205 Walker, Edward L., 162 Web, World Wide, 115, 302 Weber, Carl Maria von, 319 Weight perception factors, 116 Weintraub, Daniel J., 162 Weis, Elisabeth, 325 Well-Tempered Clavier, The, 343 Wellpot, Jack, 45 Wertheimer, Max, 105, 113, 139

White-balancing, 55

"White-out," 40

Whole-tone scale, 334

Wide-angle lens, 151–156, 171–172

and aerial perspective, 154, 156

and close-ups, 76–77, 174–175

and depth of field, 150–151, 156

distortion of, 174–175, 181

and linear perspective, 153–154, 156

and overlapping planes, 151, 156

and relative size, 152, 156

Wide screen. See Cinemascope
Width of screen. See X-axis
Wilfrid, Thomas, 68
Wilson, Benjamin P., 325
Wingler, Hans M., 15
Wipes, 261, 263. See also Transitional devices

and traffic density, 172

and z-axis, 150-156

Woal, Mike, 139

Wolfe, Thomas, 223 Wölfflin, Heinrich, 112 Wood, Donald N., 139

X

X-axis, 141-142, 161, 250, 317-318

Y

Y-axis, 141-142, 161

Z

Z-axis

articulating, 165–166, 171–175, 181 blocking, 165, 176–177, 198, 250 and camera placement, 286–287 cross-shots, 197 and depth, 141–162 and dollying, 253–255 motion, 108, 250–262, 279–286 in movies, 166
multiple, blocking, 177, 198
and narrow- and wide-angle
lenses, 150–156
position change of, 276–277
and staging, 176
successive, 271–272
in three-dimensional field,
141–143
in three-screen space, 135–136
vectors, 110–112, 236–238,
282–284
and zooming, 253–255

Zeno, and film, 225-227, 241

Zero-time quality of the present, 216–217

Zettl, Erika, 301

Zettl, Herbert, 31, 45, 60–61, 71, 87, 113, 139, 162–163, 205, 243, 263, 289, 305, 325

Zingrone, Frank, 15

Zooming and dollying, 155, 252–255, 262